WISDOM EMBODIED

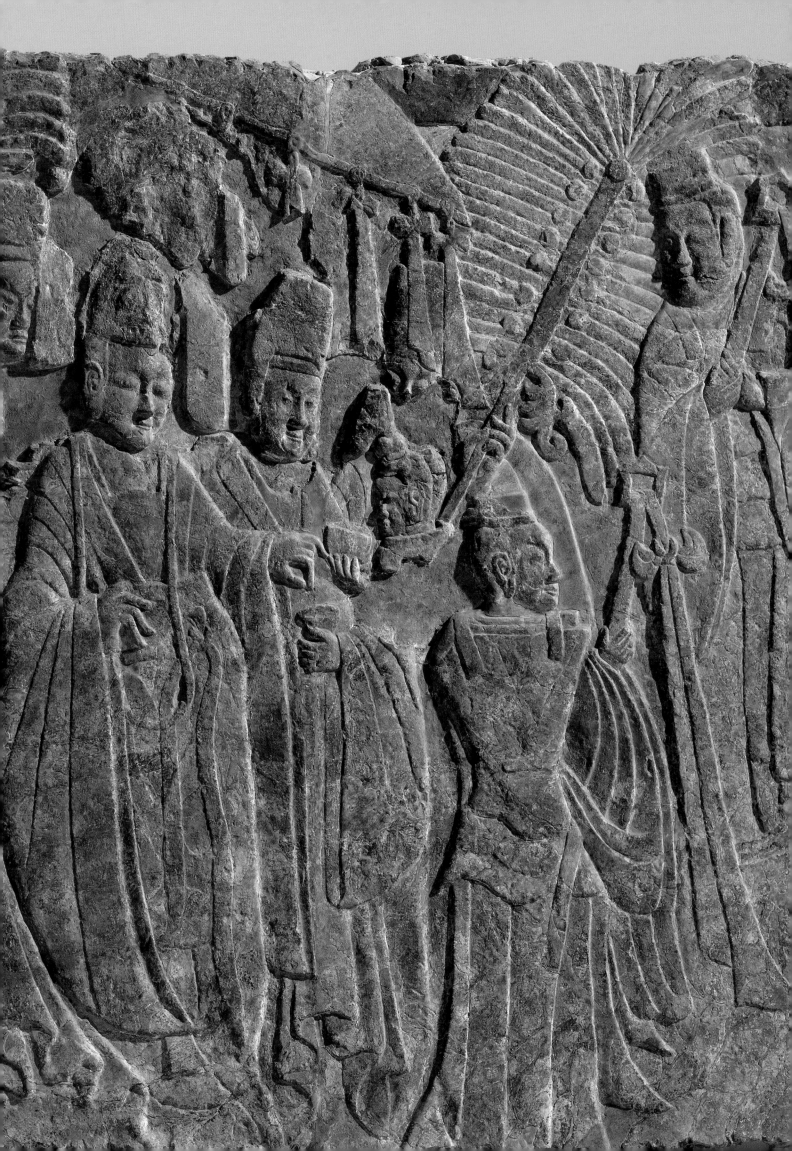

WISDOM EMBODIED

CHINESE BUDDHIST AND DAOIST SCULPTURE
IN THE METROPOLITAN MUSEUM OF ART

Denise Patry Leidy and Donna Strahan

With contributions by Lawrence Becker,
Arianna Gambirasi, Takao Itoh, Mechtild Mertz, Won Yee Ng,
Adriana Rizzo, and Mark T. Wypyski

The Metropolitan Museum of Art, New York
Yale University Press, New Haven and London

Published by The Metropolitan Museum of Art, New York
Gwen Roginsky, Associate Publisher and General Manager
Peter Antony, Chief Production Manager
Michael Sittenfeld, Managing Editor
Robert Weisberg, Assistant Managing Editor
Jennifer Bernstein, Editor
Rita Jules, Miko McGinty Inc., Designer
Douglas Malicki, Production Manager
Philomena Mariani, Bibliographic Editor

Separations by Professional Graphics, Inc., Rockford, Illinois
Printed by Brizzolis Arte en Gráficas, Madrid
Bound by Encuadernación Ramos, S.A., Madrid
Printing and binding coordinated by Ediciones El Viso, S.A., Madrid

Jacket illustration: Buddha, probably Amitabha (cat. no. 13)
Back of jacket: Bodhisattva Avalokiteshvara with One Thousand Hands and One Thousand Eyes (cat. no. 33)
Frontispiece: Emperor Xiaowen and His Court (cat. no. 6), detail

This catalogue is made possible by the Joseph Hotung Fund.

Library of Congress Cataloging-in-Publication Data

Metropolitan Museum of Art (New York, N.Y.)

 Wisdom embodied : Chinese Buddhist and Daoist sculpture in the Metropolitan Museum of Art / Denise Patry Leidy and Donna Strahan ; with contributions by Lawrence Becker . . . [et al.].
 p. cm.
 Includes bibliographical references and index.
 ISBN 978-1-58839-399-9 (hc: the metropolitan museum of art)— ISBN 978-0-300-15521-1 (hc: yale university press) 1. Buddhist sculpture—China—Catalogs. 2. Taoist sculpture—China—Catalogs. 3. Sculpture, Chinese—Catalogs. 4. Sculpture—New York (State)—New York—Catalogs. 5. Metropolitan Museum of Art (New York, N.Y.)—Catalogs. I. Leidy, Denise Patry. II. Strahan, Donna. III. Becker, Lawrence. IV. Title.
 NB1912.B83M48 2010
 730.951'0747471—dc22

 2010037222

ISBN 978-1-58839-399-9 (hc: The Metropolitan Museum of Art)
ISBN 978-0-300-15521-1 (hc: Yale University Press)

Contents

Acknowledgments

Any project requires the goodwill and support of many individuals. This volume is no exception. Thanks are due, first, to James C. Y. Watt, Brooke Russell Astor Chairman of the Department of Asian Art, for his initial and continuing support of the research that underlies this volume. Management of the project benefitted from the skills of many individuals in the Department of Asian Art, including Judith Smith and Hwai-ling Yeh-Lewis. Special thanks are due to Rebecca Grunberger and Alison Clark for their Herculean efforts in procuring comparative images and organizing new photography of the collection. Departmental technicians Beatrice Pinto, Imtikar Ali, Lori Carrier, and Luis Nuñez moved the objects, often more than once, back and forth to the conservation and photography studios with their usual patience and care. Zhixin Jason Sun and Shiyee Lee offered gracious advice regarding the always thorny issue of translating Chinese inscriptions, and Erica Yao provided additional help with translations as well as with the publications lists for the catalogued works during her tenure at the Museum as a Jane and Morgan Whitney Fellow.

The technical side of the project could not have been completed without the dedication of Won Yee Ng, Project Conservator. We also express our grateful thanks to Marijn Manuels, Conservator, for his assistance in sampling the wood sculptures for radiocarbon dating and in preparing appendix F. Much appreciation is owed to Tony Frantz, Research Scientist, for identifying all the stone in the works included in the catalogue. Over the years, conservation interns Raina Chao, Alisa Eagleston, Ariel O'Connor, and Kate Wight have contributed invaluable work on individual sculptures.

The new, detailed photography of the sculptures in the catalogue is the work of Oi-cheong Lee in the Museum's Photograph Studio and reflects his understanding and appreciation of the art. The thoughtful, precise, and intelligent editing of Jennifer Bernstein added substantially to the text, and Miko McGinty and Rita Jules provided a striking and appropriate design. In the Editorial Department, Peter Antony and Doug Malicki shepherded the book ably through the production process. Harriet Whelchel, with the assistance of Elizabeth Zechella, performed expertly as the department's interim managing editor. Gwen Roginsky, Associate Publisher and General Manager, made it possible for all this work by the aforementioned individuals to be seen to fruition.

Finally, this volume would not have been possible without the vision and generosity of Sir Joseph Hotung, whose funds supported the publication. Thank you.

Denise Patry Leidy
Curator, Department of Asian Art, The Metropolitan Museum of Art

Donna Strahan
Conservator, Sherman Fairchild Center for Objects Conservation, The Metropolitan Museum of Art

Foreword

Scholarship in several disciplines informs this evocatively titled reexamination of Chinese religious sculpture. The Museum's collection, the largest in the West, was assembled largely from 1920 to 1950, during a period marked by a rising interest in Asia and its multifaceted Buddhist traditions. The phenomenal explosion in archaeology in China since the 1960s, which has yielded an incalculable amount of material for the study of Chinese history and its impact on world culture, has also illuminated the stylistic and iconographic development of Chinese Buddhist art. In addition, the vivacity of Buddhist studies globally over the past thirty years—spurred, in part, by new research at archaeological sites and cave temples in China—has yielded insights into many works in the Metropolitan's collection. The collection itself, which ranges in date from the fourth to the twentieth century and includes portable shrines carved in wood, elegant bronze icons, and monumental stone representations, serves as an exemplar for the fascinating dialogue between Indian and Chinese cultures that characterizes the development and spread of Buddhist imagery (and that of related Daoist traditions) in China.

The Museum's contributions to scholarship in the field of Chinese art have long been supported by the Joseph Hotung Fund, and we are grateful to have its support for this publication. Written by Denise Patry Leidy, Curator in the Department of Asian Art, and Donna Strahan, Conservator in the Sherman Fairchild Center for Objects Conservation, the volume is the first study of Chinese religious sculpture to incorporate the results of scientific analysis, performed by Strahan and a number of her colleagues at the Museum. In addition to chapters discussing the overall development of Buddhist thought and imagery in China and the techniques used in the manufacture of works in metal, stone, wood, clay, lacquer, and ivory, the catalogue includes in-depth entries focusing on fifty works of art chosen for both their aesthetic quality and their scholarly significance; an illustrated checklist of other works in the collection; and detailed results of the analysis of the wood species and metal alloys used in the production of these enduring and iconic works of art. Many of the works in the collection have been redated or assigned to a different region of China as a result of this combined art-historical and scientific research.

Thanks to these important scholarly advances—and to beautiful new photographs that show the sculptures to the very best advantage—*Wisdom Embodied* will serve as a linchpin in the continuing study of Chinese religious sculpture and its relationship to other Asian traditions, particularly those of Korea and Japan, for which China rather than India often served as the source.

Thomas P. Campbell
Director, The Metropolitan Museum of Art

WISDOM EMBODIED

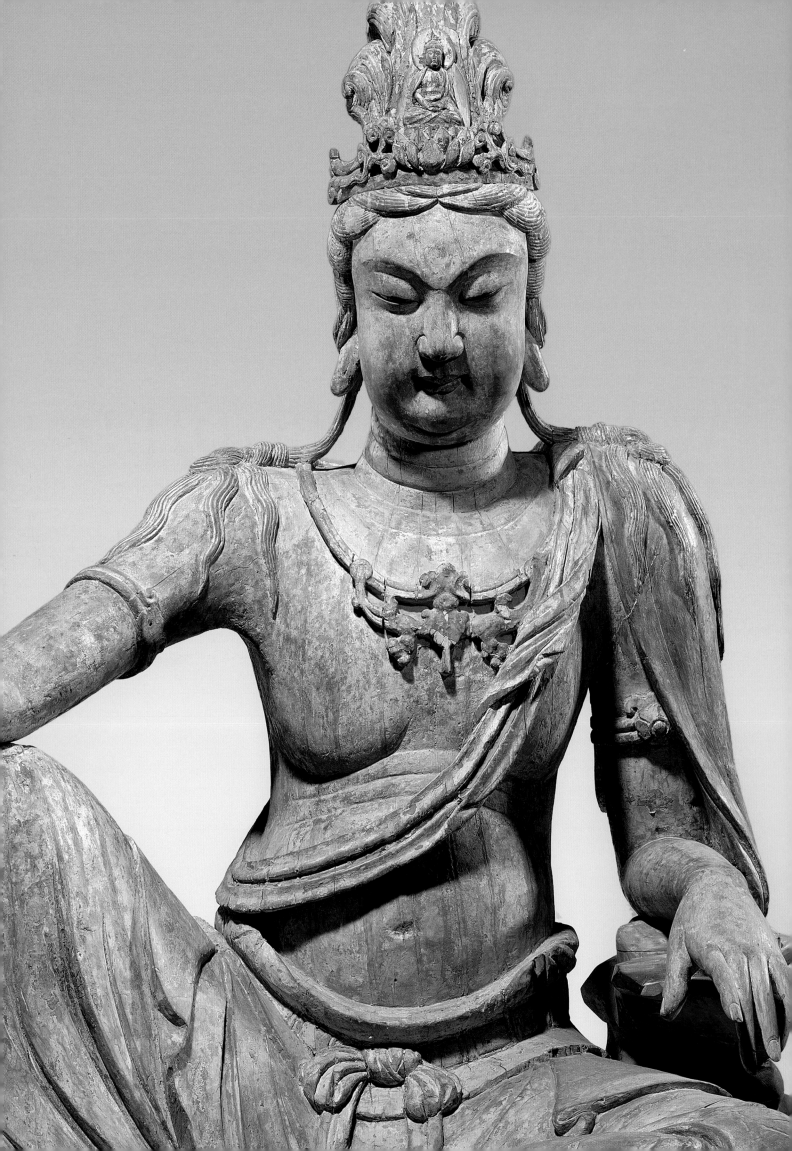

Buddhism and Buddhist Sculpture in China

A Brief Overview

DENISE PATRY LEIDY

The long-lasting interchange between the beliefs, practices, and imagery associated with the Indian religion of Buddhism and those found in Chinese traditions remains one of the most fascinating dialogues in world history.[1] Buddhism began with the life of one man, Siddhartha Gautama, who died some time around 400 B.C.E. Now revered as the Buddha Shakyamuni, Siddhartha was born in the northeastern reaches of the Indian subcontinent (now Nepal) during a time of great economic, social, and cultural turmoil. According to a worldview prevalent at the time, he had already lived numerous lives, some in human form and some as an animal. In the Buddhist perspective, the merit he had acquired during those virtuous lives enabled him to be reborn one last time, to attain enlightenment (or become a Buddha), and to share with others the wisdom he had gained.

Written versions of his biography, which postdate his actual life by centuries, indicate that he was born into a family of some status and was deliberately sheltered from the harsh realities of existence because a fortune-teller had predicted at his birth that he would become either a secular leader or a spiritual teacher; the former was deemed the preferable path, and every attempt was made to wed young Siddhartha to the pleasures of life. Nonetheless, Siddhartha managed to escape his pampered cocoon four times, witnessing various unpleasant states of humanity—sickness, old age, and death—and encountering, the final time, one of the many ascetic-teachers who wandered India during this period. After grappling with these troubling revelations, Siddhartha understood that life is inevitably difficult and often painful, and he resolved to leave his luxurious home, beautiful wife, and newborn son in order to study reality more deeply and learn how to transcend the endless cycle of death and rebirth. He practiced austerities with various teachers and groups of students for about six years before deciding that such activities would not lead to the understanding he sought. After accepting some nourishment, he sat under a fig tree (known henceforth as the bodhi tree; *bodhi* means "enlightenment" in Sanskrit) and vowed to meditate there until he had achieved enlightenment. Despite repeated attempts by the forces of evil to thwart him with distractions such as gorgeous women and violent storms, Siddhartha persevered, and when he finished his meditation, he had gained the supernal knowledge that he sought. After some consideration, he decided to share this understanding with others, and he began to teach, quickly attracting disciples, including some individuals who had previously practiced austerities with him and had initially disparaged his decision to find a different path.

The understanding that Siddhartha achieved is often termed the Four Noble Truths: existence is fundamentally painful; this pain is the result of desire for things and states of being; the pain can be relieved; and a group of eight practices known as the Eightfold Path is the cure. This path stresses the development of right and proper perceptions, thought, speech, actions, livelihood, effort, mindfulness, and concentration. It is designed to guide a practitioner through multiple lifetimes, ideally as a human being, and help him escape or transcend the potentially endless cycle of rebirth and become a Buddha. Siddhartha's own escape, known as his *parinirvana*—his passage into the transcendent state of nirvana—occurred when he was about eighty years old.

Opposite: Detail of Water-Moon Avalokiteshvara (cat. no. 24)

Siddhartha's teachings were preserved by his followers, who formalized monastic traditions and began, over time, to record the history, teachings, and activities of the historical Buddha. Today, these writings survive primarily in three languages: Pali, an Indian language designed for written documents that was also used in Sri Lanka and Southeast Asia; Chinese, used in Korea and Japan as well as in China proper; and Tibetan. The literature is voluminous. For example, the Chinese-language version of the Tripitaka (literally, "three baskets"—the name for the Buddhist canon), which is best known today in a version assembled in Japan in the early twentieth century,[2] contains more than 3,200 documents and, in many cases, multiple versions of a particular text. These documents are known as sutras or tantras if they record teachings and as shastras if they offer exegesis.

In addition to preserving the biography and teachings of the historical Buddha, some of the texts provide information regarding the history and development of the Buddhist tradition. Not long after Siddhartha's death, disagreements arose, and three councils were held by his disciples to determine the proper means of transmitting his teachings and the appropriate behavior of clerics and laypeople. One of these early meetings is said to have occurred under the auspices of Ashoka (r. ca. 273–232 B.C.E.), the famed leader of the extensive Mauryan Empire, which marked the first unification of the Indian subcontinent under one ruler. Ashoka, who is believed to have become a Buddhist at least partially in remorse for the suffering caused by the warfare that preceded this unification, is credited with helping to spread Buddhism throughout South Asia as well as into Southeast Asia. He is also said to have sent missionaries west, though with no apparent effect. Texts also record that a fourth council was convened by Kanishka I (r. ca. 127–47 C.E.), one of the most powerful rulers of the Kushan Empire (2nd century B.C.E.–early 3rd century C.E.), which included much of what is now northern India, Pakistan, and Afghanistan.

There are no images of the Buddha in human form in the artistic remains dating from the period of Ashoka's rule.[3] Instead, the Buddha is represented symbolically, as a tree, a footprint, an empty throne, or a stupa or burial mound. Stupas, which inspired the development of the pagoda in China, Korea, and Japan, were used to mark the remains of Siddhartha and his followers and eventually became symbols for the immanence of the historical Buddha. Representations of the Buddha in human form appeared in India and Gandhara (roughly, present-day Pakistan) around the second century C.E., at about the time of Kanishka I's reign. The first figural depictions of the Buddha emerged from two different stylistic traditions: one is associated with centers in Gandhara; the other flourished

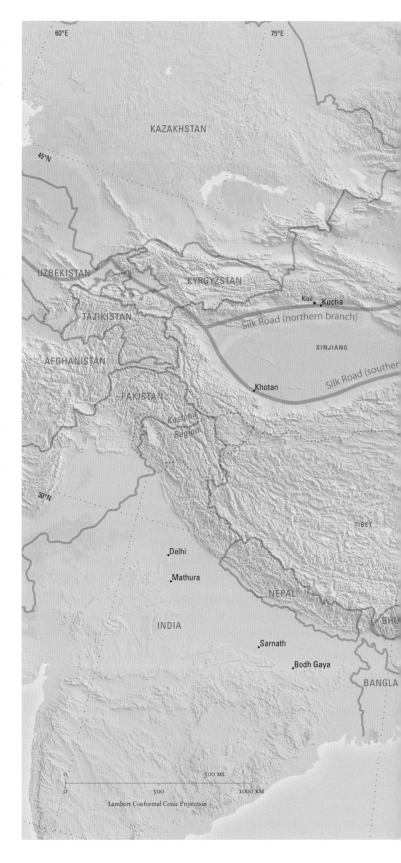

FIGURE 1. Map showing principal cave-temple sites and other Buddhist centers in China and Central Asia

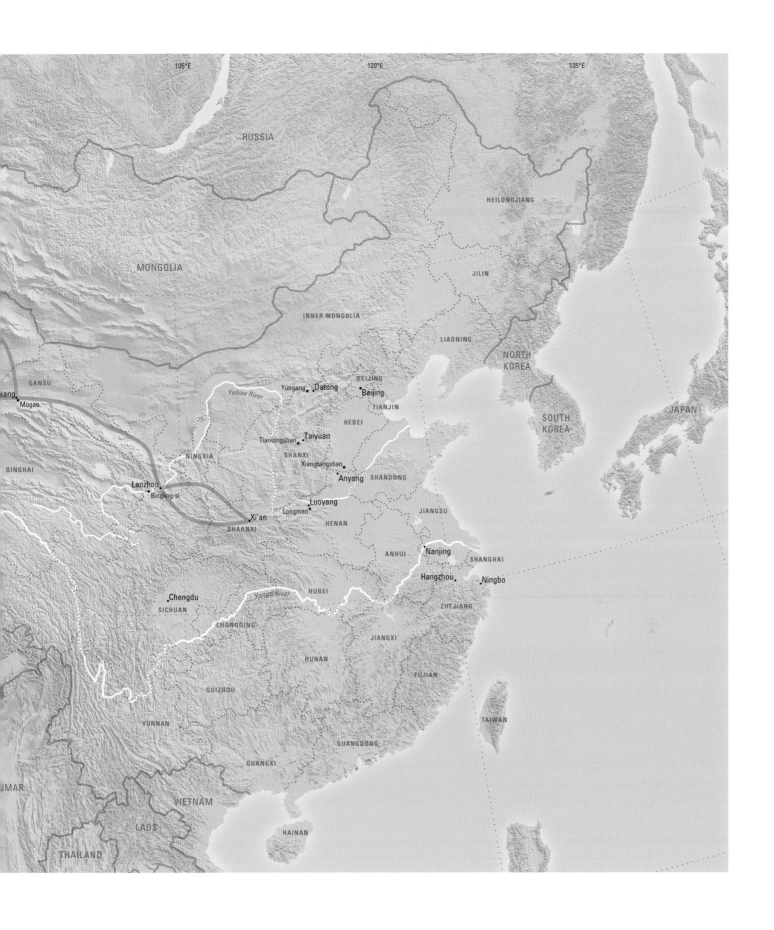

RUSSIA

MONGOLIA

HEILONGJIANG

JILIN

INNER MONGOLIA

LIAONING

NORTH
KOREA

GANSU

Yungang Datong

BEIJING

Beijing

SOUTH
KOREA

JAPAN

...ang

Mogao

Yellow River

TIANJIN

HEBEI

Tianlongshan Taiyuan

QINGHAI

NINGXIA

SHANXI

Xiangtangshan

Lanzhou

Bingling-si

Longmen

Luoyang

Anyang

SHANDONG

JIANGSU

Xi'an

HENAN

SHAANXI

ANHUI

Nanjing

SHANGHAI

Hangzhou

Ningbo

Chengdu

Yangzi River

HUBEI

SICHUAN

ZHEJIANG

CHONGQING

JIANGXI

HUNAN

FUJIAN

GUIZHOU

TAIWAN

YUNNAN

GUANGDONG

MAR

GUANGXI

VIETNAM

LAOS

HAINAN

THAILAND

around the city of Mathura in northern India. There are stylistic differences between the sculptures produced in Gandhara, which show an awareness of Greco-Roman traditions first introduced with Alexander the Great's conquest of northern Afghanistan (ca. 327 B.C.E.) and maintained through ties with the Roman Empire, and those made in Mathura, which adhere more closely to Indic traditions.

EARLY CHINESE IMAGERY: SECOND TO FOURTH CENTURY

The earliest Chinese images of the Buddha date to the second half of the second century C.E., soon after the development of such icons in South Asia, and there was no period in China in which Shakyamuni was represented primarily through symbols. Both historical records and visual evidence attest to Chinese knowledge of Buddhism in the first and second centuries C.E.,[4] during the Eastern Han dynasty (25–220 C.E.), when China rivaled Rome in size, population, wealth, and influence. By the mid-second century, an important Buddhist center had been founded in the dynasty's capital city, Luoyang, in Henan Province, attracting foreign monks as well as supportive laypeople, both foreign and Han Chinese. An Shigao, the first translator of Buddhist texts into Chinese, was one of several famous monks working in this center, as was the slightly younger Lokakshema; both had come from Parthia, a kingdom in northwestern Persia. Lokakshema was responsible for translating several works that stressed the practice of meditation and the taking of certain vows, particularly those intended to help others gain enlightenment.[5] These texts, which are preserved principally in their Chinese translations, include one of the earliest records of the making of images of the Buddha: a version of the Perfection of Wisdom Sutra (Prajnaparamita) states that such images were made to help men revere the Buddha and therefore acquire religious merit.[6] These translations also provide some of the earliest documentation of practices that are now catalogued under the term Mahayana Buddhism. Unlike earlier Buddhist traditions, formerly called Hinayana (literally, "lesser vehicle") but now known as Nikaya, the embryonic Mahayana sutras have a strong visual component that stresses the ability to see the Buddha and other divinities as a result of meditation and related practices. They also celebrate the role of the bodhisattva, a being whose essence (*sattva*) is spiritual wisdom (*bodhi*) and who has attained enlightenment in order to help others.

Although the issue is still a subject of extensive scholarly debate, it is hard to believe that changes in Buddhist practice preserved in Chinese translations of the second

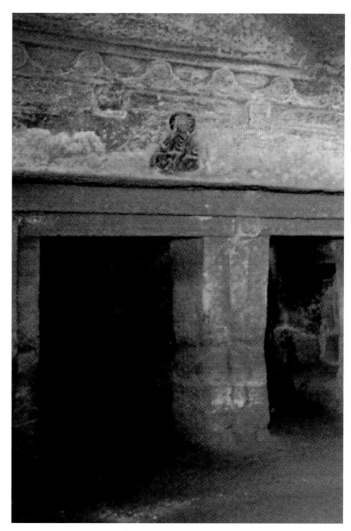

FIGURE 2. Mahao tomb. Sichuan Province, late 2nd century C.E.

century C.E. have no relationship to the creation of an anthropomorphic image of the Buddha in India at approximately the same time: in other words, it is interesting that the earliest Chinese representations of the Buddha date to the late second century C.E., about the same time they appeared farther west. These representations are associated with a funerary cult in which tombs, often enormous ones, were constructed to house the deceased and were furnished with either bronze and lacquer vessels or pottery facsimiles of such worldly goods. One of the best-known early Chinese Buddhas (fig. 2) is carved on the lintel of a tomb at Mahao, in Sichuan Province.[7] This figure derives from images made in Gandhara and related centers, such as that found seated at the top of a reliquary excavated in 1908 (fig. 4). Both Buddhas are seated in a meditative posture and hold their right hands up with the palms facing outward in a gesture of reassurance known as *abhaya mudra*. Both have haloes, a symbol that defines divinity in many cultures, and both wear large rectangular shawls that cover the shoulders. The shawl is a traditional article of South Asian monastic clothing. The cranial

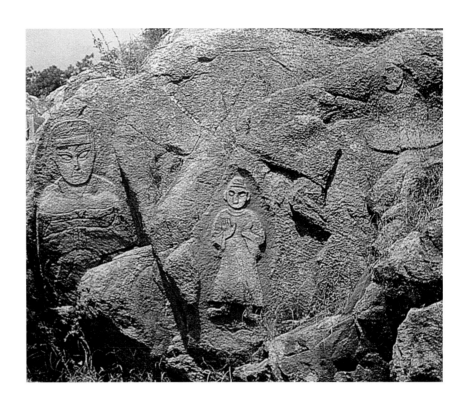

FIGURE 3. Standing Buddha (center) and other reliefs at Mount Kongwang (Kongwang-shan). Jiangsu Province, late 2nd–early 3rd century C.E.

protuberance at the top of the head is one of several marks used in India to signify spiritual advancement. It is known as the *ushnisha* and serves to indicate the consummate wisdom of the Buddha.

The Buddha on the reliquary from Gandhara is attended by two standing figures, often identified as Indic deities such as Brahma and Indra, and there are additional representations of seated Buddhas and standing attendants in the scrolling vine on the body of the container. An inscription states that the work was made during the reign of Kanishka I for the welfare and happiness of all beings and defines the reliquary as a "perfumed chamber," a term

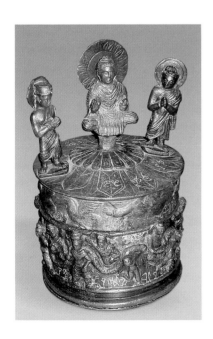

FIGURE 4. Reliquary with Buddha and attendants. Pakistan (ancient region of Gandhara), ca. 100–150 C.E. Bronze, H. 7½ in. (19 cm). Peshawar Museum of Art

typically used to designate a room in a monastery or home set aside for the use of the historical Buddha (even after his *parinirvana*). The inscription is written in Kharosthi, a script developed in the Gandharan region for recording Indo-European languages, which was often used for mercantile activities along the Silk Road.

In addition to the Buddha at Mahao, seated Buddhas are also found on sepulchral objects such as the bronze money trees from Sichuan and in the decoration of mirrors from numerous sites throughout China.[8] It remains unclear whether these representations were actual devotional icons or simply exotic additions to the panoply of Chinese funerary imagery valued for their auspiciousness. It is worth noting, however, that several contemporaneous images show a more nuanced understanding of Buddhism. For example, the murals painted on the interior walls of a multichambered tomb excavated at Helinger, in Inner Mongolia, in 1971 include a figure riding an elephant—a possible reference to the birth of the Buddha—as well as an image of a circular object that is defined in an inscription as a reliquary, a symbol of the *parinirvana*.[9] The use of relics, both real and symbolic, was introduced into China with Buddhism, and the appearance of this image, as well as the reference to the Buddha's biography, argues for a deeper understanding of Buddhism than is implied by a reading of such images as mere exoticism used in a funerary context.

The more than one hundred relief sculptures carved on the cliffs of Kongwangshan, in Jiangsu Province, which are dated to the late second or third century, contain

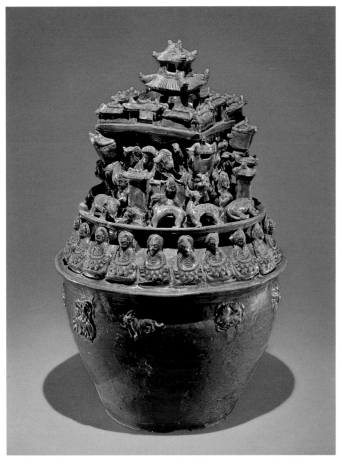

FIGURE 5. Funerary urn (*hunping*). Zhejiang or Jiangsu Province, Western Jin dynasty (265–317), ca. 3rd century. Earthenware with green glaze, H. 17⅞ in. (45.4 cm). The Metropolitan Museum of New York, Charlotte C. and John C. Weber Collection, Gift of Charlotte C. and John C. Weber, 1992 (1992.165.21)

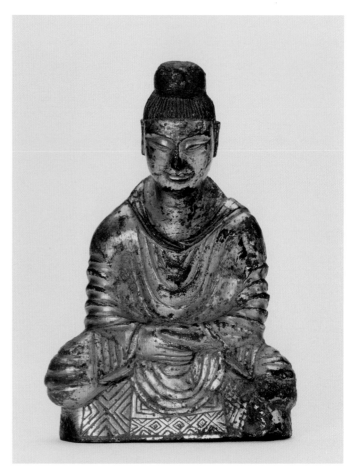

FIGURE 6. Buddha. Sixteen Kingdoms period (304–439), ca. 300. Gilt bronze, H. 5¼ in. (13.4 cm). Xi'an City Institute of Cultural Properties Protection and Archaeology

representations of the Buddha (see fig. 3) as well as scenes that illustrate narratives from his final lifetime. A large stone elephant found there is thought to refer to either Siddhartha's birth or the use of elephants in relic processions,[10] and a scene showing Siddhartha sacrificing himself to save a starving tigress and her cubs is one of several hundred jatakas, stories of the past lives of the historical Buddha that stress his virtuous actions and the accumulation of merit that allowed him eventually to become a Buddha. Another scene shows the *parinirvana*, in which the reclining Buddha is attended by a host of monks and other followers. Kongwangshan also treats themes that are linked to Daoism, an indigenous tradition that derives from the word *dao* ("way" or "path") and comprises teachings and practices that lead to a metaphysical understanding of the universe, which is constantly changing. Daoism draws on the works of the semimythological Laozi (see cat. no. 38) and Zhuangzi, said to have lived during the Warring States period (ca. 475–221 B.C.E.). Daoist terms were often used to translate Buddhist concepts in the second and third centuries and later. In addition, it is possible that the interest in representing Daoist divinities that developed in the second and third centuries was spurred, in turn, by the introduction of Buddhist icons at that time.

The carvings at Kongwangshan were executed around the time of the collapse of the Eastern Han dynasty, in 220 C.E., after which China was divided into three short-lived polities. The country was briefly reunited in the second half of the third century under the Western Jin dynasty (265–317), which was based, like the Eastern Han, in the city of Luoyang. During this period, the southern provinces of Zhejiang and Jiangsu were noted for the production of funerary urns decorated with fanciful buildings and small seated Buddhas (see fig. 5).[11] The latter are usually shown with their hands placed one above the other in their laps, palms up, in a gesture indicative of meditation known as *dhyana mudra* but otherwise have the same proportions and style of clothing found earlier at Mahao and other tombs in Sichuan Province, further attesting to the importance of traditions from the northwestern part of South Asia in the introduction of Buddhism into China.

After the dissolution of the Western Jin, China was effectively divided north-south. The north was ruled by sixteen different polities, many of which were controlled by tribal confederations with ties to the nomads of Central Asia. Foreign monks continued to arrive in China, often settling in the capitals of the various northern polities. It is interesting, however, that many of the famous clerics of the fourth and fifth centuries, unlike the first translators at Luoyang, who came from the eastern reaches of the Persian world, hailed from the oasis kingdoms of the Silk Road, reflecting the growth and wealth of those centers at the time.[12] Kucha, located at the western edge of present-day Xinjiang Autonomous Region, on the northern branch of the Silk Road, was a flourishing center for Buddhist practice from the fourth to the sixth century and played a seminal role in the development of Chinese Buddhist art. One of the best-known clerics in China at the time was Fotudeng, a native of Kucha noted for his miracle working and prognostication. Fotudeng also contributed to the growing corpus of translated texts and was an important teacher of early Chinese clerics, such as Shi Daoan (312–385). Another famed scholar and translator from Kucha was Kumarajiva (344–413), who may originally have been coerced into joining the Former Qin (351–94) court at Chang'an (now Xi'an).

A small gilt-bronze sculpture (fig. 6) excavated in 1979 in the vicinity of Xi'an is typical of the images made in northern China in the late third and fourth centuries. Unlike the earlier Chinese images, however, it is an independent, and presumably devotional, icon rather than a single element in a medley of funerary or Daoist themes. The Buddha is shown seated, once again, in a meditative posture and holds his hands in the appropriate gesture. He wears the voluminous shawl that is integral to clerical garb and has the cranial protuberance found in some of the earliest Chinese Buddhist images. He sits on a rug with

diamond-shaped decoration, placed on a platform that also bears geometric designs. An inscription in Kharosthi incised into the back of the base indicates that the work was commissioned to honor a descendant of the Marega clan, a group thought to have ties to Niya, a center on the southern branch of the Silk Road.[13]

The emergence and development of oases such as Kucha and Niya on the Silk Road, and the economic and political ties between those centers and polities in northern China, may have contributed to the introduction of cave temples into China in the early fifth century. In early Indian practice, renunciants sometimes made use of natural cave formations for seclusion and shelter; cave temples were a related phenomenon, except in that they were man-made structures, ranging from single chambers to enormous complexes that included halls for worship and teaching, living quarters for monks and travelers, and additional spaces such as libraries and kitchens. Although the earliest Indian constructions of this sort can be traced to the rule of Emperor Ashoka, they flourished in India, Afghanistan, Central Asia, and China much later, from the fourth to the eighth century C.E.

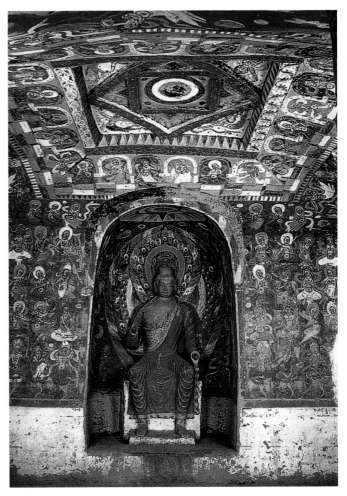

FIGURE 7. View of Mogao complex, usually referred to as "Dunhuang" after the nearby town

FIGURE 8. Buddha. Gansu Province (Dunhuang complex, cave 272, west wall), Northern Liang period (420–39)

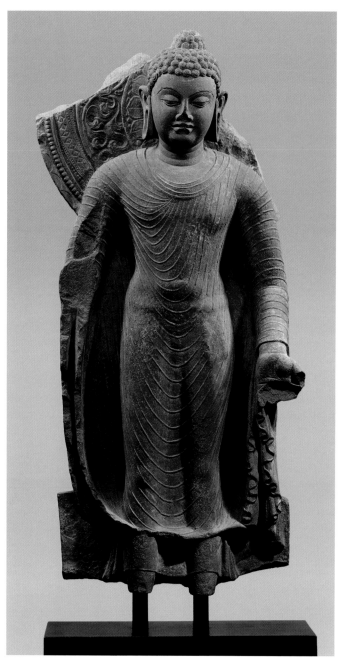

FIGURE 9. Buddha. India (Uttar Pradesh, Mathura region), Gupta dynasty (ca. 321–ca. 500), ca. 435–50. Sandstone, H. 33⅝ in. (85.5 cm). The Metropolitan Museum of Art, Purchase, Enid A. Haupt Gift, 1979 (1979.6)

The earliest Chinese cave temples are found in Gansu Province, particularly along the Hexi Corridor, one of the main access points between Chinese Buddhist centers and those located along the Silk Road.[14] The complex at Mogao (fig. 7), near the city of Dunhuang, is one of the largest and longest-lasting Buddhist centers in China: it contains nearly five hundred caves embellished with paintings and sculptures. The site is thought to have first been used around 366, by the monk Lezun, for meditation and other practices. The earliest extant caves at the site were created under the patronage of the Northern Liang (420–39 C.E.),

one of the many non–Han Chinese polities in the north at the time. Cave 272, one of three often dated to the Northern Liang period, is a small square chamber decorated with numerous paintings on the north, south, and west walls and with a carved niche containing a sculpture of the Buddha (fig. 8) in the center of the west, and most important, wall. The Buddha sits with pendant legs in what is often termed the "European pose," thought to identify him as Maitreya, who will become the teaching Buddha after the current cosmic era—in which Shakyamuni is the teaching Buddha—is destroyed, and the cosmic cycle begins anew.

The sculpture in cave 272 at Dunhuang shows an awareness of a new type of Buddha image that developed in India around the city of Sarnath in the mid-fifth century, during the rule of the powerful Gupta dynasty (ca. 321–ca. 500), and spread from there to centers on the Silk Road and into China. A Sarnath-style Buddha in the collection of The Metropolitan Museum of Art (fig. 9) has a powerful form, with a gracefully articulated waist and long legs. He wears traditional monastic clothing: a saronglike garment, visible on the lower legs, and a rectangular shawl. The head was once encircled by a large and wonderfully decorated halo. The thick, snail-shell-like curls of the hair and the elongated earlobes are other physical marks used in Indic traditions to distinguish individuals who are spiritually advanced. The longer, thinner proportions of this Buddha, which distinguish it from Kushan-period examples, are also found in the seated Buddha in cave 272. Moreover, the pleats of the clothing worn by the Chinese Buddha are also rendered with thin raised lines. The shawl, however, while falling diagonally from the left shoulder, covers the top of the right shoulder as well—an artistic device common in Chinese Buddhist sculpture that does not reflect the way such shawls could actually be worn and is not found in South Asian art.

This Gupta type of Buddha, as modified in the Gandharan region and Central Asia, continued to serve as a prototype for Chinese Buddhist sculpture during the Northern Wei dynasty (386–534 C.E.), when northern China was reunited under the control of the Tuoba Xianbei. The Tuoba were a seminomadic, probably ethnically mixed people from beyond China's northeastern border. In the early fourth century, they systematically conquered or absorbed the various polities of northern China (including the Northern Liang) and established an empire of great wealth, characterized by economic and cultural ties to Silk Road centers such as Kucha. They ruled their vast realm from Pingcheng (now Datong), in Shanxi Province, and are known to have moved monks and other knowledgeable individuals to the capital from elsewhere in China. Unfortunately, internecine strife and political rivalries at the

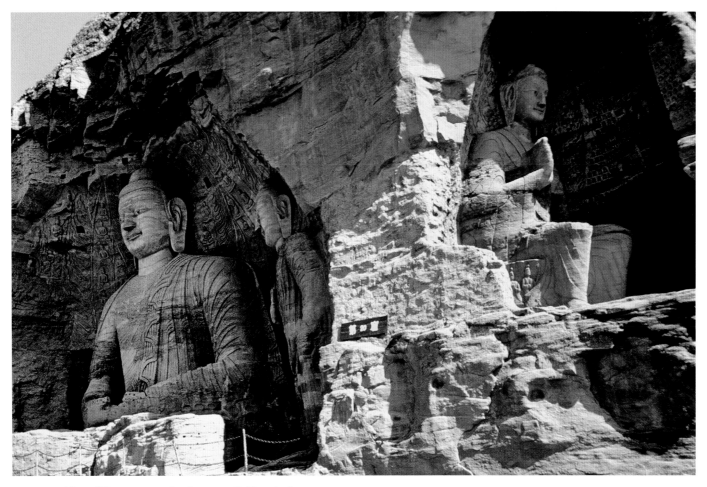

FIGURE 10. View of Yungang complex (caves 20 [left] and 19)

court, which led to an interdiction against Buddhism from 444 to 453, eradicated most of the textual and visual evidence of Buddhist practice at the time.

Discussion of Buddhism under the Northern Wei, therefore, remains focused on material from the latter part of the fifth century, such as certain caves at Dunhuang and the contemporaneous complex of fifty-three cave temples at Yungang, near Datong. This site is renowned for a group of five colossal Buddha sculptures, often identified with the first five rulers of the dynasty, in caves 16–20, which are thought to have been the first opened there (see fig. 10). Tanyao, a cleric from Liangzhou who became the superintendent of monks in 460, is known to have petitioned the court for permission to construct these sanctuaries. The seated Buddha in cave 20 follows the Gupta conventions found earlier at Dunhuang and also wears his shawl in a manner that is impossible with actual clothing. The inorganic rendering of the pleats, however, distinguishes this colossal sculpture from earlier works. Pleats that end in flame shapes such as these are often found in works produced in the second half of the fifth century; the peculiar treatment can be traced both to the Swat region of present-day Pakistan and to Kucha, illustrating the strong ties that existed between the Northern Wei and centers along the Silk Road.[15]

Relative to other cave-temple complexes in China, Yungang was active for a very short period of time. The opening of new sanctuaries there ended around 494, when the Northern Wei capital was moved southeast to the city of Luoyang, which briefly, again, became one of the major Buddhist centers in Asia. Spurred by a combination of political and economic factors, the geographic shift led to a greater awareness of a specifically Chinese aesthetic, as opposed to that imported from India and Central Asia, and to the development of a new style of Chinese Buddhist art that is exemplified by some of the earliest caves opened at Longmen (see fig. 16), not far from Luoyang. This center, which also saw imperial patronage in the late seventh and eighth centuries, is one of the most extensive cave-temple complexes in Asia, consisting of more than 2,300 sanctuaries and containing nearly 100,000 sculptures. Unlike Yungang, Dunhuang, and centers in Central Asia and on the subcontinent, Longmen is also rich in inscriptions—approximately 2,800 of them. Thus, it serves as a major resource for the study of Buddhism in China.

CHINESE DIMENSIONS: FIFTH TO NINTH CENTURY

An elegant gilt-bronze sculpture (fig. 11), dated by inscription to the year 518, exemplifies the new style associated with the second Northern Wei capital at Luoyang, a style also exhibited in the first series of caves at Longmen. The sculpture depicts two Buddhas, each encircled by a large mandorla, seated side by side on a rectangular base. Two small monks kneel on mats before the base, each holding what appears to be a lotus. Beneath the clerics, two lions guard a caryatid figure, who lifts an incense burner. The Buddhas themselves are twins: each holds his right hand in the gesture of reassurance and his lowered left in the gesture of offering (*varada mudra*); both are seated with one leg pendant and the other bent horizontally at the knee; and both have the cranial protuberance and long earlobes usually found in visual representations of the Buddha. The lower garments and large shawls are derived from Indian art, but the additional vestlike pieces worn beneath the shawls are a Chinese addition. The faces and physiques of the Buddhas are attenuated, with the bodies disappearing beneath cascading folds of clothing. The greater interest in the lines of drapery than in the volumes of the underlying bodies is typical of works produced in the early sixth century in the Luoyang region. The change in style can be linked to the attempt by the Northern Wei court to sinicize the mixed population by adopting and imposing Chinese names and issuing decrees regarding clothing and other matters.

The iconography of two Buddhas seated side by side is distinctively Chinese and has no parallel in South Asian art. Such paired Buddhas are understood to represent a seminal moment in the Lotus Sutra,[16] which was compiled around the first century B.C.E. and became particularly influential in East Asia. In a famous passage in the eleventh chapter, the Buddha Prabhutaratna (Dabao), the Buddha of the last era before this one, appears in a giant stupa in the sky while Shakyamuni is preaching, proving that he, like the historical Buddha, remains immanent. His appearance illustrates his vow to be present whenever the Lotus Sutra is taught. This text, which was translated into Chinese at least six times between the third and seventh centuries, is filled with miraculous happenings and dramatic metaphors. It states that the Buddha Shakyamuni did not become extinct after his *parinirvana* but still abides in the phenomenal world to guide the faithful. His lifetime as Siddhartha was an illusion designed to help devotees, who would otherwise be unable to grasp the reality of a transcendent being. The text also stresses the value of using different methods in the quest for enlightenment and the role of the historical Buddha in transmitting the various approaches. The Lotus Sutra is the primary

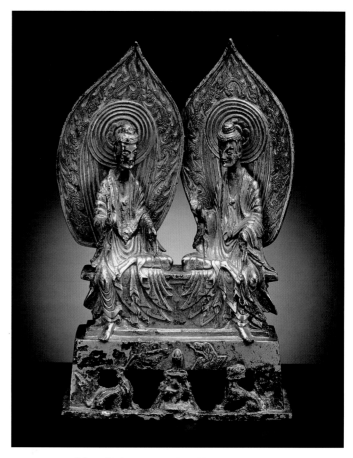

FIGURE 11. Buddhas Shakyamuni and Prabhutaratna. Hebei Province, Northern Wei dynasty (386–534), dated 518. Gilt bronze, H. 10¼ in. (26 cm). Musée Guimet, Paris

text used by the Tiantai branch of Buddhism, which is noted for its classification of Buddhist teachings into hierarchical groups and its emphasis on meditation. The Tiantai tradition, which developed in China in the sixth century, remains one of the more prominent branches of East Asian Buddhism.

The attenuated figures and cascading drapery seen in the early-sixth-century sculpture discussed above gradually disappeared over the course of the second half of the century, a period that saw the dissolution of the Northern Wei dynasty and the subdivision of northern China into western (Western Wei and Northern Zhou) and eastern (Eastern Wei and Northern Qi) polities. The combination of cascading folds for the lower garments and thinner-looking fabric for the upper garments, as seen on the central Buddha in a stele dated 557 (fig. 12), now in the collection of the Henan Provincial Museum, Zhengzhou, is typical of the mid-sixth century. The entourage that accompanies this Buddha, which includes two laymen, two bodhisattvas, two monks, and two guardians, is also characteristic of the period. A large inscription on the back of the stele states that it was commissioned by thirty members of a devotional society led by Zhang Dangui, Gao Hailing, and Huo Zao.

Steles first appeared in the mid-fifth century in Shanxi Province and were relatively common in the area around Luoyang throughout the sixth. The caryatid figure lifting an incense burner and attended by two donors and two protective lions at the bottom of the Zhengzhou example is standard in the imagery of Chinese steles, as are the dragons flanking the niche at the top. A figure is seated in the niche in a pose similar to that of the two Buddhas in the sculpture dated 518 (fig. 11). This so-called pensive pose was frequently used for bodhisattvas, particularly in the late fifth and mid-sixth centuries, and often, though not always, identifies the subject as Maitreya.[17] In the band below the niche and above the Buddha and his attendants, eight monks and one female figure attend a famous discussion between the layman Vimalakirti and the bodhisattva Manjushri, the personification of spiritual wisdom, as recorded in the Sutra on the Discourse of Vimalakirti.[18] This debate, which validated the importance of laypeople, was a major theme in Chinese Buddhist art of the late fifth and sixth centuries and often features in the imagery on steles.

An elegant standing bodhisattva excavated in Shandong Province in 1996 (figs. 13, 14) illustrates the interest in columnar form often expressed in Buddhist sculpture in the second half of the sixth century. The bodhisattva, who is unidentified, wears an elaborate crown and stands in a frontal pose. His right hand, which he once held up, probably in a gesture of reassurance, is now missing. The relatively thin clothing includes a vestlike garment; a long saronglike piece folded at the waist; and a small shawl with long, trailing ends, which falls across the chest, crosses in the center of the thighs, and drapes over the right and left wrists. A long beaded necklace falls across the front of the body in exactly the same pattern as the shawl, and additional, equally elegant adornments are shown at the sides. Hanging between the legs is an ornament composed of rectangular panels, decorated with a plump figure seated in meditation on a lotus, a leonine face spewing vegetation,[19] flowers, flaming jewels, and pearl roundels—a veritable potpourri of Indian and Central Asian motifs of the mid- to late sixth century. Traces of pigment on the front and back of the sculpture indicate that it was once brightly painted.

The columnar form of the Qingzhou bodhisattva reflects the complexity of influences found in Chinese art at this time. As was mentioned earlier, the rendering of volume in the representation of Buddhist deities is an Indic characteristic that appears and reappears in Chinese Buddhist sculpture during periods of close ties with South and Central Asia. In this case, the columnar rendering, which has parallels in contemporaneous tomb sculptures and paintings,[20] may reflect the direct influence of Central Asian, specifically Sogdian, artistic traditions. Based in present-

day Uzbekistan, the Sogdians were the premier merchants on the Silk Road from the fifth to the eighth century, and some lived and worked in China. Tomb goods, particularly funerary beds, reflecting Sogdian artistic traditions have been unearthed in some number there.[21] The figures represented in these astonishing works, all of which have been recently discovered, have columnlike physiques and wear thin clothing that defines the underlying form, in precisely the style found in Buddhist sculpture at the time.

The production of large freestanding sculptures of bodhisattvas, such as the work discussed above, is also characteristic of the second half of the sixth century. By this time, the term *bodhisattva*, which had originally been used to designate Siddhartha Gautama or any other individual at a certain point of spiritual advancement, had been redefined to denote celestial and salvific beings who

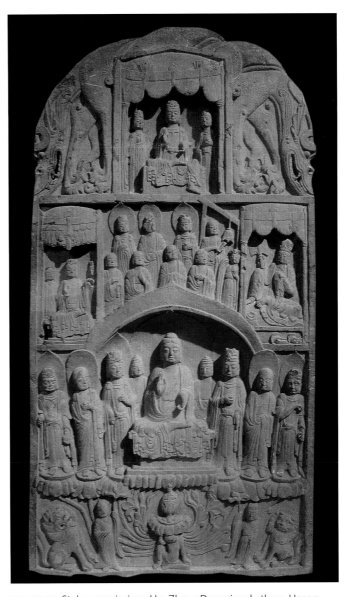

FIGURE 12. Stele commissioned by Zhang Dangui and others. Henan Province, Northern Qi dynasty (550–77), dated 557. Limestone, H. 42½ in. (108 cm). Henan Provincial Museum, Zhengzhou

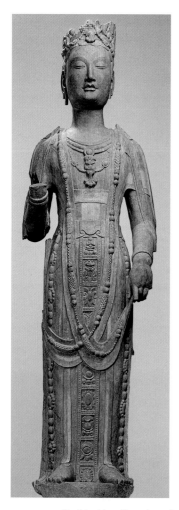
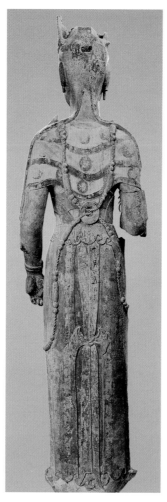

FIGURE 13. Bodhisattva. Shandong Province, Sui dynasty (581–617). Limestone with pigment and gilding, H. 53½ in. (136 cm). Excavated at Qingzhou (Longxing-si), 1996. Qingzhou City Museum

FIGURE 14. Back view of bodhisattva

had achieved the same state of spiritual development as a Buddha but had chosen not to transcend the chains of existence in favor of remaining in the phenomenal world, where they guide others in the quest for enlightenment. In early Chinese Buddhist art, bodhisattvas were rarely depicted; when they were, they were usually shown as attendants to a Buddha. By the sixth century, however, certain bodhisattvas, particularly Avalokiteshvara (Guanyin), the embodiment of the virtue of compassion, had become the focus of personal devotion. Sculptures, often large-scale, of these figures began to be produced independently rather than as part of a group of divinities attending a Buddha.

One reason for the growing importance of Avalokiteshvara and other savior-bodhisattvas was the development and flourishing of the Pure Land (Qingtu) tradition, which stresses devotion to the Buddha Amitabha, one of the celestial, or transcendent, Buddhas.[22] Practices focusing on Amitabha, which may have originated in Central Asia,

were known in China as early as the third century C.E. The tradition became formalized in the mid-sixth century, when the Indian monk Bodhiruci introduced the Chinese cleric Tanluan (488–532) to three texts describing Sukhavati, Amitabha's perfected realm; representations of the Pure Land first appeared at this time. The texts focus on attaining rebirth in Sukhavati through prostration, the calling of the Buddha's name (a practice known as *nianfo*), reflecting on and visualizing sacred realms such as Sukhavati, and the resolution to be reborn there.

The popularity of Pure Land Buddhism may have been spurred by the turmoil that defined the sixth century in China. In addition to strife between the varying northern regimes and between the north and the south, the period was marked by significant economic chaos, which led to illness and starvation. In Buddhist circles, such harsh realities led to the belief that the second half of the century was the *mofa*—an apocalyptic era when living numerous virtuous lifetimes seemed impossible and Buddhism itself might cease to exist. In response, Pure Land practice offered the possibility of rebirth in Sukhavati, where ideal living conditions create an atmosphere conducive to spiritual development. Although the Pure Land tradition, particularly from the sixth to the eighth century, stressed devotion to Amitabha, it is worth noting that other Buddhas and even some bodhisattvas, such as Avalokiteshvara, were also thought to be capable of creating and maintaining perfected realms similar to Sukhavati and that other divinities were also the focus of devotions of this kind.

At the center of a bronze altarpiece that is one of the earliest known images of Sukhavati (fig. 15), the Buddha Amitabha sits on a beautifully decorated throne, his head surrounded by an elaborate halo. An inscription on the back indicates that the work was dedicated in 593 by eight women of the Fan clan to ensure the rebirth of their ancestors and children in the Pure Land. In the background, seven small Buddhas are seated in the blossoms of the trees above Amitabha; a single phoenix, a traditional symbol of rebirth, is also situated among the branches. Tassels with pearls, a reference to the bejeweled nature of Sukhavati, hang from the trees. Two bodhisattvas, two monks, and two lay adherents (one male, one female)[23] stand beside the seated Buddha. At the bottom of the work, in the foreground, guardians and lions flank a small caryatid figure that lifts a lotus bud; in the center of the flower sits a minuscule figure representing a soul that has been, or will be, reborn in Sukhavati. Over time, this being will become a Buddha and transcend Amitabha's realm, which is a way station rather than the final goal of Buddhist practice.

This altarpiece was produced during the short-lived Sui dynasty (581–617 C.E.), when China was, once again, united under one rule. The Sui was quickly overtaken by

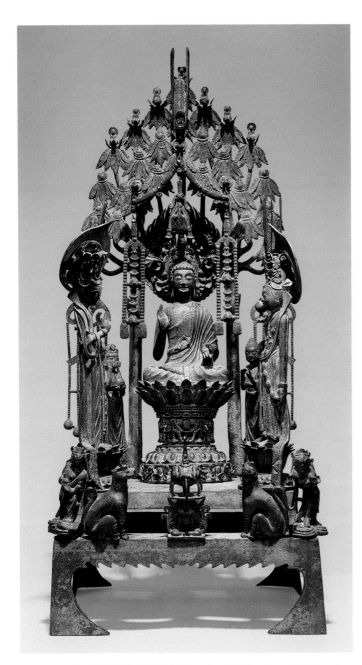

FIGURE 15. Buddha Amitabha in Sukhavati. Hebei Province, Sui dynasty (581–617), dated 593. Bronze, H. 30⅛ in. (76.5 cm). Museum of Fine Arts, Boston, Gift of Mrs. W. Scott Fitz and Edward Jackson Holmes, 1922

the long-lasting Tang dynasty (618–906), during which an economically and politically powerful China was the focal point for exchanges between West, Central, and South Asia, Korea, and Japan. Tang Buddhism saw the continuation of many traditions that had their roots in the sixth century, including those based on the Lotus Sutra and Pure Land practices. This seminal period in Chinese history also saw the flowering of a new variant of Buddhism and a new style that would serve as the foundation for the art of later centuries, both in China and in Korea and Japan.

The new variant, known as Esoteric Buddhism, was introduced into China in the eighth century by three intrepid foreign monks who studied with masters throughout Asia: Subhakarasimha (637–735), Vajrabodhi (669–741), and Amoghavajra (704–774). Best known today through material found primarily in Japan, the new form emphasized the importance of devotion to Vairocana, a celestial, or transcendent, Buddha understood to be the ultimate form of Shakyamuni, the historical, and therefore temporary, Buddha. It also introduced new manifestations of savior-bodhisattvas such as Avalokiteshvara and the use of cosmic diagrams known as mandalas. Many of the practices were intended to protect the nation and offered tangible benefits, such as health and wealth, to the ruling elite. Others involved complex rituals and forms of devotion designed for advanced practitioners.

Representations of the Buddha Vairocana first appeared in the vicinity of Kucha, at the western edge of what is now the Xinjiang Autonomous Region, in the fifth or sixth century and were found in China by the mid-sixth century. First mentioned in the fourth-century compilation known as the Sutra of the Heap of Jewels,[24] Vairocana plays a seminal role in the Flower Garland Sutra,[25] where he is described as the source for all Buddhas and bodhisattvas and all forms of sentience in the cosmos. The latter text was first translated into Chinese in the early fifth century and was retranslated twice during the Tang dynasty, once in a collaboration between Shiksananda, from Khotan, on the southern branch of the Silk Road, and Fazang, a sinicized Central Asian.

Fazang (643–712) is considered the third patriarch of the influential Huayan branch of Buddhism, which takes the Flower Garland Sutra as its central scripture. He is famous for using metaphors, often involving light, jewels, and mirrors, to explain the interpenetrability of all aspects of the cosmos, in which even the tiniest speck of dust can reveal profound truth. He is also noted for his systemization of the vast corpus of Buddhist texts and practices then extant in China into five groups, with the Flower Garland Sutra as the highest form of knowledge, followed by texts, such as the Sutra on the Discourse of Vimalakirti, that

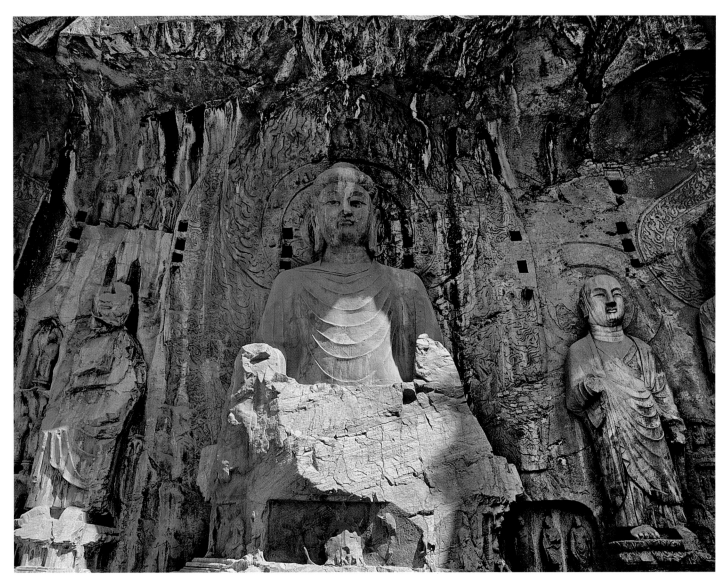

FIGURE 16. Buddha Vairocana and Disciples. Henan Province (Longmen complex [Fengxian-si], cave 1280), ca. 675. Limestone, H. of Buddha 56 ft. 3 in. (17.1 m)

accepted the possibility of a sudden awakening; those, such as the Lotus Sutra, classified as later Mahayana teachings; those deemed to be earlier Mahayana teachings; and those associated with the earliest (Nikaya) schools of Indian Buddhism. Fazang served as an advisor to the Tang emperor Gaozong (r. 650–83) and to his draconian and politically astute consort, who usurped the throne and ruled as Empress Wu Zetian (r. 690–705). Wu, who could not rely on perennial Confucian themes to validate her rule, stressed the idea of a parallel between her just, though temporary, rule and the eternal, celestial realm of Vairocana.

The colossal Buddha in a niche carved into the side of a cliff at Longmen (fig. 16) is an embodiment of Vairocana as the generative force of the cosmos. An inscription on the left side of the dais supporting the Buddha suggests that the work was begun during the early reign of Emperor Gaozong and completed as much as twenty years later, around 675; Wu Zetian donated substantial funds to the project. The inscription also lists the monks and administrators who were responsible for the construction of the niche. The Buddha measures about 56 feet (17 m) in height and is the center of a symbolic assemblage that includes two monks, two bodhisattvas, and four guardians. The monks and bodhisattvas symbolize the earthly and spiritual realms, respectively, while the guardians protect the Buddhist cosmos within.

The Buddha Vairocana is shown seated in meditation, wearing a thin shawl that falls in long, graceful arcs. He

has full shoulders, a broad chest, and a strong face with plump cheekbones and downcast eyes. The sense of volume in the Buddha's face and body, which differs from the unarticulated, columnar treatments of the sixth century, attests to a renewed interest in Indic artistic traditions in the late seventh and eighth centuries. This was an unsettled period in Indian history, and the prototypes for the new Tang icons probably originated in the northwestern part of the subcontinent; both Kashmir and nearby Swat, in present-day Pakistan, are notable for their vibrant Buddhist traditions and for the production of sculptures with powerful physiques, broad shoulders, articulated waists, and clothing that clings to the underlying body with pleats in soft arcs (see fig. 17).[26]

The earthbound body seen in a sculpture depicting an unusual manifestation of the bodhisattva Avalokiteshvara (fig. 18), which was excavated in Xi'an in 1976, illustrates a later variant of the Tang style, characterized by a heavy physique and an equally full face. The damaged horse's head at the top of the sculpture and the small Buddha seated at the front of the headdress identify the subject as Avalokiteshvara as Hayagriva (Matou Guanyin), or "with a horse's head," one of the Esoteric manifestations of the bodhisattva introduced into China with other new practices in the late seventh and early eighth centuries. This form of Avalokiteshvara has three human heads with glaring eyes and grimacing mouths; the central face has fangs. The two central arms make the "horse mouth" gesture, in which the palms are placed together and the second and fifth fingers raised. The remaining six hands emphasize the range of the bodhisattva's powers. The lower right is held in a gesture of reassurance, while the two above clutch a rosary and an ax. In Buddhist images, the ax and the sword, shown here in the upper left hand, often symbolize the destruction of ignorance and other delusions. The middle and lower left hands hold a vase and a long-stemmed lotus flower—both traditional attributes of Avalokiteshvara.

The widespread destruction of Buddhist images in the mid-ninth century makes it difficult to determine the extent to which the Esoteric practices introduced in the late seventh and early eighth centuries spread throughout China. Between 842 and 845, spurred by concerns over the obvious wealth and power of the clergy and by a growing xenophobic tendency, the state confiscated property and melted down or sold artworks to raise much-needed funds. According to historical records, 4,600 monasteries were secularized and returned to the tax rolls, as were the monks, nuns, and other workers who resided in these establishments. At least 40,000 smaller places of worship, presumably those that had not been founded and supported by the state, were also closed or converted to other uses.

FIGURE 17. Buddha. India (Kashmir region), 7th–8th century. Brass inlaid with copper and silver, H. 3⅞ in. (9.8 cm). The Metropolitan Museum of Art, Gift of Mr. and Mrs. Michael Phillips, 1984 (1984.409.2)

FIGURE 18. Bodhisattva Avalokiteshvara with a Horse's Head (Matou Guanyin). Shaanxi Province (Xi'an), Tang dynasty (618–906), mid-8th century. Marble with pigment, H. 35⅛ in. (89 cm). Forest of Steles Museum, Xi'an

FOREIGN RULE:
NINTH TO FOURTEENTH CENTURY

The social unrest that underlay this mid-ninth-century crisis derived in part from the many tensions that plagued the Tang dynasty as early as the mid-eighth century, when a rebellion led by General An Lushan came very close to succeeding. By 906, the Tang empire had completely collapsed, and China was once again divided north-south during a period known as the Five Dynasties (907–60). From the tenth to the thirteenth century, smaller polities continued to compete for control of southern China, while the north was more consolidated. The native Northern Song dynasty (960–1127) was based in Kaifeng, in Henan Province, while the rest of the north fell first under the Khitan Liao dynasty (907–1125) and later under the Jurchen Jin (1115–1234). The Khitan and the Jurchen were originally nomadic peoples from the northeast. The Jin overcame the Northern Song, forcing its leaders south of the Yangzi River, where they established a new capital at Hangzhou, in Zhejiang Province. Both the Jin and the Southern Song (1127–1279) were eventually conquered by the Mongols, who founded the Yuan dynasty (1271–1368) and ruled from Dadu, which would later be known as Beijing.

The history of Chinese Buddhism and Buddhist art during this turbulent period remains relatively unstudied, hampered by a perception that Buddhism, including the making of Buddhist works of art, declined in China after the tenth century. Recent challengers of this long-standing perception have pointed out, however, that the Song fostered the writing of Buddhist history: at least fifty texts on the subject were produced during its rule.[27] Many of these works now serve as the basis for the study of the development of certain earlier traditions, such as Chan and Tiantai. Moreover, during the tenth and eleventh centuries, about eighty South Asian monks visited China, and more than one hundred Chinese monks visited India; Chinese inscriptions are preserved in Nalanda, a major monastic and pilgrimage center in northeastern India (present-day Bengal and Bangladesh), which was one of the most vibrant Buddhist regions in Asia at the time.[28] The period also saw a flowering of translations, many sponsored by the Northern Song court, and records suggest that there were more monks and nuns in China in this era than there had been during the Tang dynasty.

The two most prominent traditions from the tenth to the fourteenth century are thought to have been the meditative Chan (better known by its Japanese name, Zen) and the Tiantai. It is, however, surprisingly difficult to find any link between this presumed prominence and the production of Buddhist sculptures. With the exception of works found in cave-temple complexes in Sichuan Province and works produced in the independent Dali kingdom (937–

1253) in Yunnan—both centered in the southwest, with ties to India and the Himalayas—few sculptures can be attributed to either the Northern[29] or Southern[30] Song. On the other hand, numerous sculptures, many made of wood—a material that superseded stone around the tenth century—are attributed to the Liao and Jin dynasties, whose practices may not be addressed in the records produced by the Song courts.[31] The iconography of the wood sculptures, as well as of related pieces cast in bronze, seems to suggest that Buddhist practices from the tenth to the fourteenth century were syncretic and often focused on divinities noted for their salvific abilities rather than on imagery that can be identified with a specific practice lineage.

A wonderful gilt-bronze sculpture of Avalokiteshvara (fig. 19), said to have been found in Hebei and now in the collection of the Palace Museum, Beijing, illustrates the Liao continuation of Tang-dynasty styles. The bodhisattva has a rounded, voluminous physique and a plump, youthful face. He wears a floral necklace with pendants, and the shape of his crown parallels that of crowns worn by the Khitan elite. The scarf that crosses his chest and the lower garment are thick and organically rendered, as is the narrower scarf that encircles his arms. The sculpture, dated stylistically to the early eleventh century, can be identified as Avalokiteshvara by the standing figure of the Buddha Amitabha in the crown and by the posture, in which the bent right leg is raised and the left crosses in front of the body.

FIGURE 19. Bodhisattva Avalokiteshvara. Hebei Province, Liao dynasty (907–1125), early 11th century. Gilt bronze, H. 7¼ in. (18.5 cm). Palace Museum, Beijing

This posture of relaxation became one of the most prominent in representations of Avalokiteshvara after the tenth century. It is often thought to show the bodhisattva seated in his personal sacred realm, known as Potalaka. Although this mountain residence was originally said to be located in the Indian Ocean, it became conflated in China with Mount Putuo, an island off the coast of Zhejiang Province that was thereafter a major center for pilgrimage. The textual source for Avalokiteshvara seated in Potalaka is the Flower Garland Sutra, the primary scripture of the Huayan tradition, in which the young pilgrim Sudhana, the protagonist of the text, visits Avalokiteshvara in his paradisiacal realm. Moreover, the stress on Avalokiteshvara in his sacred residence, as implied by the use of the relaxation pose, links sculptures such as this gilt-bronze piece to the Pure Land tradition. As was mentioned earlier, Avalokiteshvara and other advanced celestial bodhisattvas, as part of their help in guiding the devout, can also generate perfected realms akin to the Buddha Amitabha's Pure Land.

The style of the Jin dynasty, which also continued the late-Tang aesthetic, is embodied in the fleshy face and body of a standing sculpture of the bodhisattva Avalokiteshvara (fig. 20), dated by inscription to 1195 and said to have been made in Linfen, Shanxi Province. The bodhisattva is one of a pair in the collection of the Royal Ontario Museum, Toronto, and was most likely once part of a triad showing the Buddha Amitabha with two bodhisattvas. Avalokiteshvara stands in a frontal pose and wears a shawl, a thin scarf across his chest, and a lower garment with a full sash. The raised hairstyle, which appears a bit narrow for the face, and the elaboration of details in the clothing—for example, the scarf and sash—distinguish the sculpture from Liao works, as does the overall heaviness of the face and body.

The final Indian style to reach China is associated with the art of the Pala kingdom (ca. 700–ca. 1200) in northeastern India and is often linked to the Mongol conquest of China in the mid-thirteenth century. The style is affiliated, in turn, with a complex of practices and images often defined as Esoteric, or Vajrayana, Buddhism, which is today best preserved in Tibet. Vajrayana, which stresses personal development under the guidance of a teacher, focuses on the potential for enlightenment in a single determined and demanding lifetime. It includes a breathtaking pantheon of Buddhas, bodhisattvas, and protective deities, many of which have multiple manifestations. Although Vajrayana, or Vajrayana-like, practices can be traced back (to some degree) to the seventh century, there is little visual evidence for this tradition until the tenth century, and it appears to have flourished in the Pala kingdom particularly in the eleventh and twelfth centuries. The dissolution of the Pala kingdom around 1200 is often used as a

FIGURE 20. Bodhisattva Avalokiteshvara. Shanxi Province (Linfen), Jin dynasty (1115–1234), dated 1195. Wood with pigment, H. 75 in. (190.5 cm). Royal Ontario Museum, Toronto, The George Crofts Collection

marker of the end of Buddhism in India, as a result of amalgamation with Hindu practices and the introduction of Islam. The tumultuous period that preceded the fall of the Pala kingdom is reflected in the large number of Indian monks who traveled from there to Tibet and other centers in the Himalayas and Central Asia during the late tenth, eleventh, and twelfth centuries, bringing the new Vajrayana practices and related imagery with them.

One of the most interesting and unresolved questions in the study of Chinese Buddhist art is the degree to which these new practices and related images were known in China prior to the advent of the Mongols. A mixture of Chinese-style and Vajrayana traditions and imagery was employed in the Tangut Xixia kingdom (1038–1227), which was based in Ningxia, Gansu, and parts of Shaanxi and had cultural and linguistic ties to Tibet.[32] It is difficult to imagine that this "new" type of Buddhism, which not only was flourishing in Tibet in the late tenth century but was also found in the neighboring Xixia kingdom and may have been practiced by Tibetans based in the Hexi Corridor region of Gansu Province,[33] was completely unknown in central China until the advent of the Mongols.

As was mentioned earlier, the Northern Song court actively sponsored translations, and most of the texts preserved from this period are classified as sadhanas or tantras, the types of literature most closely associated with the Vajrayana tradition.[34] In addition, in the year 983, an Indian monk known by the Chinese name Juexi is said to have presented the Northern Song emperor with a painting

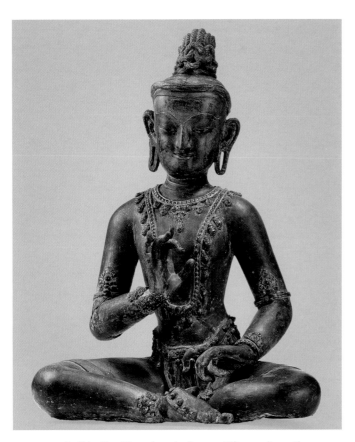

FIGURE 21. Bodhisattva. Yuan dynasty (1271–1368) or earlier, 12th–13th century. Dry lacquer, H. 23 in. (58.3 cm). Freer Gallery of Art, Smithsonian Institution, Washington, D.C., Purchase

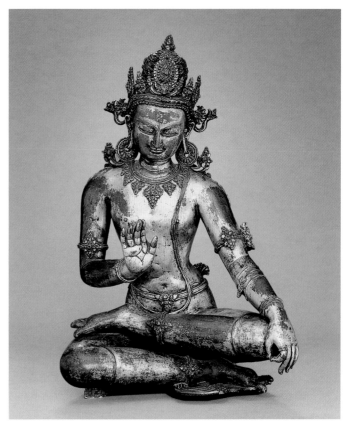

FIGURE 22. Bodhisattva. Nepal, Early Malla period, 13th century. Gilt copper inlaid with semiprecious stones, H. 18¾ in. (47.6 cm). Asia Society, New York, Mr. and Mrs. John D. Rockefeller 3rd Collection of Asian Art

on white cotton, a fabric widely used in the Pala kingdom and Tibet; in the eleventh century, Juecheng, another Indian monk, brought a painting of the Diamond Throne Buddha, an iconographic type associated with the Pala kingdom, to the Northern Song court.[35]

A wonderful sculpture of a seated bodhisattva (fig. 21) in the collection of the Freer Gallery of Art, Smithsonian Institution, Washington, D.C., may be a rare example of a Chinese icon produced before the Mongol conquest in the Indo-Himalayan style associated with Vajrayana Buddhism. Made in the dry-lacquer technique, the sculpture has traditionally been dated to the fourteenth century on account of its style and the assumption that the Indo-Himalayan idiom was introduced with the Mongols. A radiocarbon dating of the piece, however, has yielded a range of dates from 990 to 1230, prior to the founding of the Yuan dynasty in 1271.[36] The sculpture shows a scantily clad bodhisattva seated cross-legged and holding his right hand in a gesture vaguely reminiscent of teaching. He wears an extraordinary jeweled girdle, armlets, bracelets, and two necklaces. Although the face is slightly leaner, the body of the bodhisattva is strikingly similar to that of a gilt-copper sculpture from Nepal (fig. 22) that is datable to the thirteenth century. Both figures sit in a relaxed pose and bend subtly at the waist. Both have dense topknots

composed of strands of braided hair; both are bejeweled; and both have lively toes. The Chinese example lacks the crown worn by the Nepali bodhisattva; however, an adornment of this sort could have been made of metal and lost over time.

Regardless of the degree to which Vajrayana style and imagery had penetrated China prior to the advent of the Mongols, there is no doubt that this tradition, and particularly the variant associated with Sakya, one of the four primary Tibetan Buddhist lineages, was actively sponsored at the Yuan court. Sakya practices and imagery are assumed to have been brought to the court by the Nepali artist Anige (1245–1306), who, in turn, had been brought to the attention of the Mongols by the powerful monk Chogyal Phags'pa (1235–1280). In 1260, when Khubilai (1215–1294) was named khan, or ruler, of the expanding empire, Phags'pa became the state preceptor, and Anige played a prominent role at court, serving as the director of all artisan classes and the controller of the Imperial Manufactories Commission. It is reasonable to assume that he played a critical role in fostering the Indo-Himalayan style at the time.[37] It is notable, however, that while there are a few sculptures, as well as a scant number of textiles, that display this idiom, no paintings of the Indo-Himalayan type can be attributed to the Yuan court.

A small bronze sculpture (fig. 23) in the collection of the Palace Museum, Beijing, illustrates a melding of long-standing Chinese and recently introduced Indo-Himalayan styles in the early part of the fourteenth century. The sculpture, which is dated by inscription to 1336, shows a Buddha seated in meditation, with his left hand in his lap and his right reaching to touch the ground. The ground-touching, or *bhumisparsha*, gesture is the most widely used mudra in Pala-period India. It refers to a specific moment in the final lifetime of the Buddha Shakyamuni, when he touched the ground in order to justify his quest for enlightenment; it also signifies Bodh Gaya, the site of Siddhartha's enlightenment and a major pilgrimage center, which was within Pala territories. In the visual arts, the ground-touching gesture is employed by two Buddhas—the historical Buddha, Shakyamuni, and the transcendent Buddha Akshobhya, one of the most important figures in Vajrayana—and this example should likely be identified as Akshobhya. While the Buddha in the Palace Museum retains the strong physique and form-fitting clothing associated with Indian and related artistic traditions, it also has the rounded face and plump arms typical of Chinese art.

SYNTHESIS:
FIFTEENTH TO NINETEENTH CENTURY

The dry-lacquer and gilt-copper sculptures discussed above are two of the surprisingly few works preserved from the tenth to the fourteenth century that show an awareness of the Indo-Himalayan style of Buddhist art.[38] The style flourished during the early fifteenth century, however, when China was once again under native rule—that of the Ming dynasty (1368–1644)—and it was particularly

popular during the reign of the Yongle emperor (1403–24), the third Ming ruler and a follower of Tibetan Buddhism. During this period, bronze sculptures of Buddhist divinities were produced in some number for use at court and as gifts, both for native recipients and for Tibetan clerics and other dignitaries. A magnificent gilt-bronze sculpture (fig. 24), dated by inscription to the Yongle period and presumably produced at court, shows the Buddha Akshobhya seated in meditation, with his right hand in the ground-touching gesture. The Buddha, who sits on a two-tiered throne profusely decorated with flowing botanical scrolls, with a similarly decorated, beautifully cast openwork mandorla rising behind him, has a squarer face and body than the early-fourteenth-century piece discussed above (fig. 23). In addition, greater attention is paid to the clothing: the garments are thicker than those worn by the earlier Buddha, have more pleats, and flow more softly. The Yongle-period Buddha also wears an additional garment that falls from just above the waist to the feet, as indicated by a scalloped edge visible beneath the traditional clerical shawl. Finally, the mercury gilding of the later Buddha provides rich color.

Chinese variants of the Indo-Himalayan style, as well as works that are more typically Chinese, continued to be produced throughout the Ming dynasty, and by the

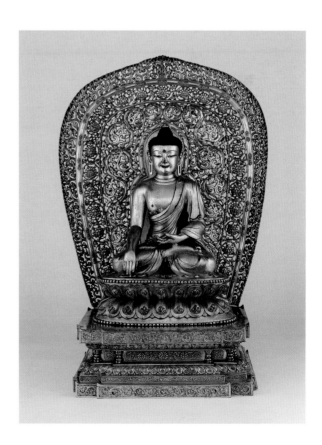

FIGURE 24. Buddha Akshobhya. Ming dynasty (1368–1644), Yongle period (1403–24). Gilt bronze, H. 23¼ in. (59 cm). British Museum, London

FIGURE 23. Buddha. Yuan dynasty (1271–1368), dated 1336. Bronze, H. 8½ in. (21.5 cm). Palace Museum, Beijing

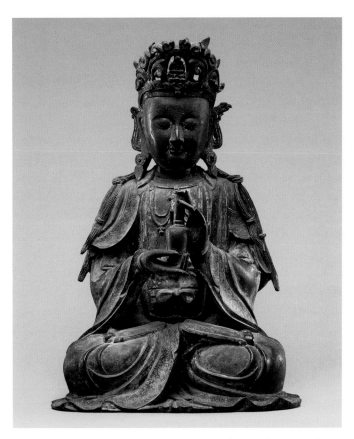

FIGURE 25. Bodhisattva Avalokiteshvara. Ming dynasty (1368–1644), 15th–16th century. Leaded brass, lost-wax cast; H. 15⅛ in. (38.4 cm). The Metropolitan Museum of Art, Rogers Fund, 1912 (12.37.160; no. A56)

numbers of books—Buddhist texts as well as new genres, such as morality tales—were printed, leading to a broader dissemination of knowledge. Lay Buddhist movements were popular, many of them emphasizing the philosophical closeness between Buddhism and other (native) traditions, such as Daoism and Confucianism. Imagery associated with all three religions, as well as motifs derived from popular culture, was employed by professional artists working at court and elsewhere and by monks and other devotees who painted, or possibly sculpted, as an act of spiritual or personal development.

Representations of arhats in many media, in both religious and nonreligious contexts, exemplify the multifaceted role of Buddhist imagery during the Ming. In early texts, the term *arhat* (*luohan* in Chinese) refers to the Buddha Shakyamuni and his historical disciples. In later writings, usually those associated with the Mahayana tradition, arhats serve as exemplars, helping others in their spiritual journeys. Although such figures are not found in Indian art or related Southeast Asian traditions, they played an important role in China beginning in the Tang dynasty, when the famed monk-pilgrim Xuanzang (602–664) brought to the court a text entitled *A Record of the Abiding Dharma Spoken by the Great Arhat Nandimitra*.[39] The text endows arhats with magical powers and describes the fantastic and hidden worlds they inhabit. It also explains that arhats remain accessible to the phenomenal world in order to protect Buddhism during the tenebrous period between the lifetime of the historical Buddha and the advent of the Buddha Maitreya. After the eighth century, devotion to arhats was a major component of Chinese Buddhist practice, and paintings and sculptures representing groups of sixteen, eighteen, or five hundred arhats were produced for use in temples and other settings.

A seated arhat holding a rosary in the Metropolitan Museum's collection (fig. 26), dated to the seventeenth or eighteenth century,[40] shows stylistic affinities with the slightly earlier bodhisattva discussed above (fig. 25). Both figures have physiques that are somewhat square and flat, with little volume; both wear thick clothing that obscures the underlying body and falls in stylized pleats, such as those seen on the lower legs of the bodhisattva and at the hems of the long, trailing sleeves of both the bodhisattva and the arhat. The greater sense of individuality expressed in the bearded face of the arhat probably derives from the iconography of these figures, who are often represented as foreigners. The works are also made of different materials, the bodhisattva of brass and the arhat of clay. Clay may have been used more frequently than is known or documented for the production of Buddhist icons; works in this material are likely to have been more prone to destruction than those of metal or wood.

sixteenth century, the two styles had commingled so much as to be interchangeable. A brass bodhisattva in the Metropolitan Museum's collection (fig. 25) illustrates the melding of the two disparate traditions that is often found in art of the late Ming. The bodhisattva's somewhat square face alludes to the Indo-Himalayan style, but the body lacks the sense of roundness seen in the Yongle-period work. The clothing retains the typical Chinese thickness, but the pleats are rendered in a more formulaic and less organic manner. This stylization is also seen in the ribbons that secure the diadem at the back of the bodhisattva's head; in the long pieces of hair that fall in flat strands along the shoulder and upper arms; and in the elements of the necklace. The flatness of the feet further distinguishes the sculpture from the early-Ming piece.

Buddhism flourished during the Ming dynasty, when members of the imperial family, court officials, and laypeople from many walks of life were active as both patrons and practitioners. The era was marked by a great synthesis among the various branches of Buddhism; by an emphasis on discipline; and by the importance of ritual specialists, who officiated at important events, such as funerals. The blending of practice traditions may have been a result, in part, of wider literacy in the second half of the Ming. Fostered by the wealth and stability of the period, large

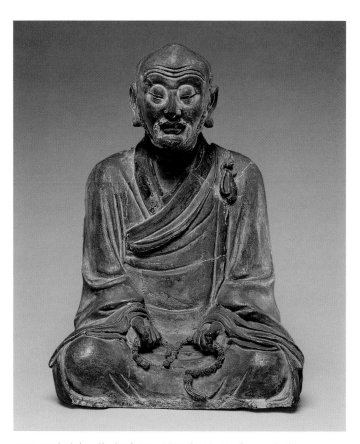

FIGURE 26. Arhat (*luohan*). Late Ming (1368–1644) or early Qing (1644–1911) dynasty, 17th–18th century. Stoneware with pigment, H. 17½ in. (44.5 cm). The Metropolitan Museum of Art, Gift of Robert E. Tod, 1938 (38.56.1; no. A65)

characteristics of the Qing dynasty. Nurhachi (1559–1626), the progenitor of the Manchu state, and his sons and descendants were adherents of the Geluk branch of Tibetan Buddhism and maintained ties with both Tibetan and Mongolian clerics. The Geluk school was founded by Tsongkhapa (1357–1419), one of the most prominent theologians of the fourteenth and fifteenth centuries. The reformist tradition he established, which is known for its complicated visual imagery, has been led by the Dalai Lamas and maintained at centers in Tibet, Mongolia, and China. (The term Dalai Lama, which can be translated as "ocean of compassion," is said to have been coined in 1578 by Altan, the leader, or khan, of a Mongol confederation based in Hohhot.) In addition to serving as the head of the Geluk order, the Dalai Lamas are understood to be incarnations of early Buddhist monks as well as of the bodhisattva Avalokiteshvara.

The fifth holder of the title, Ngawang Lobzang Gyatso (1617–1682), also known as the Great Fifth, was both a seminal figure in Tibetan history and one of the more astute political figures in seventeenth-century Asia. The Great Fifth and the Panchen Lama of the time (another very important Geluk monk who is reincarnated every generation) jointly identified Huang Taiji (1592–1643), one of the ancestors of the Manchu Qing dynasty, as a manifestation of the bodhisattva Manjushri. In 1652, the

This style of Buddhist sculpture continued during the subsequent Qing dynasty (1644–1911), when China was once again under the control of a non–Han Chinese people, the Manchus, who came from Manchuria and adjacent regions. An example dated by inscription to the year 1662 (fig. 27) shows a Buddha seated on a lotus throne, with his hands in a gesture of exposition or preaching. The stylization of the pleats in the drapery that falls over the crossed legs is similar to that seen in the bodhisattva and arhat figures discussed above; the edges of the bodhisattva's shawl and one edge of that worn by the Buddha are similarly rendered. On the other hand, the slightly triangular face of the Qing Buddha differs from the squarer faces of the Yongle-period Buddha (fig. 24) and the late-Ming bodhisattva and reflects the development of closer ties with Tibet during the Qing. The inscription at the lower edge of the lotus pedestal is given in both Chinese and Tibetan.[41] In addition to providing the date, it states that the sculpture was made for the Mindoling-si (Mindoling monastery). A smaller bilingual inscription at the upper edge of the pedestal identifies the Buddha as Dipankara, one of the more important predecessors of the historical Buddha.

A reintensification of contact between China and Tibet and a subsequent reemergence of the Indo-Himalayan aesthetic in Buddhist art are among the important cultural

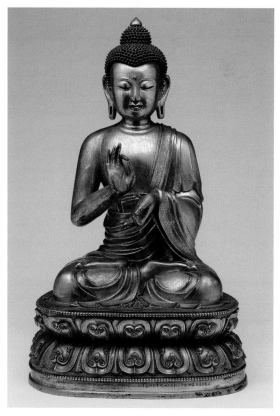

FIGURE 27. Buddha Dipankara. Qing dynasty (1644–1911), Kangxi period (1662–1722), dated 1662. Gilt bronze, H. 27⅝ in. (70 cm). Museum of Art, Rhode Island School of Design, Bequest of John M. Crawford Jr.

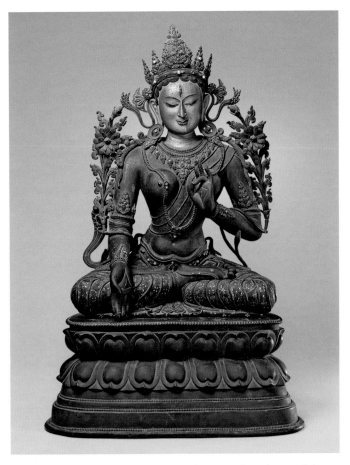

important in later Tibetan traditions, where she is seen as a savior-deity and is often associated with the bodhisattva Avalokiteshvara. The great Indian monk Atisha (ca. 980–1054), who was invited to Tibet in the mid-eleventh century and is thought to have played a critical role in the reemergence of Buddhism there, is also credited with introducing Tara into Tibet. Devotion to the goddess was known in China by the fourteenth century and may have existed earlier as part of the diffusion of Vajrayana practices in the eleventh and twelfth centuries.[43]

The sculpture in the Palace Museum follows the standard iconography for Green Tara: the figure has two arms and one head and is seated in a posture of meditation on a high lotus pedestal. Two long-stemmed lotus flowers with leaves flank the goddess. A sash falls diagonally from the left shoulder and across the chest, and the lower garment is beautifully embellished with leaves and vines that appear to have been inlaid in gold. The face is also gilded. The five-pointed crown, circular earrings, armlets, and bracelets parallel adornments on contemporaneous Tibetan sculptures, as do the stone inlays (in this case, turquoise and coral)[44] and the gilding. The soft outlines of the body and the importance given to the sash covering the chest, on the other hand, indicate that the sculpture was made in China.

CHINESE BUDDHIST SCULPTURE IN THE METROPOLITAN MUSEUM OF ART

As is true of many Western museums, the collecting of Buddhist art at The Metropolitan Museum of Art can be linked to the fascination with Buddhism and other Eastern thought systems that marked the second half of the nineteenth century.[45] Most of the early studies of Buddhist art focused on India, Sri Lanka, and Southeast Asia, and it is not surprising that the first Buddhist sculptures acquired by the Museum were (relatively inconsequential) Thai and Cambodian pieces. The first Chinese Buddhist sculpture, a small stone stele dating to the Tang dynasty, was given in 1912, and two other pieces, the late-Ming bodhisattva Avalokiteshvara discussed previously (fig. 25) and a companion piece, were also added to the collection that year. In the early twentieth century, antiquarianism in China, which included the finding and preserving of inscriptions, focused newfound attention on early Chinese Buddhist art, as did work by Japanese and Western scholars at famous cave-temple sites such as Yungang and Longmen. Most of the pieces in the Museum's collection were acquired between 1920 and 1950; many were gifts from collectors who were also interested in other facets of Chinese or Asian art.

Great Fifth traveled to China to meet the Shunzi emperor (r. 1644–61), the first Qing ruler. The importance of Geluk practices at the Manchu court continued throughout the dynasty, particularly during the reign of the powerful Qianlong emperor (1736–95), who, in 1767, commissioned a reproduction of the Potala (the primary Geluk monastery and home of the Dalai Lamas) for Chengde, the imperial summer residence north of Beijing; in 1779–80, he had a replica of the Tashilhunpo, the Panchen Lama's headquarters, built in the same city. Both monasteries were filled with textiles, paintings, sculptures, and other accoutrements for the ritual and personal lives of the two high-ranking clerics, who visited China periodically, and their disciples and other members of their entourages. Paintings from these two monasteries are preserved in some number,[42] and it is likely that many of the Qing-dynasty sculptures in the Indo-Himalayan style that are known today were also produced for Chengde.

A beautiful sculpture of the green manifestation of the goddess Tara (fig. 28) in the collection of the Palace Museum, Beijing, illustrates the eighteenth-century Chinese understanding of the Indo-Himalayan idiom. Tara, who was depicted in Indian art as early as the sixth century, is

NOTES

1. The purpose of this introduction is to provide a background for the sculptures in the Metropolitan Museum's collection rather than a full discussion of the complicated issue of Buddhism in China. For full documentation of sources cited here and throughout the catalogue, see the bibliography, beginning on p. 224.

2. Takakusu Junjirō and Watanabe Kaigyoku, eds., *Taishō shinshū Daizōkyō*, 100 vols. (Tokyo: Taishō Issaikyō Kankōkai, 1914–32). This Japanese version is known by the traditional abbreviated title *Daizōkyō*.

3. This assertion remains a subject of scholarly debate, however. For an introduction to the issue, see Dehejia 1991, S. Huntington 1992, and Rhi 1994.

4. For a succinct overview of the written evidence, see Zürcher 1990. For the visual evidence, see Yu Weichao 1990 and Wu 1986.

5. See Harrison 1987 and 1992.

6. See Lancaster 1974.

7. See Edwards 1954.

8. See Wu 1986.

9. See Yu Weichao 1990 and Wu 1986.

10. See Lai 1999.

11. For an interesting analysis of these urns, see Dien 2001.

12. The transition from the northwestern part of the subcontinent to Central Asian oasis centers is discussed in Zürcher 1990.

13. See Lin Meicun 1991.

14. See Su 1986 and *Hexi shiku* 1987.

15. For a discussion of the spread of this type of pleating, see Leidy 2005–6.

16. Saddharma Pundarika Sutra (Miao fa lian hua jing 妙法蓮花莖). Takakusu and Watanabe 1914–32, nos. 1519, 1520.

17. For a discussion of the use of the pensive pose in rendering other bodhisattvas, see Leidy 1990.

18. Vimalakirtinrdesha Sutra (Weimo jie jing 維摩詰經). Takakusu and Watanabe 1914–32, nos. 474–76.

19. The closest parallel is the *kirtimukka*, or "face of glory," that is often found in Indian, Southeast Asian, and Tibetan art.

20. For examples, see New York 2004–5, figs. 135, 137, 138, 143, 144.

21. For an example of a sarcophagus made for a Sogdian individual, see ibid., fig. 147.

22. For an interesting analysis of the use, or possible misuse, of the term Pure Land Buddhism, see Sharf 2002.

23. These figures are sometimes identified as *pratyeka* Buddhas. For an identification of such figures as lay adherents, see Tomita 1945.

24. Ratnakuta Sutra (Xumodi pusa jing 須摩提普薩經). Takakusu and Watanabe 1914–32, nos. 335, 336.

25. Avamtasaka Sutra (Huayan jing 華嚴經). Ibid., nos. 278, 279.

26. See Leidy 1997.

27. See Gregory 1999, Jan 1966, and Sen 2002.

28. See Chavannes 1896. For a revision of some of Chavannes's translations, see Chou Ta-fu 1957, pp. 79–82.

29. The only dated Northern Song work known to the author of this chapter is a towering representation of a thousand-armed bodhisattva Avalokiteshvara in a temple in Kaifeng.

30. The Southern Song dynasty is noted, however, for the Buddhist paintings produced in Ningbo and other centers, including Hangzhou. See Nara 2009 (in Japanese with English précis), which includes several sculptures that have been dated to the Southern Song; however, it is unclear whether or not this dating is accurate.

31. It is also worth noting that identification of the woods used to make these sculptures—generally, either willow or foxglove—suggests that regional workshops and styles, rather than the identities of patrons, may have played an important role in the development of Chinese sculpture in wood. It is difficult, for example, to distinguish between works produced in foxglove in the late Northern Song and those produced in the subsequent Jin dynasty. It is also likely that some pieces of wood were either cured for several years or preserved by an atelier for further use; this would help to explain the discrepancies between the radiocarbon dates and the styles of some of the sculptures in the catalogue.

32. For an overview of the Tangut Xixia material, see Samosiuk 2006. It is interesting that cave 76 at Dunhuang, which may have been constructed under Tangut rule, has murals that were based on Pala-period manuscript paintings. See Toyka-Fuong 1998.

33. See Iwasaki 1993.

34. For a discussion of the impact of the new texts in China, see Orzech 2006.

35. See Liu 2007, p. 100.

36. See Jett 1995, p. 175.

37. See Jing 1994.

38. The most dramatic example of the Indo-Himalayan style in Yuan China remains the marble reliefs at Juyongguan, a pass leading to the Great Wall, northwest of Beijing. See Murata and Akira 1955–57.

39. *Da Aluohan Nandimiduoluo suo shuo fazhuji* (大阿羅漢難南提密多羅所說法住記). Takakusu and Watanabe 1914–32, no. 2030.

40. This is one of several such works in Western collections that have traditionally been dated to the Song dynasty. The revised dating is based on a thermoluminescence analysis that yielded a date between 1600 and 1800.

41. See Schroeder 1981, fig. 152E.

42. For examples of the paintings, see Bartholomew 2001.

43. One of the earliest Chinese representations of Tara in her green form is found in cave 465 at Dunhuang. The date of this cave remains controversial. For an interesting argument against the traditional Yuan-dynasty date, see Xie 2004.

44. Identification of the inlay materials is speculative, based on comparison to other works in which such stones have been identified.

45. See Allen 2003 and Lopez 1995.

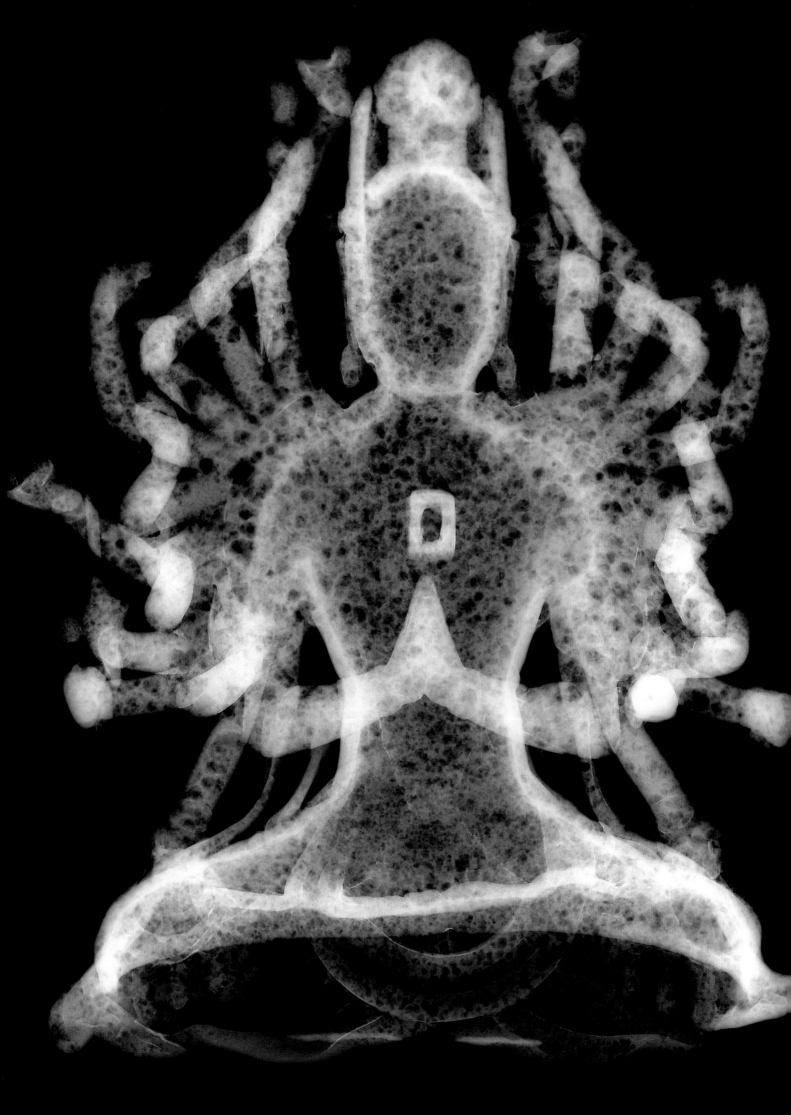

Creating Sacred Images of the Buddha
A Technical Perspective

DONNA STRAHAN

No known ancient text discusses the techniques that were used to create Buddhist sculptures. Therefore, technical examination and analysis are the only available means of discovering the processes by which the works were produced. This chapter, which serves as a complement to the stylistic and iconographic assessments of the works in the catalogue entries, is organized by material (metal, stone, wood, lacquer, ceramic, and ivory) and ends with a discussion of sculptures as receptacles for consecratory material. All the metal works in the catalogue (including those listed in appendix A, identified by numbers preceded by the letter A), as well as most of the wood and ceramic sculptures and some of the stone pieces, were examined by X-ray radiography and with the binocular microscope. Other analytical methods used in the preparation of the catalogue are discussed under each material heading. The majority of sculptures included in the book, regardless of material, were originally polychromed; for details, see appendix E. Appendices D and F provide information about, respectively, metal-alloy composition and wood types. Additional technical details are given in many of the catalogue entries.[1]

METAL

Central to Buddhist practice is the making of images, which serves the dual purpose of facilitating worship and accruing merit for those who commission and produce them. As Buddhism traveled overland from India through the Gandharan region and into western China, believers probably brought with them small, portable images of the Buddha, which served as prototypes for local production.

Merchants may also have imported such images for sale. With the full-fledged arrival of Buddhism in China in the mid-second century C.E., however, there was an unprecedented need for a multitude of images, promoting a vast production of sculptural art.

Much has been written about the historical and stylistic aspects of early Chinese Buddhist bronze sculpture (3rd–7th century C.E.), but only rarely have questions of manufacture been addressed. Since no ancient foundry for casting Buddhist images has been located, the exact methods of production are speculative and can be deduced only by examining the existing works. The small number of metal sculptures in this book (nineteen in the catalogue portion and fourteen in appendix A) and their widely spaced dates of manufacture make it difficult to draw conclusions strictly from the evidence of this group. However, by interpreting the results of our studies in conjunction with comparative published material, some trends can be identified.

In the ancient region of Gandhara (roughly, present-day Pakistan), Buddha figures were produced at this time by the lost-wax method, from bronze and brass alloys containing varying amounts of copper, tin, zinc, and lead (see fig. 29). During the initial period of Buddhism's introduction into China, it is unlikely that either the technology of fabricating images or the metalworkers themselves traveled with the monks. Therefore, when local Chinese craftsmen were asked to copy the imported images, it was natural for them to employ their own traditional casting methods and alloys. The first locally produced freestanding cast-bronze icons appeared around the end of the third century C.E.[2]

Opposite: Radiograph of Avalokiteshvara with One Thousand Hands and One Thousand Eyes (cat. no. 33)

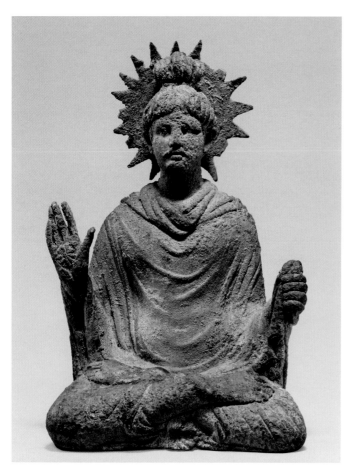

FIGURE 29. Seated Buddha. Pakistan or Afghanistan (ancient region of Gandhara), 1st–2nd century C.E. Bronze with traces of gilding, lost-wax cast; H. 6⅝ in. (16.8 cm). The Metropolitan Museum of Art, Gift of Muneichi Nitta, 2003 (2003.593.1)

In addition to stylistic and technological predilections, another important factor may have contributed to the style of these early images. Although Hebei Province had produced outstanding bronzes from the late Warring States period (ca. 475–221 B.C.E.) through the Western Han dynasty (206 B.C.E.–9 C.E.), there is little extant evidence of bronze metalworking during the third and fourth centuries C.E. The stiff look of the early Buddha images thus may also have resulted from the limitations of local workshops. During the fifth century, Hebei became a leading center for the production of Buddhist bronzes. The majority of early bronze Buddha images identified to date were produced in that region.[3]

In the course of preparing this catalogue, X-ray radiography of the metal sculptures helped reveal clues to casting methods, such as attachments, repairs, armatures, cores, core pins, and spacers. Surface details were examined with the binocular microscope and under ultraviolet radiation, which illuminated paint layers and repairs. The compositions of the alloys were analyzed quantitatively, in the scanning electron microscope and with energy dispersive and wavelength dispersive X-ray spectrometry (SEM-EDS/WDS).[4] When more information on dating was needed,

clay core samples were subjected to thermoluminescence (TL) analysis.[5]

Counter to the findings of the few technical studies of comparable works, the early Chinese Buddhist bronzes in the Museum were cast by the piece-mold, not the lost-wax, method.[6] A detailed technical analysis of three important sculptures from the fourth and fifth centuries—two in the Metropolitan's collection (cat. nos. 1, 4)—confirms that they were all piece-mold cast.[7] These works are representative of a large group of Buddha images of similar style cast in piece molds during the fourth, fifth, and sixth centuries. Two distinct piece-mold casting strategies were used for the three analyzed works: one for the two smaller sculptures and another for the large one. In the former, metal spacers held the core in position during casting; in the latter, extensions from the core supported it within the mold assemblage.

The small seated Buddha (cat. no. 1) illustrates the piece-mold method employed for the two smaller images. The trapezoidal base narrows toward the back. The lack of undercuts, the flat hands, and the simple, shallow drapery would have facilitated the removal of the mold sections from the original model, and as a rule, those characteristics, as well as the trapezoidal base, are stylistic elements that point to piece-mold as opposed to lost-wax casting. It is hypothesized that the work was cast in a three-piece mold: a front, a back, and a bottom that included the core (see fig. 30). The front mold section began at the top of the head and continued down the sides of the neck, across the shoulders, down the outside of the arms, across the thighs, and down the front edges of the base. The back mold covered the entire back half of the sculpture, including the tang and three sides of the base. The bottom mold section was the core, and the base extended out to aid in supporting the other two pieces.

The above description of the mold design for catalogue number 1 is supported by similar findings on other sculptures.[8] There is no evidence of core pins, which are typically associated with lost-wax casts. Instead, square and rectangular metal spacers were inserted between the core and the mold sections at strategic points. Radiographs (see fig. 31) reveal the locations of at least five spacers that are not visible on the sculpture's surface, as they were incorporated into the metal walls: one in the center of the chest, one below each shoulder blade, and one in each leg at mid-thigh, where it meets the base.

After casting, the entire core was removed. The exposed interior walls show the rough texture typical of as-cast surfaces and do not exhibit any evidence of toolmarks, brush marks, fingerprints or other impressions, joins between wax sheets, or drip marks, as might be present if the sculpture had been cast by the indirect lost-wax method. After

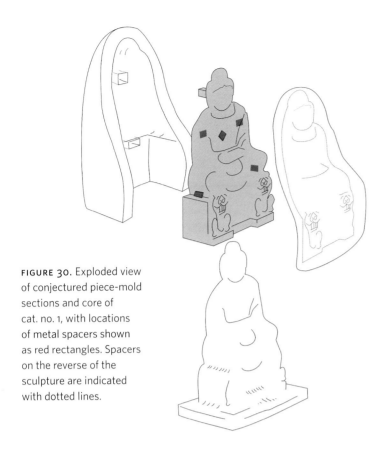

FIGURE 30. Exploded view of conjectured piece-mold sections and core of cat. no. 1, with locations of metal spacers shown as red rectangles. Spacers on the reverse of the sculpture are indicated with dotted lines.

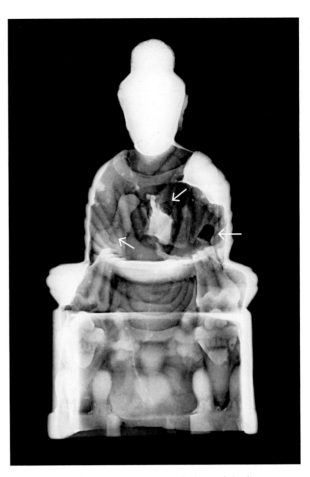

FIGURE 31. Radiograph of cat. no. 1 with three of the five spacers noted; digitally manipulated. The radiopaque (white) areas of the head, left shoulder, right knee, and center of the chest are cast-in repairs.

the work was cast, the flashings at the mold junctures were removed mechanically, eliminating all evidence of the piece-mold section joins. Abrasive materials were probably used to finish the surface, but gilding and corrosion now hide most of the finishing marks. Fine decoration and details were chased into the surface before gilding.

A technical examination of a fourth- or fifth-century Buddha from the Winthrop Collection in the Harvard University Art Museums, Cambridge (fig. 52 on p. 48), also found evidence of piece-mold casting, confirming that it was indeed made in China.[9] Another example that supports the piece-mold hypothesis is a small fifth-century seated Buddha in the collection of the Freer Gallery of Art, Smithsonian Institution, Washington, D.C. (F1911.137). During casting, metal flashing formed along the seam joins of the front and back mold sections. The flashing was not removed from the sculpture and now extends out along the base, providing visual information about the locations of the mold sections (see fig. 32).

The large work in the group of three—the monumental Buddha Maitreya in the Metropolitan (cat. no. 4)—is a fine example of fifth-century piece-mold casting and a technical tour de force. As with the small Buddha discussed above (cat. no. 1), its details were executed in low relief, without undercuts; however, the work is an order of magnitude larger in size and far more complicated. The challenges of creating such a large sculpture by the piece-mold method necessitated a different strategy. This Buddha was

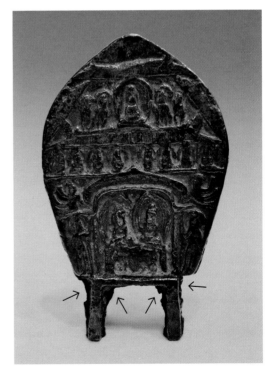

FIGURE 32. Back of Freer Buddha showing metal flashing that developed along mold seams during casting. Northern Wei dynasty (386–534), ca. 425–50. Bronze, H. 4 in. (10 cm). Freer Gallery of Art, Smithsonian Institution, Washington, D.C.

cast in one piece, with the exception of the hands, which were cast separately and placed in the mold assemblage prior to the casting of the figure itself. The model of the Buddha—an "identical twin" of the finished metal sculpture—was probably created in loess (fine local soil). Because of its large size and standing posture, the model would have needed a sturdy internal armature of metal or wood to support its weight. When the model was finished, a piece mold was taken of the entire model after a release agent, such as charcoal, was applied to the surface. The mold sections would have been made one at a time and allowed to dry in situ, so that they could be keyed to their neighbors at each seam. When the mold was complete, it was disassembled, and at this point, any necessary adjustments or refinements would have been made.[10]

Presumably, the model was then shaved down to serve as the core by removing a thickness of loess corresponding to the intended wall thickness of the finished sculpture, which had to be sufficient to support a large sculpture without an internal armature. Today, the metal of the finished sculpture ranges from about 1/4 to 3/8 inch (7 to 10 mm) in thickness. This relatively small variation shows that the subtle contours were preserved as the model was shaved down to form the casting core. During this process, numerous rectangular protrusions of loess were left standing to separate the core from the mold during casting. These core extensions were positioned at regular intervals over the entire sculpture, and in many cases, their locations on the back of the sculpture mirror those on the front (see fig. 33). The large opening in the back of the sculpture also played a key role, as it could have accommodated what was effectively a very large core extension (see fig. 34).

Since most of the mold's seam flashings were removed during the finishing process, it is not clear how many mold sections there were or how exactly they were arranged. The positioning of the core extensions may help to determine the basic mold construction. Fewer piece-mold sections were needed for the back because of the placement and size of the large opening. After the molten metal had been poured in and the assemblage had cooled, the mold sections were broken away. At that time, the core extensions were removed, and recesses that undercut the edges of the extension openings were gouged into the core. Molten bronze was poured into each hole, filling the undercuts and flowing over the outer surfaces of the wall, thus helping to secure the patch (see figs. 34, 35). The surfaces were then finished by grinding and polishing.

Research indicates that piece-mold casting was the preferred, and perhaps the only, method used for making metal Buddha images in China until the late sixth or early seventh century.[11] At that time, lost-wax casting began to take hold in northern China. Although we cannot say

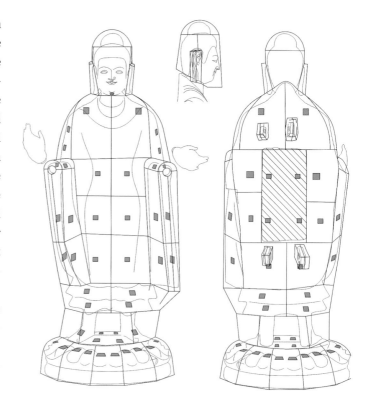

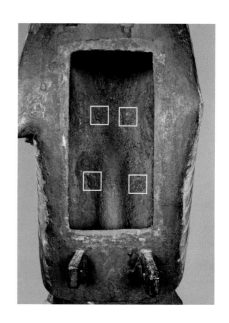

FIGURE 33. Conjectured piece-mold sections of cat. no. 4, with core extensions shown as green rectangles

FIGURE 34. Detail of back of cat. no. 4, with locations of four patched core-extension holes indicated

exactly where or how the shift occurred, it is clear, when examining Buddhas from this period, that a dramatic change in both style and technology took place. The influx of traveling artisans and foreign ideas was responsible, no doubt, for these changes.[12] Lost-wax technology may have come from both the west (India, Kashmir, Pakistan, and Afghanistan) and the south (Southeast Asia and Yunnan Province). Still, it is not always easy to recognize the difference between lost-wax and piece-mold casting, especially in solid sculptures. There were clearly times when both methods were being used, perhaps even on the same sculptures. Two sixth-century altars are good examples. While catalogue number 7a could easily have been cast by

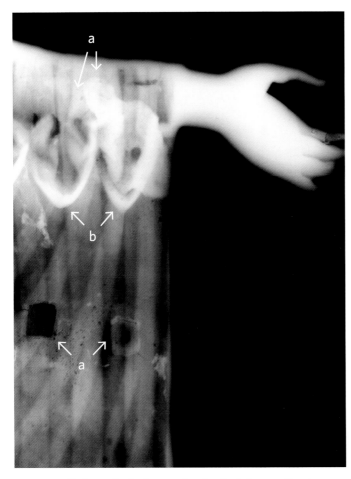

FIGURE 35. Radiograph of cat. no. 4 showing the left arm with robe, patched core extensions (a), drapery folds (b), and separately cast hand; digitally manipulated

FIGURE 36. Flat, triangular core pins extending into the body cavity of cat. no. 16

the piece-mold method, number 7b, with its more severe undercuts, is less convincing. By the eighth century, in the middle of the Tang dynasty (618–906), nearly all sculptures were being made by the lost-wax method, except, perhaps, for the occasional attachment.

Lost-wax casting can be carried out by a direct or an indirect method. Through the use of armatures, cores, and a highly malleable material such as wax for the model, figures made by either method can be abstract and static or, just as easily, naturalistic or expressive, with deep undercuts and projections in all directions. Direct lost-wax casting produces a single image, since the original model is melted out and lost. With the indirect method, the image is created in a piece mold from an original model that can be reused.[13] To cast a hollow image, the mold, once removed from the original model, is reassembled and lined with wax to create a wax "intermodel," leaving a hollow interior. Significantly, the cavity in the wax-lined mold is accessible until the core is introduced, and evidence of this sometimes survives on the interior surfaces of the cast. For example, if molten wax was poured or brushed into the mold, then drip or brush marks might be reproduced in the metal. If, instead, wax sheets were pressed into the mold, fingerprints, toolmarks, or seam lines might be visible. Next, the clay core is introduced into the wax-lined cavity and the mold is disassembled, leaving the core-filled wax intermodel. Now, any independently fashioned wax components, such as extending arms or elaborate drapery folds, can be appended. Surface detail can also be scored into the wax. Finally, the intermodel is covered with an outer clay investment.

Both direct and indirect hollow lost-wax casting depend on core pins to support the core within the mold assemblage after the wax has been melted out and until the molten metal is poured in. These core pins can be left in the finished sculpture or removed, leaving a void that can be filled with plugs, either hammered into position or cast in situ. Copper-alloy core pins, usually in a flat, triangular shape, are found in hollow lost-wax-cast sculptures beginning in the late Tang dynasty. Such core pins are clearly seen on catalogue numbers 16 and 38 and number A63 (see fig. 36). Two Ming-dynasty sculptures (nos. A56, A57) have headless iron nails for core pins.

It is likely that all the examples in the Museum's collection, prior to the late tenth century, were made by the direct lost-wax method. However, since there are no replica sculptures in the collection and not all the interiors were accessible for study, it is not always possible to determine which method was used. Individual parts of catalogue number 22 may have been made in reusable molds and cast by the indirect method. The only later pair of sculptures that might be considered indirectly cast are numbers A56 and A57; however, these works are still being studied.

Armatures have not commonly been found in Chinese sculptures.[14] In this catalogue, most of the metal sculptures are less than a foot (about 30 cm) tall, and seven are solid

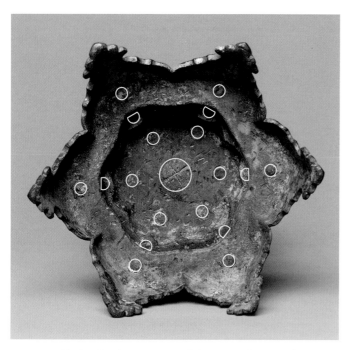

FIGURE 37. Underside of cat. no. 22, with locations of rivets indicated

cast. Of the twenty-six hollow sculptures, many have had their cores removed, which would have taken along any armature. Only six sculptures, ranging in height from about 8 to 21½ inches (20 to 55 cm), contain simple iron armatures (cat. nos. 7a, 7b, 16, 42; nos. A17, A63). The earliest examples are the Maitreya figures on the altars (cat. nos. 7a, 7b), which contain armatures in their cores (for details, see appendix C). If such armatures existed in earlier sculptures, they were removed. Of the extant armatures, no two are alike. One consists of a short rod between the head and neck (cat. no. 16), one of short rods in the legs (no. A63), and one of a rod running from the chest down to the ankles (no. A17); another is shaped like an inverted "U" (cat. no. 7a).

Regardless of the casting method, the smaller figures were cast solid, with their haloes and bases integral with the image. Larger sculptures are either solid or hollow, with mandorlas, haloes, and bases cast separately. The more complicated sculptures (such as cat. nos. 7a, 7b) have more parts that were independently cast. The separate parts were attached mechanically to tangs or protrusions and held together by metal pins. One regional workshop may be identified by a unique group of sculptures, of which one example is in the Metropolitan: a small, high-leaded Five Dynasties bodhisattva (cat. no. 22).[15] These sculptures all exhibit a complex system of rivets used to pin together the multiple parts. The Metropolitan's sculpture is made up of nine different sections and twenty-six lotus petals, all riveted together (see fig. 37).

To return to the description of the casting process: once the casting gates, sprues, and fins were removed and the surface was smoothed with abrasives, details not carved in the wax or the mold were added by chasing or engraving. The most common method of applying inscriptions was by engraving. After surface finishing, the sculptures were ready to be gilded and decorated with polychromy and inlays. Ten of the thirty-three metal sculptures in the catalogue were not gilded. The other twenty-three, even those with high lead content, were gilded by the mercury-amalgam method.[16] On occasion, additional layers of leaf gilding were added later, in which case a resin, probably lacquer, was used to affix the gold (as in no. A33).

All the metal sculptures in the catalogue made prior to the eleventh century exhibit copper corrosion products from long-term burial. It remains unclear why and how the works were placed underground. While some may have been buried deliberately, others were most likely covered with dirt by historical accidents, such as when cities, temples, or homes were abandoned.

Alloy Composition

All the metals in the Museum's collection of Chinese Buddhist images are copper-based, with varying combinations of tin, zinc, lead, and arsenic among the alloying components. In this catalogue, the terms are defined as follows: bronze is an alloy of copper with more than 2 percent tin; brass is an alloy of copper with more than 4 percent zinc; a leaded bronze or leaded brass contains more than 3 percent lead; if the lead content is higher than 10 percent, the alloy is considered a high-leaded bronze or brass. A copper alloy that contains close to 1 percent or more of arsenic is called an arsenical bronze.

All the sculptures in the catalogue believed to be piece-mold cast are bronzes of similar composition, with a lead content from 4 to 10 percent.[17] This composition compares well with Jett and Douglas's findings for early Northern Wei sculptures in the Freer Gallery of Art, which were probably also piece-mold cast.[18] During the Tang dynasty, as lost-wax casting came into use, there was a general trend toward higher lead levels. Many of the bronze sculptures made during the Tang contain higher levels of lead, up to 27 percent—again, similar to the findings in the literature. One can only speculate about whether there is a technical relationship between the alloy composition and the casting method. Certainly, higher lead content increases the flow of molten metal and absorbs gases, making it easier to cast more elaborate shapes. When zinc began to be intentionally added—perhaps to produce a nonoxidizing gold color—the lead content is generally lower. (However, some leaded brasses are found in this period.)

Past studies have found that Chinese artisans, compared to those in Afghanistan, Pakistan, Kashmir, India, and Southeast Asia, were comparatively late in adopting

brass, or zinc-containing alloys, for sculpture. The only comprehensive studies of brass are for coins and show that brass was not used extensively until the fifteenth or sixteenth century, which contrasts with Gandharan sculptures of the fifth to seventh century, which can contain up to 19 percent zinc.[19] When brass does appear, the alloys used for Chinese religious sculpture are generally more variable than those used for contemporary coinage. The zinc content is lower, and mixed alloys that contain both tin and zinc are more frequent. Within this catalogue's statistically limited group of thirty-two copper-alloy sculptures, zinc became an intentional addition in the late fourteenth century.[20] It is possible that the use of zinc alloys during this time period, along with the decorative style, reflects the influence of the Mongols (the Mongol style, for its part, was imported from the Indo-Himalayan region).

All the metal sculptures in the catalogue from the fourteenth century on are brass or leaded brass, except for those that are essentially pure copper. These findings are similar to those reported by Cowell and are supported by the presence of brass wire in fourteenth-century Chinese lacquer objects.[21] Unfortunately, the number of sculptures analyzed here is insufficient to define the date of manufacture on the basis of zinc content or the amounts of other alloying components.

Finally, the metal sculptures of the eleventh to thirteenth century from the southwestern region of Yunnan (cat. nos. 31–34) were made of arsenical bronze, which is also consistent with the literature.[22]

STONE

Most Buddhist sculptures that survive from prior to the mid-fifth century were made of clay or bronze, with some wood used in western China. During the Northern Wei dynasty (386–534), stone sculptures of the Buddha began to be produced on a regular basis. China, with its vast geography, contains many different types of stone. Usually, the type of stone selected for a sculpture represents the geological conditions of the place where it was made. At the Museum, surface details of each stone sculpture were examined with the aid of the binocular microscope, and repairs were illuminated under ultraviolet radiation. Identification of the stone was carried out by the naked eye, with the binocular microscope, and, when needed, by X-ray diffraction analysis.[23] All the stone sculptures were examined for evidence of recutting. Most of the forty-four stone sculptures in the catalogue were carved from limestone (twenty-nine works), sandstone (eight), or marble (six). Only one small stele was carved from serpentinite (no. A14). In general, limestone is much easier to work than sandstone, which, in turn, is easier to work than marble. Of the two latter types, sandstone tends to have a rough, grainy texture, while marble has a finer, smoother surface.

In addition to being categorized by stone type, the works can be divided into cave-temple and freestanding sculptures. Both types were carved in sandstone and limestone, while marble was used only for freestanding sculpture. All the freestanding stone sculptures in the catalogue were carved from a single solid main block, with occasional small additions. The largest figures, regardless of stone type, have separately carved hands (cat. nos. 5, 9; nos. A11, A13, A19, A48) and/or heads (no. A48, possibly no. A13). Separately carved parts were attached either by mortise-and-tenon joins or with iron dowels, as with the fingers and scarf on number A48 (see fig. 38). The mortises are either square or circular in section (see fig. 39). Most of the freestanding sculptures had separately carved bases

FIGURE 38. Iron dowels in right hand of no. A48

FIGURE 39. Exposed circular mortise in left arm of no. A19

the presence of lichen, cycles of heat and cold, and effects of water, which cause the surface to look different from the underlying rock substrate. Other factors that can affect a sculpture's appearance are the stone's crystal size, other mineralogical properties, and past restorations.

Cave-Temple Sculpture

Not surprisingly, a review of the major cave groups represented in the catalogue finds similarities in surface appearance within each group, even though the works are few in number.

The works from the Yungang area were carved in sandstone. Two of them, a bodhisattva with crossed ankles and a separate head of a bodhisattva (cat. no. 3b; no. A1), are unfinished: the general shapes were blocked out, but the finely carved details were not completed. The unfinished state provides an opportunity to study the toolmarks. Flat chisel marks about ⅜ inch (1 cm) wide can be seen across the forehead and cheeks of number A1. Even though the carving was unfinished, both pieces were painted. Another bodhisattva with crossed ankles in the collection (cat. no. 3a) is completely carved and has traces of red-lead pigment in the recesses of the robe.

The limestone from the Longmen caves is heavily veined and fractures very easily, making it difficult to carve. Thus, the ten sculptures in the catalogue that are likely from Longmen[24] have been reconstructed from multiple fragments. The surfaces have also been heavily restored to cover the joins, making it difficult to determine which pigments are original. Aside from the veins of white sulfates and orange-brown iron oxides, the gray stone has a dense, smooth surface.

Freestanding Sculpture

The majority of small freestanding stone sculptures in the collection are white-marble Buddhas or bodhisattvas carved in the round (nos. A20, A26, A28, A36, A48) or in relief (no. A39). Marble is much more difficult to work than sandstone or limestone. Very few ancient Chinese marble quarries have been identified; therefore, no oxygen-isotope ratios are available, making it impossible at this time to determine the provenance of stones by scientific analysis.

Only the three small Tang-dynasty figures (nos. A20, A26, A28) can be compared profitably. They are seated Buddhas, each carved from a single block of white marble and shaped with both point and flat chisels and a running drill. All three have inscriptions on their bases. Aside from stylistic differences, there is other compelling evidence that they were carved by different sculptors—namely, the different styles of the inscriptions and the different patterns of rough toolmarks on the bottom of the bases. Originally, all three works probably had separately carved

(nos. A11, A16, A18), some of which are missing today or have been replaced. The tang projecting downward from a freestanding sculpture was usually tapered to fit snugly into the base. All the steles in the catalogue originally had separate bases.

The only distinctive toolmarks identified thus far on any of the stone sculptures are those of point and flat chisels (see fig. 40). There is no evidence that claw chisels, rasps, or scrapers were ever used. Incised lines were lightly carved or punched into the surface to delineate details of anatomy or design and as a guide for inscriptions. Changes in stone-carving techniques may have occurred during the Northern Qi (550–77) and Tang dynasties, when running drills with abrasives, similar to those used in ancient jade carving, were employed (although there is little evidence of jade carving in these particular periods). Several of the marble sculptures exhibit holes made by a running drill, such as the hole in the back of a seated Buddha's head (no. A28), where the halo was attached.

Over time, during burial or aboveground exposure, weathering causes complex layers, collectively known as patina, to develop on stone surfaces. As expected, the surface patina differs from sculpture to sculpture. It is formed by various physical and chemical factors, including

haloes (now missing) attached to the back of the heads. Number A28 has two holes made by a running drill in the back of the head for halo attachment, while number A20 has a single square cavity in the same location for the same purpose. No traces of polychromy were detected on any of these sculptures, but it is likely that they were originally painted and gilded.

The other three marble sculptures in the catalogue stand apart and are unrelated. Of the three, the huge Jin-dynasty standing bodhisattva (no. A48) is more interesting technically than either the Five Dynasties bodhisattva head (no. A36) or the Liao-dynasty Manjushri relief (no. A39). The standing bodhisattva originally consisted of a body with a number of separately carved pieces—the head, left forearm, fingers of the right hand, and drapery below the right hand—attached by iron dowels, the ends of which remain lodged in the stone (see fig. 38). Unlike the small marbles discussed above, the surface of this sculpture bears elaborate painted designs (see appendix E).

Another sculpture included in the catalogue is a Buddha's head reported to be from Shandong Province (no. A12). The work was carved from gray limestone and has remains of gilding and pigment. Although analysis is forthcoming, the surface decoration on the head appears similar to that on the Shandong sculpture cache analyzed by Winter.[25]

Steles

Five of the seven steles (or stele fragments) in the catalogue were carved from limestone (cat. nos. 8, 15; nos. A11, A30; Trubner stele [see appendix B]). Nearly all the original paint has vanished from the three Northern Wei examples (cat. no. 8; no. A11; Trubner stele), and some surfaces are coated with black ink from past paper rubbings. Traces of pigment can be found in some recesses, especially around the figures in niches. The front surface of the Trubner stele has been recut. The single sandstone stele (cat. no. 5) still contains traces of pigment on its worn surface.

The two Tang-dynasty steles were carved from limestone and have varying surface qualities. When examining the well-preserved pigment on the larger example (cat. no. 15; see fig. 41), it is clear that some steles were originally kept in protected locations or indoors, not exposed to the elements. There are at least two layers of surviving polychromy. On the outermost layer, the entire frame and border were painted with yellow ocher, perhaps to imitate gilding. The haloes of all the Buddhas were multicolored, as were their robes. At some time in the past, the faces of the figures and animals on the other Tang example (no. A30) were desecrated. Prior to the Museum's acquisition of the work, the faces were restored with lead-based putty.

The small mid-sixth-century miniature stele (no. A14) was carved from a soft serpentinite. It is a central section of a more complex sculpture. Large rectangular holes at the top and bottom were used to attach it to the other parts of the work. All four sides are elaborately carved with the Thousand Buddhas motif, but no trace of polychromy or gilding remains.

WOOD

Around the twelfth century, stone sculpture started to taper off in China in favor of large-scale wood figures. Of all the works studied in the catalogue, the wood pieces are the most fragile and ethereal. They are easily damaged, and many have been extensively eaten by insects. Every wood sculpture has been repaired in the past, and many have undergone multiple restoration campaigns, ranging from the replacement of large sections of a sculpture to the reinforcement of separate and/or newly attached pieces with nails, to the repainting of the surface, often multiple times.[26] A single location on a piece might have the original

FIGURE 41. Detail of pigment layers on border of cat. no. 15

35

loose-tenon joins, nails of various dates, and wood pieces of different species. Interpreting the original construction techniques through all the restorations was a complicated and time-consuming study, thoroughly carried out by Won Yee Ng at the Museum. Pigment studies were conducted on some of the sculptures and are discussed in appendix E or in individual catalogue entries.

Unlike in Japan, where the fabrication of Buddhist sculptures has been extensively studied, there is very little comparable information in China.[27] Study of the Museum's collection reveals that there was little change in construction methods over time. The wood sculptures were predominantly carved from a single solid block of wood, and additional pieces such as arms, hands, toes, headdresses, and drapery were attached to the central block with dowels, nails, or loose-tenon joins.

Surface details were examined with the aid of the binocular microscope and under ultraviolet radiation. Radiography was the most useful tool for understanding the construction of wood sculptures—invaluable for locating composite wood sections, dowels, and repairs; matching wood grains; and revealing consecratory chambers. It was also through radiography that the original blocks could be discerned and selected for sampling for wood identification and radiocarbon ([14]C) dating. Radiocarbon dating was carried out on all the wood and lacquer sculptures except the four that have unquestioned, inscribed dates (cat. no. 35; nos. A53, A64, A67).[28] In some cases, stylistic analysis helped to narrow the range of dates provided; in others, broader dates are accepted.

Wood identification was performed by polarized-light microscopy.[29] Appendix F discusses the methods used in detail and provides photomicrographs of wood sections for comparison.

Wood Sculpture Construction

The catalogue includes twenty-six freestanding wood sculptures and three shrines. Sculptures less than about 20 inches (51 cm) tall (nos. A53, A59, A60, A64, A66, A67) were carved from a single piece of wood, as were all three shrines. The two early shrines (cat. nos. 2, 21) were carved from juniper, and the later shrine (no. A61) from linden. When complete, the shrines probably all took the same form as number A61, in which the two side sections close together over the middle section, forming a cylindrical shape that protects the delicate carving and makes the work easier to transport. Today, only the central sections of catalogue numbers 2 and 21 remain. Holes for cords or hinges are present along the sides of the latter—clear evidence of the existence of additional sections.

The construction of larger sculptures varies, depending on their size and configuration: whether the figure is

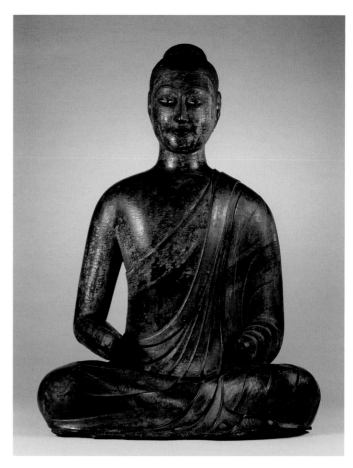

FIGURE 42. Seated Buddha. Sui dynasty (581–617). Wood-core lacquer, H. 41½ in. (105.4 cm). Walters Art Museum, Baltimore

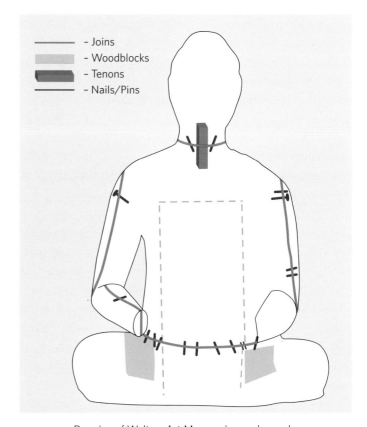

FIGURE 43. Drawing of Walters Art Museum's wood-core-lacquer Buddha (above), with individual wood pieces, loose tenons, and nails delineated

seated cross-legged, seated in a relaxed pose, or standing. Essentially, all three types were constructed from a single central block of wood, with some minor protruding pieces attached separately. This is consistent with the findings of both Rösch and Webb.[30] The predominant methods used to attach the pieces were wood dowels, loose-tenon joins, and nails (see figs. 44, 45, 47). All three methods may be used on a single sculpture. Only one tongue-and-groove join was identified (no. A41).

Iron nails join parts of practically every sculpture taller than 20 inches (about 51 cm). It is usually difficult to determine whether the nails were part of the initial construction or added in a restoration. Some nails with tapered points and distinct thin, flat heads are clearly machine-made nails used in recent restorations, while hand-wrought nails of varying sizes could be from any time period. Unfortunately, a history of Chinese nails does not yet exist, and until it does, these components cannot be dated. Toolmarks in the wood have not been studied in detail at this time, but curved and/or flat chisel marks of various widths were discerned on the interiors, where accessible.

It is instructive to review the method used to construct the earliest known large wood sculpture in an American collection, a sixth-century wood-core-lacquer seated Buddha in the Walters Art Museum, Baltimore (25.9; fig. 42). It consists of three solid main blocks: torso, head, and knees. Loose-tenon joinery, along with iron nails, was used to attach the legs and head to the body. Additional slats were added to the outside of the upper arms. Two boards form each forearm, and two blocks fill gaps at the back of the hips (see fig. 43). All the additional pieces are attached with wood dowels and iron nails. It has not been determined whether the nails are original or later additions. A single rectangular chamber, possibly for consecratory material, was carved in the back; its cover is now missing. This construction model for seated images is found again and again in wood sculptures, regardless of time period.

The earliest large seated Avalokiteshvara with crossed legs in the Museum's collection of wood sculpture (cat. no. 27) was carved from a single solid block of foxglove. The only additions, joined to the body with wood dowels, are the kneecaps and a slab on the outside of the right arm (see fig. 44). A cross-legged seated Buddha of roughly the same time period (cat. no. 29) is similar in construction to the Walters example. It has a single block for the head and torso and an additional block for the knees, which is attached by loose-tenon joins, without nails. The hands, now missing, were originally doweled in place. The work was carved from willow, and most of the interior has been hollowed out.

The catalogue contains four wood bodhisattva sculptures seated in the relaxed pose (with one leg up). Of the

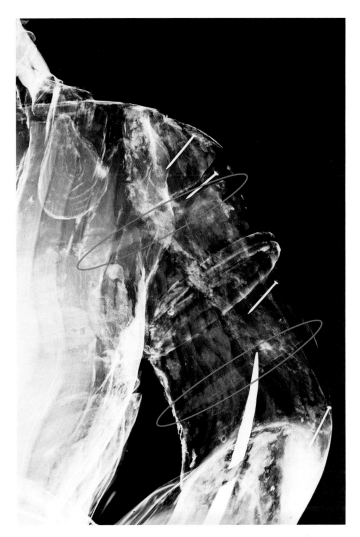

FIGURE 44. Radiograph of cat. no. 27 showing two dowels attaching wood slab to outside of upper arm

earlier two, number A44 was carved from foxglove, and catalogue number 24 from willow. Like the cross-legged examples, both have a central block for the head and torso, but contrastingly, the legs are additional blocks, attached to the body by loose-tenon joins (see fig. 45). Both sculptures have separately carved hands, toes, and topknots. The two later examples were both carved from a single large solid block. In the case of catalogue number 36 (willow with a consecratory chamber), only one hand was carved separately, and in the case of catalogue number 40 (poplar without a chamber), the headdress, now missing, was added separately.

The earliest standing wood sculpture in the catalogue is a bodhisattva (cat. no. 20) made in the ninth or tenth century, more than three hundred years after the Walters Buddha. The work consists of a single block of wood from the top of the head down to the bottom of the base. Only the left forearm and hand (now missing), small pieces of the drapery over the upper arms, and parts of the crown were carved separately and affixed with wood dowels, without nails. The larger standing sculptures in the

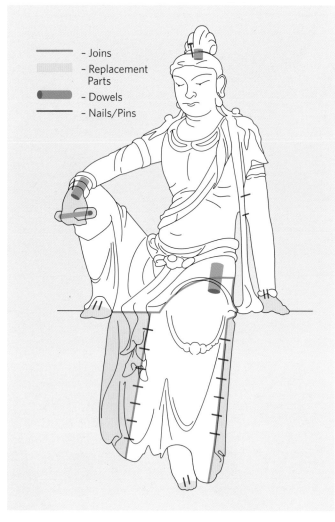

Joins
Replacement Parts
Dowels
Nails/Pins

FIGURE 45. Line drawing of no. A44 showing dowel joins

collection often have separately carved arms, hands, toes, and lotus petals—anything that could not be contained in the volume of the original tree trunk (see cat. no. 35; nos. A41, A47, A49). In the case of these larger works, all the separate pieces were attached with either loose-tenon joins, dowels, or nails. Small pieces of headdresses were doweled on.

One late-period sculpture strays from the traditional construction methods discussed above: number A72, which is dated about 1895 and consists of twenty-one separate reused blocks, glued together.

Wood Species Identification

In the few existing early texts, white sandalwood (*Santalum album*) is the only wood specifically mentioned as the best choice for creating a true likeness of the Buddha.[31] The fragrant wood was imported from India, as it does not grow in China. Rösch cites references that name foxglove (*Paulownia* spp.), a relatively rare wood, as an acceptable substitute for sandalwood.[32]

At the Museum, a study was conducted to determine whether the selection of wood species could be related to a sculpture's provenance, its construction method, or the particular Buddhist figure represented. To identify the woods, minute samples were taken from the main block of each sculpture and examined in the polarized-light microscope (see appendix F). Some separately carved pieces of the sculptures were also sampled. Efforts were made to sample only woods that were original to the piece—that is, those with similar layers of polychromy, insect damage, and wear.[33]

In summary, we can say that the major woods used for the sculptures were willow (nine works), foxglove (eight), and linden (five). The only other woods identified were white sandalwood (three), juniper (two), and poplar (one). Juniper (*Juniperus* spp.) was used for the two early portable shrines and sandalwood only for the smallest seated Avalokiteshvara sculptures, probably on account of its rarity and expense. Of the works that were sampled in multiple locations, the same wood species was used for the separately carved pieces as for the main block in all cases but two. The body of number A49 is willow but the left arm is foxglove, and the body of number A42 is foxglove, while a back section of the lotus base, a possible replacement, was carved from ash (*Fraxinus* sp.).

The most common woods—willow (*Salix* spp.), foxglove (*Paulownia* spp.), and linden (*Tilia* spp., also known as limewood)—represent two-thirds of the sculptures examined. This is consistent with the existing literature.[34] Regardless of wood type, the construction methods were essentially the same for all the sculptures studied. One difference, noted by the Metropolitan's Won Yee Ng, is that none of the foxglove sculptures has a cavity for consecratory material, while all the willow sculptures, except for those representing monks, have one or more cavities in the head and/or back. This discovery raises new questions: was the softness of the wood responsible, or was one species considered more sacred than the other? Although a common wood, willow is one of the attributes of Avalokiteshvara; thus, there may have been a religious reason for selecting it.[35] It is noteworthy that all the large wood sculptures of Avalokiteshvara identified in the collection (cat. nos. 24, 35, 36; no. A71) were carved from willow.

In appendix F, Mechtild Mertz and Takao Itoh discuss the religious significance of linden. It is often called the bodhi tree; however, the original bodhi tree was a pipal (*Ficus religiosa*), which does not grow in China. The leaf of the linden bears some resemblance to the pipal leaf and is often cultivated on temple grounds in northern China, so it may have been considered an acceptable alternative.[36]

Rösch suggests that wood types may provide regional provenances for sculptures. Willow, linden, and poplar

grow in the north and northeast, from northern Manchuria and Mongolia down to Shaanxi, while foxglove grows in central and southern China, around the Yangzi River and west toward Sichuan.[37] Our sculptures confirm this observation: the foreign Liao, Jin, and Yuan dynasties used willow, and the Song dynasties, centered in Henan Province, favored foxglove.

LACQUER

The Metropolitan Museum's large seated Buddha sculpture in hollow dry lacquer (cat. no. 13) is similar to one in the Freer Gallery of Art (44.46; fig. 46). Both are closely related to the Walters Art Museum's wood-core-lacquer seated Buddha of the same time period (fig. 42), discussed above.[38] All three sculptures have been subjected to technical study.[39] The Freer Buddha is nearly identical to the Metropolitan's. Both consist of multiple layers of plain-weave fabric with a thick, bulked, and painted lacquer surface. Inclusions in the bulked lacquer layers appear similar but must be studied further. All three sculptures have a flattened area at the back of the head and later repairs covering the two holes where the haloes were once attached. In both dry-lacquer examples, a wood block inserted between the cloth layers at the back of the head was used for attaching the halo (now missing). The block in the Metropolitan's example still retains two very large iron nails for that purpose (see fig. 47). All three Buddhas are missing their original hair curls and have two black glass eyes; in each case, the third eye has been filled in and is visible only in radiographs. The earlobes of the Freer and Metropolitan sculptures contain U-shaped iron-wire armatures to support the lacquer in these thin areas. Both also have partial wood armatures in the forearms. The polychromy on the sculptures is discussed in appendix E.

CERAMIC

Ceramic sculpture has a long, continuous history in China; thus, it is not surprising that, with the arrival of Buddhism, images of the Buddha would be made in that medium. Initially, small figures of the Buddha appeared on low-fired funerary pottery in the south. In the fourth century, extraordinary unfired-clay-and-reed sculptures began to be produced in the caves of western China, along the northern branch of the Silk Road. Subsequently, both low-fired and unfired clay votive plaques bearing the Buddha's image became common.

The authenticity of ceramics was determined by thermoluminescence (TL) analysis.[40] Note that TL dates are

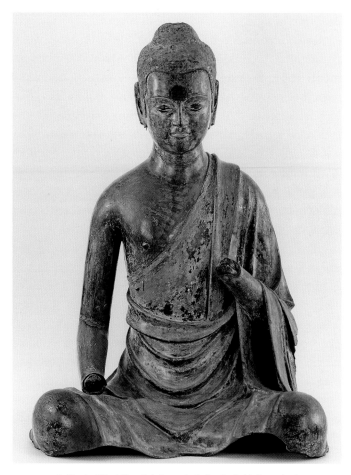

FIGURE 46. Seated Buddha. Sui dynasty (581–617). Hollow dry lacquer, H. 39 in. (99.5 cm). Freer Gallery of Art, Smithsonian Institution, Washington, D.C.

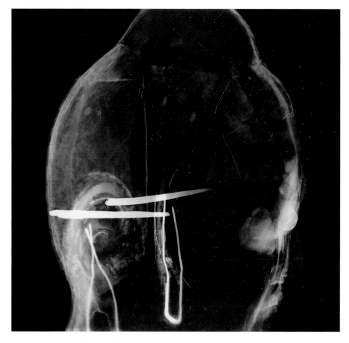

FIGURE 47. Radiograph of cat. no. 13 revealing inlaid glass eyes, two large nails used to hold missing halo, and wire armatures in ears

used only as a guide, and within the range of dates provided, each year is considered equally probable by the laboratory. Fabrication techniques, flaws, and repairs were documented by radiography, and surface details were examined with the aid of the binocular microscope and under ultraviolet radiation. The ceramic sculptures studied for the catalogue were constructed primarily by two methods: the hand-built slab technique and the piece-mold method. The simpler, low-fired pieces, such as the wall tiles (nos. A22, A23) and votive plaques (cat. no. 14; no. A21), were mold made. After firing, they were decorated with cold pigments and, occasionally, selectively leaf gilded.

Two of the three unfired, polychromed clay heads that are included in the catalogue (nos. A45, A46) were examined with the binocular microscope and by radiography. They consist of a central vertical wood support that was wrapped with fabric or rope and covered with an unfired clay matrix. The clay matrix is a mixture of sand-sized particles, unidentified plant materials, and a fine reddish clay. The clay was applied first in coarse layers, with finer layers toward the surface. Floating iron rods and wires were used to support extending parts of the headdresses, the hair, and the earlobes. A thin white ground layer provided a smooth surface for the polychromy. The crown of number A45 is gilded. Both heads have black glass eyes.

Examples of later-period low-fired ceramics are the two small arhats (nos. A65, A73). Completely solid and heavy, they were built up of multiple balls of clay over a single slim wood rod. All the details were worked into the leather-hard clay before firing. Instead of glazes, cold pigments were used after firing to decorate the surfaces.

The more complicated, higher-fired hollow stoneware and porcelain works, both large and small, were hand built by the slab technique. Many have clay-slab support walls on the inside that prevented the works from collapsing during construction and firing and continue to provide structural support. The largest works also include separately molded parts, such as hands (cat. nos. 23a, 23b). Rather than being colored with cold pigments after firing, these higher-fired ceramics were decorated with fired-on glazes.

After the Tang dynasty, ceramic sculptors took advantage of new developments in materials and methods. The two Yuan-dynasty bodhisattvas (nos. A51, A52) are *qingbai*-style porcelains with a bluish glaze; the color resulted from reduction firing and the iron that was naturally present in the raw materials. The Ming-dynasty Buddha (no. A55) and the Daoist deity dated 1482 (no. A54) are typical *sancai*-glazed stoneware. In the later periods, porcelain predominates. An example is the meditating Bodhidharma (cat. no. 43), a seventeenth-century Dehua-ware porcelain from Fujian Province.

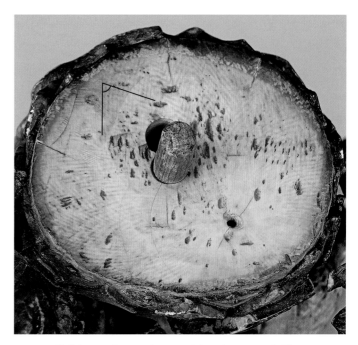

FIGURE 48. Schreger lines on ivory sculpture (cat. no. 30). The cross-hatchings, or stacked chevrons, intersect at an angle of less than 90 degrees, identifying the ivory as mammoth, not elephant.

IVORY

Few early Buddhist ivories have survived; thus, the three ivory sculptures in the Museum's collection (cat. no. 30) are extremely rare and important. Initially, radiocarbon testing was considered as a means of confirming their probable dates. However, close microscopic examination of the distinctive sharp angle of the Schreger lines (cross-hatching visible in an ivory cross section) on the sculptures determined that the ivory came from a mammoth's tusk, not an elephant's (see fig. 48). Radiocarbon testing thus would probably have produced an age of greater than ten thousand years. For now, no scientific dating method can aid the curatorial study.

Each sculpture consists of two separately carved pieces, one for the figure and one for its mount. A single bamboo peg holds the pieces together. Although much of the polychromy has worn off, the sculptures were originally elaborately painted and gilded. Even their bases were painted green to imitate vegetation (see appendix E).

SCULPTURES WITH CONSECRATORY CHAMBERS

The practice of placing precious materials that symbolize religious relics inside objects began, in Asia, in about the first century C.E., with containers made of stone and precious metals from Gandhara.[41] While no surviving relics, actual or symbolic, have been found inside Gandharan

Buddha sculptures, it is possible that, by the second century, some Gandharan stucco and stone sculptures, as well as some Chinese bronzes, may have contained ritual deposits. Although the assertion is controversial, it has been suggested that small chambers in the top of the heads of some Buddhas from present-day Pakistan and China once contained deposits.[42] Placement of ritual deposits may have begun in the head area of sculptures and then, over time, moved down into the body. Many of the Museum's Chinese sculptures may have held consecratory material, although few of the deposits have survived. Chambers, possibly for symbolic relics, were found in many of the metal and wood sculptures studied in the catalogue.[43] None were found in any of the stone or ceramic pieces.

It is important to distinguish between actual relics and symbolic relics, or ritual deposits. A symbolic relic is usually a shiny and/or precious material such as mother-of-pearl, rock crystal, lapis lazuli, silk, a rare type of wood, or a sutra. An actual relic is something like a tooth, hair, bone, ashes, or nail clippings that was believed to have been part of the Buddha's or a monk's actual body. When placed inside a sculpture, the relic invests the sculpture with the presence and power of the sacred being, thus transforming the work into a reliquary.

The earliest example in the collection of a work with a consecratory chamber is the nearly lifesize standing Buddha Maitreya in bronze (cat. no. 4), dated 486 C.E. It has a large rectangular opening in its back, and all the core material has been removed, so that it would have been easy to place deposits inside. In fact, fragments of deposits were placed in the sculpture some time between its excavation and its arrival at the Museum in 1926.[44] Interestingly, a Buddha on one of the two early bronze altars (cat. no. 7a) has a similar rectangular panel in its back, visible only in radiographs (see appendix C). It has been argued that openings such as these were used simply for removing the core material, which, in the case of larger sculptures, would have lightened them considerably; however, there was no need to remove the core from a smaller sculpture unless making room for a deposit.[45]

It is proposed here that most of the hollow-cast copper-alloy seated Buddha sculptures had metal covers over their bases to contain consecratory material, in a manner similar to later pieces, such as catalogue number 44. Certainly, it was common for Tibetan sculptures to contain ritual deposits in their bases.[46] Many base covers are missing today, but a number of the bases bear physical evidence of having once been closed by periodic chiseled flanges around the rim (see fig. 49).

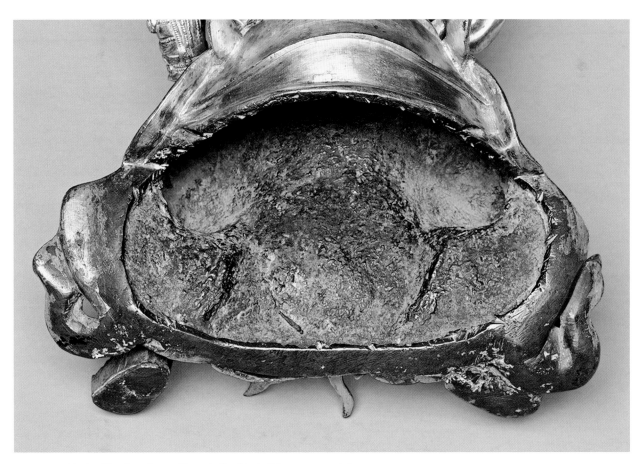

FIGURE 49. Underside of no. A70, with periodic chiseled flanges around rim

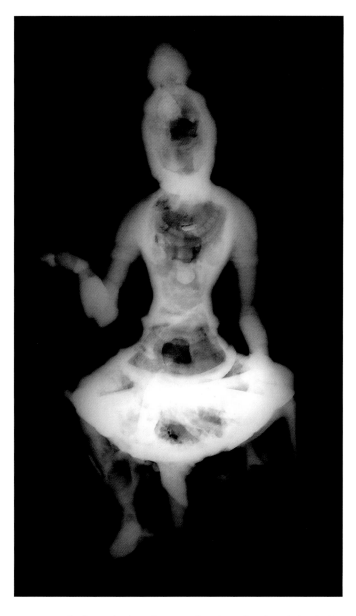

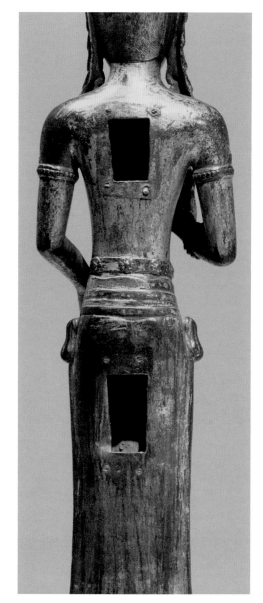

FIGURE 50. Radiograph of no. A33 revealing three chambers in back of sculpture, with darker covers

FIGURE 51. Back of cat. no. 32, showing two openings to one large chamber

Some copper-alloy sculptures contain more than one chamber. In all cases, the core was removed and the resulting cavity covered with a thin metal plate after the sculpture was cast. Chambers may be located in the back of the head, the middle of the back, or lower on the back. They are often difficult to see because the covers have corroded shut during burial, but since the covers are thinner and usually made of a different metal, radiographs reveal them clearly (see fig. 135 in appendix C). Number A33 has three chambers (see fig. 50). Catalogue number 16 has two chambers, one in the head and the other in the back. Catalogue number 25 has one chamber. A Yunnan Avalokiteshvara (cat. no. 32) has two rectangular holes in the back that were formed by core extensions during casting but were later covered to contain deposits (see fig. 51). Those chamber covers that have been analyzed are nearly

pure copper, except for that of the Yunnan Avalokiteshvara, which was made of brass. It may be a later replacement. There is evidence that the top of the crown of catalogue number 26 was once closed off, perhaps to hold ritual deposits.

Consecratory chambers are also located in many of the wood sculptures. Depending on the size of the sculpture, there are from one to three chamber covers. An early example, the sixth-century wood-core-lacquer sculpture in the Walters Art Museum (fig. 42), has a large cavity in its back that originally had a cover, presumably to contain deposits. Some chambers extend the entire length of a sculpture and are accessed by more than one cover (see cat. nos. 29, 41). As noted above, none of the sculptures made of foxglove contains a chamber, yet all those made of willow (Buddhas and bodhisattvas alike) do.

As with the metal sculptures, not all the chambers were accessible, and some could be examined only through radiography.

The interior of some chambers was painted red in the chest or base area (see metal sculptures nos. A33, A56, A57; wood sculptures no. A64, cat. no. 41). The presence of mercury suggests that the pigment used was probably vermilion. Whether this pigment was used for the color's sacred associations, as an insecticide, or for both purposes is unclear.

Some of the sculptures (cat. no. 4; no. A53) still contain deposits. In general, the deposits consist of fragrant wood samples, seeds, and fragments of mother-of-pearl, lapis lazuli, rock crystal, textiles, or sutras written on paper. Two sculptures (cat. nos. 24, 35) have a circular indentation for a mirror on the inner surface of the chamber cover. There is a depression in the middle of the indentation for the mirror's raised knob such that the polished side would have faced toward the front of the object, at stomach level. Catalogue number 35 still contains its small Yuan-period bronze mirror. More details are provided in the individual entries.

It has been suggested that some low-fired ceramics, such as the votive plaques (cat. no. 14; no. A21), were believed to contain the ashes of enlightened people mixed with the clay,[47] but this hypothesis has not been confirmed.

SUMMARY

Technical study of the Metropolitan Museum's collection has brought new information to light about the construction and use of Chinese Buddhist sculptures. Technology can have a significant effect on style, as is clearly demonstrated by the early Chinese Buddha sculptures in bronze, which were produced by a traditional method of manufacture applied to imported forms. With the arrival of Buddhism in China in the second century C.E., a new demand for images of the Buddha arose. The Chinese designs were borrowed from Gandharan sculpture, but their style was adapted to suit the available local technology: piece-mold casting. As a result, the fluid, naturalistic prototypes were transformed into much more angular and compact figures. Visual and radiographic examination confirmed that the fourth- and fifth-century images were piece-mold rather than lost-wax cast.

During the late sixth or early seventh century, lost-wax casting, which can produce more fluid and dynamic images, began to replace the piece-mold technique. Along with these casting developments, there were changes in alloy composition, depending on the geographic location and/or time period. Beginning in the fourth and continuing through the thirteenth century, sculptures were cast in various bronze (copper, tin, and lead) alloys. After the fourteenth century, the alloy composition appears to have changed with the addition of zinc. From then on, a few quaternary alloys were used, but brass (copper, zinc, and lead) predominates. Arsenical bronzes, with occasional additions of lead, were produced in the southern region of Yunnan. Analysis of more sculptures is needed to confirm or revise these findings.

From the fifth to the twelfth century, Buddhist sculptures were also commonly carved in stone, initially on cave walls and later as freestanding figures in limestone, sandstone, and marble. While the carving of cave temples continued into the fourteenth century, there is no evidence that freestanding stone sculptures were widely produced after about the twelfth century. In that period, wood began to take the place of stone. Wood sculptures of all sizes were constructed of single main blocks, with small additions attached by dowels or loose-tenon joins. Identification of the types of wood used for the sculptures revealed that the specific type was selected for some combination of its carving suitability, its geographic location, and its religious or symbolic meaning.

Regardless of whether a sculpture was made of metal, stone, wood, ivory, or ceramic, it was originally polychromed. The polychromy survives in various degrees, from barely visible traces to multiple layers applied over the centuries. In this study, it became clear that many of the metal and wood sculptures housed consecratory material in concealed chambers. Although most of the deposits were missing, some chambers still contained remnants, thus affirming the sacred nature of the images.

NOTES

1. As is usually the case with religious sculptures, many of the works in the collection have been restored or repainted in order to maintain their serviceability in rituals or possibly as part of the rededication of the icons or the complexes in which they were housed. Some of that information is available in this catalogue; however, because of space constraints, condition reports for the individual works are not found herein. They are available to interested individuals.

2. The earliest evidence of the new religion can be seen in Buddhist imagery on funerary pottery, bronze money trees, and tomb walls dating to the second and third centuries C.E.

3. See Leidy 2008, pp. 81–99.

4. All metal analyses were carried out by Mark Wypyski, Research Scientist in the Department of Scientific Research, The Metropolitan Museum of Art. See appendix D for details.

5. Certain minerals in soils and clays absorb natural radiation continually and store it as absorbed energy. When heated, they release the energy in the form of light radiation, which can be measured. Once the radiation is released, the minerals begin to absorb natural radiation again, thereby resetting the clock. Thermoluminescence (TL) analysis of ceramic works and clay cores relies on this phenomenon. For example, minerals in the clay core of a hollow-cast bronze sculpture released their radiation when the molten bronze was poured into the mold. After cooling, the minerals in the core began to absorb new radiation. The amount of stored radiation can be measured (again, by heating a small sample) in order to calculate when the object was last heated—that is, at the time it was cast. The TL analyses of the ceramics and clay cores of numerous metal sculptures in the catalogue were conducted by Doreen Stoneham and Oxford Authentication Ltd., Oxfordshire, United Kingdom.

6. The current literature states that the lost-wax casting method began to be used to make complex components of vessels in northern China during the Eastern Zhou dynasty (ca. 5th century B.C.E.). See Bagley 1987, pp. 44–45; Mackenzie 1991, pp. 136–39; New York 1991a, p. 34; Jett and Douglas 1992; Tan 1989. However, debate has recently arisen over the date of its arrival. Zhou Weirong proposes that the lost-wax method did not arrive until well after Buddhism arrived, some time in the late sixth to early seventh century C.E.; see Zhou Weirong et al. 2006 and 2009. However, other scholars disagree: Zhang Changping 2007 argues that a combination of piece-mold and lost-wax methods was being used prior to that time.

7. Parts of this section were previously published in Strahan 2010. The third analyzed work is in the Asian Art Museum of San Francisco (AAM B60B1034).

8. For more details, see Strahan 2010.

9. See Strahan 2010, no. 29.

10. Mortises and tenons cut into the mold sections would have made it much easier to realign the mold sections before casting. Here, because no foundries for Buddhist sculptures have ever been found, the use of mortises and tenons is only conjectural. Mold sections, both with and without mortises and tenons, have been found at Anyang, a site dated 13th–11th century B.C.E. See Li Yung-ti 2003, pp. 109–11.

11. Bronze money trees of the late second to early third century, found at numerous sites in Sichuan, were piece-mold cast, as is demonstrated in Steele et al. 1997.

12. For the importance of foreign influence on changing artistic styles after the sixth century, see New York 2004–5.

13. Jett and Douglas 1992 (p. 211) identifies only two sculptures that appear to have been made from the same mold. Although the dating is questioned, the works may be from the Song dynasty.

14. See Cowell et al. 2003, p. 81.

15. Two other examples are in the Freer Gallery of Art, Smithsonian Institution, Washington, D.C.: F1912.92, F1912.93. Both are high-leaded bronze alloys.

16. This is consistent with the findings in Jett 1993.

17. These include cat. nos. 1, 4, 7a, 7b, 12; nos. A17, A24. Outside the Metropolitan's collection, two other piece-mold Buddhas—the work from the Winthrop Collection in the Harvard University Art Museums (Cu 86, Sn 6.2, Pb 5.7) and the work dated 338 C.E. in the Asian Art Museum of San Francisco (Cu 86.5, Sn 8.3, Pb 3.8)—have similar compositions.

18. See Jett and Douglas 1992.

19. See Reedy 1992, p. 246.

20. See, however, Cowell et al. 2003. The authors found one Avalokiteshvara (12th–13th century) that contained 8 percent zinc and no tin.

21. See ibid., p. 88, and Jett and Douglas 1992, p. 206. Analysis of two fourteenth-century lacquer objects confirms the use of brass wire in their mother-of-pearl design. One in the Metropolitan Museum (2006.181a, b) was analyzed by the author. The other is in the Freer Gallery of Art, Smithsonian Institution, Washington, D.C.; see Jett 1990.

22. See Jett 1991.

23. Tony Frantz, Research Scientist in the Department of Scientific Research, The Metropolitan Museum of Art, identified the types of stone in each of the sculptures in the catalogue. Most were identified visually, but some were analyzed by open-architecture X-ray diffractometry.

24. Cat. no. 6; nos. A2–A8, A31, A34.

25. See Winter 2007.

26. With respect to damage and restoration, our collection is not unique. Chinese wood sculptures throughout the world have suffered similar damage and repair. For comments on the collection of the Royal Ontario Museum, Toronto, see Webb et al. 2007.

27. Japanese scholars have studied the construction of Japanese Buddhist wood sculptures intensively for many years and have developed a historical overview of developments from the eighth through the nineteenth century. Briefly, the construction method developed from massive single-block construction in the eighth century, to hollowed-out, split-and-joined construction during the ninth and tenth centuries, and, finally, to hollowed-out, multiple-block construction in the eleventh century and onward. Larger sculptures were produced with smaller units of wood, aiming to avoid the shrinkage cracks and fissure damage often caused by single-block construction. See Rösch 2007a.

28. Samples for radiocarbon dating were taken from the outermost rings of the largest block of wood available. All the radiocarbon dating analyses were performed by Beta Analytic Inc., Miami. The calculated age range for each sculpture was determined in calendar years, with a 95 percent probability (2 sigma). In other words, there is a 95 percent probability that the actual date lies between the stated years.

29. All the wood identifications were performed by Mechtild Mertz, Research Institute for Humanity and Nature, Kyoto, and Takao Itoh, Kyoto University and Nanjing Forestry University. See appendix F.

30. Rösch 2007a reports "three-block construction" for the Water-Moon Avalokiteshvara (seated in relaxed pose)—one block for head and torso, two for left and right legs. Webb et al. 2007 reports that standing and cross-legged examples had one main block, with appended pieces depending on the gesture.

31. See Rösch 2007b.

32. Ibid., p. 174.

33. Marijn Manuels, Conservator in the Sherman Fairchild Center for Objects Conservation, The Metropolitan Museum of Art, took many of the samples to assist Mertz and Itoh.

34. The Avalokiteshvara studied by Larson and Kerr is made of *Paulownia* sp. (foxglove), and of the woods identified by Rösch, *Salix* spp. (willow) and *Paulownia* spp. were also the most commonly used. See Larson and Kerr 1985 and Rösch 2007b. According to Suzanne Schnepp, an Avalokiteshvara at the Art Institute of Chicago (11th–13th century) was carved from foxglove and is of similar construction to no. A43.

35. See Rösch 2007b, p. 177.

36. See Mertz and Itoh 2007.

37. See Rösch 2007b, pp. 175–77.

38. See Strahan 1993.

39. For technical details on the Freer Gallery of Art's seated Buddha, see Jett 1995.

40. See n. 5 above.

41. See Leidy 2007 and Rhi 2005.

42. See Quagliotti 2006.

43. Twenty-two of the twenty-seven hollow metal figural sculptures have one or more chambers: cat. nos. 1, 4, 7a, 16, 22, 25, 32–34, 37, 38, 44, 45; nos. A33, A35, A37, A56, A57, A62, A63, A69, A70. Twelve of the twenty-eight wood sculptures have one or more chambers: cat. nos. 24, 29, 35, 36, 39; nos. A49, A50, A53, A60, A64, A67, A72. The authors think it is possible that, with the deposition of such materials, the sculptures themselves may then have been considered relics and not just sanctified images.

44. The hollow legs of the sculpture were plugged with wood to contain the deposits in the torso region. The deposits included fragments of lapis lazuli, rock crystal, mother-of-pearl, two silk textiles, and four small blocks of fragrant wood, two of which were identified as rosewood and agarwood (see appendix F). A hammered-copper cover, a later addition, provided protection for the interior. A woven textile soaked in resin was used to keep the cover in place; fragments of it are still present around the edge of the opening and the cover.

45. John Twilley (2007) found four rectangular patches covering openings in an eighth-century standing bronze, which he described as "rectangular foundry patches covering openings for removing the core." Chandra Reedy (1997) found covered cavities in the backs and the backs of heads of many of the Gandharan, Afghan, and Tibetan sculptures she studied.

46. See Reedy 1991.

47. See J. Huntington 1986, p. 94.

COLLECTION HIGHLIGHTS

1. Buddha, probably Shakyamuni (Shijiamouni 釋迦牟尼佛)

Sixteen Kingdoms period (304–439), late 4th–early 5th century
Gilt leaded bronze; piece-mold cast
H. 6½ in. (16.5 cm)
Purchase, Arthur M. Sackler Gift, 1974
1974.268.8a–c

Stylistically, this small sculpture can be linked to several other works produced in the fourth and fifth centuries[1] that are among the earliest known freestanding representations of Buddhas made in China. In earlier Chinese art, such images were part of the funerary cult and, at times, were used with other auspicious motifs to decorate the interiors of tombs, the sides of ceramic urns, and the branches of bronze money trees.[2] In addition, both standing and seated Buddhas were carved into a cliff at Kongwangshan as part of an early-third-century assemblage of images that incorporated Buddhist and Daoist themes.[3]

The creation of independent icons in the fourth century illustrates the spread of Buddhism and the rise of personal devotion at that time. As the name implies, the Sixteen Kingdoms was a turbulent period in Chinese history, with many small polities competing for control of various areas, particularly in northern China. The rulers of these polities often were foreigners or had family ties to the non–Han Chinese groups found north of China and in Central Asia. Many of these rulers sponsored foreign monks such as Kumarajiva (344–413), from Kucha, who introduced new Buddhist texts and translated them into Chinese. It is interesting that at least one of the examples of this type of sculpture excavated in China bears an inscription in Kharosthi, a script used in northwestern India and Central Asia. The inscription states that the sculpture was commissioned by an individual to honor members of the Marega clan. Both the clan and the individual have been linked to Niya, a station on the southern branch of the Silk Road, and it seems likely that these unknown devotees were immigrants to China.[4]

The sculpture in the Metropolitan Museum and related pieces were made by the piece-mold technique, which was developed in China to make ritual bronzes during the Shang (1600–1050 B.C.E.) and Zhou (ca. 1046–771 B.C.E.) dynasties;[5] the similarities among the more than thirty known examples of small Buddhas of this type can be explained, to some degree, by the use of such ceramic molds. The similarities may also reflect the sacred nature of the images, which were understood to reflect and transmit the charisma of the Buddha.

The Metropolitan's example, which shows a Buddha seated on a trapezoidal throne, is typical. Comparison with excavated works suggests that the throne may once have been placed on a larger stand,[6] and there may have been a parasol over the figure's head. The Buddha sits in a meditative posture with his hands resting in his lap, palms facing up. The high chignon at the top of the head is intended to cover the *ushnisha*, a mark of supernal wisdom that derives from Indian traditions and is one of the hallmarks of the Buddha.

The juxtaposition of the curly hair at the top of the chignon (another Indian mark of a spiritually advanced being) and the straight hair below is characteristic of early Chinese representations of the Buddha, as is the large square shawl that covers most of the figure. This garment, which would have been worn over a saronglike piece, and the use of posture and gesture to indicate meditation both derive from Indian art. Two snarling lions stand to either side of a large lotus on the base. Two small donors kneel in the area between the lotus and the lions.

Icons showing a Buddha seated on a throne protected by lions were among the earliest anthropomorphic representations of the Buddha in India, and examples dating to the second and third centuries are known from both Mathura, in northern India, and Gandhara, the ancient name for, roughly, present-day Pakistan, both of which were under the control of the Kushan Empire (2nd century B.C.E.–early 3rd century C.E.) at the time. A sculpture in the collection of the Harvard University Art Museums, Cambridge (fig. 52), provides an important link between the Indian images and early Chinese works.[7] It shows the Buddha, with flames behind his shoulders, seated in meditation on a rectangular

FIGURE 52. Buddha, probably Shakyamuni. Sixteen Kingdoms period (304–439), 4th–5th century. Gilt leaded bronze, piece-mold cast; H. 12½ in. (32 cm). Harvard University Art Museums, Cambridge, Grenville L. Winthrop Collection

OPPOSITE: CAT. NO. 1

throne. Two lions flank a vase overflowing with flowers (another Indian motif) on the front of the throne, and small figures of donors gaze out from the sides. The mustache and defined cheeks point to a Gandharan prototype; however, the hollowed-out hems of the Buddha's garment are more typical of Chinese workmanship, and the work was made by the distinctively Chinese piece-mold technique. In the Metropolitan's sculpture, subtle changes in the proportions of the face and figure, with the latter less full in the shoulders, illustrate further Chinese adaptations of the Indian prototype. In addition, the upper hem of the shawl is more stylized, as are the drapery folds, which no longer fall diagonally across the body but are rendered as a series of deep, symmetrical curves.

An inscription[8] incised onto the right side and part of the back of the pedestal states that the Metropolitan's sculpture was made in the second year of the Zhengguang era and represents the Buddha Maitreya, who will be the teaching Buddha of the next cosmological era. This statement does not accord well with either the style or the imagery of the sculpture. Falling in the Northern Wei period (386–534), this year of the Zhengguang era is equivalent to 521, a date that is stylistically too late for the production of this type of image, which disappeared from Chinese art after the fourth century. The incising, on the other hand, does not appear recent, and it is possible that the sculpture was found and reconsecrated in the early sixth century, a period that is noted for devotion to the Buddha Maitreya.

TECHNICAL NOTES

The trapezoidal base, lack of undercuts, flat hands, and simple drapery are stylistic elements that point to piece-mold casting, because they would have made it easy to remove the mold sections from the original model. It is speculated that the sculpture was cast in a three-piece mold: front, back, and a bottom that included the core. For an in-depth discussion, see pp. 28–29 and figs. 30, 31. During casting, flaws occurred in the right knee, left shoulder, and head, which were repaired with cast-in metal. The alloy compositions of the figure and the halo are nearly identical, and the corrosion products are similar, indicating that they were probably cast at the same time and, thus, that the halo is original. The original pin holding the halo to a tang on the back of the figure's head is nearly pure copper. See appendix D for trace elements.

All parts of the sculpture are heavily corroded from long-term burial in the ground. Most of the corrosion has been removed to expose the gilding. Except for the copper pin and the Buddha's hair, all surfaces of the figure and halo were mercury-amalgam gilded. The inscription was punched into the right side of the base after the sculpture was excavated, crushing corrosion products down into the strokes. Other than traces of black pigment in the hair, there is no visible evidence of decorative pigments on the surface.[9]

PROVENANCE

Frederick M. Mayer, New York; John Eskenazi, Ltd., London

PUBLICATIONS

Brankston 1938, pl. 2c; New York 1954, cat. no. 30; Newark 1958, cat. no. 12; New York 1979, cat. no. 16; Munsterberg 1988, fig. 4; Rhie 1999–2002, vol. 1, pp. 448–51, vol. 2, pl. IX, fig. 2.76; Whitfield 2005, fig. 2a

NOTES

1. The dating of this group of sculptures to the time range in question is based on the existence of a few dated examples, including one dated 338 c.e. in the Asian Art Museum of San Francisco and a recently excavated work dated 420. For illustrations, see Su Bai, "Buddha Images of the Northern Plain, 4th–6th Century," in New York 2004-5, pp. 79–87.
2. For an overview of these early examples, see Wu 1986 and Rhie 1995.
3. See He et al. 1993.
4. See New York 2004-5, cat. no. 44.
5. For a discussion of this technique and its relationship to earlier bronze casting, see pp. 27–30.
6. See New York 2004-5, cat. no. 45.
7. It has been suggested that the hole in the top of this Buddha's head indicates that the sculpture served as a reliquary. See Rhi 2005.
8. *Zheng guang er nian si yue shuo ri X wei fu mu jing zao Mile xiang yi qu qian xin gong yang* (正光二年四月朔日X為父母敬造彌勒像一軀虔心供養). This can be loosely translated as "on the first day of the second month of the Zhengguang era, I respectfully [had] made one image of Maitreya for my father and mother and reverently offered it."
9. For a detailed study of the piece-mold casting of early Chinese Buddhas, see Strahan 2010.

2. Portable Shrine with Buddha

Xinjiang Autonomous Region (Turfan area), 5th–6th century
Wood (juniper) with traces of pigment; single-woodblock construction
H. 14¼ in. (36.2 cm)
Fletcher Fund, 1929
29.19

Small, portable shrines played an important role in the dissemination of Buddhist practices and imagery along the Silk Road and into China.[1] Some were carried by travelers—for instance, merchants and monks—and were used for personal devotion. Others were made in one location presumably to be given to hosts or colleagues in another. All, potentially, transmitted variations in iconography and style from one part of Asia to another.

Wood shrines of this type are not known (or have not survived) from India; however, examples carved in fine stone

OPPOSITE: CAT. NO. 2

3a. Bodhisattva, probably Avalokiteshvara (Guanyin 觀音菩薩), with Crossed Ankles

Shanxi Province (Datong area, Yungang complex, cave 25), Northern Wei dynasty (386–534), ca. 470–80
Sandstone with traces of pigment
H. 57½ in. (146.1 cm)
Rogers Fund, 1922
22.134

3b. Bodhisattva with Crossed Ankles

Shanxi Province (Datong area, Yungang complex), Northern Wei dynasty (386–534), ca. 480–90
Sandstone with traces of pigment
H. 51 in. (129.5 cm)
Gift of Robert Lehman, 1948
48.162.2

The term *bodhisattva* has had many meanings in Buddhism. It originally alluded to individuals who were on the path to enlightenment but had not yet become Buddhas, such as Shakyamuni. As Buddhism developed, however, the definition of "bodhisattva" evolved to include salvific beings who were spiritually advanced but—unlike Buddhas, who had transcended the phenomenal world—remained accessible to practitioners, whom they helped and guided.

Seated bodhisattvas with their legs crossed at the ankles are among the most ubiquitous images in the cave-temple complex at Yungang (fig. 54), near Datong, in the northern part of Shanxi Province.[1] Both large and small examples were carved on the side walls of many of the caves at the site as well as on the front and sides of the large central pillars that often filled the interiors of these constructions. Typically, the bodhisattvas are shown seated in individual niches, sometimes with small kneeling attendants.

Cave temples are man-made structures found in India, Afghanistan, and various sites along the Silk Road as well as in China. They range from single chambers to enormous monastic complexes including spaces that originally functioned as halls for worship and teaching, living quarters for monks and travelers, libraries, and kitchens. Although their origins are unclear, the structures seem to have their roots in the long-standing Indian tradition of asceticism, whose adherents made use of natural formations as part of their renunciatory lifestyle. The earliest Indian examples can be traced to the rule of Emperor Ashoka (ca. 273–232 B.C.E.), who is credited with spreading Buddhism within India and abroad.

The earliest known Chinese cave temples, which date to the early fifth century C.E., are preserved in the northwest, a region with strong ties to Central Asia.[2] The complex at Yungang was begun under the patronage of the powerful Northern Wei rulers, a non-Han people of nomadic origin, known as the Tuoba Xianbei, who controlled northern China from 386 to 534. Construction of the caves began during the reign of Emperor Wencheng (452–65), when Tanyao, a monk from Liangzhou who was appointed superintendent of monks around 460, petitioned the court to create five caves with colossal Buddha sculptures (see fig. 10 on p. 11); these are the caves at Yungang currently numbered 16 through 20. Imperial and aristocratic patronage continued during a second stage

of construction, which lasted from about 471 to about 494, when the capital at Datong (formerly Pingcheng) was moved south to Luoyang, in Henan Province. The site now contains fifty-three large caves, about two hundred small niches, and approximately fifty-one thousand sculptures.

The two sculptures in the Museum's collection date to the second period of construction. The sculpture with an elaborate crown (cat. no. 3a), which once adorned a side wall in cave 25, is more complete than the other work. The undecorated crown and uncarved hair indicate that the latter (cat. no. 3b), which is from an unidentified cave, may have been left unfinished. Moreover, the fuller cheeks and more pursed lips of the bodhisattva from cave 25 are closer to those of sculptures produced in the first phase of construction at Yungang, and it is likely that this piece is a bit earlier than the other work in the Museum's collection. Both bodhisattvas once held their right hands up, with the palms facing the viewer, in a gesture of reassurance (*abhaya mudra*) derived from Indian traditions. The elongated earlobes of both figures are also Indian symbols, alluding to spiritual attainment. Both bodhisattvas wear extremely long, thin shawls that fall from the shoulders and cross at the waist and

FIGURE 54. Cat. no. 3a in situ. Shanxi Province (Yungang complex, cave 25)

are known from Gandhara (roughly, present-day Pakistan), the Kashmir region, and Central Asia.[2] Most of the Gandharan examples are diptychs, while at least one surviving work from the Turfan area consists of three pieces tied together with cord.[3] It is unclear whether the Museum's shrine originally had one or two additional elements that covered and protected the main image.

The primary icon of the shrine is a standing Buddha, his wavy hair gathered in a chignon at the top of the head, presumably to cover the *ushnisha*, the cranial protuberance indicating wisdom. The rectangular shawl and undergarment derive from Indian monastic clothing. A large halo and a mandorla, both filled with radiating lines intended to represent light, encircle the Buddha. Two small figures are found to either side of a bulbous form on the base of the shrine. The figure to the right appears to be offering something to the Buddha, while the hands of the figure to the left may once have been held in a gesture of prayer or adoration known as *anjali mudra*. The top of the central element is damaged, but it is likely to have been either an incense burner or a vase overflowing with flowers, both of which are commonly depicted on the bases of Buddhist images.

Characteristically Central Asian, the rendering of the halo and mandorla as fields of radiating lines is typical of the art of Kumtura, a cave-temple complex near Kucha, on the western reaches of the Silk Road (see fig. 53).[4] The treatment of the drapery folds as a series of thin linear curves between the legs and as stylized flames on the shoulders also reflects prototypes from that site.[5] Patronized by the rulers of the Kucha kingdom, which flourished from the fourth to the seventh century, the cave temples at Kumtura and Kizil played an important role in transmitting Buddhist iconography through Central Asia and China. The diamondlike patterning of the right edge of the large shawl worn by the Buddha is strikingly close to that in a gilt-bronze piece dated 486 (cat. no. 4), further helping to date the wood shrine to the fifth or sixth century.[6]

TECHNICAL NOTES

The existing portion of the shrine was carved from a single piece of juniper. The remains of two wood dowels are located in the bottom, just below each attending figure, indicating that there may once have been a more elaborate base.

Traces of paint and gilding on the interior provide an idea of how the work must have originally appeared. White gesso is present under all the remaining pigment, including on the mandorla, which was painted red and then leaf gilded. White ground is also present in the background along the sides, but no other color was detected there. The hair was painted black, the eyes white, and the robe pinkish red. Blue pigment is found on both sides of the incense burner/vase. There is no trace of paint on the back.

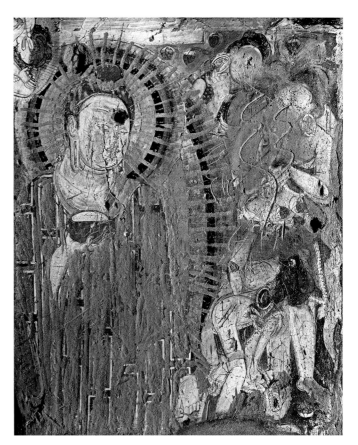

FIGURE 53. Buddha (detail of a mural). Xinjiang Uygur Autonomous Region (Kumtura complex, cave 69), Kucha kingdom, 5th–7th century

PROVENANCE
Edgar Worch, Paris

PUBLICATIONS
Priest 1939b, fig. 2; Priest 1944, cat. no. 38; *Art Treasures* 1952, fig. 190; Ingholt 1957, fig. XXIV; Hallade 1968, pl. 129; Granoff 1968–69, pp. 83–84; Nara 1978, cat. no. 68; Shi 1983, p. 1364; Los Angeles 1984, cat. no. 81; *Hai-wai Yi-chen* 1986, fig. 80; Koizumi 2000, fig. 31

NOTES
1. For a useful overview, see Sen-Gupta 2002.
2. For examples, see New York 1991–92, pp. 109–14. In his brief discussion of portable shrines, Martin Lerner suggests that the Gandharan works may have been inspired by Western prototypes, possibly Roman ivory diptychs.
3. See Granoff 1968–69.
4. The same style of halo and mandorla is also found later, in the cave temples at Bezeklik. See Meng et al. 1995, figs. 122, 126, 127, 129–131.
5. For a discussion of the origins and dissemination of this style of drapery and its impact on Chinese Buddhist sculpture, see Leidy 2005–6. See also cat. no. 4 in this volume.
6. The radiocarbon date range for this sculpture is cal [calibrated] A.D. 430–640. Note that the designations B.C. and A.D. (as opposed to B.C.E. and C.E.) continue to be used in the scientific literature.

CAT. NO. 3B

undergarments that end in stylized patterns at the feet. The torque worn by the bodhisattva from cave 25 is borrowed from Central Asian or nomadic traditions, while the crown, which consists of three triangular pieces, various tassels, and other adornments, ultimately derives from the headgear worn by the rulers of the Persian Sasanian Empire (224–651). Such crowns were introduced into present-day Pakistan, Afghanistan, and other Central Asian sites in the third and fourth centuries, when the region was often under alternating Kushan and Sasanian control, and spread from there into Chinese Buddhist art.

The small figure of a seated Buddha at the front of the finished crown is intriguing. By the late fifth century, such figures depicted in crowns were being used in Indian art to identify the bodhisattva Avalokiteshvara, who embodies the virtue of compassion, and they have remained an iconographic marker for Avalokiteshvara ever since. However, the position of the crossed ankles seen in this sculpture is thought to identify a bodhisattva as Maitreya rather than Avalokiteshvara. Images of Maitreya were the first representations of bodhisattvas in visual art, and they appeared at the same time as the first Buddhas. Maitreya, who is the

successor to the historical Buddha, Shakyamuni, is understood to be a bodhisattva in this cosmic era as well as the teaching Buddha of the next. As a result, he is the only divinity who is shown as both a bodhisattva and a Buddha.

The relationship, if any, between Maitreya and bodhisattvas seated with their ankles crossed remains perplexing. A few such representations of bodhisattvas were produced in Gandhara (roughly, present-day Pakistan) during the period of Kushan control; however, these are not necessarily identifiable as representations of Maitreya.[3] Bodhisattvas with their ankles crossed are also found in the cave temples at Kizil, near Kucha, an important center on the northern branch of the Silk Road, particularly from the fourth to the seventh century. Assemblies consisting of a bodhisattva and attendant figures, many with crossed ankles, are often painted on the tympana over doorways to the cave temples at this site (see fig. 55); these groups are commonly identified as representations of Maitreya seated in the Tushita heaven, awaiting his final rebirth, when he will become the teaching Buddha.[4] The style and imagery of the caves near Kucha served as prototypes for the postures, clothing, and adornments found in Yungang. Comparisons between the Kuchean paintings and the Yungang sculptures include the postures and gestures, the tripartite crowns, and the depiction of the folds of the lower garments as a series of concentric incisions.

As was mentioned previously, however, at Yungang, unlike Kizil, bodhisattvas with crossed ankles are depicted in numerous locations, and it remains unclear why and how an icon found in one specific location at Kizil became a dominant image at Yungang. Moreover, it is unlikely that they all represent Maitreya or any other specific divinity. It is possible that the bodhisattvas (most with legs crossed at the ankles) and Buddhas on the walls of the Yungang caves were intended to represent either a cosmos filled with archetypes, such as Buddhas or bodhisattvas as Buddhas-to-be, or a group of interrelated worlds inhabited, in some cases, by specific Buddhas and bodhisattvas. The use of the small seated Buddha in the headdress, a distinctive attribute of Avalokiteshvara, suggests that the sculpture in the Metropolitan Museum may be an early Chinese representation of that bodhisattva, who was understood first as one of several bodhisattvas and only later as an independent divinity and a focus of personal devotion.

TECHNICAL NOTES (cat. no. 3a)

The sculpture was carved in high relief; the back, formerly attached to a wall, is uncarved. A point chisel was used to trace the outlines of the clothing, crown, and hair. The raised right hand was carved in the round, but the fingers are now missing. Originally, the figure was completely painted, no doubt with decorative patterns. Although much of the original color has worn off over the centuries, red and black pigments are still found on the clothing, crown, and hair. A white ground was used under all the extant pigment.[5] Various patches of a thin gray-black layer are found on top of the red pigment. Whether this layer is an overpaint or a conversion of the red pigment is not clear at this time. The right arm has been reattached, and the toes on the right foot are replacements.

FIGURE 55. Bodhisattva Maitreya with Attendants (detail of a mural). Xinjiang Uygur Autonomous Region (Kizil complex, cave 224), Kucha kingdom, 4th–6th century. Museum für Ostasiatische Kunst, Berlin

TECHNICAL NOTES (cat. no. 3b)

This work, like the other, was carved in high relief, with an uncarved back; however, it was not finished. The crown is undecorated, and the ears, hair, and clothing are represented in the barest outlines. A roughed-out strut still connects the chest to the right hand. Rough diagonal chisel marks define the throne. Except for a repaired join across the top of the crown, the sculpture is all in one piece. Despite its lack of finish, it was completely painted, although little pigment remains today. A white ground containing the same compositional elements as on cat. no. 3a was used under the red and black pigments.

PROVENANCE (cat. no. 3a)

Paul Mallon, Paris

PUBLICATIONS (cat. no. 3a)

Chavannes 1909, fig. 247; Migeon and Moret 1920, pl. VI; Bosch Reitz 1922, cover ill.; Ashton 1924, pl. XIII; Sirén 1925, pl. XX; Ardenne de Tizac 1931, pl. LII; Sirén 1942b, fig. 227; Priest 1944, pl. 20; Sickman and Soper 1956, pl. 30b; Chow 1965, fig. 10; Lippe 1965c, fig. 2; Hearn and Fong 1974, fig. 56; Zheng 1989, pl. III; Watt 1990, fig. 58; Watson 1995, fig. 24; Xu Jianrong 1998, p. 57; Jin 2004, no. 67

PUBLICATIONS (cat. no. 3b)

Sirén 1925, pl. 68A; London 1935–36, cat. no. 479; Priest 1944, pl. XXI; Rodney 1949, p. 156; Seckel 1963, pl. 24; Chow 1965, fig. 9; Lippe 1965c, fig. 1; New York 1970–71, cat. no. 107; Nara 1978, p. 50; Xu Jianrong 1998, p. 56; Jin 2004, no. 68

NOTES

1. Bodhisattvas with their legs in this distinctive position are also common in the imagery found in the Northern Wei–period caves near Dunhuang, in Gansu Province. For illustrations, see *Chūgoku Sekkutsu* 1980–82, vol. 1, figs. 6, 34, 65. This type of bodhisattva becomes far less prominent in Chinese Buddhist art after the move of the Northern Wei capital to Luoyang.
2. It is interesting to note that, in China, the creation of cave temples parallels the rise of small devotional images, such as the figure discussed in cat. no. 1.
3. For examples, see Kurita 1988–90, vol. 2, figs. 59–61, 142.
4. For a discussion of the Tushita heaven, see cat. no. 7.
5. X-ray fluorescence analyses of both works showed the presence of lead and calcium in the ground and mercury in the red areas, with high iron content in the black. Further Fourier infrared and Raman microscopy analyses performed on cross sections of cat. no. 3a found lead sulfate in some layers and stratigraphies, with a ground consisting of clay, gypsum, talc, and, often, red ocher. Vermilion and ocher were used in the upper red areas.

4. Buddha Maitreya (Mile fo 彌勒佛)

Shanxi Province, Northern Wei dynasty (386–534), dated 486
Gilt leaded bronze with traces of pigment; piece-mold cast
H. 55¼ in. (140.5 cm)
John Stewart Kennedy Fund, 1926
26.123

The sculpture seen on the following spread is the largest early gilt bronze known from China and remains one of the best examples of the distinctive style of drapery in use in Chinese art from about 460 to 490. The Buddha stands on an upturned lotus base placed atop a two-tiered pedestal. He has wide shoulders, a defined waist, and long legs and arms. His webbed hands are overlarge and somewhat awkward. His face is youthful, with long, thin eyebrows, almond-shaped eyes, a narrow nose, and a wide mouth. The delicately cast hair, which is gathered into a large spiral above the forehead and a topknot, was originally painted black.

The Buddha wears three garments: a long saronglike undergarment; an intermediate piece; and a large rectangular shawl that falls over the left shoulder and is draped over the front of the body. The shawl and other garments hug the chest, abdomen, and upper legs. The folds of the shawl, which are shown as appliqué-like bands with a thin crease in the center, are distinctively patterned. They fall in deep, symmetrical, interconnected curves over the chest and abdomen and as vertical pleats along the sides of the torso. Those covering the shoulders and upper arms end in unusual flamelike forms. A similar interest in baroque patterning is found in the treatment of the hems of the intermediate and lower garments: the former is shown as a series of scalloped lateral folds; the latter alternates such folds with others shown as semicircles.

The rendering of the Buddha's physique derives from Indian traditions. Broad, flat figures with clinging drapery are typical of sculpture produced in central India in the fifth century, under Gupta rule (ca. 321–ca. 500). An example in the Museum's collection (see fig. 9 on p. 10), with its powerful form, slightly articulated waist, and long legs, can be dated to about 435–50 by the thin, raised folds of the shawl. The dramatically stylized patterns in the drapery of the Chinese Buddha, on the other hand, can be traced to the art of Gandhara (roughly, present-day Pakistan), as seen in a seated Buddha in the Museum of Fine Arts, Boston (fig. 56), which can be dated to the fourth or fifth century.

This dramatic and inorganic rendering of the folds of clothing, which is also found at sites such as Kucha and Tumshuk along the northern branch of the Silk Road,[1] became one of the most widespread types of drapery in Chinese art in the late fifth century. Representations of Buddhas wearing garments with this type of patterning were made in both stone and gilt bronze; examples are also found in the cave temples constructed under the patronage of the Northern Wei rulers, at sites such as Dunhuang and Yungang.[2]

Inscriptions, many badly abraded, are visible on the base of the sculpture. These include the names of members of

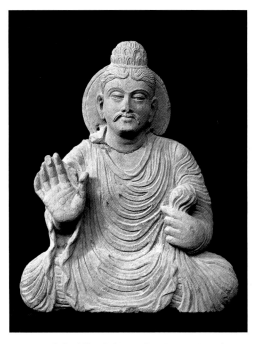

FIGURE 56. Buddha. Pakistan (ancient region of Gandhara), 4th–5th century. Schist, H. 21½ in. (55 cm). Museum of Fine Arts, Boston, Marshall H. Gould Fund

prominent families such as the Yan, Zui, and Wang, who funded the work. In addition, a dedicatory inscription, placed on the back of the upper tier of the pedestal, between the feet, can be loosely translated as "in the tenth year of the *taihe* era [equivalent to 486 C.E.], the first month of the twenty-fourth day, in honor of the dowager empress, for the benefit of ten classes of beings, one image of Maitreya was made."[3] The "dowager empress" is Grand Dowager Empress Feng (442–490), also known as Wenming, who controlled the Northern Wei toward the end of the fifth century, the period during which the distinctive style of drapery illustrated by this sculpture flowered.

Wenming's background typifies the mixed ethnic roots of much of the elite in China at the time.[4] Her father was Feng Lang (d. 452), a member of the ruling family of the Northern Yan dynasty (409–36) in northeastern China, and her mother belonged to the prominent Wang family, from the Lolang area of North Korea. Her father, most likely as a result of internecine politics, fled to the Northern Wei court in 433, prior to the Wei takeover of northeastern China in 437. He served for some time as a provincial governor but was later executed, presumably because of the potentially subversive relationship between his brother and the powerful Rouran confederacy in Central Asia. Until its defeat around 550, the latter

constituted the only serious threat to the power of the Northern Wei. At the time of her father's death, Wenming, who had been born in Chang'an (present-day Xi'an), entered the harem; her brother Feng Xi was sent west to Shaanxi to live with members of the Qiang and Ti clans, who had ties to the family.

In 456, Wenming was chosen as the consort of Emperor Wencheng (r. 452–65). His death spurred her first attempt to take control of the court in the guise of serving as regent for her son, the young emperor Xianwen (r. 466–71). After three years of struggle between various factions, Wenming was briefly rebuffed. In 469, however, she was appointed foster mother to the young heir apparent, and by 471, she was ruling as co-regent with Xianwen, who had abdicated and given the throne to his young son, Xiaowen (r. 471–99). In 476, she took the title "grand dowager empress" and became the sole regent to the young emperor, effectively controlling the court until her death in 490. In addition to her devotion to Buddhism, Wenming is noted for her unsuccessful attempt to stabilize the economic base of the Northern Wei by reforming taxation and land assignments in 483.

The choice of the Buddha Maitreya as the subject of a large gilt-bronze icon dedicated to Wenming may be significant. Historical records suggest that parallels between the Northern Wei emperors and the historical Buddha, Shakyamuni, were common: during the reign of Taiwu (425–52), five colossal bronze Buddha images were cast in honor of the first five Northern Wei emperors, and the five colossi in the cave temples at Yungang (see fig. 10 on p. 11) are also thought to represent links between those rulers and the historical Buddha and/or several celestial Buddhas.[5]

Devotion to Maitreya, based to some degree on the earlier work of Shi Daoan (312–385) and his colleagues in the translation bureau at Chang'an, was also widespread during the Northern Wei period. Maitreya is worshipped as a bodhisattva in this cosmic era and as a Buddha in the next. He maintains and governs two perfected worlds: the Tushita heaven, which he currently inhabits, and an ideal realm of the future known as Ketumati, which is conducive to the pursuit of enlightenment. In the latter, Maitreya serves as the teaching Buddha of the age. Wenming's association with the Buddha Maitreya, whose rebirth in the future heralds a utopian age, may represent a compromise between her unquestionable power and her shakier position vis-à-vis her predecessors: she could link herself, or allow herself to be linked, with a Buddha without abrogating the existing relationship between prior emperors and the historical Buddha, Shakyamuni. The numerous contributors to the casting of the sculpture in question may have chosen to represent Maitreya both as an act of devotion in honor of Wenming and as a tacit acknowledgment of the link between this bodhisattva/Buddha and the dowager empress.

TECHNICAL NOTES

This hollow Buddha is a fifth-century technical tour de force.[6] It was cast in bronze in one piece by the piece-mold method. The hands were cast separately and placed in the mold assemblage prior to the casting of the figure itself. The large opening in the back served as a core extension, along with numerous smaller ones distributed evenly over the figure, to support the many mold sections necessary for such a large sculpture. During casting, flaws occurred in the head, which were corrected with cast-in repairs. After casting, the entire core was removed, except for that in the upper half of the head. A sample of the core from the head was identified as the loess soil typically used for casting cores and molds in northern China. No coarse organic materials had been added.[7]

The opening in the back was originally covered with a separate plate, now missing. Surrounding the opening are traces of the textile and adhesive that were used to seal the plate in place. The opening allowed both for easy removal of the core after casting and for placement of consecratory materials. Vestiges of early-twentieth-century deposits—fragments of mother-of-pearl, lapis lazuli, and rock crystal; two strips of silk; and four small, wedge-shaped pieces of fragrant wood, identified as agarwood (*Aquilaria* sp.) and rosewood (*Dalbergia* sp.)—are present in the deep recesses of the drapery. Agarwood was commonly used for incense.

During the sculpture's fabrication, the surface was highly polished, and details in the drapery, face, and hair were enhanced by chasing. The engraved inscriptions were added prior to gilding. All the polished surfaces, except for the Buddha's back and hair, were then mercury-amalgam gilded. Although the sculpture has been cleaned, vestiges of extensive corrosion products from long-term burial are present on the interior, in the hair, and around the base. There are remains of black pigment in the hair. Traces of vermilion are found on the base and scattered over all the drapery, but so little has survived that the pattern cannot be determined.[8] Perhaps the robe had the patchwork design often seen on stone sculptures and in wall paintings. Traces of vermilion are also found on the lips and along the hairline, over the ears. The corners of the eyes contain traces of a white pigment not identified at this time.

PROVENANCE

Purportedly from Wutaishan, possibly from the Bishan-si (Bishan temple); Asano Umekichi, Osaka

PUBLICATIONS

Bosch Reitz 1926, pp. 238-39; Umehara 1930, fig. 39:1; New York 1938, p. 22; Sirén 1942b, p. 326; Priest 1944, p. 28; Sickman and Soper 1956, p. 44; Griswold 1963, p. 116; Rowland 1963, pl. 39; Seckel 1963, p. 18; Lippe 1965b, pp. 63–65; Hallade 1968, p. 166; Lerman 1969, p. 226; New York 1970-71, p. 146; Hearn and Fong 1974, fig. 55; Matics 1979, pp. 113–26; Los Angeles 1984, p. 309; Barnhart 1987, p. 55; Tokyo 1987, pp. 82–83; Munsterberg 1988, fig. 20; Watt 1990, p. 51; Burn 1993, p. 170; De Montebello 1994, p. 109; Jin 1994, no. 43; New York 2004-5, pp. 168–69; Leidy 2005-6, pp. 22–32; Howard et al. 2006, p. 229; *Yungang* 2006, pp. 12, 204

NOTES

1. For examples, see Leidy 2005-6, pp. 26-27.
2. See ibid., pp. 28-31.
3. *Tai he shi nian zheng yue si ri wei tai huang tai huo X xia wei X di zhong sheng zao mi le xiang yi qu* (太和十年正月為太皇太后X下為地眾生造彌勒像一區).
4. Useful studies include Holmgren 1981–83a, 1981–83b, and 1983.
5. See Soper 1959, p. 96.
6. For more details on the casting of this sculpture, see pp. 29–30 and figs. 33, 34; see also Strahan 2010.
7. See Carò 2010.
8. The red pigment was analyzed by polarized light microscopy, and mercury was detected by X-ray fluorescence analysis in both the gilding and the red areas.

OPPOSITE: CAT. NO. 4

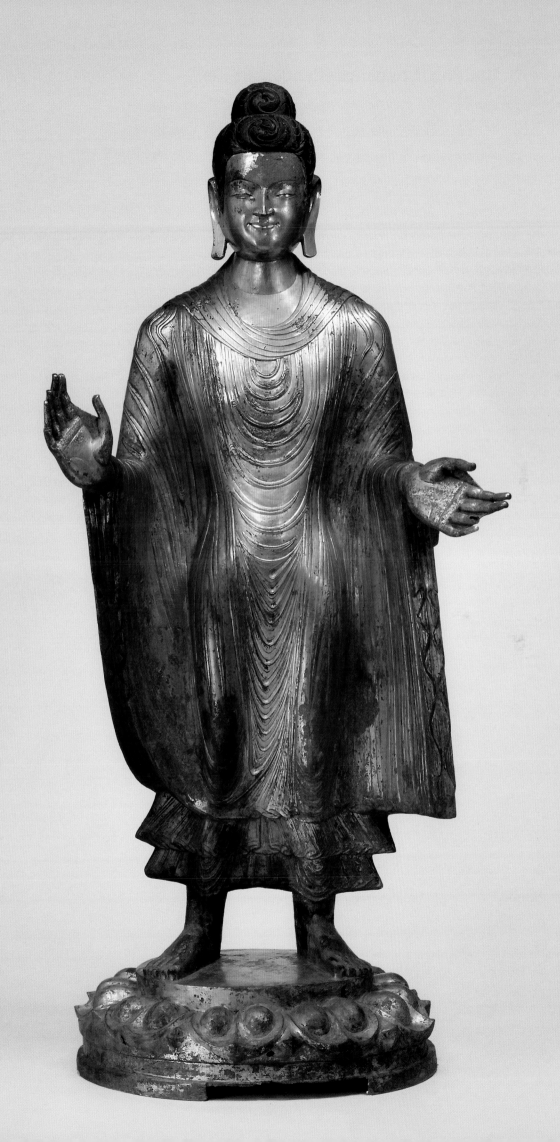

5. Stele with Buddha Dipankara (Randeng 燃燈佛)

Shanxi Province, Northern Wei dynasty (386–534), dated 489–95
Sandstone with traces of pigment
H. 10 ft. 7 in. (3.2 m)
The Sackler Collections, Purchase, The Sackler Fund, 1965
65.29.3

Made of the light beige sandstone prevalent in northern Shanxi Province, this colossal sculpture of a standing Buddha is strikingly similar in style to works found in the cave temples at Yungang. The large head and flat body resemble those of a standing Buddha in cave 5 at that site (fig. 57), as do the undecorated *ushnisha*, enormous earlobes, thick flames in the mandorla, and proportions of the small seated Buddhas in the halo. In addition, both Buddhas have over-large hands and wear rectangular monastic shawls that hug the body and fall in broad, stylized pleats. It seems likely, therefore, that the Metropolitan's work was produced in the vicinity of Yungang, presumably by artists who were also responsible for the sculptures there.

The Buddha's left hand grasps the edges of the two garments he wears under his shawl. The bent position of the right arm indicates that the missing right hand was most likely held in a gesture of reassurance, such as *abhaya mudra*.

Smaller figures wearing Xianbei clothing and headgear and making a gesture of adoration stand in four rows to the left of the main icon. They are identified by inscription and represent some of the important donors to the construction of the stele. Two additional figures are found to the right of the central Buddha. One is badly abraded and difficult to read. The other, which is the largest of the subsidiary figures, stands on a lotus beneath the Buddha's hand and holds flowers or some other offering. The size and the lotus base suggest this figure's importance.

The back of the stele is divided into two sections (see below). A Thousand Buddhas motif at the top surrounds an arcaded niche housing a Buddha seated in a cross-legged position—a position often, though not exclusively, associated with Maitreya, the Buddha of the Future. Two attendants holding offerings kneel in individual niches to either side of the cross-legged Buddha. A large and, unfortunately, damaged

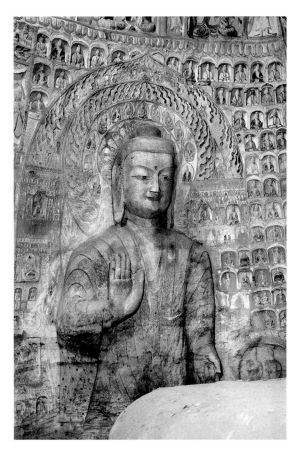

FIGURE 57. Buddha. Shanxi Province (Yungang complex, cave 5, west wall), Northern Wei dynasty (386–534), ca. 480–90

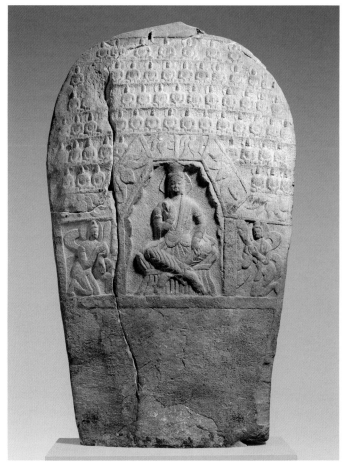

CAT. NO. 5, BACK

OPPOSITE: CAT. NO. 5, FRONT

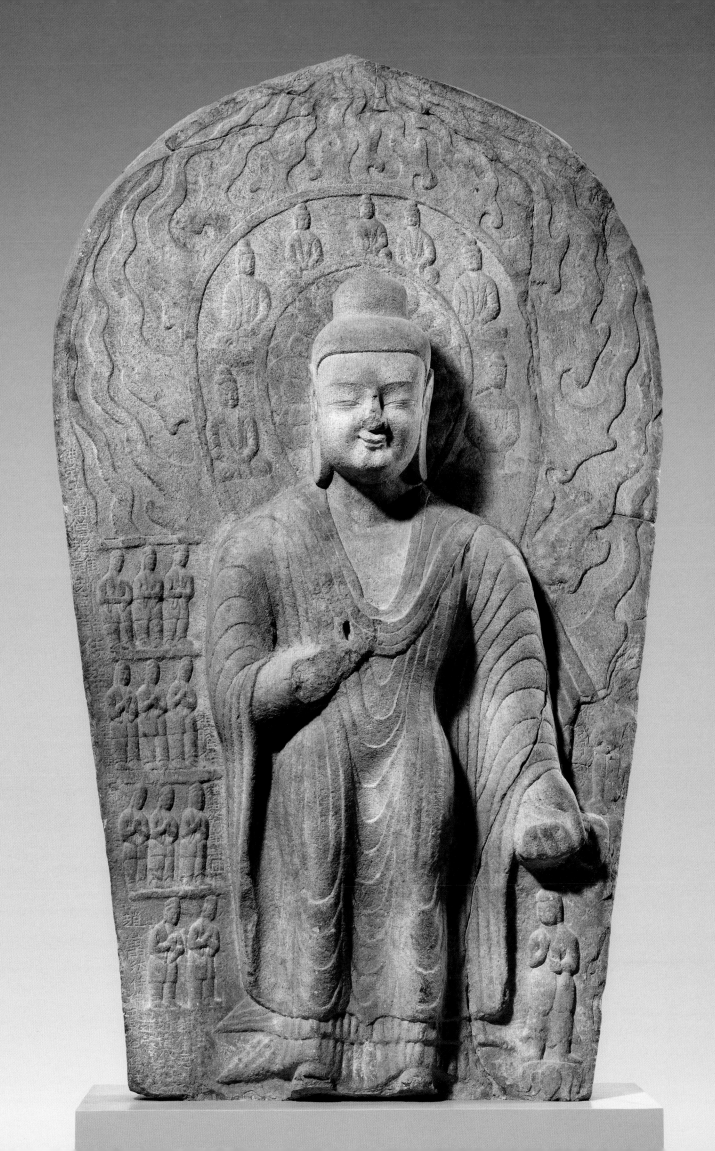

inscription fills the lower part of the back of the sculpture. It begins with a date in the nineteenth year of the *taihe* era, which is equivalent to 495 C.E. An additional inscription on the left side gives a date of 489, and the combined dates provide rare documentation of the construction of such a work over a period of six years. The inscription on the back further states that the stele was commissioned by members of the Zhao family in Tang district, Tang county, Dingzhou Prefecture, suggesting that that area was the home base for the large and powerful clan. Interestingly, there is currently a Dingzhou Prefecture in Hebei Province but not in Shanxi. Moreover, in the first publication of the stele, in 1925, it was described as belonging to the collection of a certain Theodore Culty in Beijing, which raises the possibility that the sculpture was produced in Shanxi for use elsewhere.

Finally, and most importantly, the inscription identifies the Buddha on the front of the stele as the Buddha Dipankara,[1] one of the few predecessors of the historical Buddha who is represented in the visual arts. The identification is surprising because Dipankara is best known in literature and art for his role in a jataka, one of the many tales recording Shakyamuni's previous lives. Although the sources differ slightly, works such as the Divyavadana and the Mahavastu concur that a young ascetic named Sumedha (also known as Sumati or Megha), who was the Buddha Shakyamuni in a past life, went to see the Buddha Dipankara and was so moved by the latter's enlightened state that he offered flowers and spread his hair on the ground to prevent Dipankara from walking in the mud. A rare Chinese rendering of the scene, based on numerous prototypes that once decorated stupas and other monuments in present-day Afghanistan and Pakistan, was carved on the lower part of the east wall of the antechamber of cave 10 at Yungang (fig. 58). The Buddha Dipankara is shown walking with several attendants, and Sumedha is shown purchasing

flowers, throwing them into the air, and kneeling before spreading his hair on the ground. The example at Yungang, and related works from northwestern India, are part of a larger narrative cycle detailing the history of the Buddha Shakyamuni. The Buddha Dipankara is included in such scenes because of his importance to the Shakyamuni narrative and not as the focus of personal devotion.

In the fourth and fifth centuries, the Dipankara story underwent an interesting redefinition. For example, at the entryway to cave 19 at the renowned cave-temple site of Ajanta, in Maharashtra, a representation of the Dipankara-Sumedha episode is paired with a scene depicting a moment in the final lifetime of the Buddha Shakyamuni, when he returns to the city of Kapilavastu and predicts the eventual enlightenment of his son.[2] Both moments have been displaced from their historical, linear narratives and have instead become paradigms for the process of enlightenment, which is first prophesied and then achieved over many lifetimes.[3]

A similar understanding of the Dipankara story as a reference to the promise of enlightenment is found on the large stele in the Metropolitan. The figure on a lotus to the right of the colossal Buddha is probably intended to represent the young Sumedha, who will become the Buddha Shakyamuni in a future lifetime. The seated Buddha on the back of the stele, as was mentioned earlier, represents Maitreya, the Buddha of the Future and, by extension, the promise of enlightenment in a lifetime in the very distant future. The addition of Maitreya to this type of imagery has no parallel in the art of India or Central Asia. It reflects the devotion to salvific divinities such as Maitreya (and, after the sixth century, the Buddha Amitabha) that characterizes Buddhism in China and, later, in Korea and Japan.

TECHNICAL NOTES

The sculpture was carved from a single, immense block of sandstone. The back surface of the upper left corner was exposed to extensive weathering before being reattached. Elsewhere on the stone, recessed areas were protected from weathering and are crisper. Faint traces of a white pigment containing lead remain on the face and neck of the Buddha Dipankara. Red lines delineating folds of flesh are barely discernible across the neck, just under the chin.

PROVENANCE

Theodore Culty, Beijing; Frank Caro, New York

PUBLICATIONS

Sirén 1925, vol. 1, p. 19; Sirén 1959, pp. 11–12; Chow 1965, pp. 306–7; Lippe 1965c, p. 22; Matsubara 1995, nos. 93, 94

NOTES

1. The current Chinese transliteration for "Buddha Dipankara" is given in the title of this catalogue entry. However, different characters for the name of this Buddha (定光佛) appear in the inscription on the back of the stele.
2. See Vasant 1991.
3. For a similar reworking of seminal moments in the Buddha's final lifetime, see Williams 1975 and Leoshko 1994.

6. Emperor Xiaowen and His Court

Henan Province (Longmen complex, cave 3 [Central Binyang cave]), Northern Wei dynasty (386–534), ca. 522–23
Limestone with traces of pigment
6 ft. 10 in. × 12 ft. 11 in (2.1 × 3.9 m)
Fletcher Fund, 1935
35.146

The panel seen on the following spread, which shows the emperor and his entourage, and a companion piece with an empress and her attendants that is now in the Nelson-Atkins Museum of Art, Kansas City (fig. 59), were once part of the decoration of the Central Binyang cave (also known as cave 3) in the Longmen complex, near Luoyang, in Henan Province.[1] For a brief period in the early sixth century, when Luoyang served as the second capital of the Northern Wei dynasty, this part of China was one of the most populous and wealthy regions in Asia: Luoyang was renowned for its numerous monasteries and other centers dedicated to Buddhism and for the significant population of foreigners living there.[2] Construction at Longmen, one of the largest cave-temple complexes in China, began in the late fifth century, after the move of the Northern Wei capital from Pingcheng (now Datong) to Luoyang, and continued for approximately 250 years. Longmen contains more than twenty-three hundred grottoes, nearly one hundred thousand individual sculptures, and approximately twenty-eight hundred votive inscriptions. The inscriptions provide seminal, and largely unique, information regarding patronage and practice at the site.

The Central Binyang cave, which was planned as one of a group of three, was constructed in the early decades of the sixth century under the patronage of the young emperor Xuanwu (r. 499–515) but may have been completed later.[3]

It is a square (or almost square) chamber decorated with large lotus flowers on the floor and another large lotus on the ceiling, along with angel-like figures known as *apsara*s. Each of the three interior walls holds a group of Buddhist divinities. The most important set, which is found against the west (or rear) wall, consists of a seated Buddha accompanied by two clerical disciples and two bodhisattvas (fig. 60). The Buddhas on the north and south walls, also attended by bodhisattvas, are shown standing. The grouping of three Buddhas may reflect the belief, widespread in China at the time, that in addition to the Buddha Shakyamuni, the teaching figure in this cosmic era, the past and the future had or will have their own teachers.[4] Each Buddha stands before a lush and densely decorated halo that is typical of the decoration of the early constructions at the site.

The processions of the emperor and empress were found at the front of the cave, along the southeast and northeast walls to either side of the entryway. The long, thin bodies and narrow faces of the figures in the reliefs typify the artistic style associated with the court at Luoyang. The heavy robes, which obscure the underlying figures, are also characteristic of the early sixth century. It is generally assumed that this style, which differs from that of Yungang and related sites, with its more voluminous forms and thinner garments, represents a conscious choice by the Northern Wei court to favor

FIGURE 59. Procession with Empress. Henan Province (Longmen complex, cave 3 [Central Binyang cave]), Northern Wei dynasty (386–534), ca. 522–23. Limestone with pigment, 6 ft. 4 in. × 9 ft. 11 in. (1.9 × 3 m). The Nelson-Atkins Museum of Art, Kansas City

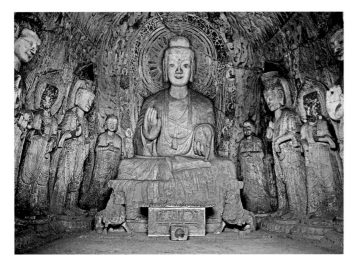

FIGURE 60. Interior of cave 3 (Central Binyang cave) showing west wall

native Chinese artistic traditions over those of Central Asia. This decision parallels a deliberate sinicizing of actual clothing, nomenclature, and other aspects of court life.

Each of the imperial processions in the Central Binyang cave was originally part of a larger grouping of images that filled four distinct registers (see fig. 61). Protective semi-divinities known as "spirit kings" were found on the lowest register of both walls. Probably inspired by foreign imagery, these figures first appear in Chinese Buddhist art in the Central Binyang cave, are found elsewhere in the sixth century, and disappear thereafter.[5] Stories of the past lives of the historical Buddha, which are known as jatakas, filled the registers above the imperial processions. That above the emperor recorded the moment when the Buddha-to-be sacrificed himself to feed a starving tigress and her cubs. The merit he acquired from this action ultimately led to his final rebirth, when he became a Buddha. A debate between the bodhisattva Manjushri and Vimalakirti, a learned layman, filled the top register of the other wall. This scene, which is based on the Sutra on the Discourse of Vimalakirti,[6] results in the layman's defeat of the bodhisattva of wisdom and extols the value of lay practice as well as the capacity of women to achieve enlightenment.

Emperor Xuanwu commissioned the construction of the Central Binyang cave in honor of his father, Emperor Xiaowen (r. 471–99), and another of the three in honor of his mother, Dowager Empress Wenzhao (d. 494); the emperor and empress in the reliefs are believed to refer to his parents. A figure wearing court garments and holding an implement with tassels stands at the front of the procession in the Museum's relief. He is followed by a smaller figure wearing armor and by another holding an incense burner, into which the emperor is placing incense. The emperor is larger than the other figures and is flanked by attendants—a standard rendering of emperors from the sixth to the eighth century.[7] Large fans and a tasseled umbrella also help to identify the emperor and reiterate his status. An additional six figures stand behind the emperor; they are separated from another group of eight figures by a slim tree with highly stylized leaves. Originally, this tree marked the point in the procession when

it moved around the corner from the north wall to the east wall. Several of the figures hold lotuses or other items, and the entire procession can be understood to be taking place in order to make offerings to the Buddhas in the cave, a meritorious act that will continue in perpetuity and improve the participants' future lives.

TECHNICAL NOTES
This large panel was carved in low relief in situ (on the cave wall) and was originally completely painted. In many places, the remains of the original pigments are mixed with modern paint from restorations.

PROVENANCE
Bin Chi Company, Beijing

PUBLICATIONS
Chavannes 1909, figs. 290–93; Perzyński 1920, pl. 20; Glaser 1925, fig. 24; Ōmura 1932, pl. 202; Tokiwa and Sekino 1939–41, vol. 2, fig. 60; Priest 1944, pp. 26–27; Carter 1948, pp. 140–43; Chow 1965, pp. 311–12; Munsterberg 1969, pp. 109–10; Gong 1981, p. 99; De Montebello 1983, p. 53; Barnhart 1987, fig. 44; Watt 1990, pp. 48–49; Chen Zhejing et al. 1993, pl. 25; McNair 2003, fig. 1; Mair et al. 2005, fig. 52; Howard et al. 2006, p. 240; McNair 2007, figs. 2.7, 2.9

NOTES
1. The noticeably better condition of the relief in the Nelson-Atkins has led to unresolved discussions regarding its authenticity and degree of restoration.
2. See Yang Hsüan-chih 1984.
3. The Binyang group is discussed in the *Bei Wei shu*, the primary document for the study of the Northern Wei period. For a translation of the pertinent passage, see McNair 2007, pp. 31–32.
4. See ibid., pp. 37–39.
5. See Bunker 1964.
6. In Chinese, this sutra is known as the Weimo jie jing (維摩經). Three recensions are known and are preserved, as text numbers 474–76, in an early-twentieth-century Japanese version of the Buddhist canon that often serves as the primary reference for Buddhist works in Chinese: Takakusu Junjirō and Watanabe Kaigyoku, eds., *Taishō shinshū Daizōkyō*, 100 vols. (Tokyo: Taishō Issaikyō Kankōkai, 1914–32), commonly referred to as the *Daizōkyō*.
7. See Boston 1997, colorpl. 3, p. 46.

FIGURE 61. Drawings of reliefs on east wall of cave 3 (Central Binyang cave)

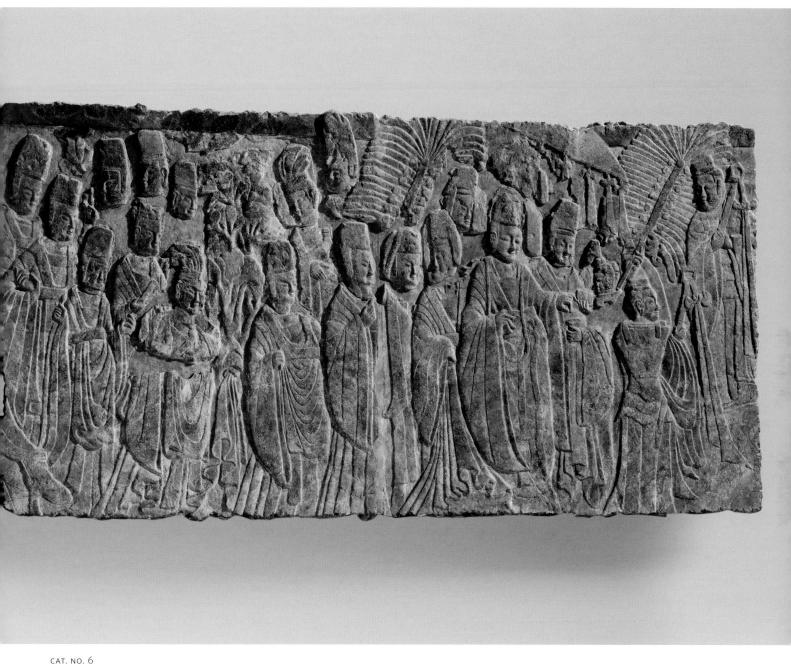

CAT. NO. 6

7a. Altarpiece Dedicated to Buddha Maitreya (Mile fo 彌勒佛)

Northern Wei dynasty (386–534), dated 524
Gilt bronze
H. 30¼ in. (76.9 cm)
Rogers Fund, 1938
38.158.1a–n

7b. Altarpiece Dedicated to Buddha Maitreya (Mile fo 彌勒佛)

Late Northern Wei (386–534) or Eastern Wei (534–50)
dynasty, ca. 525–35
Gilt leaded bronze
H. 23¼ in. (59.1 cm)
Rogers Fund, 1938
38.158.2a–g

The identification of the Buddhas in both of these altarpieces derives from an inscription on the back of the larger example (cat. no. 7a), which identifies the central figure as Maitreya; gives a date equivalent to 524 C.E.; and states that an individual commissioned the sculpture on behalf of his deceased son, Gaizhi.[1] The inscription expresses the hope that the son and other relatives will eventually be reunited in the presence of the Buddha and suggests that the altarpieces were commissioned to gain merit for the family or clan and to serve as a focus of personal devotion.

The two altarpieces are among the only remaining free-standing works exhibiting the artistic style that developed at the Northern Wei court in Luoyang in the first three decades of the sixth century.[2] The Buddhas in both examples have the attenuated physique and face and heavy, concealing drapery characteristic of this period of Chinese Buddhist sculpture. They wear long rectangular shawls over undergarments that include vests tied at the front. In both cases, the hems of the undergarments fall in extremely schematized folds—a pattern that is sometimes described as resembling the tail of a fish because of the way in which the hems flay at the sides. The slightly plumper face, squarer shoulders, and looser drapery, with larger folds, of the Buddha in the smaller altarpiece (cat. no. 7b) suggest that it may be slightly later than the larger piece. It would thus represent a transition between the court style associated with Luoyang and the fuller bodies and thinner drapery found in the second half of the sixth century, after the collapse of the Northern Wei dynasty.

Both altarpieces show the Buddha Maitreya standing before a large flaming mandorla that is surrounded by angel-like beings (known as *apsara*s) playing musical instruments. The larger example, dated 524, once had eleven such figures; only nine remain. The smaller work has four *apsara*s on each side and a rectangular chamber at the top, in which two Buddhas are seated. In the larger work, the Buddha Maitreya is attended by two standing and two seated bodhisattvas. The former stand on lotuses that spring from the mouths of coiled dragons at the sides of the altarpiece—a motif that became prominent in the second half of the sixth century.[3] The seated bodhisattvas have one leg pendant and the other bent so that the foot rests on the opposite knee, a posture commonly known as the "pensive pose." Two monks stand before the seated bodhisattvas.[4] Four figures wearing clothing typical of the Tuoba Xianbei—the non–Han Chinese rulers of the Northern Wei—stand on palmlike leaves between the two

pairs of bodhisattvas. Holding bowls and other offerings, they represent devotees, probably the donor and members of his family, who are revering the standing Buddha.[5] Two guardians stand on lotus petals at the sides of the altarpiece, and two lions protect the front, where a caryatid figure lifts a base supporting several lotus leaves and a hinged ovoid container. Two minuscule figures, one kneeling and one standing, sit on lotus flowers to either side of the bud-shaped container.

In the smaller altarpiece, two bodhisattvas attending the Buddha Maitreya stand at the sides on lotuses that are supported by creatures with demonic features, clawed feet, and flaming hair. The latter are commonly known as "thunder monsters" and are thought to be both auspicious and protective; they became prominent in funerary and religious imagery in the third decade of the sixth century.[6] A caryatid figure, similar to that found on the larger altarpiece, also lifts a container at the front of this work. Both containers were designed to be opened, and the parallels between their shape and that of earlier Chinese incense burners known as *boshanlu* suggest that they were filled with incense and used during devotions.[7]

As has been mentioned previously, Maitreya is the only divinity in Buddhism revered as both a bodhisattva and a Buddha. He is a bodhisattva—defined, in this case, as a being on the path to enlightenment—in the present cosmic era. In the next, he will be reborn into his final life, achieve enlightenment, and serve as the teaching Buddha. As is true of many Buddhas and some bodhisattvas, Maitreya has the ability to create and maintain a paradisiacal realm, or Pure Land. As a bodhisattva, he inhabits the Tushita heaven; as a Buddha, he will create the Ketumati heaven. Both realms serve as way stations on the path to enlightenment: they are perfected worlds where a devotee can escape the harsh realities of daily life and concentrate on the development of advanced awareness, moving further along the path to Buddhahood.

Elements of both altarpieces anticipate late-sixth-century Chinese imagery featuring the Buddha Amitabha descending from his Pure Land (known as Sukhavati) to rescue the souls of the deceased and bring them to that paradise.[8] Such depictions of Amitabha often show him surrounded by a host of music-making angels similar to those attached to the mandorlas on both altarpieces. Moreover, the Buddhas in both works are shown with raised right and lowered left hands, a combination of gestures that is frequently employed by the Buddha Amitabha descending to earth. Such paradisiacal

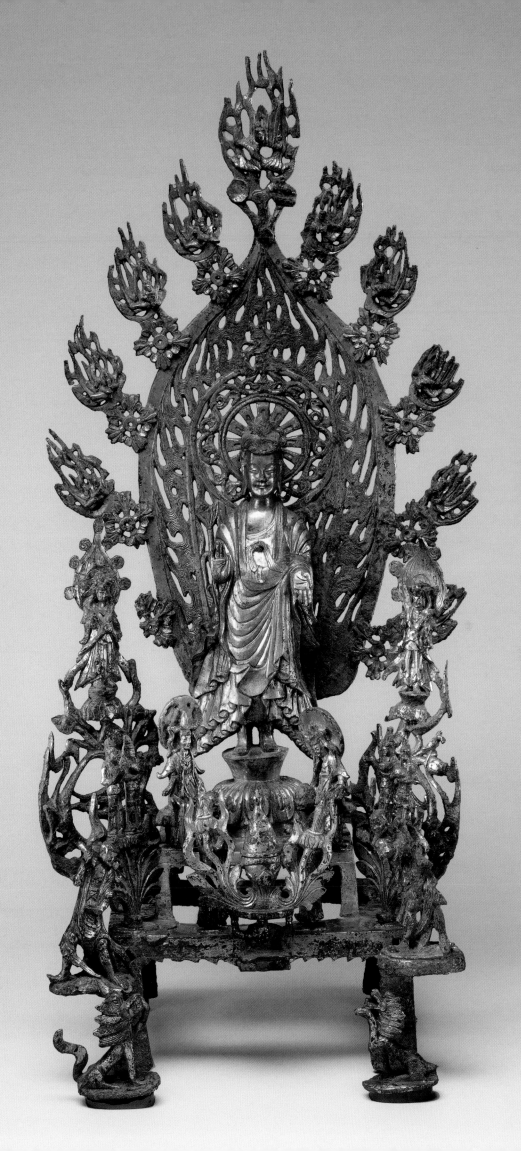

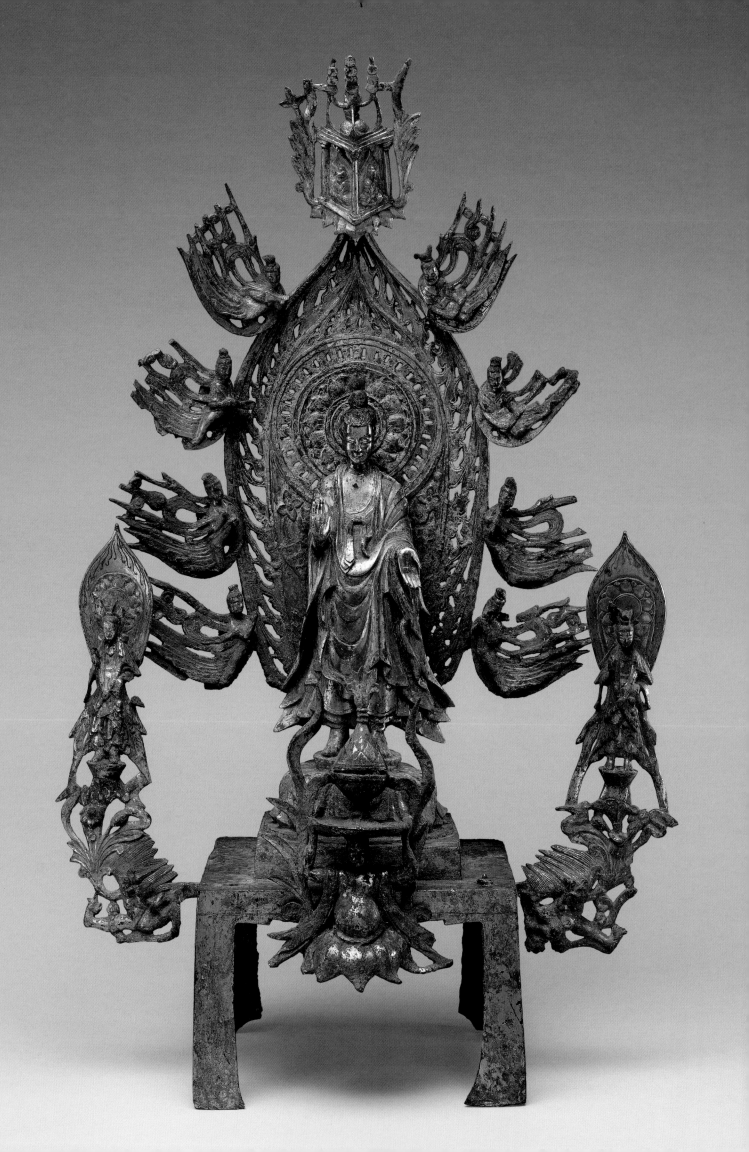

realms are filled with lotuses, ubiquitous symbols of purity in Buddhist art, and the flowers decorating the inner register of the mandorla of the smaller altarpiece may be an allusion to such imagery. The tiny figures on the lotuses at the front of the larger altarpiece resemble the newborn souls shown seated or kneeling in lotus flowers in depictions of other Pure Lands. For all these reasons (in addition to the inscription), it is likely that both altarpieces in the Metropolitan are intended to represent the Buddha Maitreya as he descends from the Tushita heaven.

The bodhisattvas seated in the pensive pose on the larger work can also be read as an allusion to the Tushita heaven. This position is often used to identify Maitreya or any other bodhisattva who, at a certain stage in his spiritual life, inhabits the Tushita heaven while awaiting the final reincarnation during which he will become enlightened.[9] Finally, the shape of the chamber at the top of the smaller altarpiece is similar to that found on Chinese reliquaries, and its placement suggests that it may be a reference to the remains of an individual who is ascending to join an assembly of divinities in Maitreya's Tushita heaven.

TECHNICAL NOTES
See appendix C for a detailed technical discussion of both works.

PROVENANCE (both works)
Found in Zhengding, Hebei Province, in 1918 and taken to Beijing by General Wang Shizhen; Yamanaka and Company, 1923; Prince Matsokada, Japan, purchased from Yamanaka and Company, ca. 1924; Yamanaka and Company, 1925; Mr. and Mrs. John D. Rockefeller Jr., New York, purchased from Yamanaka and Company, 1925

PUBLICATIONS (cat. no. 7a)
Sirén 1925, pls. 154, 155; Lodge 1928, fig. 2; Priest 1936; New York 1938, p. 23; Priest 1938b, cover ill.; Priest 1939a, figs. 1, 2; Sirén 1942b, fig. 245; Priest 1944, cat. 18b; Bowlin and Farwell 1950, p. 10; Matsubara 1959, pl. III; Sirén 1959, fig. 15; Mizuno 1960, p. 118; Lippe 1961, fig. 1; Chow 1965, fig. 14; Lippe 1965c, pl. XIX; Shirakawa 1965, p. 98; Fontein and Hempel 1968, fig. 93; Lerman 1969, p. 260; New York 1970–71, p. 146; Hearn and Fong 1974, fig. 59; Shi 1983, p. 842; *Hai-wai Yi-chen* 1986, vol. 2, pl. 15; Barnhart 1987, fig. 30; Tokyo 1987, fig. 17; Lin Shuzhong 1988, fig. 99; Munsterberg 1988, fig. 116; Leidy 1990, fig. 3; Watt 1990, fig. 60; De Montebello 1994, fig. 38; Lawton 1995, pl. 17; Matsubara 1995, pl. 171; Sirén 1998, pl. 154; Zhang Zong 2000, fig. 6; New York 2004–5, cat. no. 167; Howard et al. 2006, fig. 3.57; Leidy 2008, fig. 4.3

PUBLICATIONS (cat. no. 7b)
Sirén 1925, pl. 156; Lodge 1928, fig. 1; London 1935–6, pl. 58; New York 1938, p. 22; Priest 1939a, cover; Sirén 1942b, fig. 244; Priest 1944, cat. 19; Bowlin and Farwell 1950, p. 11; *Art Treasures* 1952, fig. 189; Matsubara 1958, pl. V; Matsubara 1959, pl. 4; Chow 1965, fig. 13; Hearn and Fong 1974, figs. 57, 58; New York 1979, fig. 15; *Hai-wai Yi-chen* 1986, fig. 16; Matsubara 1995, pl. 173; Sydney 2001–2, cat. no. 118; Nara 2004, fig. 2; Zhang Lintang 2004, p. 80; Asia Society 2006, p. 65

NOTES
1. The inscription is badly abraded and difficult to read: *Da Wei zheng guan wu nian jiu yue mou shen shuo shi ba ri xin shi xian X wu X wei wang er gai zhi zao mi le xiang yi qu yuan wang er ju jia chun shu chang yu fo hui* (大魏正光五年九月戊申朔十八日新市縣X午 X為亡兒蓋秩造彌勒像一區願亡兒 居家春屬常與佛會). For a discussion of the problems inherent in reading the inscription, see Lippe 1961.
2. It is worth noting that in Sirén 1925, pls. 154–57, the sculptures are said to have come from Hebei.
3. See London 2002, cat. nos. 3–6, 8, 9.
4. The two monks were previously displayed as part of the smaller altarpiece. However, research by Lawrence Becker and other members of the Museum's Sherman Fairchild Center for Objects Conservation and Department of Scientific Research has shown that they match the chemical composition of the other figures in the larger altarpiece, and the two sculptures have now been rearranged. For an in-depth study of the two altarpieces, including methods of manufacture and chemical compositions, see appendix C.
5. Robert Fisher (1995) has suggested that these figures are, in fact, the four guardian kings of the cardinal points of the compass.
6. The origin of these creatures remains unclear. For discussions, see Bush 1972 and 1975.
7. Neither container is reticulated, however, and they would have proved difficult to use as incense burners. On the other hand, they are designed to be opened, and it is not impossible that they may have been used for ashes (either real or symbolic) of the deceased, seeking entry into the Tushita heaven.
8. For an overview of early developments in Pure Land imagery, see Wong 1998–99. For the importance of this tradition in East Asia, see Okazaki 1977.
9. See Leidy 1990.

8. Stele Commissioned by Li Zhenwang (李真王), Yao Langzi (姚郎字), and Other Members of a Devotional Society

Henan Province, Northern Wei dynasty (386–534), dated 528
Limestone with traces of pigment
H. 91 in. (231.1 cm)
The Sackler Collections, Purchase, The Sackler Fund, 1965
65.29.1

The stele—basically, a slab of stone—was important in Chinese culture long before its incorporation into Buddhist practice in the early part of the sixth century.[1] Undecorated stones were used in ceremonies as early as the Shang dynasty (1600–1050 B.C.E.). By the Han dynasty (206 B.C.E.–220 C.E.), both plain pieces and those carved with images and/or calligraphy were being used in state ceremonies and in the funerary cult. The flowering of this type of religious art is another example of the changes that resulted from the move of the Northern Wei court to the Luoyang area in 494 C.E. The contact with more traditional Han Chinese culture and the decision of the ruling elite to adopt many aspects of that culture had a profound impact on Chinese Buddhist sculpture at the time. Like their ceremonial and funerary prototypes, Buddhist steles were public monuments, erected in prominent locations near villages, in fields, and at crossroads. At times, steles were also placed within the confines of a monastery or a cave temple.

A dedicatory inscription at the bottom of this stele gives a date equivalent to 528 C.E. and indicates that it was commissioned by a group of seventy individuals, members of a devotional group in a certain Duwu (杜塢) village, on behalf of the emperor, the country, and various ancestors and in the hope that all would, at some point, achieve enlightenment. Steles were often commissioned by such groups, which usually included members of various ranks who paid for different parts of the construction as well as monks who helped supervise the work. It is interesting that a short interpolation between the main text and the date indicates that in 743 C.E., an individual named Du Sifu performed a solemn and meritorious action, presumably with regard to this stele. It is not clear what this action may have been; it is possible that the stele was moved or somehow protected at that time. It is also possible that it was rededicated.

The tall, narrow shape of the work in the Metropolitan was common in the early sixth century, as was the use of six entwined dragons to define the top. A small niche nestled between the legs of the dragons contains a Buddha seated in a cross-legged position. Another, larger Buddha, the primary icon of the stele, is seated in a niche bordered by thin columns with dragon capitals. This niche fills the central part of the stele and is surrounded by a lively palmette-and-lotus scroll. (This combination of flora, unusual in other periods, was often used in the second decade of the sixth century.) The larger Buddha is seated in a meditative posture before a flaming mandorla and may once have held his hands in gestures of reassurance and offering. The Buddha has the

narrow, sloping shoulders and wears the heavy, cascading drapery characteristic of the style developed at Luoyang and related centers in the early sixth century. He is attended by an entourage consisting of two small monks, two bodhisattvas, and two lions. The faces of the Buddha and his attendants are missing; it is likely that they were deliberately destroyed during one of the suppressions of Buddhism that marked the late sixth and mid-eighth centuries.

The seven small Buddhas encircling the mandorla, which are standard in early Chinese Buddhist art, were understood to represent the seven Buddhas of the past—those who had attained enlightenment in the cosmic eras prior to the current age. They help, therefore, to identify the principal Buddha as the historical Buddha, Shakyamuni, while the smaller Buddha at the top of the stele probably represents Maitreya, the Buddha of the Future. The two guardians standing to either side of the central niche were derived from Indian traditions, where they are known as *dvarapalas* (*erwang* 二王) and serve as the protectors of doors and other entryways. Three music-making *apsaras* hover above each guardian.

Nine small seated Buddhas and two figures in individual pavilions with somewhat fanciful roofs are depicted in a row above the principal Buddha. The two additional figures are identified by inscriptions on the front of their pavilions as *kaimingzhu* (開明主), a term often used on Chinese Buddhist steles to indicate the members of a devotional society who sponsored the ritual animating of the image—one of the most important activities surrounding the installation of a stele or other work of art. The figure on the left is identified as Li Zhenwang and that on the right as Yao Langzi. Their position indicates that they were the most important patrons for the construction of the stele.

A member of the Qi (齊) family is identified as the donor of the small niche with the seated Buddha at the top; members of the Qi and Kai (開) families are among those listed as the patrons depicted in the three pavilions just above the inscription. One of the donors is further identified as the provider of the vegetarian feast that accompanied the dedication of the stele; his patronage was intended to honor his deceased father and older brother. Each of the three donors holds offerings and is attended by three figures bearing fans, umbrellas, and other implements of rank; it is possible to understand the scene as alluding to the festivities that accompanied the installation and dedication of the stele. Additional references to such activities are shown above the three donors. Two monks kneel on mats to either side of a large censerlike

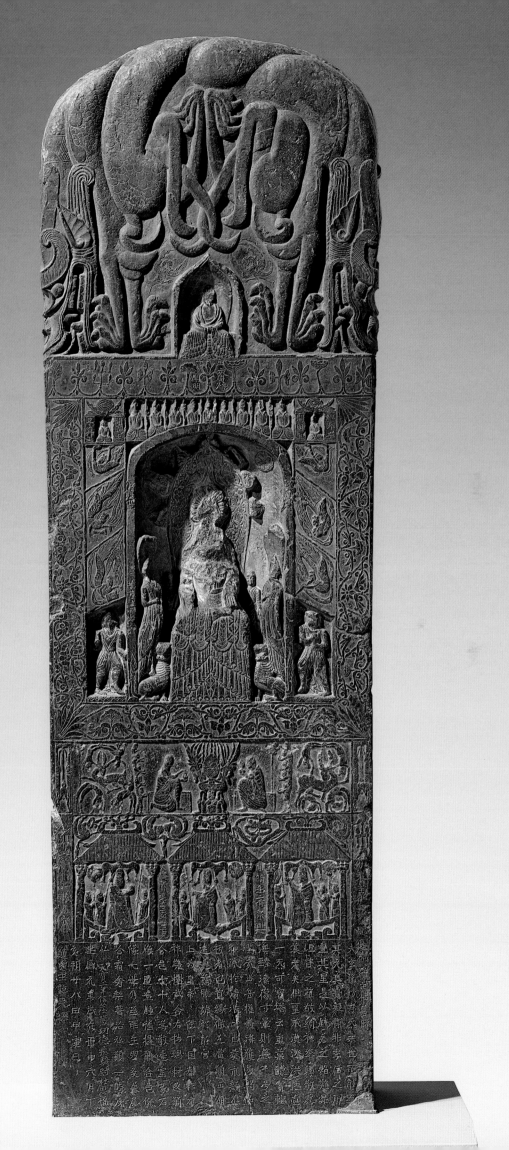

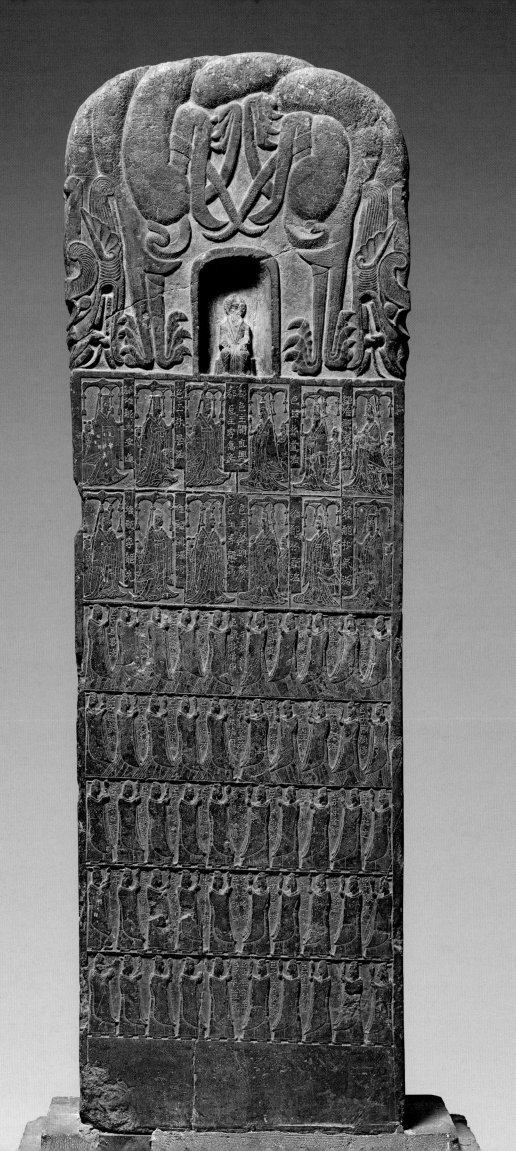

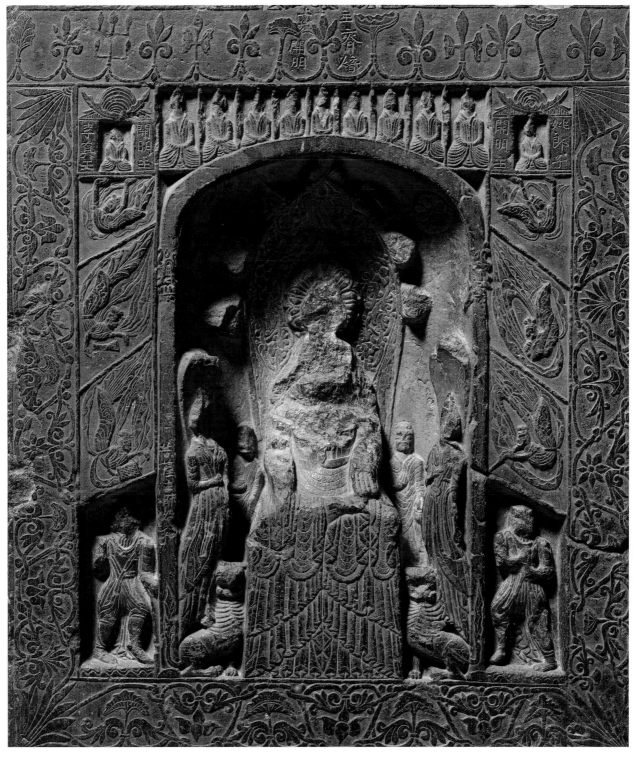

CAT. NO. 8, DETAIL OF FRONT

container that is supported by a demonic caryatid figure. Wavy lines, possibly intended to represent smoke, radiate from the container, and there are large stylized palmettes at the sides. Two groups of acrobats, each performing around a standing deer (or some other cervid), are depicted to the left and right of this scene.

The remaining sixty-five donors mentioned in the dedicatory inscription are portrayed on the sides and back of the stele. Two, with their attendants, are shown on the right side: one rides a horse, and the other walks before a horse with

an offering in his hands. Another rides his steed on the left side. Sixty-two figures are arranged in seven rows on the back of the stele (see opposite). The twelve most important are placed near the top and are shown with attendants holding umbrellas. Of these, the two in the center of the top row face each other and are labeled as *duyizhu* (都邑主), a title that indicates an important administrative role within the devotional society. Fifty smaller figures, many of them identified as members of lower status, known as *weina* (維那) and *yizi* (邑子), fill the lower part of the back of the stele.

OPPOSITE: CAT. NO. 8, BACK 73

The other images on the back and sides of the stele are also characteristic of Chinese Buddhist imagery in the first half of the sixth century. A bodhisattva is seated in a small niche between the legs of the dragons on the back. His pendant legs, in a posture that is often known as the "European pose," suggest that he is the bodhisattva Maitreya—a parallel to the same divinity, portrayed as a Buddha, on the other side. The figure seated in the pensive pose (right foot resting on left knee) between two animated trees on the left side of the stele may also refer to this important divinity. As was mentioned in catalogue number 7, Maitreya and other figures assume this pose when they are shown seated in the Tushita heaven awaiting a final rebirth. An unidentified bodhisattva fills a comparable niche on the right side of the stele, and beneath it is one of the enigmatic thunder monsters that served a protective and auspicious function.

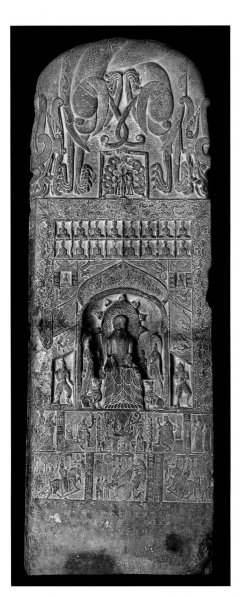

FIGURE 62. Stele. Henan or Shanxi Province, Northern Wei dynasty (386–534), dated 529. Limestone, H. 75⅝ in. (191 cm). Museum of Fine Arts, Boston, Caroline Balch Allen Fund and Cranmere Nesmith Wallace Fund, 1923

FIGURE 63. Left side of Boston stele

CAT. NO. 8, LEFT SIDE

CAT. NO. 8, RIGHT SIDE

The stele in the Metropolitan Museum is strikingly similar, in composition and style, to a work in the Museum of Fine Arts, Boston, that was commissioned by a devotional society led by Du Yanhe (杜延和) and Guan A'e (関阿娥) and is dated 529 (fig. 62). The central sections of both examples feature a niche holding a Buddha and attendants with guardians and flying *apsara*s. In both works, the niches are bordered by palmette-and-flower scrolls. In addition, both steles display two groups of figures beneath the central niche—monks and acrobats in the upper register and additional donors in the lower. Finally, the thunder monsters that are shown as subsidiary images on the left sides of both steles assume comparable poses and have similar features and flaming hair (see fig. 63).

The similarities in imagery, composition, and date suggest that the steles were produced by the same workshop, and it is interesting that many members of the group that commissioned the Boston piece had the surname Du, written with a character (杜) also used for the name of the village where the Metropolitan's stele was dedicated. It is also worth noting that some steles have been discovered in groups, suggesting that they were once arranged in sets;[2] it is possible that the pieces in New York and Boston were once part of such an assemblage.[3] They may also have been the work of an atelier that produced several similar pieces for the consumption of different groups of donors or groups that had familial or other ties.

TECHNICAL NOTES

At one time, the stele was brightly painted; however, little pigment remains today, making it difficult to determine the original pattern. Red pigment is found in the background of many of the niches, on some of the larger figures, and in the recesses of the large halo of the central Buddha. In the large niche on the back, the Buddha's halo bears traces of an as-yet-unidentified yellow pigment.

PROVENANCE

C. T. Loo, Paris; Frank Caro, New York

PUBLICATIONS

Sirén 1925, pl. 59; Sirén 1937, pl. IVa; Loo 1940, pl. XIV; Chow 1965, figs. 17, 18

NOTES

1. For an overview of steles in China, see Wong 2004.
2. See Li Xianqi 1985 and Duan Pengqi 1990.
3. It remains unclear where the steles were made; however, the dark limestone of the New York work indicates an area near Luoyang, in Henan Province. Dorothy Wong (2004) has attributed the work in Boston to Shanxi Province. If this is correct, the stele in Boston may have been made in the southern part of that province, near the border with Henan and relatively close to the Luoyang region.

9. Bodhisattva, probably Avalokiteshvara (Guanyin 觀音菩薩)

Shanxi Province, Northern Qi dynasty (550–77), ca. 550–60
Sandstone with pigment
H. 13 ft. 9 in. (4.2 m)
The Sackler Collections, Purchase, The Sackler Fund, 1965
65.29.4

Large sculptures of bodhisattvas wearing extraordinary adornments epitomize the stylistic and iconographic innovations of the second half of the sixth century in Chinese Buddhist art. The dissolution of the powerful Northern Wei empire (386–534) into rival eastern and western factions—ruled, respectively, by the Eastern Wei (534–50) and the Northern Qi in the northeast and the Western Wei (535–57) and Northern Zhou (557–81) in the northwest—contributed to the mélange of imagery that defines the era. Renewed contacts with West Asia and Central Asia also had a strong impact on ceramics, Buddhist sculpture, and the funerary arts.[1]

The pillarlike physique and thin drapery of the towering, elegantly carved sculpture seen on the following spread illustrate the development of the aptly named "columnar style" in the first decade of the Northern Qi dynasty. Showing the new awareness of volumetric Indic traditions that marks the art of the period, such forms differ noticeably from the attenuated figures and heavy, flowing drapery of the early part of the century. Here, an indistinct garment crosses diagonally across the chest from the left shoulder, and two long sarong-like garments reach to the ankles. A small cape covers the upper part of the back and cascades over the arms to the feet. A diadem is tied to the bodhisattva's head, with ribbons (now partial) on either side that fall across the shoulders. The position of the forearms suggests that the hands were once held in open gestures such as those of reassurance (*abhaya mudra*) and offering (*varada mudra*), commonly found in Buddhist sculpture at the time. Red, green, gold, and blue pigments are evident on the front and back of the sculpture, and floral arabesques decorate the clothing.[2]

The bodhisattva wears a lush necklace decorated with cabochons and looped strands of beads. An astonishing jeweled harness, which is suspended from the neck by a bow (see back view), falls along the front of the body in two strands of pearl-like clusters and multifaceted beads. Each strand supports additional pendants consisting of other pearls or beads. The strands are joined at the waist by a medallion in the form of a demon or monster mask; the medallion also supports another large element, consisting of florets, angular forms, and large beads. Ancillary discs with

FIGURE 64. Necklace. Shaanxi Province (Xi'an, excavated from tomb [dated 608] of Li Jingxun), Sui dynasty (581–617). Gold inlaid with pearls and stones, L. 16⅞ in. (43 cm). National Museum of China, Beijing

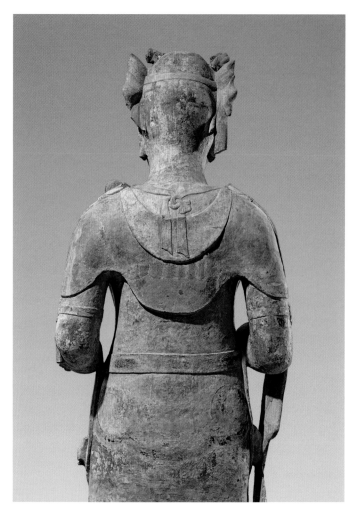

CAT. NO. 9, DETAIL OF BACK

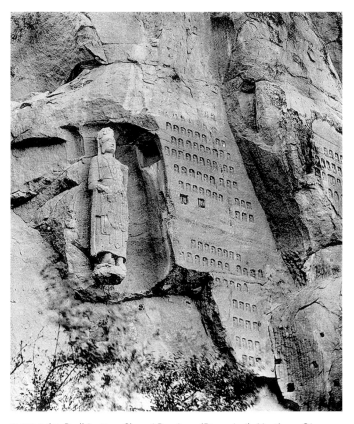

FIGURE 65. Bodhisattva. Shanxi Province (Dongzi-si), Northern Qi dynasty (550–77), ca. 550–60

holes in the center, also embellished with ribbons and bows, are found beneath the belt and the side pieces of the harness.

The earliest known example of a bodhisattva wearing such a harness is a gilt-bronze piece in the collection of the Tokyo University of the Arts, which can be dated to the mid-sixth century. Numerous examples dating to the second half of the century exist in Western collections.[3] This distinctive type of adornment exemplifies the stylistic complexities of the art of the period. While some elements can be traced to Chinese culture, others derive from northwestern India or related traditions in West Asia and Central Asia. Chinese prototypes for the discs with central holes, known as *bi*, were made in jade and other stones by some of China's oldest civilizations.[4] The earliest examples were often used in burials and are thought to have had protective implications. The triangular elements on the central pendant were based on stone forms found in early China, where they served as both chimes and adornments.[5] On the other hand, the demon mask, pearl clusters, and roundels and cabochons, all of which are depicted in numerous artistic media in the second half of the sixth century, resemble jewelry from West Asia and Central Asia.[6] The demon mask, in particular, reflects the influence of Khotan, a major center on the southern branch of the Silk Road. Pearls, pearl clusters, and pearl roundels, as well as stone cabochons, derive from cultures such as those of the Sasanian Empire (224–651), in ancient Persia, and the mercantile nation of Sogdia, in present-day Uzbekistan.

A necklace (fig. 64) discovered in 1957 in the tomb of Li Jingxun (d. 608) is a rare surviving example of the type of jewelry that may have inspired some of the decorative elements in these unusual jeweled harnesses.[7] It consists of twenty-eight gold beads inlaid with pearls, a multipart clasp set with lapis lazuli, five stones *en cabochon*, and a pale blue

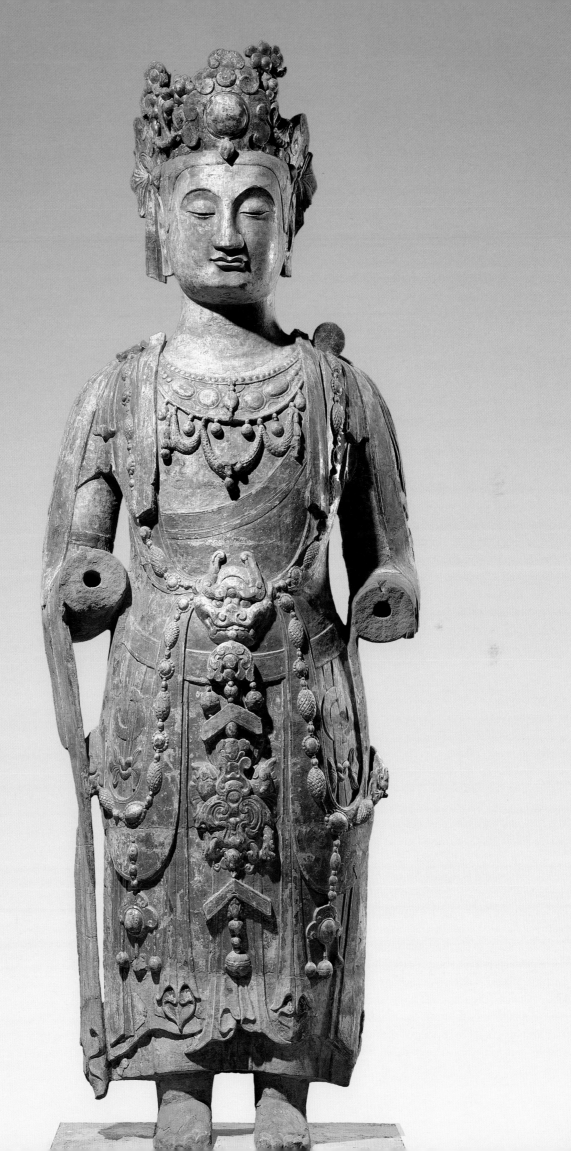

stone pendant. The inlaid beads are comparable to those seen in the harness of the Metropolitan's bodhisattva, and additional parallels are found in the pearl roundels and cabochons of the excavated necklace. Li Jingxun was the granddaughter of the eldest sister of the Sui emperor Yang (r. 605–17), and she died very young. Her sumptuous tomb contained more than two hundred objects, many of which, such as other pieces of jewelry and glass bowls, reflect Chinese interest in foreign luxury goods.

While the interest in foreign prototypes provides a plausible explanation for the development of the appearance of the jeweled harnesses, the rationale for their creation is unclear. It is possible, however, that they can be linked to the beliefs and practices of the powerful Gao family, which controlled northeastern China during the Eastern Wei and Northern Qi periods. At least one example of a figure wearing such a fantastic adornment—a towering sculpture placed on the side of a cliff overlooking the Dongzi-si (Dongzi temple) on Mount Lu, near Taiyuan, in Shanxi Province (fig. 65)—was sponsored by the Gao family. This sculpture, which is now destroyed, was carved under the patronage of Emperor Wenxuan (Gao Yang; r. 550–59) of the Northern Qi.[8] The appearance and proportions of the sculpture in the Metropolitan Museum are similar to those of the Shanxi work, and it is likely that the New York piece dates to the same period and was made in the same province.

The scale of the sculptures, their status as freestanding icons rather than parts of groups, and their production in northeastern China in the second half of the sixth century further link bodhisattvas with this distinctive jeweled harness to the rule of the Gao family. In 538, Gao Huan (d. 547), the de facto ruler of the Eastern Wei, circulated an apocryphal sutra entitled Avalokiteshvara Sutra Promoted by Emperor Gao, which proclaimed Gao's benevolence (in parallel to that of the bodhisattva) and promised instantaneous rewards to those reciting the bodhisattva's name.[9] Moreover, during the Northern Qi period, sections (or the entire text) of the Avalokiteshvara chapter of the Lotus Sutra were engraved at several sites, including a version dated 565 on the upper walls of cave 4 at Southern Xiangtangshan; an undated example on the cliff above Wahuanggong, on Mount Zhonghuang; two steles in the Mujing-si (Mujing temple), dated 571 and 573; and another stele, dated 593 (during the subsequent Sui dynasty), that was found in the Bahui-si in Hebei.[10]

Composed in India some time between the first and the third century and translated into Chinese by the early third, the Lotus Sutra is a quintessential statement of the Mahayana Buddhist emphasis on salvation for all sentient beings. The bodhisattva Avalokiteshvara is mentioned in the sutra both as an attendant to the Buddha Amitabha and as one of the more powerful savior-bodhisattvas who assist and guide the faithful. The Avalokiteshvara chapter, in the form of a dialogue between the Buddha Shakyamuni and a bodhisattva named Akshayamati, extols the munificence of Avalokiteshvara and his great compassion for others—a virtue that enables him to assume thirty-three different manifestations

in order to guide and provide solace to the faithful. At some point in the text, Akshayamati offers a precious pearl necklace to Avalokiteshvara as a mark of respect, and Shakyamuni urges a reluctant Avalokiteshvara to accept the necklace as a symbol of his compassion and availability to the devout.

The extraordinary harnesses that appear in Chinese Buddhist art in the third quarter of the sixth century may be a visual reference to this moment in the seminal text and may have been intended to identify images of the bodhisattva Avalokiteshvara definitively while stressing the links between the bodhisattva and the Gao family.

TECHNICAL NOTES

Except for the forearms, hands, and trailing scarves, this monumental freestanding bodhisattva was carved from a single block of sandstone. Although it was conceived in the round, less care was taken in carving the back, which is flatter, with fewer details. The lower arms would have been joined to the body by dowels, but only the circular holes for the dowels remain. Two holes on the left side, at the knee and ankle, contain the remains of wood dowels. They may have been used to attach the scarves that are now missing on that side.

The surface of the sculpture displays a complex web of repairs, overpaints, and other interventions. Distinguishing between the original colorants and later restorations is difficult. Clearly, the sculpture has been restored and overpainted many times; the crown alone has at least thirteen layers of paint. Some of the overpaints include gilded areas, especially visible in the jewelry. An in-depth investigation of the pigments and restorations is needed in order to thoroughly understand the history of colorants on this enormous sculpture.

PROVENANCE
Frank Caro, New York

PUBLICATIONS
Sirén 1942b, p. 381; Chow 1965, fig. 21; Leidy 1998, fig. 2; Howard et al. 2006, p. 288

NOTES
1. For an overview of the artistic traditions of the period and their impact on the subsequent Tang dynasty, see New York 2004–5.
2. As is mentioned in the technical analysis below, this pigment is not original.
3. For illustrations of many of the works of this type in Western collections, see Leidy 1998.
4. For an example in the Museum's collection, see Watt 1990, fig. 7.
5. For an example of this form used decoratively and as an instrument, see Portland 2005, pp. 85, 106–8.
6. The impact of Central Asian decorative motifs on sixth-century Chinese art has been discussed from a wide variety of perspectives. Useful works include Scaglia 1958, Lovell 1975, and Karetzky 1986.
7. For references to Chinese publications about this tomb and its contents and an interesting analysis of the necklace, see Xiong and Liang 1991.
8. For information about the history of the site, see Tokiwa and Sekino 1939–41, vol. 8, pp. 31–32 and related plates. The site was nearly destroyed by the time the Japanese scholars visited in 1930. The monumental sculpture was gone when the author of this entry visited in 2005.
9. Gao Wang Guanshiyin jing (高王觀世音經). Takakusu and Watanabe 1914–32, no. 2898.
10. Wahuanggong and the Mujing-si are discussed in Ma et al. 1995; for the Bahui-si, see Liu Jianhua 1995. For a chart listing the locations of many engraved sutras, see Chen and Ding 1989, pp. 41–42. For a discussion of the carving of sutras during the Northern Qi, see Tsiang 1996.

10a. Right Hand of Buddha

Hebei Province (Northern Xiangtangshan,
north cave), Northern Qi dynasty
(550–77), ca. 550–60
Limestone with pigment and gilding
H. 20½ in. (52.1 cm)
Gift of C. T. Loo, 1930
30.81

10b. Head of Attendant Bodhisattva

Hebei Province (Northern Xiangtangshan, central
cave), Northern Qi dynasty (550–77), ca. 550–60
Limestone with pigment
H. 32 in. (81.3 cm)
Gift of C. T. Loo, 1951
51.52

10c. Head of Attendant Bodhisattva

Hebei Province (Southern Xiangtangshan),
Northern Qi dynasty (550–77), ca. 565–75
Limestone with pigment
H. 15 in. (38.1 cm)
Rogers Fund, 1914
14.50

10d. Head of Buddha

Hebei Province (Southern Xiangtangshan),
Northern Qi dynasty (550–77), ca. 565–75
Limestone with pigment
H. 15½ in. (39.4 cm)
Gift of Mr. and Mrs. Albert Roothbert, 1957
57.176

Both the Eastern Wei (534–50) and Northern Qi dynasties were ruled from a capital at Ye (present-day Linzhang), in southern Hebei Province, and both sponsored the construction of cave temples. The complex at Xiangtangshan, near Handan, not far from Ye, is dated to the Northern Qi. It consists of three sites: three enormous cave temples at the top of the mountain, known as Northern Xiangtangshan; seven smaller shrines about nine miles (15 km) to the south, known as Southern Xiangtangshan; and a single grotto, the Shuiyu-si, located near the southern complex. Recent study of the Museum's collection has determined that four fragments of larger sculptures were once part of the Xiangtangshan material, two works from the northern site and two from the southern.[1]

Northern Xiangtangshan (see fig. 66) was strategically located on the route between Ye and Jinyang, in Shanxi Province, the home base of the powerful Gao family, who served as regents during the Eastern Wei and as emperors during the Northern Qi. The scenic area is known to have been a summer retreat for the family and may also have been used for meditation or other Buddhist activities even before the construction of the three northern cave temples at the beginning of the Northern Qi dynasty. Known as the north, central, and south caves, the shrines are colossal in scale, attesting to the power and wealth of the Gao family. A niche above the head of one of the Buddhas in the north cave is thought to have been the burial place of Wenxuan (Gao Yang; r. 550–59), the first emperor of the Northern Qi and second son of Gao Huan (d. 547), the de facto ruler of the earlier Eastern Wei.

The fleshiness and volume of the large hand in the Metropolitan—formerly attached to the right arm of the Buddha occupying the niche on the south side of the central pillar in the north cave (see fig. 67)—are characteristic of the art of the early Northern Qi period. Carved pillars are common in the center of Chinese cave temples, particularly those

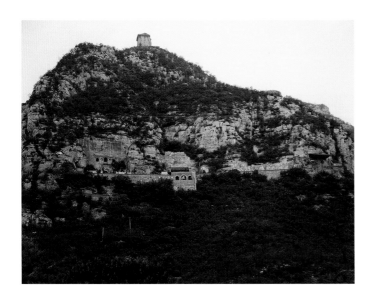

FIGURE 66. View of
Northern Xiangtangshan

FIGURE 67. Buddha on
south side of central pillar.
Northern Xiangtangshan
(north cave), Northern Qi
dynasty (550–77),
ca. 550–60

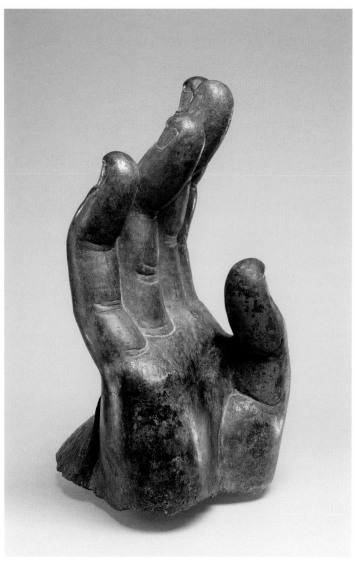

CAT. NO. 10A

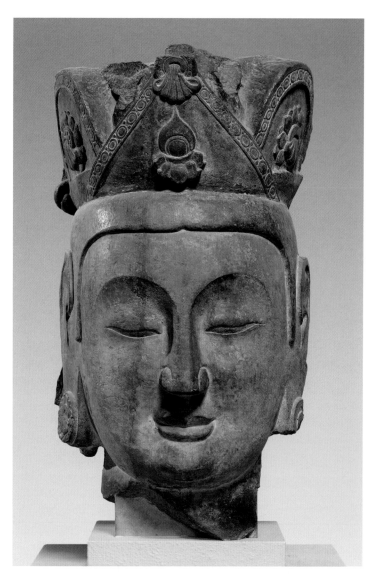

CAT. NO. 10B

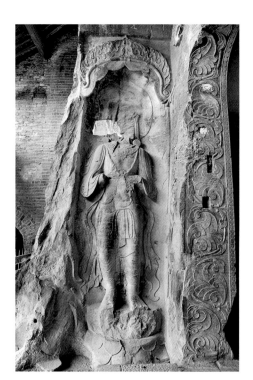

FIGURE 68. Bodhisattva to left of cave entrance (body of cat. no. 10b). Northern Xiangtangshan (central cave), Northern Qi dynasty (550–77), ca. 550–60

constructed in the fifth and sixth centuries. The pillars are thought to have derived from Indian burial mounds, or stupas, and to have served as the focus for rites of circumambulation. The identities of all the Buddhas carved on the north cave's pillar remain in question; however, it is likely that the three principal icons represent a Buddha of a past cosmic era; the historical Buddha, Shakyamuni; and Maitreya, the Buddha of the Future, to whom the Museum's hand, likely held up in a gesture of reassurance such as *abhaya mudra*, belonged.[2] All three Buddhas are situated on waisted lotus pedestals before enormous flaming mandorlas, which were created with relief decoration that appears to have been applied to the wall. Each Buddha was originally attended by two standing bodhisattvas. In addition, the walls of the cave were filled with sixteen sculptures of seated Buddhas.

Two bodhisattvas stand to either side of the entryway to the central cave at Northern Xiangtangshan. One of the Museum's bodhisattva heads (cat. no. 10b) can be identified as having belonged to the bodhisattva on the left (see fig. 68) because of its similarity to the one on the right, which remains in situ.[3] In addition, fragments of sculpted ribbon are found there that match the fragment of ribbon on the right side of the Museum's head, used to tie the diadem. The bodhisattva

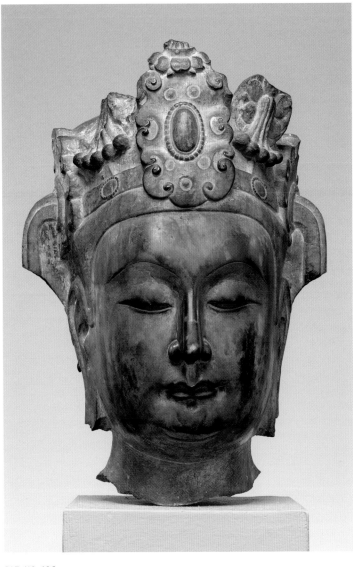

CAT. NO. 10C

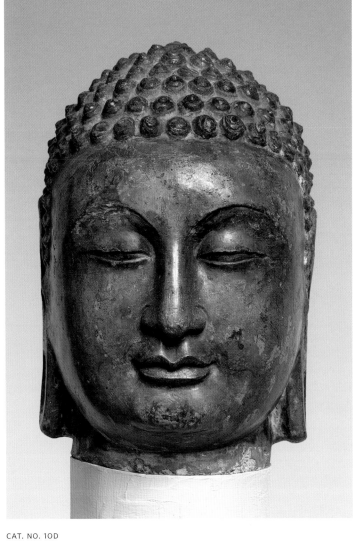

CAT. NO. 10D

wears a spectacular crown with a triangular center and two large circular elements at the sides, all bordered with narrow bands decorated with pearl cabochons. A flaming pearl rests on a lotus base in the center of the triangular panel, which is capped by a small roundel decorated with a tassel. This motif, which is repeated on the sides of the crown and in the earrings worn by the bodhisattva, derives from the art of Central Asia; it is commonly found in ceramics produced for Khotan, an important center on the southern branch of the Silk Road.

A narrow band with pearl cabochons and Central Asian tassels also decorates the crown worn by the bodhisattva (cat. no. 10c) from one of the seven cave temples at Southern Xiangtangshan (see fig. 69). An inscription found in this complex indicates that it was first opened, again under the sponsorship of the Gao family, around 565. It remains unclear which of the southern caves was the original location of the Museum's head; however, the bodhisattva in question was most likely an attendant figure that stood, possibly with a monk or some other figure, by the side of a seated Buddha.

Subtle differences between the two bodhisattva heads in the Metropolitan illustrate the stylistic differences between Northern and Southern Xiangtangshan. The crown worn by the bodhisattva from the northern site is more three-dimen-

sional than that of the southern example, and the face and features are fuller. Smaller features and a flatter treatment of the face are also seen on the head of a Buddha from Southern Xiangtangshan (cat. no. 10d), which is, again, from an undetermined cave, although it seems reasonable to suggest a provenance in one of the caves currently numbered 3 to 7.

TECHNICAL NOTES

At one time, all four sculptures were brightly painted. Residual pigment and ground layers were discerned in the recesses of each. Two of the heads (cat. nos. 10c, 10d) have a darkened coating over their carved surfaces, obscuring the normally light gray limestone and the remains of pigments. The surface of cat. no. 10b probably comes closest to the original appearance of all four. The lips of the three heads were painted red, and the faces were painted pink over a white ground. The hand was painted pink over a white ground, with traces of gilding on the flesh. X-ray fluorescence (XRF) analyses of the ground have identified lead, calcium, and iron. No gilding was found on the three heads, and no unexpected elements were detected by XRF analyses of the pigment on cat. nos. 10b, 10c, and 10d. There is a repair across the palm of cat. no. 10a, and the tip of the middle finger has been replaced.

PROVENANCE (cat. no. 10c)

S. Bourgeois, New York

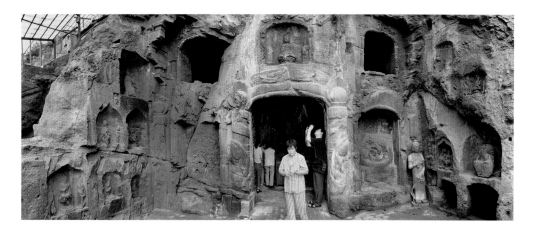

FIGURE 69. View of Southern Xiangtangshan

PUBLICATIONS (cat. no. 10a)
Priest 1933, p. 107; Priest 1944, cat. no. 44; Chow 1965, no. 33; De Montebello 1983, cat. no. 21; Chen Zhejing et al. 1993, figs. 85–87

PUBLICATION (cat. no. 10b)
Tsiang 2007, fig. 5

PUBLICATIONS (cat. no. 10c)
Valentiner 1914, p. 138; Priest 1944, cat. no. 28; De Montebello 1983, cat. no. 3; Shi 1983, p. 810; *Hai-wai Yi-chen* 1986, cat. no. 59; Watt 1990, fig. 63; Howard 1996, fig. 13; Sirén 1998, pl. 476B; Zhang Lintang 2004, fig. 18; Valenstein 2007, fig. 21

PUBLICATIONS (cat. no. 10d)
De Montebello 1983, cat. no. 15; Howard 1996, fig. 12

NOTES
1. The author of this entry is grateful to Katherine R. Tsiang of the University of Chicago for including her in a current project focusing on the Xiangtangshan site. Work on the project has contributed significantly to the author's understanding of the pieces in the Museum's collection. Thanks are also due to the Getty Foundation for their support of the project.
2. This identification is derived from the work of Dr. Tsiang and other members of the Xiangtangshan project (see n. 1).
3. See Zhang Lintang 2004, fig. 28.

11. Shrine with Four Buddhas

Northern Qi dynasty (550–77), ca. 560–75
Limestone with traces of pigment
H. 95 in. (241.3 cm)
Gift of Henry and Ruth Trubner, in memory of Gertrude Trubner and Edgar Worch, and Purchase, The Astor Foundation Gift, 1988
1988.303

The construction of small pagoda-like shrines appears to have begun in China during the Northern Qi and to have flourished until the Tang dynasty (618–906).[1] Comparison with works in situ, such as the sixth-century structure at the Lingquan-si (Lingquan monastery), in Henan Province (fig. 70), suggests that the Museum's example once stood on a square, possibly stepped, base and was capped by either a domed or a tiered roof.[2] Shrines of this type—some can be entered and others cannot—are closely related in form and function to the pagodas located at the center of East Asian monastic complexes. Pagodas derive from Indian burial mounds, or stupas, which were used to mark the physical or symbolic remains of great leaders and teachers, including the historical Buddha, Shakyamuni; his disciples; and other monks and adepts. In China, the form of these stone mounds was blended with a wood tower to create the pagoda, and this new type of architectural structure spread from there to Korea and Japan.[3]

FIGURE 70. Reliquary shrine at the Lingquan-si

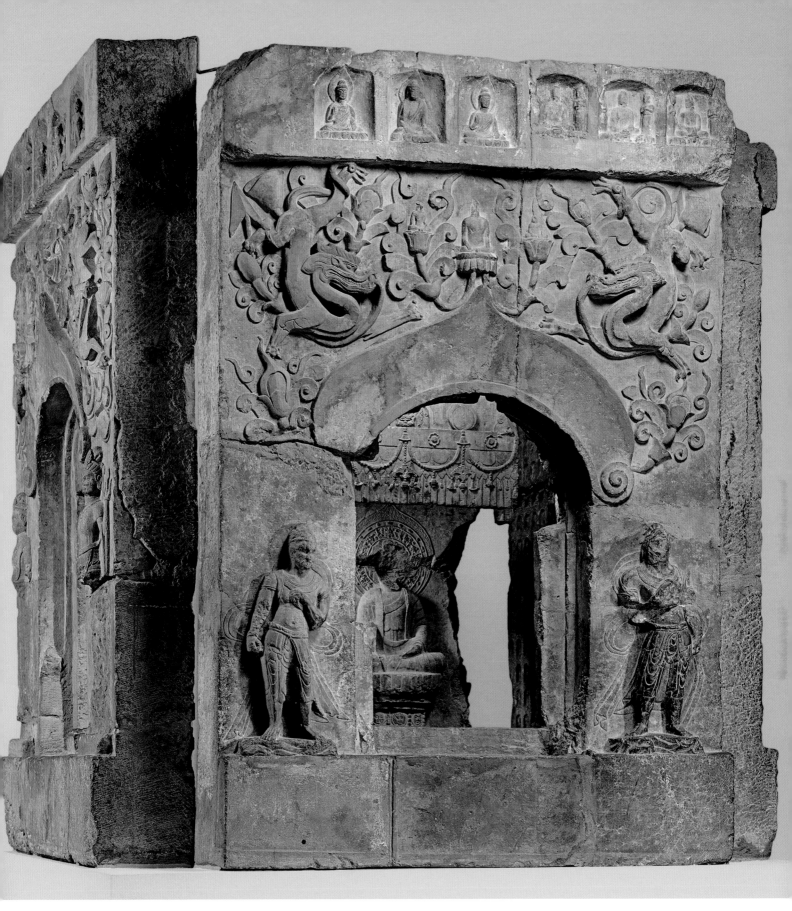

CAT. NO. 11

The shrine in the Metropolitan, which is incomplete, consists of three exterior walls with prominent openings enclosing a pillar bearing images of four seated Buddhas (see following spread). The pillar, which is cognate to the central pillar in a Chinese cave temple, is topped by a baldachin decorated on each side with a relief of flaming pearls and a monstrous face that supports beaded swags from which

additional adornments are suspended. Each of the Buddhas is seated on a tiered lotus pedestal decorated with gorgonlike masks. The latter, which are standard motifs in Northern Qi ceramics and funerary material, were most likely introduced into China from Central Asia.[4] The Buddhas have broad but slightly sloping shoulders, columnar physiques, and clinging drapery, characteristics that are often found in sculpture of

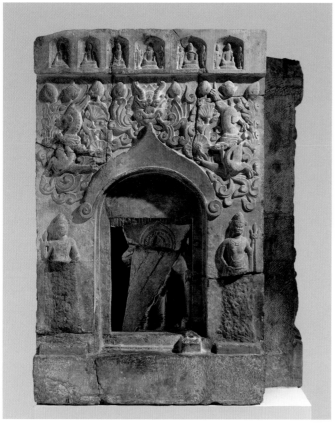

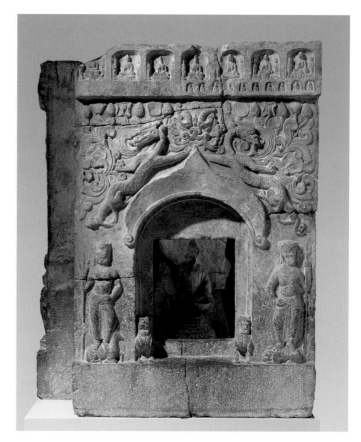

CAT. NO. 11, LEFT SIDE

CAT. NO. 11, RIGHT SIDE

the Northern Qi period and that help to date the work to the mid-sixth century.

The postures and clothing of the Buddhas vary. One Buddha wears a shawl that covers both shoulders, another a garment that covers only the left shoulder. The remaining two Buddhas are too badly damaged to allow for an understanding of their clothing. In addition, one or more of the Buddhas once had attendants, possibly monks. It is likely that the Buddhas on the pillar were intended to represent four specific divinities, each of whom was associated with a cardinal direction. Lists of such groups exist in texts dating to the early fifth century; however, they differ regarding which Buddha is associated with each quadrant. While it is not possible to identify the damaged figures in the Metropolitan's work with any certainty, it is likely that they represent Buddhas who were important in Chinese art and Buddhist practice at the time, such as the historical Buddha, Shakyamuni, and the transcendent Buddhas Maitreya, Amitabha, and Vairocana.

The compositions of the three exterior walls are similar. Each wall is capped by a lintel filled with small images of seated Buddhas in niches, some of whom are accompanied by standing attendants; paired dragons fill the upper section of each wall; and the openings are defined by ogival arches. A guardian figure stands to either side of each opening, which was also protected by paired lions, most of which are now missing. The dragons at the front of the monument hold long, many-budded lotus stems in their mouths, and a small Buddha sits

in a meditative posture on a lotus pedestal where the two stems join. Dragons holding lotuses first appeared in Chinese Buddhist art in the early sixth century (see cat. no. 7) and became prominent in the second half of the century.[5]

The lotuses held by the paired dragons on the right and left sides of the monument (see above) are more flamboyant than those on the front: they have more buds and larger flowers, and a horned monster mask rather than a seated Buddha is at the center of both groupings. The guardians on these sides stand more rigidly than those on the front and are further distinguished by the tridents they hold. Tridents are unusual implements in Chinese Buddhist art, but they are common in Indian traditions, where they are associated with the Hindu god Shiva, who served as an archetype for protective figures in later Buddhist traditions. The use of this implement may illustrate the incorporation of Indian imagery into China as a result of strong ties with Central Asia at the time.[6] Moreover, the guardian figures on the right side of the monument stand on the backs of two animals: a deer, at the right, and a bull, at the left. In Hindu art, the bull is closely associated with Shiva, and its presence here provides an additional link between South Asian traditions and protective imagery in sixth-century Chinese Buddhist art. In a further difference from the other two exterior walls, the dragons on the right side of the monument prowl upward, while the other two pairs dive downward.

The variations in design of the three outer faces exemplify problems regarding the dating of the shrine. The columnar

physiques, thin drapery, and frontal postures of the guardians on the side walls point to a date in the first decade of the Northern Qi period, while the more muscular forms and active poses of the two guardians on the front suggest a date toward the end of that dynasty; it is possible that the shrine was produced over a period of twenty years. It is also possible that the three exterior walls were carved by different teams of artisans. Alternatively, the walls of the structure may not originally have been part of the same monument.

The inner surfaces of the outer walls are filled with carvings of small seated Buddhas, a perennial theme in Chinese Buddhist art of the fifth and sixth centuries. This motif, known as the Thousand Buddhas, is usually traced to the Sutra of the Thousand Buddhas of the Blessed (also known as the Sutra of the Fortunate Eon),[7] translated by the Indian monk Dharmaraksha in the third century C.E. The sutra lists one thousand Buddhas by name and describes their abodes and assemblies. The Thousand Buddhas motif reiterates the belief that the cosmos is filled with many realms, each inhabited by a Buddha or Buddhas, and serves as a reminder that the four primary Buddhas in the shrine are part of a larger cosmos containing innumerable worlds.

The pagoda from the Lingquan-si mentioned earlier (fig. 70) is one of a pair dedicated to the monk Daoping, who died in 563; it is assumed that at least one of the two monu-

ments held ashes of this famous cleric. In addition, the Baoshan area near the Lingquan-si has yielded nearly two hundred reliefs showing similar pagoda-like structures. Many of the reliefs are identified by inscription as memorials for monks, nuns, and devout laypeople. In some cases, the remains of the deceased were placed in an urn buried beneath or behind the carving, while in others, the carving is simply a memorial rather than a marker for relics. It is possible that the Metropolitan's shrine was also intended to hold the ashes of a devotee, presumably an important cleric. Like other monuments of its type, it was most likely once part of a larger complex of funerary shrines. However, the four Buddhas in the center suggest that it may also have had another purpose. The Sea Sutra,[8] one of the texts that list groups of four Buddhas, suggests that such foursomes were intended as the focus of visualization, an important aspect of Buddhist practice, and it is possible that the Metropolitan's shrine was used for devotions rather than, or in addition to, the preservation of relics.

TECHNICAL NOTES

Each wall of this complicated shrine consists of five, six, or seven blocks of stone, all of which have been restored with cement. Some of the missing carved designs have been re-created in cement, while other areas, such as the right side of the central pillar, have been left blank. The designs on the outer walls are mismatched. Although the corners are presently empty, they must have originally contained finished carved blocks.

The exterior surface is weathered from outdoor exposure, which has removed any pigments or gilding that may have been applied originally. On the interior walls, a few of the "thousand Buddhas" retain traces of a white ground layer and a yellow pigment, as does the standing attendant on the right side of the central pillar. X-ray fluorescence (XRF) analyses identify lead, calcium, and iron in both locations. The color in these areas and the XRF analyses indicate a possible lead-based ground with yellow ocher on top.

PROVENANCE

Jorg Trubner, Berlin; Edgar Worch, Paris; Henry and Ruth Trubner

PUBLICATIONS

Kümmel 1930, p. 124; Sirén 1938, pp. 11–15; W. Ho 1968–69, figs. 19, 21, 27; Hearn 1991; Wang 2005, fig. 6.17; Valenstein 2007, fig. 45

NOTES

1. For additional examples of such structures, see Zhang and Luo 1988, pp. 10, 23, 67, 69.
2. It should be noted that the domed roof was more common during the Northern Qi.
3. For an overview of stupas and related monuments, see Cummings 2001.
4. A similar mask is found in the center of the jeweled harness worn by the bodhisattva in cat. no. 9.
5. For examples, see London 2002, figs. 2–6.
6. A guardian figure holding a trident is found on the north wall of the main room of cave 10 at Yungang. See Chūgoku Sekkutsu 1989–90, vol. 2, no. 66. Two guardians with tridents are found at the entryway to the small cave dedicated to the sage of Dazhu (dated 589) near Anyang, in Henan Province. For an illustration, see Chen and Ding 1989, fig. 209.
7. Bhadrakalpika Sutra (Xianjie jing 賢劫經). Takakusu and Watanabe 1914-32, no. 425.
8. Guanfo sanmei haijing (觀佛三昧海經). Takakusu and Watanabe 1914-32, no. 643.

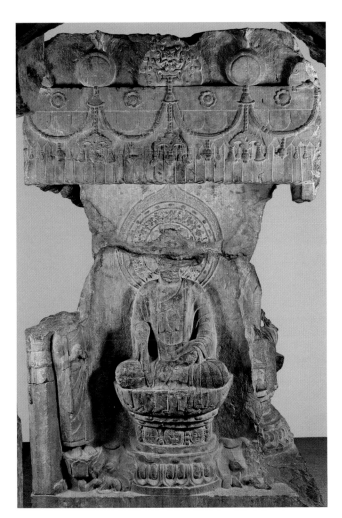

CAT. NO. 11, CENTRAL PILLAR

12. Bodhisattva Avalokiteshvara (Guanyin 觀音菩薩)

Sui dynasty (581–617), late 6th century
Gilt leaded bronze; piece-mold cast
H. 17¼ in. (43.8 cm)
Rogers Fund, 1912
12.161

This large gilt-bronze sculpture, which retains its original base and halo, is one of the earliest known examples of a form of Avalokiteshvara that became prominent in China after the eighth century. Early images of the bodhisattva, both Indian and Chinese, show him with a small image of the Buddha Amitabha seated in his headdress and a lotus flower or a water vessel in one of his hands; these attributes remained part of the imagery of Avalokiteshvara for centuries. Here, on the other hand, the bodhisattva is identified by the willow branch held in his right hand—an attribute that first appeared in the late sixth century and became standard after the eighth century, specifically in East Asian, as opposed to Indian or Southeast Asian, art.

The rationale for the addition of a willow branch to the iconography of Avalokiteshvara remains unknown. It may, however, have been based on a ritual incantation to the bodhisattva, the Samadhi Rite for the Dharani Sutra of Invoking the Bodhisattva Avalokiteshvara to Dissipate Poison and Harm,[1] which was translated into Chinese in the early fourth century. The offering of a willow branch and pure water or a water vessel was part of the ritual used in invoking the bodhisattva.[2] In addition, some of the texts dedicated to another form of the bodhisattva, Avalokiteshvara with One Thousand Hands, link the willow to healing properties and abilities. However, those texts were not translated until the early eighth century, nearly one hundred years after the production of this sculpture, and they reflect the growth of Esoteric practices at that time.

The bodhisattva stands on a lotus pedestal with a two-tiered base. Both tiers are octagonal; the upper one is decorated with rectangular medallions, while the lower one is larger and reticulated. The innermost band of the flaming halo is filled with radiating lines, and it is separated from the flames by nine small cabochons that were once painted or filled with colored paste or gems. Avalokiteshvara wears a tripartite crown decorated with tassels; a torque that supports another tassel; a bracelet; and an extremely long beaded necklace that falls below the knees. The necklace is enhanced with circular cavities that match the cabochons in the halo.

A capelike shawl falls over the left shoulder and diagonally across the chest. Such capelets first appeared in Chinese Buddhist sculpture in the late fifth century and were often worn with the long ends crossed at the abdomen and the edges falling over the arms. By the late sixth century, however, variants in the rendering of this garment—as here, where the edges of the cape fall over the right arm and an additional piece of cloth drapes over the lower part of the left arm—had

become more common. The sweep toward the left hip is also characteristic of the art of the Sui dynasty, while the girdle worn over the saronglike lower garment can be traced to the mid-sixth century.

FIGURE 71. Photomicrograph of traces of red pigment on flame of halo (cat. no. 12)

TECHNICAL NOTES

The sculpture consists of three separately cast parts: figure, base, and halo. It appears to have been made by the piece-mold casting method, although this hypothesis cannot be proved conclusively. There are few undercuts on the sculpture, and all the design elements could have been produced in the mold. The simple halo and base could also have been easily produced in piece molds. Furthermore, the composition of all three pieces is nearly identical—and similar to the alloy of other early bronzes—but composition alone is not enough to confirm which casting method was used. In comparing the major and minor alloy elements, it becomes clear that all three pieces were cast from the same pour. The figure is solid cast, with extensive porosity in the lower half; since gases and bubbles float toward the top of molten metal, this porosity indicates that the work was cast upside down. The unusual tang is a solid rectangular block that forms a bar between the two feet. Extensive chasing was performed after casting to define the jewelry.

After all three parts were mercury-amalgam gilded, the figure and halo were enhanced with bright colors; only traces of colorants remain. The figure's hair was initially painted black, but during a later campaign, it was repainted blue. The eyebrows were black, and the lips red. Two gems near the bottom of the elongated necklace were filled with red paste. The portion of the headdress ornament behind the ears was painted red; the palm of the right hand was painted orange. The hems of both the scarves and the robe were orange. Major portions of the robe and the vase may have been green, but the corrosion products are the same color and composition, so there can be no certainty. Originally, the flames of the halo were painted red. Traces of red pigment remain along the flames' edges, where they were protected from handling (see fig. 71). Although it is likely that the circular cavities in the halo and the rectangular ones in the upper tier of the base were inlaid or pigmented, no visual evidence remains.

OPPOSITE: CAT. NO. 12

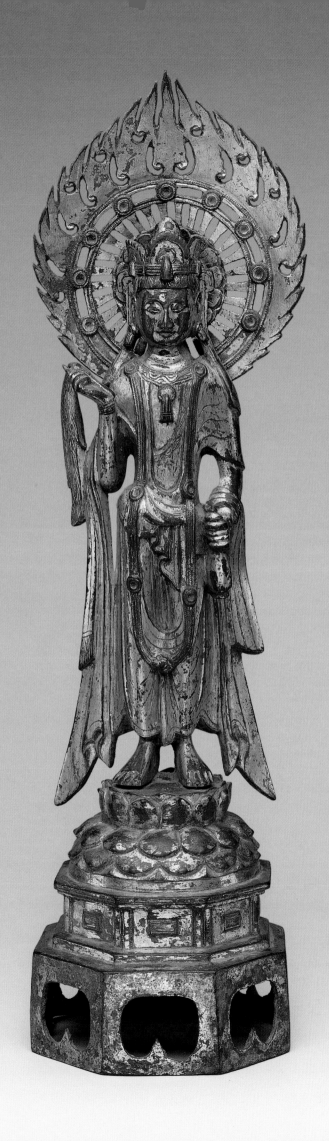

PROVENANCE
Takuma Kuroda, Yokohama

PUBLICATIONS
Ōmura 1915, pl. 290; Ashton 1924, pl. 44; New York 1938, cat. no. 284;
Priest 1944, cat. no. 30; *Hai-wai Yi-chen* 1986, fig. 67; Tokyo 1987,
cat. no. 82; Jin 1994, fig. 263; Sirén 1998, pl. 278

NOTES
1. Qing Guanshiyin Pusa Xiao fu du hai tuoloni zhou jing（請觀世音普薩
消伏海陀囉尼）. Takakusu and Watanabe 1914-32, no. 1946.
2. See Yü 2000, p. 78.

13. Buddha, probably Amitabha (Amituo 阿彌陀佛)

Tang dynasty (618-906), early 7th century
Hollow dry lacquer with pigment and gilding
H. 38 in. (96.5 cm)
Rogers Fund 1919
19.186

The position of the arms, which indicates that the hands were once held in the gesture of meditation, suggests that this sculpture represents Amitabha, a celestial Buddha who presides over the Pure Land known as Sukhavati, in the western quadrant of the cosmos. Devotion to this Buddha and the desire for rebirth in his Pure Land, a way station in which conditions are conducive to the quest for spiritual understanding, have been a major component of Chinese Buddhism since at least the sixth century, when the monk Tanluan (488–532) promoted texts and practices focusing on the Buddha Amitabha.[1] This branch of Buddhism, which stresses the impossibility of achieving enlightenment during a life lived under less-than-ideal circumstances, is also important in Korea and Japan.

The Buddha, whose torso and face are gilded, is seated in a meditative pose. He wears an interesting Chinese variant of traditional Indian attire, including a long skirtlike garment; another garment over the left shoulder; and a large monastic shawl. The over-the-shoulder piece is painted blue and has a wide border decorated with a red-and-green floral arabesque.[2] The patchwork effect of the monastic shawl, which is painted red and dark purple, refers to the historical Buddha, Shakyamuni, who often wore pieced-together fragments of discarded clothing. The subtle modeling of the face and features and the naturalistic rendering of the folds of drapery date the sculpture to the early Tang dynasty.

The complicated and time-consuming dry-lacquer technique is also characteristic of the Tang period. Lacquer, which has been used in China since the Late Neolithic period (ca. 5000–2000 B.C.E.), is produced from the resin of a family of trees (*Rhus verniciflua*) found in southern China. The viscous liquid hardens when exposed to oxygen and humidity and, because it then becomes resistant to water, certain acids, and heat, is often used as a protective coating. In the dry-lacquer technique, a core, often made of clay, is covered with pieces of hemp cloth that have been saturated with lacquer. In a nearly lifesize work such as this example, seven or eight layers of lacquer-soaked cloth were added, each of which had to dry individually. Once the lacquer had dried, the core was removed, leaving a lightweight, hollow shell.[3] As can be seen here, the hands of hollow dry-lacquer sculptures were often produced separately. In addition, it is likely that the head of this sculpture was once covered with snail-shell-shaped curls made of a lacquer putty.

Historical and literary records indicate that the dry-lacquer technique was used in China as early as the Eastern Jin dynasty (317–420).[4] By the early fifth century, the use of dry lacquer had been linked to Buddhist imagery in a reference in a translation of the Lotus Sutra.[5] Very few examples of early Chinese dry-lacquer sculptures are known today.[6] However, the technique, soon after being introduced into Japan from China in the early eighth century, became the most widely used method of making sculptures there. It is reasonable to assume that it was also important in China during the Tang dynasty, a period known for its interest in costly and elegant goods.

TECHNICAL NOTES
There were at least two campaigns of painting. Both layers of paint on the flesh consist of a white ground with a pink surface, and the uppermost layer is gold leaf. The lips are red, and, as indicated above, the robe is multicolored. Traces of bright blue pigment remain around the hairline, indicating that the now-missing curls of hair were originally painted blue. For more details on the fabrication of the sculpture, see p. 39. Analyses of the pigments are discussed in appendix E.

PROVENANCE
Yamanaka and Company

PUBLICATIONS
Bosch Reitz 1920, p. 77; London 1935-36, pl. 62; Chow 1965, p. 320; Lerman 1969, p. 203; New York 1970-71, cat. no. 117; Hearn and Fong 1974, fig. 63; *Hai-wai Yi-chen* 1986, p. 91; Barnhart 1987, fig. 31; Shi and Ren 1988, fig. 77; Watt 1990, cat. no. 72; De Montebello 1994, fig. 39; Matusbara 1995, pl. 809; Slusser 1996, fig. 4; Sirén 1998, pl. 548

OPPOSITE: CAT. NO. 13

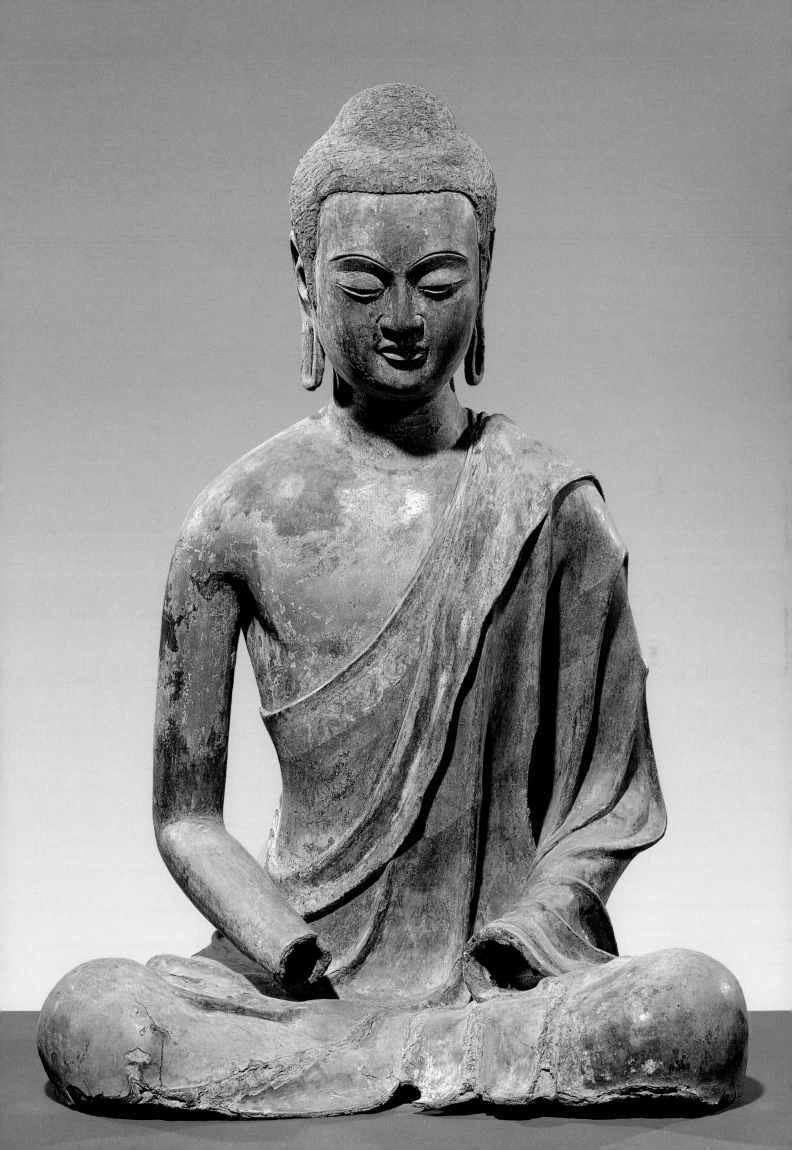

NOTES

1. Although scholars often speak of a "Pure Land tradition," it is an open question whether such practices actually existed as a distinct form of Buddhism in China or Japan. For an interesting discussion, see Sharf 2002.
2. It is likely that the top pigment layer is a restoration, and it is not possible to determine how closely the later painting may replicate the original color and patterns.
3. For a detailed discussion of this technique, see pp. 37, 39.
4. See Thote 2006. Lacquer was also used on the surface of carved wood sculptures.
5. See Pelliot 1923. For additional information, see Slusser 1996.

6. Several Chinese examples are published in Sirén 1925, vol. 2, pls. 547–53. Sirén cites the Dafo-si in Hebei Province as the provenance for the work illustrated in pl. 547, which is currently in the collection of the Walters Art Gallery, Baltimore. The similarities between the Baltimore and New York works have led some scholars to suggest that they may have come from the same site; however, there is no proof for this assertion. Moreover, the piece in Baltimore is now thought to date to an earlier period. For a study of the Walters example, see Strahan 1993.

14. Plaque with Buddhist Triad

Shaanxi Province, Tang dynasty (618–906), 7th century
Earthenware with traces of pigment and gilding
H. 5¼ in. (13.3 cm)
Rogers Fund, 1930
30.137

This small terracotta plaque shows a seated Buddha and two bodhisattvas, each standing on a lotus pedestal, before a pair of trees. The position of the Buddha's right hand—held in the earth-touching, or *bhumisparsha*, gesture—suggests that the figure represents the historical Buddha, Shakyamuni.[1] This gesture is often used to symbolize the moment in Shakyamuni's final lifetime when, challenged by the forces of evil, he touched the earth, asking it to bear witness to his right to achieve enlightenment. After the forces of the earth concurred, he finished his meditation and became a Buddha. The two bodhisattvas, who cannot be specifically identified, are almost mirror images. Each holds a vase in one hand and a wish-granting jewel, or *cintamani*, in the other, and each wears a necklace with a circular pendant. At the bottom of the plaque, two lions guard an unusual stand that supports several lotus buds, including one that sprouts the pedestal on which the Buddha is seated.

The design of this small clay tablet parallels that of other early Tang Buddhist images, such as the stone panels that once decorated the famed Terrace of Seven Treasures in the Baoqing-si (Baoqing temple) compound in the Tang capital at Chang'an (present-day Xi'an), which was constructed to mark the discovery of relics at that site in the year 677.[2] The Buddha's broad physique; the long, lean bodies of the bodhisattvas; and the sway of their hips also help to date the terracotta to the mid- to late seventh century.[3]

Pressing clay into molds is an ancient technology found throughout Asia, and the history of the technique's incorporation into Buddhist practice is unclear. Votive tablets made of molded clay are referred to in Indian ritual texts dating to the seventh century,[4] which suggests that such images became more important around that time, despite the fact that the earliest known surviving Indian examples date to the eleventh and twelfth centuries.[5] The early-Tang date for

the Museum's tablet is also suggested by the burgeoning use of such tablets in China,[6] Japan, and Thailand in the seventh century.[7]

The widespread manufacture of clay tiles in China is often attributed to the influence of the famous cleric Xuanzang (602–664), who returned in the mid-seventh century from his travels to India and other Buddhist centers. Some of the earliest examples were excavated in the late nineteenth century on the grounds of the Da Ci'en-si (Da Ci'en temple), where Xuanzang lived and worked from 648 to 658,[8] and many others have been found more recently at other sites in Xi'an.[9] Moreover, Xuanzang is known to have sponsored the construction of large numbers of Buddhist images, and, in at least one case, these images are described as having been made of clay.[10] However, other records indicate that "seals" (presumably molds for stamping clay) were introduced into China by Wang Xuance, a Chinese emissary to India, in about 660.[11] It is certainly possible that both the monk and the diplomat were just two among many who carried the idea of making clay tablets emblazoned with Buddhist imagery from South Asia back to the Tang capital.

Small clay icons such as the Museum's example are thought to have served many functions in Asia. Some were essentially souvenirs—mementos of visits to sacred sites—while others, particularly in China and Japan, may have decorated the exteriors or interiors of buildings or served as icons in small, portable shrines.[12] Evidence from Tibet suggests that small clay plaques were also used as consecratory items, placed inside larger sculptures or stupas. Both Tibetan and Thai examples have been found in caves.[13]

The inscription on the back, which reads *Da Tang shan ye ni ya de zhen ru miao se shen*,[14] suggests that the work may belong to a tradition of plaques containing at least some portion of ashes from a monk or advanced practitioner, or other

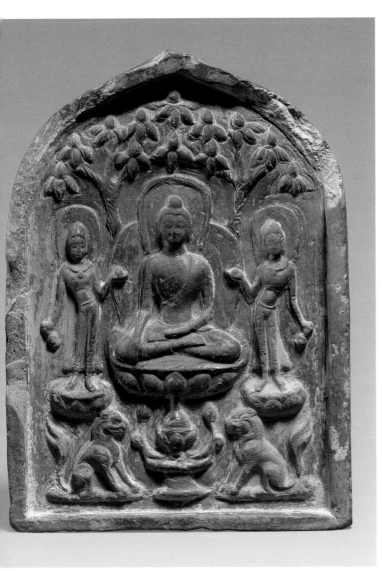

physical relic, mixed into the clay. As is often the case with classical Chinese, the reading of the inscription varies according to the presumed punctuation. In one interpretation, the third, fourth, and fifth characters, or *shan ye ni*, are read as a noun and understood to refer to the ashes of a cremated monk. In another, the third and fourth characters are read as one phrase that refers to the merit to be attained by pressing clay into molds, in which case the inscription can be roughly translated as "a pressed clay work was made during the great Tang as an act of merit and in order to obtain absolute reality and a reward body."

The tenth and eleventh characters in the inscription, *miao se*, are often used to translate the Sanskrit word *surupa*, a synonym for the "enjoyment body" or "reward body" (*sambhogakaya*). In Mahayana Buddhism, this is one of three forms taken by a Buddha; the other two are the "created body" (*nirmanakaya*), such as that of Siddhartha Gautama or any other Buddha who has lived a human life, and the "ultimate body" (*dharmakaya*) of a being who has transcended all phenomenal ties. The concept of the three bodies can be traced back to the fourth century in India, and it plays an important role in Chinese Buddhist writings from the sixth to the eighth

century. It is possible that such plaques, whether or not they incorporated actual ashes, were understood as relics that contained the essence or charisma of an individual who had achieved enlightenment, become a Buddha, and therefore acquired a transcendent form such as *sambhogakaya*.

TECHNICAL NOTES

The plaque is made of fine gray clay that was pressed into a two-part mold. The mold was probably made of clay or stone. Each mold section had the complete design carved into it prior to the taking of impressions; one section bore the figures that ended up on the front and the other the inscription that ended up on the back. The front was pressed into the mold twice before it was removed, causing double registration lines, which can be seen around many of the elements in the upper half of the design. The fingerprints of the maker are still present on the right side. Thermoluminescence analysis reveals that the tablet was last fired between nine and fifteen hundred years ago (thus, in 500–1100 C.E.), which is consistent with its style.

The plaque was fired at a low temperature and then, probably, painted. However, only traces of a white ground were found in the recesses. There is also a trace of gold leaf in the hair of the bodhisattva to the left of the Buddha. The remains of soil and encrustation are deposited in recesses over much of the surface.

PROVENANCE
Yamanaka and Company

PUBLICATIONS
Priest 1931a, fig. 2; Priest 1944, cat. no. 40; New York 1991b, cat. no. 28

NOTES

1. It should be noted that, in later Buddhist traditions, this gesture is used to identify Akshobhya, one the celestial Buddhas and an important deity in later Esoteric Buddhism.
2. For examples, see Matsubara 1995, vol. 3, pls. 656–63.
3. The radiocarbon date range for this plaque is cal A.D. 500–900.
4. See Newark 1999–2000, pl. 113.
5. For examples from South and Southeast Asia, see Dayton 1989–90, pls. 53–56, 66–67, 165.
6. It should be noted that the Metropolitan Museum holds one example of a plaque (possibly a brick) dated 526. See Priest 1931a.
7. For an overview of Japanese traditions, see Shirai 2006. For Thailand, see Chirapravati 1997.
8. See Huang 1937 and Chen Zhi 1959, pp. 49–51.
9. See New York 2007, pls. 59, 61–66.
10. See Hajime 2002, p. 90.
11. Daoshi's anthology, the *Fayuan zhulin* (法苑珠林), mentions the seals; see Takakusu and Watanabe 1914–32, no. 2122, p. 597b.
12. For a Tang-dynasty building covered with clay tiles, see *Anyang* 1983.
13. See Newark 1999–2000, pl. 113, and O'Connor 1974, p. 83.
14. 大唐善業埿壓得真如妙色身.

15. Stele with Bodhisattvas Avalokiteshvara (Guanyin 觀音菩薩) and Mahasthamaprapta (Dashizi 大試製菩薩)

Henan Province, Tang dynasty (618–906), mid- to late 7th century
Limestone with traces of pigment
H. 64½ in. (163.8 cm)
Rogers Fund, 1930
30.122

This extraordinary stele is wider than most such monuments and has a distinctive, and somewhat rare, iconography. Two nearly lifesize bodhisattvas fill the front of the stele, each standing on a floral pedestal that springs from flowing stems and each housed in an individual niche. The postures of the bodhisattvas are mirror images: the figure on the right stands with a slight sway toward the left and holds a vase in his lowered left hand and a book in his raised right; the figure on the left stands with a slight sway to the right and holds a vase in his lowered right hand and a spade-shaped implement in his raised left. This implement, which is often wielded by bodhisattvas and Daoist figures in China, remains unidentified, although the spade shape links it to the *zhuwei* used in ritualized conversations or debates in traditional Chinese culture.[1] Symbols definitively identify the two bodhisattvas: on the right is Avalokiteshvara, with a small seated Buddha in his headdress; on the left is Mahasthamaprapta, with a vase in his headdress. The latter, who represents wisdom in the pairing, is not found as an independent icon in Buddhist texts or visual art. Instead, he usually forms a triad with Avalokiteshvara and the Buddha Amitabha.

The grouping of these three divinities, which is based on references in sources such as the Sutra on the Buddha of Infinite Light,[2] is one of the principal icons of Pure Land Buddhism (Qingtu), and the representation of the two bodhisattvas without a Buddha can be traced to some of the earliest images produced in response to that tradition. As has been mentioned previously, a Pure Land is a Buddhist realm that is created and maintained by a Buddha or some other highly evolved being. Study of Pure Lands, which has a long history in China, became particularly important in the sixth century, when several renowned monk-scholars published discussions and classifications of the various realms and their respective residents. The Indian monk Bodhiruci, who was active at both the Northern Wei (386–534) and Northern Qi (550–77) courts, introduced Tanluan (488–532) to a text that praised Sukhavati, the Buddha Amitabha's Pure Land, also called the Western Paradise. This text and two others form the core of the Pure Land tradition.

Images reflecting the growing importance of Pure Land Buddhism, with its emphasis on rebirth in Sukhavati, first appeared in the visual arts in the sixth century, a period marked by warfare, drought, and other hardships and by the concomitant perception that it was not possible to achieve enlightenment while living in such a perilous time.[3] One of the more imaginative responses to the rise of Pure Land practice was found in the Northern Qi territories in the northeast, where altarpieces showing paired bodhisattvas, suggestive of such paradises, were produced in some number.[4] Some of the altarpieces show standing bodhisattvas, others seated bodhisattvas, and several are identified by inscription as representations of paired Avalokiteshvaras. An undated, and surprisingly large, example in the collection of the Museum für Ostasiatische Kunst, Cologne (fig. 72), illustrates the complex imagery found on many works of this type. The two standing bodhisattvas, who are once again mirror images, are attended by two lay devotees and two monks and protected by lions and guardians. The small Buddha seated on a pedestal above them, who may represent Amitabha, is attended by figures kneeling on clouds and a group of six *apsaras* holding

OPPOSITE: CAT. NO. 15, FRONT

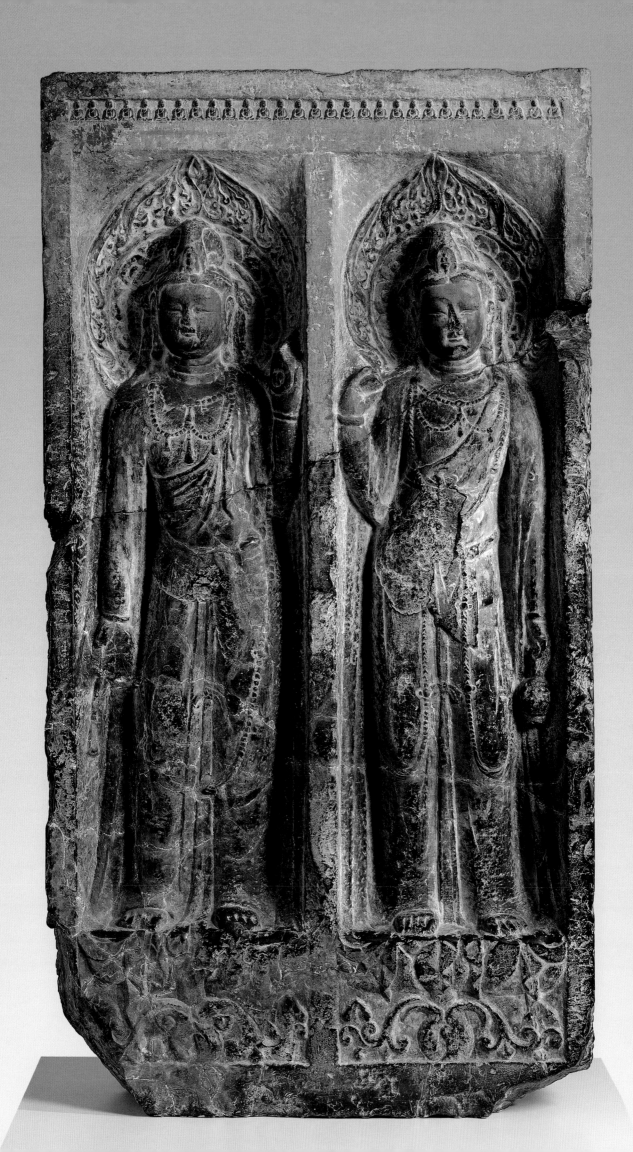

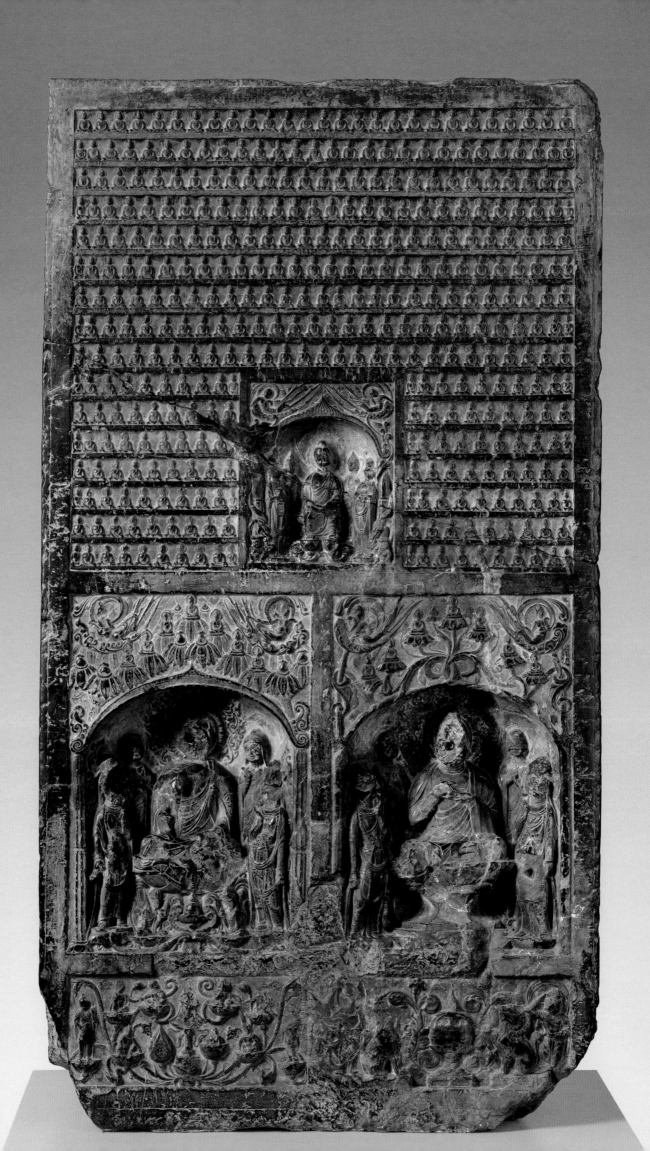

a garland. A reliquary stupa caps the top of the monument. On the back, a bodhisattva sits in the pensive pose (often associated with Maitreya in the Tushita heaven) beneath a pair of trees with a retinue of five kneeling figures holding lotuses.[5]

In several respects, the Cologne piece is a prototype for the imagery that would later become a critical aspect of Pure Land Buddhism; the stupa, in particular, may be read as an allusion to a soul that will be reborn in Sukhavati. By the eighth century, images of the Buddha Amitabha seated amid the splendors of Sukhavati, and of the Buddha and his entourage descending to earth to collect the souls of the faithful and bring them to Sukhavati, had become the dominant images in Pure Land Buddhism.

The three niches on the back of the Metropolitan's stele (see opposite), which are placed against a background of the Thousand Buddhas motif, can also be linked to the expansion of Pure Land iconography during the seventh and eighth centuries. Each niche holds a Buddha with an entourage, and each can be read as a representation of a Buddha seated in a Pure Land. The Buddha with the pendant legs in the smallest of the three niches is Maitreya in the Ketumati heaven, the Pure Land that will be created during his final birth, when he becomes the teaching Buddha of the next world era. Attended by two laypeople and two bodhisattvas, he sits beneath an ogival arch with columns encircled by dragons and supported, in turn, by caryatid figures.

The columns of the two other niches are plainer. The Buddha seated in the lower left niche is easily identified as Amitabha by the small figures seated and kneeling on buds underneath the niche. Such figures, which represent souls reborn in Sukhavati, are often shown in representations of the Buddha seated in that sacred realm. The Buddha-like figures seated on the buds of other flowers above the niche also have parallels in representations of Amitabha seated in Sukhavati.[6] Within the niche, Amitabha is attended by two bodhisattvas and two figures who appear to be monks. The figure on the right wears an unusual cap that falls to either side of the head and appears to be made of cloth. Worn by Chinese monks as early as the fifth century, such caps are often associated with famous clerics such as Baozhi (ca. 425–514) and Sengqie (617–710),[7] and it is likely that this figure was intended as a "portrait" of a cleric who was famous at the time the stele was carved. It is also worth noting that the Buddha Amitabha on the back is aligned with the bodhisattva Avalokiteshvara on the front, a possible reference to Amitabha's role as the head of Avalokiteshvara's spiritual lineage.

The Buddha seated in the niche at the lower right can be identified as Shakyamuni, the historical Buddha; the seven small Buddhas seated among the branches depicted above the niche are typically used to represent his predecessors in other, earlier eras. Shakyamuni is attended by two monks and two bodhisattvas, and the standard grouping of two guardians, two lions, and an incense burner decorates the area beneath the niche.

FIGURE 72. Stele with paired bodhisattvas. Northern Qi dynasty (550–77), ca. 560–70. Marble, H. 37¼ in. (94.5 cm). Museum für Ostasiatische Kunst, Cologne

TECHNICAL NOTES

The stele was carved in high relief from a single piece of dark gray, nearly black, limestone. An old diagonal break across the upper third has losses, but much of the original carving remains. Extensive wear on the lower protruding areas has produced a high black sheen in some places. Originally, the entire stele was brightly painted, and it was repainted multiple times. Most of the remaining pigment is found on the upper half of the sculpture and in the recesses of the numerous niches.

A yellow paint layer covers the entire sculpture, including the borders, and the haloes of the multitudes of Buddhas on the back. X-ray fluorescence analysis detected only iron, suggesting the use of yellow ocher, possibly applied as imitation gilding on top of red paint(s). Additional traces of green and red pigments are present on the larger figures and a few of the "thousand Buddhas," around the haloes as well as on the clothing. More information on the identified pigments is given in appendix E.

PROVENANCE

Jorg Trubner, Berlin; Edgar Worch, Paris

PUBLICATIONS

Eastman 1930, p. 33; Priest 1931a, pp. 14–18; Yasuhiro 1934, pl. III; Gu and Fan 1943, pl. 16; Priest 1944, cat. no. 33; Watt 1990, cat. no. 71; Matsubara 1995, pls. 665, 666; Cleveland and New York 1997–98, p. 26

NOTES

1. For a discussion of the *zhuwei*, see Liu Yang 2001. It should be noted that the *zhuwei* discussed in the article may have had short handles, while the object held by the bodhisattva is grasped in the center. For another interpretation, see Rowan 2001.
2. Sukhavativyuha Sutra (Wuliangshourulaihui jing 無量壽如來會經). Takakusu and Watanabe 1914–32, nos. 310, 360–64.
3. See Wong 1998–99.
4. Several examples were excavated at the Xiude-si (Xiude temple) and are illustrated in the excavation report; see Yang Boda 1960. For a more in-depth discussion of the relationship between these altarpieces and the rise of Pure Land practices, see Leidy 1990.
5. For an illustration, see Gabbert 1972, p. 275.
6. See Matsubara 1995, pls. 508a, 568.
7. For a portrait of Sengqie in the Museum's collection, see cat. no. 28.

16. Buddha Vairocana (Dari 大日佛)

Tang dynasty (618–906), early 8th century
Gilt arsenical leaded bronze; lost-wax cast
H. 7⅞ in. (20 cm)
Rogers Fund, 1943
43.24.3

The broad shoulders, indented waist, and powerful legs of this Buddha illustrate an important stylistic tradition found throughout East Asia in the eighth and ninth centuries. The hair is rendered as a series of loose spirals, and the Buddha wears, over two undergarments, a long rectangular shawl that covers his left shoulder and much of his torso. The stylizations of the folds of the garment are evident in the edges of the shawl, which hug the upper right arm in a manner that is physically impossible but is often depicted in Chinese sculpture. The Buddha has a somewhat square face that is accentuated by strongly arched eyebrows; prominent, almond-shaped eyes; a long, straight nose; and full lips.

The particular combination of body type and facial features points to Kashmir as the original source for this type of Buddha image, as a Kashmiri example now in the collection of the Los Angeles County Museum of Art (fig. 73), which also shares the New York work's thick, patterned drapery folds, makes clear. The Kashmir area played a long-lasting, important role in the transmission of Buddhist thought and artistic traditions to China. Many of the earliest monk-translators to reach China were Kashmiri, as was Tanyao, the superintendent of monks responsible for opening the cave temples at Yungang during the Northern Wei period (386–534). Strong ties existed between the Tang court at Chang'an (present-day Xi'an) and the Karkota dynasty of Kashmir, and diplomatic exchanges took place between Kashmir and China around 713 and in 722, 733, and 747. Kashmir supported China against Tibetan invaders in 722 and later helped defeat the Arabs at the Battle of Talas in 751. In addition, Kashmir was one of the stopping points on a series of new routes linking China with various Indian kingdoms and Buddhist centers that flourished in the seventh and eighth centuries.[1]

The Buddha in the Metropolitan holds his hands in a variant of the teaching gesture (*dharmachakra mudra*), in which the smallest finger of the left hand touches the thumb of the right. Frequently found in the art of Kashmir, the gesture is thought to identify the Buddha as Vairocana, the transcendent manifestation of the historical Buddha, Shakyamuni.[2] Vairocana is understood as the generative force of the cosmos, who both created and maintains the phenomenal world. Devotion to Vairocana, which arose in the fourth century and flourished from the sixth to the ninth, can be linked, in part, to texts and practices such as those introduced into the Chinese court by the monk-pilgrims Subhakarasimha (637–735), Vajrabodhi (669–741), and Amoghavajra (704–774). The earliest forms of these practices, which included the use of the cosmic diagrams known as mandalas as well as devotion

to new and powerful protective divinities, spread from China to Korea and Japan and, today, are best preserved in Japan.

An intriguing wheel-like device inside the base (see fig. 74) suggests that this exquisitely cast sculpture may once have been enclosed by four large lotus petals that opened and closed to reveal the icon within. Although no earlier examples are known, several Indian works of this type are preserved from the eleventh and twelfth centuries, and later examples from Tibet (see fig. 75) and China are also known. It is likely that the inner surfaces of the petals were covered with incised (or possibly cast) representations of small seated Buddhas intended to magnify the power and presence of the central Vairocana. Although no exact parallels are known from China, such seated Buddhas were incised on the petals that composed the pedestal for the now-destroyed Buddha Vairocana that was once the primary icon in the famed Tōdai-ji (Tōdai temple) complex in Nara, Japan, cast in 757.[3]

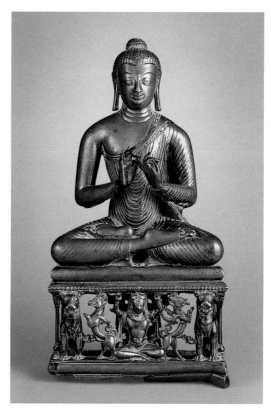

FIGURE 73. Buddha Vairocana. India (Kashmir region), ca. 725–50. Gilt brass inlaid with silver, H. 16 in. (40.6 cm). Los Angeles County Museum of Art, From the Nasli and Alice Heeramaneck Collection, Museum Associates Purchase

OPPOSITE: CAT. NO. 16

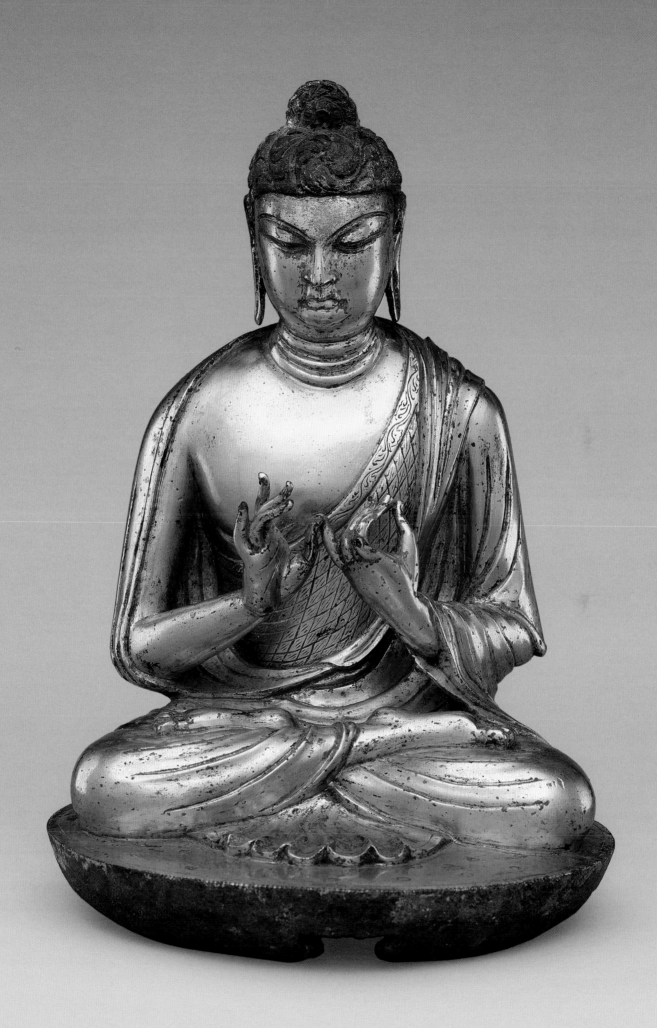

FIGURE 74. Base of sculpture (cat. no. 16)

FIGURE 75. Lotus Mandala of Amitayus. Central Tibet, 14th–15th century. Bronze, H. 10 in. (25.4 cm). Rubin Museum of Art, New York

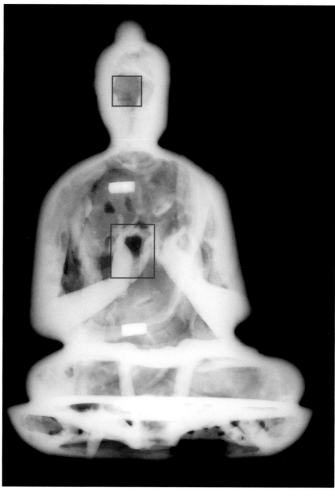

FIGURE 76. Radiograph showing thinness of chamber covers (cat. no. 16)

TECHNICAL NOTES

The Buddha was cast in one piece by the lost-wax method in an arsenical leaded bronze. The bottom is open, with an elaborate runner system consisting of six spokes that run from a central ring to the outer edge. The four rectangular holes just below the rim of the base originally held separately fabricated lotus petals, and the entire ensemble would have been placed on a post supported through the central ring. The inward slope of the base would have allowed the lotus petals to open and close around the Buddha.

The core pins used to hold the core in place during casting are, characteristically, thin and triangular. Both the head and torso are hollow, with the remains of a short armature rod running between them. Separate and unconnected, the two hollow compartments were most likely used as consecratory chambers, and each has a thin metal cover, now corroded closed. The head chamber is not accessible. Radiographs reveal the thinness of the covers, and they can barely be distinguished when viewing the back of the sculpture (see fig. 76). Two tangs extend out the back, one at shoulder height and the other directly beneath it, at hip level. The tangs may have held a separately cast mandorla.

Except for the hair, the figure and the top of the base were completely mercury-amalgam gilded. Traces of an orange-red pigment, most likely red lead, were found in the lips. Traces of black pigment were found in the eyes, eyebrows, and hair.

PROVENANCE

Mrs. Christian R. Holmes; Tonying and Company, New York

PUBLICATIONS

Yasuhiro 1934, cat. no. 70; London 1935–36, pl. 59; Visser 1936, p. 34; Buffalo 1937, pl. 36; New York 1938, cat. no. 290; Priest 1945, p. 107; Bowlin and Farwell 1950, p. 9; Los Angeles 1957, cat. no. 70; Chow 1965, fig. 32; Lippe 1965c, p. 226; Fontein and Hempel 1968, cat. no. 111; La Plante 1968, fig. 84b; Lerman 1969, p. 298; Hearn and Fong 1974, fig. 65; Nara 1978, cat. no. 35; Pal 1978, cat. no. 96; Shi 1983, p. 1360; *Hai-wai Yi-chen* 1986, pl. 105; Tokyo 1987, p. 59; Leidy 1997, fig. 7; Howard et al. 2006, p. 312

NOTES

1. See Sen 2003, pp. 30–33.
2. In Buddhist art, only Shakyamuni and Vairocana use the preaching gesture. For the identification of the variant seen here with the Buddha Vairocana, see Snellgrove 1978, figs. 267, 268.
3. For an illustration, see Kobayashi 1975, pl. 27, fig. 35.

17. Head of Bodhisattva

Shanxi Province (Tianlongshan complex, cave 21), Tang dynasty (618–906), ca. 710
Sandstone with pigment
H. 15¾ in. (40 cm)
Gift of Abby Aldrich Rockefeller, 1942
42.25.12

The head seen on the following spread once belonged to an attendant bodhisattva carved into the back wall of cave 21 at Tianlongshan (see fig. 78), a complex of twenty-four cave shrines located about twenty-five miles (40 km) southwest of Taiyuan, in Shanxi Province. Tianlongshan was opened in the mid-sixth century, when Taiyuan served as a secondary capital for the Gao family, which controlled both the Eastern Wei (534–50) and Northern Qi (550–77) dynasties, and the complex was revived during the early eighth century. The story of the site and its reopening is recorded on a large stone stele erected in 706 by a certain General Xun and his wife, who visited the site at that time.[1] Xun, who may have been of Korean origin, was a vice commander in the Tianping Army and was stationed at Taiyuan. Although the stele indicates that he and his wife contributed money to the site, it is unclear whether the funds were used to open one of the Tang-period cave temples that are found there or for maintenance of some sort.

Cave 21 is one of the larger and more important sanctuaries at this small center. Although much of the site is now destroyed, early records suggest that it once measured about eight feet (2.5 m) square and was decorated on the back and side walls with assemblages of Buddhas attended by seated or standing bodhisattvas. The triad on the north wall (see fig. 79), which was placed on a small platform typical of Tang-period constructions at the site, consisted of a seated Buddha (fig. 77) attended by two seated bodhisattvas. All three images have large flame-shaped mandorlas and were once brightly painted. The Metropolitan's head belonged to

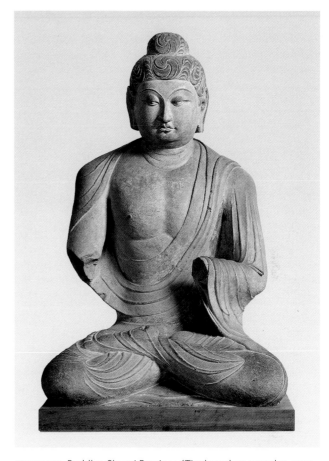

FIGURE 77. Buddha. Shanxi Province (Tianlongshan complex, cave 21), Tang dynasty (618–906), ca. 710. Sandstone with pigment, H. 43⅛ in. (109 cm). Harvard University Art Museums, Cambridge, Bequest of Grenville L. Winthrop

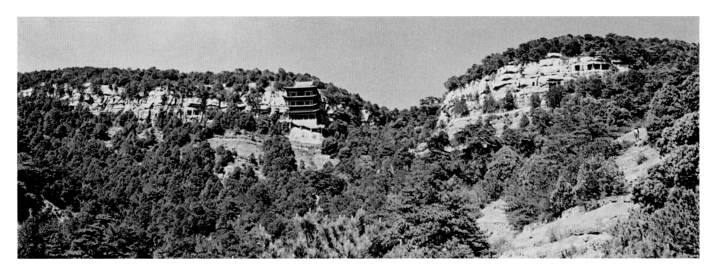

FIGURE 78. View of cave temples at Tianlongshan

99

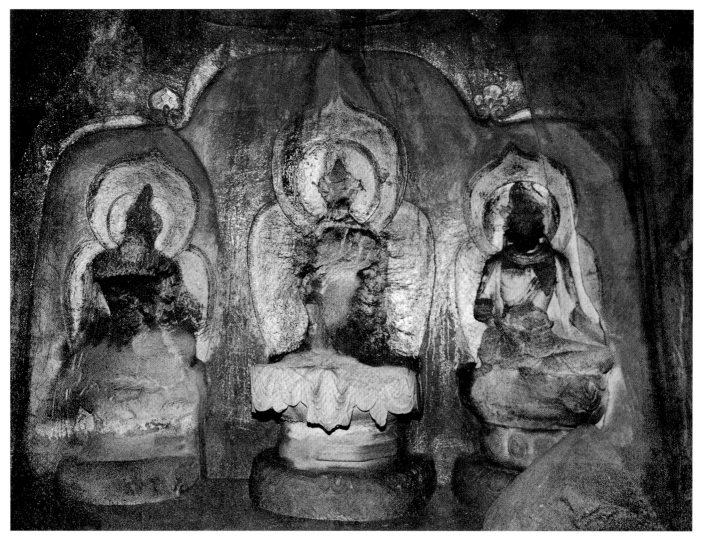

FIGURE 79. Archival photograph of north wall of cave 21 showing triad, with outline of body of cat. no. 17 at far left

the bodhisattva to the left of the Buddha, shown seated with one leg bent in front of the body; the other leg would have been pendant.[2] This posture, which is indicative of royal ease, became popular in Chinese Buddhist art after the early eighth century. The bodhisattva's broad face and cheekbones; long, upward-curving eyebrows; and full, pursed mouth typify the features of sculptures produced in the opening years of the eighth century. The hair is worn in a tall chignon; the narrow diadem ties with ribbons behind the ears; and the beaded strands of the necklace are subtly intertwined.

TECHNICAL NOTES

The delicately carved head retains much of its fine detail. A point chisel was used to incise the details in the hair. Other toolmarks were smoothed away or are obscured by the remaining pigment. The head was painted white at some point; it is unlikely that this was the original color, however, as the white pigment covers the broken edge of the earlobe. On the other hand, it does not cover the broken edge of the neck. The hair was painted reddish brown above the crown. Red pigment is also present in the lips and in the left earlobe depression. Green was found in the headdress. The white pigment was identified as lead white; the red contains iron and arsenic; and the green contains copper.[3]

PUBLICATIONS

New York 1940, cat. no. 10; Priest 1944, cat. no. 42; Chow 1965, fig. 34; Vanderstappen and Rhie 1965, fig. 74; Lerman 1969, p. 299; Hearn and Fong 1974, fig. 64; Rhie 1974–75, fig. 27; De Montebello 1983, fig. 30

NOTES

1. For a discussion and translation of the inscription, see Rhie 1974–75.
2. The torso of the bodhisattva was also removed from the cave and paired with another head. The resulting sculpture, which was once in the collection of the Nezu Museum, Tokyo, was sold at Christie's New York in March 2003. It is currently in a private collection in Hong Kong.
3. The analyses were performed quantitatively by George Wheeler, Research Chemist in the Museum's Department of Scientific Research, by energy dispersive and wavelength dispersive X-ray spectrometry in the scanning electron microscope (SEM-EDS/WDS). The March 5, 2003, report resides in the departmental files.

OPPOSITE: CAT. NO. 17

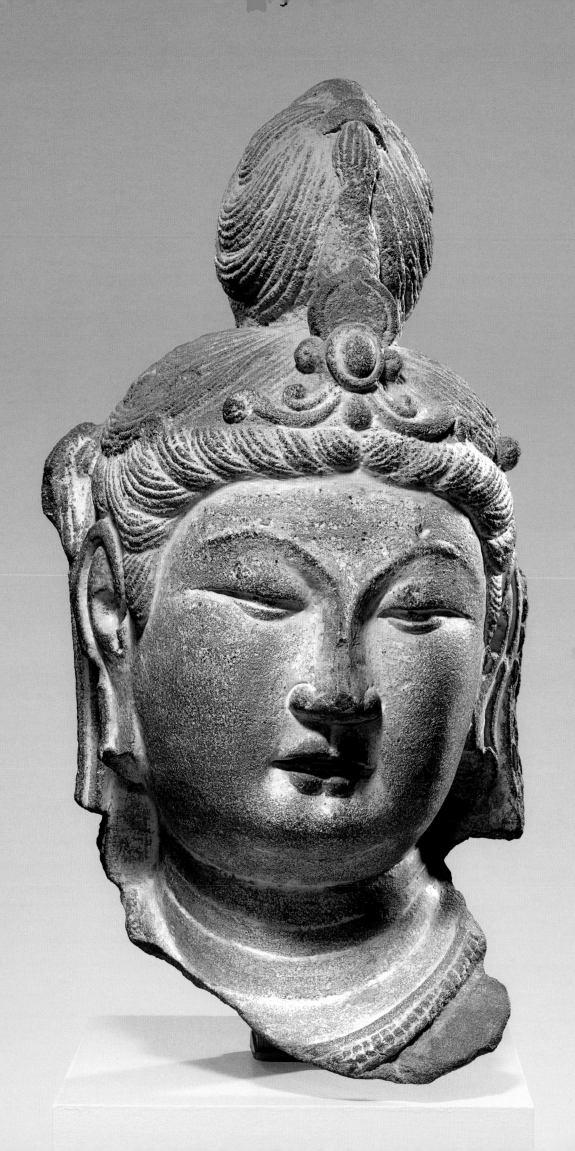

18. Monk, probably Ananda (Anantuo 阿難陀)

Tang dynasty (618–906), 8th century
Limestone with pigment
H. 69 in. (175.3 cm)
Gift of A. W. Bahr, in memory of his wife, Helen Marion Bahr, 1952
52.41

Representations of monks first appeared in Buddhist art in works produced in Gandhara (roughly, present-day Pakistan) during the rule of the Kushans, from the second to the early third century, where they are shown as subsidiary figures on the bases of Buddha and bodhisattva sculptures. Such small images played a supporting role in Chinese Buddhist art until the mid-sixth century, when monks, usually in pairs, became part of larger assemblages that included a Buddha and, in varying combinations, two bodhisattvas, two laypeople, and two guardians. Typically, one of the monks is depicted as youthful and the other as elderly, and they are often understood as representations of Ananda and Kashyapa, two of the more important disciples of the historical Buddha, Shakyamuni. The period from the sixth to the eighth century was marked by the creation of several distinctive branches of Buddhist practice, most of which can be traced to specific clerics. In addition, this period saw the rise of portraiture within Buddhism, largely in an attempt to preserve the charisma and wisdom of influential teachers. It is likely that the addition to standard Buddhist iconography of "portraits" of two of the most famous disciples of the historical Buddha was intended to extend their lineage into China.

The youthful Ananda is usually placed to the left of a Buddha and the more senior Kashyapa to the right. Ananda, who was also Shakyamuni's cousin, served as his personal attendant and was noted for his prodigious memory, for championing the rights of women, and for founding an order of nuns. Kashyapa achieved the status of arhat, an advanced form of discipleship; was renowned for his supernatural powers; and presided over the Council of Rajagrha, one of the first meetings of the Buddhist order after the death of the historical Buddha. This council, at which Kashyapa scolded Ananda for his support of nuns, established the behaviors and practices that helped Buddhism survive after the death of its founder.

This representation of a young monk, most likely Ananda, was presumably part of a larger group of images that included, at the very least, a Buddha and also, most likely, bodhisattvas and guardians. The monk stands in a frontal position and holds an unidentified object in his hands, which are clasped at the waist. This obscure object resembles a lotus bud but seems too large to be a flower. It may have been intended to represent an offering wrapped in red cloth.

The plump face and features and the style of clothing worn by the young monk date the work to the eighth century. The clothing is a Chinese transformation of the traditional Indian clerical garb (worn by images of the Buddha throughout Asia), consisting of a long saronglike lower garment, or robe, covered by a large rectangular shawl. The shawl could be worn over the left shoulder or over both shoulders. Here, the long robe is green with a brown edge, and the shawl, worn over the left shoulder, is green with red and brown patchwork. Patchwork is common in representations of clerical shawls and is intended to refer to the garments worn by the historical Buddha and his disciples, which were pieced together from remnants of discarded cloth. In the sixth century, Chinese monks began to wear an intermediate garment that crosses over the chest from left to right—shown here as green and red—between the lower robe and the clerical shawl. The sleeve of this second robe partially overlaps the clerical shawl, and the latter falls in a stylized pattern over the left arm in a rendering that is also characteristic of the eighth century.

FIGURE 80. Detail of back of sculpture (cat. no. 18) showing remnants of polychromy on patchwork robe

TECHNICAL NOTES

Over the centuries, the surface has been painted multiple times. The uppermost layer is highly elaborate, with individual patterns in each block of the patchwork robe. While much of the design has worn off, a well-preserved portion is shown above. It has not been determined when this uppermost paint layer was applied. Indeed, the study of the pigments is just beginning; thus, only a few results are reported in appendix E. The dark red on the robe under the left elbow is a mixture of vermilion and red lead. The dark blue on the drapery, on the back, is ultramarine or a related mineral such as sodalite. The bright green on the front of the robe is a mixture of copper trihydroxychlorides.[1] The white pigment on the face contains lead and calcium. Traces of gilding were found on the borders of the robe, and X-ray fluorescence analysis identified gold with a small amount of copper and lead.

NOTE

1. The pigments were analyzed by Tony Frantz, Research Scientist in the Museum's Department of Scientific Research, by X-ray microdiffraction. The August 8, 2008, report resides in the departmental files.

OPPOSITE: CAT. NO. 18

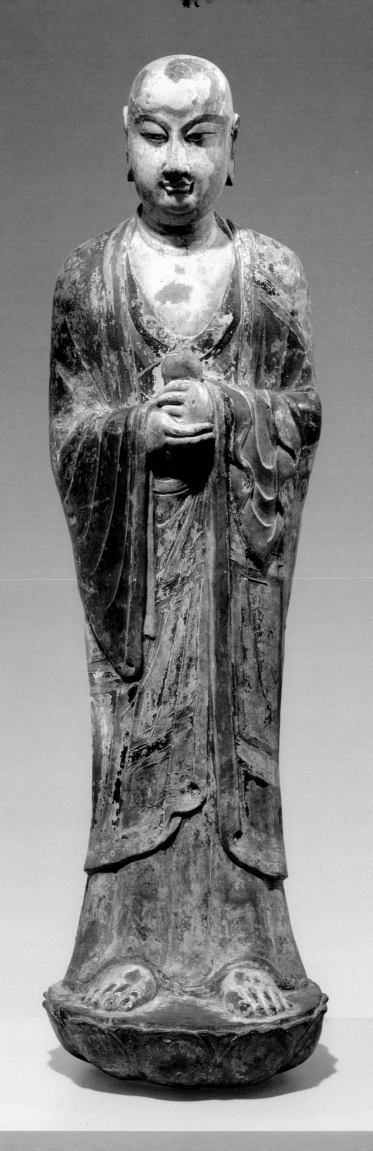

19. Bodhisattva Avalokiteshvara (Guanyin 觀音菩薩)

Tang dynasty (618–906), 8th century
Gilt leaded bronze
H. 9 in. (22.9 cm)
Gift of Abby Aldrich Rockefeller, 1942
42.25.27a, b

The posture, clothing, and adornments of this sculpture of Avalokiteshvara represent a seminal style in the depiction of bodhisattvas that emerged in the early eighth century and dominated Chinese imagery long thereafter. The bodhisattva stands with a slight sway toward his right. He wears a narrow scarf that falls over his left shoulder and wraps around his torso and a long skirtlike garment that is covered by a short girdle. The sway and the hint of musculature in the chest derive from Indian traditions that were reintroduced in the late seventh and early eighth centuries, when China, which had renewed its ties with various South Asian centers, was pivotal in the flourishing of diplomatic and economic relations among Persia, India, Central Asia, Korea, and Japan. The style of Chinese Buddhist imagery that evolved at the time, through the adaptation of various new prototypes, also made its way to Korea and Japan; accordingly, it has been termed the "International Tang" style.

Like the body and posture, the narrow scarf also has an association with South Asia: it most likely derived from the sacred thread worn by Buddhist and Hindu divinities beginning in the late fifth century. The small cape worn by the figure, on the other hand, is a Chinese invention of the late fifth century, often shown in works produced during the Tang period. The Chinese type of girdle seen here first appeared in the mid-sixth century. The bodhisattva's jewelry reflects an amalgamation of West, Central, and South Asian prototypes. The narrow diadem has a small rectangular cabochon in the center and two larger circlets at the sides and ties at the back with two long, wavy ribbons that fall along the sides of the body. There are also two short necklaces, a third necklace that hangs below the knees, and two bracelets. The shorter necklaces are composed of square elements that support large circular pendants, and similar pendants embellish the longer necklace. After the eighth century, this type of jeweled ensemble became very popular in both sculptures and paintings of Buddhist divinities.

The vessel resting on the right palm also illustrates the introduction into China of foreign traditions and the adaptation thereof in the late seventh and early eighth centuries. Popularly known as a "bird-headed ewer" (see fig. 81), this form, which derives from Persian metalwork of the Sasanian period (224–651), was reproduced in both metal and clay during the Tang dynasty.[1] The variant seen here is decorated with delicately chased circles that may have been intended to allude to the pearl roundels that were popular in the decoration of Tang ceramics and metalwork and that also derive from Persian imagery.

The standing Buddha depicted at the front of the diadem is Amitabha, the head of Avalokiteshvara's spiritual lineage, who is usually shown seated in this context. Here, the standing posture may be an indication of the importance of Pure Land Buddhism during the Tang dynasty. Icons associated with this tradition include representations of the Buddha Amitabha standing (with or without an entourage) as he descends to earth to bring the souls of the recently deceased devout back to the Western Paradise, Sukhavati, where they can be reborn and achieve enlightenment.

TECHNICAL NOTES

The sculpture was cast in leaded bronze in one piece by either the piece-mold or the lost-wax method. The flatness of the front and back, the lack of undercuts, and the shallow depth all favor piece-mold casting. The figure is solid, with no core material. Porosity in the metal at the left elbow and the right hand indicates that the sculpture was cast upside down. Circular toolmarks less than ⅛ inch (2.5 mm) in diameter delineate the lotus seeds on the side of the base. The same tool was used to produce the circular marks on the vase held in the right hand. After the surface details were chased in the face, hair, and clothing, the sculpture was mercury-amalgam gilded, and selected areas were painted. Today, traces of pigment remain only in the recesses. Originally, the hair was black, and all the bezels of the crown and necklaces were inlaid with red and green paste.

PUBLICATIONS

New York 1938, cat. no. 293; Priest 1944, cat. no. 31; Mizuno 1960, fig. 129; Pal 1978, cat. no. 94; Tokyo 1987, cat. no. 171; Matsubara 1995, pl. 698

NOTE

1. Sogdian examples of this shape are also known, and it can be traced to earlier traditions, including Iranian metalwork and Roman glass.

FIGURE 81. Bird-headed ewer with molded decoration. Tang dynasty (618–906), late 7th–8th century. Porcelain, H. 16½ in. (41.9 cm). Palace Museum, Beijing

OPPOSITE: CAT. NO. 19

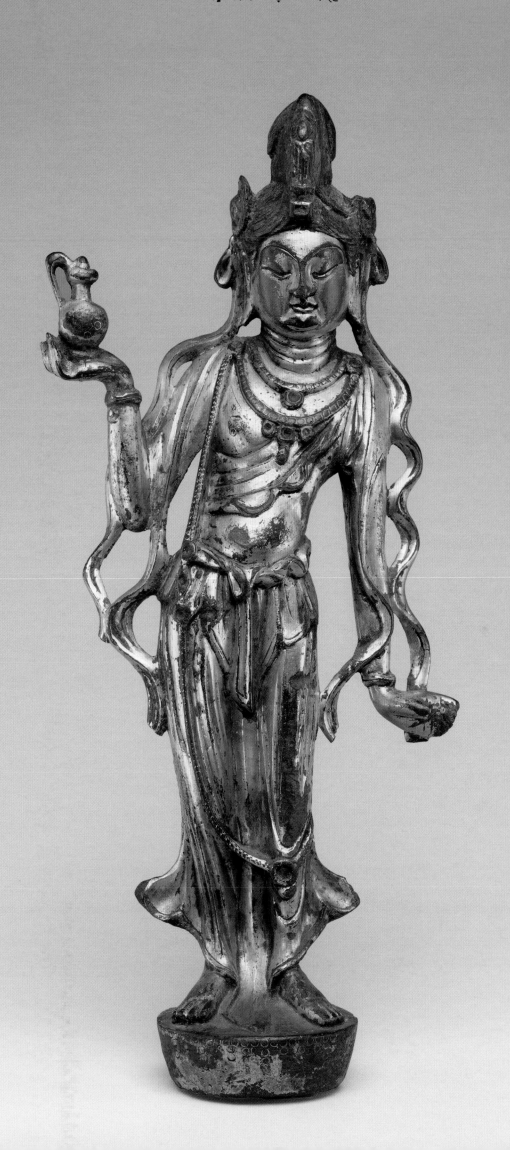

20. Bodhisattva

Tang dynasty (618–906) or Five Dynasties period (907–60), 9th–10th century
Wood (foxglove) with pigment; single-woodblock construction
H. 25¾ in. (65.4 cm)
Anonymous Gift, 1955
55.201

The bodhisattva stands in a frontal position, and the left hand (now missing) was once held in the gesture of reassurance. He wears a diadem, armlets, bracelets, and a cape that covers both shoulders. An unusual vestlike garment secured with a large buckle falls from the left shoulder and is tightened above the waist with a small sash. The long skirtlike undergarment is overlapped by two shorter girdles, and a large, dramatic sash that reaches from just below the waist to the toes is tied in a bow toward the middle of its length.

A belt composed of circular plaques at the front and square plaques at the back overlies both girdles and can be seen beneath the large sash in the frontal view. Belts made from metal plaques were known in China as early as the fourth century B.C.E., and they appeared again in Chinese art during periods of heightened foreign exchange or control of northern China by non–Han Chinese people, such as the Khitan Liao (907–1125) and the Jurchen Jin (1115–1234). The representation of such belts in Buddhist art is rare; this sculpture may be the earliest known example. Others include a seated bodhisattva Avalokiteshvara in the Museum's collection that can be dated to the Liao dynasty (cat. no. 24); two standing Jin-period bodhisattvas in the Royal Ontario Museum, Toronto, dated 1195; and a related work in the Nelson-Atkins Museum of Art, Kansas City.[1] It is also worth noting that the bodhisattva in New York and one of the two in Toronto are the only known works that depict a vestlike garment secured with a large buckle.

One of the pair in Toronto (fig. 20 on p. 19) can be identified as the bodhisattva Avalokiteshvara because of the small figure of the Buddha Amitabha in the headdress. The other (fig. 82), with a vase in the crown, is identified as the bodhisattva Mahasthamaprapta, who is usually shown, together with Avalokiteshvara, as an attendant to the Buddha Amitabha. If, as seems likely, the sculpture in the Metropolitan Museum was also part of a triad, then an identification as Mahasthamaprapta seems reasonable, and it is possible that the partially damaged element in the center of the diadem was once a vase similar to that found in the crown worn by the bodhisattva in Toronto. It should be noted, however, that the sculpture in Toronto has a raised right hand and a lowered left hand, which are appropriate for Mahasthamaprapta, who is usually shown to the right of the Buddha in a triad. The raised left and lowered right hands of the figure in the Metropolitan suggest that it would have stood to the left of the central Buddha, and it cannot, therefore, be conclusively identified as Mahasthamaprapta.

The sculpture, which was carved from foxglove, may be one of the earliest known examples of a Chinese Buddhist work made of wood, a material that became common after the tenth century. As is often the case in China, the sculpture was carved from a single block of wood rather than from multiple pieces, as is more typical in Japan.[2] Radiocarbon testing of the sculpture, which yielded a range of dates from 810 to 1010, indicates that it may also be one of the earliest examples of a type of sculpture that is usually dated to the Jurchen Jin dynasty, as are the works in Toronto and Kansas City mentioned above.[3] The dramatic sash worn by the bodhisattva in the Metropolitan and the later examples is the distinguishing characteristic of this style of sculpture. Sashes like this and, at times, belts with metal plaques are also worn by bodhisattvas depicted in paintings at sites that were commissioned by the Uygurs, such as Bezeklik,[4] near Turfan, and in cave 328 at Dunhuang (see fig. 83), thought to have been opened during a period of Tangut patronage.

A people from the northeast, the Uygurs ruled a powerful kingdom northeast of China until 840 and later established

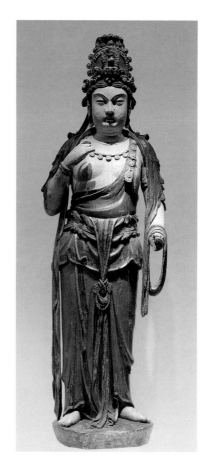

FIGURE 82. Bodhisattva Mahasthamaprapta (Dashizi). Shanxi Province, Jin dynasty (1115–1234), dated 1195. Wood with pigment, H. 72¾ in. (185 cm). Royal Ontario Museum, Toronto

OPPOSITE: CAT. NO. 20

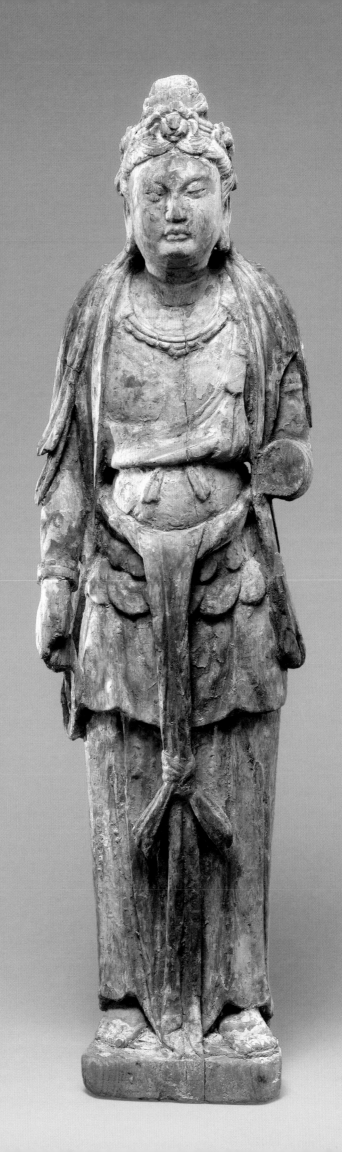

FIGURE 83. Two Bodhisattvas (detail of a mural). Gansu Province (Mogao complex, cave 328), Xixia kingdom (1038–1227), 12th century

TECHNICAL NOTES
The sculpture was carved from a single piece of foxglove and decorated with pigment and gilding over a white ground. Originally, the left forearm and hand were carved separately and attached, but they are now missing. Wood dowels were used to secure the headdress ornaments. Parts of the scarves, flowing down from the shoulders, are also attached with wood dowels.

The interpretation of the original polychromy is compromised by paint losses and overpaints. Overall, the wood appears to have been treated with a white clay ground, followed by colored paint. Despite the fact that the pigment is now more abundant on the front, evidence on the back of the figure suggests that the sculpture was originally painted in its entirety. Mineral pigments identified by X-ray fluorescence analysis, including lead white, yellow ocher, vermilion, and copper-based paint, were used extensively throughout the figure. Traces of gold on the foot and the hanging ribbon on the front suggest that the figure may have been selectively gilded at one time.

NOTES
1. See *Hai-wai Yi-chen* 1986, p. 170.
2. This point is discussed in great detail on pp. 35–38. At the moment, the author of this entry knows of only a few Chinese sculptures made from multiple blocks of wood. One is a guardian figure from a tomb in Turfan, which was carved from about thirty blocks of wood. For an illustration, see New York 2004–5, fig. 180. Another is a standing image of a Buddha dated 985 in the Seiryō-ji (Seiryō temple) in Kyoto, Japan, said to have been carved from thirty-four blocks of wood (the author is grateful to Birgitta Augustin for this information). For an illustration of the latter, see Nara 2009, fig. 23. A third example is an image of Avalokiteshvara in the Victoria and Albert Museum, London. See Larson and Kerr 1985.
3. There is also a stone sculpture of this type in the Museum's collection. See appendix B.
4. For an example from Bezeklik, see Durkin-Meisterernst 2004, colorpl. 39.

strongholds in the Turfan area and in Gansu Province. The Tanguts, a people with ties to Tibet, controlled the Xixia kingdom on China's northwestern frontier from 1038 to 1227. The links between the sculpture in the Metropolitan, the later Jin-dynasty pieces with similar clothing, and the paintings commissioned by the Uygurs and the Tanguts are intriguing and suggest that the appearance of such dramatic sashes in China may reflect strong connections with northeastern centers that were initiated in the ninth century and continued, and possibly intensified, under the Jurchen Jin.

21. Portable Shrine with Bodhisattva Avalokiteshvara (Guanyin 觀音菩薩)

Five Dynasties period (907–60), 10th century
Wood (juniper) with lacquer and gilding; single-woodblock construction
H. 8¾ in. (22.2 cm)
Gift of Abby Aldrich Rockefeller, 1941
42.25.29

This portable shrine once had a front cover or, more likely, two additional elements that closed together in the front. Four small holes on the right side and four on the left indicate that a tie of some sort was used to attach one or two other pieces to the portion of the work that remains. The back of the shrine is carved all over with lotus petals (see opposite), which may have also been found on the front cover and would have been intended to suggest that the bodhisattva was seated inside a lotus flower.

Although the tiny lotus flower on the headdress is unusual, the Buddha seated on it clearly identifies the larger divinity as the bodhisattva Avalokiteshvara. This identification is reinforced by the vase held in the palm of the left hand, a traditional attribute of the bodhisattva. Avalokiteshvara is

seated on a lotus pedestal that emerges from a stem with buds, and he is attended by two slim, elongated figures that appear to be devout laypeople and may have represented the owners of the shrine. The bodhisattva wears a high-waisted garment that is characteristic of the tenth century, a date that is reinforced by radiocarbon testing, which yielded a range of possible dates from 780 to 1000. The method of wearing the shawl so that it falls from the shoulders and over the lower arms also helps to date the sculpture to the tenth century.[1] The beads arranged into three strands at the neck are similar to, though slightly smaller than, the beads of the long chain that crosses at the waist and falls to the bottom of the lotus pedestal.

Avalokiteshvara and his adorants are situated beneath a craggy overhang that suggests either the interior of a grotto

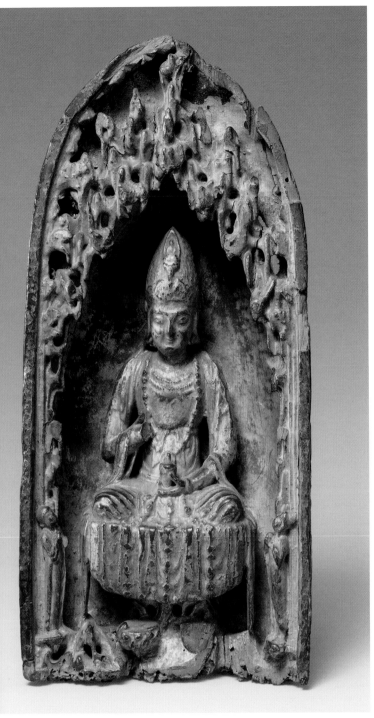

or a mountain setting. The understanding that mountains are the abodes of immortals and other spiritual beings has a long history in China and is recorded in the visual arts as early as the Han dynasty (206 B.C.E.–220 C.E.), when censers known as *boshanlu*, which depicted immortals, other beings, and wild animals in mythical mountain settings, were produced in some number.[2] By the late fourth century, this understanding had been incorporated into Chinese Buddhism, as can be seen in the life and work of the monk Huiyuan (333–417) and his disciples, who were based on remote Mount Lu in Jiangxi Province and whose practices promoted reclusiveness. By the Tang dynasty, practicing Buddhism in the mountains had become common, and certain centers, such as those on Mount Wutai, in Shanxi Province, had also become associated

with specific divinities, such as the bodhisattva Manjushri. These centers were also the focus of pilgrimages that were understood as acts of devotion and forms of spiritual practice.[3]

The growing importance of such remote cult centers is also reflected in the ethereal blue-and-green landscapes that were painted behind assemblages of divinities in some of the Tang-dynasty (618–906) caves at Dunhuang, in Gansu Province; similar backgrounds were used for a variety of narrative scenes.[4] The rocky setting for Avalokiteshvara in this shrine, however, appears consistent with a landscape style that was more common in the tenth and eleventh centuries; it is worth noting that very similar formations are found in some of the paintings in a renowned set showing arhats (*luohans*), dated to the Northern Song period (960–1127) and

now housed in the Seiryō-ji (Seiryō temple) complex in Japan (see fig. 84).

It is reasonable to assume that Avalokiteshvara, like Manjushri and other bodhisattvas, was believed to be immanent in remote, mountainous locations and may have appeared to pilgrims and other visitors from time to time. On the other hand, the grottolike setting may be an allusion to Potalaka, Avalokiteshvara's Pure Land, which was mentioned in the Gandavyuha chapter of the Flower Garland Sutra, popularized in a late-eighth-century translation. Images of Avalokiteshvara seated in his paradisiacal realm, which became popular in China after the tenth century, usually show him with one leg raised and the other pendant in the posture of royal ease. However, it is possible that this shrine represents one of the early phases of that imagery, prior to its codification in the eleventh and twelfth centuries.

TECHNICAL NOTES

Radiography reveals that the sculpture was carved from a single piece of juniper and that the figure's eyes were inlaid with spheres, possibly of metal. Four holes down each side, visible in the radiograph, help to confirm that two other sections were originally attached. There are two repaired locations along the right edge where hinges may have originally been located. At least two layers of lacquer and gilding are present.

PUBLICATIONS

Priest 1944, cat. no. 37; Shi 1983, fig. 1372; *Hai-wai Yi-chen* 1986, pl. 99

NOTES

1. For another illustration of this method of wearing the shawl, see cat. no. 22.

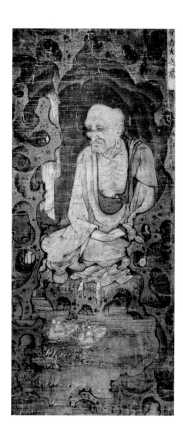

FIGURE 84. Arhat (*luohan*) (one of set of sixteen). Northern Song dynasty (960–1127), 10th–11th century. Hanging scroll; ink, color, and traces of gold on silk; 32⅜ × 14⅜ in. (82.1 × 36.4 cm). Seiryō-ji, Kyoto

2. See Erickson 1992.
3. For a good overview, see Birnbaum 1984. Birnbaum has also made some interesting suggestions regarding the rise of landscape painting in China and its relationship to Buddhist meditation traditions; see Birnbaum 1981.
4. See *Chūgoku Sekkutsu* 1980–82, vol. 4, pls. 75–76, 82.

22. Bodhisattva

Zhejiang Province, Wuyue kingdom (907–78)
High-leaded bronze; lost-wax cast
H. 11½ in. (29.2 cm)
Fletcher Fund, 1925
25.217.3

Excavations in the bases of pagodas and elsewhere in Zhejiang Province have yielded works showing Buddhas and other divinities seated on proportionally large, multifaceted lotus pedestals,[1] and it is likely that this sculpture of a bodhisattva ensconced on such a base was produced in that region. During the tenth century, Zhejiang was the center of the small but powerful Wuyue kingdom, one of several polities that controlled various parts of a divided China. The kingdom was ruled by members of the Qian family, noted for their devotion to Buddhism and their patronage of the arts as well as for important hydraulic projects.

The ovoid shape of the halo and its openwork decoration illustrate a style of adornment that was widespread in the ninth and tenth centuries, and the high-waisted gown worn by the bodhisattva is typical of sculptures produced in Zhejiang and elsewhere in the tenth century;[2] the large flowers and lively scrolls, however, are characteristic of works produced specifically in the Zhejiang region. The bodhisattva sits on a lush lotus pedestal composed of fifty-four narrow, convex petals that are individually attached to an interior structure. The pedestal rises from a censerlike platform with an openwork cover and six small legs; the platform rests, in turn, on a two-tiered, twelve-sided base that is set on yet another stand. The legs at the very bottom are presented as inverted leaves or foliage of some kind. It is unclear whether the censerlike portion of this complicated stand was functional or decorative.

It is also challenging to identify the bodhisattva. In addition to the high-waisted skirt, he wears a jacket (or jacketlike

OPPOSITE: CAT. NO. 22

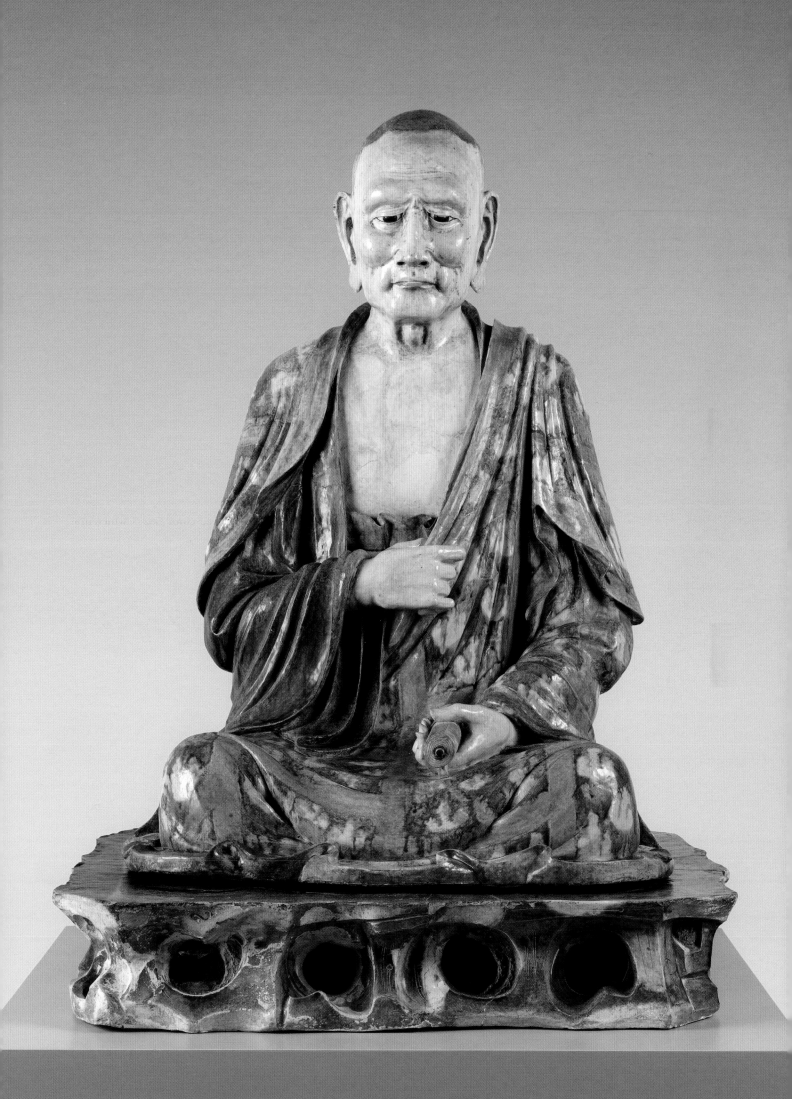

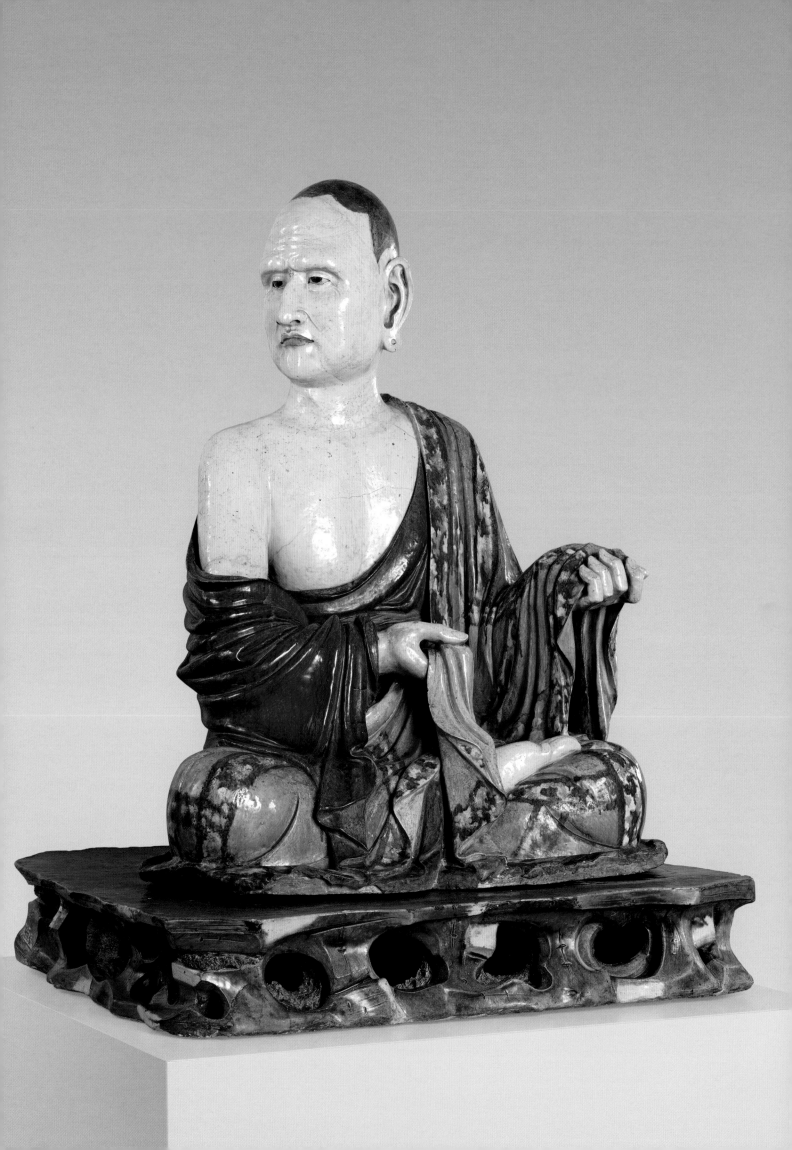

garment) with three-quarter-length sleeves, a narrow diadem, and a broad necklace and holds his right hand in the gesture of reassurance. A vessel, which may be covered or filled, rests in his left palm and, in its resemblance to the medicine bowl often held by Bhaishajyaguru (Yaoshi 藥師佛), the Buddha of Medicine, provides the only clue to the figure's identity. Bodhisattvas who embody the art and knowledge of medicine, such as Bhaishajyaraja, sometimes serve as attendants to Bhaishajyaguru and are mentioned in the Lotus Sutra and other early texts, where they are listed, along with better-known divinities, such as Avalokiteshvara and Manjushri, as intercessors for the faithful. Indian and Central Asian medicine played an important role in the introduction of Buddhism into China and of Chinese practices into Korea and Japan, and the Buddha of Medicine is often depicted in early Korean and Japanese art. It is possible that the Museum's work is a rare representation of a bodhisattva somehow associated with medical practices and a wish for good health. If this is the case, the sculpture may have been part of a group, possibly a triad that also included Bhaishajyaguru and an additional bodhisattva.

TECHNICAL NOTES

The fabrication method of this sculpture is unusual in comparison with that of other metal images in the catalogue.[3] Not only was it lost-wax cast in a very high-leaded bronze alloy, but it originally consisted of sixty-five separate pieces (eleven main pieces plus fifty-four lotus petals), all riveted together. The base, too, is made up of five separate pieces, riveted together. Atop the base is a separate collar ring that forms the stem of the lotus. A metal rod runs up the middle of the base sections and into the lotus, mechanically holding the entire sculpture together. The lotus is composed of a lower disk and an upper ring connected by four bands. The separately cast petals are each secured with an iron pin through a small hole in the lower disk. The petals were not meant to move. A separately cast, flat, removable lid with three semicircular feet serves as a cover for the lotus, and a separately cast bodhisattva sits on the lid. The vessel in the bodhisattva's left hand was also cast separately and is attached by a tang that penetrates the fingers.

The Buddha is hollow except for the arms, which are solid. The core runs up through the head. A hole in the top of the *ushnisha* is plugged with a metal pin. The Buddha is attached to the lid by a rivet through the front edge of the drapery and by a rectangular tang projecting down from the back edge of the drapery. The mandorla was once held in place with an iron nail that ran through the tang, mechanically joining it to the cover behind the Buddha. The nail has completely corroded and disappeared, but remains of iron corrosion surround the hole. The lotus may have originally held relics or ashes. Many petals are missing, thus exposing the interior, but nothing remains except, possibly, a small amount of unidentified residue imbedded in the corrosion.

The flesh of the face, arms, and feet is a denser green than the rest of the sculpture; perhaps it was originally a different color altogether, but no pigment or patina could be identified. Bright red vermilion was found on some of the petals by X-ray fluorescence analysis. There are remains of red lead in the recesses of the Buddha's robe and between the toes of his upturned feet. Traces of orange-red lead were also found in the recesses on the front of the mandorla.

PROVENANCE
Kuen, Shanghai

NOTES
1. Examples can be seen in Zhejiang Cultural Relics Bureau 2005 and Zhejiang Cultural Relics Work Team 1958.
2. For example, see the haloes adorning sculptures excavated from the base of the pagoda at the Famen-si; Shi and Han 1989, pl. 26.
3. The sculpture is nearly identical in size and construction to the Tang-dynasty seated Buddha in the Freer Gallery of Art, Smithsonian Institution, Washington, D.C. (F1912.92). That work's multiple separate parts are also riveted together, and the mandorla is identical and is attached in the same manner as this one. It does have some orange pigment (red lead?) in the center of the hair swirl, but no other pigment is apparent. Both the Freer Buddha and its similarly made attendant (F1912.93) are high-leaded bronzes.

23a. Arhat (*luohan* 羅漢)

Hebei Province, Liao dynasty (907–1125), ca. 1000
Glazed stoneware
H. 50 in. (127 cm)
Fletcher Fund, 1920
20.114

23b. Arhat (*luohan* 羅漢)

Hebei Province, Liao dynasty (907–1125), ca. 1000
Glazed stoneware
H. 41¼ in. (104.8 cm)
Frederick C. Hewitt Fund, 1921
21.76

The Sanskrit term *arhat*, which is rendered in Chinese as *luohan*, is one of the more multivalent designations in Buddhist writings. It was originally used to describe any individual, including the historical Buddha, Shakyamuni, and some of his famous disciples, who had reached an advanced but not perfected state of spiritual development. Over time, arhats came to be understood as the protectors of Buddhism who kept its practices alive between the time of Shakyamuni's death and the advent of Maitreya, the Buddha of the Future. In addition, in some texts, such as the Lotus Sutra, arhats are the equivalent of bodhisattvas and, like bodhisattvas, are thought to have achieved enlightenment.

Arhats do not appear in Indian Buddhist art or in related South and Southeast Asian traditions. They are important, however, in the art of China, Korea, Japan, and, to a lesser extent, Tibet.[1] The source for the theme is the *Record of the Abiding Dharma Spoken by the Great Arhat Nandimitra* (*Nandimitravadana*),[2] a text brought to China and translated by the famous monk-pilgrim Xuanzang (602–664). The text endows arhats with magical powers and describes

OPPOSITE: CAT. NO. 23A

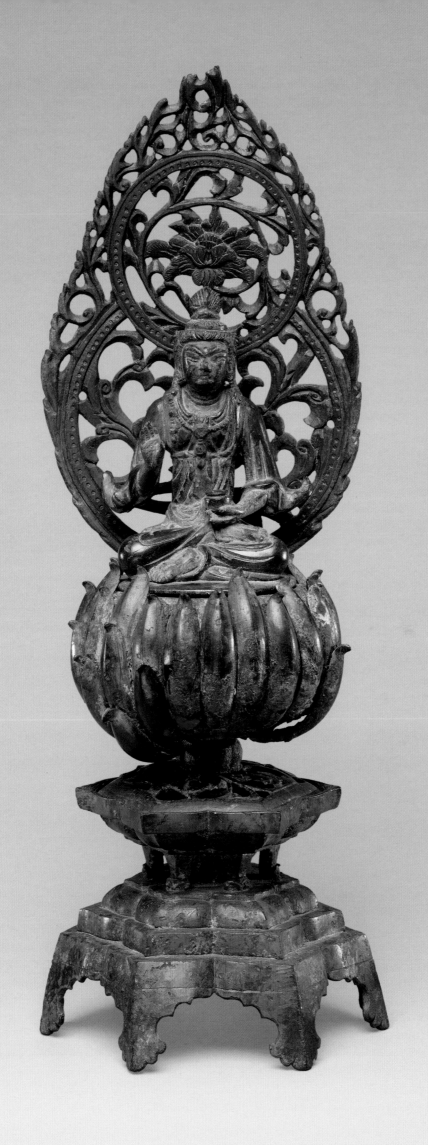

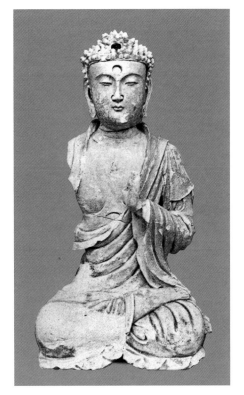

FIGURE 85. Buddha. Hebei Province, Liao dynasty (907–1125), mid-10th century. Glazed stoneware, H. 22½ in. (57 cm). Beijing Mentougou Museum

FIGURE 86. Bodhisattva. Hebei Province, Liao dynasty (907–1125), mid-10th century. Glazed stoneware, H. 21¾ in. (55 cm). Beijing Mentougou Museum

the otherworldly realms they inhabit. Paintings depicting arhats were produced in China as early as the ninth century, and arhats have played a dominant role in Chinese Buddhist imagery from the twelfth century to the present day. Images of groups of sixteen, eighteen, and one hundred are commonly found in monastery halls dedicated to these figures.

The two larger-than-lifesize ceramic examples in the Museum's collection are part of a group of presumably sixteen works that have been known in the West since 1913 and are said to have come from a cave in Yixian, in Hebei Province. The other eight that are known are in the collections of the University of Pennsylvania Museum of Archaeology and Anthropology, Philadelphia; Nelson-Atkins Museum of Art, Kansas City; Museum of Fine Arts, Boston; Royal Ontario Museum, Toronto; British Museum, London; Musée Guimet, Paris;[3] and State Hermitage Museum, Saint Petersburg.[4]

The Metropolitan's examples are typical of the group, which is justifiably acclaimed as a tour de force of ceramic sculpture. One of the figures (cat. no. 23b) is seated frontally and holds a scroll (probably a Buddhist text) in his left hand and clasps the edges of his monastic shawl with his right. His craggy features suggest that he is older than the other arhat, who gazes to his right and holds the edges of his shawl with both hands. Each is seated on a low, square dais with openwork on the sides that resembles a rocky or mountainous landscape— presumably a reference to the paradisiacal realms inhabited by the arhats. Both have high foreheads, green hair, and large, well-defined ears. The shawl of the older figure is green, with resist-dye patterns and amber-colored banding, while that of the younger is amber with patterned green bands.

The fact that the green, amber, and white coloring parallels the hues of the renowned three-color, or *sancai*, glazes of

the Tang dynasty (618–906) has led to continuing debate regarding the date and place of manufacture of this extraordinary group of sculptures. Three-color glazes, which first developed in the third quarter of the seventh century, were produced in centers in Shaanxi and Henan provinces and were used for architectural decorations, vessels, and spectacular tomb sculptures of camels, horses, guardians, musicians, and a host of other figures. Use of these expensive and time-consuming glazes (two firings are required) is often thought to have ended in the mid-eighth century, after the An Lushan rebellion severely challenged the economic and political stability of the Tang dynasty. There is no further evidence of the production of three-color glazes until the tenth century, when much of northern China was under the control of the Khitan Liao dynasty. The Khitan were a seminomadic people from north of the Great Wall who established a southern capital near Beijing in 938. They were strong patrons of the arts and are known to have moved artisans from one part of their territory to another and to have continued Tang-dynasty styles, particularly in ceramics and Buddhist sculpture. Unlike the Tang three-color wares, however, Liao ceramics, with the exception of the arhats under discussion, are exclusively vessels; as a result, some scholars have argued that the arhats from Yixian must date to the Tang period.

The 1983 discovery of a kiln producing three-color glaze pieces at Longquan, near Mentougou, in the suburbs of Beijing, provided invaluable information for dating the arhats with three-color glazes.[5] A half-lifesize sculpture of a Buddha and two half-lifesize bodhisattvas (see figs. 85, 86) were unearthed at the site. All three figures, which are shown seated, have long, thin torsos and thick clothing that resemble those of the arhats. In addition, the excavated pieces and the

Yixian arhats share overlarge ears with a distinctive piece of cartilage inside. It is also worth noting that the placement of the upturned foot of the younger arhat in the Museum's collection (cat. no. 23a) is similar to that of the Buddha from Longquan, while the folds of the clothing worn by the older-looking arhat (cat. no. 23b) parallel those of the garment worn by one of the two excavated bodhisattvas (see fig. 86).

It is not clear when the kiln was established at Longquan or whether the craftsmen working there were brought to Hebei from a different part of the Liao realm. Shards of the type of ceramics produced in this kiln have been found in a grave that can be dated to about 937. This discovery suggests that the kilns must have been in operation by the tenth century[6] and helps to date the three excavated Buddhist icons to that period. It is likely that the Yixian arhats were made slightly later, after the artists who made the half-size sculptures had developed a technique that allowed for the production of larger works. A date during the reign of Emperor Shengzong (982–1031), noted for his patronage of the arts and devotion to Buddhism, is likely.

TECHNICAL NOTES

Both of the larger-than-lifesize ceramic sculptures consist of a combination of mold-formed sections and slab-constructed parts, which were luted together and fired. Then, the figures were glazed with the *sancai* palette of colored oxides (green, white, and amber) over a transparent lead glaze. The openwork bases were created separately. Thermoluminescence analysis for cat. no. 23a estimated a date of last firing between six hundred and one thousand years ago, which is consistent with a Liao-dynasty date.

PROVENANCE (cat. no. 23a)
Friedrich Perzynski

PROVENANCE (cat. no. 23b)
C. T. Loo and Company, Paris

PUBLICATIONS (cat. no. 23a)
Bosch Reitz 1921b, p. 15; Glaser 1925, fig. 14; Priest 1944, cat. no. 73; New York 1970–71, cat. no. 137; Shi 1983, fig. 1598; Watt 1990, cat. no. 73; Sun 2003, p. 59; Howard et al. 2006, fig. 3.111

PUBLICATION (cat. no. 23b)
Bosch Reitz 1921b, p. 120; Salmony 1925, fig. 96; Sirén 1942b, pl. 11; Priest 1944, cat. no. 74; Fischer 1948, pl. 114; Chow 1965, fig. 30; Lerman 1969, p. 22; New York 1970–71, p. 165; Shi 1983, fig. 1597; Barnhart 1987, p. 82; Watt 1990, cat. no. 74; Gridley 1995–96, fig. 11; Sun 2003, p. 53; Howard et al. 2006, fig. 3.110

NOTES

1. Tibetan representations of arhats are an example of Chinese influence.
2. *Da Aluohan Nandimiduoluo suo shuo fazhuji* (大阿羅漢難提蜜多羅所説法住記). Takakusu and Watanabe 1914–32, no. 2030.
3. See Feugère et al. 2002.
4. The author of this entry is grateful to Maria Menschikova for showing her the sculpture in the Hermitage.
5. See Gridley 1995–96. Gridley's work has aided analysis of the date of the Metropolitan's sculptures.
6. See Tu 1978, p. 28.

24. Bodhisattva Avalokiteshvara in "Water-Moon" Form
(Shuiyue Guanyin 水月觀音菩薩)

Liao dynasty (907–1125), 11th century
Wood (willow) with traces of pigment; multiple-woodblock construction
H. 46½ in. (118.1 cm)
Fletcher Fund, 1928
28.56

Sculptures showing Avalokitesvhara seated with his right leg raised (or pendant) and his left crossed before his body represent the "water-moon" manifestation, one of the more prominent renderings of the bodhisattva in East Asia after the tenth century.[1] Representations of Avalokiteshvara in this posture are understood to depict him seated in his Pure Land, Potalaka, thought to be located somewhere in the Indian Ocean. In China, by the twelfth century, this mythical island had been mysteriously identified with Mount Putuo, an island off the coast of Zhejiang Province that was an important center for pilgrimage.

There are two prototypes for the posture adopted by the Water-Moon Avalokiteshvara. One is the relaxation pose often used for representations of Avalokiteshvara and other bodhisattvas in Indian and Sri Lankan art after the eighth century: these figures sit with one leg bent horizontally and the other pendant (or raised). The other prototype is a comparable pose used in China as early as the fifth century to depict immortals, sages, and retired scholar-gentlemen resting in an

OPPOSITE: CAT. NO. 24

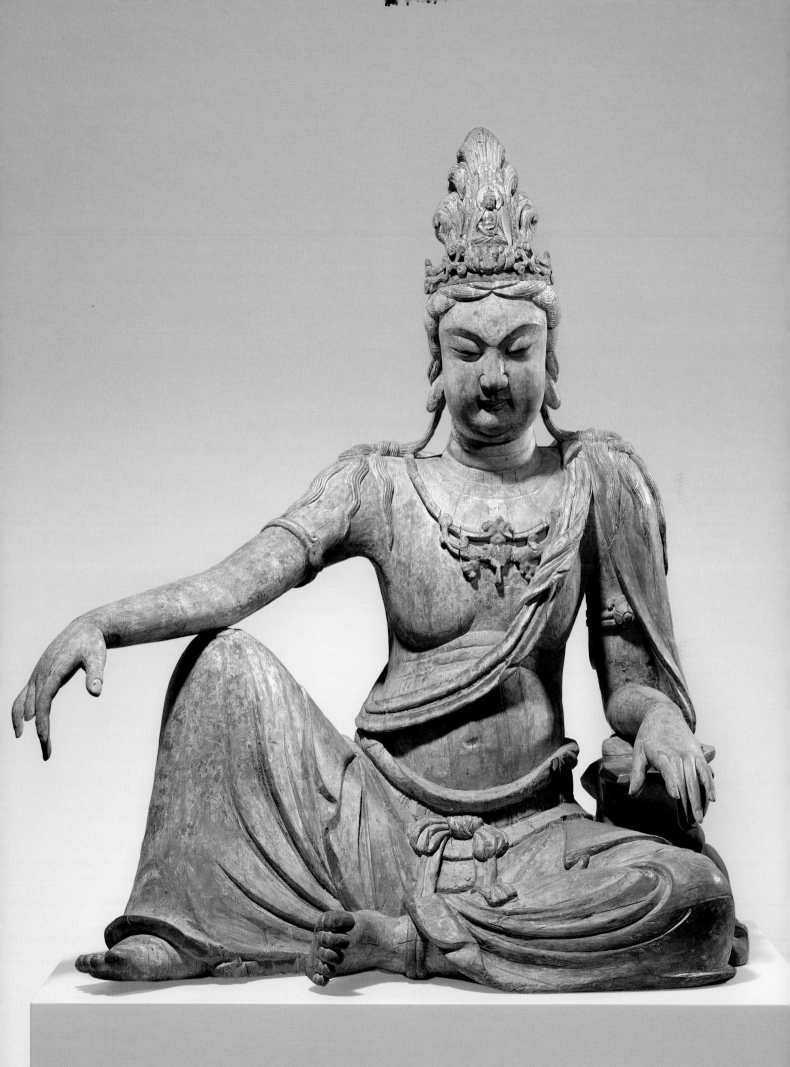

FIGURE 87. Bodhisattva Avalokiteshvara in "Water-Moon" Form. Gansu Province (Mogao complex), Tang dynasty (618–906) or Five Dynasties period (907–60), late 9th–10th century. Pigment on paper, 21 × 14⅝ in. (53.3 × 37.2 cm). Museé Guimet, Paris

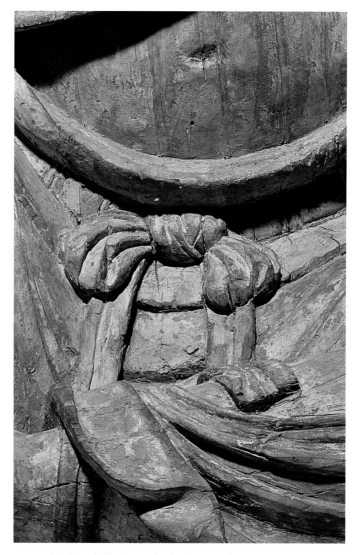

FIGURE 88. Detail of belt worn by bodhisattva (cat. no. 24)

idyllic landscape, sometimes with one arm encircling or resting on a raised knee.[2] The type of landscape, featuring bamboo and waterfalls, found in painted representations of the Water-Moon Avalokiteshvara also derives from the natural scenery and artistic and literary traditions of China.

The "water-moon" manifestation of the bodhisattva illustrates the complicated intersection of image, text, and practice that characterizes Chinese Buddhism after the tenth century. The textual source is the Gandavyuha chapter of the longer Flower Garland Sutra, which discusses the lushness and beauty of Potalaka when the young protagonist, the pilgrim Sudhana, visits it; particularly influential was the translation of this seminal text produced by the Indian monk Prajna in the late eighth century.[3] Historical records indicate that a Water-Moon Avalokiteshvara, encircled by a full moon and seated in a bamboo grove, was painted by Zhou Fang in the eighth century;[4] however, the earliest extant works showing the theme are from Dunhuang, in Gansu Province, including a tenth-century example that identifies the Water-Moon Avalokiteshvara by inscription and is now in the collection of the Musée Guimet, Paris (fig. 87). The work was

painted on paper and shows the bodhisattva seated in the characteristic pose, with one leg pendant and the other crossed in front of the body, on a large rock set in the midst of a swirling body of water filled with lotuses and aquatic birds. Lush bamboo and other plants fill the background.[5] It is possible that the Metropolitan's elegant sculpture was once placed before a painting or three-dimensional rendering of the rich and verdant landscape of Potalaka.

This representation of the Water-Moon Avalokiteshvara has the plump cheeks, small features, and pursed mouth often found on works produced during the Liao dynasty.[6] The bodhisattva wears a narrow diadem with a large central element that shows the Buddha seated on a lotus pedestal; a complex necklace that appears to have been based on a metal prototype; and two armlets. A narrow, twisted scarf falls diagonally from the left shoulder and across the chest. The bodhisattva also wears a long saronglike garment and an unusual belt that consists of square plaques and ties at the front (see fig. 88).

The sculpture is one of two in the Museum's collection that had a mirror embedded in its interior (see also cat.

no. 35). During the Warring States period (ca. 475–221 B.C.E.) and Han dynasty (206 B.C.E.–220 C.E.), mirrors played a complicated role in Chinese culture and were often placed in burials for protection and as symbols of auspiciousness.[7] Although there is less evidence for the funerary use of mirrors from the third to the eighth century, elegant examples, often inlaid with gold, silver, or mother-of-pearl, are known in some number from the Tang dynasty (618–906), suggesting, at the very least, that they were considered luxuries at that time. From the ninth to the fourteenth century, mirrors again appeared in burials and played an interesting, if not completely understood, role in religious imagery.[8] A mirror was placed in the center of the vaulted ceiling of the underground crypt at the ninth-century Famen-si (Famen temple),[9] and others are found in similar locations beneath pagodas dating from the tenth to the fourteenth century.[10] In addition, the Liao-period Baita pagoda in Inner Mongolia has thousands of small mirrors embedded in its exterior walls.[11]

It is tempting to link the appearance of mirrors in Buddhist art after the ninth century (if not earlier) to the work of such early Esoteric masters as Fazang (643–712), who often used them as a metaphor in his writings. The addition of mirrors to a Buddhist sculpture, such as this example, may have been intended to enhance its spiritual potency as well as to protect it. Moreover, it is possible that sculptures with mirrors in them were produced for use in specific, probably Esoteric, ceremonies.

TECHNICAL NOTES

Three large blocks of wood make up the main part of the figure, with smaller pieces added for the arms, hands, feet, and top of the hair. The head and torso make up the central block, and each leg is a separate block, attached on either side of the hips. All the pieces were held in place by loose tenons and dowels of various sizes (see fig. 89). Radiographs reveal the use of a multitude of nails, including old hand-wrought nails; large U-shaped staples; and modern nails with pointed tips. The nails and the condition of the wood indicate that the hands and three-quarters of each arm are replacements. Dowel holes in the headdress confirm that it was originally more elaborate. The radiocarbon date range for the central block is cal A.D. 1020–1210, which is consistent with a Liao-dynasty date.

Two separate consecratory chambers with covers are present in the head and the center of the back. The inner surface of the cover in the back has a circular depression 4¾ inches (12.1 cm) in diameter that once held a mirror. In the center of the circular depression is a deeper depression for a raised knob, indicating that the mirror faced inward, toward the front of the body.

X-ray fluorescence analysis detected iron, mercury, arsenic, and cobalt in differently colored areas. However, the existence of multiple painting campaigns precludes accurate interpretation and localization of pigments.

PROVENANCE
Yamanaka and Company

PUBLICATIONS
Priest 1928b, p. 157; Ōmura 1932, pl. 136; Priest 1944, cat. no. 66; Chow 1965, fig. 38; Shi 1983, fig. 1681; *Hai-wai Yi-chen* 1986, vol. 2, pl. 140; Shi 1988, pl. 74

NOTES

1. It should be noted that examples in painting as well as sculpture are known from China, Korea, and Japan.
2. For examples, see Dayton 1989–90, pls. 4, 6, 17, 33.
3. In addition to individual chapters of this long and complex text, which were known in China as early as the second century, two full Chinese translations are preserved, one by Buddhabhadra, written around 420, and a second one by Shiksananda, written around 699.
4. See Yü 2000, p. 235.
5. For an overview of works from Dunhuang exhibiting this iconography, see Wang Huimin 1987.
6. Scientific examination by Donna Strahan and Won Yee Ng has shown that the mountainlike rest at the right, as well as the portions of the arms noted above, is a recent replacement or addition. Moreover, at one point, the sculpture also had a rocklike base. See Ōmura 1932, pl. 136.
7. See Brashier 1995.
8. See Schulten 2005 and C. Ho 2005.
9. See Shi and Han 1989, fig. 58.
10. See Schulten 2005, p. 78.
11. See Qing 1998, pp. 67–68.

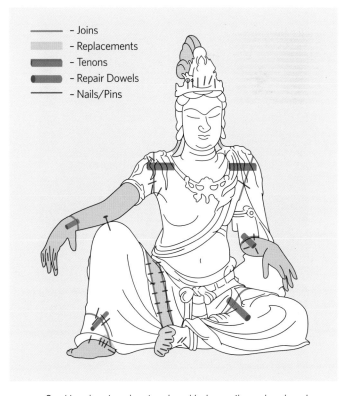

FIGURE 89. Line drawing showing dowel holes, nails, and replaced areas (cat. no. 24)

25. Manjushri, the Bodhisattva of Wisdom, with Five Knots of Hair
(Wuji Wenshu 五髻文殊菩薩)

Liao dynasty (907–1125), mid-11th century
Gilt arsenical tin bronze; lost-wax cast
H. 6¼ in. (15.9 cm)
Purchase, Mary Livingstone Griggs and Mary Griggs Burke Foundation, Janet Neff Charitable Trust and Christian Humann Gifts; Mrs. Robert Herndon Fife Gift, in memory of her husband; and Seymour Fund, 1967
67.228

The remnants of a sword hilt in the right hand and the position of the left, which suggests that it once held a book, identify this charming sculpture as a representation of Manjushri, the bodhisattva of wisdom, who is usually shown as a youthful figure. The five small knots that constitute the hairstyle, which reinforces the identification as Manjushri, allude to the five syllables in the Sanskrit invocation *a-ra-pa-ca-na*, which is used in devotions to the bodhisattva. Each syllable has precise properties, and repetition of the individual sounds can provide specific benefits. For example, one recitation of the initial *a* can help eliminate danger, while five of the final *na* can lead to ultimate awakening. There are three manifestations of Manjushri that can be identified based on the number of knots in the hair: one with eight knots, one with five, and one with a single knot.[1]

The sculpture is one of the earliest extant freestanding representations of this form of Manjushri,[2] which was popular in Japan from the twelfth to the fourteenth century and also known in India and the Himalayan region during the same period.[3] It is likely that this form of the bodhisattva was introduced into China in the eighth century as part of the complex of images and ideas brought there by the foreign monks Subhakarasimha (637–735), Vajrabodhi (669–741), and Amoghavajra (704–774), who were responsible for the introduction of early Esoteric practices into East Asia. Manjushri with Five Knots of Hair is shown in the Manjushri section of the Womb World Mandala, which is based on the Great Vairocana Sutra, as translated into Chinese by Subhakarasimha.[4] Devotion to Manjushri was furthered by the work of Amoghavajra, in particular, who stressed the bodhisattva's role as a protector of the nation and may also have chosen Manjushri as a personal guide.[5] Historical records indicate that, in 769, he lobbied to make Manjushri the focus of monastery dining halls, replacing another divinity, and later, in 772, he arranged for halls devoted to the bodhisattva of wisdom to be added to monasteries.

The bodhisattva wears a long skirtlike garment derived from Indian clothing; a narrow shawl that wraps around his left shoulder and torso; four bracelets; and two armlets. The slightly square face and plump features as well as the rendering of the ears are comparable to those in sculptures of attendant bodhisattvas in the Huayan-si (Huayan temple) in Shanxi Province (see fig. 90), which can be dated to about 1038 by an inscription found on one of the beams. Another parallel between the Metropolitan's bronze and works in the Huayan-si, which are made of wood, is seen in the armlets with ovoid pendants.

TECHNICAL NOTES

The figure was cast in one piece in arsenical tin bronze by the lost-wax method and mercury-amalgam gilded, with no visible pigments or inlays. The core, now missing, ran from the head through the torso and into the legs. A thin rectangular core pin, used to hold the core in place, is visible just above the belly in radiographs. The arms are solid. A rectangular consecratory chamber with a missing cover is located in the back. The opening was formed in the wax before casting. A thin rim, visible in the radiograph, helped to hold the original cover in place. Two small, square depressions above and below the opening have a rough surface, as though tangs or casting sprues were broken off. It is unclear what their function may have been. There is an intentional circular hole in the top of the head, but its original purpose is also unknown. The

FIGURE 90. Attendant Bodhisattva in the Huayan-si. Shanxi Province, Liao dynasty (907–1125)

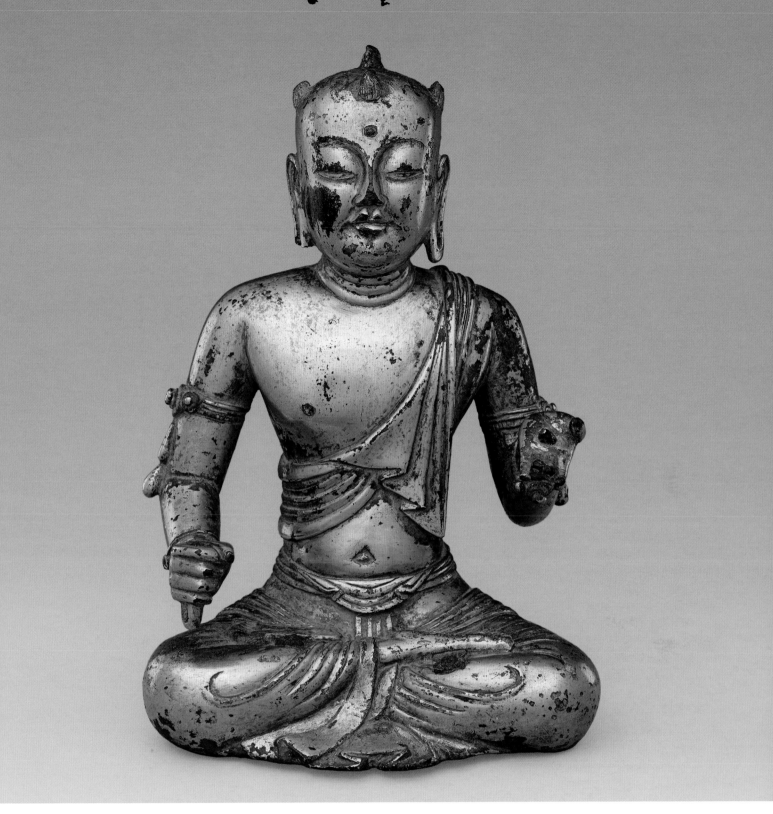

CAT. NO. 25

bottom is completely open. A hole in the left ear reveals that the sculpture once wore earrings (the right earlobe is missing).

PROVENANCE
Ellsworth and Goldie, New York

PUBLICATIONS
Birnbaum 1983, pl. 5; De Montebello 1984, pl. 41; Gridley 1993, pl. 146

NOTES
1. See Birnbaum 1983 for a discussion of Manjushri with Eight Knots of Hair and his importance in Japan. The monograph discusses two important Japanese paintings in the Museum's collection that exhibit this iconography.
2. Another Liao-period example is in the collection of the Nelson-Atkins Museum of Art, Kansas City. For an illustration, see Gridley 1993, pls. 14a, 14b.
3. For the Japanese material, see Guth 1979; for Indian and Himalayan examples, see Mallmann 1964, pp. 26-30.
4. See Snodgrass 1988, vol. 1, p. 380.
5. For a discussion of the relationship between Amoghavajra and the bodhisattva Manjushri, see Birnbaum 1983, pp. 25-38.

26. Buddha Vairocana (Dari 大日佛)

Liao dynasty (907–1125), 11th century
Gilt bronze; lost-wax cast
H. 8½ in. (21.5 cm)
Purchase, Lila Acheson Wallace Gift, 2006
2006.284

Known as the "wisdom fist," the distinctive hand gesture in which the right fist encloses the index finger of the left hand identifies this sculpture as a representation of Vairocana, one of the most important celestial Buddhas and a seminal divinity in early Esoteric traditions. The gesture is commonly used by Vairocana when he is depicted as the central (and generative) divinity of the Diamond World Mandala, and it is possible that the beautifully cast sculpture was once part of a three-dimensional rendering of the mandala.[1] The sculpture may also have been a stand-alone icon intended to symbolize the larger mandala.

The Diamond World Mandala is a guide to spiritual practice based on the Diamond Pinnacle Sutra, which was translated by the influential monk Amoghavajra (704–774).[2] Unlike in South and Southeast Asia, where the Diamond World Mandala tends to appear alone rather than as one of a pair, in East Asia, particularly Japan, the mandala is often coupled with another, known as the Womb World Mandala.[3] Based on the Great Vairocana Sutra,[4] translated by Subhakarasimha (637–735) at about the same time as Amoghavajra produced his text, the Womb World Mandala is thought to represent the possibility of achieving Buddhahood in the phenomenal world.

Here, the Buddha Vairocana is seated in a meditative posture on a lotus pedestal and wears an undergarment, a large shawl, a necklace, and a tall crown that is tied at the back with two long ribbons. The crown, which parallels examples worn by Liao rulers and aristocrats, is incised with stylized cloud motifs that are repeated in high relief at the edges (see fig. 91); other decorations include florets at the top and bottom and a small seated Buddha in the center. The sculpture is unusual because seated Buddhas are usually shown in the crowns not of Buddhas but of other divinities: the bodhisattva Avalokiteshvara, for instance, customarily carries an image of Amitabha in his headdress. It is unclear what meaning, if any, can be attributed to the small Buddha in Vairocana's crown. It seems reasonable, however, to suggest that the additional Buddha may have been intended to allude to the existence of many other enlightened beings in the cosmos.

The shape of the crown and its decoration are noticeably similar to those of the headdress of a seated image of the bodhisattva Avalokiteshvara in the Palace Museum, Beijing (see fig. 19 on p. 18), which also shares with the Metropolitan's work the plump Liao face and features and the patterned depiction of folds near the lower legs. Both can be dated to the eleventh century.

TECHNICAL NOTES

The thick, heavy sculpture was cast in one piece by the lost-wax method in a tin bronze with a minor amount of zinc and virtually no lead. The torso and head contained separate cores, both of which have been removed. At one time, the top of the crown was closed, but its cover is now missing. It is possible that the head contained consecratory material. There is no evidence that the base was ever closed. Remains of a small tang with a hole protrude from the back of the shoulders; the tang may have held a mandorla. The sculpture is mercury-amalgam gilded, with no visible evidence of inlays or pigments. However, there does appear to be a red glaze over the gold in some of the recesses that is not related to the corrosion products from burial found elsewhere on the sculpture.

PROVENANCE

A & J Speelman, Ltd., London

NOTES

1. There are no known examples of three-dimensional mandalas from China, and this suggestion remains speculative. Nonetheless, it is worth noting that groups of sculptures arranged in the Diamond World Mandala formation have been found at sites in Indonesia. For examples, see Dayton 1989–90, cat. no. 83.
2. Vajrasekhara Sutra (Jin gang ding yi qie rulai zhen shi she da zheng xian zheng da jiao wang jing 金剛頂一切如來真實攝大乘現證大教王經). Takakusu and Watanabe 1914–32, no. 865.
3. For the Japanese tradition, including paintings showing the Buddha Vairocana making the "wisdom fist" gesture, see ten Grotenhuis 1999, pp. 33–57.
4. This is an abbreviation for the longer title Mahavairocana Abhisambodhi Vikurvita Adhisthana Vaipulya Sutra (Da pi lu zhe na cheng fo shen bian jia chi jing 大毗盧遮那成佛神變加持經). Takakusu and Watanabe 1914–32, no. 848.

FIGURE 91. Detail of Buddha Vairocana's crown (cat. no. 26)

OPPOSITE: CAT. NO. 26

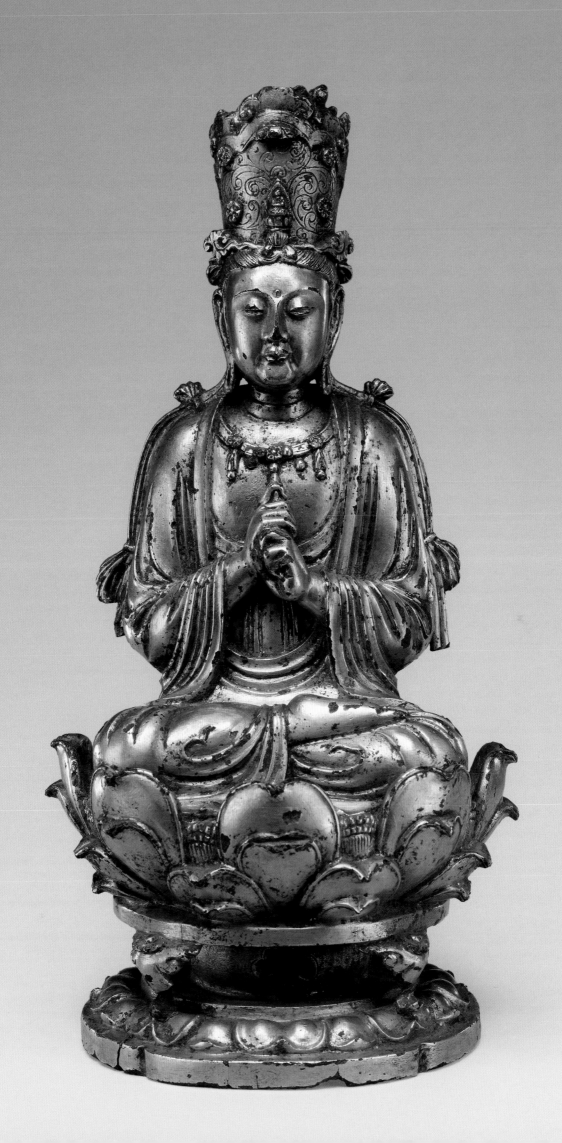

27. Bodhisattva Avalokiteshvara (Guanyin 觀音菩薩)

Possibly Northern Song dynasty (960–1127), late 10th–early 11th century
Wood (foxglove) with pigment and gilding; single-woodblock construction
H. 37 in. (94 cm)
Fletcher Fund, 1933
33.116

The high waist of the skirtlike garment worn by this bodhisattva and the overall simplicity of his garments are characteristic of works produced throughout China in the tenth and eleventh centuries. Avalokiteshvara wears a sash at the waist and the small cape with long ribbons that is found in Chinese sculpture beginning in the late fifth century. However, unlike in earlier images, where the ribbons cross in front of the chest, here they fall from the shoulders and over the forearms. The long, narrow scarf that crosses the chest diagonally derives from the art of the early eighth century, as does the heavy jewelry.[1]

The roundels that decorate the narrow diadem are similar in shape and proportion to those of the necklace and earrings, which, unusually for Chinese sculpture, match and appear to belong to a set. They consist of flowerlike elements inlaid with semiprecious stones. The carnelian or carnelian-like stone in the necklace is likely a replacement;[2] however, this particular stone, which is sometimes found among the consecratory deposits in sculptures, may have been the original inlay material. The proportions of the bodhisattva's body, particularly the broad shoulders, narrow waist, and long legs, derive from Chinese traditions that developed in the eighth century in response to a new awareness of the art of India. However, the density of the sculpture—seen, for example, in the plump arms and legs and the thickness of the coils of hair in the chignon—illustrates a tenth-century adaptation of the earlier style. This characteristic is also exhibited in the distance between the knees, which is less than is found in earlier works.

The radiocarbon dates for the sculpture, which range from 980 to 1140, suggest that it may be a rare example of a work that can be attributed to the Northern Song dynasty. Although historical records indicate that Buddhism was actively supported at the Northern Song court, there is surprisingly little extant sculpture or painting from the period. This work is made of foxglove, rather than willow, which was used for the contemporaneous Khitan Liao (907–1125) and Jurchen Jin (1115–1234) works in the collection; the different material suggests a different region of manufacture and possibly different patronage. Unfortunately, the lack of comparable material precludes a definitive attribution to the Northern Song. Nonetheless, it is possible that the sculpture was produced during that period in Henan or southern Shanxi, where there is some evidence that foxglove was used.[3] It is also worth noting that the heaviness in the lower part of the bodhisattva's face is a precursor to a similar quality in sculptures produced in the twelfth and thirteenth centuries under the rule of the Jurchen Jin, suggesting that regional styles may have continued in China despite political transi-

tions, possibly as a result of the existence of local workshops for the manufacture of sculptures.[4]

It is unusual to find a sculpture of the bodhisattva Avalokiteshvara seated in the meditative posture associated with the practice of yoga. This posture is usually reserved for representations of Buddhas, while Avalokiteshvara is shown either standing or seated in the posture of royal ease, with one leg bent horizontally and the other pendant (or raised). There are exceptions, however, as when Avalokiteshvara is included in a scene taking place in the Pure Land of the Buddha Amitabha, and it is possible that this sculpture was once part of such a larger composition. The use of a seated posture may also reflect the bodhisattva's growing importance in China during the tenth century and the concomitant understanding that his awareness and compassion equal those of the less accessible Buddha.

TECHNICAL NOTES

The bulk of the sculpture was carved from a single solid block of foxglove, which spans most of the height and breadth of the figure. The central block was not large enough for the entire design, however, so separate pieces of wood were added to the outside of the right arm and the tops of both knees and attached to the body with loose tenons. Radiographs of the attached pieces reveal a grain structure identical to that of the main block, indicating that they are also foxglove. The tips of all the fingers of the left hand, the right thumb, and the right middle finger are replacements. There are minor restorations in the headdress. The inset stones are replacements.

The current polychrome surface of the sculpture is a result of up to five discernible painting campaigns. The wood was originally coated with a whitish kaolin ground, followed by a single colored layer, both applied in a protein medium. The flesh was painted naturalistically with variable mixtures of vermilion and lead white. Subsequent overpaints included incoherent sequences of gilding and naturalistic renderings. The hair was originally painted blue with indigo, which survives in traces on the lower back of the head. Indigo blue was also used for the outer folds of the cape's ribbons as well as for the overskirt, tightened around the waist by the sash; in parts of the overskirt, the indigo was layered or mixed with lighter blue azurite (basic copper carbonate). The color of the overskirt was later changed to yellow and was gilded and repainted yellow twice, each time with the application of a new whitish ground. In the recesses of the folds, the red skirt preserves the original vermilion pigment. The cape was originally painted pale green or bluish green with a mixture of copper minerals consisting of atacamite (basic copper chloride) and copper oxalates; there are traces of azurite, from which the pigment was likely sourced.[5] The collar was repainted red, yellow, and red again, all with ocher pigments, and ultimately bright emerald green, with the nineteenth-century synthetic pigment copper aceto-arsenite. Appendix E offers a comparative discussion of polychromed wood sculptures and the scientific techniques used to analyze pigments.

OPPOSITE: CAT. NO. 27

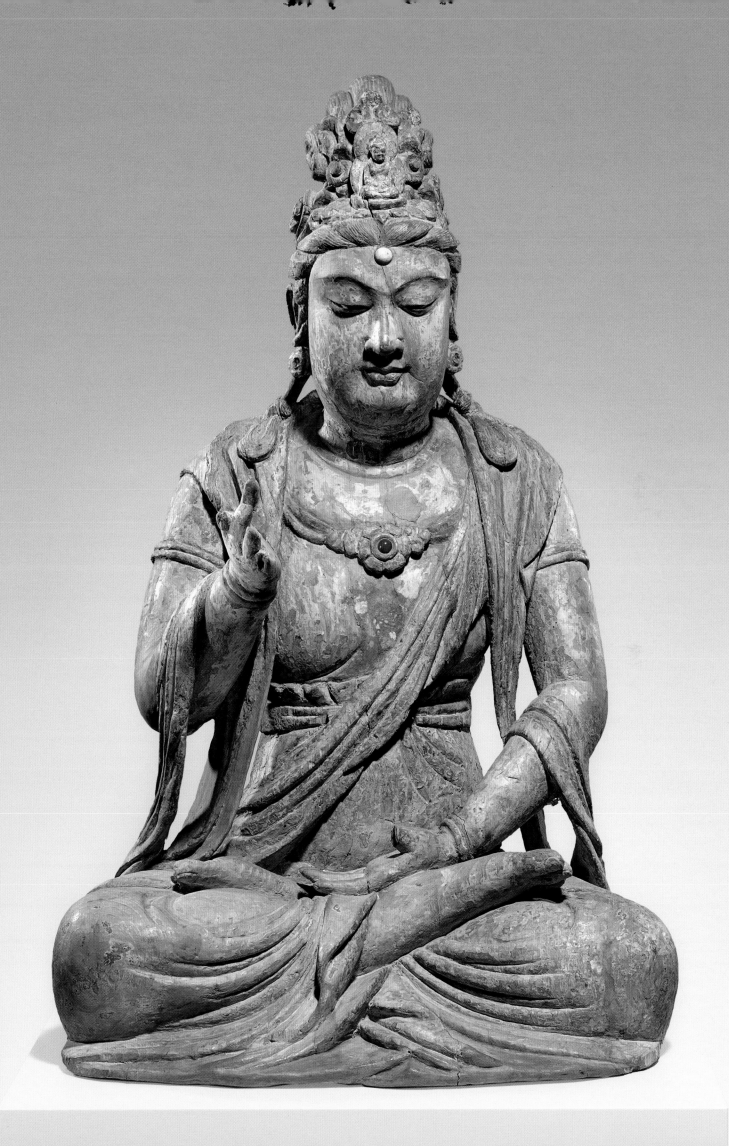

PROVENANCE
S. M. Franck and Co., Ltd., London

PUBLICATIONS
Priest 1934a, p. 29; Priest 1944, cat. no. 64; Shi 1983, fig. 1613; *Hai-wai Yi-chen* 1986, p. 137

NOTES
1. Similar jewelry is worn by several of the bodhisattvas and other attendants in a mural in cave 328 at Dunhuang. See *Chūgoku Sekkutsu* 1980–82, vol. 2, pl. 113.
2. The same may be true of the stone, likely quartz, used for the *urna*, or "third eye," in the center of the forehead.
3. There are several other pieces made of foxglove in the collection that have also been tentatively assigned to the Northern Song (see appendix A). For an earlier example, see cat. no. 20; the parallels to this piece, such as the two Jin-period sculptures in the Royal Ontario Museum, Toronto, have inscriptions that indicate that they were produced in southern Shanxi Province. If the piece in the Metropolitan was also made in that region, as seems likely, then it could be argued that foxglove was used in southern Shanxi, which could provide support for the Northern Song date of this piece. The only other example made of foxglove that the author of this entry can find is a famous piece in the collection of the Victoria and Albert Museum, London, which is also attributed to Shanxi by comparison with the Toronto works. See Larson and Kerr 1985.
4. There may be an interesting parallel to the painting workshops that existed in Shanxi and elsewhere; it seems reasonable to infer that similar groups were involved in the production of sculptures.
5. Copper oxalates have previously been reported in copper-containing blue and green paints and may derive from microbiological alteration of the paint layers. See Moffatt et al. 1985. Azurite can be found naturally associated with malachite (basic copper carbonate, which is green). Atacamite has been commonly found in green paint in Chinese artworks as early as the fourth century and is reported as a chemical alteration product of malachite and azurite. See Scott 2000, p. 47, and references within; Winter 2008, pp. 26–29, and references within.

28. Monk Sengqie (僧伽)

Northern Song dynasty (960–1127), late 11th–12th century
Limestone with pigment
H. 35 in. (88.9 cm)
Gift of Evangeline Zalstem-Zalessky, 1943
43.114

This compelling portrait of a famous monk named Sengqie (617–710), identified by comparison with several excavated pieces,[1] is a rare example of a stone rendering of a cleric. He sits on a pearl-bedecked lotus pedestal in a meditative posture behind an elaborate armrest. Divided into two sections, the armrest, a symbol of erudition, stands on three clawed feet that spring from the mouths of horned and fanged creatures and is scalloped along its lower edge. Sengqie has downcast eyes and wears formal monastic clothing, including an inner robe, visible only at the neckline, and an outer robe, tied at the waist. A sizable surplice covers the left shoulder and is tied with a careful knot; two medallions, one on the front and one, slightly smaller, on the back, retain remnants of green pigment. Traces of red found along the folds suggest that this garment may be of the type known as a red surplice, characterized by both its color and its large size.[2]

Sengqie's headdress has a full fold at the center and is tied precisely at the back. Monks have worn such cloth hats for funerals since the eleventh century, and instructions for their creation are included in *Essential Reading for Buddhists* (the *Shishi yaolan*), compiled in 1019 by the cleric Daocheng.[3] A variant of this headgear, known as Master Zhi's hat, is named for Baozhi (ca. 425–514), another divine monk who is said to have worn three such caps, one on top of the other, when summoned to an audience with Emperor Wu of the Southern Qi dynasty (479–502).[4] In that case, the hats were prophetic, foretelling the death of the emperor, his heir apparent, and another prince, all within the next two years. Caps of this type are standard elements in portraits of Baozhi, Sengqie, and another monk, Wanhui (632–711), who, by the Tang dynasty (618–906), were revered as a triad (see fig. 92). It is likely that the choice of headgear was intended to illustrate the close ties among the three monks.

Historical sources detail Sengqie's life and record his transformation from a monk into a personification of the eleven-headed form of Avalokiteshvara, the bodhisattva of compassion, and finally into a Buddha.[5] One of the earliest citations is an inscription written by Liyi (673–742) on a stele recording Sengqie's establishment of the Puguangwang-si (Puguangwang monastery) in present-day Sihong, Jiangsu Province.[6] According to this source, Sengqie, who was noted for his compassion and wonder-working abilities, came to China in 661 from Hegou, probably in ancient Sogdia (present-day Uzbekistan). After briefly residing at the Longtou-si in Shanyang, Shaanxi Province, Sengqie traveled with a companion to the Sizhou (a term for the area comprising northwestern Jiangsu and northeastern Anhui), where he established the monastery mentioned previously. Sengqie was summoned to the Tang capital during the reign of the Zhongzong emperor (684–710) and honored as a national preceptor. He died while seated in meditation, and, as an act of respect, the emperor served as one of the disciples who covered the corpse with lacquer-saturated cloth in order to preserve both the body and the divine charisma of the sacred monk.[7]

OPPOSITE: CAT. NO. 28

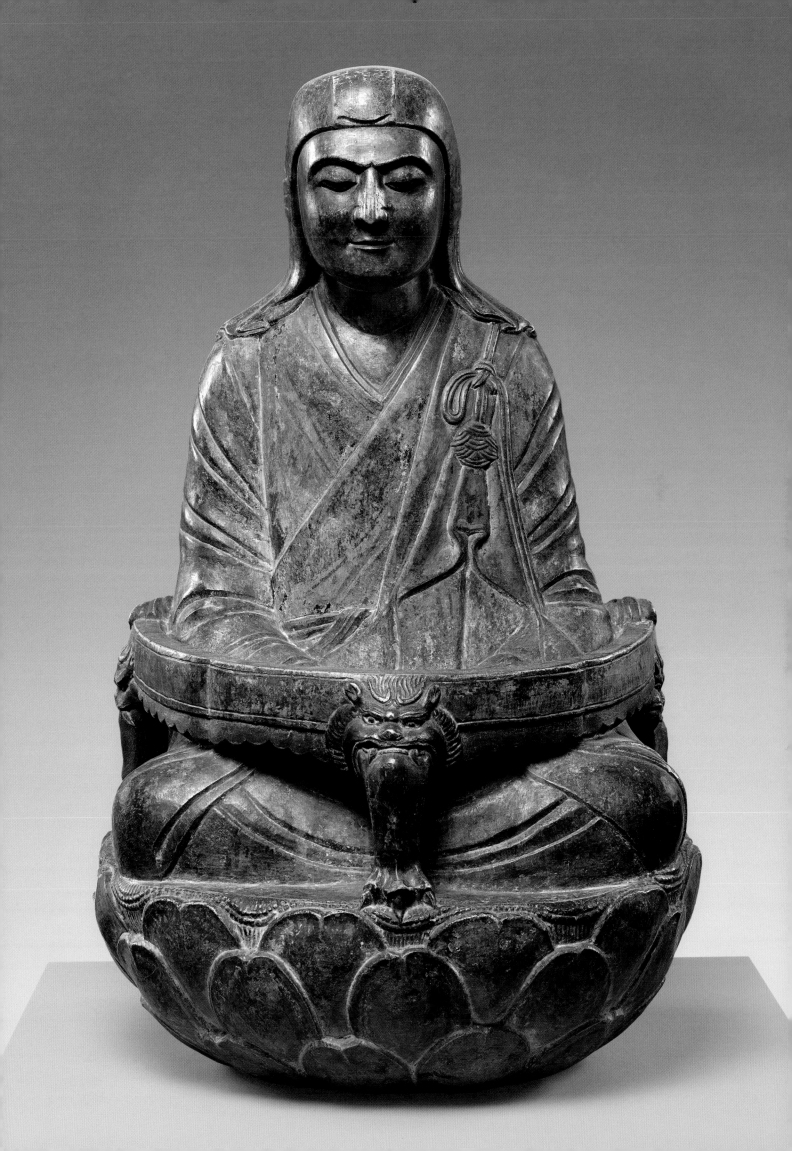

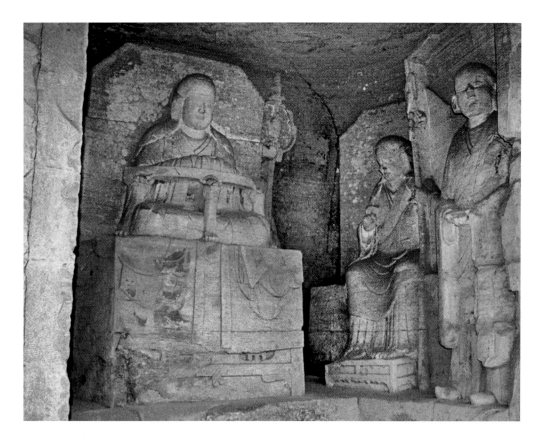

Two tenth-century sources, *Great Record of the Taiping Era* (*Taiping guangji*), edited by Li Fang (925–996), and *Biographies of Eminent Monks of the Song* (*Song gaoseng zhuan*), by the historian Zanning (919–1009), provide further details.[8] According to the former, the unusual name of the monastery founded by Sengqie derives from a golden statue inscribed *Puzhao Wang Fo*, or "Buddha That Illuminates All," that he unearthed at the future site of the establishment. *Great Record of the Taiping Era* also claims that Sengqie had a hole on the top of his head, which, when not plugged with cotton, emitted wonderful fragrances; and that the Zhongzong emperor intended to keep the monk's mummy in the temple where he had died, but the unpleasant smells permeating the city were interpreted as reflecting Sengqie's desire to return to the Sizhou. Thus, his body was sent there, and it became a focus of devotion and a catalyst for miracles. The other source, Zanning's text, specifies that Sengqie was a manifestation of the eleven-headed form of Avalokiteshvara and that he used a willow branch and a water vessel in the Indian *kundika* shape, both traditional attributes of the bodhisattva, to perform cures and miracles. By the early eleventh century, worship of Sengqie was widespread, and a hall dedicated to him was commonly found in temples, along with structures dedicated to Hariti, the "Mother of Demons," known in Chinese as Guizimu; and to Pindola Bharadvaja, the only arhat to give rise to an individual cult.[9]

The *Record of the Lineage of Buddhas and Patriarchs* (*Fozu tongji*), by the monk Zhiban (active 1258–69),[10] adds yet another element to Sengqie's hagiography, stressing his role as a controller of bodies of water and patron of the art of navigation. Similar information is found in the Sutra on the Six Perfections as Spoken by the Monk Sengqie before Entering Nirvana,[11] discovered in the Mogao caves at Dunhuang, in Gansu Province, and most likely dating to before the eleventh century: it describes the monk as a Buddha actively involved in the salvation of others, particularly during a great deluge in which all sentient beings are to be turned into aquatic creatures.[12] Japanese pilgrims such as Ennin (794–864), who traveled throughout China from 838 to 847, and Seijin, who visited in the late eleventh century, record the importance of Sengqie in Chinese Buddhism. Both mention seeing images of Sengqie in various parts of China, and a list dated 847 of material that Ennin brought back to Japan includes a reference to a portable altar containing images of Sengqie, Wanhui, and Baozhi.[13]

Several stylistic elements point to a date in the late eleventh or twelfth century for the Metropolitan's sculpture. The monk's broad, flat physique and slightly rounded shoulders are both found in a stone portrait of the monk from Luoyang, dated by inscription to 1092, as well as in a dry-lacquer sculpture of an arhat in the Honolulu Academy of Arts (fig. 93), dated 1099.[14] The depiction of the drapery as broad arcs, the stylization of the folds along the upper arms, and the attention paid to the knot of the surplice also point to a date in the late eleventh or early twelfth century. Limestone was commonly used as a sculptural medium in Henan Province, and it is likely that the portrait was produced either there or in a neighboring province where the same stone could be found. In the late eleventh to early twelfth century, this part of China was under the control of the native Northern Song dynasty, while regions farther north were ruled by the Khitan Liao (907–1125).

TECHNICAL NOTES
The sculpture was carved from a single block of gray limestone. Although the surface is worn and a dark coating hides the brilliant colors, much remains of an elaborate design that was painted over the smooth carved stone. It was common for sculptures to be repainted, and the date of this top paint layer is unknown. The robe was painted in a patchwork pattern, with an indistinct design contained within each block. A spiral pattern in copper green and red lead remains on the right thigh. The monk's eyes were painted white, with a black iris; the lips were red; and the pink flesh appears brown on account of the coating. The headdress was once red. The armrest was painted with red lead, with an indistinguishable multicolored pattern on the side band; the scalloped border is red. The lotus petals were painted white, with a thick copper-green band outlined on both sides in red lead. (An X-ray fluorescence survey contributed to the identification of the pigments.) An ongoing study has yet to conclude how many times the work was painted.

PUBLICATION
Leidy 2003

NOTES
1. See Xu Pingfang 1996. See also Wang-Toutain 1995.
2. See Mochizuki 1973–80, vol. 1, p. 13.
3. Takakusu and Watanabe 1914–32, vol. 54, no. 2217. A gloss of the pertinent passage is found in Mochizuki 1973–80, vol. 10, p. 4865.
4. See Berkowitz 1995, pp. 579–80, and Yü 2000, pp. 198–211.
5. A good English-language overview of this material is provided in Yü 2000, pp. 211–12. Sengqie (alternatively, Sengjia) is also known as Jielan.
6. The stele is published in Makita 1981–89, vol. 2, pp. 29–34. See also Chen 1997, n. 5.
7. This practice may have contributed to the development of portraiture of monks in East Asia. For further information, see Sharf 1992.
8. Part of the former is glossed in Xu Pingfang 1996, n. 9. The latter is preserved in Takakusu and Watanabe 1914–32, vol. 50, no. 2061, pp. 822a2–823b11.
9. See Strong 1979.

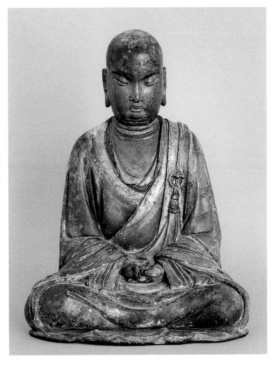

FIGURE 93. Monk or Arhat (*luohan*). Northern Song dynasty (960–1127), dated 1099. Dry lacquer with pigment and gilding, H. 17½ in. (44.5 cm). Honolulu Academy of Arts, Purchase, 1939

10. Takakusu and Watanabe 1914–32, vol. 49, no. 2035, pp. 417–23.
11. Sengqie Heshang yu ru niepan shou liu du jing (僧伽和尚浴入涅槃說六度經). Takakusu and Watanabe 1914–32, no. 2090.
12. This text is translated in Yü 2000, pp. 218–20.
13. Takakusu and Watanabe 1914–32, vol. 55, no. 2167, p. 1084c.
14. This sculpture has also been identified as a Chan priest. See Matsubara 1995, pl. 832, and related text.

29. Buddha, probably Shakyamuni (Shijiamouni 釋迦牟尼佛)

Jin dynasty (1115–1234), 12th century
Wood (willow) with pigment; single-woodblock construction
H. 25¼ in. (64.1 cm)
Rogers Fund, 1932
32.148

The positions of the arms indicate that the missing left and right hands were most likely held in gestures indicative of actions such as reassurance, teaching, or the granting of wishes and thus suggest that the sculpture seen on the following spread depicts the historical Buddha, Shakyamuni. It was likely once part of a larger group of images that included bodhisattvas and other divinities. A triad showing Shakyamuni with the bodhisattvas Avalokiteshvara and Samantabhadra was one of the most popular icons in painting and sculpture from the tenth to the fourteenth century. The relatively small size of the sculpture suggests that it was intended for a private setting rather than a large chamber in a monastery.

The sculpture, which was carved from willow and has a radiocarbon date range of 1040 to 1260, exemplifies the many problems inherent in attributing such works to centers in northern China. Analysis of works in the Metropolitan's collection suggests that willow was one of the most common materials used in the production of sculpture in the north from the tenth to the fourteenth century. This was a complicated period in Chinese history, however, when the native

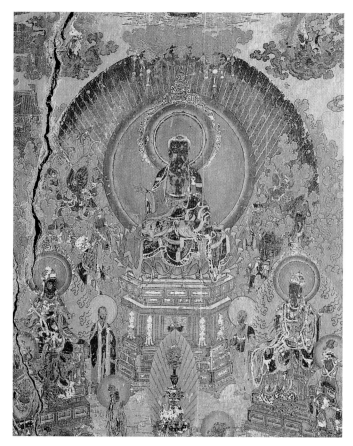

FIGURE 94. Buddha Shakyamuni Preaching to an Assembly (detail of a mural). Shanxi Province (Yanshan-si), Jin dynasty (1115–1234), ca. 1158

FIGURE 95. Radiograph of lap of Buddha (cat. no. 29), viewed from above, showing leg's attachment to torso

Northern Song (960–1127), the Khitan Liao (907–1125), and the Jurchen Jin, which sometimes controlled overlapping areas, all supported Buddhism and sponsored the production of religious sculptures.

Subtle features such as the relative simplicity of the clothing worn by the Buddha and the low waistline of the garment worn under the traditional monastic shawl suggest that the sculpture was made during the Jurchen Jin dynasty. The waistlines of sculptures produced under the Liao, such as those found in the Huayan-si (Huayan temple) in Datong, Shanxi Province, tend to be higher. In addition, the Buddha's face lacks the plumpness of Liao-period works, and the nose is larger and has broader nostrils than in works produced under the Liao.[1] Moreover, the relatively large *ushnisha* on top of the Buddha's head and the fleshy earlobes are strikingly similar to those found in a mural depicting a Buddha (fig. 94) at the Yanshan-si (Yanshan monastery) in Shanxi, which is dated to the Jin period; the mural was most likely painted around 1158.

TECHNICAL NOTES

The sculpture was constructed from two blocks of wood, one for the torso, including the head and arms, and another for the crossed legs. The latter are attached by loose tenons along the lap (see fig. 95). Both hands, now missing, were carved separately and attached with wood dowels. The figure is hollow from the head down to the legs, and the interior surface has rough toolmarks left by a curved chisel. The large chamber has two rectangular openings, one located in the back of the head and one in the middle of the back. Originally, both had covers, possibly to seal in consecratory deposits. The base is now open and lacks a cover.

The surviving paint consists, on average, of two protein-bound layers: a yellowish kaolin ground with occasional gypsum under a pinkish layer of similar composition, with the addition of red ocher particles. The transition between the two layers is not well defined, and the survival of gold leaf directly on top of the pink layer in parts of the flesh and the drapery, including on the back, suggests that the sculpture may originally have been completely gilded. The gilded areas are now obscured by dark accretions and the uneven presence of grayish overpaint. See appendix E for further information and comparative discussion.

PROVENANCE

Herbert J. Devine, New York

PUBLICATIONS

Priest 1933, p. 108; Priest 1944, cat. no. 63; Shi 1983, p. 1601; *Hai-wai Yi-chen* 1986, vol. 2, pl. 149

NOTE

1. For comparisons, see *Huayansi* 1980, esp. pls. 32–38.

OPPOSITE: CAT. NO. 29

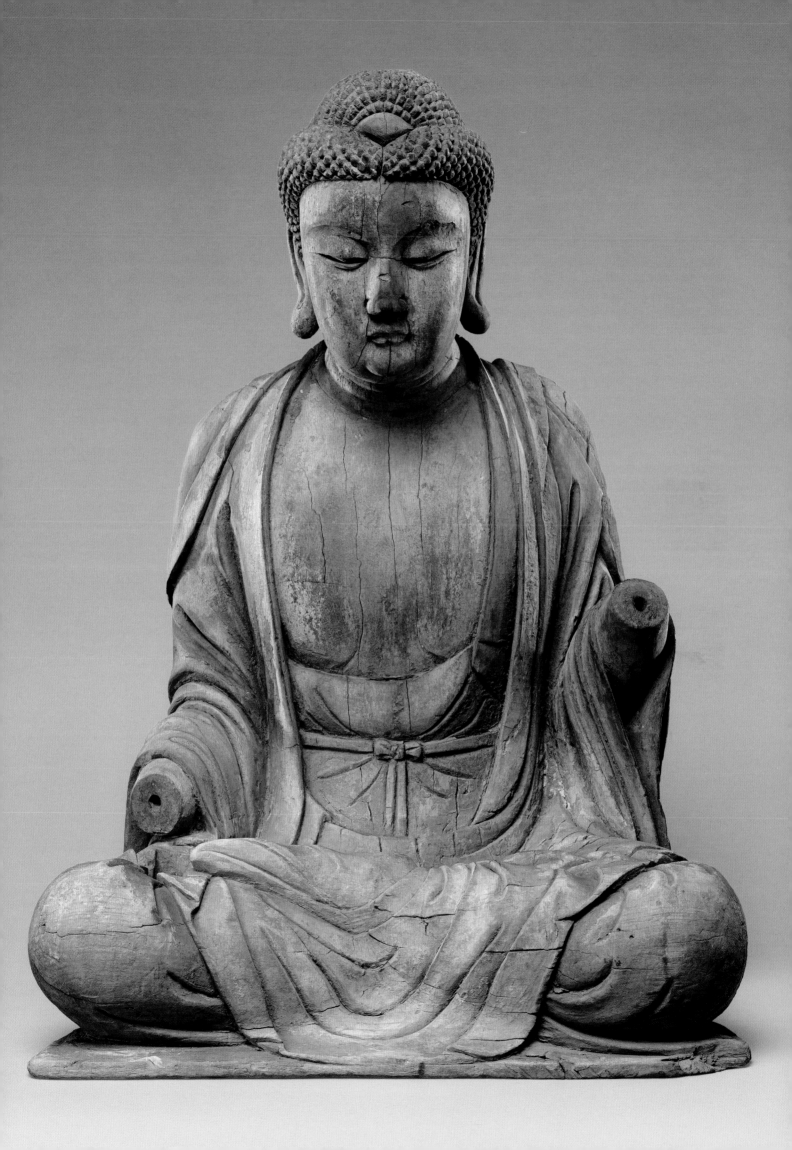

30. Buddha Shakyamuni (Shijiamouni 釋迦年尼佛) with Attendant Bodhisattvas

Possibly Southern Song (1127–1279) or Yuan (1271–1368) dynasty, 12th–14th century
Mammoth ivory with pigment and gilding
H. approx. 10 in. (25.4 cm) each
Fletcher Fund, 1934
34.26.1–.3

The Flower Garland Sutra provides the scriptural basis for images of a Buddha attended by the bodhisattvas Manjushri, who embodies wisdom, riding a lion, and Samantabhadra, who embodies Buddhist practice, riding an elephant. This text, which had probably been compiled in India by the third century C.E., was first translated into Chinese in the early fifth and reworked in the seventh and eighth centuries. It was influential in the development of East Asian Buddhist thought, especially in the formation of the Huayan order, which flourished in China during the Tang dynasty (618–906) and spread from there to Korea and Japan. After the tenth-century revival of the Tiantai tradition, which is based on the Lotus Sutra and extols the virtues and understanding of the same two bodhisattvas, the triad consisting of a Buddha,[1] Manjushri, and Samantabhadra became an important icon in both Huayan and Tiantai practices.

In this beautifully carved and embellished group, the Buddha is seated on the back of a *qilin*, a mythical creature with the body of a lion, the head of a dragon, and the hooves of a deer. He holds his hands in a gesture indicative of preaching, in which the thumbs touch the index fingers, and wears a thick, high-waisted garment, which ties at the front, under a small cape. An additional scarf twists wonderfully around his lower arms. Similar clothing, including the delicate scarves, appears on the bodhisattvas, who also wear bracelets identical to those worn by the Buddha. Both bodhisattvas hold the remnants of an implement known as a *ruyi*, and both are shown seated in a meditative posture. The representation of Samantabhadra is more complete, with a small crown containing an image of a seated Buddha at the front. This Buddha, who holds his hands in a gesture indicative of teaching, was most likely intended to represent the head of Samantabhadra's spiritual lineage, who is sometimes identified as Akshobhya and sometimes as Vajrasattva. Interest in the spiritual lineages of divinities is characteristic of the complicated later Esoteric traditions that are usually associated with Tibetan Buddhism, and it is likely that the presence of a Buddha in Samantabhadra's crown reflects the burgeoning of those traditions in the eleventh and twelfth centuries.

All three figures have slim physiques, with no articulation of the waist or the musculature of the chest; rounded limbs; and youthful features. All wear heavy clothing with thick pleats. All were originally gilded and painted: traces of blue are found in the hair of the Buddha and Manjushri, in the manes of the *qilin* and the lion, and on the saddlecloths and other adornments; an ocher or red pigment defines the hems of the shawls; and there are remnants of green at the edges of the lotus pedestals and in the area between the bottom of these pedestals and the saddlecloths.

Although ivory was known and used in some of China's earliest cultures, few sculptural examples made prior to the sixteenth or seventeenth century are extant.[2] The dating of this triad, which is made of mammoth ivory and cannot, therefore, be scientifically dated, remains controversial.[3] It is also impossible to determine the source of the mammoth ivory, although northern Asia or Siberia is likely.[4] However, comparison to wood sculptures in the Museum's collection and to works in other media suggests that these exquisite carvings may be rare examples of thirteenth- or fourteenth-century sculpture produced in southern China. The high waistline of the thick garments worn by the Buddha and the bodhisattvas is characteristic of works produced in northern China in the tenth and eleventh centuries, and the beaded adornments in Manjushri's crown and the beaded bracelets worn by all three divinities can also be traced to sculptures produced in the north at that time. However, the broad faces and strong noses with wide nostrils are more comparable to works produced in the twelfth and thirteenth centuries (see cat. no. 29). Such features are also found in a small group of sculptures, including an image of the young pilgrim Sudhana (fig. 96), that have recently been assigned, tentatively, to the Southern Song period.[5]

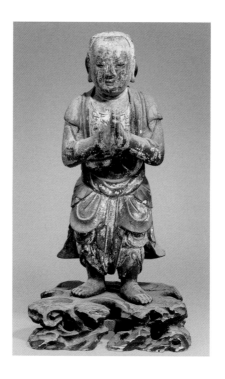

FIGURE 96. Pilgrim Sudhana. Southern Song dynasty (1127–1279), 13th century. Wood with pigment, H. 25⅜ in. (64.5 cm). Japan, Gifu Prefecture (Chōryū-ji)

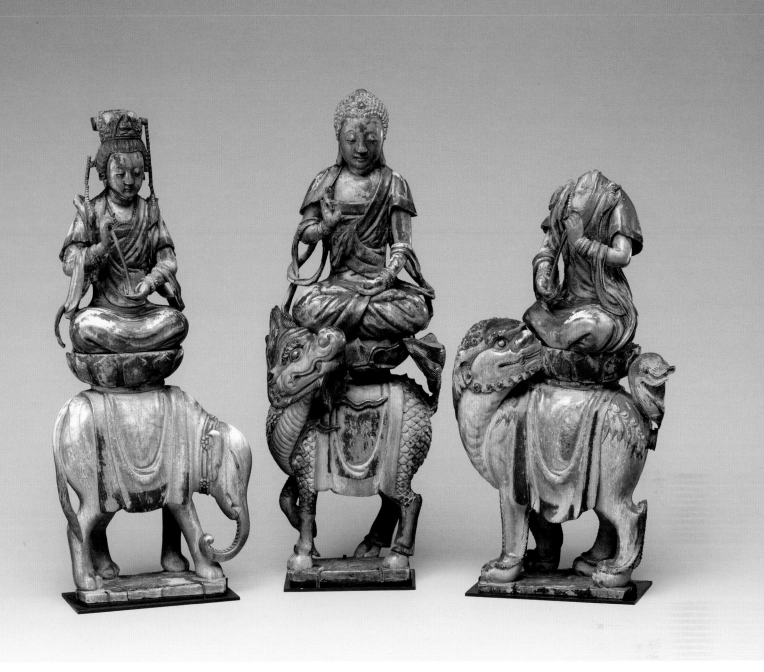

CAT. NO. 30

TECHNICAL NOTES

The three sculptures were carved and decorated as a group. Each figure and each mount were separately carved from an individual piece of ivory. Examination of the Schreger lines (the cross-hatchings, or stacked chevrons, visible on ivory cross sections) on every piece revealed an angle of intersection less than 90 degrees, thus identifying the material as having come from the tusk of a mammoth and not an elephant (see fig. 48 on p. 40). In addition, the stark gray-white color of the ivory is typical of mammoth and not elephant. The riders are attached to their mounts by a bamboo peg.

All the pieces were elaborately painted at least twice. Much of the pigment has flaked off, but enough remains to determine the general color scheme. Among the traces of original pigments on the Buddha, azurite (basic copper carbonate) was found in the hair and red ocher in the scarf. The painted grass at the feet of the *qilin* was rendered with green copper minerals malachite (basic copper carbonate) and brochantite (basic copper sulfate). A different pigment containing pure blue smalt was used in the blue areas under the chin of Manjushri's lion. For further details, see appendix E.

PROVENANCE

Mrs. E. J. Gerli, New York

PUBLICATIONS

Priest 1935a, p. 9; Watson 1984, cat. no. 14; Leidy et al. 1997, p. 39

NOTES

1. It is worth noting that the Flower Garland Sutra identifies the Buddha as the celestial Buddha Vairocana and not as the historical Buddha, Shakyamuni. However, Vairocana is understood as the transcendent form of the temporal Shakyamuni, and it is not impossible that the Buddha in such triads was understood to symbolize both divinities. It is also likely that the contemporary understanding of this Buddha reflects the incorporation of the triad into the Tiantai tradition, which focuses on Shakyamuni.

2. A seated Buddha in the collection of the Freer Gallery of Art, Smithsonian Institution, Washington, D.C. (F.1916.159a–c), is dated between 1440 and 1550.

3. For another example of a sculpture carved from mammoth ivory, see Christie's 2009, lot 601.

4. See Laufer 1925.

5. For additional examples, see Nara 2009, figs. 87, 89–91.

31. Guardian of the East (Dongfangchigou tianwang 東方持国天王)

Probably Yunnan Province, Dali kingdom (937–1253), 11th–12th century
Partially gilt arsenical bronze; lost-wax cast
H. 6¼ in. (15.9 cm)
Purchase, Bequest of Dorothy Graham Bennett, 2001
2001.77

Guardians of various types play an important role in Buddhist practices and imagery. Some, known as *lokapalas* (*tianwang* 天王), are associated with the four cardinal points; others, known as *dvarapalas* (*erwang* 二王), protect doors and entryways; and a host of terrifying figures (largely found in later traditions) provide safety and guidance to practitioners at different stages.[1] Individual *lokapalas* from the first century B.C.E. are found at Indian sites such as Bharhut, in Madhya Pradesh.[2] A distinct group of four protectors was not codified, however, until the fifth or sixth century. A version of the Sutra of Golden Light[3] redacted in the Khotan region of Central Asia (now the Xinjiang Autonomous Region of China) is often cited as the source for the standardization of the four guardians' identities and for the definition of their role as protectors of the state. Central Asia is also credited with having dressed the guardians in armor.

The earliest Chinese examples are the four small guardians painted on the west wall of cave 285 in the Mogao complex, near Dunhuang, dated 538.[4] By the late sixth century, such figures were often shown standing on the backs of animals or demons, both in Buddhist art and in tomb sculptures. This development may reflect the rise of early Esoteric traditions in India: protectors in later Indian and Tibetan art are also shown on the backs of such creatures, which symbolize delusion and other flaws that must be eradicated in order to attain enlightenment. The earliest Chinese examples of seated guardians were excavated from the underground chamber of the Famen-si (Famen monastery) in the early 1980s.[5] It is unclear why these protective figures, who should logically be shown as active and standing, began to sit, and it is worth noting that representations of seated guardians remain rare until the fourteenth century.

Alert, with bulging eyes, the Museum's guardian is seated on the backs of two demons, with his right leg pendant and his left leg crossed before him in the posture associated with relaxation. He wears full body armor, decorated with animal masks at the stomach and shoulders and rosettes on the breastplates, and a leather (or fabric) helmet with upturned corners. In East Asian Buddhism, this distinctive helmet is often associated with the Guardian of the East (Dhritarashtra). However, Dhritarashtra is usually shown holding a sword and not the bow and arrow held by the Museum's example. Exceptions are found in the art of the Dali kingdom, in Yunnan Province, where the Guardian of the East does hold a bow and arrow.[6] Moreover, the pudgy face and physique seen here, as well as details such as the gathering of the sleeves at the elbows, draw a strong parallel to a wood sculpture of a

FIGURE 97. Guardian. Yunnan Province, Dali kingdom (937–1253), 10th–12th century. Wood. Yunnan Provincial Museum, Kunming

seated guardian now in the collection of the Yunnan Provincial Museum, Kunming (fig. 97). For all these reasons, and because the sculpture was cast in a copper alloy with a high arsenic content, which is more commonly found in Yunnan than in other parts of China, it is likely that the work was produced there.

TECHNICAL NOTES

The sculpture was cast of arsenical bronze in one piece by the lost-wax method. Unlike the extremely porous castings of other arsenical bronzes in the catalogue (cat. nos. 32–34), this is a fine, dense casting, with no porosity. The main figure is hollow throughout its body, head, shoulders, and legs; only the arms are solid. There is an additional lump of the same metal on the bottom. Two holes in the bottom open into the body cavity, which has been emptied of core material. The heads and upper torsos of the two small demon figures are solid. All parts of the guardian figure are mercury-amalgam gilded, but neither small figure is gilded. Each retains the rich, dark, purple-brown color of copper oxide. Traces of pigments—white in the center, outlined with red—remain in the eyes of all three figures.

PROVENANCE

A & J Speelman, Ltd., London

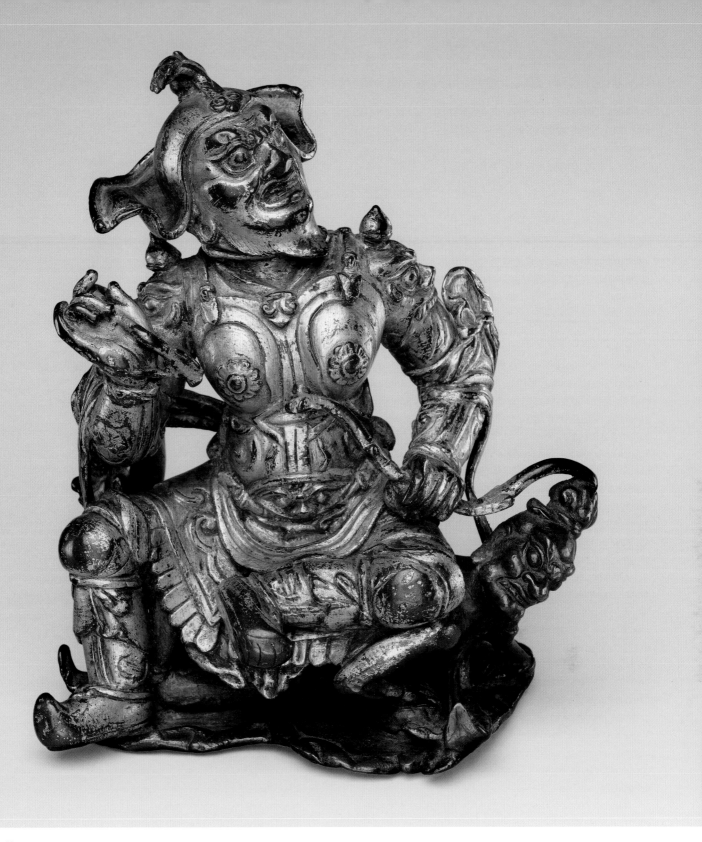

CAT. NO. 31

NOTES

1. For the development of these later figures, see Linrothe 1999.

2. See Fisher 1995.

3. Survnaprahbhasa Sutra (Qing guang ming jing 金光明經). Takakusu and Watanabe 1914–32, nos. 663–65.

4. For an illustration, see *Chūgoku Sekkutsu* 1980–82, vol. 1, pls. 114, 115.

5. For an example from the Famen-si, see *Famensi* 1994, p. 89.

6. A guardian with the same headgear and bow and arrow is found on the sides of a *dharani* pillar from Yunnan that is dated to the early thirteenth century. See Howard 1997, esp. fig. 5a. For a similar rendering in the famous handscroll by Zhang Shengwen, see Chapin 1972, pl. 27.

32. Bodhisattva Avalokiteshvara (Guanyin 觀音菩薩)

Yunnan Province, Dali kingdom (937–1253), 12th century
Gilt arsenical bronze; lost-wax cast
H. 19¾ in. (50. 2 cm)
Gift of Abby Aldrich Rockefeller, 1942
42.25.28

One of several similar works in Western collections, this gilt-bronze bodhisattva is dated to the twelfth century and assigned to Yunnan Province, in southwestern China, thanks to an inscription on the back of an example in the San Diego Museum of Art, which cites a ruler in Yunnan and provides a date of 1147–72.[1] The relatively large image of the Buddha Amitabha seated at the front of the headdress identifies the Museum's sculpture as a representation of Avalokiteshvara. The bodhisattva stands in a frontal position on a lotus pedestal and holds his right hand in the gesture of discussion (*vitarka mudra*) and his left in that of offering (*varada mudra*). He wears his long, matted hair piled high on his head and bound together with cords in a style known as *jatamukata*, commonly found in Indian art. His adornments include a delicately decorated torque, two armlets, a bracelet in the shape of a rosary, a decorated band just above the waistline, and a floral ornament at the waist-level gathering of his saronglike lower garment. The long scarf that falls below the waist is knotted at the sides.

Historical documents trace this type of Avalokiteshvara image to an Indian monk who visited the Yunnan region in the mid-seventh century. According to such traditions, the monk, who was a manifestation of Avalokiteshvara, predicted the rise to power of the Meng family after the wife and daughter of an important member of that clan fed him as he wandered in the nearby fields. The monk then cast a sculpture of the bodhisattva Avalokiteshvara that had miraculous rain-making abilities, thereby fostering the establishment of the Nanzhao kingdom, which controlled Yunnan during the eighth and ninth centuries. After 957, the same region, now controlled by the Duan family, became known as the Dali kingdom.

The monk and his casting of the sculpture are also recorded in two intriguing paintings: a handscroll in the Fujii Yurinkan collection, Kyoto, which details the history of the Nanzhao kingdom and is dated to 1194, and an astonishing work in the National Palace Museum, Taipei (fig. 98), by the little-known artist Zhang Shengwen, which is dated 1172–90. Both works show the Yunnanese-style Avalokiteshvara icon and the monk in question, in the process of finishing the surface of the sculpture. The earlier painting is the source for the Chinese term "Acuoye Guanyin,"[2] which is sometimes used to describe the Yunnanese images. The meaning of *acuoye* is unclear, but it is sometimes thought to be a transliteration of the Sanskrit *ajaya*, which means "all victorious"—an appropriate reference for an icon that is associated with members of a ruling family.

 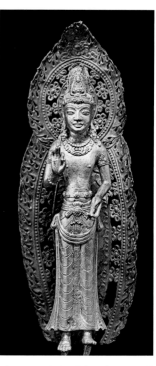

FIGURE 98. Zhang Shengwen (active 12th century). Avalokiteshvara and the Indian Monk, from *A Long Scroll of Buddhist Images*. Yunnan Province, Dali kingdom (937–1253), dated 1172–90. Handscroll; ink, color, and gold on paper. National Palace Museum, Taipei

FIGURE 99. Bodhisattva Avalokiteshvara. Yunnan Province, Nanzhao kingdom (8th–9th century), 9th century. Gold with silver halo, H. 21¾ in. (55 cm). Yunnan Provincial Museum, Kunming

Despite the purported creation of the first example of this type of Avalokiteshvara in the seventh century, the earliest known extant example is a ninth-century gold sculpture with a silver halo (fig. 99) that was excavated in 1978 inside the Qianxun pagoda of the Chongsheng-si (Chongsheng temple) in Dali, a complex that has long been associated with the ruling family of the Nanzhao kingdom.[3] The sculpture, which retains its halo (and thus gives an idea of the appearance of the haloes that are missing from other examples), can be distinguished from later works primarily by the rounder and fuller shape of the face.

Identifying the prototype for the Yunnanese images of the bodhisattva Avalokiteshvara is complicated. The link between the icon and a mysterious Indian monk suggests a source on the subcontinent. The art of the Pallava kingdom (ca. 4th–9th century), a trading nation on the southwest coast, is a possibility; sculptures from that kingdom are also

OPPOSITE: CAT. NO. 32

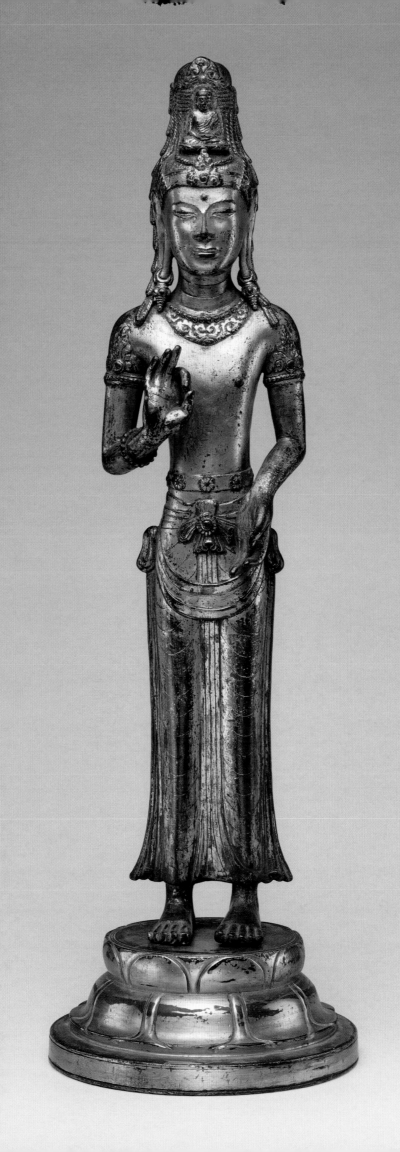

characterized by frontal postures, elegant hand gestures, and decorative belts worn above the waistline.[4] It is unclear, however, whether the Pallava prototype was introduced into Yunnan directly or by an intermediary, such as the contemporaneous trading nation of Srivijaya, which was based in Sumatra and controlled the Malay Peninsula, or some other polity in mainland Southeast Asia.[5]

It is also unclear whether the ninth-century piece is a rare preserved example of what was actually a popular icon at the time or whether production of the Yunnanese type of Avalokiteshvara was actually more widespread in the twelfth and thirteenth centuries. Several reasons can be adduced for the growing popularity of this icon after the tenth century. On the one hand, it would have provided a link to the rule of the previous Nanzhao kingdom, helping to legitimate that of the subsequent Dali. On the other, the icon, which had long been understood as an insignia of the royal family, may have been intended to illustrate the Dali rulers' adoption of the Indian concept of *devaraja*, in which the ruler was a god-king, understood both as his mortal self and as a manifestation of divinity. This belief, which played an enduring role in mainland Southeast Asia, could easily have been introduced into Yunnan by the neighboring Thais or others from the region who were ethnically related to the Yunnanese and maintained diplomatic and economic relationships with them.

TECHNICAL NOTES

This sculpture was cast of arsenical bronze in one piece by the lost-wax method. Two large rectangular openings in the back (see fig. 51 on p. 42) were left by core extensions that held the core in place within the mold during casting. A corroded iron pin in the top of the head may also have helped to stabilize the core. Radiographs reveal a very porous casting. The porosity is no surprise, considering that the metal is nearly pure copper, with 3 percent arsenic. Casting pure copper is very difficult and,

because of its gaseous nature, produces a highly porous metal. The arms are solid. The right leg is a later replacement in a brass alloy, as are the base and both tangs of the feet. Much of the core was removed through the openings, possibly to leave a space for depositing consecratory material. Each rectangular opening in the back was originally covered with a metal plate held on with four iron pins, one at each corner. Corrosion from iron pins remains in the pin holes, and a fragment of brass (presumably from the cover) is still attached at one corner. There are remnants of black core material with carbonaceous inclusions in the head. The figure was gilded twice, first by the mercury-amalgam method and then with gold leaf, adhered to the sculpture with a brown resin (possibly lacquer). There is no evidence that a halo was ever attached to the back.

The sculpture is comparable in form, technique, and material to at least nine others that have been analyzed.[6] Some type of model was closely followed in the creation of these figures, but differences in the details are sufficient to prove that a single model could not have been used as the basis for the casts. The same basic arsenical-bronze alloy was used for all nine figures; they were all mercury-amalgam gilded. Lead-isotope ratios confirm the use of different but similar ore sources, reaffirming that various batches of metal were used.

The separate circular base was cast in a brass alloy of similar composition to that of the sculpture's leg repair and may have been made at the time of the restoration; thus, it is not original to the sculpture.

PUBLICATIONS

Chapin 1944, pl. 16; Priest 1944, cat. no. 58; New York 1971, cat. no. 90; New York 1979, cat. no. 22; Guy 1995, fig. 1

NOTES

1. The first and still seminal discussion of these sculptures is Chapin 1944. For further discussion, see Guy 1995.
2. 阿嵯耶觀音菩薩.
3. See Yunnan Provincial Cultural Relics Work Team 1981 and Lutz 1991.
4. For examples, see Beck 2006, pp. 53, 70, 93, 169, 182, 191, 203.
5. For Srivijayan and Cham parallels, see Guy 1995, figs. 14, 15.
6. See Jett 1991.

33. Bodhisattva Avalokiteshvara with One Thousand Hands and One Thousand Eyes (Qianshou Qianyan Guanyin 千手千眼觀音菩薩)

Probably Yunnan Province, Dali kingdom (937–1253), 11th–12th century
Gilt arsenical bronze; lost-wax cast
H. 8¼ in. (21 cm)
Rogers Fund, 1956
56.223

Although paintings depicting this powerful form of the bodhisattva often show every one of the thousand hands, each with an eye in the palm, sculptures such as this example follow a convention in which only twenty-four hands are depicted. Avalokiteshvara with One Thousand Hands first appears in China during the Tang dynasty (618–906), when thirteen texts describing this form of the bodhisattva and the rituals used in devotions to him were translated.[1] Of these,

the Great Compassionate Heart Dharani of the Bodhisattva Avalokiteshvara with One Thousand Hands and One Thousand Eyes (or Great Compassion Dharani),[2] translated by the Indian monk Amoghavajra (704–774), was particularly influential, and a short rendering of the invocation passages, or *dharani*, of the text soon became an important aspect of Chinese devotions. The earliest known example of this iconography is preserved in cave 2141 of the Longmen complex,[3]

OPPOSITE: CAT. NO. 33

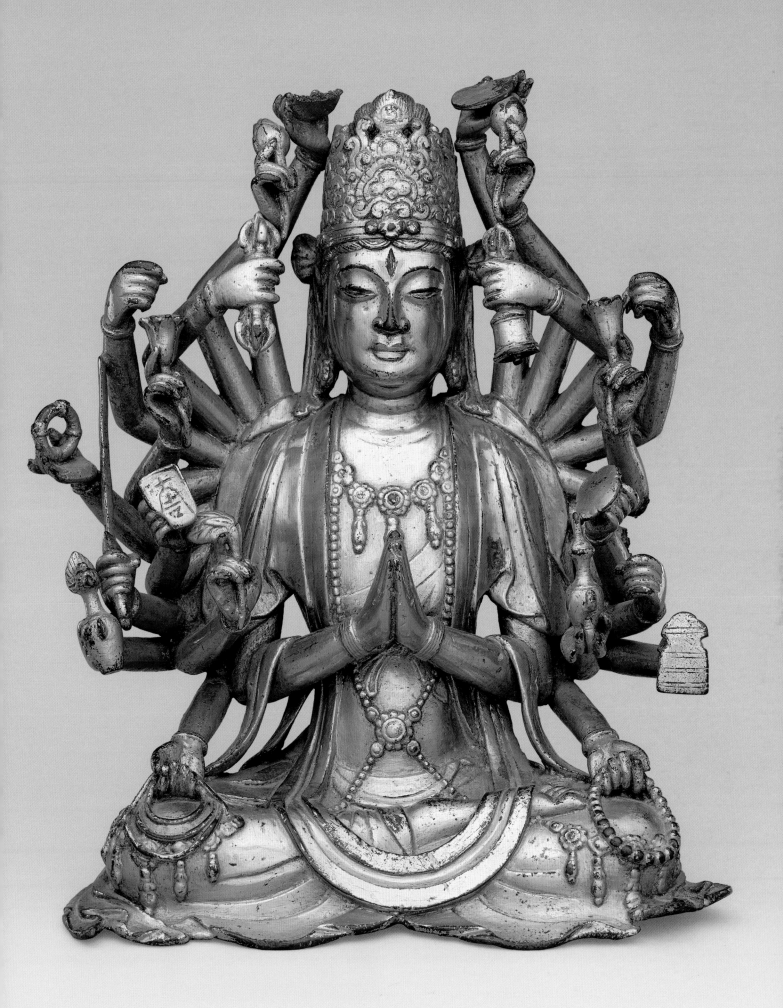

FIGURE 100. Bodhisattva. Yunnan Province, Dali kingdom (937–1253), 12th century. Bronze, H. 8⅞ in. (22.5 cm). Yunnan Provincial Museum, Kunming

suggesting that devotion to this form of the bodhisattva began to flourish throughout Asia in the eighth century as part of the early spread of Esoteric Buddhism.

The sculpture was most likely seated on a lotus pedestal and had a halo or mandorla at the back. The bodhisattva sits in a meditative posture and wears a short capelet with ends that fall along the sides of the body and loop over the lower arms, a long saronglike garment, a crown, several bracelets, and two necklaces. He holds his two primary hands in a prayerful gesture in front of his chest. The remaining twenty-two arms, which hold implements that illustrate the potency of this important manifestation, are paired to the right and left. The lower two hold a rosary and a miraculous lasso that is the primary implement of another form of the bodhisattva Avalokiteshvara. Reading from bottom to top, the next pair of hands holds a water vessel in the Indian *kundika* shape and a willow branch, attributes that are common in Chinese renderings of Avalokiteshvara after the late sixth century. A bird-headed ewer, a type of vessel that became common in Chinese ceramics and metalwork in the seventh and eighth centuries (see fig. 81 on p. 104), is held in the right hand of the fourth pair, opposite an unidentified implement or tablet.

A sword is matched with an unrecognizable object in the fifth pair of hands. The sixth holds a tablet with the Chinese characters for *taiji*, or "great auspiciousness," and, perhaps, a mirror, long an auspicious emblem in Chinese culture. The right hand of the seventh pair holds a large ring; the left hand is missing. Two half-open lotuses are held in the eighth pair of hands; they were most likely intended to represent one of the several types and colors of lotuses mentioned in the texts describing this bodhisattva, as were the closed lotuses held in the tenth. Both variants allude to descriptions of Avalokiteshvara as a lotus bearer. The *vajra* in the right hand and bell in the left hand of the ninth pair are ritual

implements used in ceremonies geared toward figures such as Avalokiteshvara with One Thousand Hands. The two disks in the uppermost, or eleventh, pair represent the moon and sun and are often found, from the tenth to the fourteenth century, in representations of this form of Avalokiteshvara. The moon was thought to repel poison and danger and the sun to dispel ignorance.

The low-waisted skirt and the crown, with its uneven shape at the top and decoration of thick curlicues, are comparable to those worn by bodhisattvas produced in Yunnan Province (see fig. 100) during the rule of the Dali kingdom. In addition, the sculpture was cast in copper containing arsenic (arsenical bronze), which is also typical of works produced in southwestern China at that time.

TECHNICAL NOTES

Remarkably, this sculpture, with all its arms and accoutrements, was completely cast in one piece in arsenical bronze. Because of the nearly pure copper content, it is extremely porous throughout, which shows up in radiographs as a multitude of bubbles (see fig. 101). On top of the mercury-amalgam-gilded surface are traces of pigments. The eyes were originally white, with a red outline and black irises. There are remains of black pigment in the hair, and the lips were red. Traces of a pink color covered with powdered gold paint are found on top of the gilding in the face and hands—a technique similar to Tibetan cold-painting methods (see appendix E).

PROVENANCE

J. J. Klejman, New York

PUBLICATIONS

Priest 1944, cat. no. 21; Lee and Ho 1968, cat. no. 11; New York 1971, cat. no. 42; New York 1979, cat. no. 21; Amherst 1984, cat. no. 76; Howard 1984, pl. 40

NOTES

1. For a discussion of the more important texts, see Yü 2000, pp. 59–69.
2. The Chinese title is Qian yan qian bi Guanshiyin pusa tuoluoni shen zhou jing (千眼千臂觀世音菩薩陀羅尼神呪經). Takakusu and Watanabe 1914–32, no. 1057.
3. For an illustration, see Liu Jinglong et al. 2002, vol. 10, p. 86.

FIGURE 101. Radiograph showing extreme porosity of casting (cat. no. 33)

34. Adept

Probably Yunnan Province, Dali kingdom (937–1253), 12th–13th century
Partially gilt arsenical bronze; lost-wax cast
H. 6⅜ in. (16.2 cm)
Purchase, Friends of Asian Art Gifts, in honor of Douglas Dillon, 2001
2001.209

Three features suggest that the intriguing sculpture seen on the following spread may have been produced in Yunnan Province, in southwestern China: the nearly pure copper; the position of the weapon in the right hand; and the necklace of flower-shaped beads and pendants. An alloy of copper and arsenic was commonly used to make Buddhist sculptures in Yunnan, helping to distinguish works produced there from those made elsewhere in China. The unusual position of the right hand, which holds the hilt of a sword up near the figure's skull, has parallels in images of fierce protectors that have been excavated in Yunnan (see fig. 102).[1] In shape and decoration, the necklace duplicates that worn by a seated bodhisattva in the Museum's collection (cat. no. 33), which is also attributed to Yunnan Province.

The adept sits with his left leg crossed before his body and his right leg bent at the knee and holds a long, thin *vajra* (ritual implement) in his left hand. A large cavity in the center of his chest contains a second *vajra*. In addition to the necklace, he wears armbands, bracelets, and anklets but no clothing. He has a diamond-shaped *urna*, or third eye, in the center of his forehead, and large teeth or fangs appear to emerge from either side of his open mouth.

The nudity, pudgy physique, and specific combination of adornments and ritual implements link the sculpture to later representations of a group of figures generally known as "great adepts," or *mahasiddha*s, and commonly associated with later Esoteric traditions, particularly in Tibet. The best-known group consists of eighty-four figures, mostly male, who are noted for their heterodox behavior, highly evolved spiritual skills, and, at times, magical abilities. Questions remain about the historicity of some of these figures, who are supposed to have lived between the eighth and twelfth centuries; however, similarities to the practices of the Ari in Burma and the Azhali (possibly, a rendering of the Sanskrit *acharya*, meaning "guide") in Yunnan indicate that such nontraditional and, to some degree, nonmonastic practitioners were found in multiple centers in Asia at the time. The practices and beliefs of such figures include divergent and, generally, solitary lifestyles; psychophysical disciplines, such as the uttering of incantations as a means to immediate enlightenment; the importance of a teacher-disciple relationship in the transmission of techniques; and the refusal to accept that a highly esteemed teacher must necessarily have been trained in a monastic context in order to achieve enlightenment and help others in their own pursuits.

The Ari sect of Burma is said to have been banned by King Aniruddha in the eleventh century, and understanding

FIGURE 102. Wisdom King (*vidyaraja*). Yunnan Province, Dali kingdom (937–1253), 12th century. Gilt bronze, H. 6 in. (15 cm). Yunnan Provincial Museum, Kunming

of its practices remains speculative on account of a resultant lack of historical material.[2] Nonetheless, it is generally accepted that its adherents were solitary monks noted for their austerities, magical feats, and incantations. Similar abilities and activities are attributed to the Azhali monks of Yunnan,[3] and it is interesting that such practitioners are depicted, together with more traditional monks, in the famed handscroll of Buddhist images painted by Zhang Shengwen in the late twelfth century (see fig. 98). It is likely that such individuals played an important role in Yunnanese practices in the twelfth and thirteenth centuries.

By definition, asceticism does not lead to the writing of history or the commissioning of art objects, and with the exception of the Indo-Tibetan *mahasiddha*s, the names, biographies, and iconography of these individuals are not pre-

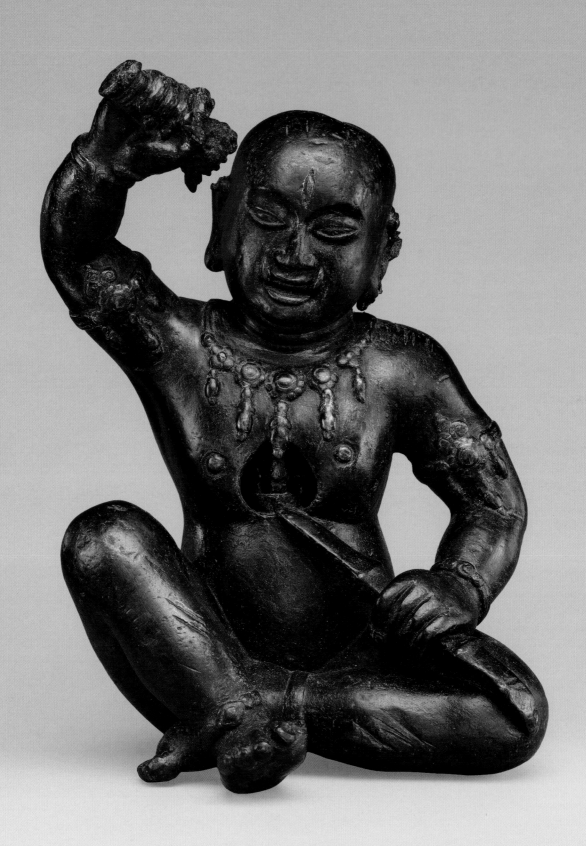

served. The distinctive *vajra* in the center of the chest of the adept in the Museum's collection has no parallel in the imagery that developed in Tibet from the twelfth to the fifteenth century to portray the *mahasiddha*s; he cannot be identified as one of that group.[4] It is worth noting, however, that historical records indicate that at the time of his passing, a *vajra* emerged from the chest of the Tibetan monk Phagmo Drupa (1110–1170) and entered that of his disciple Jigten Gonpo (ca. 1143–1212), presumably as a symbol of the transmission of a specific lineage from one master to another.[5] Phagmo Drupa was one of the most revered teachers of his time, and it is reasonable to assume that he was known in Yunnan as well as in Tibet. This sculpture may be a rare representation of this seminal teacher as an adept rather than as a member of a monastic group. It may also represent another such practitioner, unknown to us by name, whose advanced spiritual state led to the appearance of a *vajra* in his chest.

TECHNICAL NOTES

The sculpture was cast in one piece by the lost-wax method. The alloy is extremely porous, as is consistent with its nearly pure copper content. It is a heavy, thick-walled casting, measuring approximately ⅛ inch (3 mm) overall. The figure is hollow throughout the head, torso, legs, and arms to the elbows. Most of the core has been removed, but a small amount

may still reside in the arms and knees. A rectangular consecratory chamber in the middle of the back has a cover made by casting in a copper plug, with a thin gap left around it. The opening was probably used for removal of the core as well as for insertion of the second *vajra* and any consecratory material. That *vajra* is not porous, indicating that it was cast neither at the same time nor of the same alloy. A circular hole was cast in the bottom of the figure for attachment to a base or other object, which is now missing. There are no inlays present, nor does it appear that any are missing, other than one in the sword hilt. On top of the jewelry are remains of gold foil adhered to the metal with a black resin.

PROVENANCE

Joseph G. Gerena Fine Art, New York

PUBLICATION

Metropolitan Museum of Art 2008, p. 48

NOTES

1. See Yunnan Provincial Museum 2006, fig. 27.
2. See Strong 1992, pp. 70, 176–78, 244, 249. For a slightly different interpretation, see Chutiwongs 1984, pp. 100–110. For seminal work in uncovering the lost Esoteric traditions of mainland Southeast Asia, see Bizot 1988. For an interesting overview of Bizot's work, see Crosby 2000.
3. See Howard 1990, p. 9.
4. See New York 2006.
5. See Linrothe 2007, p. 48.

35. Bodhisattva Avalokiteshvara (Guanyin 觀音菩薩)

Probably Hebei Province, Yuan dynasty (1271–1368), dated 1282
Wood (willow) with traces of pigment; single-woodblock construction
H. 39¼ in. (99.7 cm)
Purchase, Joseph Pulitzer Bequest, 1934
34.15.1

An inscription on the back of the wood cover used to close the cavity at the back of the sculpture, which gives a date in the nineteenth year of the Yuan dynasty,[1] makes the elegant rendering of the bodhisattva Avalokiteshvara on the following spread one of the rare examples of a Chinese Buddhist sculpture that can be securely dated. This cavity and a second chamber in the head of the figure were used to store consecratory material, including pieces of raw and colored silk, various seeds and grains, incense, and semiprecious stones. This material was intended both to sanctify the statue and to enliven it so that it might be inhabited, at least temporarily, by the bodhisattva of compassion. A small bronze mirror was inlaid into the inward-facing surface of the inscribed wood cover (see fig. 103). Another, earlier sculpture in the collection (cat. no. 24) also had a mirror set into an interior wall, suggesting that the use of mirrors may have been prevalent in Buddhist practice from the eleventh to the fourteenth century.

As is almost always the case, the seated Buddha at the front of the diadem identifies the wearer as the bodhisattva of compassion, whose other adornments include a bulky neck-

FIGURE 103. Wood cover used to close reliquary chamber, with inscription and embedded bronze mirror (cat. no. 35)

FIGURE 104. Detail of Avalokiteshvara's hair (cat. no. 35)

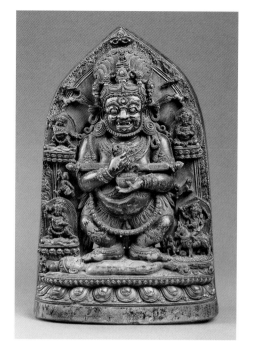

FIGURE 105. Mahakala of the Tent. Tibet or China, Yuan dynasty (1271–1368), dated 1292. Limestone with pigment and gilding, H. 19 in. (48 cm). Musée Guimet, Paris, Gift of Lionel Fournier

lace, armlets, a saronglike garment, and a narrow shawl over the left shoulder. An additional girdlelike piece of cloth, which can be traced to the sixth century in Chinese Buddhist sculpture, covers the longer skirt and is tied with a cloth sash. The necklace, which is decorated with floral pendants, also reflects the continuation of older Chinese traditions. Ornaments in this style became popular in the tenth century and are often found in works from northern China as well as from centers such as Bezeklik, near Turfan.[2]

Several other features, however, illustrate an awareness of contemporaneous Indian artistic traditions, particularly those of the northeastern Pala kingdom (ca. 700–ca. 1200) and Tibet in the twelfth and thirteenth centuries. This style of Buddhist art, which is often associated with the rise of Esoteric traditions at the time, spread from India into Tibet and Central Asia and was also known in northern China at centers such as Dunhuang, in Gansu Province,[3] and at those associated with the Tangut Xixia kingdom (1038–1227).[4] Of these features, the most dramatic is the rendering of the hair, in which the strands or braids are shown as upright, individual pieces that end in small curls (see fig. 104). Notably, in Pala-period and related Tibetan works, this hairstyle is typically used in depictions of ferocious protectors such as Mahakala (see fig. 105) rather than in representations of bodhisattvas.

In addition, Avalokiteshvara's face has a slightly oval shape that alludes to Indian imagery and distinguishes it from the broad, square visages with lower cheekbones commonly found in Chinese Buddhist sculpture. The subtle shift in the bodhisattva's posture and the hint of musculature in the chest and arms also reflect an awareness of Indo-Himalayan art. Understanding of that tradition intensified in the second half of the thirteenth century, when the young Nepali artist Anige (1245–1306) resided at the Yuan court.[5] It is likely that this important work was produced at court by an artist who was adept in the long-standing Chinese tradition of wood sculpture but also familiar with other traditions, such as that brought to China by Anige.

TECHNICAL NOTES

The sculpture was carved predominantly from a single block of willow, with additions of the right forearm, outer left elbow, left hand, and lotus petals around the base (see fig. 106). The right forearm and the outer

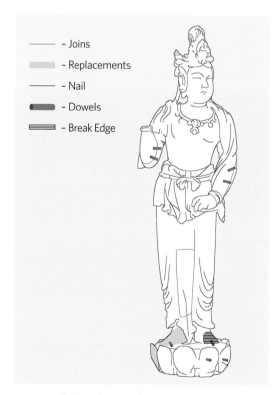

— – Joins

▒ – Replacements

— – Nail

● – Dowels

▦ – Break Edge

FIGURE 106. Line drawing showing single woodblock and additions (cat. no. 35)

OPPOSITE: CAT. NO. 35

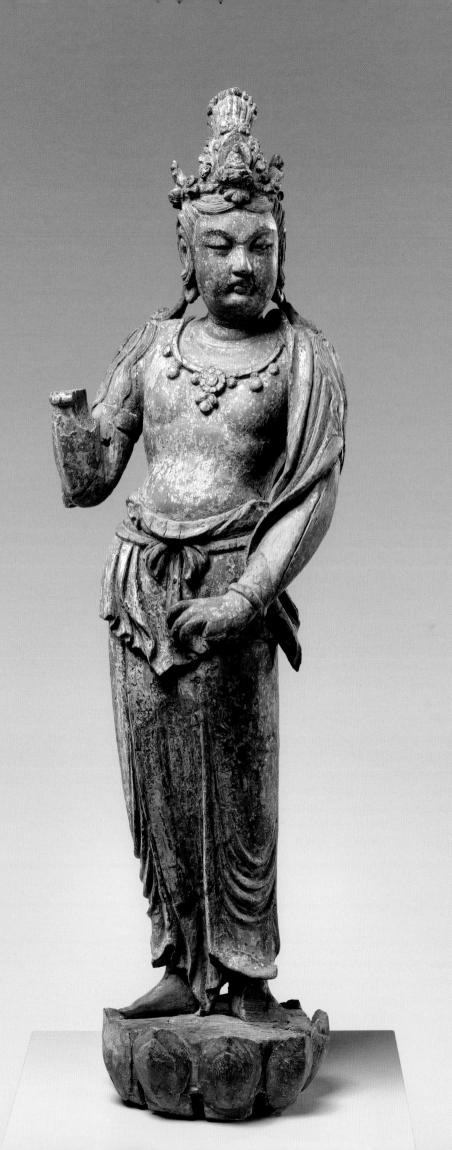

left forearm are held on by pairs of dowels. The missing right hand probably had a tenon that fit into the empty mortise in the wrist. Wood dowels originally held the lotus petals to the base.

There is a small chamber in the back of the head; a larger chamber runs from the middle of the back down to the calves. Each has a rectangular access panel in the back, but, oddly, a third panel is present on the front, from mid-thigh level down to the ankles. The panel in the back of the torso bears a black-inked inscription, and a small bronze mirror is set into a circular depression cut into its inner surface. The reflective plane of the mirror faces in, toward the body cavity. A two-character inscription is punched into the rim of the mirror.

The sculpture is decorated with multiple layers of polychromy and gilding. Fine details include black-painted eyebrows, irises, and a thin, curvy mustache. From surface X-ray fluorescence examination, the orange-red color of the flesh can be identified, most probably, as red lead. Ornaments such as the necklace and armbands are covered in gold foil with a significant amount of tin.

PROVENANCE

Ralph M. Chait, New York

PUBLICATIONS

Priest 1934b, pp. 62–63; Bachhofer 1938a, fig. 10; Bachhofer 1938b, figs. 1, 2; p. 291; Sirén 1942b, fig. 389; Priest 1944, cat. no. 69; Matsubara 1961, fig. 1; Lippe 1965c, fig. 9; Fontein and Hempel 1968, cat. no. 118; Lee and Ho 1968, cat. no. 3; Tanabe 1969, fig. 2; New York 1979, cat. no. 29; Shi 1983, pl. 1705; *Hai-wai Yi-chen* 1986, pl. 160; Jin 1994, pl. 331

NOTES

1. *Da Yuan Guo Zhi Yuan shi jiu nian si yue geng yin shuo nian ri* (大元国至元十九年四月庚寅朔廿日).
2. This style of necklace is often found in the cave temples at Mogao, near Dunhuang, after the tenth century. For examples, see *Chūgoku Sekkutsu* 1980–82, vol. 5, pp. 119, 141, 144, 145, 153. For related adornments at Bezeklik, see Meng et al. 1995, figs. 102, 104, 112, 136.
3. For a discussion of cave 76 at Dunhuang, which has imagery based on a Pala-period palm-leaf manuscript, see Toyka-Fuong 1998.
4. See Lugano 1993 and Samosiuk 2006.
5. See Jing 1994.

36. Bodhisattva Avalokiteshvara in Water-Moon Form
(Shuiyue Guanyin 水月觀音菩薩)

Probably Shanxi or Hebei Province, Ming dynasty (1368–1644), dated 1385
Wood (willow) with gesso and traces of pigment; single-woodblock construction
H. 30¼ in. (76.8 cm)
Anonymous Gift, in memory of Edward Robinson, 1953
53.196

This powerful sculpture is another rare work in wood in the Museum's collection that has an inscription and thus can be securely dated. Moreover, the inscription,[1] written on the inner surface of the wood slab used to close a chamber that once held consecratory material (see fig. 107), provides rare and useful information regarding the production of the sculpture and its intended use. Although part of the inscription has been abraded and is difficult to read, it states that the sculpture was made in 1385[2] under the direction of an individual named Xin Zhongwen, who held the title of *weina*, the same appellation as was given earlier to people who sponsored the construction of stone steles.[3] Xin worked with the inhabitants of a village called Dong'an to sponsor the creation of the piece. In addition, the inscription gives the names of Feng Xiaozhong, who is identified as the woodcarver-in-attendance, and his son and explains that the sculpture was produced for use in a temple that guarded a road or crossroads. It also suggests that the sculpture was once one of three; however, it is unclear whether this means that it was one of three representations of Avalokiteshvara or part of a triptych, presumably consisting of a Buddha and two bodhisattvas, or perhaps a group of three independent divinities that included the "water-moon" form of the bodhisattva of compassion.

FIGURE 107. Wood cover used to close reliquary chamber, with inscription (cat. no. 36)

OPPOSITE: CAT. NO. 36

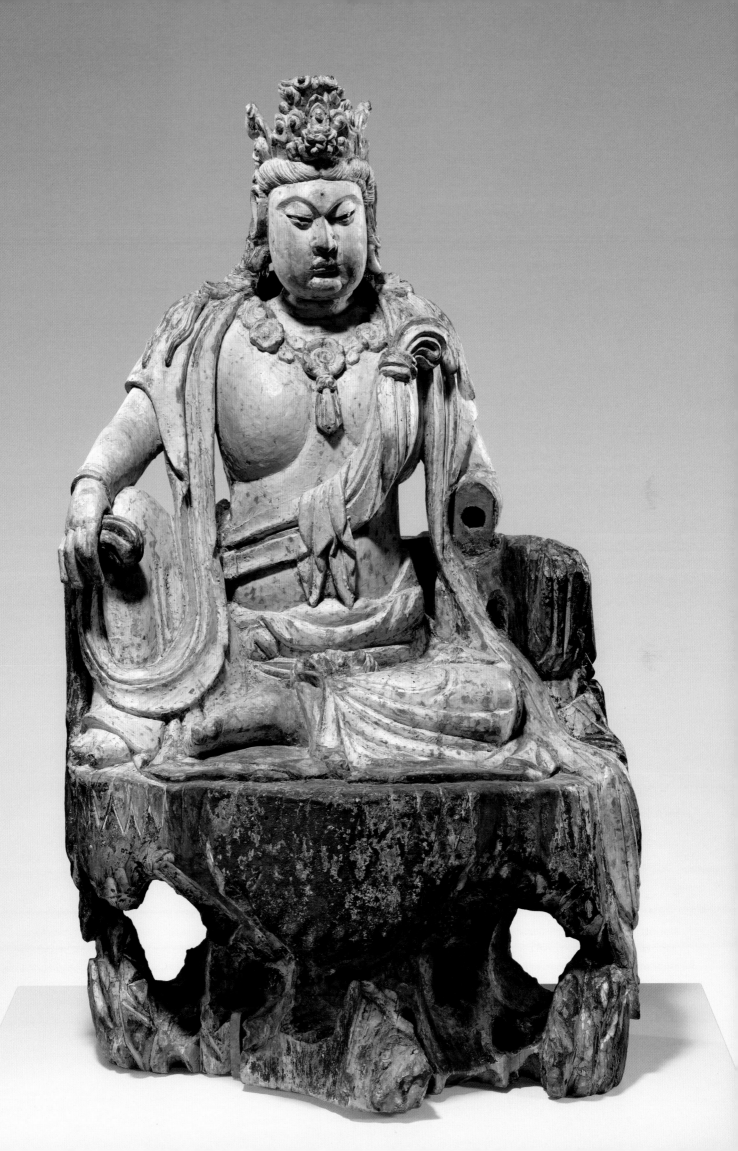

Avalokiteshvara is identified by the seated Buddha Amitabha in the headdress, and the posture and rocky base specify the "water-moon" manifestation. The bodhisattva's oval face, high cheekbones, and pursed mouth reflect a continuing awareness of certain Indian, or Indo-Himalayan, traditions in Buddhist sculpture that first appeared in China in the twelfth century and intensified during the Yuan period (1271–1368) thanks to strong ties between the Mongol Yuan court and Tibet. The heaviness of the drapery, on the other hand—especially of the scarf that falls from the left shoulder and around the torso and is tied at the left—derives from earlier representations of bodhisattvas in which the lines of the clothing are more important than the volume of the underlying body. This tension between volumetric modeling, which plays an important role in Indian aesthetics, and a linear emphasis that is more typically Chinese is often found in Chinese Buddhist images.

TECHNICAL NOTES

This sculpture was carved from a single large block of willow, with a small, shallow consecratory chamber cut out of the back. The interior wall of the cavity is roughly hewn, and the toolmarks reflect a flat-edged chisel. On the inside of the cover is a black-ink inscription, written directly on the wood. The right forearm was originally carved separately and attached with either a dowel or a tenon; only a hole remains today. A pair of oval holes at the back of the headdress probably held ornaments that were doweled in place. A fragment of an iron pin on the right side of the headdress and a corresponding hole on the left side were probably used to attach additional ornaments. A small hole in the center of the figure's forehead suggests that it once held a gem. Black stones or

glass beads were inlaid in the eyes. Radiographs clearly show the drilled perforation through each.

Throughout its history, the sculpture was subjected to at least four painting campaigns, including gilding, which radically changed the color scheme. The original painted surface consists of a white kaolin-based ground followed by a colored paint layer, both bound in a protein medium. Originally, the flesh was painted orangish pink with a mixture of vermilion, white clay, and silica. The hair and the cape with long ribbons were painted blue with indigo. The sash was painted with red lead, and the skirt (or leggings) was painted red-orange with vermilion over an orange layer of red lead. The color and composition of the ground and the pigments on the flesh, hair, and cape are similar to those on a Jin-dynasty carved Avalokiteshvara in the Victoria and Albert Museum, London.[4] See appendix E for further details and comparisons.

PUBLICATIONS

Bachhofer 1938a, fig. 13; Priest 1944, cat. no. 80; Fontein and Hempel 1968, cat. no. 119; Shi 1983, p. 1809; *Hai-wai Yi-chen* 1986, pl. 172; Jin 1994, pl. 313

NOTES

1. *Dong an cun zhong cun ren deng yu weina Xin Zhongwen deng jin fa qian xin . . . lu miao yi zuo qing dao ben cun kan mu tai shi Feng Xiaozhong bing nan Feng Beigong xi kan tian yi Guanyin san wei yi tang wei yuan ben cun tong . . . ji xiang he jia le an . . . Hongwu shih ba nian zheng yue . . .* (東安 村 眾村人等與維那辛种忟等謹發處心 . . . 路一座請到本村刊木 太侍馮孝 中并男馮傄工細刊天衣觀音三位一堂為願本村通 . . . 吉祥和家樂安 . . . 洪武十八年上月 . . .).

2. It is worth noting that the radiocarbon date range for this sculpture is cal A.D. 1310–1440.

3. See cat. no. 8, p. 73.

4. See Larson and Kerr 1985.

37. Bodhisattva Manjushri as Tikshna-Manjushri (Minjie Wenshu 敏捷文殊菩薩)

Ming dynasty (1368–1644), Yongle period (1403–24)
Gilt leaded brass; lost-wax cast
H. 7½ in. (19.1 cm)
Rogers Fund, 2001
2001.59

The inscription "Bestowed in the Yongle era of the Great Ming,"[1] which is engraved on the top of the base, at the front, dates this sculpture of the bodhisattva Manjushri to the early fifteenth century. Manjushri sits in a meditative posture on the base, which is decorated with lotus petals and beaded borders. He holds a sword in his primary right hand and a volume of the Perfection of Wisdom Sutra (Prajnaparamita), on a small lotus blossom, in his primary left. Remnants of a bow and arrow can be seen in his secondary hands, and the four hands and their respective implements identify the figure as Tikshna-Manjushri, a manifestation that refers to the bodhisattva's quick wit and elucidates his position as the embodiment of spiritual wisdom.

Images of this type are known in Chinese Buddhist art from the fifteenth to the eighteenth century. Identification of their subject is based, to a large extent, on Chinese texts dating to the Qianlong era (1736–95) of the Qing dynasty (1644–1911).[2] There are no references to Tikshna-Manjushri in the *Garland of Sadhanas* (*Sadhanamala*), a seminal late-eleventh-century compilation by the famed Indian monk-scholar Abhayakaragupta, or in any other iconographic treatise used to identify the numerous divinities of the later Esoteric tradition (best known today in Tibet),[3] and it is difficult to determine when this form of the bodhisattva was introduced into China and how it was understood.

OPPOSITE: CAT. NO. 37

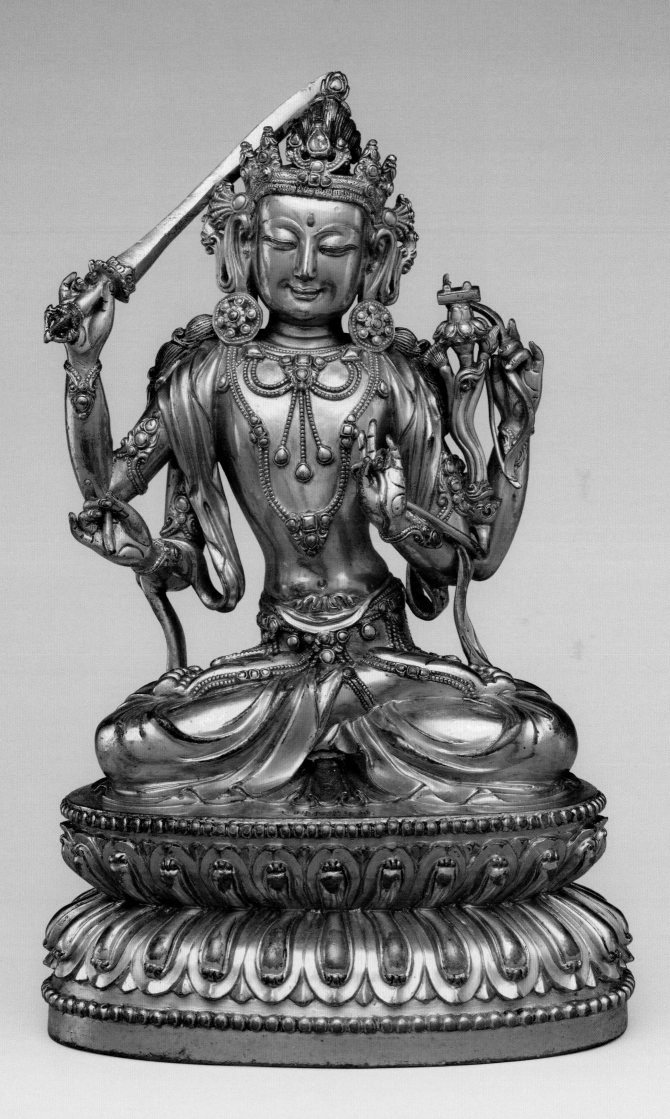

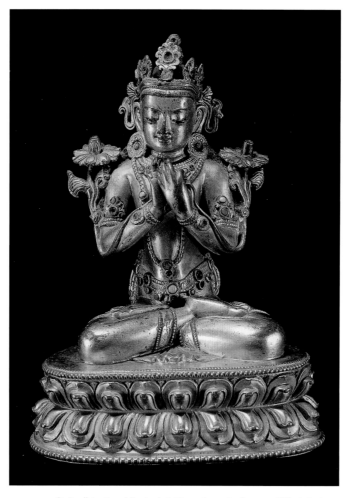

FIGURE 108. Bodhisattva Manjushri. Yuan dynasty (1271–1368), dated 1305. Gilt copper alloy inlaid with turquoise, lapis lazuli, and coral; H. 7⅛ in. (18 cm). Palace Museum, Beijing

An intriguing parallel to the later Chinese examples is found, however, in the Ladakh region of Jammu and Kashmir. Paintings showing a four-armed Manjushri holding the pertinent implements fill one wall in the Sumstek, a hall in the monastery at Alchi, which was built in the early thirteenth century. The sculptures and paintings in this building[4] illustrate new styles and iconographies that were being transmitted at the time from the eastern reaches of India and Kashmir to the Himalayan region and that are often understood to represent an important phase in the development of Tibetan art. The representation of this type of Manjushri in this particular sanctuary suggests that Tikshna-Manjushri may also have been introduced into China in the thirteenth or fourteenth century.

The style of the sculpture belongs to a long artistic tradition that can be traced to eastern India (Bangladesh and the present-day Indian states of Bihar and West Bengal) in the eleventh and twelfth centuries, which then spread to Nepal and Tibet. The flowering of the Nepali variant of the style during the Yuan dynasty (1271–1368) is often linked to the influence of Anige (1245–1306), a young Nepali artist who was brought to Beijing in 1262 by Chogyal Phags'pa (1235–1280), an influential Tibetan monk of the Sakya sect and state preceptor for Khubilai Khan (1215–1294), the founder of the dynasty. Anige played an important role at the Mongol court, serving as the director of all artisan classes and the controller of the Imperial Manufactories Commission.[5] At least two artists, his son Acenge and a Han Chinese named Li Yuan, are known to have worked in his style.

FIGURE 109. Text found inside Manjushri sculpture (cat. no. 37)

One of the earliest known examples of a work in a distinctly Chinese version of the style presumably introduced by Anige is a gilt-bronze sculpture of the bodhisattva Manjushri in the Palace Museum, Beijing, which is identified by an inscription on the base and is dated 1305 (fig. 108).[6] The smooth torso, broad shoulders, and long legs of the bodhisattva derive from Indian traditions, as do the thin clothing and some of the jewelry, such as the armbands. The large circular earrings; the broad, somewhat square face with high cheekbones and elegant, curved eyebrows; and the prolific use of inlays, on the other hand, stem from Nepali and Tibetan traditions. Broad faces with thin, elongated features help to distinguish Nepali sculptures from those made in India.

Although the introduction of this Indo-Nepali artistic tradition is often linked to Anige and his followers, surprisingly few extant works in this style can be dated to the fourteenth century. Numerous examples produced during the reign of Zhu Di (1360–1424; r. 1403–24), the third emperor of the native Ming dynasty, are known, however, and the style continued into the sixteenth century. Zhu Di, who used the reign name Yongle, followed later Esoteric (Tibetan) Buddhist practices and sponsored the production of numerous elegant, beautifully cast Buddhas and bodhisattvas in the Indo-Himalayan style, such as this representation of Manjushri. The soft folds in the scarf draped over the bodhisattva's shoulders and arms and the loose pleats of the saronglike undergarment are typical of works produced in the imperial workshops during the Yongle reign, as is the careful casting of the back. The delicacy of detail and the rich pink tones of the gilding are also characteristic of works produced at court during this period.

The sculpture retains its consecratory or dedicatory material, including several bunches of textiles; packets of Tibetan paper containing seeds, semiprecious stones (such as turquoise), and ground-up roots (see fig. 110); and a fifty-six-inch-long (142 cm) scroll written in red ink on blue paper (fig. 109).[7] The latter is largely in Tibetan but is glossed with Chinese characters that identify the text as a discussion of a four-armed image of the bodhisattva Manjushri.

TECHNICAL NOTES

Aside from the sword, this leaded-brass sculpture was cast entirely in one piece by the lost-wax method. Small round core pins of copper, which held the core immobile during casting, are particularly visible inside the base. Most of the fine details were molded in the wax and enhanced by chasing after casting. The inscription was engraved after casting and prior to gilding. The sculpture is mercury-amalgam gilded

FIGURE 110. Interior of Manjushri sculpture (cat. no. 37)

overall and was painted in the Tibetan style; traces survive of the cold gold paint that originally covered the face. The hair was originally painted with ultramarine blue and later with carbon black. The lips were vermilion red, and the eyebrows were black. Some of the gemstones in the jewelry have a red glaze on them. A copper plate covers the base to contain the consecratory material and is presently held in place with red wax.

PROVENANCE

J. J. Lally & Co., New York; Christie's, New York

PUBLICATION

New York 2005, pl. 25

NOTES

1. *Da Ming Yongle nian shi* (大明永樂年施).
2. These are generally not canonical texts but dictionaries or encyclopedias listing the various forms of the many divinities in the Esoteric pantheon. For one example, see Clark 1937, pp. 322–23.
3. Sheila Bliss (1996) has suggested that sculptures with this iconography may represent another form of Manjushri known as Vajrananga-Manjughosha.
4. For illustrations, see Goepper and Poncar 1996, pp. 96–97.
5. A good overview of Anige's role at the court is found in Jing 1994.
6. For a full transcription of this inscription, see *Zhongguo Zang chuan fo* 2002, vol. 2, p. 47.
7. This group of objects is reminiscent of the ritual deposits often found in Korean Buddhist sculptures during the Joseon dynasty (1392–1910) and earlier, which include packets of seeds and grains, often in groups of five, as well as textiles and threads, differently colored and grouped by five. This Korean practice is discussed in Yi 2005. The author of this entry is grateful to Dr. Unsook Song for this information.

38. Daoist Immortal Laozi (老子)

Chen Yanqing (active 15th century)
Zhejiang Province, Ming dynasty (1368–1644), dated 1438
Gilt brass; lost-wax cast
H. 7¼ in (18.4 cm)
Purchase, Friends of Asian Art Gifts, 1997
1997.139

The immortal sits behind an armrest with three cabriole legs that issue from the jaws of lions and terminate in paws. The clothing and the distinctive hat, in particular, help to identify the sculpture as a representation of one of the Three Purities (Sanqing), an important triad in Chinese Daoism beginning in the Tang dynasty (618–906). The full beard further identifies the sculpture as an image of the Celestial Worthy of the Way and Its Virtue (Daode Tianzhu), the member of the triad popularly known as Laozi. Although it is still a matter of debate whether this ancient sage lived in the sixth or the fourth century B.C.E., and even whether he lived at all, Laozi, his imagery, and his (purported) thoughts and practices have played a critical role in Daoism for centuries.

The term "Daoism" (the Chinese character *dao* is usually translated as "way" or "path") is used to define an amalgamation of beliefs and practices that include the quest for immortality; metaphysical and philosophical speculation; and the ability to become a sage, or a fully realized individual. Although the first written records of these beliefs and practices can be traced to the third and second centuries B.C.E., they are generally understood to refer to earlier traditions that may originally have been transmitted orally. The first mention of Laozi and his lifetime is found in *Records of the Historian* (the *Shiji*), written by the famed Sima Qian (145–86 B.C.E.), who discusses therein Laozi's authorship of the generative *The Way and Its Virtue* (the *Daodejing*) and tells of the sage's discomfort with his life at court and his disappearance into the mysterious lands to the west.[1] *The Way and Its Virtue* is preserved today as a collection of short aphorisms assembled by the scholar Wang Bi (ca. 226–249 C.E.). This text played a critical role in the formation of Daoist practices from the second to the fourth century, when several existing traditions coalesced into a more formalized group of practices.

Interestingly, representations of both Daoist and Buddhist figures appeared in Chinese art around the second and third centuries C.E., and it has been suggested that the development of Daoist icons was spurred, to some degree, by the importation and use of Buddhist images. Moreover, Daoist terms were often used to explain or translate Buddhist concepts when Buddhism first reached China. Indeed, the two "religions," as well as the other major Chinese tradition, Confucianism, had a complicated relationship, often borrowing from one another but also undergoing periods of competition and distrust. Both Daoism and Buddhism evolved continuously in China as new practice traditions were created and different divinities, or new manifestations of older divinities, were emphasized. Both also responded in varying ways to the renaissance of Confucianism in the twelfth century; similarly, many Confucian thinkers were aware of and responded to Daoist and Buddhist thought and practices. The first official canon of Daoist writings was compiled in the early fifteenth century, during the Ming dynasty, as a result of the practice of Daoism at court and within literati circles.

An abraded inscription on the back of the legs identifies the sculpture as the work of Chen Yanqing, a member of a family of artists working in Zhejiang Province, in southeastern China. It also gives the cyclical date *wuwu*, which is read here as 1438. Finally, the inscription suggests that the sculpture may have been made for use in a temple that has not yet been identified.

TECHNICAL NOTES

This hollow gilt-brass sculpture was cast in one piece by the lost-wax method. It is a thick, segregated casting, varying from ⅛ to 3/16 inch (3 to 5 mm) in thickness. None of the core remains, except for a small amount in the top of the head. Thin triangular core pins, similar in shape to those in no. A63, are located in the chest and back. A small hole in the back of the hat originally held ornaments, which are now missing. Fine chasing produced an elaborate design on the borders of the robe and delicate lines in the hair and eyebrows. The surface is mercury-amalgam gilded. No traces of pigments were found.

The lengthy inscription on the back of the legs was incised in the wax before the figure was cast. The inscribed area was never gilded, and sections of it are worn, making the text difficult to read. Chiseled metal fins around the bottom edge confirm that the sculpture was originally closed with a metal plate, which would not have covered the inscription. It is possible that, like Buddhist sculptures, some Daoist sculptures once held religious deposits.

PROVENANCE

J. J. Lally & Co., New York; Christie's, New York

PUBLICATION

Metropolitan Museum of Art 2008, p. 19

NOTE

1. This citation later led to a belief that Laozi was the historical Buddha, who had returned to China.

OPPOSITE: CAT. NO. 38

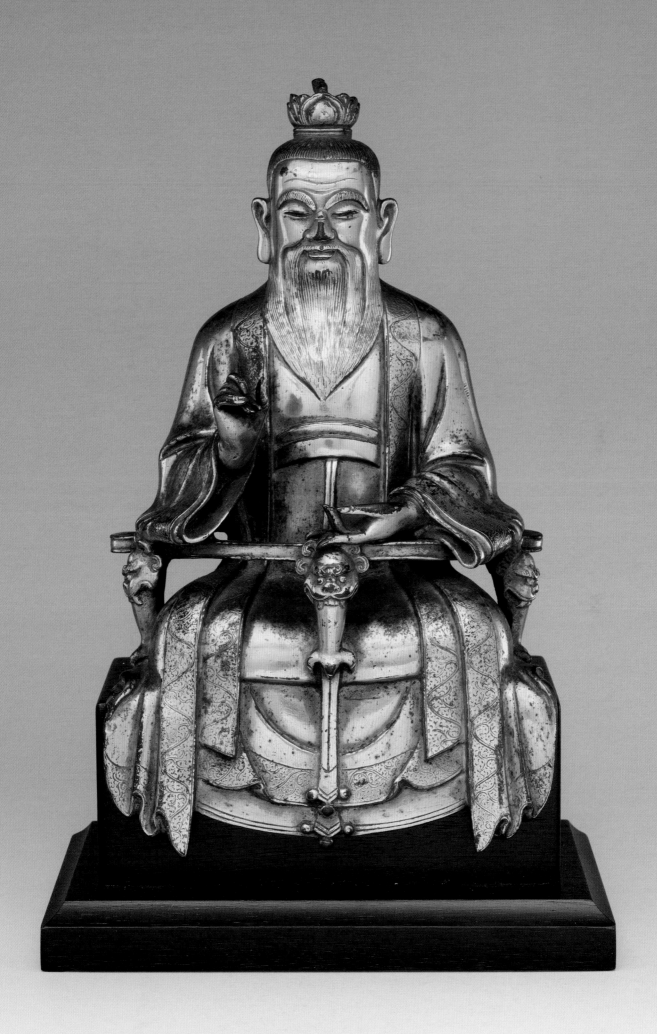

39. Buddha, possibly Amitabha (Amituo 阿彌陀佛), on a Peacock

Ming dynasty (1368–1644), 15th century
Wood (linden) with traces of pigment; single-woodblock construction
H. 21¾ in. (55.2 cm)
Rogers Fund, 1929
30.76.167

Securely dated to the fifteenth century,[1] this modest sculpture may be a unique example of a Chinese icon showing a Buddha riding on a peacock. The choice of mount suggests that the sculpture may relate to the Esoteric Buddhist traditions that are now best preserved in Tibet. Introduced into China around the tenth century, late Esoteric (Vajrayana) Buddhism flourished during the Yuan (1271–1368) and early Ming dynasties. In the Vajrayana view, the pantheon of Buddhist deities is divided into five families, each headed by a Buddha. The identities of the five Buddhas are not entirely consistent;[2] however, most lists proceed from Vairocana to Akshobhya, Amitabha, Ratnasambhava, and Amoghasiddhi. Within this scheme, the Buddha Amitabha is the head and progenitor of the lotus family and is associated with fire, the color red, summer, the west, and the power of meditation; moreover, he rides a peacock. The five Buddhas are sometimes depicted individually in the visual arts but are also found in sets, and it is possible that this sculpture was once part of a group that included representations of the other four.

Devotion to the Buddha Amitabha has a long history in China; by the sixth century, he was the most important divinity in the Pure Land tradition, which focuses on the possibility of rebirth in Sukhavati, Amitabha's perfected world, where conditions are conducive to the pursuit of enlightenment. The Buddha Amitabha is frequently depicted in both sculpture and painting, and he is often shown with two attendant bodhisattvas.

Here, the Buddha sits with his legs in a meditative posture and holds his damaged right hand in the gesture of reassurance. His left hand rests on his lap. He wears the standard monastic cloak, and an undergarment that falls from his left to his right side, with a wide hem and a bow, is visible at the chest. Both the figure and his mount were once brightly painted, and traces of green and blue can still be seen in the Buddha's clothing and in the bird's tail. The peacock stands frontally on a lotus pedestal that also supports several rounded forms, possibly intended to represent wish-granting, or *cintamani*, jewels. The peacock's wings are rendered as a series of semicircles that terminate in long horizontal lines. Some of the tail feathers point downward, but most are raised in the dramatic display that is characteristic of the male of the species. As is often the case in East Asian representations, the shaft of each tail feather terminates in a heartlike shape.

FIGURE 111. Detail of back of Buddha (cat. no. 39) showing small chamber without cover

TECHNICAL NOTES

The Buddha and the body of the peacock, as well as the circular base and wish-granting jewels, were carved from a single block of linden (also known as limewood). The large tail is a separate piece of linden with a tab on the bottom that keys into a slot cut into the rear of the peacock. Small holes located on either side of the base of the tail are aligned with holes in the rear of the peacock; dowels would have been inserted through these holes to steady the tail. A small chamber with a separate cover was cut into the back of the Buddha (see fig. 111). Although the work was once brilliantly painted, pigment can now be seen only in the recesses. As is typical of the wood sculptures in the catalogue, a white ground is present under all the colors.

PUBLICATION

Priest 1944, cat. no. 80

NOTES

1. The radiocarbon date range is cal A.D. 1420–80.
2. See Bhattacharya 1985.

OPPOSITE: CAT. NO. 39

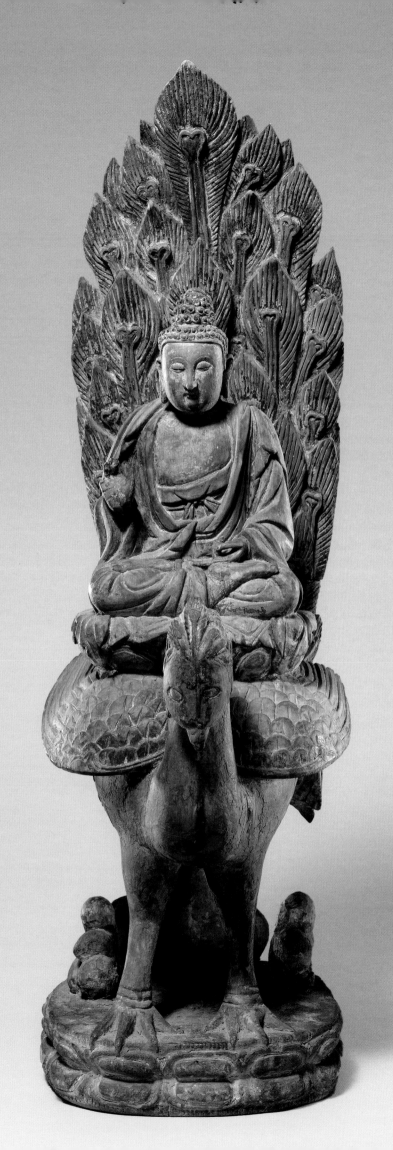

40. Bodhisattva Avalokiteshvara of the Lion's Roar, or Simhanada Avalokiteshvara (Shi Hou Guanyin 獅吼觀音菩薩)

Ming dynasty (1368–1644), late 15th–early 17th century
Wood (poplar) with pigment; single-woodblock construction
H. 42⅛ in. (107 cm)
Purchase, The Dillon Fund Gift, in honor of Brooke Astor, 2000
2000.270

Two bodhisattvas are identified by the fact that they some-times ride a lion: one is Manjushri, the bodhisattva of wisdom, who is frequently shown on this mount; the other is Avalo-kiteshvara, the bodhisattva of compassion, who sits on a lion in his Simhanada form. In both, the implied roar of the lion symbolizes the intensity of the moment of enlightenment. Here, the lion's recumbent pose and the bodhisattva's side-ways position suggest an identification as Avalokiteshvara, although the telltale seated Buddha in the headdress is miss-ing. Moreover, the raised right leg and pendant lower leg are often found in representations of Avalokiteshvara, including the well-known "water-moon" form. This posture is rarely used for icons depicting Manjushri.

The earliest textual reference to this rare form of Avalo-kiteshvara appears in the *Garland of Sadhanas* (*Sadhanamala*), the great iconographic compendium assembled by the Indian monk-scholar Abhayakaragupta in the late eleventh century, where the manifestation is thought to have had the ability to heal diseases. A few Indian representations are known from the eleventh and twelfth centuries.[1] An unusual Chinese sculpture showing Avalokiteshvara seated on a lion, made of iron and dated 1112, is preserved in Japan,[2] suggesting that this form of the bodhisattva may have been introduced into China with other late Esoteric practices around the twelfth century. Interestingly, in later Chinese traditions, various forms of Avalokiteshvara are shown either riding or accompa-nied by a lion or lionlike creature; it is plausible that Simhanada Avalokiteshvara had melded with popular Chinese manifesta-tions, such as that of the bodhisattva as the "bestower of sons."[3]

In the Museum's work, Avalokiteshvara wears a narrow filament that may once have supported a larger crown, a torque from which two strands of beads and a larger pendant are suspended, and armlets. The traditional saronglike garment is visible beneath the large shawl that covers both shoulders, and a scarf is tied at the center of the chest. The broad, somewhat square face and the thick garments reflect traditions dating to the twelfth and thirteenth centuries, revived in the fifteenth and sixteenth centuries. The wide hem near the raised right foot is not found earlier, however, and the bodhisattva's flat physique is typically Ming, as is the full but unarticulated body of the lion. The creature has a long tail and comparatively short legs, and the patterned treatment of the mane, the tail, and the front of the chest further parallels Ming-dynasty representations of various real, mythical, and hybrid creatures.

TECHNICAL NOTES

Remarkably, this figure, including the right arm, and its mount were carved from a single, solid, enormous block of poplar. The radiocarbon date ranges for the sculpture are cal A.D. 1430–1520 and 1590–1620. Clearly, the sculpture was intended to be viewed only on three sides, as the detailed carving and decoration are not present on the back. Patchy remnants of gilding were found on the front of the bodhisattva but not on the back or anywhere on the lion. A gilded *pastiglia* design (raised design within the ground), typical of the Ming period, is present in the decorative border of Avalokiteshvara's garment.

A thorough analysis of the pigments was carried out. There are as many as ten paint layers in some places. The average original stratigraphy ranges from two to six layers of color, interspersed with ground layers. All the original layers are bound in a protein medium.

The wood was prepared with a whitish kaolin ground containing scattered particles of red ocher. Originally, the flesh appears to have been painted orange with red lead and later gilded at least twice. Traces of indigo survive in the hair, suggesting that it may have been painted dark blue. The robe was originally painted yellowish orange by superimpos-ing yellow ocher over an orange layer of red lead. Bright orange patches of red lead are now visible in some areas of losses in the drapery.

The lion's fur was painted naturalistically overall with a mixture of yellow and reddish ocher. In contrast, the carved areas of the mane were colored a bold red-orange with a mixture of vermilion and red lead. The decorative band along the lion's throat and chest was painted with the same bold pigment mixture. The white eye of the lion (lead white) and its red outline were also painted over the fur color, accounting for the highest number of paint layers found on the sculpture. The outline was made with vermilion over a layer of red lead. This technique, also found in a later repainting of the decorative band, has been previously reported in the original and later paints of several other Chinese sculptures[4] and appears in cat. no. 36 as well. The rocky base was painted gray to repli-cate the natural color of a rock, and green paint based on atacamite (basic copper chloride) was used to suggest patches of grass.

PROVENANCE
Eskenazi, Ltd., London

NOTES
1. For illustrations, see Niyogi 2001, fig. 12, and Mallmann 1948, pl. 13.
2. See Matsubara 1995, vol. 3, pl. 834.
3. For example, see Lawrence–San Francisco 1994–95, figs. 46, 54. At some point, the lionlike mount seems to have become identified as a *hou* (吼). See Yü 2000, p. 139.
4. See Webb et al. 2007, p. 195.

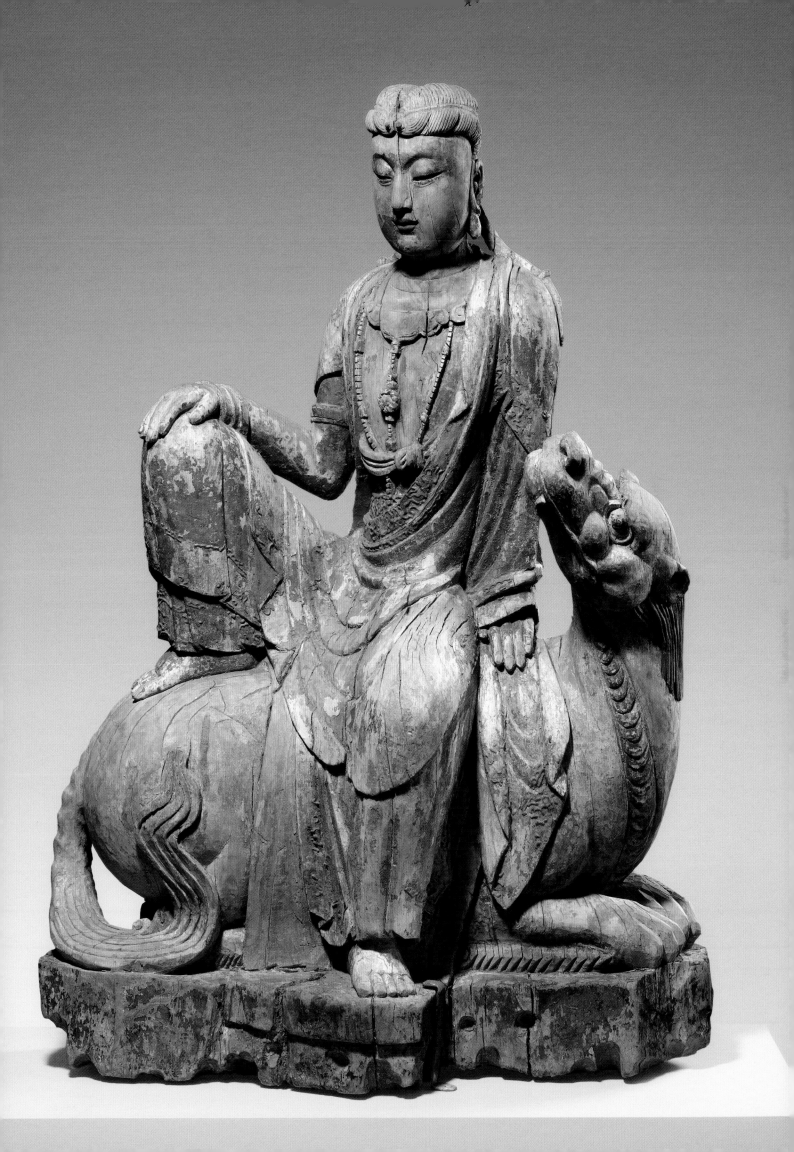

41. Pilgrim Sudhana (Shancai tongzi 善財童子)

Ming dynasty (1368–1644), late 15th–early 17th century
Wood (linden) with pigment, lacquer, and gilding; single-woodblock construction
H. 27½ in. (69.9 cm)
Gift of Abby Aldrich Rockefeller, 1942
42.25.6

The prayerful gesture and upturned head and eyes identify this sculpture as a representation of Sudhana, a young acolyte who often serves as an attendant to the bodhisattva Avalokiteshvara, especially in his Pure Land, Potalaka. Sudhana is the protagonist of the Gandavyuha, the last chapter of the enormously influential Flower Garland Sutra. According to the text, under the tutelage of the bodhisattva Manjushri, Sudhana sought out and studied with fifty-two learned teachers, including several bodhisattvas, in a quest to gain deeper spiritual understanding and become enlightened. One of his teachers was Avalokiteshvara, whom he visited in Potalaka; after the twelfth century, small images of Sudhana gazing up at a larger representation of Avalokiteshvara became common in Korea and Japan as well as in China. A young woman known as the Dragon Girl is sometimes shown with the pair as a visual response to texts that state that Avalokiteshvara taught an invocation, or *dharani*, to a Dragon King and his daughter while visiting their undersea realm. It is likely that this lively sculpture was once part of a larger group.

Sudhana has bare feet and wears a long saronglike garment over leggings. An unusual jacket with very full sleeves falls from the lower part of his shoulders. The clothing, particularly the ends of the sleeves, the back of the jacket, and the hems of the skirtlike piece, flutters dramatically as if blown by the wind—a condition probably consistent with the climate of the island off the coast of Zhejiang that had long been identified with Potalaka and was well known to visitors and pilgrims after the twelfth century.

Remnants of the standard green, blue, and red paints that were used on Chinese Buddhist sculptures are found on the surface. Sudhana's full but flat physique, the thickness of the clothing, and the stylization and patterning of the pleats point to a date in the second half of the Ming dynasty.

TECHNICAL NOTES

The sculpture was carved, in the main, from a single block of linden; six separate pieces were attached to it, perhaps originally with wood dowels, although today only modern nails can be detected. The additions are the clasped hands (carved as a single unit); the toe section of each foot; the tip of each sleeve; and the back hemline of the robe. Examination of the grain structure of the separate pieces in radiographs confirms that they were probably carved from the same type of wood. Two small wood dowels, which perhaps originally held ribbons, are located at the outer edge of the clasped hands. The radiocarbon date range for the sculpture is cal A.D. 1470–1660.

The figure has two consecratory chambers, one running the length of the body and the other in the head. Three oval covers in the back and one circular cover in the back of the head provide access to the chambers. The upper third of the chest chamber is painted with vermilion. The rest of the body chamber and the head chamber are unpainted. From the extant low knob at the top of the head, it cannot be determined how much more elaborately the hair was carved or whether it was embellished with ornaments.

Fragmentary evidence of the original lacquering survives in recesses where the surface has been relatively undisturbed, such as the carved areas of the drapery and face, including the lips and eyes; the underside of the figure; and, particularly, the upper part of the legs and the lining of the jacket and skirt. Gold leaf was adhered to a translucent layer of vermilion lacquer applied over a layer of red-orange ocher paint over a gray silica ground. The gilded surface was then lacquered to produce a clear, glossy, and resistant surface.

The pigments currently visible on the surface were applied much later over a white calcium-carbonate ground. A green layer containing the eighteenth-century pigment Prussian blue is found under the current red vermilion of the jacket, and the nineteenth-century pigment emerald green is found in repainting campaigns on the leggings and jacket. The lips were repainted with vermilion directly on the original gilded lacquer, and the flesh was repainted naturalistically with the same red pigment admixed with calcium carbonate. See appendix E for further discussion.

PUBLICATIONS

Priest 1944, cat. no. 65; Shi 1983, pl. 1605

OPPOSITE: CAT. NO. 41

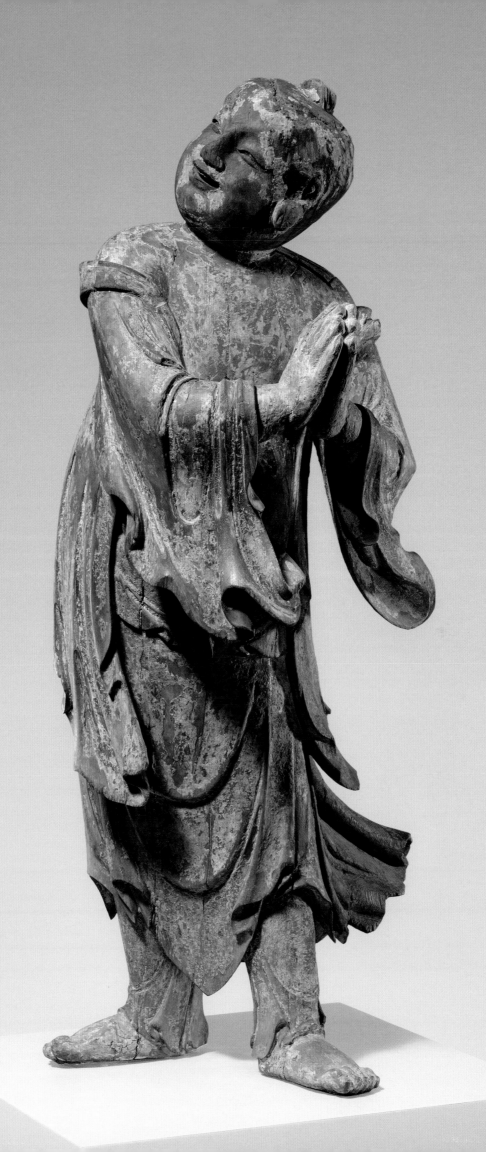

42. Polestar Deity Kui Xing (魁星)

Ming dynasty (1368–1644), 16th–17th century
Leaded tin brass; lost-wax cast
H. 9½ in. (24 cm)
Purchase, Friends of Asian Art Gifts, 1998
1998.146

By the Tang dynasty (618–906), a range of different astrological beliefs and images, as well as less formalized and regional practices, had been incorporated into Buddhism and Daoism.[1] Some stemmed from native Chinese traditions that had developed, or at least been codified, during the Han dynasty (206 B.C.E.–220 C.E.); others, introduced with Buddhism, alluded to Indian, Central Asian, and Greek astrological systems. This unprepossessing figure, known as Kui Xing, is one of a host of embodied stars that played roles in various devotions. He is usually identified with Polaris, or the North Star, the earth's current polestar, found at the end of the constellation Ursa Minor (also known as the Little Dipper).[2]

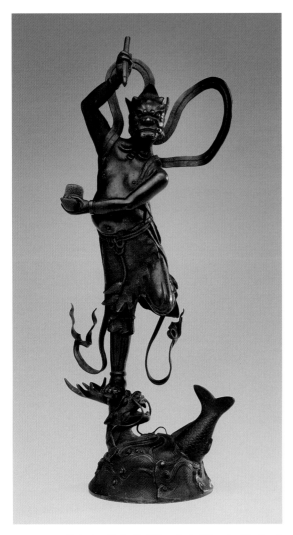

FIGURE 112. Polestar Deity Kui Xing. Late Ming (1368–1644) or early Qing (1644–1911) dynasty, 16th to mid-17th century. Gilt bronze, H. 11 in. (28 cm). Royal Ontario Museum, Toronto, Gift of Prof. E. A. Dale

Often associated with Wen Chang, another such being who was revered as the patron of literature, Kui Xing was thought to have the ability to ensure success in the demanding civil-service examinations without which it was impossible to achieve a position in the government bureaucracy. Sculptures of Kui Xing were often found in temples and shrines dedicated to Wen Chang, and both deities were popular in the art of the Ming and Qing (1644–1911) dynasties.[3]

This sculpture illustrates the standard iconography for Kui Xing. He stands on one foot with the other raised behind him and holds his right hand above his head and his left before him. A work in the collection of the Royal Ontario Museum, Toronto (fig. 112), shows Kui Xing standing on the head of a fish, probably a carp. The combination of this fish and the stubby horns on Kui Xing's head can be understood as a reference to the idea of a carp leaping a waterfall and turning into a dragon—a euphemism for the successful completion of the grueling civil-service examinations. The deity's raised hand is often shown holding a pen, another reference to the examination process. Moreover, the Chinese character for "pen" is pronounced *bi*, a homonym for the word "must"; in other words, one *must* succeed at the examinations. In the case of the Museum's sculpture, the rounded object held in the right hand is usually understood as an ingot, representative of the financial rewards of civil service.

Several explanations are given for Kui Xing's unpleasant appearance. He is sometimes thought to have been based on an unfortunate historical figure who drowned himself after having been deemed too unattractive to work at court. Another explanation derives from the meaning of the deity's name: *kui*, which means "eminent," is composed of the ideographs for "demon" and "dipper." (*Xing* is translated as "star.")

Here, Kui Xing wears a long jacket with long, full sleeves that ties in the center of his chest and is superimposed by a long scarf that falls along the sides and flutters toward the back (see following spread). The skirtlike lower garment and leggings are often found in representations of subsidiary figures, such as the young pilgrim Sudhana (see cat. no. 41), in later Chinese religious art. The wide lapels of the coat and the rendering of the folds of the lower garment as large, looping arcs date the sculpture to the sixteenth or seventeenth century.

TECHNICAL NOTES

The sculpture was cast in one piece by the lost-wax method in a quaternary alloy of copper, zinc, tin, and lead. The core runs from the head into the torso and ends at midcalf. The location of core pins could not be determined, although iron corrosion products on the back of the head may be

OPPOSITE: CAT. NO. 42

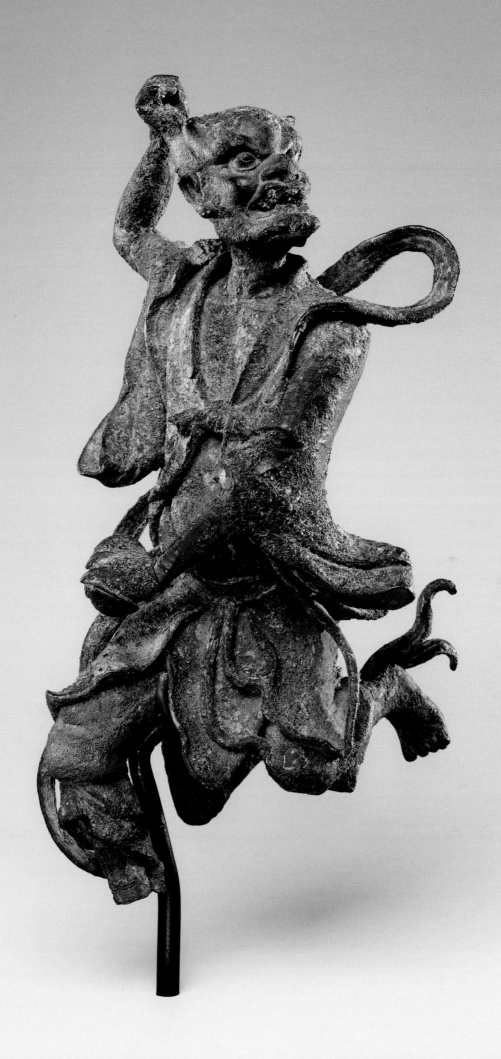

the remains of an iron core pin. The end of an iron rod (possibly part of an armature) is exposed between the legs. Radiographs show that the rod runs up into the center of the chest; it may originally have extended out from between the legs in order to support the figure during casting or to mount it after casting. An ancient lead repair is located in the shoulder. No evidence of decorative inlay, pigment, or gilding was detected.

PROVENANCE
Joseph G. Gerena Fine Art, New York

PUBLICATION
Metropolitan Museum of Art 2008, p. 43

NOTES
1. For an overview, see Birnbaum 1980.
2. For a more precise discussion of the relationship between Western constellations, Polaris, and Chinese astronomy, see Werner 1932, p. 554.
3. Kui Xing is also sometimes shown as a young boy.

43. Chan Patriarch Bodhidharma (Damo 達摩)

Fujian Province, Ming dynasty (1368–1644), 17th century
Glazed porcelain; Dehua ware
H. 11¾ in. (29.8 cm)
Gift of Mrs. Winthrop W. Aldrich, Mrs. Arnold Whitridge, and Mrs. Sheldon Whitehouse, 1963
63.176

Archaeological evidence indicates that the kilns near Dehua, Fujian Province, on China's southeastern coast, opened in the late thirteenth century and flourished after the sixteenth, when they became known for their distinctive white porcelains with thick, lustrous glazes.[1] Frequently exported to Europe in the seventeenth and eighteenth centuries, the ceramics produced in Fujian are often known by the French term "blanc de chine," which was coined in the nineteenth century. In addition to sculptures of religious figures, such as this example,[2] the Fujian kilns produced items for the preparation and serving of food as well as brush holders, inkstands, ink stones, and other goods used by the scholarly class. The best porcelains of this type, with glazes ranging from satiny white to a blue or rosy hue, are classified as Dehua wares, while lesser examples are known as Fujian wares. It is thought that there were at least thirty kilns producing these ceramics in the seventeenth and eighteenth centuries.

The bald head, meditative posture, and monastic clothing identify the sculpture on the following spread as a representation of Bodhidharma,[3] the foreign monk credited with founding the Chan tradition of East Asian Buddhism (known in Japanese as Zen). He is shown seated on a straw or grass mat—a long-standing emblem for austerity—and has curly eyebrows, a beard, a mustache, and locks of hair over his ears and at the nape of his neck. The astonishing fluidity of his clothing, in particular, illustrates the subtle sculpting and molding for which the Fujian potters were noted.

Bodhidharma first appeared in historical writings in the *Record of the Buddhist Monasteries of Luoyang*,[4] written in 547, where he is described as a monk of Central Asian or Persian origin who was active at the Northern Wei (386–534) capital, Luoyang. In later texts, he is described as a monk of South Indian or Tamil origin. Bodhidharma is said to have reached southern China by sea and to have spent time at the court of the powerful Liang dynasty (502–57) before difficulties forced him to flee north to the contemporaneous Northern Wei court. Legend recounts that he crossed the Yangzi River, separating northern and southern China, while standing on a reed. He was also renowned for having spent nine years seated in a cave, facing a wall and meditating. Both events are frequently depicted in the visual arts. In one explanation of the development and transmission of Chan practices, Bodhidharma is said to have been interrupted during his heroic meditation by Huike, a Chinese monk who is also revered as one of the founders of the tradition and famed for having cut off his arm to prove his commitment.

PUBLICATIONS
New York 1970–71, cat. no. 257; Valenstein 1975a, pl. 115; Valenstein 1975b, fig. 31; Valenstein et al. 1977, pl. 42; Barnhart 1987, cat. no. 58; Dunne 2000, p. 204; New York 2002, cat. no. 30

NOTES
1. Recent overviews of the evolution of Dehua ware can be found in Kerr and Ayers 2002 and New York 2002.
2. The Metropolitan Museum holds at least seventeen other Dehua-ware representations of religious figures. They are not included in this publication largely for reasons of length. However, such works can certainly be understood as examples of sculpture as well as of porcelain, and the author of this entry would suggest that they need to be studied as works of sculpture in order to gain a better understanding of the role of Buddhist and Daoist art and imagery during the Ming and Qing dynasties. It should also be noted that the use of porcelain for religious images can be traced to the fourteenth century and the Qingbai kilns in Jianxi Province. For two examples, see nos. A51 and A52 in appendix A.
3. For a brief overview of Bodhidharma's biography, see Broughton 1999. The Chinese name for Bodhidharma, Damo, is a shortening of the transcription of his name, which is more properly given as Putidamo (普提達摩).
4. For a translation of this text, see Yang Hsüan-chih 1984.

OPPOSITE: CAT. NO. 43

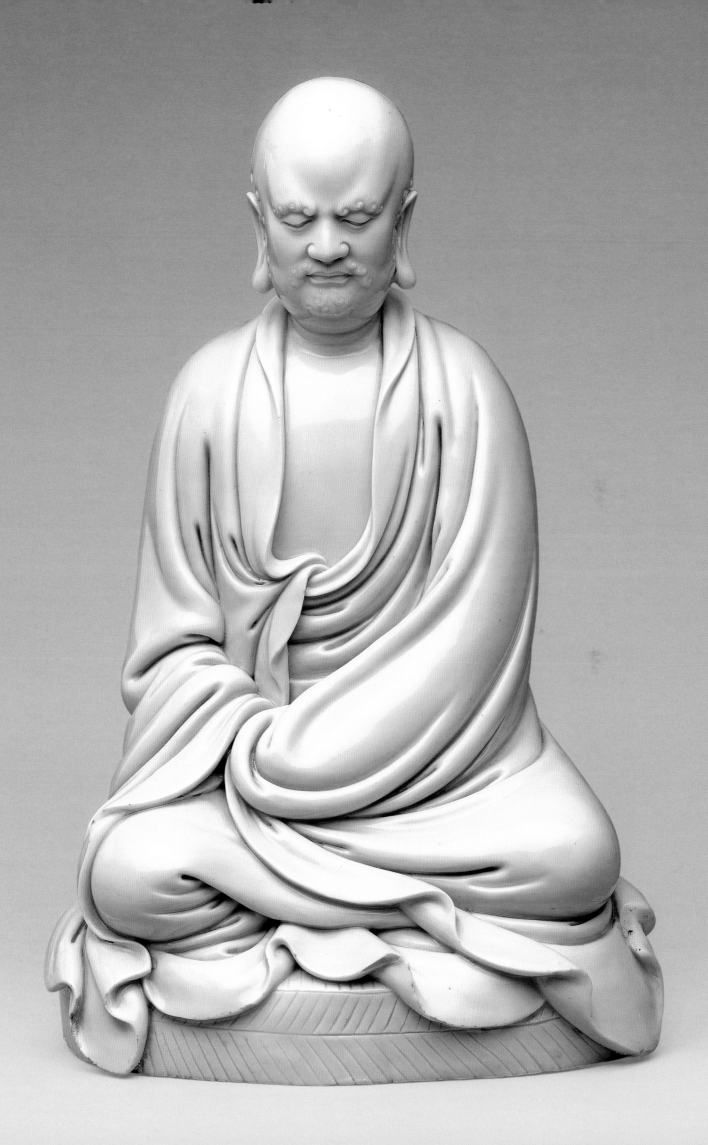

44. Buddhist Divinity Ushnishavijaya (Zun Sheng fo mu 尊勝佛母)

Qing dynasty (1644–1911), late 17th–18th century
Gilt brass; lost-wax cast
H. 7 in. (17.8 cm)
Purchase, Friends of Asian Art Gifts, 2007
2007.75a, b

The implements she holds identify this eight-armed goddess as Ushnishavijaya, one of several female divinities who began to play a prominent role in Indian Buddhism in the seventh and eighth centuries. She is understood to personify the *ushnisha*, or cranial protuberance that marks a Buddha, and she is, by extension, associated with practices focusing on spiritual understanding. These practices played a critical role in the flowering of later Esoteric Buddhism, particularly the variant of the tradition best known today in Tibet.

Records preserved in East Asia suggest that Ushnishavijaya was known in China by the seventh century. Devotion to her is said to have been introduced into China by the Indian monk Buddhapali during his quest to encounter the bodhisattva Manjushri in his sacred abode on Mount Wutai.[1] One of the earliest preserved examples of the invocation, or *dharani*, in her honor, which also dates to the seventh century, is found in the collection of the famed Hōryū-ji (Hōryū temple) in Japan.[2] The Museum's sculpture follows the description of the goddess given in the late-eleventh-century *Garland of Sadhanas* (*Sadhanamala*), where she is described as having three faces and eight arms. Two of her three visages are calm, while the third, at the right, is ferocious. She holds a small sculpture of a seated Buddha in her upper right hand and a long rope, used to suspend a two-pronged *vajra*, a ritual implement symbolizing adamantine power, in her upper left. The Buddha is most likely Amitabha, the head of Ushnishavijaya's religious lineage. Another pair of hands brandishes a bow and arrow, while the third pair holds a four-pronged *vajra* before her chest. The right hand of the lowest pair of arms is shown making the gesture of offering, and the left supports a covered vase.

Ushnishavijaya is seated in a posture of meditation on a two-tiered, beautifully cast lotus pedestal. She is encircled by a dense and lively mandorla filled with curlicue forms that may be intended to represent flames. She wears a skirtlike lower garment; a long, narrow scarf that cascades over her shoulders and upper arms; and an additional scarf that is tied at the center of the chest. In addition to a complicated crown, she wears an elaborate necklace, armlets, and anklets.

Stylistically, the sculpture belongs to a long tradition of Buddhist imagery based on eleventh- and twelfth-century Indian and Nepali prototypes that were transmitted to both Tibet and China. The style was particularly important in China during the Mongol Yuan dynasty (1271–1368), which had close ties to Tibet, and was revived during the Qing partly as a result of imperial practice and patronage of Tibetan Buddhism. Strong political and economic connections are reflected in shared religious practices at the Chinese and Mongolian courts and several Tibetan monasteries and in the sharing of styles and iconographies; thus, it can be difficult to distinguish among works produced in the three centers. The subtle roundness in the face, body, and arms of this representation of Ushnishavijaya, however, points to Chinese manufacture, as do the linear flow of the drapery and the length and elegance of the fingers. In addition, the narrow scarf worn diagonally from the left shoulder is typically Chinese and derives from traditions first developed in the early eighth century; such an accessory is rarely found in Tibetan art.

Comparison to a sculpture of another female divinity, Kurukulla (Zhi xing fo mu 智行佛母; fig. 113), which is dated to the Qianlong period (1736–95), helps to date the Museum's sculpture to the late seventeenth or early eighteenth century. Ushnishavijaya's face is softer and has more rounded features than that of Kurukulla. Moreover, Ushnishavijaya's arms are slightly plumper and more articulated than Kurukulla's. Finally, the lively openwork of Ushnishavijaya's mandorla differs from the stiff geometric forms in that encircling Kurukulla.

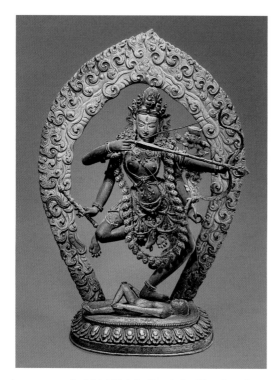

FIGURE 113. Buddhist Divinity Kurukulla. Qing dynasty (1644–1911), Qianlong period (1736–95). Gilt copper alloy, H. 20⅛ in. (51 cm). Palace Museum, Beijing

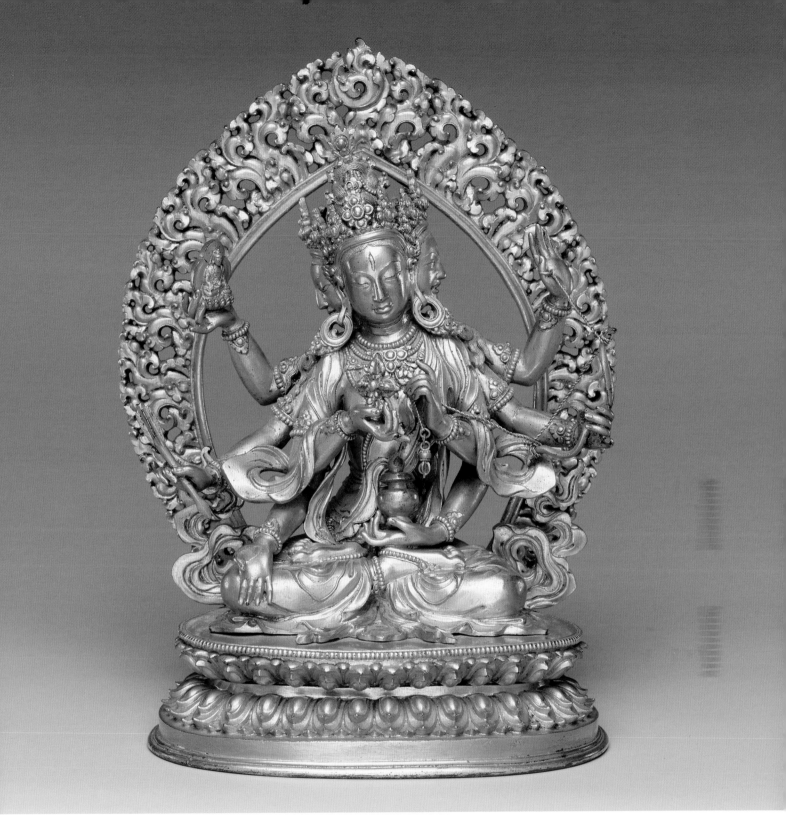

CAT. NO. 44

TECHNICAL NOTES

The fine lost-wax-cast image is made up of multiple pieces, all of which were joined prior to gilding. The torso and head are hollow. The solid arms are riveted to the body, which, in turn, is riveted to the lotus base. Each ornament was cast separately, with its hand, and then attached at the wrist. Pieces of drapery are also riveted to the image. The mandorla was cast separately, with a tang that fits into the lotus base. The upper and lower sections of lotus petals were cast separately and are held together mechanically. The base is closed underneath with a copper plate that was once held on with a black resin. The plate is engraved with a *vajra*, indicating that the work was consecrated and, at one time, held deposits. The hair has traces of a pale blue pigment; no other colorants were detected.

PROVENANCE

Michael C. Hughes, New York

PUBLICATION

Metropolitan Museum of Art 2008, p. 61

NOTES

1. The Sanskrit *dharani* to Ushnishavijaya was translated into Chinese at least fifteen times between the seventh and fourteenth centuries. See Takakusu and Watanabe 1914-32, nos. 967-974, 978, 979, 1409, 1413, 1803. For an interesting discussion of the role of Ushnishavijaya in the Xixia kingdom, see Linrothe 1998.
2. See Müller and Nanjio 1972.

45. Jambhala in White Manifestation (Bai cai bao shen 白財寶神)

Mongolia, 19th–20th century
Brass with pigment, inlaid with copper and silver; lost-wax cast
H. 5¼ in. (13.3 cm)
Bequest of Kate Read Blacque, in memory of her husband, Valentine Alexander Blacque, by exchange, 1948
48.30.12

Jambhala (also known as Kubera) is one of many protective divinities who are associated with wealth in later Buddhist traditions. He takes several forms, which are distinguished by color (red, black, yellow, green, and white) and by the number of arms. In the white form, understood as an emanation of the bodhisattva Avalokiteshvara, he has two arms and helps to guard against worldly attachments. Here, the left arm holds a bar of gold, and the right once held a parasol, most likely separately cast.

The prowling dragon upon which the benevolent divinity sits sideways further identifies him as the white manifestation, as do the objects held in the one of the creature's front paws and both back paws. These wish-granting, or *cintamani*, jewels illustrate Jambhala's ability to grant wishes. The figure's plumpness, which reiterates his wealth-conferring role, is also part of the iconography. He has the flaming hair and glaring eyes that are often given to protective Buddhist divinities and wears a diadem with five ovoid elements, large earrings, short and long necklaces, and matching armlets, bracelets, and anklets. A narrow scarf falls across his chest, looped over itself at both the front and the back. His sarong-like garment is decorated with geometric patterns, including pearl roundels and rhomboids inlaid in silver and copper.

Images of this type, which show White Jambhala seated on a dragon, were particularly popular in China, Mongolia, and Tibet in the nineteenth and twentieth centuries and are linked to the practices of the dominant Geluk tradition, headed by the previous and current Dalai Lamas. This branch of Tibetan Buddhism was founded by the famed theologian Tsongkhapa (1357–1419) in the fifteenth century. The word *geluk* means "virtuous," and Tsongkhapa's movement, which began as an attempt to reform monastic practices and curriculum, evolved over time into several eclectic practices and a highly complicated visual imagery. Introduction of Geluk traditions into Mongolia and China is linked to Ngawang Lobsang Gyatso (1617–1682), the "Great Fifth" Dalai Lama, and his influence at the Mongolian and Chinese courts.

The three centers shared practices and types of images as well as a style based on earlier Indian and Nepali traditions, often melded with Chinese or other styles. For instance, the dragon was a quintessentially Chinese motif that was incorporated into Tibetan and Mongolian imagery after the seventeenth century. The attribution of the Museum's sculpture to Mongolia is based on the treatment of the narrow scarf tied across the chest. This type of garment, worn in this fashion, is a Chinese convention that first appeared in the eighth century and was widely depicted thereafter. It is rarely found in

FIGURE 114. White Jambhala. Mongolia, 19th–20th century. Ground mineral pigment on cotton. Collection of Rainy Jin and Johnny Bai

Tibetan art[1] but does appear in Mongolia, particularly in the nineteenth and twentieth centuries. Both the jewelry worn here and the placement of the scarf over the adornments are similar to the representation of the same items in a painting of White Jambhala from Mongolia (fig. 114).

FIGURE 115. Detail of pigment on dragon's face (cat. no. 45)

OPPOSITE: CAT. NO. 45

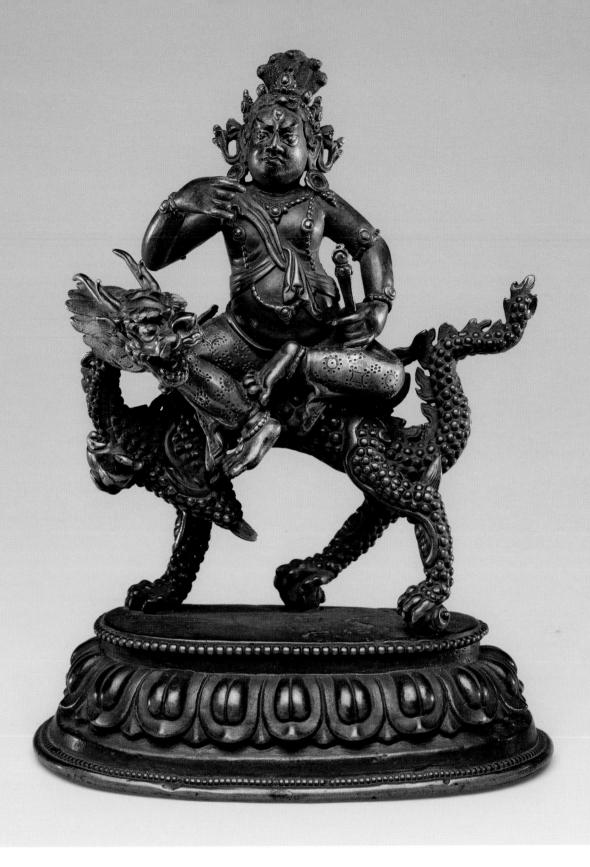

TECHNICAL NOTES

The sculpture was finely cast in one piece, of brass with no lead, by the lost-wax method. Radiographs confirm that it is solid, with no core. Silver and copper inlays are present in the clothing, bracelets, nipples, and eyes. The sculpture was once extensively painted (see fig. 115). Detailed information about pigments analyzed by X-ray fluorescence is given in appendix E.

PUBLICATIONS

Getty 1914, p. 159; Pal 1969, cat. no. 78; New York 1971, cat. no. 43

NOTE

1. The only sculpture the author of this entry can identify that is catalogued as Tibetan and wears a scarf in this fashion is illustrated in Schroeder 1981, fig. 125B. For a very similar image of Jambhala that is attributed to Tibet, but without the scarf, see fig. 138D in the same volume.

Additional Works in the Collection

A1. Head of Bodhisattva

Shanxi Province (Yungang complex), Northern Wei dynasty (386–534), late 5th century. Sandstone with traces of pigment, H. 14 in. (35.6 cm). Gift of Abby Aldrich Rockefeller, 1942 (42.25.11)

PUBLICATIONS: New York 1940, cat. no. 37; Priest 1944, cat. no. 9; Howard and He 1983, cat. no. 2

A2. Bodhisattva, possibly Maitreya (Mile 彌勒菩薩)

Henan Province (Longmen complex, probably Guyang cave), Northern Wei dynasty (386–534), early 6th century. Limestone, H. 18 in. (45.7 cm). Fletcher Fund, 1939 (39.190)

PROVENANCE: Bin Chi Company, Beijing

PUBLICATIONS: Lippe 1961, p. 31; Chang 2007, fig. 7

A3. Figure in Pensive Pose (siwei 思維像)

Henan Province (probably Longmen complex), Northern Wei dynasty (386–534), early 6th century. Limestone, H. 20½ in. (52.1 cm). Fletcher Fund, 1939 (39.191)

PROVENANCE: Bin Chi Company, Beijing

PUBLICATIONS: Priest 1944, cat. no. 14; *Nihon Bukkyō* 1984, cat. no. 46; Chang 2007, fig. 14

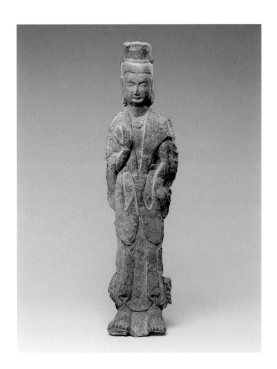

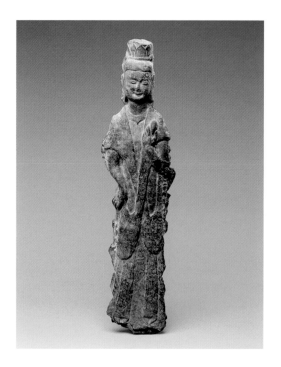

A4. Attendant
Henan Province (Longmen complex, possibly Guyang cave), Northern Wei dynasty (386–534), early 6th century. Limestone, H. 22 in. (55.9 cm). Rogers Fund, 1948 (48.176)
PROVENANCE: Mathias Komor, New York
PUBLICATION: Chang 2007, fig. 10

A5. Attendant
Henan Province (Longmen complex, possibly Guyang cave), Northern Wei dynasty (386–534), early 6th century. Limestone, H. 23¼ in. (59.1 cm). Gift of Mathias Komor, New York, 1948 (48.182.4)
PUBLICATION: Chang 2007, fig. 9

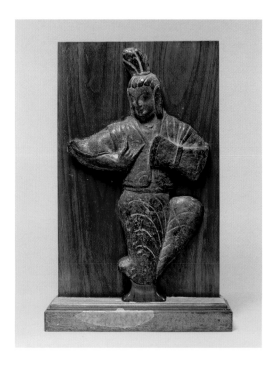

A6. Flying Celestial *Apsara* (*feitian* 飛天)
Henan Province (probably Longmen complex), Northern Wei dynasty (386–534), early 6th century. Limestone, W. 14¾ in. (37.5 cm). Rogers Fund, 1946 (46.53)
PROVENANCE: Mathias Komor, New York
PUBLICATIONS: Flushing 1982, cat. no. 26; Chang 2007, fig. 12

A7. Musician Playing a Drum
Henan Province (possibly Longmen complex), Northern Wei dynasty (386–534), early 6th century. Limestone, H. 14¼ in. (36.2 cm). Gift of Ernest Erickson Foundation, 1985 (1985.214.140)

A8. Head of Bodhisattva, probably Avalokiteshvara
(Guanyin 觀音菩薩)
Henan Province (possibly Longmen complex), Northern Wei
dynasty (386–534), early 6th century. Limestone, H. 21¼ in.
(54.1 cm). Rogers Fund, 1918 (18.56.40)
PROVENANCE: Purchased by curator in Beijing
PUBLICATIONS: Priest 1944, cat. no. 12; Chow 1965, fig. 12;
Howard and He 1983, cat. no. 7; Chang 2007, fig. 13

A9. Stele with Buddha Maitreya (Mile fo 彌勒佛)
Northern Wei dynasty (386–534), dated 533.
Limestone, H. 45 in. (114.3 cm). Gift of Mr. and
Mrs. Alan Hartman, 1967 (67.255)
PUBLICATIONS: Wichita 1977–78, pl. 67; Howard and
He 1983, cat. no. 10

A10. Head of Buddha
Henan Province (possibly Gongxian complex), Northern
Wei (386–534) or Eastern Wei (534–50) dynasty, mid-6th century.
Limestone with traces of pigment, H. 16 in. (40.6 cm). Gift of Abby
Aldrich Rockefeller, 1942 (42.25.36)
PUBLICATION: Priest 1944, cat. no. 16

A11. Buddha (Fragment of a Stele)
Henan Province, Eastern Wei dynasty (534–50),
mid-6th century. Limestone with traces of pigment,
H. 31½ in. (80 cm). Gift of Mr. and Mrs. Earl Morse,
in honor of A. Schoenlicht, 1963 (63.25)
PUBLICATIONS: Berlin 1929, cat. no. 257; Visser 1948,
pl. 80; Howard and He 1983, cat. no. 12

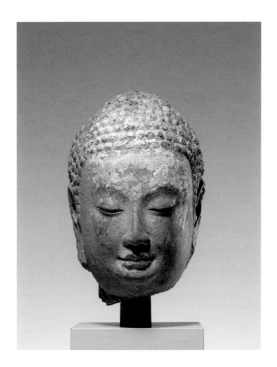

A12. Head of Buddha
Shandong Province, Northern Qi dynasty (550–77),
mid-6th century. Limestone with traces of pigment and
gilding, H. 9½ in. (24.1 cm). Purchase, The Vincent Astor
Foundation Gift, 2001 (2001.422)
PROVENANCE: Gisèle Croes, Brussels

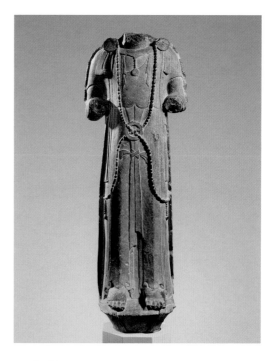

A13. Bodhisattva
Northern Qi dynasty (550–77), mid- to late 6th century.
Limestone with traces of pigment, H. 40½ in. (102.9 cm).
Gift of Mr. and Mrs. Herbert Beskind, 1956 (56.209)
PUBLICATIONS: Hearn and Fong 1974, fig. 60; Howard
and He 1983, cat. no. 17

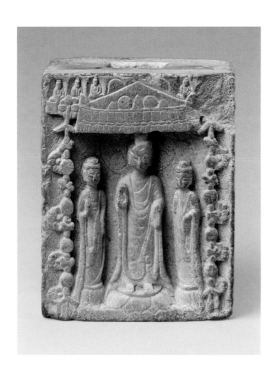

A14. Section of a Pagoda-Shaped Stele
Western Wei (535–57) or Northern Zhou (557–81) dynasty,
mid-6th century. Serpentinite, H. 5 in. (12.7 cm).
Fletcher Fund, 1928 (28.17)
PROVENANCE: Dr. Herbert Müller, Beijing
PUBLICATIONS: Priest 1928a, p. 133; Priest 1944, cat. no. 25;
Howard and He 1983, cat. no. 13; New York 1991b, cat. no. 27

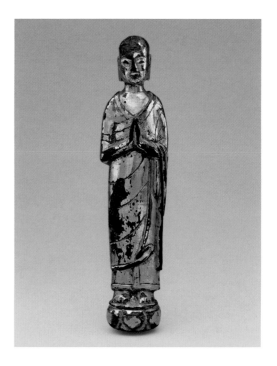

A15. Monk
Northern Qi (550–77) or Sui (581–617) dynasty,
mid- to late 6th century. Gilt leaded bronze, piece-mold
cast; H. 4⅝ in. (11.7 cm). Gift of Harold G. Henderson,
1966 (66.155.5)

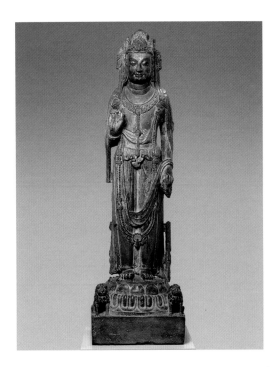

A16. Bodhisattva, probably Avalokiteshvara (Guanyin 觀音菩薩)
Possibly Henan Province, Sui dynasty (581–617), late 6th century.
Limestone with traces of pigment, H. 73 in. (185.4 cm). Gift of
Abby Aldrich Rockefeller, 1942 (42.25.3a, b)
PUBLICATIONS: Priest 1944, cat. no. 27; Xu Jianrong 1998, p. 109

A17. Monk
Sui dynasty (581–617), late 6th century. Leaded bronze,
possibly lost-wax cast; H. 21½ in. (54.6 cm). Rogers Fund, 1928
(28.122.2)
THERMOLUMINESCENCE (TL) DATE RANGE (CORE): 400–1000 C.E.
PROVENANCE: Yamanaka and Company
PUBLICATIONS: Priest 1944, cat. no. 22; Chow 1965, fig. 28

A18. Bodhisattva Avalokiteshvara (Guanyin 觀音菩薩)
Probably Sui dynasty (581–617), late 6th–7th century.
Limestone with traces of pigment, H. 39¾ in. (100.8 cm).
H. O. Havemeyer Collection, Bequest of Mrs. H. O. Havemeyer,
1929 (29.100.32a, b)
PUBLICATIONS: Sirén 1925, pl. 312; Priest 1944, cat. no. 26;
Hearn and Fong 1974, fig. 62

A19. Monk
Sui (581–617) or Tang (618–906) dynasty, late 6th–7th century.
Sandstone with traces of pigment, H. 39 in. (99.1 cm). Gift of
Ernest Erickson Foundation, 1985 (1985.214.144)

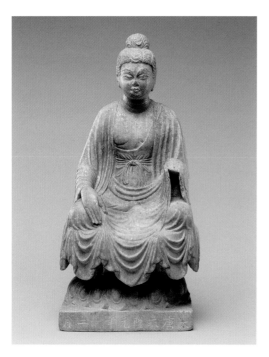

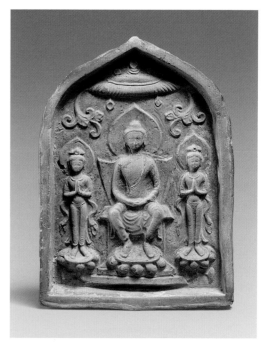

A20. Buddha
Possibly Hebei Province, Tang dynasty (618–906),
dated 680. Marble, H. 21¾ in. (55 cm). Gift of Enid A.
Haupt, 1997 (1997.442.3)
PUBLICATION: Leidy 1997, fig. 10

A21. Votive Tablet with Buddhist Triad
Probably Shaanxi Province, Tang dynasty (618–906),
7th century. Earthenware with traces of pigment,
H. 5¾ in. (14.6 cm). Rogers Fund, 1917 (18.56.29)
TL DATE RANGE: 500–1100 C.E.
PROVENANCE: Purchased by curator in Beijing
PUBLICATION: Howard and He 1983, cat. no. 25

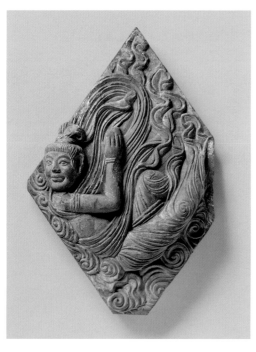

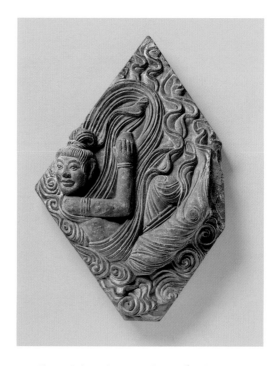

A22. Flying Celestial *Apsara* (*feitian* 飛天)
Henan Province (Xiuding-si pagoda), Tang dynasty (618–906),
7th century. Earthenware with traces of pigment, H. 26¾ in.
(67.9 cm). Purchase, Mrs. Vincent Astor Gift, 1965 (65.178.1)
TL DATE RANGE: 500–1100 C.E.
PUBLICATION: Chow 1965, p. 80

A23. Flying Celestial *Apsara* (*feitian* 飛天)
Henan Province (Xiuding-si pagoda), Tang dynasty
(618–906), 7th century. Earthenware with traces of pigment,
H. 26¾ in. (67.9 cm). Purchase, Mrs. Vincent Astor Gift,
1965 (65.178.2)
PUBLICATIONS: New York 1979, cat. no. 14; Howard and
He 1983, cat. no. 20

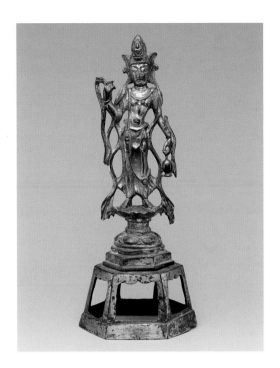

A24. Bodhisattva Avalokiteshvara (Guanyin 觀音菩薩)
Tang dynasty (618–906), late 7th–early 8th century.
Gilt leaded bronze, piece-mold cast; H. 9 in. (23 cm).
Fletcher Fund, 1933 (33.91)

A25. Head of a Monk.
Possibly Henan Province, Tang dynasty
(618–906), 7th century. Limestone, H. 9 in. (22.9 cm). Gift of
Abby Aldrich Rockefeller, 1942 (42.25.10)
PUBLICATIONS: New York 1940, no. 16; Priest, 1944, cat. no. 26

A26. Buddha
Possibly Hebei Province, Tang dynasty (618–906), dated 717.
Marble, H. 12½ in. (31.8 cm). Gift of Ernest Erickson Foundation,
1985 (1985.214.143)
PUBLICATION: Jin 1994, pl. 279

A27. Bodhisattva
Possibly Gansu Province, Tang dynasty (618–906), late 7th–early
8th century. Sandstone with traces of pigment, H. 13½ in. (34.3 cm).
Purchase, Barbara and William Karatz Gift, 2000 (2000.446)
PROVENANCE: Eskenazi, Ltd., London

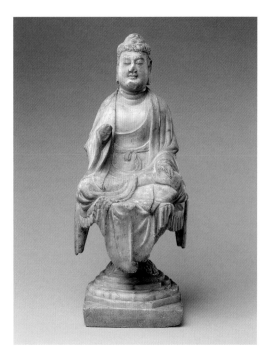

A28. Buddha

Possibly Henan Province, Tang dynasty (618–906), mid-8th century.
Marble, H. 21 in. (53.3 cm). Gift of Ralph M. Chait, 1928 (28.114)
PUBLICATIONS: Sirén 1942a, pl. 10.2–3; Priest 1944, cat. no. 47;
Howard and He 1983, cat. no. 33

A29. Head of Buddha

Possibly Henan Province, Tang dynasty (618–906),
mid-8th century. Limestone with traces of pigment,
H. 5½ in. (14 cm). Gift of Cornelius von Erden Mitchell
and William Mitchell Van Winkle, 1930 (30.38)

A30. Stele with Pure Land Imagery

Henan Province, Tang dynasty (618–906), dated 758.
Limestone, H. 33 in. (83.8 cm). Rogers Fund, 1912 (12.37.130)
PROVENANCE: Takuma Kuroda, Yokohama
PUBLICATIONS: Ōmura 1915, pls. 773–75; Matsubara 1968,
fig. 14; Howard and He 1983, cat. no. 35

A31. Head of Bodhisattva

Henan Province (Longmen complex), Tang dynasty
(618–906), 8th century. Limestone, H. 9¾ in (24.8 cm).
Bequest of Edmund C. Converse, 1921 (21.175.406)
PUBLICATION: Chang 2007, fig. 16

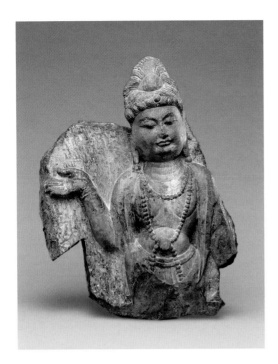

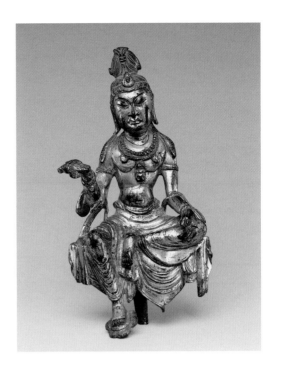

A32. Bodhisattva
Henan Province (Longmen complex), Tang dynasty
(618–906), 8th–9th century. Limestone with traces of
pigment, H. 18½ in. (47 cm). Fletcher Fund, 1940 (40.173)
PROVENANCE: Dikran G. Kelekian, Inc., New York
PUBLICATIONS: Priest 1941, p. 115; Priest 1944, cat. no. 43;
Chang 2007, p. 86

A33. Bodhisattva, probably Manjushri (Wenshu 文殊菩薩)
Tang dynasty (618–906), 8th–9th century. Gilt leaded
bronze, lost-wax cast; H. 7¾ in. (19.7 cm). Gift of Ernest
Erickson Foundation, 1985 (1985.214.142)

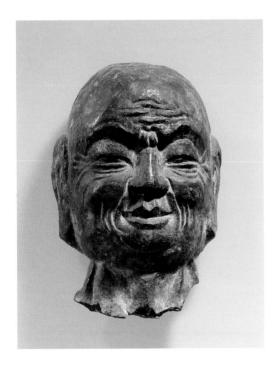

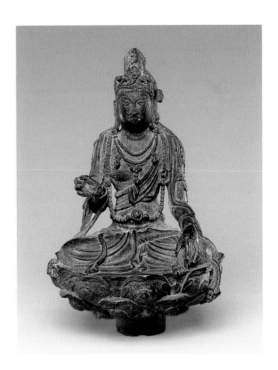

A34. Head of Arhat (*luohan* 羅漢)
Henan Province (Longmen complex, Yaofang cave), Tang dynasty
(618–906), 8th–9th century. Limestone with traces of pigment,
H. 21 in. (53.3 cm). Harris Brisbane Dick Fund, 1960 (60.73.1)
PROVENANCE: Heeramaneck Galleries, New York
PUBLICATIONS: Chavannes 1909, pls. 219, 350; Chow 1965, fig. 27;
Nara 1981, cat. no. 195; Chang 2007, fig. 1

A35. Bodhisattva
Late Tang dynasty (618–906) or Five Dynasties period (907–60),
10th century. Gilt leaded bronze, lost-wax cast; H. 7¾ in. (19.7 cm).
Bequest of John M. Crawford Jr., 1988 (1989.363.220)

A36. Head of Bodhisattva
Possibly Hebei Province, Five Dynasties period (907–60),
10th century. Marble with traces of pigment, H. 4 in.
(10.2 cm). Gift of Edward B. Bruce, 1924 (24.13.7)

A37. Daoist Immortal, probably Laozi (老子)
Five Dynasties period (907–60), 10th century.
High-leaded bronze, lost-wax cast; H. 9½ in. (24.1 cm).
Gift of Abby Aldrich Rockefeller, 1942 (42.25.19)
TL DATE RANGE (CORE): 700–1200 C.E.

A38. Bodhisattva
Possibly Gansu Province (Dunhuang complex),
10th–11th century. Wood (linden) with traces of pigment
and gilding, single-woodblock construction; H. 33½ in.
(85.1 cm). Fletcher Fund, 1942 (42.103)
RADIOCARBON DATE RANGE: Cal A.D. 970–1120
PROVENANCE: Mathias Komor, New York

A39. Bodhisattva Manjushri (Wenshu 文殊菩薩)
with Attendants
Possibly Hebei Province, Liao dynasty (907–1125),
11th century. Marble, H. 23 in. (58.4 cm). Purchase,
The Vincent Astor Foundation Gift, 2002 (2002.440)
PROVENANCE: Mrs. Hsu Ju Hua, Honolulu;
A & J Speelman, Ltd., London

A40. Head of Attendant

Liao (907–1125) or Jin (1125–1234) dynasty, 11th–12th century. Unfired clay with traces of pigment and gilding, H. 12⅞ in. (32.7 cm). Gift of A. W. Bahr, 1958 (58.64.1)
PROVENANCE: Ralph M. Chait, New York

A41. Attendant Bodhisattva

Northern Song dynasty (960–1127), 10th–11th century. Wood (foxglove) with traces of pigment, single-woodblock construction; H. 45½ in. (115.6 cm). Rogers Fund, 1928 (28.123)
RADIOCARBON DATE RANGE: Cal A.D. 900–1030
PROVENANCE: Jan Kleykamp Galleries, New York
PUBLICATIONS: *Metropolitan Museum of Art Bulletin* 24, no. 2 (February 1929), cover ill.; Priest 1944, cat. no. 48

A42. One of a Pair of Attendant Bodhisattvas

Northern Song dynasty (960–1127), 10th–11th century. Wood (foxglove) with pigment, single-woodblock construction; H. 26¾ in. (67.9 cm). Fletcher Fund, 1939 (39.76.1)
RADIOCARBON DATE RANGE: Cal A.D. 1030–1230
PROVENANCE: A. W. Bahr; American Art Association–Anderson Galleries, Inc.
PUBLICATIONS: Priest 1939b, p. 222; Priest 1944, cat. no. 50

A43. One of a Pair of Attendant Bodhisattvas

Northern Song dynasty (960–1127), 10th–11th century. Wood (foxglove) with pigment, single-woodblock construction; H. 26⅞ in. (68.3 cm). Fletcher Fund, 1939 (39.76.2)
RADIOCARBON DATE RANGE: Cal A.D. 1030–1230
PROVENANCE: A. W. Bahr; American Art Association–Anderson Galleries, Inc.
PUBLICATIONS: Priest 1939b, p. 223; Priest 1944, cat. no. 50; Xu Jianrong 1998, p. 254

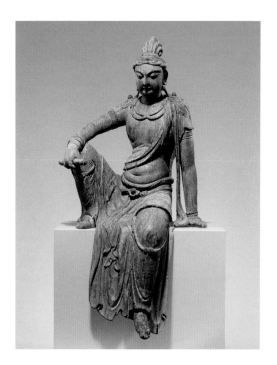

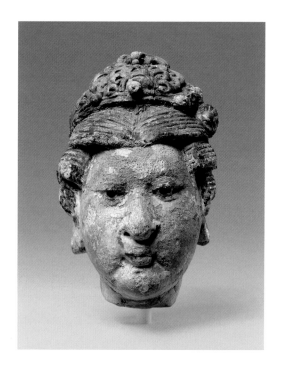

A44. Bodhisattva, probably Manjushri (Wenshu 文殊菩薩)
Northern Song dynasty (960–1127), late 10th–early 12th
century. Wood (foxglove) with traces of pigment, single-
woodblock construction; H. 43 in. (109.2 cm). Gift of Abby
Aldrich Rockefeller, 1942 (42.25.5)
RADIOCARBON DATE RANGE: Cal A.D. 990–1160
PUBLICATIONS: Priest 1944, cat. no. 49; *Art Treasures* 1952, pl. 200;
Matsubara 1961, fig. 15; Chow 1965, fig. 37; Tanabe 1969, fig. 13;
Xu Jianrong 1998, p. 258

A45. Head of Attendant
Northern Song (960–1127) or Jin (1115–1234) dynasty,
11th–12th century. Unfired clay with pigment and gilding,
H. 6⅜ in. (16.2 cm). Rogers Fund, 1928 (28.103)
PROVENANCE: Ralph M. Chait, New York
PUBLICATION: Priest 1944, cat. no. 64

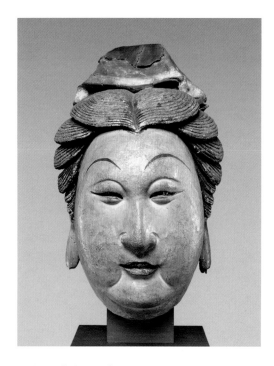

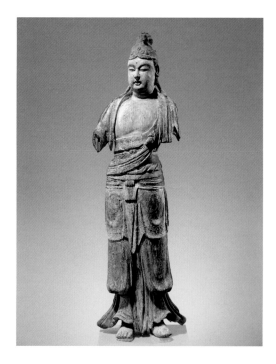

A46. Head of Attendant
Northern Song (960–1127) or Jin (1115–1234) dynasty,
11th–12th century. Unfired clay with pigment, H. 15½ in.
(39.4 cm). Rogers Fund, 1930 (30.136)
PROVENANCE: Ralph M. Chait, New York
PUBLICATIONS: New York 1940, cat. no. 10; Priest 1944,
cat. no. 72

A47. Bodhisattva
Northern Song (960–1127) or Jin (1115–1234) dynasty,
11th–12th century. Wood (foxglove) with traces of pigment
and gilding, single-woodblock construction; H. 54¾ in.
(139.1 cm). Gift of D. Herbert Beskind, 1961 (61.237)
RADIOCARBON DATE RANGE: Cal A.D. 1040–1240

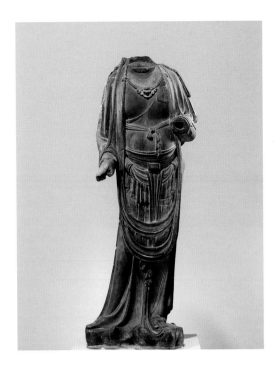

A48. Bodhisattva
Possibly Hebei Province, Jin dynasty (1115–1234),
12th–13th century. Marble with pigment, H. 86 in.
(218.4 cm). Fletcher Fund, 1934 (34.56a, b)
PROVENANCE: Demotte, Inc., New York
PUBLICATIONS: Sirén 1925, pl. 540; Priest 1935b, pp. 74–75;
Bachhofer 1938a, fig. 8; Priest 1944, cat. no. 62; Sirén 1998, fig. 114

A49. Attendant Bodhisattva
Jin dynasty (1125–1234), 12th–13th century. Wood (willow)
with traces of pigment, single-woodblock construction;
H. 59 in. (149.9 cm). Rogers Fund, 1928 (28.122.1)
RADIOCARBON DATE RANGE: Cal A.D. 1030–1220
PROVENANCE: Yamanaka and Company
PUBLICATIONS: Priest 1929, p. 17; Priest 1944, cat. no. 69

A50. Bodhisattva Mahasthamaprapta (Dashizhi 大勢至菩薩)
Jin dynasty (1115–1234), 13th century. Wood (willow) with traces
of pigment and gilding, single-woodblock construction;
H. 39⅜ in. (100 cm). Gift of Clara Mertens, in memory of her
husband, André Mertens, 1978 (1978.543)
RADIOCARBON DATE RANGE: Cal A.D. 900–1040
PROVENANCE: Breuer, Berlin
PUBLICATION: Berlin 1929, cat. no. 489

A51. Bodhisattva
Jiangxi Province, Yuan dynasty (1271–1368), 14th century.
Glazed porcelain (*qingbai* ware), H. 20 in. (50.8 cm).
Gift of Edgar Bromberger, in memory of his mother,
Augusta Bromberger, 1951 (51.166)
PUBLICATIONS: Valenstein 1975a, pl. 26; Valenstein et al.
1977, pl. 69; Valenstein 1989, fig. 120

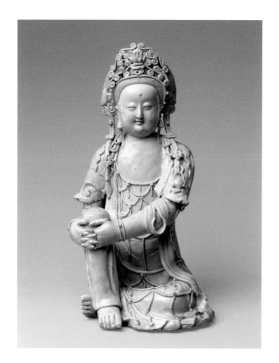

A52. Bodhisattva
Jiangxi Province, Yuan dynasty (1271–1368), 14th century.
Glazed porcelain (*qingbai* ware), H. 11¾ in. (29.8 cm).
Gift of Stanley Herzman, in memory of Adele Herzman,
1991 (1991.253.27)
PUBLICATION: Valenstein 1992, fig. 11

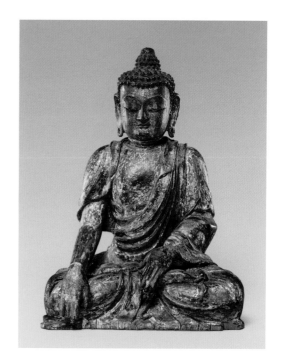

A53. Buddha, probably Akshobhya (Achu fo 阿閦佛)
Ming dynasty (1368–1644), Yongle period (1403–24),
dated 1411. Wood (linden) with lacquer and gilding,
single-woodblock construction; H. 8¾ in. (22.2 cm).
Anonymous Gift, 1942 (42.151.4a, b)
PUBLICATIONS: Priest 1942, p. 30; Priest 1944, cat. no. 50

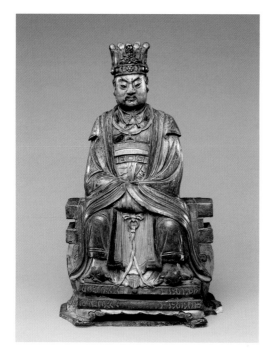

Qiao Bin (active 1481–1507)
A54. Daoist Deity, probably Heavenly Marshal Zhao
(Zhao Gong Ming 趙公明)
Shanxi Province, Ming dynasty (1368–1644), dated 1482.
Glazed stoneware, H. 23¾ in. (60.3 cm). Bequest of
Harrison Cady, 1971 (1971.163)
PUBLICATION: Cox 1979, p. 526

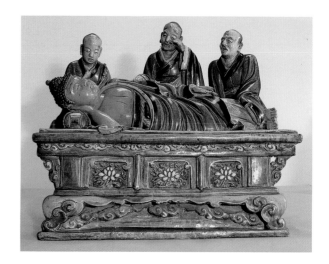

Attributed to Qiao Bin (active 1481–1507)
A55. Final Transcendence (*Parinirvana*) of the Buddha
Shanxi Province, Ming dynasty (1368–1644), dated 1503. Glazed
stoneware, H. 14½ in. (36.8 cm). Fletcher Fund, 1925 (25.227.1)
PUBLICATIONS: Cox 1979, p. 527; Riddell 1979, fig. 105

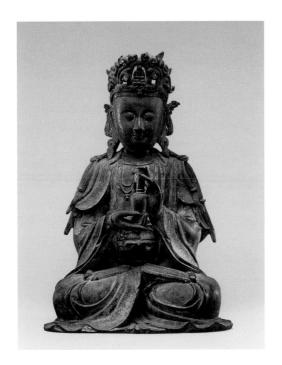

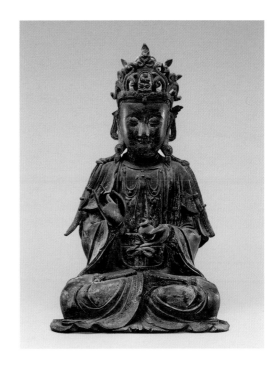

A56. Bodhisattva Avalokiteshvara (Guanyin 觀音菩薩)
Ming dynasty (1368–1644), 15th–16th century. Leaded brass,
lost-wax cast; H. 15⅛ in. (38.4 cm). Rogers Fund, 1912 (12.37.160)
PROVENANCE: Takuma Kuroda, Yokohama

A57. Bodhisattva
Ming dynasty (1368–1644), 15th–16th century. Leaded brass,
lost-wax cast; H. 16⅛ in. (41 cm). Rogers Fund, 1912 (12.37.161)
PROVENANCE: Takuma Kuroda, Yokohama

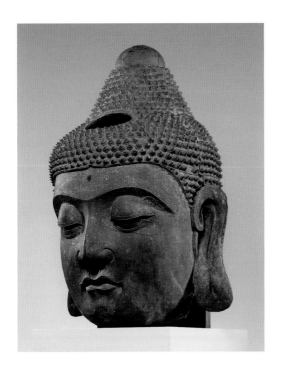

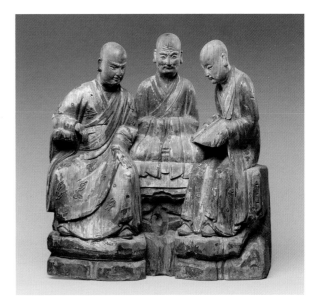

A58. Head of Buddha
Ming dynasty (1368–1644), ca. 16th century. Iron, piece-
mold cast; H. 45 in. (114.3 cm). Fletcher Fund, 1961 (61.94)
PUBLICATIONS: Fitzgerald 1935, pl. 16; *Metropolitan
Museum of Art Bulletin* 20, no. 2 (October 1961), cover ill.;
Fingesten 1968, fig. 11

A59. Three Arhats (*luohans* 羅漢)
Ming dynasty (1368–1644), 16th–17th century. Wood
(willow) with traces of pigment and gilding, single-woodblock
construction; H. 22¼ in. (56.5 cm). Purchase, Gifts from various
donors, in honor of Douglas Dillon, 1995 (1995.417)
RADIOCARBON DATE RANGE: Cal A.D. 1450–1650
PROVENANCE: Christie's, New York
PUBLICATIONS: New York 1993–94, p. 15; Watt 1996, p. 78;
Metropolitan Museum of Art 2008, p. 38

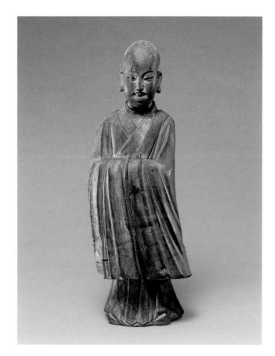

A60. Arhat (*luohan* 羅漢)
Ming dynasty (1368–1644), 16th–17th century. Wood (willow)
with traces of pigment, single-woodblock construction;
H. 19⅛ in. (48.6 cm). Purchase, Friends of Asian Art Gifts,
1990 (1990.113)
RADIOCARBON DATE RANGE: Cal A.D. 1460–1660
PROVENANCE: Estate of Louise March

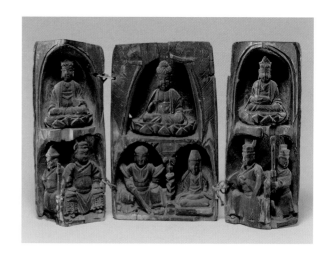

A61. Portable Shrine with Buddhist Deities, Guardians, and Donors
Ming dynasty (1368–1644), 16th–17th century. Wood (linden) with
traces of pigment, single-woodblock construction; H. 11¼ in.
(28.6 cm). Rogers Fund, 1929 (30.76.158a–c)
RADIOCARBON DATE RANGE: Cal A.D. 1430–1620

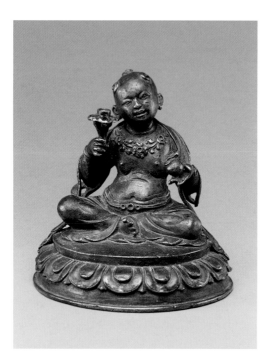

A62. Bodhisattva Manjushri with Five Knots of Hair
(Wuji Wenshu 五髻文殊菩薩)
Ming dynasty (1368–1644), 16th–early 17th century.
Brass with pigment, lost-wax cast; H. 3½ in. (8.9 cm).
Gift of Cynthia Hazen Polsky, 1984 (1984.491.1)

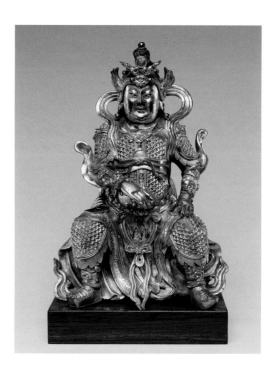

A63. Guardian, probably a *Lokapala* (*tianwang* 天王)
Ming dynasty (1368–1644), early 17th century. Gilt brass,
lost-wax cast; H. 12½ in. (31.8 cm). Purchase, The Vincent
Astor Foundation Gift, 2002 (2002.254)
PROVENANCE: Robert Hatfield Ellsworth Collection

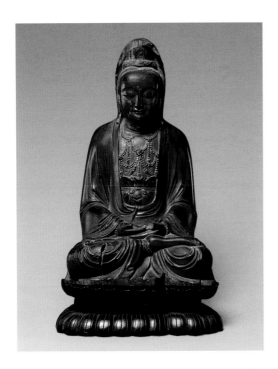

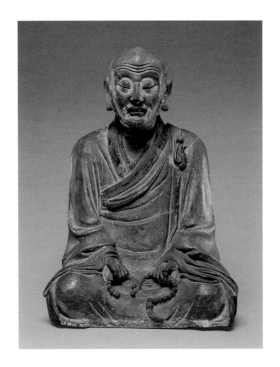

A64. Bodhisattva Avalokiteshvara in White-Robed Form
(Baiyi Guanyin 白衣觀音菩薩)
Ming dynasty (1368–1644), dated 1624. Wood (sandalwood)
with lacquer, single-woodblock construction; H. 8¼ in. (21 cm).
Fletcher Fund, 1936 (36.40a–c, e)
PROVENANCE: John A. Dean
PUBLICATIONS: Priest 1942, p. 31; Priest 1944, cat. no. 76

A65. Arhat (luohan 羅漢)
Late Ming (1368–1644) or early Qing (1644–1911) dynasty,
17th–18th century. Stoneware with pigment, H. 17½ in.
(44.5 cm). Gift of Robert E. Tod, 1938 (38.56.1)
TL DATE RANGE: 1600–1800 C.E.
PROVENANCE: E. and J. Baerwald, Berlin; Ralph M. Chait,
New York
PUBLICATION: Berlin 1929, p. 197

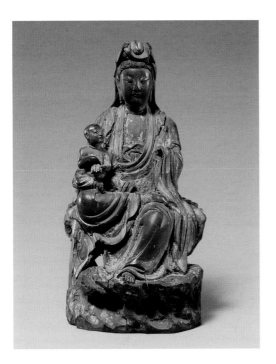

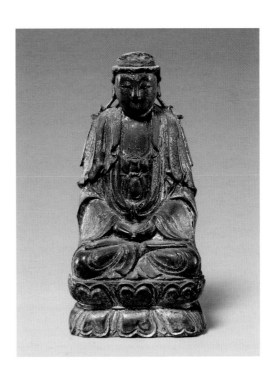

A66. Bodhisattva Avalokiteshvara as the Bestower of Sons
(Songzi Guanyin 送子觀音菩薩)
Late Ming (1368–1644) or Qing (1644–1911) dynasty, 17th–
18th century. Wood (sandalwood) with traces of pigment
and gilding, single-woodblock construction; H. 5⅜ in.
(13.7 cm). Rogers Fund, 1951 (51.15)
RADIOCARBON DATE RANGE: Cal A.D. 1660–1960
PROVENANCE: Esoterica, New York

A67. Bodhisattva Avalokiteshvara (Guanyin 觀音菩薩)
Qing dynasty (1644–1911), dated 1678. Wood (sandalwood)
with lacquer and gilding, single-woodblock construction; H. 5¾ in.
(14.6 cm). Gift of R. Hatfield Ellsworth, 1962 (62.219a, b)

A68. Bodhisattva Avalokiteshvara (Guanyin 觀音菩薩)
Qing dynasty (1644–1911), Qianlong period (1736–95).
Leaded brass with pigment, lost-wax cast; H. 12⅝ in. (32.1 cm).
Bequest of Kate Read Blacque, in memory of her husband,
Valentine Alexander Blacque, by exchange, 1948 (48.30.15)
PROVENANCE: Alice Getty, New York
PUBLICATION: Dayton 1989–90, cat. no. 161

A69. Bodhisattva Avalokiteshvara (Guanyin 觀音菩薩)
Late Ming (1368–1644) or Qing (1644–1911) dynasty, 19th century.
Leaded brass with pigment and gilding, lost-wax cast; H. 6⅞ in.
(17.5 cm). Purchase, Bequest of Florance Waterbury, in memory of
her father, John I. Waterbury, by exchange, 2009 (2009.2)
TL DATE RANGE (CORE): 1800–1900 C.E.
PROVENANCE: Eskenazi, Ltd., London

A70. Vaishravana as Kubera (Dou Wen Tian 多聞天)
Mongolia or China, 19th century. Brass with traces of
pigment, lost-wax cast; H. 3⅞ in. (9.8 cm). Purchase,
Friends of Asian Art Gifts, 2006 (2006.129)
PROVENANCE: Joseph G. Gerena Fine Art, New York
PUBLICATION: Metropolitan Museum of Art 2008, p. 59

A71. Bodhisattva Avalokiteshvara of the Lion's Roar, or
Simhanada Avalokiteshvara (Shi Hou Guanyin 獅吼觀音菩薩)
Qing dynasty (1644–1911), 19th–20th century. Wood (willow)
with traces of pigment, single-woodblock construction;
H. 59⅞ in. (152.1 cm). Purchase, Laurance S. Rockefeller Gift,
1976 (1976.326)
RADIOCARBON DATE RANGE: Cal A.D. 1520–1950
PROVENANCE: Allen S. Chait, London

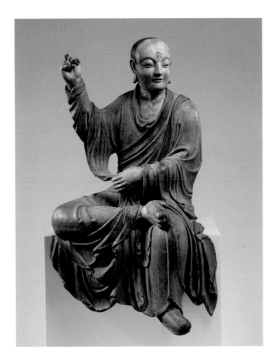

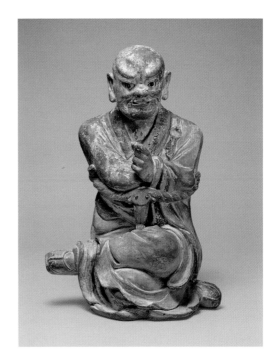

A72. Arhat (*luohan* 羅漢)
Qing dynasty (1644–1911), late 19th century. Wood
(foxglove) with pigment, multiple-woodblock construction;
H. 44⅞ in. (114 cm). Purchase, Friends of Asian Art Gifts,
2008 (2008.67)
RADIOCARBON DATE: Cal A.D. 1894
PROVENANCE: Château Smith, Nice

A73. Arhat (*luohan* 羅漢)
Qing dynasty (1644–1911) or later, 20th century.
Stoneware with pigment, H. 17½ in. (44.5 cm).
Purchase, Friends of Asian Art Gifts, 2003 (2003.276)
TL DATE RANGE: 1900–2000 C.E.
PROVENANCE: A & J Speelman, Ltd., London
PUBLICATIONS: Barcelona 2004, cat. no. 9;
Metropolitan Museum of Art 2008, p. 55

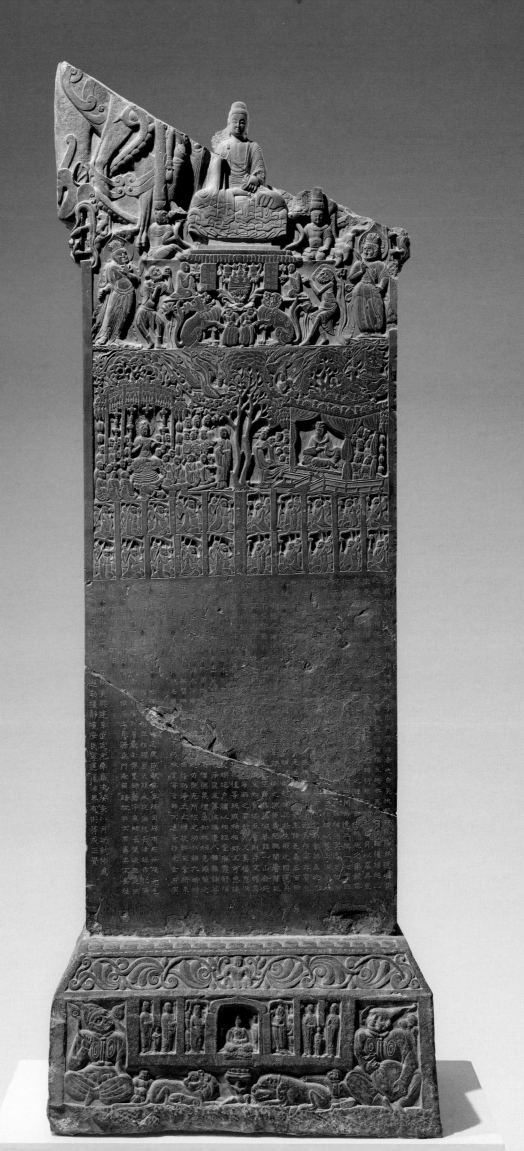

The Issue of the Trubner Stele

DENISE PATRY LEIDY

Popularly known as the Trubner stele after a former owner, a towering work in the collection of The Metropolitan Museum of Art, dated by inscription to 533–43 C.E., remains one of the most controversial Chinese sculptures in a Western institution (fig. 116).[1] It has been extolled as a masterpiece, reviled as a forgery, and dismissed for having been substantially recarved or restored.[2] The stele and its imagery belong to a tradition that developed in the mid-fifth century in Shanxi and flourished in the early sixth century, particularly around the city of Luoyang, in Henan Province, the second capital of the Northern Wei dynasty (386–534).

The top of the stele, which is damaged, was once capped by six dragons placed back to back, three to each side (see fig. 118). Between the legs of the addorsed dragons, a columned niche originally contained a seated Buddha and two standing bodhisattvas (most of the Buddha, the body of the bodhisattva on the left, and a substantial part of the left-hand column survive). In the register beneath the seated Buddha, two kneeling monks flank an elaborate incense burner supported by a pair of caryatid figures. Each monk holds an implement and a flower. A lion stands protectively at the side of each caryatid figure, and two guardians are found at the far left and right. The figures standing between the guardians and the lions are standard in Chinese Buddhist imagery: the Indian ascetics Mrgashirsa (Lutou Fanzhi 鹿頭梵志), holding a skull, and Vasu (Bo Sou Xian 菠藪仙), holding a bird.

A dramatic and complex rendering of one of the seminal scenes in the Sutra on the Discourse of Vimalakirti[3] fills the rest of the upper half of the stele (see fig. 119). Written in India around 150 C.E. (or at least recorded at that time), the sutra validates the importance of lay practice, stresses the danger of superficial judgments, and recommends the pursuit of perfected wisdom, or deep spiritual understanding. The text was first translated into Chinese by Kumarajiva (344–413), a monk from the Kucha kingdom in western Central Asia and one of the most influential clerics in early Chinese Buddhism. A defining moment in the text, the debate between the learned layman Vimalakirti (Weimo 維摩) and Manjushri (Wenshu 文殊), the bodhisattva of wisdom, was an important motif in Chinese Buddhist art of the fifth and early sixth centuries;[4] the layman's victory over the bodhisattva

clearly reflects the importance of the secular community at that time.

In the rendering on the Trubner stele, the debate takes place in a windblown landscape. Vimalakirti, at the right, is seated in a curtained and tasseled pavilion and attended by fourteen additional figures, some laypeople, others monks. Manjushri, at the left, sits on a lotus pedestal under a bejeweled and tasseled canopy and has thirty attendants. In addition to laypeople and clergy, the attending figures include three who wear animal headgear and may represent guardians serving the bodhisattva and his entourage. The monk Shariputra, standing just to the left of the twin trees in the center of the scene, and the woman on the other side of the trees illustrate the most dramatic moment in the debate: Shariputra first transforms himself into a woman and then changes back to his original form to stress the impermanence and irrelevance of gender and other states of being, which is a main point of the sutra. This is one of the many moments when the learned and elderly Vimalakirti trounces the bodhisattva of wisdom.[5]

The twenty figures seated in two tiers of individual niches beneath the debate scene represent some of the most important donors to the construction of the monument. Each holds a lotus and is accompanied by a figure holding a parasol, a symbol of rank. As is typical, the donors are identified in the cartouches, which also list their positions within the devotional society that sponsored the stele.[6] The most important donor was Helian Ziyue (赫蓮子悅; ca. 501–573), who is shown just right of center in the topmost row of figures (see fig. 117). His name indicates that he was of Central Asian rather than Han Chinese origins. Helian Ziyue is a rare

OPPOSITE: FIGURE 116. Stele commissioned by Helian Ziyue and a devotional society of five hundred individuals (Trubner stele). Henan Province, Eastern Wei dynasty (534–50), dated 533–43. H. 121¼ in. (308 cm). The Metropolitan Museum of Art, Rogers Fund, 1929 (29.72, 30.76.302), and Gift of Kochukyo Co., Ltd., 1982 (1982.200)

FIGURE 117. Front of Trubner stele, detail of donor Helian Ziyue

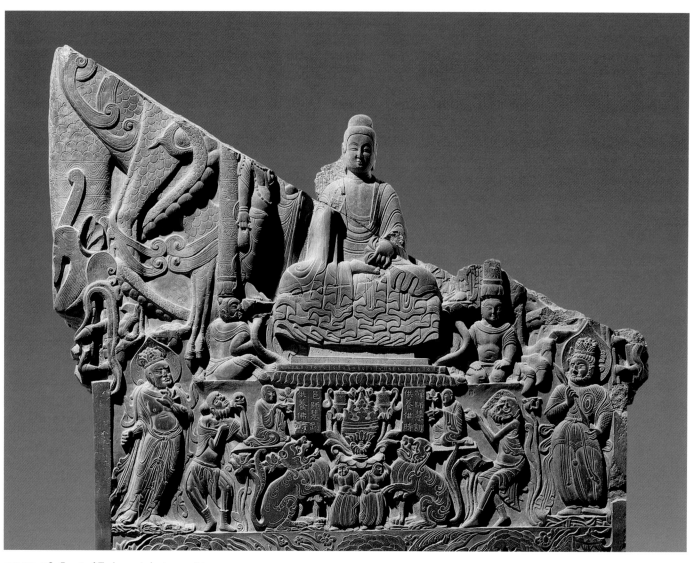

FIGURE 118. Front of Trubner stele, top register

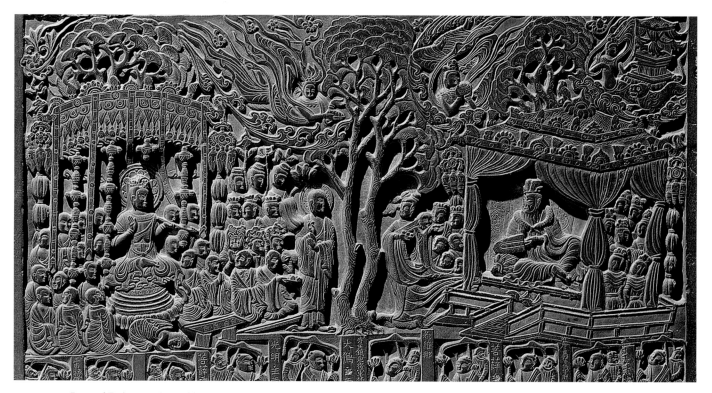

FIGURE 119. Front of Trubner stele, middle register

FIGURE 120. Front of Trubner stele, detail of inscription

example of a donor mentioned on a Buddhist work of art who can also be identified in Chinese historical writings.[7] His family included the chieftain of a tribe originally based in the Ordos Desert region. In the fifth century, the clan was incorporated into, or possibly married into, the ruling Tuoba Xianbei of the Northern Wei dynasty. Some members of the clan joined the six garrisons that helped guard the northern frontier. It is not clear what role, if any, Helian Ziyue played in the uprising against the Northern Wei that was spurred, in part, by discontent among the six garrisons and displeasure with the luxurious and sedentary lifestyle of the court. After the dissolution of the Northern Wei, however, he gained the support of a powerful minister, was placed in charge of a group of subjugated rebels of mixed ethnicity, and settled in the town of Linlei, in northern Henan Province. The title given in the cartouche on the Metropolitan's stele, *wumeng congshi* (武猛從事), indicates that he was a brave military retainer and played a major administrative role in the territory around present-day Qixian.

The long, partially abraded inscription on the bottom half of the stele records the production of the stele, and the construction of the temple that housed it, from 533 to 543

(see fig. 120). It also states that the devotional society in question numbered five hundred individuals. The twenty donors shown on the front of the stele, including Helian Ziyue, were the most important members of the society. Symbolic portraits of some of the other members, also seated and identified by name and rank within the society, are found on the back of the stele (see fig. 121). They are arranged in twenty-seven rows of sixteen figures each, for a total of 432 figures. Above these figures is a damaged scene showing a seated Buddha with pendant legs and two attendant bodhisattvas between the legs of dragons.

The two narrow sides of the stele are identical (see fig. 122): a Buddha sits in an ogival niche at the top; below, smaller icons in similar niches are arranged in twenty-nine rows of four. The theme represented is that of the Thousand Buddhas, a symbol of the immanence of numerous Buddhas in time and space that is common in early Chinese Buddhist art. There are scant traces of green pigment among the seated Buddhas.

The stele is set into a stepped base (see fig. 123). An arabesque with a caryatid figure in the center and flaming pearls on the sides decorates the angled top of the base. A seated

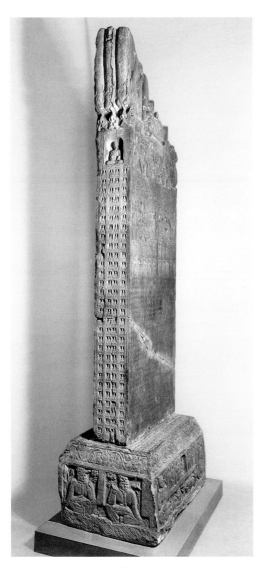

FIGURE 122. Right side of Trubner stele

Buddha in a smaller niche is set into a rectangular section on the front plane of the base. He is attended by two monks and four additional donors. Two sprawling lions and a small caryatid figure lifting a lotus pedestal, which appears to support the large rectangular section, are also shown on the front. The bottom edge of the base is decorated with a delicately incised scene of figures in a landscape, which is sometimes identified as one of the many jatakas, or tales of the former lives of the historical Buddha, Shakyamuni.

Two of the spirit kings, a group of eight protective divinities of enigmatic origins[8] that are often found in Chinese sculpture, are seated at the far left and right of the base. They wear armor. The figure on the far right, holding a large bag, is the wind spirit king, while the one on the far left, wearing a flaming hat, is the fire spirit king. The dragon and lion spirit kings are shown on the left side of the base, and the bird and fish spirit kings on the right side. The tree and mountain spirit kings are depicted on the back of the base to either side of a scene of two figures meditating in huts in a tree-filled, mountainous landscape (see fig. 121).

It is unclear whether the base is original to the stele. Scientific analysis of the base, the two sections into which the body of the stele is broken, and the top half of the crowning Buddha, which was acquired by the Museum in 1982, indicates that the base is made of a slightly different type of stone than the other parts.[9] Moreover, cement or a similar material was used to affix the stele to the base, suggesting that the body of the stele did not fit properly into the base. However, the style of the images on the base follows mid-sixth-century conventions, and it is not impossible that a large work such as the Trubner stele could have been made of two slightly different

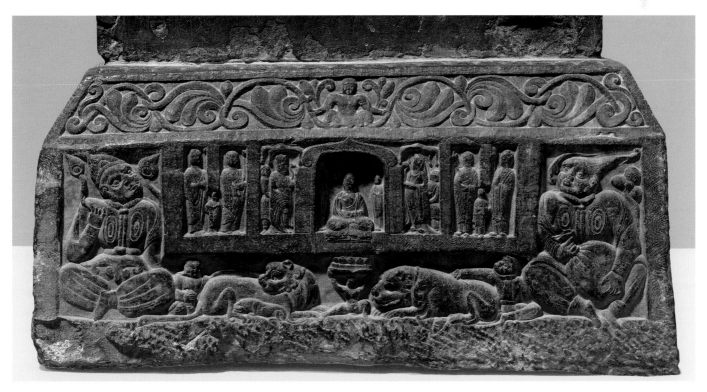

OPPOSITE: FIGURE 121. Back of Trubner stele ABOVE: FIGURE 123. Base of Trubner stele (front)

types of stone. It is also worth noting that the base has been with the stele since it was first photographed, in the early part of the twentieth century, at which point both pieces were enclosed in a roofed brick shrine intended to protect the monument (see fig. 124).

With the exception of the information provided by the inscription on the stele itself, there is no historical documentation of this monument.[10] A possible pre-twentieth-century record is found in an epigraphic study of bronze and stone inscriptions by Miao Quansun (1844–1919) entitled *Yifeng-tang jinshi wenzi mu* (藝風堂金石文字目), which discusses a stele with a Buddha at the top and a long inscription in clerical script that includes a date in the first year of the Wuding era (543–49) of the Eastern Wei (534–50), equivalent to 543, one of the dates given in the inscription on the Trubner stele.[11] Although the volume was not published until 1906, it reflects research undertaken from 1896 to 1898 and suggests that the piece was known in the late nineteenth century. Another early transcription of the inscription, also published without a photograph of the work, appears in a 1915 Japanese volume on Chinese sculpture and inscriptions.[12] The first

FIGURE 124. First published photograph of Trubner stele, in situ

photograph (fig. 124) appeared in a volume entitled *Heshou guji tushi* (河朔古跡圖識), which documents the research conducted by Gu Xieguang (1875–1949) and Fan Shouming (1870–1921) in northern Henan Province from 1914 to 1918. However, this volume was not published until about 1943, long after the monumental stele had been acquired by the Metropolitan Museum with the help of C. T. Loo, a dealer based in Paris.

As mentioned earlier, the long and abstruse inscription on the front of the Trubner stele links its production to the construction of a temple complex. According to Gu Xieguang, the stele was found outside the main gate of the Fengchong-si, a temple that is supposed to have existed on Mount Fu not far from the modern city of Qixian, in northwestern Henan Province. Unfortunately, no additional record of the Fengchong-si has been found.[13] It has recently been suggested that the Fushan-si, located in approximately the same region and thought to have been reconstructed in the early Ming dynasty (1368–1644), may have been the original location of the Trubner stele. While it would be useful to be able to associate the stele with a specific temple and thus to glean more information about the stele's production from the history of the temple in question, this datum would still not resolve the persistent, and valid, concerns regarding the stele's authenticity. These are, fundamentally, issues of style, and they can be divided into two related queries: the overall appearance of the stele, on the one hand, and idiosyncrasies in some of the details on the front of the stele, on the other.

The Trubner stele, like most steles produced after the fall of the Northern Wei, is wider than early-sixth-century steles tend to be. The flatness of the low-relief carving of the narrative scenes and figures is also characteristic of the mid-sixth century and is found on a number of works from Henan and related centers in southern Shanxi Province.[14] The interest in movement seen in the rendering of the debate between Vimalakirti and Manjushri, however, is distinctive (see fig. 119). Movement is depicted in the swaying tree trunks and the fluttering garments worn by the *apsara*s at the top of the scene and the female manifestation of the monk Shariputra in the center. It should be noted that this interest may have been one aspect of a style found in northwestern Henan in the mid-sixth century. A similarly energetic rendering of figures and backgrounds is seen on the stucco tiles that cover the surface of the extraordinary pagoda at the Xiuding-si (fig. 125), which was also published in the survey of the region by Gu and Fan.[15] The pagoda, in its current state, is thought to date to the early seventh century. No parallels to the lively *apsara*s, dancers, and other figures that decorate this monument are known today, except possibly those on the Trubner stele. Given their geographic proximity, it is possible that the two works are rare examples of an aesthetic that may have been common in the northern part of Henan in the sixth and seventh centuries.[16]

Unfortunately, the possible existence of such an artistic tradition does not resolve the other stylistic issues that plague the study and analysis of the Metropolitan's stele.

FIGURE 125. Exterior of Xiuding-si pagoda. Henan Province, Tang dynasty (618–906), 7th century

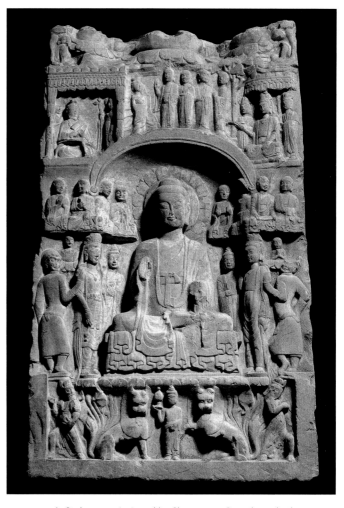

FIGURE 126. Stele commissioned by Shangguan Sengdu and others. Anhui Province, Northern Qi dynasty (550–77), dated 563. Limestone, H. 39 in. (99 cm). Anhui Provincial Museum, Hefei

Most of these concerns have to do with the front face of the stele, which is noticeably darker than the sides and back, probably because rubbings have so often been made of it. The carving here, however, is crisper and less worn than on the other three sides, suggesting that the surface has been recarved. Many of the details in the scenes on the front confirm this assumption. For example, the excessive patterning seen in the columns in the top register, in the bodies of the lions in the same register, and in the tree trunks in the debate scene has no parallel in contemporaneous works.

The Buddha at the top of the stele wears the traditional long rectangular shawl and saronglike undergarment found in most Chinese Buddha images. The hems of the garments are rendered as a series of thick, cascading, alternately concave and convex pleats, which fall over the knees and the front of the pedestal. This kind of drapery, which is common throughout the sixth century, can be traced to conventions that developed in the Luoyang area in the closing decades of the Northern Wei dynasty. The evenness of the hems, however, which is also seen in a work dated 563 in the collection of the Anhui Provincial Museum, Hefei (fig. 126), is typical of the mid-sixth century: in the early sixth, the hems tend to fall in more jagged patterns, and there is greater variation in the widths and lengths of the pleats. Moreover, the depiction of the garments worn by the Buddha on the Trubner stele is overly flat and detailed and lacks the subtle sense of naturalism seen in the work dated 563.

Comparisons between the donor portraits on the front of the stele and those on the back (see figs. 127, 128) also attest to the recarving of the front. The donors on the front are flatter than those on the back; more incised lines were used to indicate the pleats of their drapery; and their garments lack the subtle volume seen in the clothing on the back. In addition, the profiles of the donors on the front are too sharp, and their features are rendered in a somewhat inorganic fashion, which may be the result of attempting to depict such features on a surface that was slightly smaller than it had originally been.

The full trousers worn by the guardian figures and the boots worn by the ascetics in the top register of the front of the stele (see fig. 118) are also problematic. Neither is easy to explain. The pantaloons could be classified as "harem" pants, now associated with Turkey and other parts of West Asia, and may reflect knowledge of such garb in the mid-sixth century, a period when many foreigners were known in China. The boots, on the other hand, are completely inappropriate for the ascetics, both because of their renunciant lifestyle and because Vasu and Mrgashirsa were thought to be of Indian origin, and such footwear is not common in India.

The only parallel to the trousers is found on the base of a stele now in the collection of the Poly Art Museum, Beijing (fig. 129), which has been dated to the Northern Zhou dynasty (557–81).[17] The Beijing stele, which may have been recarved during the Tang dynasty (618–906), also provides a parallel to the boots worn by the ascetics and the unusual censer in the center of the top register of the Trubner stele. The latter is

FIGURE 127. Front of Trubner stele, detail of donor figures

FIGURE 128. Back of Trubner stele, detail of donor figures

set amid lotus tendrils and buds; two of the buds support cylindrical vessels that are unidentified and appear to be covered. Similar vessels are seen not only with the censer on the Beijing stele but also with the censer depicted on the back of a stele dated by inscription to 543 and now in the collection of the Isabella Stewart Gardiner Museum, Boston (fig. 130), and may have been a standard part of Buddhist imagery in the mid-sixth century. However, the censer and vessels on the back of the Gardiner piece are rendered more convincingly: the incense burner is clearly supported by the underlying flower; the cylindrical vessels fit firmly into their respective leaves; and the tendrils appear at the sides and back. In contrast, the inorganic treatment of a floral form at the base of the incense burner in New York, which may have been intended to represent a pedestal supporting this implement, typifies the stylistic problems that characterize the Trubner stele. The rendering of the monks to either side of the incense burner is also awkward; they kneel on platforms that should be supported by the lotus flowers that grow from the base, but there is little relationship between the blossoms and the platforms.

The awkwardness and lack of perspective in the censer and its floral base are probably the result of recarving, which would have been necessitated by damage to the front of the stele at some point in its long history. The sides, back, and base, however, retain their original appearance from the creation of the stele in 533–43.

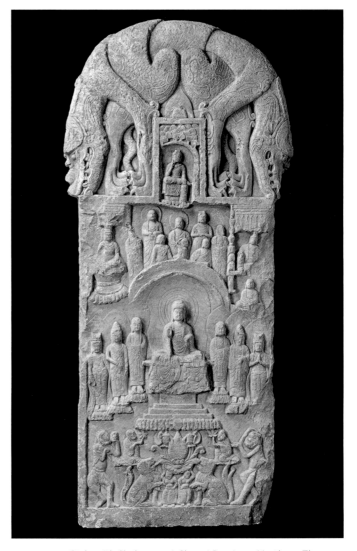

FIGURE 129. Stele with Shakyamuni. Shanxi Province, Northern Zhou dynasty (557–81), mid-6th century. Limestone, H. 55½ in. (141 cm). Poly Art Museum, Beijing

FIGURE 130. Stele, back view. Henan Province, Eastern Wei dynasty (534–50), dated 543. Limestone, H. 32¼ in. (81.9 cm). Isabella Stewart Gardiner Museum, Boston

NOTES

1. Publications of this controversial work include Ōmura 1915, figs. 262, 263; Kümmel 1930, pls. 62, 63; Priest 1930a, pp. 234–35; Sirén 1942b, figs. 248, 249; Priest 1944, cat. no. 23; Sickman and Soper 1956, pl. 44; Bunker 1965; Chow 1965, fig. 19; Lippe 1965a; Lippe 1965c, figs. 5, 6; Bunker 1968, fig. 9; Watt 1990, fig. 56; W. Ho 2001; and Hsu 2007.

2. There are several other works in the collection that have been published previously, particularly in the volume by Alan Priest (1944), which are not included in this catalogue. They are works that are currently considered problematic or that study has shown to consist more of reconstruction than of original material.

3. Vimalakirtinrdesha Sutra (Weimo jie jing 維摩詰經) is found in Takakusu and Watanabe 1914–32, nos. 474–76.

4. Although the debate is depicted in earlier images, it is possible that its rise to prominence in the late fifth century was due, in part, to imperial patronage, specifically that of Grand Dowager Empress Wenming (442–490) and her grandson Emperor Xiaowen (r. 471–99). See Su 1996, pp. 76–88.

5. Wai-kam Ho (2001) has suggested that the inclusion of this scene as one of the major motifs on the stele, which is admittedly unusual, argues against the authenticity of the work because the foreign donors of the stele could not have understood the complex content of the sutra. This is unlikely, however: the debate was a primary motif in the art of the late fifth and sixth centuries and would have been widely known even to those who had not actually read the work. Moreover, the scale of the stele clearly reflects the high rank and probable learning of its patrons, despite the fact that some of them were of non-Chinese origin.

6. For a discussion of some of the titles used in such devotional societies, see cat. no. 8, p. 73.

7. Reconstruction of Helian Ziyue's biography is based on W. Ho 2001.

8. For further information, see cat. no. 6.

9. George Wheeler and Tony Frank of the Metropolitan Museum's Department of Scientific Research are responsible for this analysis.

10. This is not unusual: few of the works of Chinese Buddhist sculpture that are known today have a documented provenance that predates the early twentieth century.

11. The author is grateful to Chang Qing for discovering this citation during his work as a fellow in the Department of Asian Art. The pertinent citation is on p. 27 in Miao Quansun's study.

12. See Ōmura 1915, figs. 262, 263.

13. See Hsu 2007 and W. Ho 2001 for further discussion.

14. See Taggart et al. 1973, p. 32.

15. Gu and Fan 1943, pl. 94. The Museum has two tiles from this pagoda. See nos. A22 and A23 in appendix A.

16. It is also possible that, at some point, this style was thought to represent a Central Asian aesthetic. It may be no coincidence that the so-called Berenson scroll, once thought to be the work of the (foreign) painter Weichi Yiseng, is another example of the style. For an illustration, see Bussagli 1979, pp. 64–65. It is possible to dismiss both the Berenson scroll and the Trubner stele; however, the authenticity of the pagoda at the Xiuding-si has not been questioned.

17. The author is indebted to Chang Qing for bringing this piece to her attention. Li Yuqun has pointed out that at least the back may be recarved; see his discussion of the work in Poly Art Museum 2000, pp. 214–21.

Technical Study of Two Northern Wei Altarpieces Dedicated to the Buddha Maitreya

LAWRENCE BECKER

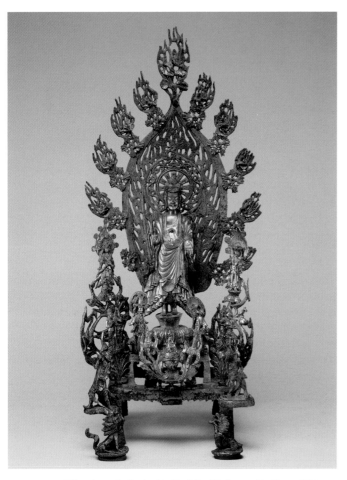

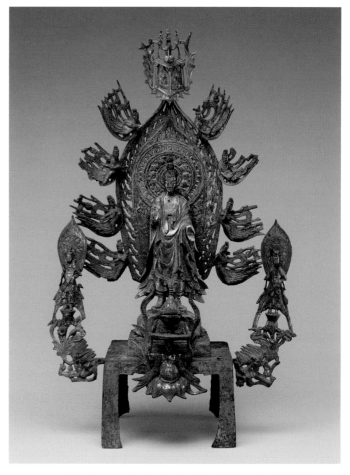

FIGURE 131. Altarpiece dedicated to Buddha Maitreya. Northern Wei dynasty (386–534), dated 524. Gilt bronze, H. 30¼ in. (76.9 cm). Rogers Fund, 1938 (38.158.1a–n; cat. no. 7a)

FIGURE 132. Altarpiece dedicated to Buddha Maitreya. Late Northern Wei (386–534) or Eastern Wei (534–50) dynasty, ca. 525–35. Gilt leaded bronze, H. 23¼ in. (59.1 cm). Rogers Fund, 1938 (38.158.2a–g; cat. no. 7b)

Among the largest surviving early Buddhist gilt-bronze altars, The Metropolitan Museum of Art's two Maitreya altarpieces (cat. nos. 7a, 7b; figs. 131, 132) have been associated with each other since they were reportedly found together in the first quarter of the twentieth century. They are iconographically rich works, with a level of artistry and craftsmanship that suggests court-related production. The altars exhibit casting and metalworking practices typical of the Northern Wei period (386–534) and share a range of technical features.[1] Despite many similarities, however, certain key differences in manufacture make it unlikely that they are contemporary products of the same workshop.

Each altar consists of a central figure of the Buddha Maitreya with a flaming mandorla, surrounded by bodhi-sattvas and other attendants that were separately cast and inserted into openings in the altar platforms. The larger altar (cat. no. 7a) is dated by inscription to the year 524 C.E.; the smaller altarpiece (cat. no. 7b) is uninscribed.

Instrumental analysis revealed a general consistency in alloy composition among the components of each altar but a marked difference in composition between the two works (see appendix D). To begin with the smaller altarpiece, all the samples analyzed, except the modern mandorla on one of the bodhisattvas, are leaded bronze alloys, with a similar range of minor constituents. From the fourteen samples analyzed, two groupings emerge. One group, consisting of Maitreya, Maitreya's mandorla, and the bases and platforms on which the Buddha stands, displays tin levels tightly clustered

between 4.8 and 5.2 percent. This result is consistent with the visual and radiographic evidence that the Buddha figure and its multiple bases are integral.[2] While there is some variation in the lead levels, it is within the range expected given the immiscibility of lead in copper alloys. The second group, comprising the bodhisattvas, the *apsara*s, and the caryatid figure, displays tin levels between 6.0 and 6.6 percent and lead levels from about 5 to 8 percent; the lead levels are slightly lower, on average, than those of the first group.

Moving on to the larger altar, alloy compositions for all components, except the lions, are closely clustered. Lead levels are low, from about 0.5 to 2.0 percent, with an average of 1.1 percent; tin levels are about 7 to 9 percent; and there are consistent amounts of minor and trace elements. As with the smaller altar, two main groupings emerge. Samples from Maitreya, Maitreya's mandorla, and the three-tiered altar platform display tin levels from 8 to slightly above 9 percent, with about 0.5 percent of both iron and zinc. While there is some variation in the tin and lead levels, all samples fall within the possible range for a single batch of metal, which is, again, consistent with the visual and radiographic evidence that the Buddha figure and its multiple bases are integral. The other components, excluding the lions, have somewhat less tin, from 7 to 8 percent, and smaller amounts of iron and zinc. The seated bodhisattvas, donors, and guardians are all close enough in alloy composition that they could have been cast from the same batch of metal. Analytically, the only real outliers on the large altar are the two lions, which contain roughly 3.5 to 5.5 percent lead, only about 6 percent tin, and somewhat more antimony and arsenic than the other samples.

The Buddha Maitreya on the smaller altar is hollow cast except for the feet, arms, head, and shoulders, which are solid (see fig. 133). There is an inverted-U-shaped iron armature extending from the ribcage through the ankles. This framework appears relatively uncorroded; there are no signs of cracking in the core or the bronze from expansion of the armature. Where the armature approaches the surface, at the left ankle, it strongly attracts a magnet. On the whole, the casting is well executed, with little porosity. One exception is a casting flaw with a crack extending from the proper-right shoulder to an area of radiotransparency at the center and proper-right chest. There are two areas of radiopacity corresponding to casting fins at the center and in the lower proper-right part of the figure, caused by molten metal's having entered fissures in the core. There is no evidence of a consecratory chamber.

The figure of the Buddha Maitreya on the larger altar is also hollow cast but with thinner walls and a core that conforms more closely to the contours of the sculpture (see fig. 134). The head, neck, arms, and feet are solid. Several features visible on the radiograph are difficult to interpret. A somewhat disordered pile of radiopaque fragments in the middle to lower portion of the figure's interior is probably the remains of an iron armature that extended through the feet. Excavation of an area on the back of the figure, above and

FIGURE 133. Radiograph of Buddha Maitreya from smaller altar (cat. no. 7b). The radiopaque rectangles at shoulder and knee height correspond to tangs on the back of the sculpture (see fig. 140).

FIGURE 134. Radiograph of Buddha Maitreya from larger altar (cat. no. 7a). The rectangular radiotransparent area at the center corresponds to the reliquary chamber originally accessible from the rear. The radiopaque rectangles at shoulder and knee height correspond to tangs on the back of the sculpture (see fig. 139).

slightly to the left of the lower tang, confirmed the presence of heavily corroded iron.[3] A radiopaque triangular area across the shoulders, tapering to midchest (frontal view) and faintly discernible in the corrosion layer on the rear of the figure, is likely a cast-in repair that may also have entrapped part of the upper armature.

The rectangular boundary of a reliquary chamber is well articulated in the radiograph but is no longer clearly apparent on the surface. There is little surviving metal in the area, suggesting that only a thin applied sheet sealed the opening. Exploratory excavation of the interior revealed, along with iron, a coarse, compact, ocher-colored fill with quartz inclusions. No vestiges of core material were encountered, and it is likely that most of the core was removed to house consecratory deposits. The collapse of the armature may have stemmed from moisture in the chamber that accelerated corrosion of the iron. It is also possible that the armature was damaged in the process of removing core material to create the chamber. While the radiopaque elements in the lower part of the figure are likely residual armature, remains of consecratory deposits may also be present. The lower proper-right portion of the drapery is solid and appears to have been cast on. A crack and disjuncture at the interface are visible in the radiograph and at some places on the surface.

On the larger altarpiece, both the cone-shaped lotus pod and the lotus pedestal on which Maitreya stands are hollow. In contrast, on the smaller altar, the Buddha's lotus pedestal is hollow but the lotus pod directly under the figure is solid. The interior of the lotus pedestal on the larger work is partially filled with metal that appears to have been poured into the cavity. Why this would have been done is unclear. Excavation on the edges of the poured-in metal encountered fine, grayish brown, tightly packed material considerably different in appearance from the ocher-colored fill found when excavating the reliquary chamber.

On both altars, tangs on the back of the Buddha, rectangular in section, pass through corresponding rectangular slots on the mandorla, joining the two elements. Judging by their appearance and the difficulty in anticipating their exact placement beforehand, the openings were likely cut with a chisel after casting. On the larger altar, there are three tangs, with the lower tang oriented horizontally and the two upper tangs oriented vertically, side by side at the shoulders (see fig. 135). Completing the attachment are rectangular holes in the tangs for the insertion of cross pins. The original pins do not survive. The decoration of the mandorla is not symmetrical. To compensate for this, and to ensure that the nimbus was directly behind Maitreya's

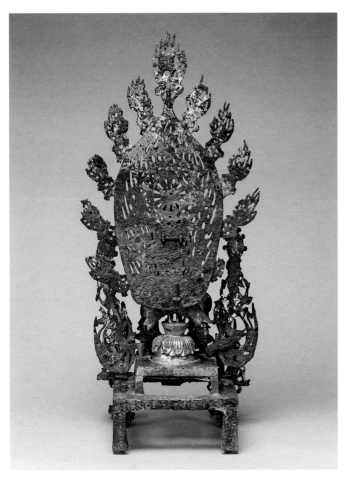

FIGURE 135. Rear view of larger altar (cat. no. 7a). Note the inscription on the bottom tier of the altar platform and the tangs and cross pins securing the Buddha's mandorla.

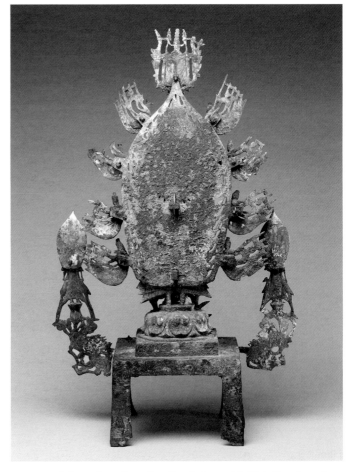

FIGURE 136. Rear view of smaller altar (cat. no. 7b). Note the pierced tangs and cross pins used to secure the large mandorla, the mandorlas of the two bodhisattvas flanking the Buddha, and the *apsara*s and shrine pendant to the large mandorla.

FIGURE 137. Detail of back of Buddha's mandorla on larger altar showing that the *apsara*s are integral to the mandorla (cat. no. 7a)

FIGURE 138. Detail of back of Buddha's mandorla on smaller altar showing that the *apsara*s and the shrine were separately cast and attached mechanically (cat. no. 7b)

head, the perforations in the mandorla were also positioned off-center.

On the smaller altar, two tangs suffice to secure the mandorla, with the upper tang oriented horizontally and the lower tang vertically (see fig. 136). As on the other example, cross pins, now lost, were used to complete the attachment. However, the perforations in the tangs are circular rather than rectangular.

On both altars, *apsara*s surround the Buddha's mandorla. Visually, the presentation is similar, but the metalworking on the two altars is very different. On the larger work, the *apsara*s were cast integrally with the mandorla (see fig. 137)— hence, the close correspondence in alloy composition among samples analyzed from the mandorla and two of the *apsara*s. On the smaller altar, however, the *apsara*s were cast separately and the attachment is mechanical. While similar in composition to the mandorla, the *apsara*s have tin levels sufficiently different to indicate that they were cast from a different batch of metal. Tangs on the backs of the *apsara*s fit into perforated flanges on the edge of the mandorla and are secured with cross pins inserted into holes in the tangs (see fig. 138). Again, none of the original pins appears to survive, although corrosion in some holes may obscure original remains.

The difference in joining methods is repeated in the manufacture of the bodhisattvas. On the larger altar, the bodhisattvas and their mandorlas were cast as a unit (see fig. 139). On the smaller altar, however, they are separate elements. Rectangular tangs on the backs of the bodhisattvas fit into corresponding openings in the mandorlas and, like the *apsara*s, are secured with cross pins (see fig. 140). From the limited number of comparable objects available for study, the mechanical joining method seen on the smaller altar seems more common.[4]

On both works, the bodhisattvas and other attendant figures have integral rectangular tangs for insertion into corresponding openings on the sides and top of the altar platforms. On the larger altarpiece, eleven rectangular slots were cut in

FIGURE 139. Detail of back of standing bodhisattva on proper-left side of larger altar showing that the mandorla is integral to the mandorla (cat. no. 7a)

FIGURE 140. Detail of back of standing bodhisattva on proper-right side of smaller altar showing that the mandorla was cast separately and attached mechanically (cat. no. 7b)

the altar platforms to receive tanged figures. In one instance, the placement of the slot was changed after work had begun, and the chiseled outline of the original position can be seen adjacent to the final location. The four slots on the top of the lower platform and the two forward slots on the top of the upper platform are roughly centered on raised circular or rectangular pedestals, which were part of the casting. The other slots are flush with the platform. The variation is probably related to the arrangement of the figures. Pedestals would have been superfluous for the two standing bodhisattvas

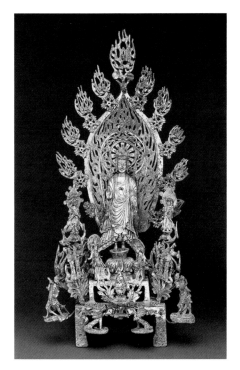

FIGURE 141. View of larger altar (cat. no. 7a) showing prior configuration of subsidiary figures. The guardians and lions were not attached to the altar itself but fitted into a modern brass mount concealed beneath the altar platform.

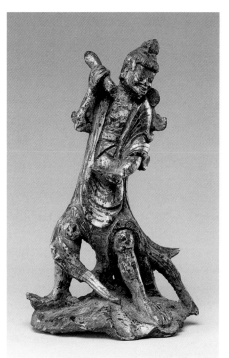

FIGURE 142. Guardian figure from proper-right side of larger altar (cat. no. 7a)

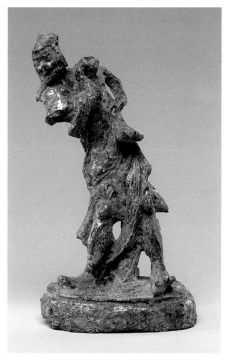

FIGURE 143. Guardian figure from proper-left side of larger altar (cat. no. 7a)

extending out from the sides of the upper platform as well as for the figures extending forward from the front of the lower platform.

The guardian figures and lions on the larger altar do not readily fit into any of the perforations in the altar platforms, and past installations have displayed them either separately, on individual bases, or attached to the altar with a modern brass mount (see fig. 141). This circumstance naturally raises the question of whether the guardians and lions originally belonged to the altar. The guardians are especially trouble-some. One is considerably larger than the other, and the bases on which they stand are quite different in conception. The larger guardian, on the proper left (fig. 143), stands on a plain, raised, oval base, while the figure on the proper right (fig. 142) stands on a lotus petal. On the other hand, their alloy compositions are virtually identical—certainly well within the analytical margin of error for having been cast from the same pour of metal. They are, at the same time, a visual mismatch and analytical siblings.

While a typical configuration would place the guardians in the two slots at the front corners of the altar platform, neither figure fits easily into its opening. Interestingly, the two slots are oriented differently. The perforation on the proper right is diagonal, about 45 degrees counterclockwise from the vertical orientation of the slot on the proper left. The tang on the larger guardian figure fits about halfway into the vertical slot and would go in farther were it not for corro-sion and some distortion of the metal that occurred before

burial. The fit is close enough that the figure could have originally belonged there. However, the guardian on the proper right is more problematic. Inserting the tang into the diagonal orientation of the slot tilts the figure upward at an improbable angle.[5]

In considering whether both guardians originally belonged with the larger altar, the document describing the discovery of the altars prepared by Yamanaka and Company after acquiring the objects in January 1923 may be relevant. The document reports that "the principal find consisted of four gilt statuettes with their accessories, of which two were of real importance." The location of the other two works found at that time is unknown, but from the description, it is likely that all four objects were altars. It is possible that rather than being of inferior quality, the other works were merely more fragmentary, in which case better-preserved figures from the purportedly lesser finds may have been used to complete their companions.

The lions also differ from each other, although less dra-matically than the guardians. Their postures are similar, but they vary in size and in the treatment of certain details. For example, the jaw of the smaller lion is articulated in the round, while the jaw of its counterpart is detailed only on the side facing the viewer. While these differences in execution are notable, other paired elements on the altar show similar, if not greater, inconsistencies. For example, both donor couples were cast from virtually the same alloy, and their fronts are almost identical. However, the backs are quite different. The

rear of one twosome is flat and undecorated, while the other couple is three-dimensional, with linear details throughout. There is also variation in the mandorlas of the seated bodhisattvas. The mandorla of the figure on the proper right is pierced, while that of the other figure is not.[6]

Without a larger body of comparative material, preferably excavated, it is difficult to assess the import of these variations. In some cases, such as that of the guardians, the figures may have been contemporaneous castings originally intended for different altars. The reason for seemingly minor differences such as those found in the donors or the bodhisattvas is, in some ways, more difficult to ascertain, particularly where the alloy compositions are quite close. Some variations may relate to casting or cold-working practices. Variability is characteristic of both lost-wax and piece-mold casting, even among images intended to be identical, while inconsistencies in engraving or chasing are typical from workshops where numerous hands were involved in the finishing process. As long as figures conveyed the same iconographic or spiritual meaning, even major stylistic variations may have had little or no bearing on the function or use of the altars.

Recent examination of the larger altar revealed two slots obscured by soil accretions located on the lower third of the front legs of the altar platform. The perforations are slightly smaller than the others on the altar. As with those for the guardians, the two slots are oriented differently. The slot on the proper right is horizontal, and the slot on the proper left is vertical. With the lions opposed, the shape of their tangs matches the orientation of the slots. While the tangs insert only a short way into the openings, this could be attributed to the increased volume of the corrosion layer as well as to some distortion of the metal prior to burial. In any case, only the ends of the long tangs would have entered the slots, the extra length having been needed to position the beasts beyond the overhanging guardians. Indeed, given the length of the animals' tangs, there is no other logical location for them on the altar.

The lions are different in alloy composition from the other components of the altar but close in composition to each other, supporting the proposition that they are related in time and place of manufacture. The difference in composition does not preclude the lions' having originally belonged to the altar. It is reasonable to expect that iconographic types such as lions, guardians, and bodhisattvas may sometimes have been manufactured independently and brought together only later for assembly into altars.[7] Another feature shared by the lions is considerable casting porosity on their undersides, in an area where one might expect the entrapment of gases if the animals were cast upside down.

Of special note on the larger altar is a repair spanning a break to the foliage just below the lotus base of the proper-left standing bodhisattva (see fig. 144). The repair consists of a bronze strip about 3⅛ inches (8 cm) long and ⅜ inch (1 cm) wide, with a cross member providing further support at the break. The repair is held in position with four, originally possibly five, rivets. It is gilded and heavily corroded and

FIGURE 144. Contemporary repair (indicated by arrow) on back of standing bodhisattva on proper-left side of larger altar (cat. no. 7a)

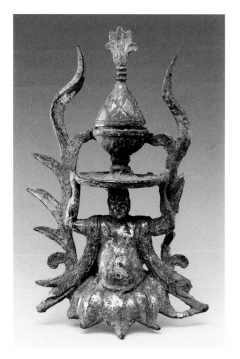

FIGURE 145. Caryatid figure from smaller altar (cat. no. 7b). Note the lack of perforations on the lid.

appears on examination to be unquestionably ancient. This assessment is supported by alloy analysis, which indicates that the composition of the strip is close to that of the standing bodhisattvas and other elements of the altar. In short, the damage occurred during or shortly after casting and was repaired before gilding.

Displayed on the center front of both altars is a caryatid figure holding a small vessel with a hinged lid. While the vessels are conventionally described as incense burners, only the lid on the larger altar is pierced (see fig. 145). Neither vessel shows evidence of burnt material or any other sign of use.

In ancient China, bronze was generally cast in piece molds. At some point in the first millennium c.e., lost-wax casting, the process prevalent in South and West Asia, was introduced into China and came to be the predominant casting method for sculpture. The dating for the transmission of lost-wax technology is uncertain, and there was probably a transitional period during which the technique was practiced alongside traditional piece-mold methods.[8] There is no definitive evidence for which technique was used to cast the Museum's Maitreya altars or whether the same method was used for both altars. While the deep folds in the drapery of the smaller Buddha suggest lost-wax casting, it is possible that the lack of undercuts on the larger Buddha was intended to facilitate the use of piece molds.

Because of corrosion and modern cleaning, it is difficult to distinguish cast details from subsequent engraving and chasing in some places. Nonetheless, it appears that, prior to gilding, engraving was used to refine cast features or to add details such as the inscription on the larger altar and that surfaces were chased and burnished after gilding. Removal of burial accretions from the smaller altar revealed fine, parallel burnishing marks. Elemental analysis of the gold on both altars detected mercury, confirming that they were amalgam gilded.[9] On the larger altar, possible traces of black and red pigment were observed on the Buddha's hair and lips, respectively.

In summary, although the two altars are similar in spiritual content and imagery and clearly reflect the same metalworking tradition, examination revealed notable differences in manufacture between them. While some variations may be inconsequential and others related more closely to intended use or donor preference than to technique, such as the presence or absence of an inscription or a reliquary chamber,[10] consistent differences in joining methods and alloy composition stand out as likely indicators of different workshops or artists.

Faced with the problem of creating a whole from multiple parts, a metalworker can choose between two fundamental approaches. One is metallurgical—that is, to cast integrally, solder, or fuse the elements together. The other is mechanical—to physically engage the elements with pins, dowels, rivets, and the like. Although the two methods can be used in combination, when particular joins—as, in this case, the connection of the *apsara*s to the mandorla and the mandorlas to the bodhisattvas—are accomplished metallurgically on one object and mechanically on another, the choice is likely a matter of the maker's personal preference, characteristic of an artist or workshop.

While both altars are bronze, the alloys are significantly different. The leaded bronze of the smaller altar is typical of early Chinese Buddhist sculpture, but the low lead levels of the larger altar are anomalous, at least to the extent that we can judge from the admittedly limited corpus of comparative material that has been analyzed to date. Lead levels in the range of those found on the larger altar were not encountered on any of the other early sculptures analyzed for this catalogue or on the forty or so Buddhist sculptures dated to about 450–600 c.e., some with multiple parts, that were analyzed at the Freer Gallery of Art, Smithsonian Institution, Washington, D.C.[11]

Indeed, at the levels detected here, the lead may not be an intentional alloy component at all but an impurity. There is no consensus about the level at which lead may be confidently considered an intentional addition; opinions generally range from 1 to 2 percent, which places the larger altar in the gray area.[12] The problem is compounded by the immiscibility of lead in copper alloys and the consequent analytical variability, even with samples from the same object. Whether the lead was added intentionally or not, the disparity in lead levels between the two altars makes it doubtful that one workshop would have used both alloys concurrently. Given the benefits of adding lead to copper alloys, including a lower melting point and improved fluidity during casting, and given that lead-bearing ores appear to have been in good supply in sixth-century China, it is unlikely that a foundry in the habit of using the metal would have cut back so drastically. The low lead levels may mark the output of a particular workshop at a particular time, or scholars may find, as more objects are analyzed, that low-lead compositions were more common than originally thought.[13]

In comparing the altars, one of the more intriguing questions involves the status of the two monks, which have traditionally been exhibited and published as part of the smaller altar (see fig. 146) but are now displayed with the larger altarpiece. The basis for assigning the monks to the smaller altar is uncertain, and the arrangement apparently predated their acquisition by the Museum.[14] Unlike the other subsidiary figures, which clearly fit on one altar or the other, the monks are of a size and orientation that could place them with either work, and slots to accommodate them exist on both altars, in each case above and behind the caryatid figure.[15] Analysis suggests, however, that the figures belong with the larger work. In alloy composition, the monks match components of the larger altar closely and are quite different from all parts of the smaller altar. This correspondence with the composition of the larger altar applies not only to major alloying elements but also to minor constituents, such as antimony and arsenic. Since the two altars were reportedly found together and appeared on the art market in tandem, it is certainly plausible that components from one altar were placed with the other, either in error or in order to balance the two works visually.

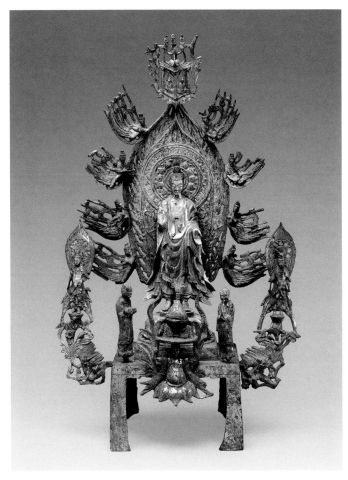

FIGURE 146. View of smaller altar (cat. no. 7b) showing previous arrangement of figures, with monks mounted on either side of altar platform

NOTES

1. The altarpieces were examined with a combination of optical microscopy, X-ray radiography, and energy dispersive and wavelength dispersive X-ray spectrometry in the scanning electron microscope (SEM-EDS/WDS). Microsamples for alloy analysis were taken from underneath the layer of surface corrosion. For a full description of the operating conditions and complete analytical results, see appendix D.

2. On both altars, the mandorla was cast separately from the Buddha.

3. An area of about ⁹⁄₁₆ by ³⁄₁₆ inch (1.4 x 0.5 cm), normally hidden from view by the attached mandorla, was excavated to a depth of approximately half an inch (1.25 cm).

4. See Jett and Douglas 1992, p. 207.

5. Since neither tang fits securely in its slot, and the orientation of the proper-right guardian is uncertain, the guardians are mounted alongside the slots on a modern support, which is hidden behind the feet of the altar platform. The appearance of the tangs suggests that they may have been added after the original casting, perhaps even in conjunction with a reuse of the figures. However, samples from both tangs match their respective figures closely in composition—evidence that they are contemporary with the guardians, although possibly cast on after the initial pour.

6. There is also some variation in the lotuses beneath the bodhisattvas on the smaller altar.

7. Of the six samples taken from the lions and their tangs, one is anomalous, conforming more closely to the general alloy composition of the altar. There is no obvious reason for this, and the explanation may be a mix-up of samples or data. See also Jett and Douglas 1992, pp. 211–12.

8. See pp. 30–31.

9. Samples were analyzed by energy dispersive X-ray spectrometry. Some silver is present in the gold alloys, but copper contamination from the base metal interfered with any meaningful quantitative analysis.

10. With limited comparative material, it can be difficult to judge intent. It is possible that the lack of an inscription and a reliquary chamber on the smaller altar was not planned but was a function of the work's having been interrupted or hurried and never finished.

11. See Jett and Douglas 1992, pp. 210–18.

12. See, for example, Cowell 1987, p. 98, and Reedy 1997, p. 19. Even at the low levels found on the larger altar, lead would have had some beneficial effect on the casting, as seen in its minimal porosity and generally high quality.

13. While a composition well outside the normal range sometimes gives rise to questions of authenticity, there are no such questions here. All elements of the larger altar display typical archaeological corrosion, and the metalworking techniques employed are appropriate for the Northern Wei period.

14. See Priest 1944, pp. 28–30. Museum records indicate that the monks were listed with the smaller altar in the 1925 bill of sale from Yamanaka and Company to John D. Rockefeller Jr., who owned the altars before the Museum acquired them in 1938.

15. The tangs, a feature that would normally help to clarify the situation, only add a degree of confusion in this case. Neither monk has its original tang. One monk has no tang at all, and the tang on the other figure is attached with modern lead solder. More perplexing still, the alloy composition of the soldered-on tang bears no relation to that of the monk and falls instead within the compositional range of the smaller altar. One possibility is that the tang on the proper-right bodhisattva from the smaller altar, which is intact in an early Museum photograph but is now truncated, broke off and was fashioned into a tang for the monk.

Compositional Analysis of Metal Sculpture in the Collection

MARK T. WYPYSKI

Microsamples of metal were removed with a scalpel or drill from all but one of the copper-alloy sculptures in the catalogue and appendix A. The metal samples were analyzed quantitatively by energy dispersive and wavelength dispersive X-ray spectrometry in the scanning electron microscope (SEM-EDS/WDS). The analyses were performed with an Oxford Instruments INCA Energy 300 microanalyzer equipped with a Link Pentafet high-resolution Si(Li) SATW EDS detector and a Microspec WDX-400 WDS spectrometer, operated with a LEO Electron Microscopy variable-pressure scanning electron microscope (model 1455VP). The analyses were performed under high-vacuum conditions at an accelerating voltage of 20 kV. Weight percentage concentrations of the detected elements were calculated according to well-characterized reference metals and standards. Weight percentages of major and minor elements were taken from the EDS analysis; results below 1 percent were taken from the WDS analysis. Under these analytical conditions, the minimum detection limits for most elements are estimated at approximately 0.01 percent, with elements such as lead, bismuth, and gold somewhat higher, about 0.03 percent. Thirteen elements were sought in all the samples: manganese (Mn), iron (Fe), cobalt (Co), nickel (Ni), copper (Cu), zinc (Zn), arsenic (As), silver (Ag), tin (Sn), antimony (Sb), gold (Au), lead (Pb), and bismuth (Bi).

The results are listed by catalogue number (or appendix A number) in the table below, in weight percentages of the detected elements. "PL" stands for "proper left," and "PR" for "proper right"; "nd" indicates "not detected."

Object No.	Sample Site	Mn	Fe	Co	Ni	Cu	Zn	As	Ag	Sn	Sb	Au	Pb	Bi
1	Base	nd	0.02	nd	0.06	87.6	nd	0.33	0.12	5.3	0.32	nd	6.2	0.04
	Halo	nd	0.03	0.02	0.05	90.2	nd	0.31	0.12	4.5	0.28	nd	4.4	nd
	Pin	nd	0.05	nd	nd	98.2	nd	0.20	0.06	0.03	0.27	nd	1.1	nd
4	Base	nd	0.40	0.05	0.07	86.5	0.12	0.34	0.15	8.3	0.26	nd	3.8	nd
	PL hand	nd	0.50	0.05	0.08	85.7	0.18	0.35	0.20	9.3	0.39	nd	3.2	nd
	Core extension	nd	0.04	0.02	0.08	85.7	0.02	0.34	0.20	6.8	0.34	nd	6.4	0.05
7a	Back of Maitreya	nd	0.42	0.02	0.02	90.6	0.40	0.07	0.02	8.0	0.04	nd	0.44	nd
	Front of Maitreya	nd	0.45	0.02	0.01	89.6	0.36	0.09	0.01	8.8	0.03	nd	0.63	nd
	Lower altar platform	nd	0.43	0.02	0.01	87.9	0.42	0.08	0.01	9.3	0.05	nd	1.8	nd
	Upper altar platform	nd	0.50	0.02	0.02	88.8	0.41	0.11	0.02	8.8	0.06	nd	1.3	nd
	Lotus base	nd	0.47	0.02	0.02	89.7	0.41	0.09	0.01	8.8	0.05	nd	0.43	nd
	Back of Maitreya, cast-on area of drapery	nd	0.49	0.02	0.01	88.1	0.41	0.08	0.01	8.5	0.04	nd	2.3	nd
	Back of Maitreya's mandorla	nd	0.48	0.02	0.01	88.6	0.39	0.08	0.02	8.5	0.05	nd	1.9	nd
	Front of broken apsara (PR)	nd	0.46	0.02	0.02	88.9	0.38	0.08	0.02	8.4	0.04	nd	1.7	nd
	Back of uppermost apsara	nd	0.49	0.02	0.01	89.2	0.40	0.08	0.01	8.3	0.04	nd	1.5	nd
	Standing bodhisattva (PL)	nd	0.09	nd	0.02	91.1	0.04	0.08	0.02	7.6	0.04	nd	0.98	nd
	Rear of standing bodhisattva, repair	nd	0.02	0.01	0.01	91.8	0.05	0.08	0.01	7.0	0.04	nd	0.95	nd
	Standing bodhisattva (PR)	nd	0.13	0.02	0.02	90.8	0.03	0.09	0.02	7.9	0.04	nd	0.94	nd
	Lion, haunch (PL)	nd	0.06	0.01	0.02	91.6	0.04	0.07	0.02	7.0	0.05	nd	1.2	nd
	Lion, under chin (PL)	nd	0.07	0.01	0.03	88.0	0.05	0.16	0.10	6.1	0.10	nd	5.4	nd
	Lion, tang (PL)	nd	0.06	0.01	0.03	89.3	0.05	0.17	0.10	6.0	0.13	nd	4.1	nd
	Lion, under chin (PR)	nd	0.07	0.02	0.03	90.1	0.05	0.14	0.10	6.0	0.10	nd	3.4	nd
	Lion, tang (PR)	nd	0.07	0.01	0.04	88.4	0.07	0.14	0.11	6.2	0.12	nd	4.8	nd
	Lion, haunch (PR)	nd	0.06	0.01	0.03	89.3	0.04	0.15	0.11	6.3	0.13	nd	3.8	nd
	Seated bodhisattva (PR)	nd	0.29	0.02	0.01	90.8	0.12	0.07	0.02	7.2	0.05	nd	1.4	nd
	Seated bodhisattva (PL)	nd	0.02	0.01	0.01	91.8	0.03	0.06	0.01	7.0	0.04	nd	1.0	nd
	Donors (PR)	nd	0.01	0.01	0.01	91.6	0.03	0.07	0.01	7.2	0.04	nd	1.0	nd
	Donors (PL)	nd	0.03	0.01	0.02	91.8	0.04	0.10	0.02	7.1	0.05	nd	0.61	nd
	Guardian (PL)	nd	0.02	0.01	0.02	91.8	0.03	0.09	0.02	7.1	0.05	nd	1.0	nd
	Guardian, tang (PL)	nd	0.06	0.02	0.03	91.2	0.05	0.06	0.01	7.2	0.02	nd	1.3	nd
	Incense burner, rear of lotus petal	nd	0.03	0.01	0.02	91.2	0.04	0.06	0.02	7.2	0.02	nd	1.4	nd
	Incense burner, base	nd	0.02	0.01	0.02	91.6	0.04	0.07	0.02	7.0	0.05	nd	1.2	nd

Object No.	Sample Site	Mn	Fe	Co	Ni	Cu	Zn	As	Ag	Sn	Sb	Au	Pb	Bi
7a	Guardian (PR)	nd	0.10	0.01	0.01	91.5	0.03	0.08	0.03	7.2	0.04	nd	1.0	nd
	Guardian, tang (PR)	nd	0.10	0.01	0.01	91.5	0.04	0.10	0.02	7.2	0.05	nd	1.0	nd
	Monk (PL)	nd	0.11	0.01	nd	91.2	0.03	0.08	0.02	7.3	0.04	nd	1.2	nd
	Monk, tang (PL)	nd	0.32	0.03	0.04	85.3	nd	0.32	0.13	5.0	0.25	nd	8.6	nd
	Monk (PR)	nd	0.10	0.01	nd	91.0	0.03	0.09	0.02	7.6	0.07	nd	1.0	nd
7b	Front of Maitreya	nd	0.46	0.03	0.05	86.6	nd	0.46	0.11	4.9	0.29	nd	7.1	nd
	Back of Maitreya	nd	0.27	0.03	0.05	85.2	nd	0.49	0.11	5.1	0.29	nd	8.5	nd
	Lotus base	nd	0.36	0.03	0.07	85.6	nd	0.34	0.09	5.0	0.29	nd	8.2	nd
	Upper altar platform	nd	0.26	0.03	0.06	85.8	nd	0.50	0.13	5.2	0.48	nd	7.5	nd
	Lower altar platform	nd	0.25	0.02	0.07	85.4	nd	0.31	0.10	4.8	0.10	nd	9.0	nd
	Back of Maitreya's mandorla	nd	0.32	0.02	0.07	86.5	nd	0.47	0.08	5.0	0.34	nd	7.2	nd
	Apsara	nd	0.30	0.02	0.06	86.1	nd	0.38	0.10	6.2	0.28	nd	6.6	nd
	Shrine	nd	0.21	0.02	0.06	86.8	nd	0.38	0.09	6.1	0.31	nd	6.0	nd
	Incense burner, rear of caryatid figure	nd	0.29	0.02	0.06	87.2	nd	0.42	0.09	6.6	0.31	nd	5.0	nd
	Incense burner, lid	nd	0.34	0.02	0.06	84.9	nd	0.33	0.07	6.0	0.25	nd	8.0	nd
	Bodhisattva (PR)	nd	0.36	0.03	0.05	87.2	nd	0.37	0.13	6.6	0.30	nd	5.0	nd
	Bodhisattva's mandorla (PR)	nd	0.24	0.02	0.08	87.2	nd	0.42	0.10	6.4	0.27	nd	5.3	nd
	Bodhisattva (PL)	nd	0.27	0.02	0.05	85.3	nd	0.36	0.13	6.2	0.31	nd	7.3	nd
	Bodhisattva's mandorla (PL)	nd	0.18	0.02	6.2	66.9	25.8	0.02	nd	0.13	nd	nd	0.78	nd
12	Base	nd	0.07	0.02	0.02	88.0	nd	0.16	0.06	6.5	0.16	nd	5.0	nd
	Head, tang	nd	0.05	0.02	0.03	87.6	nd	0.18	0.07	6.6	0.18	nd	5.3	nd
	Halo	nd	0.07	0.01	0.02	88.2	nd	0.17	0.08	6.9	0.16	nd	4.4	nd
	Pin	0.01	0.08	nd	nd	67.4	32.2	0.01	0.04	nd	nd	nd	0.22	nd
16	Base	nd	0.36	0.06	0.12	73.2	nd	1.2	0.18	8.5	0.84	nd	15.5	0.05
19	Figure	nd	0.60	0.06	0.09	73.9	nd	0.42	0.35	9.2	0.32	nd	15.0	0.03
	Base, tang	nd	0.63	0.07	0.09	82.6	0.02	0.36	0.30	9.5	0.25	nd	6.1	0.04
22	Base	nd	0.05	0.01	0.08	73.6	nd	0.26	0.08	7.7	0.18	nd	18.0	0.04
	Mandorla	nd	0.21	0.01	0.03	65.1	nd	0.16	0.04	6.7	0.14	nd	27.6	0.03
	Lotus petal	nd	0.05	nd	0.08	69.1	nd	0.19	0.07	7.2	0.11	nd	23.2	nd
25	Figure	nd	0.09	nd	nd	91.9	0.05	1.0	0.84	6.0	0.02	nd	nd	nd
26	Figure	nd	0.43	0.04	0.14	91.0	1.1	0.03	0.13	7.0	nd	nd	0.10	nd
31	Top	nd	0.61	nd	0.02	95.2	nd	3.2	0.07	0.85	nd	0.06	nd	nd
	Base	nd	0.79	nd	0.02	95.5	nd	2.9	0.04	0.70	nd	0.03	nd	nd
32	Figure, drapery	nd	0.01	nd	0.02	96.5	nd	2.9	0.04	0.51	0.03	nd	nd	nd
	Base	nd	0.13	nd	0.12	91.2	7.6	0.18	nd	0.25	nd	nd	0.48	nd
	Tang	nd	0.11	nd	0.13	88.6	9.7	0.25	nd	0.25	nd	nd	1.0	nd
	Door cover	nd	0.18	nd	nd	73.7	24.8	0.02	0.04	nd	nd	Au	1.3	nd
33	Figure	nd	0.34	0.02	0.07	98.2	nd	0.87	0.04	0.31	nd	nd	0.12	nd
34	Figure	nd	0.11	nd	0.09	99.2	nd	0.45	0.02	0.09	nd	nd	nd	nd
37	Figure	nd	0.11	nd	nd	80.9	15.1	0.07	0.08	0.22	0.03	nd	3.5	nd
38	Figure	nd	0.43	nd	0.02	77.1	18.7	0.07	0.15	0.54	0.04	nd	2.9	0.06
42	Back, drapery	nd	0.48	nd	0.04	79.4	6.1	0.89	0.14	5.5	0.2	nd	7.2	nd
44	Figure	nd	0.04	nd	0.06	93.2	6.0	0.02	0.06	0.55	0.01	nd	0.05	nd
	Halo	nd	0.05	nd	0.08	91.7	7.1	0.03	0.05	0.87	0.04	nd	0.08	nd
	Base	nd	0.04	nd	0.06	91.3	7.5	0.04	0.20	0.71	0.07	nd	0.04	nd
45	Base	nd	0.09	nd	0.07	78.8	20.7	0.15	0.07	0.04	0.03	nd	0.04	nd
A15	Tang	nd	0.05	0.01	0.04	75.2	nd	0.21	0.10	9.3	0.17	nd	14.9	nd
A17	Tang (PL)	nd	0.09	0.02	0.05	88.6	nd	0.29	0.14	5.9	0.27	0.13	4.5	nd
A24	Figure	0.02	0.10	0.02	0.07	82.2	nd	0.48	0.22	12.1	0.46	nd	4.2	0.08
	Base	nd	0.83	0.15	0.13	80.4	0.05	0.37	0.10	9.4	0.12	nd	8.4	nd
A33	Figure	nd	0.08	0.03	0.06	78.5	nd	0.36	0.12	8.8	0.22	nd	11.8	0.06
A37	Tang	nd	0.12	0.01	0.04	75.8	nd	0.19	0.11	9.8	0.08	nd	13.8	0.05
A56	Base	nd	0.36	nd	0.03	74.5	15.3	0.22	0.03	1.7	0.08	nd	7.7	0.04
A57	Base	nd	0.21	nd	0.03	76.7	10.4	0.31	0.04	2.3	0.07	nd	9.9	nd
A62	Figure	nd	0.02	nd	0.12	86.0	13.4	0.10	0.02	0.33	nd	nd	0.04	nd
A63	Figure	nd	0.11	nd	0.02	81.6	15.2	0.16	0.02	0.07	0.04	nd	2.8	nd
A68	Figure	nd	0.06	0.01	0.02	86.1	7.2	0.15	0.04	0.05	0.12	nd	6.2	nd
	Base	nd	0.04	nd	0.03	84.1	6.7	0.11	0.05	0.03	0.06	nd	8.9	nd
	Halo	nd	0.12	nd	0.04	86.5	6.7	0.17	0.03	0.10	0.09	nd	6.2	nd
	Umbrella cap	nd	0.52	nd	0.02	66.3	31.4	0.21	0.06	0.22	0.12	nd	1.1	nd
A69	Base	nd	0.35	nd	0.03	76.6	15.3	0.10	0.09	2.4	0.05	nd	5.0	0.04
A70	Figure	nd	0.62	nd	0.08	57.3	39.0	1.2	0.02	0.06	nd	nd	1.7	nd

Polychrome Decoration on Chinese Sculpture

DONNA STRAHAN, ADRIANA RIZZO, WON YEE NG, AND ARIANNA GAMBIRASI

The majority of the sculptures examined for this catalogue were originally polychromed, regardless of the material from which they were manufactured: metal, stone, ceramic, ivory, or wood. In all cases, color was used to enliven the sculptural forms. The first Buddhas to be polychromed were probably wall paintings in cave temples; the clay or stucco sculptures associated with those paintings; and small, portable wood images. Stone and metal objects were also painted, according to, essentially, the same color scheme. Frequently, sculptures were restored and repainted multiple times during their service, and on rare occasions, the restoration campaigns were documented. Larson and Kerr (1985) identify inscriptions on a few wall paintings and sculptures that demonstrate that craftspeople traveled around China with their materials, models, and copybooks, creating new images as well as repairing old ones. One inscription inside a wood bodhisattva in the Nelson-Atkins Museum of Art, Kansas City, provides the name of a restorer and date of a repair and redecoration in 1349, roughly 150 years after the sculpture was made.[1] The historical study of restoration techniques on Chinese sculptures is relatively new, however, and it is particularly complicated when paint sequences contain an inconsistent number of layers.

Often, any pigment that remains on a work is barely visible with the naked eye and is evident only with the aid of the binocular microscope, usually in recesses, where the color has remained relatively undisturbed over centuries of weathering and handling. Among the sculptures presented in the catalogue, multiple paint layers are most common on the wood sculptures but were also found on stone (cat. nos. 9, 15, 18; nos. A18, A48) and metal (no. A69) objects. Not all the sculptures have had their polychromy characterized to the same extent. Nonetheless, the results of the Museum's study shed light on the techniques and materials used by Chinese artisans in general. It is hoped that this brief summary will encourage further research into restoration techniques and changing aesthetic tastes over the centuries.

Primarily, the extant pigments on sculptures were characterized instrumentally, with the noninvasive technique of X-ray fluorescence (XRF) analysis,[2] which provides in situ elemental composition of colored areas for preliminary identification of pigments. For example, the detection of mercury (Hg) and sulfur (S) suggests the presence of vermilion[3] (mercuric sulfide; HgS); lead (Pb) suggests the presence of lead white (basic lead carbonate; $Pb(OH)_2 2CO_3$) and/or red lead (lead tetroxide; Pb_3O_4); iron (Fe) suggests the presence of ocher, which contains iron oxides and/or hydroxides, or of another iron-containing pigment, such as Prussian blue

($Fe_7(CN)_{18} \cdot H_2O$). However, XRF results are difficult to interpret when the analyzed areas are multilayered and contain mixtures of pigments. While this method does not identify specific compounds, it does help to determine whether certain modern pigments are present, such as those containing zinc, cadmium, titanium, or chromium. Therefore, minimally destructive analysis is desirable in order to provide more specific information. Some objects were sampled in order to obtain paint flakes representative of paint buildup. These flakes were embedded in a synthetic resin and polished to reveal the pigment stratigraphy, which helped to differentiate original paint layers from later repainting campaigns. Where uncontaminated layers of paint or coatings were present, microscopic scrapings were obtained for analysis.

Further characterization of painted areas and pigment particles in paint layers was pursued with complementary techniques such as polarized-light microscopy (PLM); Raman microscopy (Raman), which identifies pigments at a molecular level; and Fourier-transform infrared microscopy (FTIR) and attenuated total reflectance–Fourier-transform infrared microscopy (ATR-FTIR), which provide additional information about the media of pigmented and clear layers.[4] Energy dispersive X-ray spectrometry in the scanning electron microscope (SEM-EDS) was used for elemental characterization of metal leafs and pigments and their distribution within layers as well as for studies of metal corrosion.[5] X-ray microdiffraction (XRD) was used for detailed characterization of mineral pigments on the basis of crystal structure, particularly on the Tang-dynasty dry-lacquer Buddha (cat. no. 13). Characterization of lacquer layers was performed with reactive pyrolysis-gas chromatography mass spectrometry (Py-TMAH-GCMS).[6]

In general, it was found that a variety of colored pigments, both natural (clays and colored minerals) and man-made (lead white, red lead, vermilion, indigo, and smalt), were applied pure, in superimposed layers, and in mixtures, usually bound in a protein medium. Precious materials such as gold leaf, stone inlays, and rare minerals such as lapis lazuli were also used to enhance the sculptures.

METAL

Nearly all the metal sculptures in the collection were mercury-amalgam gilded, with traces of pigments appearing on top of the gilding in selected areas. The ungilded sculptures were also selectively painted. The pigments are similar

regardless of casting method, alloy composition, or time period. The paint was consistently applied directly on to the metal surfaces, without a preparatory ground. The earliest metal sculptures contain only traces of pigments, making it difficult to determine the original extent of the painting. While it is not possible to determine exactly when the pigments were applied, their presence under layers of corrosion products on the archaeological sculptures suggests that they were applied prior to burial.

Most of the early sculptures appear to have been selectively colored. While the bodies of the fourth- to ninth-century copper-alloy Buddha sculptures were mercury-amalgam gilded, the hair was left ungilded on most of them (cat. nos. 1, 4, 7a, 7b, 12, 16, 19; no. A33). In these works, the hair appears to have typically been painted black and, later, blue, usually with carbon black followed by a blue pigment such as ultramarine or indigo. Copper-based blues were also found (cat. no. 12). The lips were painted red with vermilion, the eyes white with lead white, and the irises and eyebrows black. Sometimes, the eyes were outlined in red (cat. no. 31). Some robes have traces of paint on them, such as the vermilion on a Maitreya (cat. no. 4) and the red lead on an Avalokiteshvara (cat. no. 12). Copper-based green in the form of basic copper carbonate or chloride may also have been used (cat. no. 12), but because the composition of those pigments is the same as that of typical copper-alloy corrosion products, it is difficult to distinguish them from corrosion.[7] Gems in jewelry were often painted red, most likely with red lead. The flames of the Avalokiteshvara's mandorla (cat. no. 12), as well as the headdress, were originally completely painted bright red with red lead, as seen in figure 71. The lotus flower on which a bodhisattva (no. A33) is seated was first painted red with vermilion and, later, pink with a mixture of lead white and vermilion.

In the tenth- to nineteenth-century sculptures, similar shades of blue in the hair and red in the lips continued to be used (cat. no. 44). One sculpture (cat. no. 22) was not gilded but may have been chemically patinated in multiple colors or elaborately painted. However, the only pigments found were red lead in the mandorla, robe, and toes and vermilion in the lotus petals. Red lead was found on a brass guardian figure (no. A63).

The color schemes of Tibetan, Mongolian, and Sino Tibetan–style sculptures differ from those of Chinese pieces. Reedy's (1997) discussion of the pigments used on Himalayan sculptures is helpful in understanding their decorative and symbolic purpose. The flesh tones in the face, and sometimes in other exposed areas, were usually created with cold gilding (gold powder mixed with a binder, applied without the use of heat or mercury). Various colors of hair helped to define the mood of a sculpture. Blue or black hair was associated with peaceful deities, and red-orange with wrathful deities. The pigments found on some sculptures in the Metropolitan (cat. nos. 33, 37; nos. A63, A68) are consistent with Reedy's findings.[8]

The most elaborately painted metal sculptures in the collection are catalogue number 45 and numbers A68 and A69. The late-Ming or Qing brass Avalokiteshvara (no. A69) was

FIGURE 147. Cross section of paint from Avalokiteshvara's cape (no. A69), showing early red-orange campaign under four blue repaints. Viewed in reflected visible light

painted more than once, requiring a thorough study. There are up to six layers of paint in the folds of the ribbons of the cape. The cape, now blue, had earlier been painted pale red-orange with a mixture of red lead, vermilion, lead white, calcium sulfate and carbonate, and white clay (see fig. 147). The skirt was painted red with vermilion and later coated with a reddish translucent layer, possibly Chinese lacquer, containing red lead and organic inclusions, probably starch. The same coating was applied on gilded areas of the flesh, formerly painted pink. Inconsistent clay layers of varied compositions are visible underneath the cape, the skirt, and the nineteenth-century paints of the flesh and overskirt. The layers could be interpreted as soiling, which would prevent an accurate identification and dating of the colors applied over them.

The nineteenth-century Vaishravana as Kubera (no. A70) has a black beard, lead-white eyes with black irises, carbon-black eyebrows, vermilion lips, black hair, and red paint behind the crown. The colors in his decorative accessories include green in the necklace, armbands, and bracelet and red in the gems; red was also used in the rat's mouth. The Mongolian White Jambhala (cat. no. 45) was embellished with silver and copper inlays in the clothing, bracelets, nipples, and eyes and was also extensively painted. Both the dragon and the divinity have lead-white eyes with black irises outlined in vermilion red. The claws and fingernails were painted with lead white, as were the teeth (see fig. 115). Jambhala's face, neck, hands, and feet were painted gold with a mixture of gold and silver (no mercury present). The hair was originally blue, but the surface has now converted to dark gray on account of the deterioration of the smalt. The eyebrows are black, and there is red (a mixture of vermilion and red lead) in the back of the crown and in the lips. The dragon's mane was painted green with a copper pigment; the mouth and,

perhaps, the belly were painted red. There are black lines on the top of the base, possibly meant to imitate rocks.

STONE

All the stone sculptures in the catalogue were originally painted. A white ground layer was used on some of them, perhaps to fill in cracks and flaws and provide a smooth surface for the application of paint; on others, the paint was applied directly to the stone. In general, red was the most common pigment found in the Museum's study. Unfortunately, the dates of the painting campaigns cannot be determined, as the pigments identified were available in China long before the sculptures were carved. Notes on the painted decoration of some of the cave-temple sculptures are found in specific catalogue entries. The groupings of cave-temple sculptures in the collection are too small to draw any conclusions regarding their coloration. Traces of red and white paint remain on the seated figures from Yungang (cat. nos. 3a, 3b), but any other pigments have long since disappeared from them. XRF analysis shows comparable elemental composition in painted areas of the two figures. In particular, more detailed analysis of catalogue number 3a shows inconsistent paint stratigraphies in the flesh and drapery, complicating the interpretation of the original polychromy.[9] Early paint and preparatory layers contain clay, gypsum, talc, and, often, red ocher. Evidence of lead sulfate was also found in some of the layers, as suggested by high XRF readings for lead. Lead sulfate has been detected in repainting campaigns on other polychromed Chinese sculptures.[10]

A late-sixth- or seventh-century Avalokiteshvara (no. A18) was analyzed in detail.[11] The present surface of the figure shows clear evidence of selective gilding. However, mostly because of the paint's poor adhesion to the substrate, only scattered areas of original colored paint below the gilding could be

FIGURE 148. Cross section of paint from carved area of bead on bodhisattva's long necklace (no. A18), showing lower sequence of translucent brown and gray layers followed by a black application and a gilding campaign. Viewed in reflected visible light

studied in cross section and loose samples. In most areas, it appears that the stone was treated with a white kaolin-based preparatory layer in a protein medium. The mouth of the figure was painted red with red ocher and vermilion. The fold-over section of drapery was painted blue with azurite (basic copper carbonate). Two sequential clay layers, first brown and then gray, occasionally followed by a thin, discrete layer of black paint or lacquer, are present in carved areas around the beads of the long necklace and in carved areas of the drapery (see fig. 148). The function of these layers is not clear, but their presence in recesses and spacers between the beads suggests that they may have been intended to enhance the contrast with adjacent colors. These layers, and some of the colored areas of the figure, bear evidence of the gilding campaign, which contributes to the current appearance of the sculpture. The gold leaf was adhered with a binder to a yellow ocher layer, which itself was applied over a white kaolin ground. On the base, red lead was used in the drapery of the figure handling the snake, while the drapery hanging from the column by the left arm of the figure grasping a jug was painted bluish green with azurite, which included particles of atacamite and botallackite (both basic copper chlorides) and copper oxalates. Basic copper chlorides have been frequently reported in Chinese paintings from the fourth century onward. Their presence in combination with azurite may suggest their occurrence in the same copper ore. Concomitant atacamite and azurite were also found in the cape of another bodhisattva (cat. no. 27), suggesting a similar origin.[12]

The torso of a Northern Qi–period bodhisattva (no. A13) has green and red pigments applied over a white ground and remains of gilding around the band of the robe. A fragmented Tang-dynasty relief (no. A32) has traces of polychromy over a lead-white ground. The face was painted beige, and areas of the drapery were painted with red lead. A pigment mixture containing red lead and lead white was used for the original pink color of the torso and right hand. The background of the relief was painted beige.

At one time, the black Tang-dynasty stele (cat. no. 15) was certainly completely painted, including the borders (see fig. 41). The top layer of yellow paint, identified by XRF as yellow ocher, may have been applied as imitation gilding on top of red paint(s) containing vermilion, red lead, and red ocher. An ocher pigment was also used to color the yellow haloes of the multitudes of Buddhas on the back. The larger figures and a few of the "thousand Buddhas" have, in addition, traces of green and red pigments around their haloes as well as on their clothing. One can imagine how colorful this work must have once been.

A Jin-dynasty bodhisattva (no. A48) is elaborately painted, and some areas of very fine quality remain. A white ground is present as well as a number of paint layers not yet studied. Remains of delicate brushstrokes in a floral design on the robe, near the waist, are reminiscent of Chinese paintings (see fig. 149). A Sui-dynasty standing bodhisattva (no. A16), a Tang-dynasty monk (probably Ananda), and a Northern Song–dynasty figure of Sengqie (cat. nos. 18, 28; see individ-

FIGURE 149. Detail of floral design on bodhisattva's robe, under arm (no. A48)

FIGURE 150. Cross section of paint from recess of back of Buddha's robe (cat. no. 29), showing gold leaf applied over sequence of yellowish and pinkish layers. Viewed in reflected visible light

ual entries) also have many paint layers. Thus far, all the pigments identified on stone sculptures are the same as those used on sculptures produced in other materials.

WOOD

Multiple layers of polychromy were found on the wood sculptures in the collection, indicating significant restorations and changes in design over time in the interest of presenting a beautiful, well-cared-for sculpture for ritual use. All the sculptures studied had changed in appearance, sometimes frequently, over their long histories. While the palette of pigments did not change significantly, the design details and application methods did change. The evolution observed within the collection is consistent with that presented in the literature. Larson (1988) reports that a radical change occurred in the appearance of sculptures during the Ming dynasty: a naturalistic scheme, with pink flesh and flat, brightly colored clothing, was abandoned in favor of materials that created the illusion of a "gilded metal image with the flesh painted and gilded to look like a reddish copper bronze."[13]

For the most part, noninvasive XRF was used to survey the elements present in the exposed paint layers. However, a clearer understanding of the original palettes could be achieved when samples were taken. Among the polychrome wood sculptures examined, six were selected for sampling (cat. nos. 27, 29, 36, 40, 41; no. A59).

The Sudhana sculpture (cat. no. 41) was identified as having originally been lacquered, as is consistent with its period of manufacture. A Jin-dynasty Buddha (cat. no. 29) differs from the rest of the group by the use of gilding; the gold leaf appears to have been simply adhered, without a visible binder, over a pinkish kaolin layer containing red ocher and gypsum, which was itself applied over a yellowish ground layer containing kaolin and gypsum (see fig. 150). On all the other analyzed sculptures, a whitish kaolin-based clay was used as a ground, followed by the colored paints, all bound in a protein medium.

A number of the original color schemes are discussed in the individual catalogue entries, and some are compared in the table on the following page. Despite the wide range of periods and regions represented by the sculptures, the choice of pigments is strikingly similar. The limited palette and generally high degree of restoration required extensive sampling in order to correctly interpret the chronology of the paint stratigraphy. The comparative visualization, and analysis in cross section, of the ground layers applied to a single sculpture was crucial for discriminating between the original ground and grounds that were applied later, particularly when repaints using traditional pigments were found in areas of early losses. Multiple applications of translucent whitish kaolin-based grounds were employed not only as the base for the original color buildup (cat. no. 40) but also as foundation layers in repainting campaigns. Among the sculptures, some variability is found in the composition of the original grounds. In some instances, they contain, in addition to kaolin, other white clay minerals (cat. nos. 27, 36), sometimes mixed with particles of red ocher (cat. no. 40) or silica and gypsum (no. A59). Oxalate salts were occasionally found in the form of calcium oxalates in grounds and paint layers

Proposed Original Palette of Polychrome Wood Sculptures				
	Cat. No. 27	**Cat. No. 36**	**Cat. No. 40**	**No. A59**
Binder	Protein	Protein	Protein	Protein
Ground	Kaolin,[14] calcium oxalates	Kaolin	Kaolin, red ocher, calcium oxalates	Kaolin, gypsum, silica, calcium oxalates
Flesh	Vermilion, lead white	Vermilion, kaolin, silica	Red lead	Vermilion, clay, gypsum
Hair	Indigo	Indigo	Indigo	Indigo
Red	Vermilion	Vermilion, red lead	Vermilion, red lead	Vermilion
Yellow	nd	nd	Yellow ocher	nd
Green	Atacamite, copper oxalates	nd	Atacamite	Atacamite, copper oxalates
Blue	Indigo, azurite	Indigo	nd	nd

nd: not detected

(cat. no. 41). Different shades of red were produced either by using darker vermilion or oranger red lead in separate applications or by overlapping them in sequences. For example, red lead was used for the red-orange sash in catalogue number 36, but a sequence of vermilion over red lead was used to create the darker hue of the skirt. Common in Chinese sculpture, this layering technique was also used for the red outline of the lead-white eye of the lion and for repaints of the decorative band along its throat in the Avalokiteshvara of the Lion's Roar (cat. no. 40; see fig. 151).[17] In the same work, a similar layering technique, with a layer of yellow ocher over a layer of red lead, was used to create the yellowish orange color of the figure's robe.

Mineral greens containing atacamite and copper oxalates, likely derived from malachite and azurite sources, were the most common greens encountered in the early layers and repaints of the wood statuary. Green mixtures of basic copper chlorides similar to those found on the late-sixth- or seventh-century stone Avalokiteshvara previously discussed (no. A18) were also found on the wood sculptures, as in the green cape of the late-tenth- or eleventh-century Avalokiteshvara (cat. no. 27) and in the garments of the three arhats (no. A59), particularly the shawl of the proper-right figure and the robes of the other two figures (see figs. 152, 153).[18] The trim of the robes was accented with vermilion and gold. The three arhats compare with ceramic sculptures in which the robes and shawls of the figures have maintained their green color (see no. A55). Moreover, the raised cloud patterns in gilded *pastiglia* on the robes are consistent with

(cat. nos. 27, 40; no. A59) and as copper oxalates in combination with green copper pigments (cat. no. 27; no. A59).[15]

Generally, the figures were painted naturalistically, with flesh tones ranging from shades of pink, obtained by mixing vermilion with either the white formulation used for the ground (cat. no. 36; no. A59) or lead white (cat. no. 27), to orange-red, produced with red lead (cat. no. 40). The latter color may also have served as a base for the application of gold leaf, although no concrete evidence was found to support this hypothesis. The hair was painted blue with indigo, mostly surviving in traces.

The color of the clothing often varied from repaint to repaint. The original garments, including robes, capes, scarves, sashes, skirts or trousers, and overskirts, were rendered mainly in bold, juxtaposed colors, such as green, red, blue, yellow, and red-orange. It is likely that the choice of colors in the garments was dictated by stylistic tradition. For instance, the color scheme of red skirt and blue cape with long ribbons in the Water-Moon Avalokiteshvara (cat. no. 36) is very similar to that of an earlier carved Avalokiteshvara (Victoria and Albert Museum, London), which shares a comparable paint composition in the flesh and use of indigo in the hair and cape.[16] Red seems to have been most commonly used on the trousers and skirts of Buddhas in the original layers (cat. nos. 27, 36; no. A69) but was also used in repaints

FIGURE 151. Cross section of paint from lower rim of lion's eye (cat. no. 40), showing six original paint layers, including early yellowish paint of fur, white eye, and red rim, all applied over new kaolin grounds. Viewed in reflected visible light

the taste of the Ming dynasty, when the sculptural group was originally painted.

Indigo is the most common blue pigment encountered in the drapery on the analyzed works. It was used in the robe of the proper-right arhat in the group (no. A59). In addition, it features in the outer ribbons of the capes of two Avalokiteshvaras (cat. nos. 27, 36). In the former, it is also used, in combination with azurite, in the overskirt.

In general, the dating of the sculptures' various restoration campaigns is complicated, but some trends can be discerned, particularly in the treatment of the flesh. Overall, similarly to the trend seen in other substrates, the flesh changed from naturalistic coloring to gilding at some point. For instance, in one Avalokiteshvara (cat. no. 27), the rendering of the the flesh alternated between gilded and naturalistic, and in the arhat group (no. A59), the original orange flesh tones were repainted a more naturalistic pink and later were gilded and lacquered. In another Avalokiteshvara (cat. no. 40), a similar orange flesh tone was later gilded at least twice, while the flesh and overall painted surface of a third (cat. no. 36) were lacquered and repeatedly gilded.

More complicated is the interpretation of the changes in the colors of the garments, which may have reflected specific stylistic changes. In catalogue number 27, the undisturbed area of the green collar of the cape was repainted red, yellow, and red with ocher pigments and then green again with nineteenth-century emerald green. The blue overskirt was repeatedly painted yellow with yellow ocher and then gilded and repainted yellow twice. The skirt was overpainted twice

with red and then with blue. The yellow-orange robe of the figure in catalogue number 40 was repainted yellow with ocher pigments and red with vermilion, later gilded, and later repainted yellow and red again. On the other hand, the robes of two arhats and the shawl of the third in the group (no. A59) continued to be repainted green, with similar pigment formulations containing atacamite and botallackite or simply atacamite. The trims were also repainted red with vermilion. Blue smalt was used locally, for repainting an abraded area of the blue robe of the proper-right arhat.

In scattered areas of some wood sculptures (cat. nos. 20, 27, 36, 40; no. A66), patches of paper, or perhaps a continuous layer of it, was used as a restoration surface for application of a new paint layer and/or for relief designs. This material was also discovered on a stone work (cat. no. 9) and, apparently, was not uncommon in Chinese sculpture. Webb et al. (2007) report having found a layer of paper between paint layers on several Ming-dynasty wood bodhisattvas, and one of the authors of this appendix has identified paper between paint layers on a stone bodhisattva in the Walters Art Museum, Baltimore.[19]

The study of original and later polychrome in the Museum's collection of wood sculpture supports Larson's aforementioned observations about the preference of Ming-period restorers for an overall gilded surface with relief decorations on the clothing. However, further study is required to decipher other trends, including the changes in color schemes of the garments, which cannot be extrapolated from such a limited set of objects.

FIGURE 152. Cross section of paint from lining of Avalokiteshvara's cape at collar (cat. no. 27). A pale green layer containing blue azurite particles is seen above the whitish ground. Viewed in reflected visible light

FIGURE 153. Cross section of paint from robe of proper-right arhat (no. A59), showing original green layer followed by two green repaints over new yellowish ground containing red particles. The middle, darker green layer is composed of botallackite, which is absent from the other two green layers. Viewed in reflected visible light

LACQUER

The lacquer Buddhas in the Metropolitan Museum (cat. no. 13); the Walters Art Museum, Baltimore (25.9; fig. 42); and the Freer Gallery of Art, Smithsonian Institution, Washington, D.C. (44.46; fig. 46), were gilded only on the flesh areas, over a white ground and a layer of pink paint. The ground has been identified as lead white on all three sculptures, and the pink flesh color as a mixture of red lead and vermilion. Traces of bright blue azurite mixed with lead white, together with some tenorite (black), were found around the hairline of the Metropolitan's Buddha. No pigment was found in the hair of the Walters example, and none was reported on the Freer Buddha.

Originally considered a work of polychromed wood, a Ming-dynasty sculpture depicting the pilgrim Sudhana (cat. no. 41) was instead originally lacquered and gilded. The decoration of the object was performed in five phases. Initially, the wood was prepared with a coarse, inhomogeneous, grayish ground consisting of silica minerals in an aqueous, probably protein, medium. This layer then received an application of a smoother, reddish ocher mixture containing silica minerals and bound in an oil-lacquer medium, followed by a translucent reddish lacquer incorporating particles of vermilion. A very thin gold leaf was adhered to this layer and coated with clear lacquer, which produced a lustrous and brilliant surface overall (see figs. 154, 155). The formulation of the clear medium is consistent with Chinese lacquer, made of resin from the *Rhus verniciflua* tree and tung oil, a drying medium commonly used in such applications.

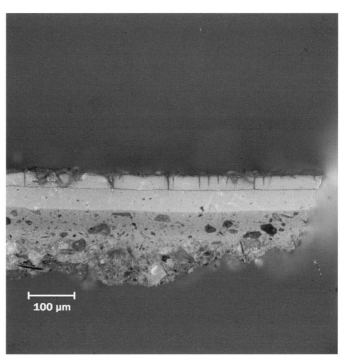

FIGURE 155. Cross section of paint from lining of Sudhana's skirt (cat. no. 41) as seen under ultraviolet radiation. The lacquer layers are recognizable by their yellowish white fluorescence. The top coating shows the characteristic fissuring of aged lacquer. Viewed in ultraviolet radiation

CERAMICS

On the high-fired ceramics in the collection, colored glazes were used to produce a vivid effect. The low-fired ceramics were cold painted after firing, and some were selectively gilded, including the votive tablets (cat. no. 14; no. A21). Catalogue number 14 has a white ground in the recesses and gold leaf in the hair of the proper-right figure. The red and white flames in the haloes of the two outer figures in number A21 were rendered with vermilion and lead white, respectively. The large central umbrella was once painted with red and white stripes, with both a bright red and a dark red pigment in evidence. Traces of a yellow pigment were found in the base of the proper-right figure. The front surfaces of both wall tiles (nos. A22, A23) show the remains of a brown paint, the application of which is impossible to date.

The two ceramic arhats (nos. A65, A73) must have appeared very vibrant at one time, judging from their color remains. Black details such as the eyes, eyebrows, and beard hairs were painted on. XRF analysis detected copper pigments in the greens of the ribbon of the older example (no. A65) and in the robe of the twentieth-century work (no. A73) and did not find any evidence of metal leaf on either sculpture. Pure red lead was used in the belt of number A65, and red lead mixed with vermilion in the skirt or trousers.

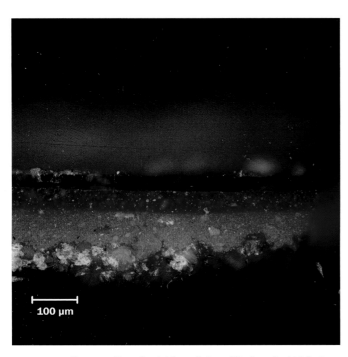

FIGURE 154. Cross section of paint from lining of Sudhana's skirt (cat. no. 41), showing coarse, grayish silica layer followed by red-ocher lacquer layer, vermilion-speckled lacquer layer, gold leaf, and final clear lacquering. Viewed in reflected visible light

IVORY

All three ivory sculptures in the catalogue (cat. no. 30) were elaborately painted and gilded. Even the smallest details, such as the facial features and fingernails, were finely painted. In the work's original finished state, it is unlikely that any of the ivory itself would have been visible. The layers of colors are very similar to those found on the wood sculptures. In the most recent campaign, the figures were completely gilded.

Only the Buddha and the dragon will be described in detail. The Buddha has blue azurite hair, red lips, black eyebrows, black irises, and red on the pearl in the hair and on the topknot. The border along the edge of the robe is stained dark brown, with traces of a gilded design along it. There were two campaigns of color: the first was multicolored, and the second featured extensive use of gilding. Red pigment was found under the gilding on the robe and scarves. Particular evidence of red ocher was found in the scarves.

The dragon has white eyes with a black iris; its mane and tail and the fringe on its leg are green; the scales and saddle blanket are blue; and the mouth, flames, and peak down the middle of the back are red. The base around the dragon's feet is green from malachite and brochantite (basic copper carbonate and sulfate, respectively). There is a green band around the lotus-flower base, and the petals are gilded. A gilded vine pattern embellishes the edges of the saddle blanket. Again, there appear to have been two campaigns of coloration, indicated by the two different layers of green paint on the mane and the two layers of red on the flames.

CONCLUSIONS

The study of polychromed sculpture from various periods and with different substrates confirmed the continuity with which traditional pigments were used throughout the centuries and regardless of the material on which they were applied. Similarities were also seen in the colors used for rendering clothing, adornments, and human and animal features.

The range of pigments on metals and their method of application were found to be similar to those on other Himalayan and Chinese objects.[20] Likewise, the pigments on the wood sculptures studied thus far are similar to those reported elsewhere.[21] Although preparatory grounds were found on wood and stone substrates, they were not evident on any of the metal sculptures examined.

The study of wood sculptures has provided a clearer understanding of painting practices because of better survival of original polychromy than on metal and stone supports. This evidence has allowed for clarification of the binder of the grounds and paint layers as having been protein-based. Chinese lacquer could also be characterized as the primary medium in a fifteenth- or sixteenth-century wood sculpture (cat. no. 41). Although the information presented in this appendix, and in this volume generally, does not allow for the prediction of general trends in the painting of Chinese sculpture, the authors hope that, by presenting these findings, others will build on their research.

NOTES

1. See Larson and Kerr 1985, p. 12.
2. XRF analysis was performed by the Metropolitan's Won Yee Ng on most of the wood sculptures.
3. The terms "vermilion" and "cinnabar" are used synonymously. Cinnabar is the natural mercuric sulfide mineral mined in China. Its synthetic counterpart, vermilion, was available in China beginning in the eighth century. Discrimination between the natural and synthetic pigments is not possible with the techniques used for this analysis.
4. These analyses were performed by Adriana Rizzo, Assistant Research Scientist, and Arianna Gambirasi, Research Specialist (2008–9), in the Department of Scientific Research of The Metropolitan Museum of Art.
5. SEM-EDS analysis was performed by Mark T. Wypyski, Research Scientist, and Federico Carò, Andrew W. Mellon Research Fellow (2007–10), in the Department of Scientific Research of The Metropolitan Museum of Art.
6. Reactive pyrolysis was perfomed by Adriana Rizzo. Experimental procedures for preparation of cross sections and instrumental analysis by ATR-FTIR, FTIR, Raman, SEM-EDS, and Py-TMAH-GCMS are reported in Rizzo 2008.
7. See Twilley 2007.
8. Catalogue no. 33 was initially mercury-amalgam gilded, followed by cold gilding, with the white rendered with kaolin and the red lips with vermilion. The face of no. A68 is gold, with lead-white eyes and red lips (a mixture of vermilion and red lead). Catalogue no. 37 has a cold-gilded face, ultramarine hair, and vermilion lips. Number A63 has cold gilding on the headdress, red lips, white eyes with black outlines, and orange on the feathers of the hat, the robe, and the leg armor. On cat. no. 34, no cold gold was found, but there are traces of yellow and red ocher on the ankles.
9. ATR-FTIR and Raman were carried out by Raina Chao, Graduate Intern (2009–10) in the Department of Scientific Research of The Metropolitan Museum of Art.
10. See Webb et al. 2007.
11. Pigment and medium analyses were carried out by Adriana Rizzo and Arianna Gambirasi. See n. 4 above.
12. See the entry for cat. no. 27, n. 4.
13. See Larson 1988.
14. Kaolin is present as a mixture of minerals of the kaolinite groups, including kaolinite, dickite, nacrite, and hallosyte.
15. See the technical notes in cat. no. 27.
16. See Larson and Kerr 1985.
17. See Webb et al. 2007, p. 195.
18. Atacamite, on its own and/or in combination with botallackite and copper oxalates, is reported in a number of Chinese artworks and wall paintings. See ibid., p. 194, and references within. See also Malenka and Price 1997.
19. See Webb et al. 2007. In 1990, Strahan studied the Walters Art Museum's sixth-century sandstone bodhisattva (25.4). Julie A. Lauffenburger identified the paper layer as a restoration applied on both the head and body. See unpublished report #5216, Conservation Analytical Laboratory (now Museum Conservation Institute), Smithsonian Institution, Washington, D.C.
20. See Cowell et al. 2003, p. 85; Reedy 1997, pp. 70–71; Béguin and Liszak-Hours 1982, pp. 46–49; Twilley 2007.
21. See Webb et al. 2007, pp. 194–96; Larson and Kerr 1985, pp. 27–56; Larson 1988, pp. 120–25; Winter 2008, pp. 13–44; Malenka and Price 1997, pp. 127–38.

Analysis of Wood Species in the Collection

MECHTILD MERTZ AND TAKAO ITOH[1]

For the study of the wood material in thirty[2] Chinese Buddhist sculptures in the collection of the Metropolitan Museum, forty-eight samples were obtained and characterized through microscopic identification. The results provide basic data for the discussion of the dates, provenances, and spiritual contexts of the sculptures. In this appendix, a presentation of materials and methods is followed by descriptions of the identified genera or species, including their scientific, Chinese, and English[3] names, and by a list of the works in the catalogue (including appendix A) in which they were found. Information regarding distribution is derived from the "Flora of China" online database,[4] unless otherwise indicated in an endnote. The overall results and conclusions of the study appear after the genus and species descriptions.

Photomicrographs can be found at the end of the appendix. They are organized by catalogue or appendix A number. The sample location (for example, wood armature, base, or ritual deposit), is given next, then the scientific name of the identified species. The orientation of a section's plane is indicated as transverse (Tr), radial (R), or tangential (Ta).

MATERIALS AND METHODS

By means of a scalpel or utility knife, minute samples were removed so as to harm the integrity of the sculptures as little as possible. Sample locations were chosen in the back cavities or on the underside of the works, usually adjacent to natural cracks or other impairments, and were recorded in photographs. Most of the sculptures were carved from a single block of wood, but some may have been made from multiple wood blocks. In other instances, new material had been added some time after the work's initial creation, as part of a restoration. For these reasons, much effort was made, through visual examination and X-ray radiography, to select representative sample locations. Samples were prepared in Japan for microscopic observation by the authors at the Research Institute for Sustainable Humanosphere (formerly, Wood Research Institute) of Kyoto University.[5] After the samples were soaked in water for several days for softening, thin sections (20 to 50 μm thick) were taken by hand in transverse, radial, and tangential planes by means of a double-edged razor blade. In a few instances, sections (20 to 30 μm thick) were obtained with a sliding microtome (Yamato Kōki model TU-213, Japan). Gum chloral was used as the mounting medium.

Several samples were too small or fragile for hand sectioning. After being dehydrated in a graded series of alcohol (50 percent alcohol and 50 percent water, then 70 percent alcohol, then 95 percent, then 100 percent) and in propylene oxide, the samples were embedded in epoxy resin (TAAB Epon 812, United Kingdom). A rotary microtome (Leica model RM2145, Germany) was used to prepare transverse, radial, and tangential sections (2 to 3 μm thick), which were then stained with safranine and mounted with Bioleit mounting medium (Ōken-shōji, Japan). The mounted slides were analyzed under a microscope (Olympus model BH2 or BX51, Japan) at magnifications of 40x to 400x; photomicrographs were obtained with a digital camera (Olympus model DP70, Japan).

GENUS AND SPECIES DESCRIPTIONS[6]

Scientific name	*Salix* spp.
Family	Salicaceae
Chinese name	liu shu 柳属
English name	willow
Object numbers	cat. nos. 24, 29, 35, 36
	nos. A49,[7] A50, A59, A60, A71

Willow is the wood found most frequently in the Metropolitan's collection of Chinese Buddhist wood sculptures, and analyses of other collections confirm the importance of the species.[8] Its softness, light color, and fine grain make it easy to work, although it is not durable under conditions favoring decay. Of the 520 willow species known worldwide, all distributed in cold and temperate regions, 189 are native to China. Many are shrubs and therefore not suitable for timber. There are two important timber trees. The weeping willow (*Salix babylonica*; chui liu 垂柳) grows to about sixty feet (18 m) tall and is distributed widely throughout China, although it does not grow well in the colder and drier northern areas.[9] More suitable for northern China is the Hankow willow (*Salix matsudana*; han liu 旱柳), which also reaches a height of about sixty feet (18 m) and is commonly planted on plains and riverbanks in the provinces of Anhui, Fujian, Gansu, Hebei, Heilongjiang, Henan, Jiangsu, Liaoning, Nei Mongol, Qinghai, Shaanxi, Sichuan, and Zhejiang.

Scientific name	*Paulownia* spp.
Family	Scrophulariaceae
Chinese name	pao tong 泡桐
English name	foxglove, paulownia
Object numbers	cat. nos. 20, 27; nos. A41, A42, A43, A44, A47, A49 [proper-left shoulder], A72

The second-most common wood in the Metropolitan's collection, paulownia, or foxglove, provides a very light, soft, and stable material, ideal for carving.[10] All seven known species are native to China. Two are important timber trees. The white-flowered Fortune paulownia (*Paulownia fortunei*; bai hua pao tong 白花泡桐) reaches almost one hundred feet (30 m) in height and lives (both cultivated and wild) below 6,500 feet (2,000 m) on mountain slopes and in valleys and wastelands in the provinces of Anhui, Fujian, Guangdong, Guangxi, Guizhou, Hubei, Hunan, Jiangxi, Sichuan, Yunnan, and Zhejiang. The violet-flowered royal paulownia (*Paulownia tomentosa*; mao pao tong 毛泡桐) reaches up to sixty-five feet (20 m) in height and grows (wild and cultivated) below 5,900 feet (1,800 m) in the provinces of Anhui, Gansu, Hebei, Henan, Hubei, Hunan, Jiangsu, Jiangxi, southern Liaoning, Shaanxi, Shandong, Shanxi, and northern Sichuan.

Scientific name	*Tilia* spp.
Family	Tiliaceae
Chinese name	duan mu 椴木
English name	linden, limewood, basswood
Object numbers	cat. nos. 13,[11] 39, 41
	nos. A38, A53, A61

Twenty-three species of *Tilia* grow worldwide,[12] primarily, according to "Flora of China," in temperate and subtropical regions; fifteen species are native to China, mostly tall trees in mountain forests, although a few are cultivated. Linden is known for being easy to work, and besides many other uses, it is highly prized for carving.[13] The most frequently cultivated species in northern China, valued for both its wood and bark, is the Manchurian linden (*Tilia mandshurica*; kang duan 糠椴), which grows up to sixty-five feet (20 m) tall and can reach over two feet (0.7 m) in diameter. Its distribution comprises the provinces of Hebei, Heilongjiang, northern Jiangsu, Jilin, Liaoning, Nei Mongol, and Shandong. The most common timber tree of the same height and usage in eastern China is *Tilia miqueliana* (nan jing duan 南京椴), which grows in the provinces of Anhui, Guangdong, Jiangsu, Jiangxi, and Zhejiang.[14]

Scientific name	*Santalum album*
Family	Santalaceae
Chinese name	tan xiang mu 檀香木
English name	white sandalwood
Object numbers	nos. A64, A66, A67

The *Santalum* species are hemiparasites that attach themselves to the roots of other plants. *Santalum album* is an evergreen tree, indigenous to the Indian subcontinent (from Nasik and the Northern Circars southward, centered in Mysore) and to the Indo-Malayan vegetation zone.[15] It can reach almost one hundred feet (30 m) in height but is usually shorter. The formation of aromatic heartwood demands a diameter of 7¾ to 8¾ inches (20 to 30 cm).[16] The sapwood is white and unscented; the heartwood is yellowish brown

when freshly cut, eventually turning a dark-reddish brown, and dull or somewhat lustrous, with an oily feel. It is dense, heavy, and very finely and evenly textured.[17] Freshly cut surfaces exude a strong, permeating aroma, the strength of which is directly correlated to the intensity of coloration.[18] Sandalwood is the material from which the first image of the Buddha was supposedly made, and it is therefore sought after for religious sculpture.[19]

Scientific name	*Juniperus* spp.
Family	Cupressaceae
Chinese name	ci bai shu 刺柏属
English name	juniper
Object numbers	cat. nos. 2, 21

Of about sixty species of *Juniperus* in the northern hemisphere, ten are native to China. Most are shrubs or small trees, with three important timber-yielding species.[20] A widely distributed timber tree is the Chinese juniper (*Juniperus chinensis*; yuan bai 圆柏 or gui 檜), which reaches up to eighty feet (25 m) tall at altitudes of 5,000 to 7,500 feet (1,400 to 2,300 m) in most of the central and eastern provinces. A more westerly species is the Tibetan juniper (*Juniperus tibetica*; da guo yuan bai 大果圆柏), which grows in forests on mountain slopes or in valleys at altitudes of 8,850 to 15,750 feet (2,700 to 4,800 m) in southern Gansu, southern Qinghai, and Sichuan as well as in eastern and southern Tibet. The wood is fragrant and lustrous. A third timber tree, the Qilian juniper (*Juniperus przewalskii*; qi lian yuan bai 祁连圆柏), grows in forests on mountain slopes at altitudes of 8,530 to 14,100 feet (2,600 to 4,300 m) in Gansu, Qinghai, and northern Sichuan, attaining a height of up to sixty-five feet (20 m). It is worth noting that a dendrochronological database of this species, based on archaeological finds, has been established in China.[21]

Scientific name	*Populus* sp.
Family	Salicaceae
Chinese name	yang mu 杨木
English name	poplar
Object number	cat. no. 40

The wood of the poplar shrinks greatly as it seasons and is not very durable but has a close grain and a smooth, firm, uniform texture.[22] Of about one hundred species worldwide, forty-seven are native to China. The Maximoviczii poplar (*Populus maximoviczii*; liao yang 辽杨) is an important timber tree, growing to almost one hundred feet (30 m) tall in forests at altitudes of 1,640 to 6,500 feet (500 to 2,000 m) in the northeastern provinces of Hebei, Heilongjiang, Jilin, Liaoning, Nei Mongol, and Shaanxi. Distributed toward the south is the Chinese white poplar (*Populus tomentosa*; mao bai yang 毛白杨), growing at altitudes of up to 4,900 feet (1,500 m) in the provinces of Anhui, Gansu, Hebei, Henan, Jiangsu, southern Liaoning, Shaanxi, Shandong, Shanxi, Sichuan, Yunnan, and Zhejiang.

Scientific name	*Fraxinus* sp.
Family	Oleaceae
Chinese name	qin shu 梣属, bai la shu 白蜡树
English name	ash
Object number	no. A42 [base]

Of about sixty species of *Fraxinus*, mostly distributed in the temperate regions and subtropics of the northern hemisphere, twenty-two species are represented in China. There are two important timber trees.[23] The Chinese ash (*Fraxinus chinensis*; bai la shu 白蜡树) grows to a height of ten to sixty-five feet (3 to 20 m) on slopes, along rivers, on roadsides, and in mixed woods at altitudes of 2,625 to 7,550 feet (800 to 2,300 m) throughout China. The Manchurian ash (*Fraxinus mandschurica*; shui qu liu 水曲柳) reaches a height of almost one hundred feet (30 m) and grows in sparse woods on slopes and in open valleys of montane regions at altitudes of 2,300 to 6,900 feet (700 to 2,100 m) in the provinces of Gansu, Hebei, Heilongjiang, Henan, Hubei, Jilin, Liaoning, Shaanxi, and Shanxi. The wood is very tough and elastic, with a coarse texture.[24]

Scientific name	*Aquilaria* sp.
Family	Thymelaeaceae
Chinese name	chen xiang shu 沉香属, bai mu xiang 白木香
English name	agarwood, aloeswood, eaglewood
Object number	cat. no. 4 [ritual deposit]

One of four wood fragments forming part of the consecratory deposits inside the bronze Buddha Maitreya sculpture (cat. no. 4) is a piece of agarwood (*Aquilaria* sp.). Members of this genus are important as the source of an aromatic gum produced by the tree in response to injury. Depending on the region, this resin is known as *chen xiang* (沉香), *gaharu* (Indonesian and Malay), *jinkō* (Japanese), or *oud* (Arabic), and it is used as incense, in perfumes, and in traditional medicine. About fifteen species of *Aquilaria* are distributed in Bhutan, Cambodia, China, northeastern India, Laos, Malaysia, Myanmar, Thailand, and Vietnam. Two species, both endemic, grow in China. *Aquilaria sinensis* (tu chen xiang 土沉香) grows sixteen to fifty feet (5 to 15 m) tall in lowland forests, on sunny slopes, and along roadsides in the southern provinces of Fujian, Guangdong, Guangxi, and Hainan. This species has been very heavily exploited; the heartwood is prized for its fragrance, while its bark is used to make paper. *Aquilaria yunnanensis* (yun nan chen xiang 云南沉香) grows in valley forests in Yunnan Province at an altitude of about 3,900 feet (1,200 m). The trees are small, only ten to twenty-six feet (3 to 8 m) tall.

Scientific name	*Dalbergia* sp.
Family	Leguminosae
Chinese name	huang tan (shu) 黄檀(属), huang huali 黄花梨
English name	rosewood
Object number	cat. no. 4 [ritual deposit]

Another wood fragment deposited in the bronze Maitreya (cat. no. 4) is a piece of *Dalbergia* sp. The genus comprises

more than two hundred species of trees, shrubs, and woody climbers distributed throughout the tropics of the world. Many produce valuable reddish or dark-colored timber.[25] The fragment in question has a reddish color and therefore probably belongs to the so-called red woods (*hongmu* 红木), a group of hard, dense, and heavy subtropical or tropical timbers known under the names *huali* (花梨), *huanghuali* (黄花梨), and *zitan* (紫檀) and used for precious furniture in the Ming and Qing dynasties. Chinese wood scientists divide the red woods into three groups: the "scenting branch," the "black acid branch," and the "red acid branch."[26] The first is represented by a single species, the scented rosewood (*Dalbergia odorifera*; jiang xiang huang tan 降香黄檀), which grows up to fifty feet (15 m) tall and is native to Hainan. The heartwood of the roots is used as materia medica under the name *jiang zhen xiang* (降真香).[27] The only species of "black acid branch" that grows in China is the black rosewood (*Dalbergia fusca*; hei huang tan 黑黄檀), while the "red acid branch" is not represented at all in China. Of the reddish rosewoods, only *D. odorifera* and *D. fusca* can be found in China, and these are therefore the most likely candidates for the consecratory deposit, unless the wood came from elsewhere.

Scientific name	*Celtis* sp.
Family	Ulmaceae
Chinese name	po shu 朴属
English name	hackberry
Object number	no. A53 [ritual deposit]

A piece of hackberry was found within the ritual deposits of a small seated Buddha (no. A53) made of linden. Of about sixty species of *Celtis* distributed worldwide in tropical and temperate areas, four are native to China. Most species yield fine timber. An important timber tree is *Celtis sinensis* (po shu 朴树), a deciduous tree that reaches up to sixty-five feet (20 m) in height. It grows on roadsides and slopes at altitudes of 330 to 4,900 feet (100 to 1,500 m) in the central and southern provinces of Anhui, Fujian, Gansu, Guangdong, Guizhou, Henan, Jiangsu, Jiangxi, northeastern Shandong, Sichuan, Taiwan, and Zhejiang. The wood is moderately hard and heavy, while its color ranges from yellowish gray to light brown with yellow streaks.

RESULTS AND DISCUSSION

Of the twenty-eight wood sculptures selected for species identification, nine were found to be made of *Salix* spp. (willow), eight of *Paulownia* spp. (foxglove, or paulownia), five of *Tilia* spp. (linden, limewood, or basswood), three of *Santalum album* (white sandalwood), two of *Juniperus* spp. (juniper), and one of *Populus* sp. (poplar). The wood armature of the dry-lacquer sculpture (cat. no. 13) was found to consist of two species, *Tilia* sp. and *Pinus* subgen. *Diploxylon* (two-leaved pine), but the pine portion is a recent addition and is therefore omitted from the charts above.

Wood ritual deposits were found in the interior cavities of two sculptures: a bronze Buddha Maitreya (cat. no. 4) contains pieces of *Dalbergia* sp. (rosewood) and *Aquilaria* sp. (agarwood, aloeswood, or eaglewood), among other materials, such as semiprecious stones; and a small seated Buddha (no. A53) made of linden contains, among various grains, a piece of *Celtis* sp. (hackberry).

That the most commonly identified species in the wood sculptures are willow, foxglove, and linden corresponds with analyses of Chinese sculptures in other museums.[28] It is interesting that at least three sculptures were made of the sacred sandalwood. Their comparatively small size is in keeping with the small diameter of the tree trunk. Two sculptures were made of juniper. Despite its prominence as an archaeological wood in Dulan County of the Qinghai-Tibetan plateau—where it was used in tombs with burial chambers made of logs and blocks[29]—this is the first time that juniper (*Juniperus* sp.) has been confirmed in Chinese Buddhist sculpture. A single sculpture was made of poplar (*Populus* sp.), a small proportion of the total as compared to the results from other museums.

The discovery of wood ritual deposits inside the sculptures is very interesting. Although they are probably not coincident with the works' creation and initial service, their presence is important for the study of the role and nature of symbolic relics. In the present cases, they may have been included for their aroma or medicinal value.

Two works in the collection consist of more than one wood species, demonstrating the importance of taking samples from various parts of a sculpture. The first example is a torso of a bodhisattva (no. A49) largely made of willow. Analysis revealed, however, that a piece of the proper-left shoulder was made of foxglove. In this context, it is notable that a standing bodhisattva in the Musées Royaux d'Art et d'Histoire, Brussels, identified as willow overall, also includes a piece of foxglove—in that case, as part of the skirt.[30] Rösch 2007 points to another example displaying such an inclusion, an Avalokiteshvara in the Rijksmuseum, Amsterdam.[31] The second example in the Metropolitan's collection is a standing bodhisattva (no. A42) made of foxglove whose base (probably a later restoration) is partially ash (*Fraxinus* sp.).

In conclusion, the study of the wood material used in the manufacture of Chinese Buddhist sculptures is relatively new, compared with that in Japanese sculptures.[32] The results presented here underscore our earlier finding that the materials used for Buddhist sculpture were very different in China and Japan.[33] The major wood species used in China were willow, foxglove, and linden, while their Japanese counterparts were camphorwood (*Cinnamomum camphora*), Japanese nutmeg (*Torreya nucifera*), and hinoki cypress (*Chamaecyparis obtusa*). The identification of the wood species in the Metropolitan Museum's collection is an essential contribution to the study of the criteria of wood selection for Chinese Buddhist sculpture. Additional data from other collections could expand upon the results of this important research.

NOTES

1. The authors are, respectively, associate professor at the Research Institute for Humanity and Nature, Kyoto, and professor emeritus at Kyoto University, Japan (currently visiting professor at Nanjing Forestry University, China).
2. Of the thirty objects studied, twenty-three are single-woodblock sculptures (one containing a wood ritual deposit that was also analyzed), two are multiple-woodblock sculptures, three are pilgrim shrines, one is a dry-lacquer sculpture with a wood armature, and one is a bronze sculpture containing wood ritual deposits (cat. no. 4).
3. For English names, see also Fèvre and Métailié 2005 and Wang Zongxun 1996.
4. See http://flora.huh.harvard.edu/china/.
5. The authors are grateful for the support of Professor Junji Sugiyama and Dr. Yoshiki Horikawa of the Research Institute for Sustainable Humanosphere (RISH) of Kyoto University. The authors also thank Midori Kawakami, who prepared some of the microscopic slides in her atelier.
6. Wood identification is usually performed to the genus level. When a sculpture was made of several pieces of wood of the same genus, the authors assumed that the same species was used for all the pieces; they also assumed that two sculptures made of the same genus of wood may well have been made of different species within that genus. Thus, the epithet of the scientific name is abbreviated "sp." when referring to one sculpture and "spp." when referring to multiple sculptures.
7. Four samples from no. A49 were identified as willow; one sample from the proper-left shoulder, however, is foxglove.
8. See Mertz 2007; Mertz and Itoh 2005 and 2007.
9. See H. Li 1958a, p. 5.
10. See Corkhill 1979, p. 285. Throughout the catalogue, the term "foxglove" is used to refer to the foxglove tree (*Paulownia* spp.), not to be confused with the herbaceous plant (*Digitalis* spp.) after which it was named on account of the resemblance between their flowers.
11. This is a dry-lacquer sculpture with a wood armature.
12. See Mabberley 1998, p. 860.
13. See H. Li 1958b, p. 40.
14. See ibid., p. 41.
15. See Pearson and Brown 1932, pp. 864–66.
16. See Bärner 1942–61, vol. 1, p. 437.
17. See Pearson and Brown 1932, p. 866.
18. See Bärner 1942–61, vol. 1, p. 438.
19. See Soper 1959, p. 259.
20. See Cheng et al. 1985, pp. 12–14.
21. See Shao et al. 2009.
22. See Corkhill 1979, pp. 421–22.
23. See Cheng et al. 1985.
24. See Corkhill 1979, p. 17.
25. See Pearson and Brown 1932, vol. 1, p. 362.
26. See National Standard of the People's Republic of China 2000, pp. 6–7.
27. See Fèvre and Métailié 2005, p. 230.
28. See Mertz 2007; Mertz and Itoh 2005 and 2007.
29. See Shao et al. 2009.
30. See Mertz and Itoh 2005, pp. 131, 145.
31. See Rösch 2007b, p. 178.
32. See Kohara 1963.
33. See Mertz 2007; Mertz and Itoh 2005 and 2007.

PHOTOMICROGRAPHS OF WOOD SAMPLES

OBJECT NO. / SAMPLE SITE / SPECIES	TRANSVERSE	RADIAL	TANGENTIAL
CAT. NO. 2, underside at mounting hole (Tr) **CAT. NO. 2**, underside at mounting hole (R) **CAT. NO. 2**, lower back edge (PR of center) (Ta) *Juniperus* sp.	 200 μm	 50.0 μm	 200 μm
CAT. NO. 4, light-colored relic *Aquilaria* sp.	 500 μm	 200 μm	 200 μm
CAT. NO. 4, dark-colored relic *Dalbergia* sp.	 500 μm	 500 μm	 200 μm
CAT. NO. 13, wood armature at base (PL) toward back *Tilia* sp.	 200 μm	 200 μm	 200 μm
CAT. NO. 20, underside at drill hole closest to front *Paulownia* sp.	 500 μm	 200 μm	 200 μm

OBJECT NO. / SAMPLE SITE / SPECIES	TRANSVERSE	RADIAL	TANGENTIAL

CAT. NO. 21, center of underside

Juniperus sp.

CAT. NO. 24, PL leg cavity (Tr)

CAT. NO. 24, underside of main section (R)

CAT. NO. 24, underside of PR leg (Ta)

Salix sp.

CAT. NO. 27, underside

Paulownia sp.

CAT. NO. 29, underside of front addition (Tr)

CAT. NO. 29, underside of front addition (R)

CAT. NO. 29, front surface of interior (Ta)

Salix sp.

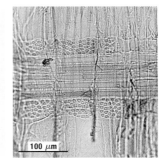
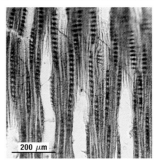

CAT. NO. 35, PL lower portion of torso cavity

Salix sp.

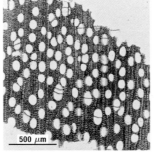
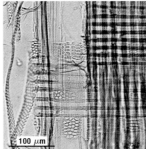

CAT. NO. 36, chamber cover (PL) (Tr)

CAT. NO. 36, interior wall (R)

CAT. NO. 36, interior "ceiling" (Ta)

Salix sp.

OBJECT NO. / SAMPLE SITE / SPECIES	TRANSVERSE	RADIAL	TANGENTIAL
CAT. NO. 39, crack in back of tail (Tr) CAT. NO. 39, interior of cavity in back of figure (R) CAT. NO. 39, interior of cavity in back of figure (Ta) *Tilia* sp.	200 μm	100 μm	100 μm
CAT. NO. 40, underside (PR) *Populus* sp.	500 μm	100 μm	200 μm
CAT. NO. 41, dislodged chip from interior *Tilia* sp.	500 μm	100 μm	200 μm
NO. A38, interior of hollow at bottom, inside surface of robe (PR) *Tilia* sp.	500 μm	200 μm	200 μm
NO. A41, underside of hem of robe (PL) *Paulownia* sp.	200 μm	200 μm	200 μm
NO. A42, bottom of large split at rear *Paulownia* sp.	500 μm	200 μm	500 μm

OBJECT NO. / SAMPLE SITE / SPECIES	TRANSVERSE	RADIAL	TANGENTIAL
NO. A42, rear section of base *Fraxinus* sp.			
NO. A43, back of base (PL of center) (Tr) **NO. A43**, garment at lower center back (R) **NO. A43**, back of base (PL of center) (Ta) *Paulownia* sp.			
NO. A44, underside of front drapery (PR of center) *Paulownia* sp.			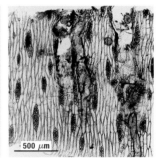
NO. A47, lower back edge of flaring hem (PL) *Paulownia* sp.	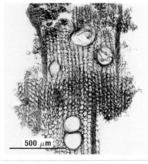	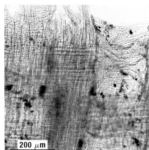	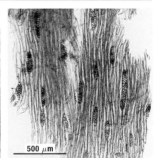
NO. A49, PL arm (separate from torso) *Paulownia* sp.			
NO. A49, top of PR shoulder (Tr) **NO. A49**, PL front corner of torso cavity (R) **NO. A49**, front wall of torso cavity (Ta) *Salix* sp.		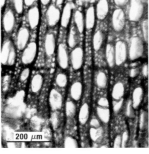	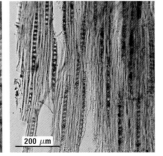

OBJECT NO. / SAMPLE SITE / SPECIES	TRANSVERSE	RADIAL	TANGENTIAL

NO. A50, crack near upper back edge of lotus base (PR)

Salix sp.

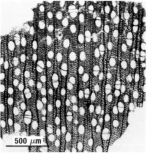 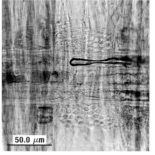 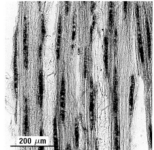

NO. A53, top of front interior wall

Tilia sp.

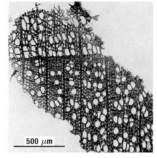 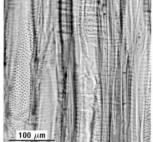 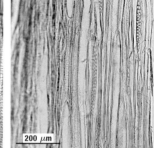

NO. A53, relic

Celtis sp.

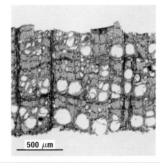 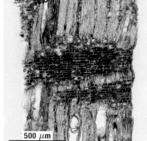 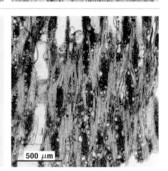

NO. A59, underside, close to PR edge

Salix sp.

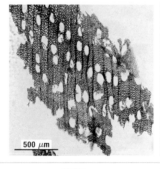 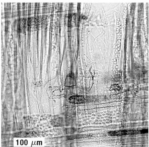 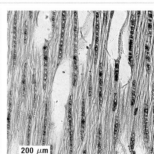

NO. A60, underside at mounting hole in center of base

Salix sp.

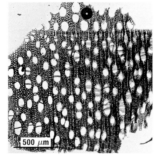 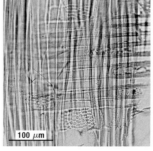 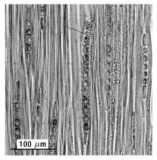

NO. A61, bottom of PL wing

Tilia sp.

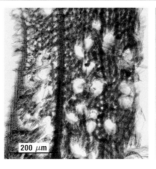 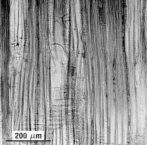 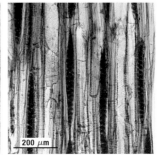

OBJECT NO. / SAMPLE SITE / SPECIES	TRANSVERSE	RADIAL	TANGENTIAL

NO. A64, edge of drapery just below knee
(PR of center) (Tr)

NO. A64, lower PL edge of cavity in back of
figure (R)

NO. A64, lower PL edge of cavity in back of
figure (Ta)

Santalum album

NO. A66, gap toward bottom of base (PR)

Santalum album

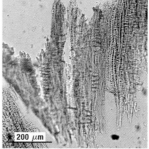
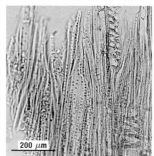

NO. A67, lower PR corner of torso cavity

Santalum album

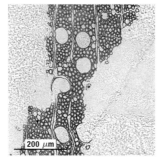
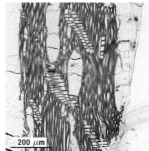
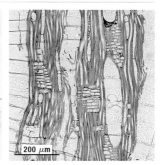

NO. A71, underside of back of base
(PL of center) (Tr)

NO. A71, chip from interior (R)

NO. A71, chip from interior (Ta)

Salix sp.

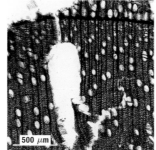
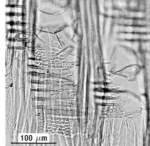
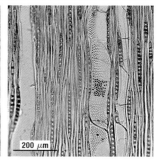

NO. A72, rear surface of "apron"

Paulownia sp.

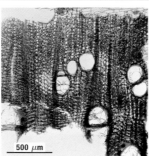
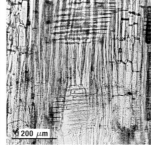
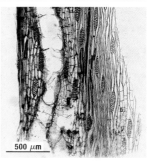

Bibliography

Abe 1990. Stanley K. Abe. "Art and Practice in a Fifth-Century Buddhist Cave Temple." *Ars Orientalis* 20 (1990), pp. 1–20.

Abe 2002. Stanley K. Abe. *Ordinary Images*. Chicago: University of Chicago Press, 2002.

Allen 2003. Charles Allen. *The Search for the Buddha: The Men Who Discovered India's Lost Religion*. New York: Carroll & Graf, 2003.

Amherst 1984. *From the Land of the Snows: Buddhist Art of Tibet*. Exh. cat. by Marylin M. Rhie and Robert A. F. Thurman. Amherst, Mass., Mead Art Museum, October 3–November 15, 1984. Amherst: Mead Art Museum, 1984.

Antwerp 2001. *The Buddha in the Dragon Gate: Buddhist Sculpture of the 5th–9th Centuries from Longmen, China*. Exh. cat. edited by Jan Van Alphen. Antwerp, Etnografisch Museum, March 22–June 27, 2001. Ghent: Snoeck-Ducaju & Zoon, 2001.

Anyang **1983.** *Anyang Xiudingsi ta* (Pagoda at the Xiuding Temple near Anyang). Beijing: Wenwu Chubanshe, 1983.

Ardenne de Tizac 1931. Henri d'Ardenne de Tizac. *La sculpture chinoise*. Paris: G. Van Oest, 1931.

Art Treasures **1952.** *Art Treasures of the Metropolitan: A Selection from the European and Asiatic Collections*. New York: Abrams, 1952.

Ashton 1924. Leigh Ashton. *An Introduction to the Study of Chinese Sculpture*. London: E. Benn, 1924.

Asia Society 2006. *A Passion for Asia: The Rockefeller Legacy: A Publication in Celebration of the 50th Anniversary of the Asia Society*. New York: Asia Society in association with Hudson Hills Press, 2006.

Bachhofer 1938a. Ludwig Bachhofer. "Zur Geschichte der chinesischen Plastik vom VIII–XIV." *Ostasiatische Zeitshchrift* 14 (1938), pp. 65–81.

Bachhofer 1938b. Ludwig Bachhofer. "Two Chinese Wooden Figures." *Art Quarterly* (Autumn 1938), pp. 289–98.

Bagley 1987. Robert W. Bagley. *Shang Ritual Bronzes in the Arthur M. Sackler Collections*. Washington, D.C.: Arthur M. Sackler Foundation, 1987.

Baker 1998. Janet Baker, ed. *The Flowering of a Foreign Faith: New Studies in Chinese Buddhist Art*. New Delhi: Marg Publications, 1998.

Barcelona 2004. *La condición humana: El sueño de una sombra = The Human Condition: The Dream of a Shadow*. Exh. cat. Barcelona, Museu d'Història de la Ciutat, May 10–September 26, 2004. Barcelona: Lunwerg, 2004.

Bärner 1942–61. Johannes Bärner, with Johann Friedrich Müller. *Die Nutzhölzer der Welt*. 4 vols. Neudamm: J. Neumann, 1942–61.

Barnhart 1987. Richard M. Barnhart. *Asia*. New York: Metropolitan Museum of Art, 1987.

Barrett 1998. Timothy H. Barrett. "Did I-ching Go to India: Problems in Using I-ching as a Source on South Asian Buddhism." *Buddhist Studies Review* 15, no. 2 (1998), pp. 142–56.

Bartholomew 2001. Terese Tse Bartholomew. "Thangkas for the Qianlong Emperor's Seventieth Birthday." In *Cultural Intersections in Later Chinese Buddhism*, edited by Marsha Weidner, pp. 170–88. Honolulu: University of Hawai'i Press, 2001.

Beck 2006. Elisabeth Beck. *Pallava Rock Architecture and Sculpture*. Pondicherry: Sri Aurobindo Institute of Research in Social Sciences, 2006.

Béguin and Liszak-Hours 1982. Gilles Béguin and Juliette Liszak-Hours. "Objets himalayens en métal du Musée Guimet: Étude en laboratoire." *Annales du Laboratoire de recherche des musées de France* (1982), pp. 28–82.

Beijing 2002a. *Tu xiang yu feng ge: Gu gong zang chuan fo jiao zao xiang = Iconography and Styles: Tibetan Statues in the Palace Museum*. Beijing: Zijincheng Chubanshe, 2002.

Beijing 2002b. *Beijing Longquanwu yao fajue baogao* (Excavation of the Longquanwu Kiln Site in Beijing). Beijing: Wenwu Chubanshe, 2002.

Berkowitz 1995. Alan K. Berkowitz. "An Account of the Buddhist Thaumaturge Baozhi." In *Buddhism in Practice*, edited by Donald S. Lopez, pp. 578–85. Princeton: Princeton University Press, 1995.

Berlin 1929. *Ausstellung chinesischer Kunst*. Exh. cat. by Otto Kümmel. Berlin, Gesellschaft für Ostasiatische Kunst, January 12–April 2, 1929. Berlin: Würfel Verlag, 1929.

Bhattacharya 1985. Gouriswar Bhattacharya. "Buddha Sakyamuni and Panca-Tathagata: Dilemma in Bihar-Bengal." *South Asian Archaeology* (1985), pp. 350–71.

Birnbaum 1980. Raoul Birnbaum. "Introduction to the Study of T'ang Buddhist Astrology: Research Notes on Primary Sources and Basic Principles." *Bulletin of the Society for the Study of Chinese Religions* 8 (Fall 1980), pp. 5–19.

Birnbaum 1981. Raoul Birnbaum. "Buddhist Meditation Teachings and the Birth of 'Pure' Landscape Painting in China." *Bulletin of the Society for the Study of Chinese Religions* 9 (Fall 1981), pp. 42–58.

Birnbaum 1983. Raoul Birnbaum. *Studies on the Mysteries of Mañjuśrī: A Group of East Asian Mandalas and Their Traditional Symbolism*. Boulder: Society for the Study of Chinese Religions, 1983.

Birnbaum 1984. Raoul Birnbaum. "Thoughts on T'ang Buddhist Mountain Traditions and Their Context." *T'ang Studies*, no. 2 (1984), pp. 5–23.

Bizot 1988. François Bizot. *Les traditions de la pabbajjā en Asie du Sud-Est*. Göttingen: Vandenhoeck & Ruprecht, 1988.

Bliss 1996. Sheila Bliss. "Sino-Tibetan Sculpture: The Tibetan Legacy." In *On the Path to Void: Buddhist Art of the Tibetan Realm*, edited by Pratapaditya Pal, pp. 142–61. Mumbai: Marg Publications, 1996.

Bosch Reitz 1920. S. C. Bosch Reitz. "A Chinese Kanshitsu or Dried Lacquer Figure." *Metropolitan Museum of Art Bulletin* 15, no. 4 (April 1920), pp. 77–79.

Bosch Reitz 1921a. S. C. Bosch Reitz. "A Large Pottery Lohan of the T'ang Period." *Metropolitan Museum of Art Bulletin* 16, no. 1 (January 1921), pp. 15–16.

Bosch Reitz 1921b. S. C. Bosch Reitz. "A Second Pottery Lohan in the Metropolitan Museum of Art." *Metropolitan Museum of Art Bulletin* 16, no. 6 (June 1921), p. 120.

Bosch Reitz 1922. S. C. Bosch Reitz. "The Statue of a Bodhisattva from Yun-Kang." *Metropolitan Museum of Art Bulletin* 17, no. 12 (December 1922), pp. 252–55.

Bosch Reitz 1926. S. C. Bosch Reitz. "A Bronze Gilt Statue of the Wei Period." *Metropolitan Museum of Art Bulletin* 21, no. 10 (October 1926), pp. 225, 236, 238–40.

Boston 1997. *Tales from the Land of Dragons: 1,000 Years of Chinese Painting.* Exh. cat. by Wu Tung. Boston, Museum of Fine Arts, April 13–July 20, 1997. Boston: Museum of Fine Arts, 1997.

Bowlin and Farwell 1950. Angela C. Bowlin and Beatrice Farwell. *Small Sculptures in Bronze.* New York: Metropolitan Museum of Art, 1950.

Brankston 1938. A. D. Brankston. "An Exhibition of Chinese Metalwork." *The Burlington Magazine* 73 (December 1938), pp. 268–70.

Brashier 1995. K. E. Brashier, "Longevity like Metal and Stone: The Role of the Mirror in Han Burials." *T'oung Pao* 81 (1995), pp. 201–29.

Broughton 1999. Jeffrey L. Broughton. *The Bodhidharma Anthology: The Earliest Records of Zen.* Berkeley: University of California Press, 1999.

Buffalo 1937. *Master Bronzes Selected from Museums and Collections in America.* Exh. cat. Buffalo, N.Y., Albright Art Gallery, February 1937. Buffalo, N.Y.: Burrow, 1937.

Bunker 1964. Emma C. Bunker. "The Spirit Kings in Sixth Century Chinese Buddhist Sculpture." *Archives of the Chinese Art Society of America* 18 (1964), pp. 26–37.

Bunker 1965. Emma C. Bunker. "The Style of the Trübner Stele." *Archives of the Chinese Art Society of America* 19 (1965), pp. 26–32.

Bunker 1968. Emma C. Bunker. "Early Chinese Representations of Vimalakīrti." *Artibus Asiae* 30, no. 1 (1968), pp. 28–52.

Burn 1993. Barbara Burn, ed. *Masterpieces of the Metropolitan Museum of Art.* Boston: Bullfinch Press, 1993.

Bush 1972. Susan Bush. "Iconography of the Sixth-Century Thunder Monster." *Bulletin of the Museum of Fine Arts, Boston* (1972), pp. 22–55.

Bush 1975. Susan Bush. "Thunder Monsters, Auspicious Animals, and Floral Ornament in Sixth-Century China." *Ars Orientalis* 10 (1975), pp. 19–33.

Bussagli 1979. Mario Bussagli. *Central Asian Painting.* New York: Rizzoli, 1979.

Carò 2010. Federico Carò. "Petrographic and Mineralogical Analysis of the Casting Core of a Bronze Buddha Maitreya." *Metropolitan Museum Studies in Art, Science, and Technology* 1 (2010), pp. 155–61.

Carter 1948. Dagny Carter. *Four Thousand Years of China's Art.* New York: Ronald Press, 1948.

Chandra and Rani 1978. Lokesh Chandra and Sharada Rani, eds. *Mudras in Japan: Symbolic Hand-Postures in Japanese Mantrayāna or the Esoteric Buddhism of the Shingon Denomination.* New Delhi: Sharada Rani, 1978.

Chang 2001. Chang Qing. "Shilun Longmen chu Tang mijiao diaoke" (A Preliminary Survey of the Esoteric Carvings in the Longmen Grottoes in the Early Tang Dynasty). *Kaogu Xuebao* 3 (2001), pp. 335–60.

Chang 2007. Chang Qing. "Revisiting the Longmen Sculptures in the Collection of the Metropolitan Museum of Art." *Orientations* 38, no. 1 (January–February 2007), pp. 81–89.

Chapin 1944. Helen B. Chapin. "Yunnanese Images of Avalokitesvara." *Harvard Journal of Asiatic Studies* 8, no. 2 (August 1944), pp. 131–86.

Chapin 1972. Helen B. Chapin. *A Long Roll of Buddhist Images.* Revised by Alexander C. Soper. Ascona: Artibus Asiae, 1972.

Chavannes 1896. Édouard Chavannes. "Les inscriptions chinoises de Bodh-Gaya." *Révue de l'histoire des réligions* 34, no. 1 (1896), pp. 1–58.

Chavannes 1909. Édouard Chavannes. *Mission archéologique dans la Chine septentrionale.* Paris: Éditions E. Leroux, 1909.

Chen 1997. Chen Changan. "Luoyang chutu Sizhou Dasheng shidiaoxiang" (The Stone Sculpture of the Sizhou Saint Unearthed in Luoyang). *Zhongyuan Wenwu* 2 (1997), pp. 93–95, 109.

Ch'en 1973. Kenneth K. S. Ch'en. *The Chinese Transformation of Buddhism.* Princeton: Princeton University Press, 1973.

Chen and Ding 1989. Chen Mingda and Ding Mingyi. *Gongxian, Tianlongshan, Xiangtangshan Anyang shi ku diao ke* (The Cave Temples of Gong County, Tianlongshan, Xiangtangshan, and Anyang). Beijing: Wenwu Chubanshe, 1989.

Chen Zhejing et al. 1993. Chen Zhejing, Wen Yuching, and Wang Zhenguo. *Longmen liu san diao xiang ji* (Lost Statues of the Longmen Caves). Shanghai: Shanghai Renmin Meishu Chubanshe, 1993.

Chen Zhi 1959. Chen Zhi. "Tang dai san ni foxiang" (Three Chinese Clay Buddhist Images of the Tang Dynasty). *Wenwu* 8 (1959), pp. 49–51.

Cheng et al. 1985. Cheng Junqing, Yang Jiaju, and Liu Peng. *Zhongguo mucai zhi* (Atlas of Chinese Woods). Beijing: Zhongguo Linye Chubanshe, 1985.

Chicago–San Francisco 2000–2001. *Taoism and the Arts of China.* Exh. cat. by Stephen Little and Shawn Eichman. Chicago, Art Institute, November 4, 2000–January 7, 2001; San Francisco, Asian Art Museum, February 21–May 13, 2001. Berkeley: University of California Press, 2000.

Chinese Academy of Forestry 2000. *Hongmu guojia biaozhun* (Red Woods National Standard). Beijing: Zhongguo biaozhun Chubanshe, 2000.

Chirapravati 1997. Pattaratorn M. L. Chirapravati. *Votive Tablets in Thailand: Origins, Styles, and Uses.* New York: Oxford University Press, 1997.

Chou and Bagchi 1944. Chou Ta-fu and P. C. Bagchi. "New Lights on the Chinese Inscriptions of Bodhgaya." *Sino-Indian Studies* 1 (1944), pp. 111–14.

Chou Ta-fu 1957. Chou Ta-fu. "Kaizheng Faguo Hanxue Jia Shawan dui Yindu chutu Hanwei Bei de wu shi" (Corrections of Chavannes's Interpretation of Stone Inscriptions Unearthed in India). *Lishi Yanjiu* 6 (1957), pp. 79–82.

Chou Yiliang 1945. Chou Yiliang. "Tantricism in China." *Harvard Journal of Asiatic Studies* 8 (March 1945), pp. 241–332.

Chow 1965. Fong Chow. "Chinese Buddhist Sculpture." *Metropolitan Museum of Art Bulletin* 23, no. 9 (1965), pp. 301–24.

Christie's 2009. *Fine Chinese Ceramics and Works of Art.* Sale cat. New York, Christie's, March 19, 2009, lot 601. New York: Christie's, 2009.

Chūgoku Sekkutsu **1980–82.** *Chūgoku Sekkutsu: Tonkō Bakukōkutsu* (The Grotto Art of China: The Dunhuang Mogao Caves). 5 vols. Tokyo: Heibonsha, 1980–82.

Chūgoku Sekkutsu **1983–85.** *Chūgoku Sekkutsu: Kijiru Sekkutsu* (The Grotto Art of China: The Kizil Caves). 3 vols. Tokyo: Heibonsha, 1983–85.

Chūgoku Sekkutsu **1989–90.** *Chūgoku Sekkutsu: Unkō Sekkutsu* (The Grotto Art of China: The Yungang Grottoes). 2 vols. Tokyo: Heibonsha, 1989–90.

Chutiwongs 1984. Nandana Chutiwongs. "The Iconography of Avalokiteśvara in Mainland Southeast Asia." Ph.D. diss., Rijksuniversiteit te Leiden, 1984.

Clark 1937. Walter E. Clark, ed. *Two Lamaistic Pantheons.* 2 vols. Cambridge, Mass.: Harvard University Press, 1937.

Clarke 2004. John Clarke. *Jewellery of Tibet and the Himalayas.* London: Victoria & Albert Museum, 2004.

Cleveland and New York 1997–98. *When Silk Was Gold: Central Asian and Chinese Textiles.* Exh. cat. by James C. Y. Watt and Anne E. Wardwell. Cleveland Museum of Art, October 26, 1997–January 4, 1998; New York, Metropolitan Museum of Art, March 3–May 17, 1998. New York: Metropolitan Museum of Art, 1997.

Corkhill 1979. Thomas Corkhill. *A Glossary of Wood*. New ed. London: Stobart, 1979.

Cowell 1987. R. Michael Cowell. "Scientific Appendix I: Chemical Analysis." In W. V. Davies, *Catalogue of Egyptian Antiquities in the British Museum. VII, Tools and Weapons. I, Axes*. London: British Museum Publications, 1987.

Cowell et al. 2003. R. Michael Cowell, Susan La Niece, and Jessica Rawson. "A Study of Later Chinese Metalwork." In *Scientific Research in the Field of Asian Art: Proceedings of the First Forbes Symposium at the Freer Gallery of Art*, edited by Paul Jett, pp. 80–89. London: Archetype, 2003.

Cox 1979. Warren E. Cox. *The Book of Pottery and Porcelain*. Rev. ed. New York: Crown Publishers, 1979.

Crosby 2000. Kate Crosby. "Tantric Theravada: A Bibliographic Essay on the Writings of François Bizot and Others on the Yogavacara Tradition." *Contemporary Buddhism* 1 (2000), pp. 141–98.

Cummings 2001. Joe Cummings. *Buddhist Stupas in Asia: The Shape of Perfection*. Melbourne: Lonely Planet Publications, 2001.

Davidson 2005. Ronald M. Davidson. *Tibetan Renaissance: Tantric Buddhism in the Rebirth of Tibetan Culture*. New York: Columbia University Press, 2005.

Dayton 1989–90. *Leaves from the Bodhi Tree: The Arts of Pāla India (8th–12th Centuries) and Its International Legacy*. Exh. cat. by Susan L. Huntington and John C. Huntington. Dayton [Ohio] Art Institute, November 17, 1989–January 14, 1990. Seattle: University of Washington Press, 1989.

De Montebello 1983. Philippe de Montebello. *The Metropolitan Museum of Art Guide*. Edited by Kathleen Howard. New York: Metropolitan Museum of Art, 1983.

De Montebello 1994. Philippe de Montebello. *The Metropolitan Museum of Art Guide*. New York: Metropolitan Museum of Art, 1994.

Dehejia 1991. Vidya Dehejia. "Aniconism and the Multivalence of Emblems." *Ars Orientalis* 21 (1991), pp. 45–66.

Dien 2001. Albert E. Dien. "Developments in Funerary Practices in the Six Dynasties Period: The Duisuguan or 'Figured Jar' as a Case in Point." In *Between Han and Tang: Cultural and Artistic Interaction in a Transformative Period*, edited by Wu Hung, pp. 509–46. Beijing: Cultural Relics Publishing House, 2001.

Dien 2007. Albert E. Dien. *Six Dynasties Civilization*. New Haven: Yale University Press, 2007.

Duan Pengqi 1990. Duan Pengqi. "Luoyang Pingdengsi Bei yu Pingdengsi" (Some Remarks on the Pingdeng Temple at Luoyang and Its Stele). *Kaogu* 7 (1990), pp. 632–37.

Dunne 2000. Claire Dunne. *Carl Jung: Wounded Healer of the Soul*. New York: Parabola Books, 2000.

Durkin-Meistererernst 2004. Desmond Durkin-Meistererernst, ed. *Turfan Revisited: The First Century of Research into the Arts and Cultures of the Silk Road*. Berlin: Reimer, 2004.

Eastman 1930. Alvan C. Eastman. "Two Exhibitions of Asiatic Sculpture." *Parnassus* 2, no. 7 (November 1930), pp. 30–33.

Edwards 1954. Richard Edwards. "The Cave-Reliefs at Ma-hao." *Artibus Asiae* 17 (1954), pp. 4–28.

Erickson 1992. Susan N. Erickson. "Boshanlu: Mountain Censers of the Western Han Period: A Typological and Iconological Analysis." *Archives of Asian Art* 45 (1992), pp. 6–28.

Famensi 1994. *Famensi* (Famen Temple). Xi'an: Zhongguo Shanxi Lü You Chubanshe, 1994.

Feugère et al. 2002. Laure Feugère, Anne Bouquillon, Béatrice Beillard, and Martine Bailly. "Le lohan en terre vernissée du Musée Guimet." *Techne* 16 (2002), pp. 20–26.

Fèvre and Métailié 2005. Francine Fèvre and Georges Métailié. *Dictionnaire RICCI des plantes de Chine: Chinois, français, latin, anglais*. Paris: Association RICCI, 2005.

Fingesten 1968. Peter Fingesten. "The Smile of the Buddha." *Oriental Art* 14 (Autumn 1968), pp. 176–82.

Fischer 1948. Otto Fischer. *Chinesische Plastik*. Munich: R. Piper, 1948.

Fisher 1995. Robert E. Fisher. "Noble Guardians: The Emergence of the Lokapalas in Buddhist Art." *Oriental Art* 41, no. 2 (Summer 1995), pp. 17–24.

Fitzgerald 1935. Charles Patrick Fitzgerald. *China: A Short Cultural History*. London: Cresset Press, 1935.

Flushing 1982. *Flights of Fantasy*. Exh. cat. Flushing, N.Y., Queens Museum, August 14–November 7, 1982. Flushing, N.Y.: Queens County Art and Cultural Center, 1982.

Fontein and Hempel 1968. Jan Fontein and Rose Hempel. *China, Korea, Japan*. Berlin: Propyläen Verlag, 1968.

Forte 1976. Antonino Forte. *Political Propaganda and Ideology in China at the End of the Seventh Century*. Naples: Istituto Universitario Orientale, 1976.

Gabbert 1972. Gunhild Gabbert. *Buddhistische Plastik aus China and Japan*. Wiesbaden: Franz Steiner Verlag, 1972.

Getty 1914. Alice Getty. *The Gods of Northern Buddhism: Their History, Iconography, and Progressive Evolution through the Northern Buddhist Countries*. Oxford: Clarendon Press, 1914.

Glaser 1925. Curt Glaser. *Ostasiatische Plastik*. Berlin: B. Casirer, 1925.

Goepper and Poncar 1996. Roger Goepper and Jaroslav Poncar. *Alchi: Ladakh's Hidden Buddhist Sanctuary: The Sumtsek*. Boston: Shambhala Publications, 1996.

Gong 1981. Gong Dazhong. *Longmen shiku yishu* (Art of the Longmen Grottoes). Shanghai: Shanghai Renmin Chubanshe, 1981.

Gong 2002. Gong Dazhong. *Longmen shiku yishu* (Art of the Longmen Grottoes). Beijing: Renmin Chubanshe, 2002.

Gongxian 1989. *Gongxian shikusi* (Cave Temples at Gongxian). Beijing: Wenwu Chubanshe, 1989.

Granoff 1968–69. Phyllis Granoff. "A Portable Buddhist Shrine from Central Asia." *Archives of Asian Art* 22 (1968–69), pp. 81–95.

Gregory 1999. Peter N. Gregory. "The Vitality of Buddhism in the Sung." In *Buddhism in the Sung*, edited by Peter N. Gregory and Daniel A. Getz Jr., pp. 1–20. Honolulu: University of Hawai'i Press, 1999.

Gridley 1993. Marilyn Gridley. *Chinese Buddhist Sculpture under the Liao*. New Delhi: International Academy of Indian Culture and Aditya Prakashan, 1993.

Gridley 1995–96. Marilyn Gridley. "Three Buddhist Sculptures from Longquanwu and the Luohans from Yi Xian." *Oriental Art* 41 (Winter 1995–96), pp. 20–29.

Griswold 1963. Alexander B. Griswold. "Prolegomena to the Study of the Buddha's Dress in Chinese Sculpture." *Artibus Asiae* 26, no. 2 (1963), pp. 85–131.

Gu 1930. Gu Xieguang. *Heshuo fanggu xinlu* (Updated Notes on Antiquities in the Heshuo Region). Shanghai: Kexue Yiqiguan, 1930.

Gu and Fan 1943. Gu Xieguang and Fan Shouming. *Heshuo guji tushi* (Pictorial Notes on Antiquities in the Heshuo Region). 2 vols. Shanghai: Hezhong Tushu Guan, 1943.

Guth 1979. Christine Guth. "Kakei's Statues of Mañjuśrī and Four Attendants in Abe no Monjuin." *Archives of Asian Art* 32, no. 8 (1979), pp. 8–26.

Guy 1995. John Guy. "The Avalokitesvara of Yunnan and Some South East Asian Connections." In *South East Asia and China: Art, Interaction, and Commerce*, edited by Rosemary Scott and John Guy, pp. 64–83. London: Percival David Foundation of Chinese Art, 1995.

Hai-wai Yi-chen 1986. Hai-wai Yi-chen, Fo jiang = Chinese Art in Overseas Collections, Buddhist Sculpture. 2 vols. Taipei: National Palace Museum, 1986.

Hajime 2002. Hajime Hagiwara. "Genjō hatsugan 'jūkuchi zō' kō zengyōdei senbutsu o megutte" (Xuanzang's Vow to Create "Ten Koti Buddhist Images"—A Study of *Shanyeni* Tiles). *Bukkyō Geijutsu* 260 (2002), p. 90.

Hallade 1968. Madeleine Hallade. *Gandharan Art of North India and the Graeco-Buddhist Tradition in India, Persia, and Central Asia.* New York: Abrams, 1968.

Han 2001. Han Yong, ed. *Beijing wenwu jing cui daxi: Fozaoxiang juan* (Gems of Beijing Cultural Relics Series: Buddhist Statues). Beijing: Beijing Chubanshe, 2001.

Harrison 1987. Paul Harrison. "Who Gets to Ride the Great Vehicle? Self-Image and Identity among the Followers of Early Mahayana." *Journal of the International Association of Buddhist Studies* 10 (1987), pp. 67–89.

Harrison 1992. Paul Harrison. "Searching for the Origins of Mahayana: What Are We Looking For?" *Journal of the International Association of Buddhist Studies* 15 (1992), pp. 48–69.

He et al. 1993. He Yun'ao et al. *Fo jiao chu chuan nan fang zhi lu* (Early Routes of Buddhism to China). Beijing: Wenwu Chubanshe, 1993.

Hearn 1991. Maxwell K. Hearn. "Pagoda Sanctuary" in "Recent Acquisitions: A Selection, 1990–91." *Metropolitan Museum of Art Bulletin*, n.s., 49, no. 2 (Autumn 1991), pp 91–92.

Hearn and Fong 1974. Maxwell K. Hearn and Wen Fong. *The Arts of Ancient China.* New York: Metropolitan Museum of Art, 1974.

Hexi shiku 1987. Hexi shiku (Cave Temples in the Hexi Corridor). Beijing: Wenwu Chubanshe, 1987.

C. Ho 2005. Chuimei Ho. "Magic and Faith: Reflections on Chinese Mirrors in the Tenth to the Fourteenth Century." *Cleveland Studies in the History of Art* 9 (2005), pp. 90–97.

W. Ho 1968–69. Wai-kam Ho. "Notes on Chinese Sculpture from the Northern Qi to Sui, Part I: Two Seated Stone Buddhas in the Cleveland Museum." *Archives of Asian Art* 22 (1968–69), pp. 7–55.

W. Ho 2001. Wai-kam Ho. "The Trubner Stele in the Metropolitan Museum: A Problem of Authentication and Connoisseurship." *Kaikodo Journal* 18 (Fall 2001), pp. 16–27.

Holmgren 1981–83a. Jennifer Holmgren. "Social Mobility in the Northern Dynasties: A Case Study of the Feng of Northern Yen." *Monumenta Serica* 35 (1981–83), pp. 19–32.

Holmgren 1981–83b. Jennifer Holmgren. "Women and Political Powers in the Traditional T'o-Pa Elite: A Preliminary Study of the Biography of Empresses in the Wei Shu." *Monumenta Serica* 35 (1981–83), pp. 33–74.

Holmgren 1983. Jennifer Holmgren. "The Harem in Northern Wei Politics 398–498." *Journal of the Economic and Social History of the Orient* 26 (1983), pp. 71–96.

Howard 1984. Angela F. Howard. "Buddhist Sculpture of the Liao Dynasty: A Re-assessment of Osvald Sirén's Study." *Bulletin of the Museum of Far Eastern Antiquities* (1984), pp. 1–95.

Howard 1990. Angela F. Howard. "A Gilt Bronze Guanyin from the Nanzhao Kingdom of Yunnan: Hybrid Art from the Southwestern Frontier." *Journal of the Walters Art Gallery* 48 (1990), pp. 1–12.

Howard 1996. Angela F. Howard. "Buddhist Cave Sculpture of the Northern Qi Dynasty: Shaping a New Style, Formulating New Iconographies." *Archives of Asian Art* 49 (1996), pp. 6–25.

Howard 1997. Angela F. Howard. "The Dharani Pillar of Kunming, Yunnan: A Legacy of Esoteric Buddhism and the Burial Rites of the Bai People." *Artibus Asiae* (1997), pp. 33–72.

Howard et al. 2006. Angela F. Howard, Wu Hung, Li Song, and Yang Hong. *Chinese Sculpture.* New Haven: Yale University Press, 2006.

Howard and He 1983. Angela F. Howard and He Pignan. *Zhongguo gu dais hi diao yi shu* (Chinese Buddhist Sculpture from the Wei through the Tang Dynasty). Taipei: National Palace Museum, 1983.

Hsu 2007. Eileen Hsiang-ling Hsu. "The Trübner Stele Re-examined: Epigraphic and Literary Evidence." *Artibus Asiae* 67, no. 2 (2007), pp. 177–98.

Huang 1937. Huang Jun, ed. *Zun gu zhai tao fo liu zhen* (Reproductions of Buddhist Pottery Plaques). 2 vols. Beijing: Zunguzhai, 1937.

Huayansi 1980. Huayansi (Huayan Monastery). Beijing: Wenwu Chubanshe, 1980.

J. Huntington 1986. John C. Huntington. "A Note on Dunhuang Cave 17: 'The Library,' or Hong Bian's Reliquary Chamber." *Ars Orientalis* 16 (1986), pp. 93–101.

S. Huntington 1992. Susan L. Huntington. "Aniconism and the Multivalence of Emblems: Another Look." *Ars Orientalis* 22 (1992), pp. 111–56.

Ingholt 1957. Harold Ingholt. *Gandhāran Art in Pakistan.* New York: Pantheon Books, 1957.

Iwasaki 1993. Iwasaki Tsutomu. "The Tibetan Tribes of Ho-hsi and Buddhism during the Northern Sung Period." *Acta Asiatica* 67 (1993), pp. 17–37.

Jan 1966. Jan Yün-hua. "Buddhist Relations between India and Sung China." *History of Religions* 6, no. 1 (1966), pp. 24–42, and no. 2 (1966), pp. 135–98.

Jett 1990. Paul Jett. "An Example of the Use of Brass in Chinese Lacquer-ware." *Archives of Asian Art* 43 (1990), pp. 59–60.

Jett 1991. Paul Jett. "Technologische Studie zu den vergoldeten Guanyin-Figuren aus dem Dali-Königreich." In *Der Goldschatz der drei Pagoden*, edited by Albert Lutz, pp. 68–74. Zürich: Museum Rietberg, 1991.

Jett 1993. Paul Jett. "A Study of Gilding of Chinese Buddhist Bronzes." In *Metal Plating and Patination*, edited by Susan La Niece and Paul Craddock, pp. 193–200. Oxford: Butterworth-Heinemann, 1993.

Jett 1995. Paul Jett. "The Study and Treatment of Chinese Dry Lacquer Sculpture." In *International Symposium of the Conservation and Restoration of Cultural Property: Conservation of Urushi Objects*, pp. 167–85. Tokyo: Tokyo National Research Institute of Cultural Properties, 1995.

Jett and Douglas 1992. Paul Jett and Janet G. Douglas. "Chinese Buddhist Bronzes in the Freer Gallery of Art: Physical Features and Elemental Composition." In *Materials Issues in Art and Archaeology III*, edited by Pamela B. Vandiver et al., pp. 205–23. Pittsburgh: Materials Research Society, 1992.

Jin 1994. Jin Shen. *Zhongguo li dai ji nian fo xiang tu dian* (Illustrated Catalogue of Chinese Buddhist Sculptures). Beijing: Wenwu Chubanshe, 1994.

Jin 2004. Jin Shen. *Fo jiao mei shu cong kao* (Collected Essays on Buddhist Art). Beijing: Kexue Chubanshe, 2004.

Jing 1994. Anning Jing. "The Portraits of Khubilai Khan and Chabi by Anige (1245–1306)." *Artibus Asiae* 54 (1994), pp. 40–86.

Karetzky 1986. Patricia Karetzky. "The Engraved Designs on the Late Sixth Century Sarcophagus of Li Ho." *Artibus Asiae* 47, no. 2 (1986), pp. 81–106.

Kerr and Ayers 2002. Rose Kerr and John Ayers. *Blanc de Chine: Porcelain from Dehua*. Chicago: Art Media Resources, 2002.

Kezi'er 1996. *Kezi'er shiku* (Cave Temples at Kizil). Beijing: Wenwu Chubanshe, 1996.

Kieschnick 1999. John Kieschnick. "The Symbolism of the Monk's Robe in China." *Asia Major* 12, no. 1 (1999), pp. 9–32.

Kieschnick 2003. John Kieschnick. *The Impact of Buddhism on Chinese Material Culture*. Princeton: Princeton University Press, 2003.

Kobayashi 1975. Takeshi Kobayashi. *Nara Buddhist Art, Todai-ji*. New York: Weatherhill, 1975.

Kohara 1963. Jirō Kohara. "Nihon chōkoku yōzai chōsa shiryō" (Data on the Investigation of the Wood Material Used for Japanese Sculpture). *Bijutsu Kenkyū*, no. 229 (1963), pp. 74–83.

Koizumi 2000. Koizumi Yoshihide. "Seihoku Indo no Keitai yo Ganzō" (Study of Portable Shrines in Northwestern India). *Tokyo Kokuritsu Habubutsukan Kiyō* 35 (2000), pp. 87–158.

Kumagai 1959. Kumagai Nobue. "Chūgoku shoki kondō butsu no ni-san no shiryō" (Three Buddhist Bronzes of the Earlier Age in China). *Bijutsu Kenkyū*, no. 203 (March 1959), pp. 29–37.

Kümmel 1930. Otto Kümmel. *Jörg Trübner zum Gedächtnis*. Berlin: Klinkhardt & Biermann, 1930.

Kurita 1988–90. Kurita Isao. *Gandhara Bijutsu* (Gandharan Art). 2 vols. Tokyo: Nigensha, 1988–90.

La Plante 1968. John D. La Plante. *Asian Art*. Dubuque: W. C. Brown, 1968.

Lai 1999. Ming-chiu Lai. "On the Image Procession in China from the Second to the Sixth Centuries A.D.: An Interpretation of an Elephant Sculpture at the Kongwangshan Site." In *Politics and Religion in Ancient and Medieval Europe and China*, edited by Frederick Hok-ming Cheung and Ming-chiu Lai, pp. 41–75. Hong Kong: Chinese University Press, 1999.

Lancaster 1974. Lewis Lancaster. "An Early Mahayana Sermon about the Body of the Buddha and the Making of Images." *Artibus Asiae* 36 (1974), pp. 287–91.

Larson 1988. John Larson. "The Treatment and Examination of Polychrome Chinese Sculpture at the Victoria and Albert Museum." In *The Conservation of Far Eastern Art: Preprints of the Contributions to the Kyoto Congress, 19–23 September 1988*, edited by John S. Mills et al., pp. 120–25. London: International Institute for Conservation of Historic and Artistic Works, 1988.

Larson and Kerr 1985. John Larson and Rose Kerr. *Guanyin: A Masterpiece Revealed*. London: Victoria & Albert Museum, 1985.

Laufer 1925. Berthold Laufer. *Ivory in China*. Chicago: Field Museum of Natural History, 1925.

Lawrence–San Francisco 1994–95. *Latter Days of the Law: Images of Chinese Buddhism, 850–1850*. Exh. cat. edited by Marsha Weidner. Lawrence, Kansas, Spencer Museum of Art, August 27–October 9, 1994; San Francisco, Asian Art Museum, November 30, 1994–January 29, 1995. Honolulu: University of Hawai'i Press, 1994.

Lawton 1995. Thomas Lawton, "Yamanaka Sadajiro: Advocate for Asian Art." *Orientations* 26, no. 1 (January 1995), pp. 80–93.

Lee 2000. Lee Yumin. *Guanyin te zhan = Visions of Compassions: Images of Guanyin in Chinese Art*. Taipei: National Palace Museum, 2000.

Lee and Ho 1968. Sherman E. Lee and Wai-kam Ho. *Chinese Art under the Mongols*. Cleveland: Cleveland Museum of Art, 1968.

Lefebvre d'Argencé 1974. René-Yvon Lefebvre d'Argencé, ed. *Chinese, Korean, and Japanese Sculpture: The Avery Brundage Collection, Asian Art Museum of San Francisco*. Tokyo: Kodansha, 1974.

Leidy 1990. Denise Patry Leidy. "The Ssu-Wei Figure in Sixth-Century A.D. Chinese Buddhist Sculpture." *Archives of Asian Art* 43 (January 1990), pp. 21–37.

Leidy 1997. Denise Patry Leidy. "Kashmir and China: A Note about Styles and Dates." *Orientations* 28, no. 2 (February 1997), pp. 66–70.

Leidy 1998. Denise Patry Leidy. "Avalokiteshvara in Sixth-Century China." In *The Flowering of a Foreign Faith: New Studies in Chinese Buddhist Art*, edited by Janet Baker, pp. 88–103. New Delhi: Marg Publications, 1998.

Leidy 2003. Denise Patry Leidy. "A Northern Song Sculpture of the Monk Sengqie in The Metropolitan Museum of Art." *Oriental Art* (Spring 2003), pp. 52–64.

Leidy 2005–6. Denise Patry Leidy. "Notes on a Sculpture of Buddha Maitreya Dated 486 in The Metropolitan Museum of Art." *Oriental Art* (Winter 2005–6), pp. 22–32.

Leidy 2007. Denise Patry Leidy. "Asian Reliquaries." In *Eternal Ancestors: The Art of the Central African Reliquary*, edited by Alisa LaGamma, pp. 14–30. New Haven: Yale University Press, 2007.

Leidy 2008. Denise Patry Leidy. *The Art of Buddhism: An Introduction to Its History and Meaning*. Boston: Shambhala, 2008.

Leidy et al. 1997. Denise Patry Leidy, Anita Siu, and James C. Y. Watt. *Chinese Decorative Arts*. New York: Metropolitan Museum of Art, 1997.

Leoshko 1994. Janice Leoshko. "Scenes of the Buddha's Life in Pala-Period Art." *Silk Road Art and Archaeology* 3 (1994), pp. 251–76.

Lerman 1969. Leo Lerman. *The Museum: One Hundred Years and The Metropolitan Museum of Art*. New York: Viking Press, 1969.

H. Li 1958a. Hui-Lin Li. "The Weeping Willow and Lombardy Poplar." *Morris Arboretum Bulletin* 9, no. 1 (1958), pp. 3–9.

H. Li 1958b. Hui-Lin Li. "The Cultivated Lindens." *Morris Arboretum Bulletin* 9, no. 3 (1958), pp. 39–44.

Li Jingjie 1998. Li Jingjie. "Zaoqi danti shifo quyu xing fenxi" (An Analysis of the Characteristics and Regions of What Are Known as Early Stone Buddhas). *Gugong Bowuyuan Yuankan* 2 (1998), pp. 30–42.

Li Kunsheng 1999. Li Kunsheng. *Nanzhao Daliguo diaoke huihua yishu* (Sculpture and Painting of the Nanzhao and Dali Kingdoms). Kunming: Yunnan Renmin Chubanshe, 1999.

Li Song 2000. Li Song. *Shaanxi gudai fojiao meishu* (Early Buddhist Art from Shaanxi). Xi'an: Shaanxi Renmin Jiaoyu Chubanshe, 2000.

Li Song 2002. Li Song. *Chang'an yishu yu zongjiao wenming* (Arts and Religious Civilization of Chang'an). Beijing: Zhonghua Shuju, 2002.

Li Wensheng 1991. Li Wensheng. "Longmen Tangdai mizong zaoxiang" (Tang Esoteric Sculptures at Longmen). *Wenwu* 1 (1991), pp. 61–64.

Li Xianqi 1985. Li Xianqi. "Bei Qi Luoyang Pingdengsi zaoxiangbei" (Northern Qi Pictorial Stele at Pingdeng-si, Luoyang). *Zhongyuan Wenwu* 4 (1985), pp. 89–97.

Li Yung-ti 2003. Li Yung-ti. "The Anyang Bronze Foundries: Archaeological Remains, Casting Technology, and Production Organization." Ph.D. diss., Harvard University, 2003.

Li Yuqun 2003a. Li Yuqun. *Bei chao wan qi shikusi yanjiu* (Research on Cave Temples during the Late Period of the Northern Dynasties). Beijing: Wenwu Chubanshe, 2003.

Li Yuqun 2003b. Li Yuqun. *Tianlongshan shi ku* (Tianlongshan Grottoes). Beijing: Kexue Chubanshe, 2003.

Lin Meicun 1991. Lin Meicun. "A Kharosthi Inscription from Chang'an." In *Ji Xianlin jiaoshou bashi huadan jinian lunwenji* (Papers in Honor of Professor Dr. Ji Xianlin on the Occasion of His Eightieth Birthday), vol. 1, edited by Li Zheng and Jiang Zhongxin. Beijing: Beijing Waiwen Yinshan he Jiangxi Renmin Chubanshe, 1991.

Lin Shuzhong 1988. Lin Shuzhong, ed. *Wei Jin Nanbei chao diaosu, Zhongguo meishu quanji* (Sculpture of the Wei, Chin, Northern and Southern Dynasties Periods). Beijing: Renmin Meishu Chubanshe, 1988.

Linrothe 1998. Rob Linrothe. "Xia Renzong and the Patronage of Tangut Buddhist Art: The Stupa and the Ushnishavijaya Cult." *Journal of Sung-Yuan Studies* 28 (1998), pp. 91–121.

Linrothe 1999. Rob Linrothe. *Ruthless Compassion: Wrathful Deities in Early Indo-Tibetan Esoteric Buddhist Art*. Boston: Shambhala, 1999.

Linrothe 2007. Rob Linrothe. "A Winter in the Field." *Orientations* 38, no. 4 (May 2007), pp. 40–53.

Lippe 1961. Aschwin Lippe. "A Gilt Bronze Altarpiece of the Wei Dynasty." *Archives of the Chinese Art Society of America* 15 (1961), pp. 29–31.

Lippe 1965a. Aschwin Lippe. "The Date of the Trübner Stele." *Archives of the Chinese Art Society of America* 19 (1965), pp. 61–62.

Lippe 1965b. Aschwin Lippe. "From Maitreya to Shakyamuni." *Archives of the Chinese Art Society of America* 19 (1965), pp. 63–65.

Lippe 1965c. Aschwin Lippe. "The Religions of Asia." *Apollo* (September 1965), pp. 220–29.

Liu 2007. Heping Liu. "Juecheng: An Indian Buddhist Monk Painter in the Early Eleventh-Century Chinese Court." *Journal of Inner Asian Art and Archaeology* 2 (2007), pp. 95–116.

Liu Jianhua 1995. Liu Jianhua. "Hebei Quyang Bahui-si Sui Dai Kejing Kan" (A Sui Shrine Inscribed with Buddhist Sutras at Bahui-si, Quyang). *Wenwu* 5 (1995), pp. 77–86.

Liu Jinglong 2001. Liu Jinglong, ed. *Guyang dong: Longmen shi ku di 1443 ku* (Guyang Cave: Cave 1443 of the Longmen Grottoes). 3 vols. Beijing: Kexue Chubanshe, 2001.

Liu Jinglong 2002. Liu Jinglong, ed. *Lianhua dong: Longmen shi ku 712 ku* (Lotus Cave: Cave 712 of the Longmen Grottoes). Beijing: Kexue Chubanshe, 2002.

Liu Jinglong et al. 2002. Liu Jinglong et al. *Longmen shiku zaoxiang quanji* (Complete Works of Statues in the Longmen Grottoes). Beijing: Wenwu Chubanshe, 2002.

Liu Yang 2001. Liu Yang. "Origins of Daoist Iconography." *Ars Orientalis* 31 (2001), pp. 31–64.

Lodge 1928. J. E. Lodge. "A Note on Two Chinese Dedicatory Groups." *Bulletin of the Museum of Fine Arts, Boston* 26 (August 1928), pp. 57–60.

London 1935–36. *The Chinese Exhibition*. Exh. cat. by Laurence Binyon. London, Royal Academy of Arts, November 1935–March 1936. London: Faber & Faber, 1936.

London 1984. *Chinese Ivories from the Shang to the Qing*. Exh. cat. by Craig Clunas et al. London, British Museum, May 24–August 19, 1984. London: British Museum Press, 1984.

London 2002. *Return of the Buddha: The Qingzhou Discoveries*. Exh. cat. edited by Lucas Nickel. London, Royal Academy of Arts, April 26–July 14, 2002. London: Royal Academy of Arts, 2002.

***Longmen* 1997.** *Longmen shiku* (Longmen Cave Temples). Beijing: Wenwu Chubanshe, 1997.

Loo 1940. *An Exhibition of Chinese Stone Sculpture*. New York: C. T. Loo, 1940.

Lopez 1995. Donald S. Lopez, ed. *Curators of the Buddha: The Study of Buddhism under Colonialism*. Chicago: University of Chicago Press, 1995.

Los Angeles 1957. *The Art of the Tang Dynasty*. Exh. cat. by Henry Trubner. Los Angeles County Museum, January 8–February 17, 1957. Los Angeles: Los Angeles County Museum of Art, 1957.

Los Angeles 1984. *Light of Asia: Buddha Shakyamuni in Asian Art*. Exh. cat. edited by Pratapaditya Pal. Los Angeles County Museum of Art, March 4–May 20, 1984. Los Angeles: The Museum, 1984.

Lovell 1975. Hin-cheung Lovell. "Some Northern Chinese Ceramic Wares of the Sixth and Seventh Centuries." *Oriental Art* 21 (Winter 1975), pp. 328–43.

Lugano 1993. *Lost Empire of the Silk Road: Buddhist Art from Khara Khoto (X–XIIIth Century)*. Exh. cat. edited by Mikhail Piotrovsky. Lugano, Fondazione Thyssen-Bornemisza, June 25–October 31, 1993. Milan: Electa, 1993.

Lutz 1991. Albert Lutz. *Der Tempel der drei Pagoden von Dali*. Zürich: Museum Rietberg, 1991.

Ma et al. 1995. Ma Zhongli et al. "Shexian Zhonghuangshan Bei Qi Fojiao Moya Kejing Diaocha" (Buddhist Cliff Inscriptions of the Northern Qi Dynasty at Zhonghuangshan, Shexian, Hebei). *Wenwu* 5 (1995), pp. 66–76.

Mabberley 2008. David J. Mabberley. *Mabberley's Plant-Book: A Portable Dictionary of the Vascular Plants, Their Classification and Uses*. 3rd ed. New York: Cambridge University Press, 2008.

Mackenzie 1991. Colin Mackenzie. "Chu Bronze Work: A Unilinear Tradition, or a Synthesis of Diverse Sources?" In *New Perspectives on Chu Culture during the Eastern Zhou Period*, edited by Thomas Lawton, pp. 107–57. Washington, D.C: Arthur M. Sackler Gallery, Smithsonian Institution, 1991.

Mair et al. 2005. Victor H. Mair, Nancy S. Steinhardt, and Paul R. Goldin, eds. *Hawai'i Reader in Traditional Chinese Culture*. Honolulu: University of Hawai'i Press, 2005.

Makita 1981–89. Makita Tairyō. *Chūgoku Bukkyō shi kenkyū* (Research on Chinese Buddhist Sculpture). 3 vols. Tokyo: Daitō Shuppansha, 1981–89.

Malandra 1993. Geri H. Malandra. *Unfolding a Mandala: The Buddhist Cave Temples at Ellora*. Albany: State University of New York Press, 1993.

Malenka and Price 1997. Sally Malenka and Beth A. Price. "A Chinese Wall Painting and a Palace Hall Ceiling." In *Conservation of Ancient Sites on the Silk Road: Proceedings of an International Conference on the Conservation of Grotto Sites*, edited by Neville Agnew, pp. 127–38. Los Angeles: Getty Conservation Institute, 1997.

Mallmann 1948. Marie-Thérèse de Mallmann. *Introduction à l'étude d'Avalokiteçvara*. Paris: Civilisations du Sud, 1948.

Mallmann 1951. Marie-Thérèse de Mallmann. "Notes sur les bronzes du Yunnan représentant Avalokiteśvara." *Harvard Journal of Asiatic Studies* 14 (December 1951), pp. 567–601.

Mallmann 1964. Marie-Thérèse de Mallmann. *Études iconographique sur Mañjuśrī*. Paris: École Française d'Extrême-Orient, 1964.

Mallmann 1975. Marie-Thérèse de Mallmann. *Introduction à l'iconographie du tântrisme bouddhique*. Paris: Librairie Adrien-Maisonneuve, 1975.

Matics 1979. Kathleen Matics, "Thoughts Pertaining to the 'Maitreya' Images in the Metropolitan Museum of Art." *East and West* 29 (1979), pp. 113–26.

Matsubara 1958. Matsubara Saburō. "Hokugi seikō gahokuke kondō butsu no ichi tenkai" (A Typical Example of a Buddhist Bronze of the Hopei Style Made in the Cheng Kuang Period). *Bijutsu Kenkyū* (1958), pp. 11–33.

Matsubara 1959. Matsubara Saburō. "Tōgi chōkoku ron: Sono tokusei to waga Asuka Tori yōshiki to no kankei" (Eastern Wei Sculpture and Its Connections with the Japanese Tori Style Sculpture of the Asuka Period). *Bijutsu Kenkyū* (1959), pp. 185–201.

Matsubara 1961. Matsubara Saburō. "Sōgen Chōkoku no keifu" (On the Genealogy of Sculpture in the Song and Yuan Periods). *Kokka*, no. 833 (1961), pp. 341–55.

Matsubara 1968. Matsubara Saburō. "Seitō Chōkoku ikō no tenkai" (Developent of Chinese Sculpture from the High T'ang Onward). *Bijutsu Kenkyū*, no. 257 (1968), pp. 29–34.

Matsubara 1995. Matsubara Saburō. *Chūgoku Bukkyō chōkoku shiron* (History of Chinese Buddhist Sculpture). 4 vols. Tokyo: Yoshikawa Kōbunkan, 1995.

McNair 2003. Amy McNair. "The Relief Sculptures in the Binyang Central Grotto at Longmen and the 'Problem' of Pictorial Stones." In *Between Han and Tang: Visual and Material Culture in a Transformative Period*, edited by Wu Hung, pp. 157–90. Beijing: Wenwu Chubanshe, 2003.

McNair 2007. Amy McNair. *Donors of Longmen: Faith, Politics, and Patronage in Medieval Chinese Buddhist Sculpture*. Honolulu: University of Hawai'i Press, 2007.

Meng et al. 1995. Meng Fanren, Zhao Yixiong, and Geng Yukun. *Gaochang bihua jiyi* (Compendium of Murals from Gaochang). Urumqi: Xinjiang Renmin Chubanshe, 1995.

Menshikova 2008. Maria L. Menshikova. "Skulptura Arhata iz Yizhou" (Sculptures of Arhats from Yizhou). *Trudy Gosudarstvennogo Ermitazha* 39 (2008), pp. 114–18.

Mertz 2007. Mechtild Mertz. "Identification microscopique du bois, un regard sur l'âme du bois dans la sculpture bouddhique chinoise et japonaise." In *La conservation-restauration des oeuvres asiatiques, 17 octobre 2005, École Supérieure des Beaux-Arts de Tours*, pp. 25–41. Les Rencontres de l'ARSET 2. Tours: ARSET, 2007.

Mertz and Itoh 2005. Mechtild Mertz and Takao Itoh. "Identification des bois de huit sculptures chinoises et de deux sculptures japonaises conservées aux MRAH." *Bulletin des Musées Royaux d'Art et d'Histoire* (Brussels), no. 76 (2005), pp. 127–48.

Mertz and Itoh 2007. Mechtild Mertz and Takao Itoh. "The Study of Buddhist Sculptures from Japan and China Based on Wood Identification." In *Scientific Research on the Sculptural Arts of Asia: Proceedings of the Third Forbes Symposium at the Freer Gallery of Art*, edited by Janet G. Douglas et al., pp. 198–204. London: Archetype, 2007.

Metropolitan Museum of Art 2008. *Friends of Asian Art Gifts, 1985–2007*. New York: Metropolitan Museum of Art, 2008.

Migeon and Moret 1920. Gaston Migeon and Alexandre Moret. *Collection Paul Mallon*. 2 vols. Paris, 1920.

Miyaji 1992. Miyaji Akira. *Nehan to Miroku no zuzōgaku: Indo kara Chūō Ajia e* (Iconology of *Parinirvana* and Maitreya: From India to Central Asia). Tokyo: Yoshikawa Kōbunkan, 1992.

Mizuno 1960. Mizuno Seiichi. *Chūgoku no chōkoku: Sekibutsu, kondōbutsu* (Bronze and Stone Sculpture of China). Tokyo: Nihon Keizai Shinbunsha, 1960.

Mizuno and Nagahiro 1937. Mizuno Seiichi and Nagahiro Toshio. *Kyōdōzan sekkutsu: Kahoku Kanan shōkyō ni okeru Hokusei jidai no sekkutsu jiin = The Buddhist Cave-Temples of Hsiang-t'ang-shan on the Frontier of Honan and Hopei*. Kyoto: Tōhō Bunka Gakuin Kyōto Kenkyōjo, 1937.

Mochizuki 1973–80. Mochizuki Shinkō. *Mochizuki Bukkyō daijiten* (Encyclopedia of Buddhism). 10 vols. Tokyo: Sekai Seiten Kankō Kyōkai, 1973–80.

Moffatt et al. 1985. Elizabeth A. Moffatt, Neil T. Adair, and Gregory S. Young. "The Occurrence of Oxalates on Three Chinese Wall Paintings." In *Application of Science in Examination of Works of Art: Proceedings of the Seminar, September 7–9, 1983*, edited by Pamela A. England and Lambertus van Zelst, pp. 234–38. Boston: Research Laboratory, Museum of Fine Arts, 1985.

Müller and Nanjio 1972. F. Max Müller and Bunyiu Nanjio, eds. *The Ancient Palm-Leaves Containing the Pragñā-pàramitâ-hridaya-sùtra and the Ushnîsha-vigaya-dhârani*. Amsterdam: Oriental Press, 1972.

Munsterberg 1946. Hugo Munsterberg. "Buddhist Bronzes of the Six Dynasties Period." *Artibus Asiae* 9, no. 1 (1946), pp. 275–315.

Munsterberg 1969. Hugo Munsterberg. *A Short History of Chinese Art*. New York: Greenwood Press, 1969.

Munsterberg 1988. Hugo Munsterberg. *Chinese Buddhist Bronzes*. New York: Hacker Art Books, 1988.

Murata and Akira 1955–57. Murata Jirō and Akira Fujieda. *Koyōkan (Chü-Yung-Kuan, the Buddhist Arch of the Fourteenth Century A.D. at the Pass of the Great Wall Northwest of Beijing)*. 2 vols. Kyoto: Kyoto Daigaku Kōgabuka, 1955–57.

Nara 1978. *Nihon Bukkyō bijutsu no genryū = Sources of Japanese Buddhist Art*. Exh. cat. Nara National Museum, April 29–June 11, 1978. Nara: Nara National Museum, 1978.

Nara 1981. *Nihon no Bukkyō o kizuita hitobito* (Special Exhibition of Buddhist Portraiture). Exh. cat. Nara National Museum, April 29–June 7, 1981. Nara: Nara National Museum, 1981.

Nara 2004. *Hōryūji: Nihon Bukkyō bijutsu no reimei* (Hōryūji: Dawn of Japanese Buddhist Art). Exh. cat. Nara National Museum, April 24–June 13, 2004. Nara: Nara National Museum, 2004.

Nara 2009. *Seichi Ninpō (Ninpō): Nihon Bukkyō 1300-nen no genryū = Sacred Ningbo, Gateway to 1300 Years of Japanese Buddhism*. Exh. cat. Nara National Museum, July 18–August 30, 2009. Nara: Nara National Museum, 2009.

National Standard of the People's Republic of China 2000. National Standard of the People's Republic of China. *Hongmu* (Red Woods). N.p.: Zhoughua Renmin Gongheguo guo jia biao zhun, 2000.

Needham et al. 1986. Joseph Needham, Lu Gwei-Djen, and Huang Hsing-Tsung. *Science and Civilisation in China*, vol. 6, *Biology and Biological Technology*, part 1, *Botany*. Cambridge: Cambridge University Press, 1986.

New York 1938. *Chinese Bronzes of the Shang (1766–1122 B.C.) through the T'ang Dynasty (A.D. 618–906)*. Exh. cat. New York, Metropolitan Museum of Art, October 19–November 27, 1938. New York: Metropolitan Museum of Art, 1938.

New York 1940. *A Special Exhibition of Heads in Sculpture from the Museum Collection*. Exh. cat. New York, Metropolitan Museum of Art, January 16–March 3, 1940. New York: Metropolitan Museum of Art, 1940.

New York 1954. *Small Sculpture: Shang through Sung Dynasties*. Exh. cat. New York, China House, February 19–April 17, 1954. New York: China Art Society, 1954.

New York 1970–71. *Masterpieces of Fifty Centuries*. Exh. cat. by Kenneth Clark. New York, Metropolitan Museum of Art, November 14, 1970–June 1, 1971. New York: E. P. Dutton, 1970.

New York 1971. *Art from the Rooftop of Asia: Tibet, Nepal, Kashmir*. Exh. cat. by Fong Chow. New York, Metropolitan Museum of Art, April 22, 1971–January 30, 1972. New York: Metropolitan Museum of Art, 1971.

New York 1978. *The Auspicious Dragon in Chinese Decorative Art*. Exh. cat. by Sandra Carr Grant and Catherine Coleman Brawer. New York, Katonah Gallery, September 24–November 26, 1978. New York: Katonah Gallery, 1978.

New York 1979. *Treasures from the Metropolitan Museum of Art*. Exh. cat. by Laurance Roberts. New York, China House Gallery, October 24–November 25, 1979. New York: China Institute, 1979.

New York 1991a. *Ancient Chinese Bronze Art: Casting the Precious Sacral Vessel*. Exh. cat. by W. Thomas Chase. New York, China House Gallery, April 20–June 15, 1991. New York: China Institute, 1991.

New York 1991b. *The Story of a Painting: A Korean Buddhist Treasure from the Mary and Jackson Burke Foundation*. Exh. cat. by Kim Hongnam. New York, Asia Society, April 30–July 28, 1991. New York: Asia Society, 1991.

New York 1991–92. *The Lotus Transcendent: Indian and Southeast Asian Art from the Samuel Eilenberg Collection.* Exh. cat. by Martin Lerner and Steven Kossak. New York, Metropolitan Museum of Art, October 2, 1991–June 28, 1992. New York: Metropolitan Museum of Art, 1991.

New York 1993–94. *A Decade of Collecting, 1984–1993: Friends of Asian Art Gifts.* Exh. cat. New York, Metropolitan Museum of Art, September 29, 1993–January 9, 1994. New York: Metropolitan Museum of Art, 1993.

New York 2002. *Blanc de Chine: Divine Images in Porcelain.* Exh cat. by John Ayers. New York, China Institute, September 19–December 7, 2002. New York: China Institute, 2002.

New York 2004–5. *China: Dawn of a Golden Age.* Exh. cat. by James C. Y. Watt et al. New York, Metropolitan Museum of Art, October 12, 2004–January 23, 2005. New Haven: Yale University Press, 2004.

New York 2005. *Defining Yongle: Imperial Art in Early Fifteenth-Century China.* Exh. cat. by James C. Y. Watt and Denise Patry Leidy. New York, Metropolitan Museum of Art, April 1–July 10, 2005. New York: Metropolitan Museum of Art, 2005.

New York 2006. *Holy Madness: Portraits of Tantric Siddhas.* Exh. cat. edited by Robert N. Linrothe. New York, Rubin Museum of Art, February 11–September 3, 2006. Chicago: Serindia Publications, 2006.

New York 2007. *Buddhist Sculpture from China: Selections from the Xi'an Beilin Museum: Fifth through Ninth Centuries.* Exh. cat. by Annette L. Juliano. New York, China Institute, September 20–December 8, 2007. New York: China Institute, 2007.

New York and Zürich 1998–99. *Sacred Visions: Early Paintings from Central Tibet.* Exh. cat. by Steven M. Kossak and Jane Casey Singer. New York: Metropolitan Museum of Art, October 6, 1998–January 17, 1999; Zürich, Rietberg Museum, February 14–May 16, 1999. New York: Metropolitan Museum of Art, 1998.

Newark 1958. *Art in Buddhism.* Exh. cat. by Eleanor Olson. Newark [New Jersey] Museum, January 28–April 17, 1958. Newark: The Museum, 1958.

Newark 1999–2000. *From the Sacred Realm: Treasures of Tibetan Art from the Newark Museum.* Exh. cat. by Valrae Reynolds et al. Newark [New Jersey] Museum, October 15, 1999–January 20, 2000. New York: Prestel Verlag, 1999.

Nihon Bukkyō **1984.** *Nihon Bukkyō bijutsu no genryū = Sources of Japanese Buddhist Art.* 2 vols. Nara: Nara National Museum, 1984.

Niyogi 2001. Puspa Niyogi. *Buddhist Divinities.* New Delhi: Munshiram Manoharlal, 2001.

O'Connor 1974. Stanley J. O'Connor. "Buddhist Votive Tablets and Caves in Peninsular Thailand." In *Art and Archaeology in Thailand.* Bangkok: National Museum, Fine Arts Department, 1974.

Okazaki 1977. Okazaki Jōji. *Pure Land Buddhist Painting.* Tokyo: Kodansha, 1977.

Ōmura 1915. Ōmura Seigai. *Shina bijutsushi: Chōsohen* (History of Chinese Art: Sculpture). Tokyo: Bussho Kankōkai Zuzōbu, 1915.

Ōmura 1932. Ōmura Seigai. *Shina kobijutsu zufu* (Illustrations of Ancient Chinese Art). Tokyo: Shimba Shoin, 1932.

Orzech 2006. Charles D. Orzech. "Looking for Bhairava: Exploring the Circulation of Esoteric Texts by the Song Institute for Canonical Translations." *Pacific World: Journal of the Institute for Buddhist Studies* 8 (2006), pp. 139–66.

Pal 1969. Pratapaditya Pal. *The Art of Tibet.* New York: Asia Society, 1969.

Pal 1978. Pratapaditya Pal. *The Ideal Image: The Gupta Sculptural Tradition and Its Influence.* New York: Asia Society, 1978.

Pal 2007. Pratapaditya Pal. "A Pala Period Jataka Panel in the Norton Simon Museum." In *Kalhār: Studies in Art, Iconography, Architecture, and Archaeology of India and Bangladesh,* edited by Gouriswar Bhattacharya et al., pp. 213–16. New Delhi: Kaveri Books, 2007.

Paris 2009–10. *Les Buddhas du Shandong.* Exh. cat. by Gilles Béguin et al. Paris, Musée Cernuschi, September 18, 2009–January 3, 2010. Paris: Paris Musées, 2009.

Pearson and Brown 1932. R. S. Pearson and H. P. Brown. *Commercial Timbers of India: Their Distribution, Supplies, Anatomical Structure, Physical and Mechanical Properties and Uses.* 2 vols. Calcutta: Government of India Central Publication Branch, 1932.

Pelliot 1923. Paul Pelliot. "Les statues en 'lacque sèche' dans l'ancien art chinois." *Journal Asiatique* 202 (April–June 1923), pp. 181–207.

Peng et al. 1982–87. Peng Huashi et al. *Dunhuang Mogao ku* (Caves at Mogao, Dunhuang). 5 vols. Beijing: Wenwu Chubanshe, 1982–87.

Perzyński 1920. Friedrich Perzyński. *Von Chinas göttern: Reisen in China.* Munich: Kurt Wolff, 1920.

Poly Art Museum 2000. *Bao li yi shu bo wu guan cang shi ke fo jiao zao xiang jing pin xuan* (Selected Works of Sculpture in the Poly Art Museum). Exh. cat. Beijing: Poly Art Museum, 2000.

Portland 1976. Donald Jenkins. *Masterworks in Wood: China and Japan.* Portland, Ore.: Portland Art Museum, 1976.

Portland 2005. *Mysterious Spirits, Strange Beasts, Earthly Delights: Early Chinese Art from the Arlene and Harold Schnitzer Collection.* Exh. cat. by Donald Jenkins et al. Portland [Oregon] Art Museum, May 21–October 2, 2005. Portland: Portland Art Museum, 2005.

Priest 1928a. Alan Priest. "A Stone Stele of the Six Dynasties." *Metropolitan Museum of Art Bulletin* 23, no. 5 (May 1928), pp. 133–35.

Priest 1928b. Alan Priest. "Chinese Wood Sculpture." *Metropolitan Museum of Art Bulletin* 23, no. 6 (June 1928), pp. 156–58.

Priest 1929. Alan R. Priest. "Two Chinese Wood Sculptures." *Metropolitan Museum of Art Bulletin* 24, no. 1 (January 1929), pp. 16–18.

Priest 1930a. Alan Priest. "A Chinese Stele." *Metropolitan Museum of Art Bulletin* 25, no. 11, pt. 1 (November 1930), cover ill., pp. 234–39.

Priest 1930b. Alan Priest. "Two Central Asian Sculptures." *Metropolitan Museum of Art Bulletin* 25, no. 5, pt. 1 (May 1930), cover ill., pp. 125–26.

Priest 1931a. Alan Priest. "A Collection of Buddhist Votive Tablets." *Metropolitan Museum of Art Bulletin* 26, no. 9 (September 1931), pp. 209–13.

Priest 1931b. Alan Priest. "A T'ang Stele." *Metropolitan Museum of Art Bulletin* 25, no. 1 (January 1931), pp. 14–18.

Priest 1933. Alan Priest. "Acquisitions of Far Eastern Art: Chinese Sculpture." *Metropolitan Museum of Art Bulletin* 28, no. 6 (June 1933), pp. 107–11.

Priest 1934a. Alan Priest. "A Chinese Wood Figure." *Metropolitan Museum of Art Bulletin* 29, no. 2 (February 1934), p. 29.

Priest 1934b. Alan Priest. "A Dated Chinese Wood Figure." *Metropolitan Museum of Art Bulletin* 29, no. 4 (April 1934), cover ill., pp. 62–63.

Priest 1935a. Alan Priest. "Three Chinese Ivories." *Metropolitan Museum of Art Bulletin* 30, no. 1 (January 1935), pp. 8–9.

Priest 1935b. Alan Priest. "A Chinese Bodhisattva." *Metropolitan Museum of Art Bulletin* 30, no. 4 (April 1935), cover ill., pp. 73–75.

Priest 1936. Alan Priest. "Two Important Bronzes in the London Exhibition." *Parnassus* 8, no. 2 (1936), pp. 13–14.

Priest 1938a. Alan Priest. "An Anonymous Gift for the Far Eastern Department." *Metropolitan Museum of Art Bulletin* 33, no. 8 (August 1938), cover ill., pp. 176–77.

Priest 1938b. Alan Priest. "An Exhibition of Chinese Bronzes from American Collections." *Metropolitan Museum of Art Bulletin* 33, no. 10 (October 1938), cover ill., pp. 216–22.

Priest 1939a. Alan Priest. "Two Buddhist Altarpieces of the Wei Dynasty." *Metropolitan Museum of Art Bulletin* 34, no. 2 (February 1939), cover ill., pp. 32–38.

Priest 1939b. Alan Priest. "Two Chinese Wood Figures." *Metropolitan Museum of Art Bulletin* 34, no. 10 (October 1939), pp. 222–23.

Priest 1939c. Alan Priest. "Indian Sculpture." *Metropolitan Museum of Art Bulletin* 34, no. 6 (June 1939), pp. 152–58.

Priest 1941. Alan Priest. "A Stone Fragment from Lung Men." *Metropolitan Museum of Art Bulletin* 36, no. 5 (May 1941), pp. 114–16.

Priest 1942. Alan Priest. "Two Dated Wood Sculptures of the Ming Dynasty." *Metropolitan Museum of Art Bulletin*, n.s., 1, no. 1 (Summer 1942), pp. 29–32.

Priest 1944. Alan Priest. *Chinese Sculpture in the Metropolitan Museum of Art*. New York: Metropolitan Museum of Art, 1944.

Priest 1945. Alan Priest. "Chinese Bronzes." *Metropolitan Museum of Art Bulletin*, n.s., 4, no. 4 (December 1945), pp. 106–12.

Qing 1998. Qing Gele. "Liao Qingzhou Baitia tasheng qianshe de liangjian jinian mingwen tongjing" (Two Liao-Period Bronze Mirrors with Inscriptions Inlaid on the White Pagoda in Qingzhou). *Wenwu* 9 (1998), pp. 67–68.

Quagliotti 2006. Anna Maria Quagliotti. "A Buddha Head from Afghanistan." In *Vanamālā: Festschrift A. J. Gail*, edited by Gerd J. R. Mevissen and Klaus Bruhn, pp. 190–98. Berlin: Weidler Buchverlag, 2006.

Reedy 1991. Chandra L. Reedy. "The Opening of Consecrated Tibetan Bronzes with Interior Contents: Scholarly, Conservation, and Ethical Considerations." *Journal of the American Institute for Conservation* 30 (1991), pp. 13–34.

Reedy 1992. Chandra L. Reedy. "Appendix: Technical Analysis." In *The Crossroads of Asia: Transformation in Image and Symbol in the Art of Ancient Afghanistan and Pakistan*, edited by Elizabeth Errington and Joe Cribb, pp. 241–87. Cambridge: Ancient India and Iran Trust, 1992.

Reedy 1997. Chandra L. Reedy. *Himalayan Bronzes: Technology, Style, and Choices*. Newark: University of Delaware Press, 1997.

Rhi 1994. Juhyung Rhi. "From Bodhisattva to Buddha: The Beginning of Iconic Representation in Buddhist Art." *Artibus Asiae* 54, no. 3 (1994), pp. 207–54.

Rhi 2005. Juhyung Rhi. "Images, Relics, and Jewels: The Assimilation of Images in the Buddhist Relic Cult of Gandhara—or Vice Versa." *Artibus Asiae* 65, no. 2 (2005), pp. 169–211.

Rhie 1974–75. Marylin M. Rhie. "A T'ang Period Stele Inscription at Cave XXI at T'ien-Lung Shan." *Archives of Asian Art* 28 (1974–75), pp. 6–33.

Rhie 1995. Marylin M. Rhie. "The Earliest Chinese Bronze Bodhisattva Sculptures." *Arts of Asia* 25, no. 2 (1995), pp. 86–98.

Rhie 1999–2002. Marylin M. Rhie. *Early Buddhist Art of China and Central Asia*. 2 vols. Leiden: Brill, 1999–2002.

Riddell 1979. Sheila Riddell. *Dated Chinese Antiquities, 600–1650*. London and Boston: Faber & Faber, 1979.

Rizzo 2008. Adriana Rizzo. "Progress in the Application of ATR-FTIR Microscopy to the Study of Multi-layered Cross-sections from Works of Art." *Analytical and Bioanalytical Chemistry*, no. 392 (2008), pp. 47–55.

Rodney 1949. Nannette B. Rodney. "Far Eastern Art: The Reopened Galleries." *Metropolitan Museum of Art Bulletin*, n.s., 7, no. 6 (February 1949), pp. 152–61.

Rösch 2007a. Petra H. Rösch. "Chinese Buddhist Wood Sculptures of Water-Moon Guanyin: Preliminary Research on Their Wood Construction and Material." In *Scientific Research on the Sculptural Arts of Asia: Proceedings of the Third Forbes Symposium at the Freer Gallery of Art*, edited by Janet G. Douglas et al., pp. 205–12. London: Archetype, 2007.

Rösch 2007b. Petra Rösch. *Chinese Wood Sculptures of the 11th to 13th Centuries*. Stuttgart: Ibidem-Verlag, 2007.

Rowan 2001. Diana P. Rowan. "Identifying a Bodhisattva Attribute: Tracing the Long History of a Small Object." *Oriental Art* 47, no. 1 (2001), pp. 31–36.

Rowland 1963. Benjamin Rowland. *The Evolution of the Buddha Image*. New York: Asia Society, 1963.

Salmony 1925. Alfred Salmony. *Chinesische Plastik*. Berlin: R. C. Schmidt, 1925.

Samosiuk 2006. Kira Samosiuk. *Buddhiiska i a zhivopis iz Khara-Khoto XII–XIV vekov*. Saint Petersburg: State Hermitage Museum, 2006.

Scaglia 1958. Giustina Scaglia. "Central Asians on a Northern Ch'i Gate Shrine." *Artibus Asiae* 21 (1958), pp. 9–28.

Schroeder 1981. Ulrich von Schroeder. *Indo-Tibetan Bronzes*. Hong Kong: Visual Dharma Publications, 1981.

Schulten 2005. Caroline Schulten. "Some Notes on the Use of Bronze Mirrors in the Tomb of Zhang Wenzao, Liao Period." *Cleveland Studies in the History of Art* 9 (2005), pp. 68–89.

Scott 2000. David A. Scott. "A Review of Copper Chlorides and Related Salts in Bronze Corrosion and as Painting Pigments." *Studies in Conservation* 45, no. 1 (2000), pp. 39–53.

Seckel 1963. Dietrich Seckel. *The Art of Buddhism*. New York: Crown Publishers, 1963.

Sen 2002. Tansen Sen. "The Revival and Failure of Buddhist Translations during the Song Dynasty." *T'oung Pao*, 2nd ser., 88 (2002), pp. 27–80.

Sen 2003. Tansen Sen. *Buddhism, Diplomacy, and Trade: The Realignment of Sino-Indian Relations, 600–1400*. Honolulu: University of Hawai'i Press, 2003.

Sen-Gupta 2002. Achinto Sen-Gupta. "Portable Buddhist Shrines." *Arts of Asia* 32 (2002), pp. 42–61.

Shanxi 1991. *Shanxi fo jiao cai su* (Buddhist Sculpture of Shanxi Province). Beijing: Zhongguo Fojiao Xiehui, 1991.

Shao et al. 2009. Shao X., Wang S., Zhu H., Xu Y., Liang E., Yin Z., Xu X., and Xiao Y. "A 3585-Year Ring-Width Dating Chronology of Qilian Juniper from the Northeastern Qinghai-Tibetan Plateau." *IAWA Journal* 30, no. 4 (2009), pp. 379–94.

Sharf 1992. Robert H. Sharf. "The Idolization of Enlightenment: On the Mummification of Ch'an Masters in Medieval China." *History of Religions* 32 (August 1992), pp. 1–31.

Sharf 2002. Robert H. Sharf. "On Pure Land Buddhism and Chan/Pure Land Syncretism in Medieval China." *T'oung Pao*, 2nd ser., 88, nos. 1–2 (2002), pp. 282–331.

Shi 1983. Shi Yan. *Zhongguo diaosu shi tulu* (A Pictorial History of Chinese Sculpture). 4 vols. Shanghai: Xinhua Shudian, 1983.

Shi 1988. Shi Yan. *Wu dai Song diao su, Zhongguo meishu quanji* (Sculpture of the Five and Sung Dynasties). Beijing: Renmin Meishu Chubanshe, 1988.

Shi and Han 1989. Shi Xingbang and Han Wei. *Famensi digong zhen bao* (Precious Cultural Relics in the Crypt of the Famen Temple). Xi'an: Shanxi Renmin Meishu Chubanshe, 1989.

Shi and Ren 1988. Shi Yan and Ren Rong. *Sui Tang diao su, Zhongguo meishu quanji* (Sculpture of the Sui and Tang Dynasties). Beijing: Renmin Meishu Chubanshe, 1988.

Shimonaka 1931–35. Shimonaka Yasaburō. *Dai hyakka jiten* (Comprehensive Encyclopedia). 28 vols. Tokyo: Heibonsha, 1931–35.

Shirai 2006. Shirai Yoko. "Senbutsu: Figured Clay Tiles, Buddhism, and Political Developments on the Japanese Islands, ca. 650 CE–794 CE." Ph.D. diss., University of California, Los Angeles, 2006.

Shirakawa 1965. Shirakawa Ichiro. "Hokusai Hiten fuku shō zō" (*Apsaras* Playing Clustered Flutes). *Kobijutsu* (September 1965), pp. 96–98.

Sickman and Soper 1956. Laurence Sickman and Alexander C. Soper. *The Art and Architecture of China*. Baltimore: Penguin Books, 1956.

Sirén 1925. Osvald Sirén. *Chinese Sculpture from the Fifth to the Fourteenth Century*. 4 vols. London: E. Benn, 1925.

Sirén 1937. Osvald Sirén. "La sculpture chinoise à l'Exposition de l'Orangerie." *Révue des Arts Asiatiques* 9 (1937), pp. 1–8.

Sirén 1938. Osvald Sirén. "A Great Chinese Monument in America." *Parnassus* 10 (March 1938), pp. 11–15.

Sirén 1942a. Osvald Sirén. "Chinese Sculpture of the Sung, Liao, and Chin Dynasties." *Bulletin of the Museum of Far Eastern Antiquities* 14 (1942), pp. 45–64.

Sirén 1942b. Osvald Sirén. *Kinas konst under tre årtusenden*. Stockholm: Natur och Kultur, 1942.

Sirén 1959. Osvald Sirén. "Two Chinese Buddhist Stele." *Archives of the Chinese Art Society of America* 13 (1959), pp. 8–21.

Sirén 1998. Osvald Sirén. *Chinese Sculpture from the Fifth to the Fourteenth Century*. 2 vols. New ed. Bangkok: SDI Publications, 1998.

Slusser 1996. Mary Shepherd Slusser. "The Art of East Asian Lacquer Sculpture." *Orientations* 27, no. 1 (January 1996), pp. 16–30.

Smith and Weng 1973. Bradley Smith and Wango Weng. *China: A History in Art*. New York: Harper & Row, 1973.

Smithies 1984. Richard Smithies. "The Search for the Lohans of I-chou (Yixian)." *Oriental Art* 30 (Autumn 1984), pp. 260–74.

Snellgrove 1978. David L. Snellgrove, ed. *The Image of the Buddha*. London: Serindia Publications, 1978.

Snodgrass 1988. Adrian Snodgrass. *The Matrix and Diamond World Mandalas in Shingon Buddhism*. 2 vols. New Delhi: Aditya Prakashan, 1988.

Soper 1958. Alexander C. Soper. "Northern Liang and Northern Wei in Kansu." *Artibus Asiae* 21, no. 2 (1958), pp. 131–64.

Soper 1959. Alexander C. Soper. *Literary Evidence for Early Buddhist Art in China*. Ascona: Artibus Asiae, 1959.

Soper 1966. Alexander C. Soper. "Imperial Cave-Chapels of the Northern Dynasties: Donors, Beneficiaries, Dates." *Artibus Asiae* 28, no. 4 (1966), pp. 241–70.

Soper 1969. Alexander C. Soper. "Some Late Chinese Bronze Images (Eighth to Fourteenth Centuries) in the Avery Brundage Collection, M. H. De Young Museum, San Francisco." *Artibus Asiae* 31, no. 1 (1969), pp. 32–54.

Sorensen 2006. Henrik H. Sorensen. "The Spell of the Great, Golden Peacock Queen: The Origins, Practices, and Lore of an Early Esoteric Buddhist Tradition in China." *Pacific World: Journal of the Institute of Buddhist Studies* 8 (2006), pp. 89–123.

Steele et al. 1997. John Steele, Leon Stodulski, and Karen Trentleman. "Deciphering the Puzzle: The Examination and Analysis of an Eastern Han Dynasty Money Tree." *Objects Specialty Group Postprints* (American Institute for Conservation of Historic and Artistic Works) 5 (1997), pp. 125–41.

Steinhardt 2003. Nancy Shatzman Steinhardt. "A Jin Hall at Jingtusi: Architecture in Search of Identity." *Ars Orientalis* 33 (2003), pp. 76–119.

Strahan 1993. Donna K. Strahan. "The Walters Chinese Wood-and-Lacquer Buddha: A Technical Study." *Journal of the Walters Art Gallery* 51 (1993), pp. 105–20.

Strahan 2010. Donna Strahan. "Piece-Mold Casting: A Chinese Tradition for Fourth- and Fifth-Century Bronze Buddha Images." *Metropolitan Museum Studies in Art, Science, and Technology* 1 (2010), pp. 133–53.

Strong 1979. John S. Strong. "The Legend of the Lion-Roarer: A Study of the Arhat Pindola Bharadvaja." *Numen* 26 (June 1979), pp. 50–88.

Strong 1992. John S. Strong. *The Legend and Cult of Upagupta*. Princeton: Princeton University Press, 1992.

Su 1986. Su Bai. "Liangzhou shiku yiji he 'Liangzhou moshi'" (The Liangzhou Cave Temple and the "Liangzhou Type"). *Kaogu Xuebao* 4 (1986), pp. 435–45.

Su 1989. Su Bai. "Dunhuang Mogaoku mijiao yiji zaji" (Miscellaneous Notes on the Historical Remains of the Esoteric Sect at Dunhuang). *Wenwu* 9 (1989), pp. 45–53.

Su 1996. Su Bai. *Zhongguou shikusi yanjiu* (Studies on the Cave Temples of China). Beijing: Wenwu Chubanshe, 1996.

Sun 2003. Sun Di. "Shen rong bi zhen—Hebei Yixian bafowa Liaodai sancai luohan zuo xiang kuai bo" (Divine and Lifelike—Liao-Dynasty Three-Color-Glaze *Luohan*s from Bafowa, Yixian, Hebei). *Gugong Wenwu Yuekan* 243 (2003), pp. 52–63.

Sun 2004. Sun Di. *Tianlong Shan shiku: Liu shi hai wai shike zaoxiang yan jiu* (Tianlongshan Grottoes: Research on the Overseas Stone Statues). Beijing: Waiwen Chubanshe, 2004.

Sydney 2001–2. *Buddha: Radiant Awakening*. Exh. cat. edited by Jackie Menzies. Sydney, Art Gallery of New South Wales, November 10, 2001–February 24, 2002. Sydney: Art Gallery of New South Wales, 2001.

Taggart et al. 1973. Ross E. Taggart, George L. McKenna, and Marc F. Wilson, eds. *Handbook of the Collections in the William Rockhill Nelson Gallery of Art and Mary Atkins Museum of Fine Arts, Kansas City, Missouri*, vol. 2, *Art of the Orient*. 5th ed. Kansas City, Mo., 1973.

Takakusu and Watanabe 1914–32. Takakusu Junjirō and Watanabe Kaigyoku, eds. *Taishō shinshū Daizōkyō*. 100 vols. Tokyo: Taishō Issaikyō Kankōkai, 1914–32.

Tan 1989. Tan Derui. *Canlan de Zhongguo gudai shila zhuzao = The Splendid Craft of Lost Wax Casting in Ancient China*. Shanghai: Shanghai Scientific and Technological Literature Publishing House, 1989.

Tanabe 1969. Tanabe Saburōsuke. "Amerika Kanada ni aru Chūgoku mokuchō zō" (Wood Statues Existing in America and Canada). *Museum*, no. 214 (1969), pp. 29–34.

ten Grotenhuis 1999. Elizabeth ten Grotenhuis. *Japanese Mandalas: Representations of Sacred Geography*. Honolulu: University of Hawai'i Press, 1999.

Thote 2006. Alain Thote. "Lacquer Craftsmanship in the Qin and Chu Kingdoms: Two Contrasting Traditions (Late 4th–3rd Century B.C.)." *Journal of East Asian Archaeology* 5 (2006), pp. 337–74.

Tokiwa and Sekino 1939–41. Tokiwa Daijō and Sekino Tadashi. *Shina bunka shiseki* (Buddhist Monuments of China). 12 vols. Tokyo: Hōzōkan, 1939–41.

Tokyo 1987. *Tokubetsuten kondōbutsu: Chūgoku, Chōsen, Nihon* (Special Exhibition of Gilt-Bronze Buddhist Statues). Exh. cat. Tokyo: Tokyo National Museum, 1987.

Tokyo and Kyoto 1972. *Nyūyokū Metoroporitan Bijutsukan ten = Treasured Masterpieces of the Metropolitan Museum of Art*. Exh. cat. Tokyo National Museum, August 10–October 1, 1972; Kyoto Municipal Museum, October 8–November 26, 1972. Tokyo: Tokyo National Museum, 1972.

Tomita 1945. Kojiro Tomita. "A Chinese Bronze Buddha Group of 593 A.D. and Its Original Arrangement." *Boston Museum Bulletin* 43 (June 1945), p. 19.

Toyka-Fuong 1998. Ursula Toyka-Fuong. "The Influence of Pala Art on 11th-Century Wall-Painting of Grotto 76 in Dunhuang." In *The Inner Asian International Style 12th–14th Centuries*, edited by Deborah E. Klimburg-Salter and Eva Allinger, pp. 67–96. Vienna: Verlag der Österreichischen Akademie der Wissenschaften, 1998.

Tsiang 1996. Katherine R. Tsiang. "A Monumentalization of Buddhist Texts in the Northern Qi Dynasty: The Engraving of Sutras in Stone at the Xiangtangshan Caves and Other Sites in the Sixth Century." *Artibus Asiae* 56, nos. 3–4 (1996), pp. 233–65.

Tsiang 2002. Katherine R. Tsiang. "Changing Patterns of Divinity and Reform in the Late Northern Wei." *Art Bulletin* 84, no. 2 (June 2002), pp. 222–45.

Tsiang 2004. Katherine R. Tsiang. "A Reconstruction of the Southern Cave at Bei Xiangtangshan" (in Japanese with English précis). *Kokka* (April 2004), pp. 3–15.

Tsiang 2007. Katherine R. Tsiang. "The Xiangtangshan Caves Project: An Overview and Progress Report with New Discoveries." *Orientations* 38, no. 6 (September 2007), pp. 74–83.

Tsiang 2008. Katherine R. Tsiang. "Bodhisattvas, Jewels, and Demons: Reconstructing Meaning in the North Cave at Xiangtangshan." *Apollo* (May 2008), pp. 36–41.

Tu 1978. Tu Qi. "Beijing Mentougou qu Longquanwu faxian Liaodai Yaoshi" (Remains of a Liao-Dynasty Porcelain Kiln Found at Longquanwu, Mentougou, Beijing). *Wenwu* 5 (1978), pp. 26–32.

Twilley 2007. John Twilley. "Polychrome Decoration on Far Eastern Gilt Bronze Sculptures of the Eighth Century." In *Scientific Research on the Sculptural Arts of Asia: Proceedings of the Third Forbes Symposium at the Freer Gallery of Art*, edited by Janet G. Douglas et al., pp. 174–87. London: Archetype, 2007.

Umehara 1930. Umehara Sueji. "Amerika no hakubutsukan ni yoteru bunka no kobijutsu" (Ancient Chinese Arts as Seen in American Museums). *Bukkyō Bijutsu* 16 (1930), pp. 20–40.

Valenstein 1975a. Suzanne G. Valenstein. *A Handbook of Chinese Ceramics.* New York: Metropolitan Museum of Art, 1975.

Valenstein 1975b. Suzanne G. Valenstein. "Highlights of Chinese Ceramics." *Metropolitan Museum of Art Bulletin*, n.s., 33, no. 3 (Autumn 1975), pp. 115–64.

Valenstein 1989. Suzanne G. Valenstein. *A Handbook of Chinese Ceramics.* New York: Metropolitan Museum of Art, 1989.

Valenstein 1992. Suzanne G. Valenstein. *The Herzman Collection of Chinese Ceramics.* New York: Stanley Herzman, 1992.

Valenstein 1997–98. Suzanne G. Valenstein. "Preliminary Findings on a 6th Century Earthenware Jar." *Oriental Art* 43, no. 4 (Winter 1997–98), pp. 2–13.

Valenstein 2007. Suzanne G. Valenstein. *Cultural Convergences in the Northern Qi Period: A Flamboyant Chinese Ceramic Container: A Research Monograph.* New York: Metropolitan Museum of Art, 2007.

Valenstein et al. 1977. Suzanne G. Valenstein, Julia Meech, and Marilyn Jenkins. *Oriental Ceramics: The World's Great Collections.* Tokyo: Kodansha International, 1977.

Valentiner 1914. Wilhelm R. Valentiner. "Two Chinese Sculptures." *Metropolitan Museum of Art Bulletin* 9, no. 6 (June 1914), pp. 137–40.

Vanderstappen and Rhie 1965. Harry Vanderstappen and Marylin M. Rhie. "The Sculpture of T'ien Lung Shan: Reconstruction and Dating." *Artibus Asiae* 27, no. 3 (1965), pp. 189–237.

Vasant 1991. Suresh Vasant. "Dipankara Buddha at Ajanta." In *Aksayanivi: Essays Presented to Dr. Debala Mitra in Admiration of Her Scholarly Contributions*, edited by Gouriswar Bhattacharya, pp. 171–86. Delhi: Sri Satguru Publications, 1991.

Visser 1936. H. F. E. Visser. "Over eenige particuliere collecties Aziatische Kunst te New York." *Maandblad voor Beeldende Kunst* (1936), pp. 35–38.

Visser 1948. H .F. E. Visser. *Asiatic Art in Private Collections of Holland and Belgium.* Amsterdam: De Spieghel, 1948.

Wang 2005. Eugene Y. Wang. *Shaping the Lotus Sutra: Buddhist Visual Culture in Medieval China.* Seattle: University of Washington Press, 2005.

Wang Huimin 1987. Wang Huimin. "Dunhuang shuiyue Guanyin xiang" (Images of the Water-Moon Guanyin at Dunhuang). *Dunhuang Yanjiu* 10 (1987), pp. 31–38.

Wang-Toutain 1995. Françoise Wang-Toutain. "Une peinture de Dunhuang conservée à la Bibliothèque Nationale de France." *Arts Asiatiques* 44 (1995), pp. 53–69.

Wang Ziyun 1988. Wang Ziyun. *Zhongguo diaosu yishu shi* (History of Chinese Sculptural Art). 2 vols. Beijing: Renmin Meishu Chubanshe, 1988.

Wang Zongxun 1996. Wang Zongxun, ed. *Xin bian la han ying* (Newly Edited Latin Chinese English Plant Name Index). Beijing: Gonye Chubanshe, 1996.

Watson 1984. William Watson. *Chinese Ivories from the Shang to the Qing.* London: British Museum Press, 1984.

Watson 1995. William Watson. *The Arts of China to AD 900.* New Haven: Yale University Press, 1995.

Watt 1990. James C. Y. Watt. "The Arts of Ancient China." New York: *Metropolitan Museum of Art Bulletin*, n.s., 48, no. 1 (Summer 1990), pp. 1–72.

Watt 1996. James C. Y. Watt. "Three Lohans" in "Recent Acquisitions: A Selection, 1995–96." *Metropolitan Museum of Art Bulletin*, n.s., 54, no. 2 (Autumn 1996), p. 78.

Webb et al. 2007. Marianne Webb, Elizabeth Moffat, Marie-Claude Corbeil, and Nicholas Duxin. "Examination and Analysis of the Chinese Polychrome Sculptures in the Collection of the Royal Ontario Museum." In *Scientific Research on the Sculptural Arts of Asia: Proceedings of the Third Forbes Symposium at the Freer Gallery of Art*, edited by Janet G. Douglas et al., pp. 188–97. London: Archetype, 2007.

Werner 1932. E. T. C. Werner. *A Dictionary of Chinese Mythology.* Shanghai: Kelly and Walsh, 1932.

Whitfield 2005. Roderick Whitfield. "Early Buddhas from Hebei." *Artibus Asiae* 65 (2005), pp. 87–98.

Wichita 1977–78. *5000 Years of Art from the Metropolitan Museum of Art.* Exh. cat. edited by Howard E. Wooden. Wichita [Kansas] Art Museum, October 23, 1977–January 15, 1978. Wichita: The Museum, 1977.

Williams 1975. Joanna Williams. "Sarnath Gupta Steles of the Buddha's Life." *Ars Orientalis* 10 (1975), pp. 171–92.

Winter 2007. John Winter. "Surface Decoration on the Limestone Sculptures from Qingzhou, Shandong Province, China." In *Scientific Research on the Sculptural Arts of Asia: Proceedings of the Third Forbes Symposium at the Freer Gallery of Art*, edited by Janet G. Douglas et al., pp. 165–73. London: Archetype, 2007.

Winter 2008. John Winter. *East Asian Paintings: Materials, Structures and Deterioration Mechanisms.* London: Archetype, 2008.

Wolf 1969. Marion Wolf. "The Lohans from Yizhou." *Oriental Art* 15, no. 1 (Spring 1969), pp. 51–75.

Wong 1993. Dorothy C. Wong. "A Reassessment of the Representation of Mt. Wutai from Dunhuang." *Archives of Asian Art* 44 (1993), pp. 27–51.

Wong 1998–99. Dorothy C. Wong. "Four Sichuan Buddhist Steles and the Beginning of Pure-land Imagery in China." *Archives of Asian Art* 51 (1998–99), pp. 56–79.

Wong 2004. Dorothy C. Wong. *Chinese Steles: Pre-Buddhist and Buddhist Use of a Symbolic Form*. Honolulu: University of Hawai'i Press, 2004.

Wu 1986. Wu Hung. "Buddhist Elements in Early Chinese Art (2nd and 3rd Centuries)." *Artibus Asiae* 47 (1986), pp. 263–352.

Xie 2004. Xie Jisheng. "The Murals of Mogao Cave 465: New Evidence for 12th Century Tangut Xia Patronage." *Orientations* 35, no. 5 (June 2004), pp. 38–45.

Xiong and Liang 1991. Victor Cunrui Xiong and Ellen Johnston Liang. "Foreign Jewelry in Ancient China." *Bulletin of the Asia Institute* 5 (1991), pp. 163–71.

Xu Jianrong 1998. Xu Jianrong. *Pusa zaoxiang* (Images of Bodhisattvas). Shanghai: Shanghai Renmin Meishu Chubanshe, 1998.

Xu Pingfang 1996. Xu Pingfang. "Sengqie Zaoxiang de faxian he Sengqie Chongbai" (Sengqie Statues and Worship). *Wenwu* 5 (1996), pp. 50–58.

Yamamoto 1989. Yamamoto Yōko. "Suigetsu Kannon zu no seiritsu ni kansuru ichi kosa" (The Formation of the "Water-Moon" Guanyin). *Bijutsushi* 38 (March 1989), pp. 28–37.

Yang Boda 1960. Yang Boda. "Quyang Xiudesi chutu ji nian zaoxiang de yishu fengge yu dezheng" (Artistic Style and Special Characteristics of the Inscribed Sculptures Excavated at Xiude Temple, Quyang). *Gugong Bowuyuan Yuankan* 2 (1960), pp. 43–60.

Yang Boda 1988. Yang Boda. *Yuan Ming Qing diao su, Zhongguo meishu quanji* (Sculpture of the Yuan, Ming, and Qing Dynasties). Beijing: Renmin Meishu Chubanshe, 1988.

Yang Hsüan-chih 1984. Yang Hsüan-chih. *A Record of Buddhist Monasteries in Lo-yang*. Translated by Yi-t'ung Wang. Princeton: Princeton University Press, 1984.

Yasuhiro 1934. Yukio Yasuhiro. "Todai Chōkoku Sanshu" (Three Tang Sculptures from American Collections), *Bijutsu Kenkyū* (April 1934), pp. 207–19.

Yen 1980. Yen Chuan-ying. "The Double Tree Motif in Chinese Buddhist Iconography." Parts 1 and 2. *National Palace Museum Bulletin* 14 (1980), no. 5, pp. 1–13; no. 6, pp. 1–14.

Yen 1986. Yen Chuan-ying. "The Sculpture from the Tower of the Seven Jewels: The Style, Patronage, and Iconography of the T'ang Monument." Ph.D. diss., Harvard University, 1986.

Yen 1987. Yen Chuan-ying. "Wu Zetian yu Tang Chang'an qibaotai shidiao foxiang" (Buddhist Sculptural Images from the Seven Treasures Tower). *Yishuxue*, no. 1 (1987), pp. 41–89.

Yi 2005. Yi Seon-yong. "Bulbokjangmu Guseong-gwa jingmul-e gwanhan yeongu" (Study of Relics and Textiles from Buddhist Sculptures). Master's thesis, Dongguk University, 2005.

Yongjing 1989. *Yongjing Binglingsi* (Bingling-si Grottoes at Yongjing). Beijing: Wenwu Chubanshe, 1989.

Yü 2000. Chün-fang Yü. *Kuan-yin: The Chinese Transformation of Avalokiteśvara*. New York: Columbia University Press, 2000.

Yu Weichao 1990. Yu Weichao. "Dong Han Fojiao Tuxiang Kao" (Notes on Eastern Han–Dynasty Images of the Buddha). *Wenwu* 5 (1990), pp. 68–77.

Yungang 2006. *2005 nian Yungang guoji xue shu yan tao hui lun wenji* (Records of the 2005 National Conference on the Yungang Caves). Beijing: Wenwu Chubanshe, 2006.

Yunnan Provincial Cultural Relics Work Team 1981. Yunnan Provincial Cultural Relics Work Team. "Dali Chongsheng si santa zhuta shici he qingli" (Survey and Renovation of the Main Pagoda at the Chongsheng Temple in Dali). *Kaogu Xuebao* 2 (1981), pp. 245–67.

Yunnan Provincial Museum 2006. *Yunnan Sheng Bowuguan* (Yunnan Provincial Museum). Beijing: Wenwu Chubanshe, 2006.

Zhang and Luo 1988. Zhang Yuhuan and Luo Zhewen. *Ancient Chinese Pagodas*. Translated by Gao Guopei and Ma Chunguang. Beijing: Science Press, 1988.

Zhang Changping 2007. Zhang Changping. "Guanyu Zenghouyi zunpan shi foucai yong shilafa zhuzao zenglun de pingshu" (A Review of the Discussion of Whether the Lost-Wax Technique Was Used on the Zenghou Yi Vessel). *Jianghan Kaogu* 4 (2007), pp. 85–90.

Zhang Lintang 2004. Zhang Lintang. *Xiangtang shan shi ku* (Xiangtangshan Grottoes). Beijing: Waiwen Chubanshe, 2004.

Zhang Zong 2000. Zhang Zong. "Exploring Some Artistic Features of the Longxingsi Sculptures." *Orientations* 31 (December 2000), pp. 34–63.

Zhejiang Cultural Relics Bureau 2005. Zhejiang Cultural Relics Bureau. *Leifeng ta yi zhi* (Leifeng Pagoda Site). Beijing: Wenwu Chubanshe, 2005.

Zhejiang Cultural Relics Work Team 1958. Zhejiang Cultural Relics Work Team. *Jinhua Wanfo ta chu tu wen wu* (Cultural Relics Excavated from the Wanfo Pagoda, Jinhua). Beijing: Wenwu Chubanshe, 1958.

Zheng 1989. Zheng Zhenduo. *Wei da de yi shu chuan tong tu lu* (Illustrated Catalogue of the Great Heritage of Chinese Art). Shanghai: San Lian Shudian, 1989.

Zhongguo Zang chuan fo 2002. *Zhongguo Zang chuan fo diao su quan ji* (Compendium of Buddhist Sculpture from China and Tibet). 6 vols. Beijing: Beijing Meishu Sheying Chubanshe, 2002.

Zhou Weirong et al. 2006. Zhou Weirong, Dong Yawei, Wan Quanwen, and Wang Changsui. "Zhongguo qingtong shidai bucun zai shilafa zhuzao gongyi" (No Lost-Wax Casting Technology in Chinese Bronze Age). *Jianghan Kaogu* 2 (2006), pp. 80–85.

Zhou Weirong et al. 2009. Zhou Weirong, Dong Yawei, Wan Quanwen, and Wang Changsui. "New Research on Lost-Wax Casting in Ancient China." In *Metallurgy and Civilisation: Eurasia and Beyond*, edited by Mei Jianjun and Thilo Rehren, pp. 73–78. London: Archetype, 2009.

Zhou Zheng 1985. Zhou Zheng. "Xi Wei Jushiguang Zaoxiangbei kaoshi" (Sculptured Stone Tablet of Jushiguang in the Western Wei). *Zhongguo lishi bowuguan guankan* 7 (1985), pp. 90–94.

Zhou Zheng 1990. Zhou Zheng. "Bei Wei Xue Fenggui zaoxiangbei kao" (A Study of the Northern Wei Stele with Images of Xue Fenggui). *Wenwu* 8 (1990), pp. 58–65.

Zürcher 1990. Erik Zürcher. "Han Buddhism and the Western Regions." In *Thought and Law in Qin and Han China*, edited by W. L. Idema and Erik Zürcher, pp. 158–82. Leiden: Brill, 1990.

Index

monks
altarpieces dedicated to
Maitreya with attendant
figures, Northern Wei
dynasty, gilt bronze (cat. no.
7a) and gilt leaded bronze
(cat. no. 7b), 204, *205,*
205n15
Ari and Azhali sects, 141
early representations of, 102
great adepts (*mahasiddha*s),
141–43
headgear associated with,
95, 124
monk or arhat, Northern
Song dynasty, dry lacquer,
128, *129*
Northern Qi dynasty, gilt
leaded bronze (no. A15),
172, 207
Sengqie. (*See under* Sengqie)
Shariputra, on Trubner stele,
189, 194
Sui dynasty: leaded bronze
(no. A17), 32, 44n17, *173,*
207; Sui or Tang dynasty,
sandstone (no. A19), 33,
33, 173
Tang dynasty: Ananda, figure
prob. representing,
limestone (cat. no. 18), 102,
102, 103, 208, 210; head of
monk, possibly Henan Prov.,
limestone (no. A25), *175;* Sui
or Tang dynasty, sandstone
(no. A19), 33, *33, 173*
mountain settings, as abodes of
spiritual beings, 109–10
Mujing-si steles, engraving of
Avalokiteshvara chapter of
Lotus Sutra, Northern Qi
dynasty, stone, 6th c., 78
musician playing drum, Northern
Wei dynasty, Henan Prov.,
possibly Longmen complex,
limestone (no. A7), 44n24,
170

N
Nalanda (monastic and pilgrimage
center), 18
Nandimitravadana (*A Record of
the Abiding Dharma Spoken
by the Great Arhat Nandi-
mitra*), 22, 112–15
Nanzhao kingdom, 138
necklaces: in archaizing style, 144;
in Avalokiteshvara chapter
in Lotus Sutra, 78; on
bodhisattvas on Buddhist
triad plaque (cat. no. 14), 90;
from Dunhuang complex,
146n2; Gao family,
bodhisattvas with jeweled
harnesses linked to, 75–78;
on International Tang–style
Avalokiteshvara (cat. no. 19),
104; in Li Jingxun tomb,
76, *76;* on Liao-dynasty
Avalokiteshvara, 18; with
matching earrings, 124;
on Ming-dynasty
Avalokiteshvara, 22;

on Shandong Province
bodhisattva, 13; on Sui-
dynasty Avalokiteshvara
(cat. no. 12), 86; on
Ushnishavijaya (cat. no. 44),
164; on Water-Moon
Avalokiteshvara (cat. no. 24),
118; on Yuan-dynasty
bodhisattva, 21; on Yunnan
figures, 140, 141
Nepal, 3, 20, 144, 150, 164, 166
Ng, Won Yee, 36, 38, 119n6,
208, 215n2
Ngawang Lobzang Gyatso
("Great Fifth" Dalai Lama),
23–24, 166
nianfo (calling of the Buddha's
name), 14
Nikaya/Hinayana Buddhism, 6, 16
Ningbo, 25n30
Ningxia, 19
nirmanakaya, 91
Niya, 9, 48
Northern Liang period, 9–10
Northern Qi dynasty, 12, 34, 75,
78, 79, 82, 85, 92, 99
Northern Song dynasty, 18, 19–20,
25n29, 39, 124, 128, 130
Northern Wei dynasty, 10–12, 33,
50, 53, 57–58, 66, 70, 76, 92,
96, 162, 189, 191, 195, 198
Northern Xiangtangshan, Hebei
Prov., Northern Qi dynasty,
79, *79;* attendant
bodhisattva, central cave,
limestone, *80,* 80–81;
Buddhas on central pillar,
north cave, limestone, *79,*
79–80; head of attendant
bodhisattva, central cave,
limestone (cat. no. 10b),
79–82, *80;* right hand of
Buddha, prob. north cave,
limestone (cat. no. 10a),
79–82, *80;* stylistic
differences between
Southern Xiangtangshan
and, 81
Northern Zhou dynasty, 12, 76
Nurhachi (Manchu-dynasty
progenitor), 23

O
oversized hands, Buddhas with,
57, 60

P
pagoda-shaped stele section,
Western Wei or Northern
Zhou dynasty, serpentinite
(no. A14), 33, 35, *172*
pagodas, 82, 85
painting
arhat handscrolls, Northern
Song dynasty, Seiryō-ji,
Kyoto, 109–10, *110*
blue-and-green landscapes,
Tang dynasty, Dunhuang
complex, 109
guardians, cave 285, Dunhuang
(Mogao) complex, 538, 134
handscroll of Buddhist images
by Zhang Shengwen, 134,
135n6, 136, *136,* 141

Helinger, Inner Mongolia,
multichambered tomb with
murals, late 2nd c., 7
Jambhala in white manifesta-
tion, Mongolian painting,
19th–20th c., 166, *167*
Kucha kingdom: Buddha mural,
Kumtura complex, cave 69,
52; tympanum with
Maitreya, Kizil complex,
cave 224, 56, *56*
mural of Shakyamuni
preaching to an assembly,
Jin dynasty, Yanshan-si,
130, *130*
mural of two bodhisattvas,
Xixia kingdom, Dunhuang
complex, cave 328, 106, *108*
paintings of Water-Moon
Avalokiteshvara: Tang
dynasty or Five Dynasties
period, Dunhuang complex,
118, *118;* by Zhou Fang,
8th c., 118
of sculptures (*See* polychromy)
Sumstek, Alchi monastery,
Tikshna Majushri
iconography in, 13th c., 150
paired or twin bodhisattvas:
altarpieces with paired
bodhisattvas from Xiude-si,
95n4; mural of two
bodhisattvas, Xixia
kingdom, Dunhuang
complex, cave 328, 106, *108;*
in Pure Land (Qingtu)
tradition, 92; stele with
Avalokiteshvara and
Mahasthamaprapta, Tang
dynasty, Henan Prov.,
limestone (cat. no. 15), 35,
35, 92–95, *93, 94,* 208, 210;
stele with paired bodhi-
sattvas, Northern Qi
dynasty, stone, 92–95, *95;*
paired or twin Buddhas
Shakyamuni and
Prabhutaratna, Northern
Wei dynasty, Hebei Prov.,
gilt bronze, 12, *12*
Pakistan. *See* Gandhara; Swat
region of Pakistan
Pala kingdom, 19–20, 144
Pallava kingdom, 136–38
Panchen Lamas, 23, 24
paper, as restoration surface on
wood, 213, 215n19
parinirvana (final transcendence)
of the Buddha, 3, 7, 12, *182*
Parinirvana (Final Transcendence)
of the Buddha, attrib. to
Qiao Bin, glazed stoneware,
dated 1503 (no. A55), 40,
182, 212
pastiglia design, 156, 212
patina on stone sculptures, 34
Paulownia spp. *See* foxglove
peacock, Buddha (possibly
Amitabha) riding, Ming
dynasty, wood (cat. no. 39),
45n43, 154, *154, 155*
pensive pose, 13, 66, 74, 95

pensive-pose figure, Northern
Wei dynasty, prob. Longmen
complex, Henan Prov.,
limestone (no. A3),
44n24, *169*
Perfection of Wisdom Sutra
(Prajnaparamita), 6, 148
Persian (Sasanian) influence on
Buddhist sculpture, 8, 55,
76, 104, 162
Phagmo Drupa (monk), 143
photomicrographs of wood
samples, 216, *220–25*
piece-mold casting method:
ceramic sculptures, 40;
metal sculptures, 28–32,
29–33, 204; style and
technique, interplay of, 43
pigments. *See* polychromy
Pindola Bharadvaja (arhat), 128
Pingcheng (now Datong), 10, 53, 63
pipal tree, 38
plaque with Buddhist triad, Tang
dynasty, possibly Shaanxi
Prov., earthenware (cat. no.
14), 40, 43, 90–92, *91,* 214
polarized-light microscopy (PLM),
208
polestar deity. *See* Kui Xing
polychromy, 208–15; on
Avalokiteshvara, prob.
Northern Song dynasty
(cat. no. 27), 210, 212, 213,
213; on ceramic objects,
40, 214; consecratory
chambers, sculptures with,
43, 158; halo and mandorla
with red-painted flames, 86,
86, 209; on ivory objects,
40; on lacquer objects, 39,
214, *214;* on metal objects,
32, 208–9; on monk, prob.
Ananda (cat. no. 18), 102,
102, 208, 210; on Sengqie
figure (cat. no. 28), *129,*
210; on Simhanada
Avalokiteshvara (cat. no.
40), 156, 211, 212, *212,* 213,
222; on stone objects, 35,
35, 210, *210, 211;* on Water-
Moon Avalokiteshvara (cat.
no. 36), 148, 211, 212, 213;
wide use of, 27, 43; on wood
objects, 36, 211–13, *211–13*
(*See also* gilding)
poplar (*Populus* spp.), 37, 38–39,
217, 218, 219, *222*
porcelain, 40, 162
portable shrines: with
Avalokiteshvara, Five
Dynasties period, wood
(cat. no. 21), 36, 38, 108–10,
109, 221; with Buddha,
Turfan area, wood, 5th–6th c.
(cat. no. 2), 36, 38, 50–52,
51, 220; with Buddhist
deities, guardians, and
donors, Ming dynasty, wood
(no. A61), 36, *184,* 217, *224*
portraiture in Buddhism, 95, 102,
126, 129n7
Potala, 24
Potalaka, 19, 110, 116, 118, 158

Photograph Credits

Figure and page numbers in this volume are shown in boldface. Full bibliographic information for sources identified here with shortened citations is available in the bibliography, beginning on p. 226.

Unless otherwise noted below, photographs of works in the Metropolitan Museum's collection are by the Photograph Studio, The Metropolitan Museum of Art; new photography is by Oi-cheong Lee.

p. 26, figs. 31, 32, 35, 40, 44, 47, 48, 50, 51, 71, 76, 80, 95, 101, 111, 115, 133, 134, 149: Sherman Fairchild Center for Objects Conservation, The Metropolitan Museum of Art

fig. 1: Map by Anandaroop Roy
fig. 2: *Les Buddhas du Shandong*. Exh. cat. Paris, Musée Cernuschi, September 18, 2009–January 3, 2010 (Paris: Paris Musées, 2009), fig. 7
fig. 3 "New Discovery of Ancient Buddhas," *China Pictorial*, no. 1 (1982)
fig. 4: Peshawar Museum of Art
figs. 6, 13, 14, 19, 23, 28, 64, 81, 108, 113: Courtesy of Hu Chui
fig. 8: Angela Falco Howard, *Chinese Sculpture* (New Haven: Yale University Press; Beijing: Foreign Languages Press, 2006), fig. 3.6
fig. 10: The John C. and Susan L. Huntington Photographic Archive of Buddhist and Asian Art, Columbus, Ohio
figs. 11, 87: Thierry Olivier © Réunion des musées nationaux EO 2604, EO 1136 / Art Resource, NY
figs. 15, 56, 62, 63: Photograph © 2010 Museum of Fine Arts, Boston
fig. 16: Werner Forman / Art Resource, NY
fig. 18: Forest of Steles Museum, Xi'an
figs. 20, 82, 112: Published with permission of the Royal Ontario Museum © ROM
figs. 21, 46: Freer Gallery of Art, Smithsonian Institution, Washington, D.C.
fig. 22: Courtesy Asia Society, New York
fig. 24: © The Trustees of the British Museum / Art Resource, NY
fig. 27: Photography by Erik Gould, courtesy of the Museum of Art, Rhode Island School of Design, Providence (1989.110.62)
figs. 30, 33: Federico Caro, based on drawing from Sherman Fairchild Center for Objects Conservation
fig. 42: Photo © The Walters Art Museum, Baltimore
figs. 43, 45, 89, 106: Douglas Malicki, based on drawing from Sherman Fairchild Center for Objects Conservation
fig. 52: Michael A. Nedzweski © President and Fellows of Harvard College (1943.53.80.A)
figs. 53, 57, 58: *Chūgoku Sekkutsu* 1983–85, vol. 1, pl. 3, p. 30, fig. 60
figs. 54, 65: Tokiwa and Sekino 1939–41, vol. 2, figs. 44, 45

fig. 55: Iris Papadopoulos. Bildarchiv Preussischer Kulturbesitz / Art Resource, NY
fig. 59: Photograph by John Lamberton, The Nelson-Atkins Museum of Art, Kansas City, Missouri. Purchase: William Rockhill Trust, 40-38
fig. 60: Werner Forman / Art Resource
fig. 61: Mizuno and Nagahiro 1937, figs. 18, 19
figs. 66, 68, 69: Courtesy of Dan Downing, Light on Paper
fig. 67: Zhang Lintang 2004, p. 131
fig. 70: Chen and Ding 1989, p. 146
fig. 72: Rheinisches Bildarchiv, Cologne, Inv.-No. Bc 11, 11
fig. 73: Digital Image © 2009 Museum Associates / LACMA M.69.13.5 / Art Resource, NY
fig. 75: © Rubin Museum of Art C2003.13.1 (Har 65215) / Art Resource, NY
fig. 77: Junius Beebe © President and Fellows of Harvard College (1943.53.22)
fig. 79: Li Yuqun 2003b
fig. 83: *Chūgoku Sekkutsu* 1980–82, vol. 5, pl. 125
fig. 84: *Sō Gen Butsuga: Kaikan 40-Shūnen Kinen Tokubetsuten* (Buddhist Paintings of the Song and Yuan Dynasties: 40th-Anniversary Special Exhibition). Exh. cat. Yokohama, Kanagawa Prefectural Museum of Cultural History, October 13–November 25, 2007 (Yokohama: Kanagawa Prefectural Museum of Cultural History, 2007), p. 33
figs. 85, 86: Gridley 1995–96, figs. 2, 3
fig. 90: *Huayansi* 1980, fig. 44
fig. 92: Sherry Fowler, "The Splitting Image of Bauzhi at Saioji and His Cult in Japan," *Oriental Art* 46, no. 4 (2000), p. 7
fig. 93: Honolulu Academy of Arts (4818)
fig. 94: Chai Zejun, *Shanxi si guan bi hua* (Temple Murals in Shanxi Province) (Beijing: Wenwu Chubanshe, 1997), fig. 108
fig. 96: Nara 2009, p. 132
fig. 97: Yunnan Provincial Museum 2006, p. 35
fig. 98: National Palace Museum, Taipei
figs. 99, 100, 102: Lutz 1991, figs. 56, 53, 65
fig. 105: Evandro Costo © Réunion des musées nationaux / Art Resource, NY
fig. 114: Collection of Rainy Jin and Johnny Bai, Himalayan Art Resource (www.himalayanart.org)
fig. 124: Gu and Fan 1943
fig. 125: *Anyang* 1983, p. 7
fig. 126: Lin Shuzhong 1988, p. 145
fig. 129: Poly Art Museum 2000, p. 214
fig. 130: Isabella Stewart Gardiner Museum, Boston
figs. 147, 148, 150–55: Department of Scientific Research, The Metropolitan Museum of Art
pp. 220–25: Takao Itoh and Mechtild Mertz